GREEK GEMS
AND FINGER RINGS

photographs by

ROBERT L.
WILKINS

51 plates in color
1081 photographs
323 line drawings

JOHN BOARDMAN

GREEK GEMS AND FINGER RINGS

EARLY BRONZE AGE TO LATE CLASSICAL

new expanded edition

© 1970 and 2001 Thames & Hudson Ltd, London

This new expanded edition published in the United States of America
in 2001 by Thames & Hudson Inc., 500 Fifth Avenue,
New York, New York 10110

Library of Congress Catalog Card Number 00-101391
ISBN 0-500-23777-8

Printed and bound in Singapore by Kyodo Printing Co (S'pore) Pte Ltd.

for
SHEILA
JULIA
MARK

CONTENTS

PREFACE

This is a big book about the smallest works of art to have survived intact from antiquity. They have long fascinated collectors, and if they have missed their due of attention from scholars this is because of the difficulties inherent in their study. I have attempted to satisfy the curiosity of scholars and students who are concerned with the history of gem engraving in Greek antiquity, with its relationship to other arts and with the iconography of the engraved scenes; and I hope my approach will serve both archaeologist and art historian. For collectors, connoisseurs and any lovers of fine objects the range of illustrations and comment tries to provide a rich selection and comprehensive view of all Greek gems surviving in museums and from excavations; or, if not *all*, at least as many as I have been able to discover in some years of search in collections and publications. The subject is a rewarding one and I hope I have conveyed something of the satisfaction I have derived from the study.

The scheme of the book is, first, to provide a narrative account of gem engraving from the Early Bronze Age in Greece to the Hellenistic period. This is closely linked to the illustrations which are chosen to represent all the important styles and motifs and which, for some periods, in fact present a very large part of the surviving material. Special attention is paid to the shapes of the gems and rings, to their materials and iconography.

The authorities, ancient and modern, for statements in the text will be found either in the Lists of Illustrations, which include both description and further comment, or in the Notes on the Text. It is in the Notes that the rather disparate state of modern studies in this subject is revealed. Much has been published about Bronze Age gems (Chapter II) in recent years, but generally piecemeal, and an overall view relating the gems to the other arts and to the history of their times seemed desirable. The gems themselves have been, or are being, well published, so in the Notes references are often selective, documenting styles or subjects rather than listing all known specimens. The Geometric and Archaic gems and rings of the Greek Iron Age (Chapters III, IV) have already been discussed by the writer in *Island Gems* (1963), *Archaic Greek Gems* (1968) and an article on Archaic Finger Rings (1967). A different, more historical account can be given here, and the lists merely supplemented in the Notes. For the Classical period (Chapter V) and the Greco-Persian gems (Chapter VI) a fuller treatment is required, and I have listed in the Notes all specimens known to me. The story of Hellenistic gem engraving belongs rather with that of the Roman period, and only a summary account is offered in Chapter VII. Techniques are discussed throughout, but some basic problems are treated more fully in a final chapter, where the origins, nature and periods of use of the main materials are also listed. There are some practical hints on making impressions and on photography in the Notes and a summary Gazetteer of collections.

It will be easy for the reader, as it has been at times for the author, to forget just how small these objects are—none bigger than a penny; many smaller than the smallest finger nail. Despite skills in photography and reproduction the objects have to be shown in illustrations up to four times their natural size if all their detail is to be appreciated. The colour photographs, also enlarged, may serve not only to indicate the colours of stones but also something of their quality as jewels.

Most of the plate illustrations are of plaster impressions, and these require some words of explanation. It is fashionable today to decry the use of plaster impressions for the study of engraved gems, and it is certainly true that there are few museum workshops which can produce plaster impressions of the quality of those made over fifty years ago. But there is no doubt whatever that the ideal material for viewing and for the photography of impressions is plaster of Paris, slightly tinted. All plasticene, plastic or rubber compounds have a disconcerting surface sheen, and photographs of the original stone are often impossible, regularly deceptive (see below). If ancient authority is required for the practice followed in preparing most of the impressions illustrated in this book we may cite Theophrastus, the fourth-century BC philosopher and scientist, who declared plaster superior to all other earths or clays for taking moulds and impressions. White plaster casts of ancient metalwork, of the Hellenistic and later periods (as from Begram) are by now familiar and valuable evidence both for lost originals and for the ancient use of the material for moulds and casting.

The modern answer to the labour of making and photographing a plaster impression is to declare that the only true view of an engraved gem is of the original stone, and two recent volumes almost wholly abjure use of impressions in any material. This, of course, ignores the artist's intention, which was to create something from which an impression can be made or a sealing recognised. Some devices are quite unintelligible on the stone because its colouring is mottled or banded, or because the convex surface does not allow even reflection of light. These considerations are not weakened by the fact that many engraved gems may have been intended as jewels rather than seals, by the minority of examples which can be viewed successfully in original, or by metal finger rings which can all be viewed in original, since even for these (in the Greek period) the artist took care to see that right-handedness was shown in the impressions and not on the stone or metal.

There are aesthetic considerations too. The photograph of a stone or metal intaglio will give the eye a satisfactory illusion of relief, since we are not accustomed to viewing hollowed figures; but it is still an illusion. In such photographs emphasis inevitably falls upon the contour of the figure, set off sharply from the flat and often polished background. However, the artist's intention was to create, ultimately, a relief figure whose value would be judged by the light falling on the relief modelling and not by the crispness of contour. And for indicating *relative* relief of modelling photographs of intaglios rather than impressions can be seriously misleading. The greatest dangers lie in viewing and judging Archaic and Classical Greek gems in original and not in impression, since the more formal qualities of the figures suffer greater change. The writer has been more than once deceived in judgement of style or hand by the use of photographs of originals. There is less danger with the more abstract pattern of many Bronze Age gems or with the shallow cut, realistic styles of the later Hellenistic and Roman periods.

In the interests of truth, then, we study and present the gems in impressions—but these gems are jewels too, their intaglios sparkle beneath the lamp and the clear marks of drill and polisher help the illusion of viewing works of art at first- and not second-hand. A number of photographs of originals, accordingly, have been used in the book: freely for finger rings, where the subject seems to suffer less when viewed thus, as it must regularly have been in antiquity; less often for stone gems, and only where good photographs of impressions are available for study elsewhere. Occasionally both stone and impression are illustrated, and, once, two views of the same impression, differently lit. The line drawings in the text present pieces for which good impressions were not available for photography, or whose interest lies in their subjects rather than their style. For the Bronze Age in particular there is a tendency to study gems in drawings rather than good impressions, well photographed. But where devices are confused the subjective interpretation of a draughtsman can be seriously misleading, while the differences in drawings of the same piece by different hands show what poor sources they are for stylistic judgements.

In collecting the material for this book I have tried the temper and generosity of many museum curators and other scholars. Detailed acknowledgements are made at the end of the book but my debts to others involved in other aspects of its production may be mentioned here: to the late Walter Neurath, who encouraged my gem books, and to the staff of Thames and Hudson, especially Miss P. Lowman; to the Librarian of the Ashmolean Museum Library, Mr R. F. Ovenell, and his staff; to Robert L. Wilkins for his brilliant photographs; to Miss O. Rennie for help with plaster impressions; to Mrs M. E. M. Cox for the drawings; and to my family, for years of patience with tiny photographs, dumps of plasticene and congealed plaster of Paris.

JOHN BOARDMAN

This volume is a reprint of the edition of 1970 to which has been added a chapter, 'Epilogue 1970–2000'. The study of ancient engraved gems and finger rings has been busy in the last thirty years, with much serious publication of collections, and discussion of iconography and artists. The historical importance of many classes, especially those made on the periphery of the Greek world, has also attracted much attention. It would not be too much to claim that by now the subject has regained the important position it used to hold in studies of classical art. The opportunity has been taken here to reflect on this, to summarize recent work, to offer an additional select bibliography and seventy new illustrations.

JB April 2000

ACKNOWLEDGEMENTS

The following museums, scholars and collectors are thanked for facilities to study their gems and permission to mention or publish them:

Athens, Numismatic Museum (M. Karamessini-Oikonomides); Baltimore, Walters Art Gallery (D. K. Hill); Berlin, East (E. Rohde, H. von Littrow); Berlin, West (A. Greifenhagen); Bonn (H. Himmelmann-Wildschutz); Boston, Museum of Fine Arts (C. C. Vermeule, M. Comstock); Bowdoin College (K. Herbert, R. V. West); Budapest (J. G. Szilagyi); Cambridge, Fitzwilliam Museum (R. V. Nicholls, G. Pollard); Geneva (M. L. Vollenweider); the Hague (M. Maaskont-Kleibrink); Hanover (M. Schlüter); Harvard, Fogg Museum (A. Ramage); Heraklion (S. Alexiou); Istanbul (N. Firatli); Leningrad (K. S. Gorbunova); Liverpool (E. Tankard, D. Slow); London, British Museum (D. E. L. Haynes, R. D. Barnett); Munich (H. Küthmann); Naples (A. de Franciscis, A. Gallina); New York, Metropolitan Museum (D. von Bothmer); Nicosia (V. Karageorghis, K. Nikolaou); Oxford, Ashmolean Museum (R. W. Hamilton); Paris, Bibliothèque Nationale (G. le Rider, F. Rosswag); Paris, Louvre (P. Devambez, P. Amiet); Péronne (J. Baradat); Rome, Villa Giulia (M. Torelli); Salonika (Ph. Petsas); Syracuse (P. Pelagatti); Taranto (F. lo Porto, E. Lattanzi); Toronto (N. Leipen); Vienna (R. Noll); H. Hoek, H. Cahn, M. L. Erlenmeyr (Basel); E. Merz (Bern); K. J. Müller (Bonn); N. Metaxas (Heraklion); J. Bard, the Lady Adam Gordon, D. Russell (London); A. Moretti (Milan); H. Seyrig (Neuchâtel); Gordon (Oxford); A. J. Palmer (Rustington); H. Remund, L. Mildenberg (Zurich); E. Oppenländer.

Of the scholars whose advice I have sought on particular points I have to thank M. A. V. Gill, who read an early draft of chapter II; also, the late A. W. L. Kingsbury; J. H. Betts, D. Bivar, E. Brandt, B. Buchanan, H. Cahn, I. Dakaris, E. Diehl, P. M. Fraser, V. Grace, L. H. Jeffery, V. E. G. Kenna, O. Masson, H. W. Mitchell, P. R. Moorey, C. M. Robertson, B. B. Shefton, M. L. Vollenweider.

Robert L. Wilkins took the photographs of virtually all the impressions, and of stones and rings in London, Oxford and Nicosia. Stones and rings in Paris (BN) and Leningrad were photographed by the author. Some other photographs have been kindly provided by the following scholars, collectors, photographers, and institutions: E. Bielefeld, B. Buchanan, H. Cahn, W. Forman, M. Hirmer, H. Hoek, H. Hoffmann, O. Masson, J. Powell, M. L. Vollenweider, D. Widmer; Boston, New York, Oxford, Paris (Louvre), Plovdiv, Taranto, Vienna.

The drawings are by Marion Cox.

Nearly all the impressions were made by the author, with the help of Miss O. Rennie for the final plaster impressions. Impressions in the Ashmolean Museum (as of the Lewes House gems) have also been freely used. Other impressions were provided from: Athens (Numismatic Museum), West Berlin, Boston, Bowdoin College, the Hague, Hanover, Harvard, Rome (Villa Giulia), Salonika; M. A. V. Gill, K. J. Müller, M. L. Vollenweider.

The Meyerstein and Greene Funds in Oxford kindly helped me with the expenses of some visits to museums, and a Visiting Professorship at Columbia University in 1965 gave a valuable opportunity to study the American collections.

In compiling the Epilogue I have been much helped by Helen Brock (Bronze Age bibliography) and Jeffrey Spier. For photographs I am indebted to various sources, museums and collectors; some photographs are my own (mainly Paris and Swiss private); others, with most photographs of impressions, are by R. L. Wilkins. Others who have helped to this end have been Adriana Calinescu, Derek Content, Robert Hindley, Joan Mertens, Jonathan Rosen, Erika Zwierlein-Diehl.

Chapter I

INTRODUCTION

Gems, seals, stamps, signets—the ways in which we describe the objects of this study may be very varied, and they may call to mind activities as different as magic or book-keeping, forgery or haute couture. In Greek antiquity the descriptions and range of possible uses were no less diverse, but the forms of the objects themselves are more easily defined. Most are small, semi-precious stones, ranging in overall size from about one to three centimetres and designed to be worn as pendants, strung on necklaces or set on finger rings; or they may be all-metal rings with broad flat bezels instead of a setting for a stone. What they have in common is a device—a figure, pattern or even inscription—cut in intaglio so that when it is pressed onto wax or clay the 'engraving' (a convenient misnomer) is rendered in relief. This is one of the reasons why we normally study these devices in impressions, and why most are here illustrated from impressions.

Nowadays, when seal use is slight, when signets are rarely cut and even more rarely used, it is not easy to appreciate the importance attached to them in antiquity. In each of the following chapters an attempt is made to judge the surviving evidence for the practice of sealing, but there are some general considerations about the use of seals and engraved gems which can usefully be discussed without reference to any particular period or place. The basic purpose of sealing is to secure and identify property by so marking the sealing material that, if it is broken, it can be replaced only with the use of the same signet with its distinctive device. As a result of such usage either the signet or its device may acquire a special significance as the identification of the owner, and by gift of a signet authority may be delegated to a steward, messenger or subordinate officer. This is a personal use, whether in private or public affairs, but a seal may also be used on behalf of a state or government to certify a document or guarantee official standards. A close corollary of this is the use of state devices on coins, which were struck from intaglios similar to those on stone seals or signet rings, and there will be other related uses to observe in the Classical period. From this varied usage it became easy to ascribe other properties, magical or healing, to seals and rings.

A social and economic system which involves a need for seals indicates not only some degree of organisation, but a special regard for and recognition of personal property and authority. Seals were in general use throughout the Bronze Age in the Near East, Egypt and in most of the Aegean world, but only in Italy and the rest of Europe after the example had been set by Phoenicians and Greeks. The use does not presuppose literacy, and there were literate societies—parts of Archaic Greece and Italy—which did without seals, just as there were many societies which did without coinage even after it was in general use in Greece and on the eastern shores of the Mediterranean.

Any individual device must be readily identifiable, but in antiquity it was seldom thought necessary to add an inscription which would make the ownership explicit and there are often only nuances of difference between very similar devices which are popular in a given period or place. This may suggest that the identity of a device was not always of primary importance, but simply the act of sealing—just as, today, sealing wax is often used without seals. To make a distinctive impression, whether individual or not, the most accessible implement would be some natural object, like the broken end of a stick or a

broken stone. Nowadays we would think of thumb prints. We shall find evidence for the use of worm-eaten pieces of wood as seals, and there is record of the use of matching halves of broken sticks to establish identification, while the idea behind the use of the broken end of a bar as the stamp for the reverse of early coins is closely related. The patterns produced by natural objects when impressed on clay had recommended themselves at various periods in antiquity to potters, and there may have been more widespread use of similar decorative devices on the unfired mud or clay used for bricks or to face walls. The impressions left on clay or daub fallen away from wattle or sticks—a common and primitive type of walling—could have indicated the value and variety of such patterns. And one way to secure a door fastened by a stick or cord would be to press clay over the latch or knots and to mark its surface with a device.

One of the earliest forms of seal, widespread in the Near East and for a while in Egypt, was the cylinder with its intaglio cut in its long curved walls. It is tempting to think that its use might owe something to patterns produced by rolling the rough bark of a length of stick over moist clay—a primitive form of rouletting. It is otherwise a strange shape to invent for a seal, although, when worked in stone, it does provide some technical advantages for the engraver since he cuts less deep into the convex stone to produce, in the rolling, relief on a flat background. It could also produce strip decoration or uninterrupted sealing across a mass or tablet. The other basic seal shape is the stamp, producing a single impression whose outline is that of the seal face. This is the commonest form in Egypt, it was much used in the Near East and preferred before all others in the Aegean world. The seals are worn on strings or pins (for some cylinders) on different parts of the body, and their attachment to a ring worn on the finger comes comparatively late in the history of ancient seals, and indeed only becomes at all common after the sixth century BC, in Greece and Italy. The way some seals were worn, on necklaces or wristlets, helped determine their form, like the bead-shaped seals of Bronze Age Greece. Convenience of use indicated handles for stamp seals, or their attachment to swivels and finger rings. Religious or decorative considerations introduced seal types, like the Egyptian scarab and the various figure seals which were fashionable in many periods.

The decorative value of seals has to be considered with regard to both their shapes and their devices. When they are elaborately set in gold, as occasionally in the Near East and often in Etruria, we may suspect that the purpose was more cosmetic than sphragistic. This certainly becomes true of finger rings in precious metal in the Greek Classical period and later. Once the wearing of seals is as much a matter of fashion as of business it becomes the hallmark of the dandy, as Aristophanes observes, and a wider demand is created and eventually satisfied by the production of second rate seals or by mass production in glass. The impressed patterns from seals could also be used for purely decorative purposes, and in Greece we have evidence for their employment on objects of fired clay—vases and loomweights.

In the Near East and Egypt the intaglio devices on seals had a comparatively restricted range of subjects —animals, religious or royal occasions, and, especially in Egypt and the Hittite empire, inscriptions. Scenes became stereotyped, and there were rare periods in which seal engraving clearly shared the status of the highest arts although seals were being produced in considerable numbers. In Greek lands, including Minoan Crete, the story is somewhat different and the history of seal engraving has a special contribution to make to our understanding of the development of other arts. This, I hope, will become apparent in the following chapters, but it requires some preliminary remarks about the manner in which Greek gems have been studied hitherto, and some words of justification for the way in which they are presented in this book.

The Greek tradition of gem and cameo carving has enjoyed a virtually uninterrupted career, in different parts of Europe, to the present day. Gems were among the first antiquities to arouse the ardour

of a collector, even in antiquity, and we hear of cabinets of engraved gems being formed by Hellenistic kings and Late Republican Romans, generally in their eastern provinces, but soon in Rome itself. Many Greek and Roman gems remained above ground in the Middle Ages, set in caskets, vases or religious furniture, to be admired and copied in the Renaissance and later. They were assiduously collected by Renaissance artists and patrons, and some of the finer European collections were begun in the seventeenth century. This meant that the study of gems was generally conducted by amateurs, connoisseurs and collectors, and although these were also the scholars of the day, this combination of skills and interests is out of tune with the modern prerequisites for collecting and scholarship—on the one hand a fat purse, on the other the dedication of a professional. The tradition of amateur study persisted for gem engraving longer than it did for Greco-Roman sculpture, dominated by considerations of aesthetics, the evocation of an ideal Classical past, and the less precise 'art-historical' rules. Nevertheless, the gems bulked large in the studies of scholars who devoted themselves to a proper understanding of Classical antiquity and its art, from Winckelmann on. The corpus of Classical myth could most easily be illustrated by collections of gem impressions, and in the late eighteenth century a collector or scholar could choose his cabinet of impressions from Tassie's catalogue of nearly 16,000 pieces (not all ancient). At the end of the nineteenth century Adolf Furtwängler brought the discipline and range of a truly great scholar's mind to the subject, but his example has been little followed and the study has, until recent years, been regarded as peripheral to that of Greek art, rather as numismatics is to that of Greek archaeology, with as little reason and to the detriment of both studies. One of the challenges set by the study is to strike a mean between the usual art-historical approach, which takes gem impressions as mirrors in miniature of the other and 'major' arts, and inbred studies, usually conducted by scholars dedicated to gems alone, which do not readily place them in their proper historical context or relate them to other and sometimes foreign arts. They perhaps require a more cold-bloodedly archaeological approach, prepared to consider the full evidence of shape, material and context rather than simply submit to the fascination of the intaglio; searching for indications of their use and purpose; relating them to the achievements in other crafts, in other places; reading their iconography both as a supplement to other sources and as an important and independent source of its own. Furtwängler attempted much of this, and the last two generations have brought our knowledge of Greek art and archaeology to the point at which it is worth attempting again. For too long gems have been judged as isolated works and either dated in terms of direct comparisons with better documented arts, like vase painting, or suspected of being undatable. A result is that recent studies and catalogues can still date Island Gems to the eighth century BC or earlier, instead of the sixth and seventh; or Archaic Greek scarabs and Etruscan rings to the seventh century instead of the sixth; Archaic passes as Bronze Age; Roman passes as Greek; modern passes as Roman; while in Bronze Age studies modern systems of chronology seem to be controlling the material instead of being dictated by it. It is, moreover, still a regular practice in catalogues and corpora to fail to record shapes properly. No other class of antiquities still suffers such mistakes and shortcomings in its study. This book cannot remedy them all, nor could it compete with much of Furtwängler's, but I hope it succeeds in reviewing as great a range of the relevant evidence as possible, and that it may point the way for further studies which may correct it in detail.

It might, then, be judged a comparatively simple matter to reduce the study of Greek gems to the familiar terms of the study of Greek vases or bronzes: to observe excavated contexts; to trace the development of style and compose a typology of shapes; to distinguish workshops and artists; to classify the scenes and relate them to their treatment by other artists or authors. Unfortunately this is not so. The study has problems of its own, as well as problems which it shares with other arts but to a special degree. Some may be mentioned here.

The vast majority of Greek gems entered public and private collections with no indication of provenience or no certifiable origin. Only a very small proportion are from clear excavated contexts —more from the Bronze Age, hardly any in later periods. None carry inscriptions with explicit reference to a historical personage or event. But while we mourn the lack of contexts which might indicate origin or date we have also to consider the limitations of such contexts as are available. These are dictated by the nature of the material, and are not shared to the same degree by other antiquities. No work of art is more portable and likely to be found far from its place of origin. No artist can have been more mobile than the gem engraver, with his drill and a pocket full of pebbles. No other ancient works are so indestructible, and although this means that many are preserved in almost 'mint' condition, it also indicates their suitability for very long periods of use, passed on to heirs or successors in office, or simply as precious objects. Datable contexts are therefore strictly *ante quos non* and many are demonstrably very much later than the probable date of production. There are several extreme examples of this—Greek Bronze Age gems in Roman period graves, or the Middle Assyrian cylinder found recently in a Roman legionary's grave at Mainz. In the course of long use a gem might be recut, a new intaglio supplied on an old back, a subsidiary device or inscription added or the main device 'improved'. On grounds of technique alone these changes can hardly ever be proved on gems, as they can on vases, bronzes or major sculpture, and we rely on more subjective criteria of style.

What, then, for attributions to hands or workshops? There are no signatures on Bronze Age gems, and on Archaic and Classical gems less than a score of probable signatures are met, with Dexamenos signing four gems and Onesimos three. We are left with wholly stylistic criteria to determine the nuclei of studio or individual oeuvres, rarely helped by distinctive shapes or materials. What measure of success can be expected? Some 5,000 Greek Bronze Age gems or devices are known, an average of about six per annum over the period of production, but for most of it far less, with some useful concentrations of material at certain points. They were being made in different places in both Crete and Greece. Of the Archaic Island Gems we have three or four per annum, but since these may all be from one centre there are better chances of identifying individual styles. The later Archaic gems were made in the islands, East Greece and Cyprus, and we have an average of five or six per annum for the period of production. Classical gems and finger rings may have been made in different parts of the Greek world, outside it to the east and in the western colonies. Again we have perhaps an average of five or six per annum. Compare, for a moment, our knowledge of Athenian figure-decorated vases of the sixth and fifth centuries BC which we know to be all from the potters' quarter of one city. For an average figure of surviving examples 300 per annum is modest, and often more than a hundred works can be attributed to a single artist. The prospects for comparable success in the study of gems are nil. The attribution of two or three to a single hand is something of an achievement, and the likelihood of being able to identify early or late work is minimal.

When so much is left to subjective judgements about style the problems of identifying regional rather than individual styles become even more acute than they are in other arts. They arise when the art of gem engraving is introduced by one culture to another, or when a style is indebted to two different cultures. To the former class belongs the introduction of gem engraving to Mycenaean Greeks by Minoan Cretans, and to Etruscans by Archaic Greeks; and the problem is to distinguish the work of immigrant artists and the establishment of native studios. To the latter belong the Greco-Persian and Greco-Roman gems, and the problem is to determine the degree of dependence on Greek or oriental, Greek or Italian styles, and the nationality of the engravers. Or rather, these are the problems as they are usually defined and argued—inevitably to no clear conclusion. They are posed in this form because it is believed that there was 'something in the blood' of, say, a Greek artist which must characterise his

16

work, and 'something in the blood' of an oriental or Etruscan which made it impossible for him to learn certain subtleties of Greek style. The existence of clearly definable national or regional styles cannot be denied, but it can have been no more difficult for an Etruscan or Mycenaean apprentice to learn to work like a Greek or a Minoan, than it is for a Pakistani art student in London to learn to draw like an English academic. So in the crucial transitional periods, when artists are on the move and styles are being taught and learnt, the questions 'Minoan or Mycenaean?', 'Greek or Etruscan?' are meaningless, although after this transition the development of a local style will be determined by the environment and society it has to serve, and unskilled copies can always be detected. We shall waste little time in these chapters on speculation about the nationality of artists, rather than deciding where, when and why different classes of gems were made, but the historical problems of borrowed styles and travelling artists have always to be faced.

Other difficulties are posed by the gems themselves, regardless of origin and style. Although most have survived in near perfect condition even the harder stones are subject to wear. It is easy to misjudge what the effects of wear on the stone might be on the impression. Surface wear reduces what, on the impression, is seen as the background and not the higher relief, which is the deepest cut in the stone. The outlines of figures may suffer, the area of high relief in impression is reduced in size, while outlines may spread. All this may seem obvious but in a recent gem book the absence of breasts on a presumed female figure was explained by a 'worn surface', while of course the loss of these features on the impression could only be effected by filling in the stone intaglio, not wearing it down.

A chimerical difficulty is forgeries, of which scholars have an unreasonable fear. Acquaintance with excavated examples and with undoubtedly authentic pieces in collections soon breeds a justifiable confidence in the identification of forgeries. There are at any rate few modern forgeries of Greek gems of a quality which could mislead. The problem only becomes acute with later gems of styles familiar to skilled copyists and artists of the eighteenth and nineteenth centuries. More serious difficulties arise from the extremely small size of the gems themselves and the miniaturist quality of their engraving. They are difficult to display adequately, difficult to study, difficult to publish except in gross enlargements and it is difficult to make completely perfect impressions from many of them. So it is easy to understand why they have been neglected.

Given all these difficulties in the path of the student of ancient gems it might well be asked whether anything of value can be achieved through detailed study of the subject. *Solvitur ambulando*. The rewards are rich and often unexpected. In the Bronze Age the sequence of engraved gems provides an archaeological continuum only matched by the pottery, they illustrate vividly the interaction of the two great Bronze Age cultures of the Greek world, and, by any standards, the gems are among the most original works of art of that age. In Archaic Greece they speak not only of the effect on Greek life and art of renewed contact with the east, but also of how the relics of a lost culture can affect the work of later artists. The main Archaic and Classical series afford some of the masterpieces of their day in any art, and offer evidence for the arts in areas of the Greek world, and outside it (as in the Persian empire), where the archaeological record is otherwise scant or equivocal. The figure scenes indicate iconographic traditions outside those most familiar from studies of vase painting and sculpture. And in all periods the gems and seals are evidence for a usage affecting the community at all levels—state security, official standards, private security, personal adornment.

Perhaps the most interesting problem posed by the study of gems can bring us closer to an understanding of the basic principles and character of Classical art. The essential unity of the arts in Classical Greece has often been remarked. We can study and judge a gem impression and its subject with much the same criteria which we use in the face of major sculpture or painting. It is likely that this unity

is less a matter of any vaguely defined, all pervasive sense of style or period interpreted by the artists, and more a matter of personal versatility. The arts may today be studied in isolation, but they were not practised in isolation. The most famous Archaic gem engraver recorded by ancient writers was Theodoros of Samos. He was particularly renowned for the engraved ring which he made for the tyrant Polycrates, but he was also an architect associated with two of the greatest Ionic temples of all time, and a sculptor remembered for his casting of bronze. The great sculptor Pheidias, doyen of the High Classical style in Periclean Athens, was a painter, and remembered too for his miniaturist glyptic—a cicada, a fly and a bee—all subjects of surviving Classical intaglios. And it has always been so. Benvenuto Cellini, whose profession was goldsmith, also engraved gems, made coin dies, carved marble, cast bronze and was an architectural designer and military engineer. It is easy to multiply examples. We may never be able to recognise a gem engraved by Pheidias, or a sculpture by Dexamenos, but we may feel sure that such existed and may still survive. It is with this knowledge that we should approach the arts of Classical Greece, and not just those arts that are best known or have best survived. In the light of it our study of one of the major arts, gem engraving, can be seen to be a contribution to our understanding of the whole.

Chapter II
MINOANS AND MYCENAEANS

INTRODUCTION

'LOADSTONE. (*A seal.*) *Ch. Townley* Esq. A bull thrown upon the ground and torn by a lion, and a griffin winged.' This is entry no. 665, illustrated in Raspe's 1791 catalogue of the gem impressions advertised by James Tassie. It is a haematite Minoan seal, now in the British Museum (our *Pl. 113*). The other 15,799 entries in the same catalogue are of impressions from Greek, Roman, Renaissance and later stones, and the Minoan singleton was the first modern publication of a Greek Bronze Age seal, at a time in which artists and collectors were fascinated by engraved gems. Almost all our knowledge of the Greek Bronze Age derives from discoveries and studies of the last hundred years, beginning with Schliemann's work at Troy and Mycenae in the 1870's. But the interest in Bronze Age gems had been awakened already. Ludwig Ross had travelled in the Greek islands earlier in the century and in a book published in 1843 he drew attention to the engraved gems—the *Inselsteine*—to be found there, especially on the island of Melos. Most of these were to prove Archaic Greek (the Island Gems, see below, pp. 118ff.) but many were of Bronze Age date and their appearance and style puzzled scholars, while the collecting continued. Schliemann's discoveries at Mycenae, and subsequent excavations at Mycenae and, for instance, Vaphio in Laconia, revealed the civilisation of Mycenaean Greece and the home of the gems, but it was only at the end of the century that Furtwängler successfully distinguished the Archaic from the Mycenaean among the island stones. By this time a new and, as it was to prove, a more important source was being explored. Arthur Evans' interest in primitive scripts had led him to study the Mycenaean finds, and in his visits to Athens he was shown seals with what appeared to be hieroglyphs upon them from the island of Crete. He visited Crete in 1894 and in a series of journeys explored its ancient sites and collected engraved gems. These formed the nucleus of a collection which for sheer quality remains unrivalled. The greater part of it is in Oxford and has been used extensively to illustrate this chapter. He found many of the stones in Crete being worn by peasants. Those with white veins were the 'milk-stones', worn on the breast to ensure the milk of a nursing mother; those with red veins were the 'blood-stayers', worn round the neck. His trips to Crete led to the excavations at Knossos and the revelation of the Minoan world. His interest in the gem stones never flagged and his studies of them incorporated in his publication of the Palace at Knossos remain basic to any further researches on the subject. The older collections of *Inselsteine* had found their way into public museums, in Leningrad, London, Berlin and Paris, while other scholars made their own collections—R. M. Dawkins, for example, and Richard Seager, whose gems are now in New York. But it is the Cretan and mainland Greek excavations of the last seventy years which have enriched the national museums of Heraklion and Athens, and which have to serve as our prime source of evidence for Bronze Age glyptic. Evans' publications and an important book by Matz on early Cretan seals dominated studies before the second world war. Since the war interest has been renewed with critical studies by Biesantz, Mrs Sakellariou and Kenna, and by the appearance of new catalogues and corpora.

The importance of these studies is by now generally acknowledged for they are central to many of the sorest of problems of Greek prehistory. The seals provide an archaeological and artistic continuum

rivalled only by the painted pottery, and being a higher art form they provide a more sensitive index to the effect of foreign influences and the development of native taste. In themselves they provide evidence for the conduct of private and public business, and the scenes on them are a major source of evidence for the religious practices of the day. One of the results of their importance is that study of them has often been bedevilled by considerations which can only fairly be entertained once the basic material is properly understood and dated. These considerations may be historical—the dominance of Crete over Greece, or vice versa; artistic—the distinction between Minoan and Mycenaean, or the Cretans' alleged 'eidetic vision'; religious—the use of amulet or talisman, the interpretation of cult scenes. And there is the usual serious temptation to consider gem-engraving in isolation from the other arts.

Another problem is set by terminology. Evans proposed a tripartite system for the archaeology of Minoan Crete: Early, Middle and Late Minoan—EM, MM, LM, subdivided I, II, III, and sometimes further subdivided by letter and number. The same system is adopted for mainland Greece—Helladic, not Minoan, the late Helladic period often being called simply Mycenaean. The system is defined primarily by pottery styles, the archaeologist's usual yardstick. It is, of course, wholly artificial but there are those who seem to believe that there is some sort of absolute 'MMIII', for instance, which existed in antiquity and can be comprehended as an entity by modern scholarship. A different system based on a more historical approach distinguishes the two main Palace periods of Crete, with pre-palatial and post-palatial phases. This cannot be applied to the mainland and presents dire difficulties when construction and destruction dates for different palaces were not the same, but it is convenient for any broad expository account, and is used for the main headings in this chapter, while Evans' tripartite system is retained for closer dating. Attempts to re-define and improve Evans' system with reference to the apparent development of gem-engraving on its own must be resisted. Problems of absolute chronology may fairly be avoided here and I give below a scheme which many scholars would find acceptable:

EM/EH	I	3000–2500 BC
	II	2500–2200
	III	2200–2000
MM/MH	I	2000–1700
	II	1700–1600
	III	1600–1550
LM/LH	I	1550–1450
	II	1450–1400
	IIIA	1400–1300
	IIIB	1300–1200
	IIIC	1200–1050

Given a working terminology and system for relating the gems to other arts and historical events, the remaining problems are of a type familiar in any archaeological study, although too easily overlooked by the art-historian. There is the danger of thinking the evidence is at least near-complete, yet some of our main sources result from the accidents of antiquity—conflagrations which bake hard and preserve clay sealings. But again, these sealings are from official archives and can tell us nothing about private usage. And the sealings suggest the existence of whole classes of seals cut in materials which have not survived, like wood. Gold signet rings and engraved gems in semi-precious stones (semi-precious to us—probably more valuable in antiquity) are luxury objects, not easily destroyed, capable of being used for a long time or of being reused long after they were made. The long survival of gems is most apparent if the find-contexts are in periods when the finer stones were no longer being cut. During the main

1 2 3 4 5

periods of gem engraving a piece might continue long in use for personal, family or official reasons, but it is possible to be over-pessimistic about the value of all datable groups which include gems. The Minoans were probably more sensitive to changes in the style of their own glyptic than we are today, and they may have been little prepared to be out-of-date.

In this chapter our principal guide must be datable excavated contexts. From these may be extracted a generalised view about what styles and shapes were current in different periods. The process is a familiar one to archaeologists working at the typology of any group of objects, from arrowheads to temples. It is not a different process because the criteria have to be applied to the main body of material, which has been found out of context, before the full sequence can be reconstructed.

EARLY GREECE (EH)

The history of engraved seals in Greece and the islands, excluding Crete, before the Late Bronze Age is patchy and tantalising. Moreover, it is almost wholly confined to the Early Bronze Age (EH) period preceding the arrival of the presumed Greek-speakers in their future homeland.

A characteristic find in some of the very earliest sites in Anatolia (modern Turkey) is a roughly conical clay stamp, usually with a round base on which is incised a very simple geometric pattern. These objects are like seals, although it is not easy to understand the circumstances in which they might be used, and it is possible that their purpose and use was mainly decorative, even for marking human or animal skin. Objects of a similar form are found in Early Bronze Age sites in the Balkans and North Greece, as far south as the Peloponnese. These indicate the survival of a tradition which passed from the east to Greece several centuries before, and might even be regarded as the first arrival of a true seal usage in Greek lands.

The most dramatic and unexpected evidence for seal use in Greece appeared in the recent excavations at the site of Lerna, which lies by the sea beyond the south edge of the plain of Argos. A palatial building known as the House of the Tiles was destroyed by fire at about the end of the EHII period. In its debris was recovered a series of clay sealings which had been preserved by being baked hard in the conflagration, a disaster of the type we have to thank for several other important finds of clay sealings from Bronze Age Crete and Greece.

The sealings at Lerna show from the markings on their underside that many were used to secure cords fastening wooden boxes, either on the sides of the box or around pegs. Some are from the shoulders or mouths of jars, others from wicker boxes. The impressed devices are flat and circular, extremely homogeneous in style. Some show linked spirals but the usual pattern is a running line, rather like a broken spiral or swastika, with variations which defy description in words (see *Figs. 1–11*). Sometimes different devices are interlocked symmetrically. The only recognisable objects shown are tiny spiders,

set at the centre of a pattern (*Fig. 11*), and beaked jugs, in a whirl with trefoils (*Fig. 8*). The quality and finesse of the cutting were clearly very high. No seals with devices of just this type are preserved, nor is this decoration seen on other objects from mainland Greece at this date. But the patterns are quite similar to some on Cretan ivories (the Mesara Group, see below), a few of which may be as early, and on other Cretan seals attested by later sealings, as at Phaistos. On the Cretan seals too we often see the spiders and jugs. It is tempting to assume that the Lerna sealings are from Cretan seals, very probably of wood, and somewhat earlier than most of the ivories which admit more animal motifs. We have to remember that spiral patterns very probably reached Crete from the north, via the Cyclades islands. Also that the boxes at Lerna were probably sealed locally and that there is virtually no evidence for imports from Crete to Lerna at this time, although there is evidence for relations with the islands, and notably Kythera. But the Cyclades have produced no seals or sealings to match these, nor any variations on the monotonous spiral patterns to suggest that their artists were capable of the imaginative compositions which were becoming commonplace in Crete. In Greece itself this brief period of sophisticated seal usage remains unparalleled. Can we believe in the existence of such a distinctive native art which was never expressed in materials which have survived? Did it emerge again in Greece only in the patterns on some of the gold discs from the Mycenae Shaft Graves centuries later? Such stone seals as survive from Early Bronze Age Greece are crude enough, their shapes resembling Hittite (from A. Kosmas in Attica) or the Near East (from the island Amorgos), and although these have simple spiral patterns they cannot compare with Lerna. Some sealings and seal-like amulets, like the one from Asine in *Fig. 12*, show simple spirals, and an elaborate cylinder of clay or wood was used to roll spiral and animal patterns (*Fig. 13*) on Early Helladic vases found on three different Peloponnesian sites. This witness to seal and cylinder use in Greece shows that we ought perhaps not to assume too hastily that the Lerna sealings or seals came from Crete, although on present evidence this is the only plausible solution.

PRE-PALATIAL CRETE (EMII–MMI)

For the period before the first palaces were built the important sources for our knowledge of Cretan culture are the tombs excavated in and near the rich south-central plain of Mesara, and a few other sites along the north coast and to the east. The southern tombs, regularly now called *tholoi* through association with the later vaulted tombs, were apparently family graves and in use for many generations so that precise association of the seals found in them with datable pottery is not possible, although some tombs seem to have had a restricted period of use. Most were excavated at the beginning of this century, and a few subsequent discoveries, as at Lebena and the town at Myrtos, may give promise for more precision in the dating. In terms of pottery the period covered is from EMII to MMI at least (EMIII is a short but distinct period), and since the first palaces were built in MMI this means that some of the tomb finds may belong to the Early Palace period. Crete was waxing prosperous in these years. The jewellery and stone vases attest wealth and close relations with the civilisations of the Near East and Egypt. The designs on pottery are simple, mainly geometric, with some curvilinear and spiral motifs. In all this complex the seals probably pose the most serious problems with regard to their origins, development and use.

The earliest seals can be very broadly divided into two classes by their commonest material and shapes—and a description of the two classes can usefully precede speculation about their relationship and use. They may be called the Mesara Group, mainly represented by ivories and diverse shapes, and

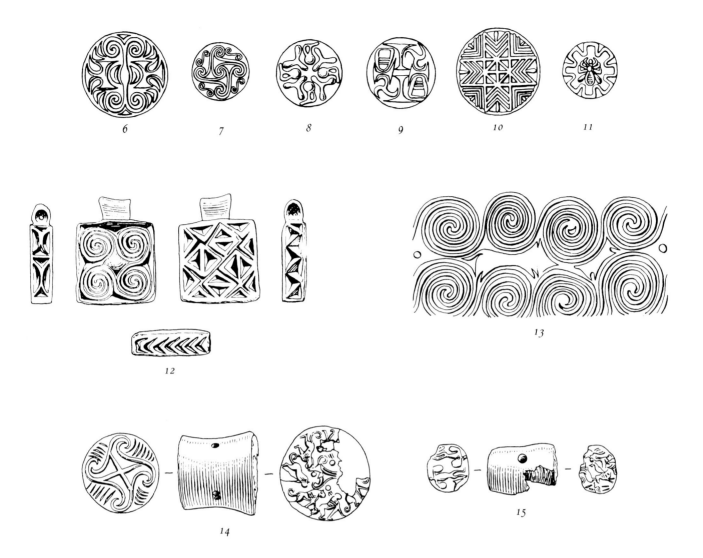

6 7 8 9 10 11

12

13

14

15

the Group of the Archaic Prisms I (for there is a later phase) where all are stone, and usually three-sided prisms in shape. The ivories, with some seals of related form but cut in a soft stone, usually grey or white resembling ivory, are best known from the Mesara tombs, but there are examples from the north and Mochlos, so it may be that their relatively greater numbers in the south reflect no more than either the prosperity or the taste of the southern Cretans in the period of their greatest use. There is, moreover, still no clear evidence that the northern ivories need be earlier than the southern. We have already had to discuss the possible antecedents to this whole class, represented by the sealings found at Lerna in mainland Greece.

A great variety of shapes is seen in the ivories and a number of basic classes can be distinguished. The engraved surface is usually flat but the back may be treated in various ways: (1) Commonest are broad cylinders, often naturally shaped pieces of tusk cut flat on the ends, which are each engraved, while the curved sides are left plain, the reverse of the practice with eastern cylinder seals. The ivory cylinders are pierced across their axes, usually once or twice (*Figs. 14–16, Pls. 1–3*). (2) A number of other simple geometric forms are used: conoids, pyramids, half-cylinders, half-spheres, tabloids, cuboids (*Fig. 19*). (3) Some seals derive from basic bead shapes, like the discs engraved on two faces, usually stone, or oval seals with gable backs (*Fig. 20*, in stone). (4) Stamp seals with engraved rectangular

23

or circular plaques have handles in the form of round knobs or irregular, often pointed projections (*Fig. 18*). (5) More elaborate stamp seals are cylindrical, with a handle at one end, or pear-shaped (*Fig. 21*, in stone). (6) A small number are ring-seals, with open loops or cylinders as handles, too narrow for use as finger rings, but for suspension on a necklace or the like (*Fig. 22*). (7) Finally, and most characteristic, are those with figures or parts of figures cut in the round on their backs (*Figs. 24–27*; *Pl. 4*). The commonest subjects are animals: birds, monkeys and reclining beasts, some of which are shown in a summary but appealing manner in pairs, each with its head laid across the other's back, while another is of a lion crushing a man. There is one in the shape of a woman, and a few of animal heads or legs, the forepart of a boar, and a human foot.

An odd feature of some of the cylinder and ring-seals is the way in which part of the engraved surface is detachable. Professor Platon has explained this as a means of rendering the seal useless. Partners might well keep separate parts of an office seal, on grounds of security or mutual suspicion, but even if we can credit such involved business methods in early Crete there is still the fact that the devices are usually extremely crude—no more than a net pattern of incisions, while there are some cylinder faces with detachable parts which are not engraved at all. It is hard to believe that all these went to the tomb unfinished, when all that was required to 'finish' them was a few straight cuts with a knife.

There is a considerable range in the engraved devices on the ivories and yet the basic schemes can be fairly simply described. Whirl compositions which own no top or bottom are particularly common, and of course well suited to the usually circular field. Spirals and circles play an important part in these patterns, the spirals linked in various ways and sometimes combined with hatched patterns resembling leaves or florals. But often it is animal friezes which are repeated in circles, with or without spiral or other fillings (*Pls. 1, 2*). The usual animals are lions, scorpions or spiders, rarely men or monkeys; in other words, preference is given to threatening subjects—there is a particularly poisonous spider indigenous to Crete. When only two figures are shown they may be set antithetically, head to toe (as *Figs. 15, 22*), observing the same general principle, and the simple figure of a lion is sometimes contorted to produce the same effect. This is a motif we shall have to discuss further. Single standing animals, to be viewed only one way up, are comparatively rare. The only other important class of decoration is of all-over patterns, floral or geometric, almost arbitrarily cut off by the edge of the engraved face (*Fig. 25*), although along one straight edge of some there is a decorative border (*Fig. 18*), like a sample rug pattern, and this scheme may have some bearing on the 'architectural' devices of a later age. The devices are carefully but not very deeply cut, with fine linear incised detail in floral patterns and on some animal bodies. Exceptions are a few seals with deeper and more rawly cut figures which clearly copy the style of the stone prisms which have yet to be described.

The principle of this decoration and many of the details of the devices are to be repeated often in Minoan art. Torsional patterns remain popular on seals, but also dominate many of the finer painted vases of the Early Palace period. The same is true of the interlocking all-over patterns. But it is not easy to detect much of this style, especially that involving figures, in other works of Minoan art of the period of the seals. One motif, however, can be matched—the contorted lion with his legs twisted in opposite directions (*Fig. 27*). The motif is one more often discussed à propos of its appearance on much later seals, of the Late Palace period, but its origin lies here and the conception is one basic to Minoan art, yet easily misunderstood. To explain it merely as an artistic device, to create a whirl or torsional pattern from a single figure, ignores one of the more remarkable phenomena of Minoan art. Animal studies in early antiquity are highly conventionalised especially in the arts of the Near East and Egypt. The creatures are seen in strict plan or profile. Yet the human-eye view of a quadruped is a top-three-quarter one, and the Minoan artist, who, for all his skill with abstract pattern, seemed to look at life with sharper

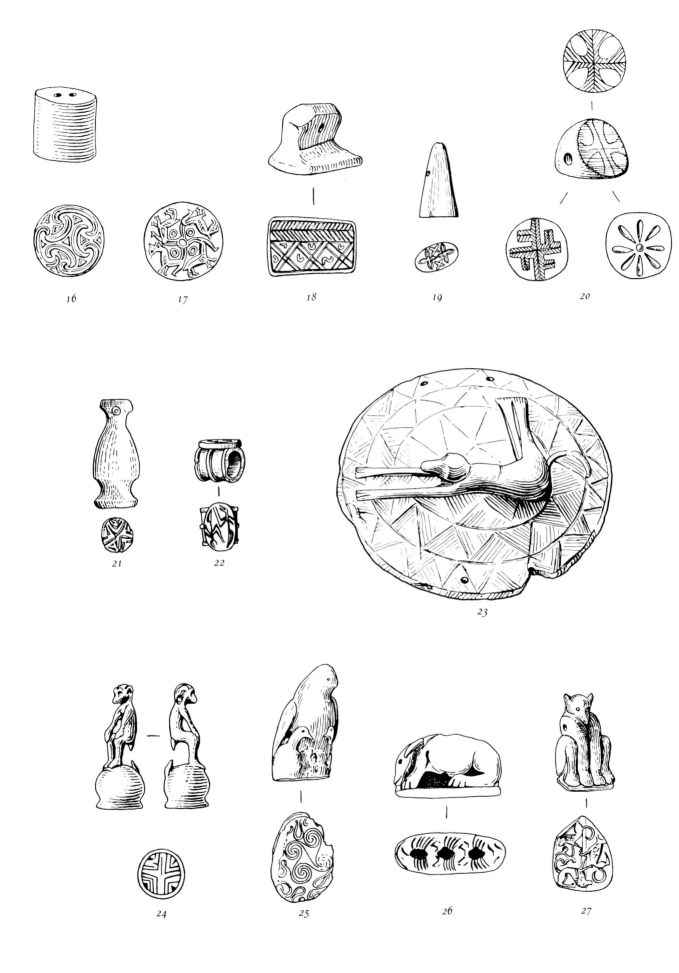

16

17

18

19

20

21

22

23

24

25

26

27

wits than his foreign colleagues, attempted to convey this viewpoint both in the round, and in the near-two-dimensional field of gem engraving. In the round, we think of the pairs of animals on the backs of some of the ivory seals, but especially of the elegant statuettes of dogs carved on stone lids and belonging to the period of the seals. The dogs extend their forelegs but their hind legs lie together, stretched to one side (as *Fig. 23*). The pose is a natural one, and viewed from above, to one side, we have exactly the 'contortion' which is shown on the gems rather less successfully in two dimensions—not an artistic convention but an imaginative essay based on observation.

With the second main group of pre-palatial seals, the Archaic Prisms, we have to face what is to be a recurrent problem in the study of Greek Bronze Age seals—the fact that most extant examples are not from excavations or even given exact proveniences. The commonest form has three sides, each roughly square, circular or a broad oval (*Pls. 5–7; Figs. 28–30*), and is cut from a mottled green serpentine (*colour, p. 29. 1, 2*), so long miscalled 'steatite' by archaeologists that it would be misleading to correct the term. The only other shapes we may associate with the prisms must be those whose devices clearly belong to the same style. These shapes are principally tabloids (*Pl. 8*), conoids, cylinders or pear-shaped and there is a fine rectangular stamp with a handle, from Mallia: all these forms are met also in the ivories.

A very few of the prisms have been found in tombs or other contexts which also yielded the ivory seals and their kin, both in the Mesara and, for instance, the Trapeza Cave in east central Crete. There are no clear indications of date, but the prisms are fairly common in the island and their association with the ivories might suggest that as a series they begin when the ivories are in decline. There are a few from north, central and eastern Crete, and the alleged proveniences of other examples perhaps weigh rather in favour of these areas, where the ivories seem scarcer. But the pattern of finds could be illusory and need not mean that one type was current in the north, the other in the south, rather than that one preceded the other in general popularity. And if some ivories seem to borrow devices from the prisms, it might perhaps equally be argued that the new style was experimental on ivories and only established on stone. Even factors like availability of material could have effected the difference. But it is not a simple change, for it seems that the ivories, or seals like them, perhaps wooden, continued in use in the Early Palaces. Certainly the tradition of the prisms continues uninterrupted and they are most characteristic of the Early Palaces, at least in north Crete. What are here defined as Archaic Prisms I are associated with some ivories and there are ivories which share motifs with them, so this period of transition may be a real one, however difficult it may be to place absolutely. Another explanation for the two classes, proposed by Kenna, is that the ivories were for use as seals while the prisms had an amuletic character. Certainly, there are no sealings from early prisms, but there are only a very few apparently from ivories and it is the ivories whose only figure devices, like the spiders and scorpions, seem most appropriate to amulets, as well as their diverse shapes. The explanation is, however, possible, and the special character of the prisms and their devices, to which we now turn, must not be forgotten.

In describing the motifs on the early prisms we have, of course, to draw upon the evidence of the many seals without context or provenience which can be associated by style, shape and technique with the few of probable pre-palatial date. This seems a reasonably safe procedure. The cutting of the intaglios is rough and deep in the soft stone with very little detail. A drill was less often used than might appear for preparing parts of the intaglio and much was cut or gouged out. It was not even always used to bore the string hole. It is necessary both to be cautious of interpretations which rely on the appearance of minor cuts, and not to expect detailing which goes beyond the limitations of the technique. This accounts for the bird-like appearance of the human heads, where the artist has tried to render nose and chin (as *Pls. 5, 6*).

28 29 30

The stone prisms from the Mesara tombs have fairly simple devices—animals, spirals, hatched patterns resembling those on the ivories, but the commonest type of prism has a far more homogeneous style, it need not be earlier than MMI (possibly not even pre-palatial) and was perhaps more popular in the north, although some motifs were borrowed on the Mesara ivories. The explicit motifs are fairly simple: men, seated or standing, in ones or twos, and rarely drawing a bow; pots, ships; goats running or leaping, boars and other quadrupeds, perhaps lions or dogs; spiders, scorpions, waterbirds, fish; bucrania, whirls. More involved scenes show what are usually taken for pots slung from a pole or on either side of a pole, sometimes attended by men (*Pl. 6*). There is what seems to be a man busy with a pot by a kiln (*Pl. 6*), another making a pithos (storage jar; *Pl. 5*), and a third carrying animals on a pole (*Pl. 8*). Two women converse (*Pl. 6*), and another deposits something in a buried storage jar. A man sits before a table or gaming board (*Pl. 5*). There are rare examples of figures set antithetically or in a circle, as on the ivories and probably influenced by them. Although there is some doubt about the identification of the rows of pots, vessels are shown singly and it does seem that the repertory of devices is devoted partly to wild life, partly to industry and hunting. The latter motifs are new to Cretan glyptic but will remain important. On other prisms, or on other sides of prisms with explicit subjects, there are semi-abstract, usually curvilinear patterns, quite unlike those on the ivories. Most of these seem to be excessively stylised versions of the animal studies, combining the 'saw patterns' of necks or bodies with arcs suggesting limbs; sometimes suggesting a single animal, sometimes two set antithetically. On *Fig. 29* the head and neck of an animal is joined to one such stylised body, while on another side an antithetic pair is reduced to arcs and semicircles. On *Fig. 30* the water bird on one side is translated into the strange idiom on another, while on *Fig. 28* we see half a bird, a completely transformed antithetic pair, and joined heads and necks producing what elsewhere is just a spiky S pattern. This translation and fragmentation of the devices may recall the way Celts treated Greek coin devices, but on the seals the practice is deliberate, with the explicit and the transformed shown side by side and clearly by the same hand. It has been taken to support the suggestion that the devices of all these seals have an amuletic, magic character, and it must be admitted that a similar treatment is seen on later Cretan gems which also seem not to have been much used for sealing. If this is true it should be the treatment of the motifs which is significant, not their subjects or the shapes of the seals involved. What is perhaps more important is that this translation of the motifs brings them close to what Evans called the earliest 'pictographic' script of Crete. It is on the prisms that we shall see the development of this truly hieroglyphic writing. Early examples of it appear on an ivory prism and a disc seal found recently at Archanes, near Knossos, in an ossuary, no later than early MMI. They serve to emphasise the lack of precision in defining what should be regarded as pre-palatial, but it is still fair to regard the main development of writing as a product of palace organisation and requirements.

Since these ivories and prisms are the earliest extant groups of Cretan seals we must devote a word to the question of the sources of inspiration for their shapes and motifs. North, east and south—Europe, the Greek islands; Anatolia, Syria; Egypt, Libya—are involved in this problem, but it is likely to admit a simpler solution. Spiraliform patterns were probably introduced from the north, via the Cyclades

islands, into EM art, and so on to the seals. The strength of this tradition is easily underestimated. The only eastern shapes of stamp seal—the cylinder stamp and perhaps the pear-shaped and figure seals—might also have been introduced from the islands rather than their Anatolian homeland (see above) but it is a primitive and non-eastern form of cylinder stamp that is seen in EMII Myrtos. In Egypt, on the other hand, most of the shapes or close approximations to them, are known, and in Egypt ivory was available and (as not in the east) used regularly for seals. The example of Egypt promoted the vigorous production of stone vases in EM Crete, and it is likely also to have promoted the cutting of seals. But there must have been a need for the seals too, and this implies a degree of commercial organisation, even if only at a personal level. A few motifs and compositions on the Cretan ivories may also be traced to Egypt, but by EMII–III Cretan artists were sufficiently independent to create new forms and compositions for themselves.

CRETE: THE EARLY PALACES (MMI–MMII)

The earliest building of palace complexes at Knossos, Mallia and Phaistos falls within the pottery phase MMI. To judge from their arrangements for storage and the later accounting tablets found in them it seems likely that from the first each was as much a commercial focus for the economic life of the area it controlled as a royal residence. Such circumstances would encourage the use of seals, for identification and certifying of goods, and of writing, for accounts. As we have seen, already early in MMI seals with hieroglyph devices are found near Knossos, and for the period of the Early Palaces seals and script are to be often associated in our story. Otherwise there is not a great deal to help us define precisely what the new era meant immediately to seal usage and design, and it seems clear that the traditions of both the major classes distinguished in the pre-palatial phase continued in the Early Palace period. But as it progressed there are several new styles, shapes and techniques which can be detected.

The end of the period falls at the end of MMII and is marked by destructions variously attributed to earthquake, revolt or invasion. The following period of rebuilding, MMIII, shows a steady development in the other arts of Minoan Crete and in seal engraving, with no decisive break, although there are significant changes with the transition to LMI styles in pottery. So, for seals, the end of the Early Palace period is as difficult to define as its beginning.

Our first important source for the Early Palaces is the hoard of over one hundred seals found recently in the town area near the palace at Mallia. It is not yet fully published but its character has been well described and some pieces illustrated. From the accompanying pottery it is said to belong to the end of MMI or earliest MMII. Tools were found, including files, burins and polishers, and these, together with a number of unfinished seals, suggest that we have to do with the debris from a seal-engraver's studio. It is interesting to notice the report that some seals were spoiled in their final stage by the cutting of the string hole. It might seem foolish to leave this dangerous operation to the end, but it could well have taken longer than the engraving of the rough intaglios. Most of the seals are prisms of green or grey steatite, some with the old-fashioned, rather square faces, but most with rectangular or long oval faces. These are our main excavated evidence for the Group of Archaic Prisms II. The devices are much as they had been before: potters are mentioned on the Mallia seals, a man holding a fish, ships and various animals, but there are also a number of purely hieroglyphic devices, the fore-runners of which we saw on the earlier prisms and the ivory seals from Archanes.

With these prisms, still in the soft stone, can be associated a considerable number of others in various collections from north Cretan sites. A number appear in *Fig. 31* and *Pls. 9–12*. A new feature in their

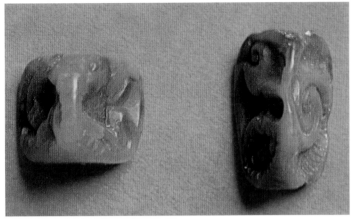

<div align="center">1 2</div>

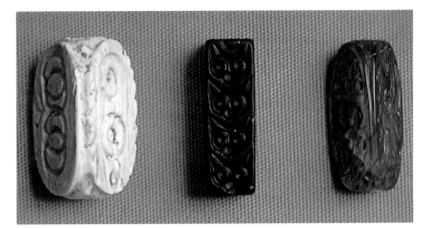

<div align="center">3 4 5</div>

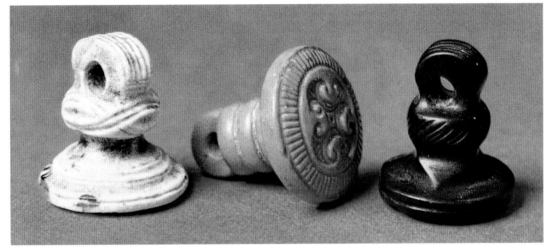

<div align="center">6 7 8</div>

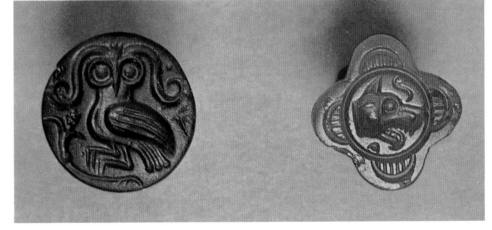

<div align="center">9 10</div>

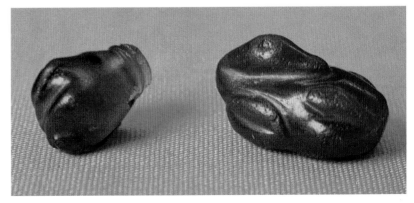

<div align="center">11 12 13 14</div>

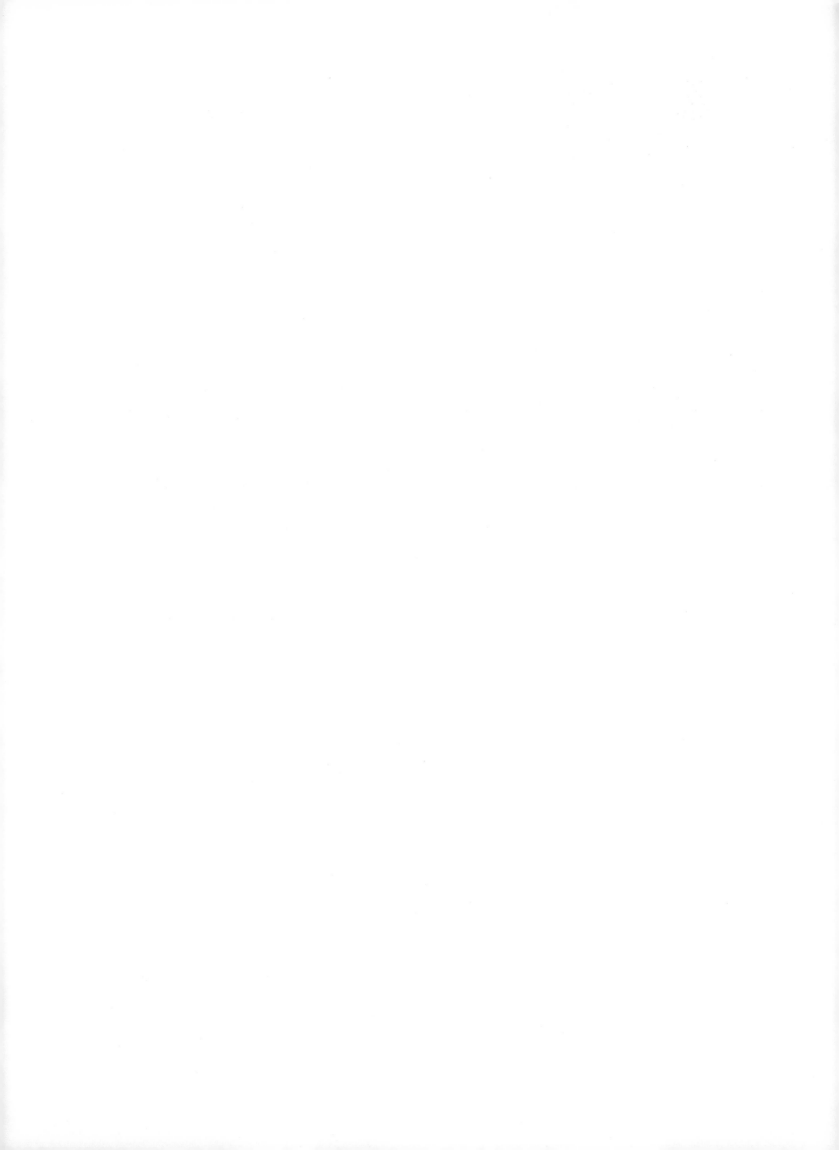

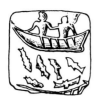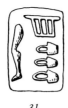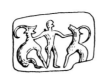

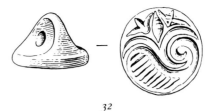

<div align="center">

31　　　　　　　　　　　　　　　　　　　　　　*32*

</div>

decoration is the use of a tubular drill, which relates them to gems we have yet to discuss. Kenna has observed that a number of these stylistically late prisms in soft stone appear to be the older, squarer prisms cut down. This gives them disproportionately large stringholes and the elongated form. It seems quite plausible that the older stones should be refurbished in this way, especially if their purpose was more magic than sphragistic, but not all the new prisms take this form, and many of the old motifs are repeated. If we may reasonably assume continuity between this series and the later hieroglyph prisms in hard stone, we may take it that the Archaic Prisms were still being made in MMII. None was used for extant sealings. The style seems not particularly popular in south Crete, where there are some 'depressed' gable prisms bearing patterns common also to the ivories.

One other shape must be mentioned here—the 'button', with flat or lightly convex face and what looks like a pinched, pierced back serving as a flat handle (*Pl. 13; Fig. 32*). There are some primitive examples in the Mesara tombs and others, without context, have spiral patterns recalling the Archaic prisms, and tubular drill patterns. The shape may have been introduced already in EM, from Egypt, where it was by then going out of fashion. It may not have survived MMI in Crete, but it contributes to the development of a more sophisticated stamp shape.

The next most important source is a deposit from below the floor of a room in the palace at Phaistos. This included nearly 7,000 clay sealings, hardened by fire, on which nearly three hundred different devices can be detected. Most seem to have been used to seal boxes, over cords wound around pegs. The pottery suggests a date towards the middle of the MMII phase, appreciably earlier than the destruction of the Early Palace. In his fine publication of the sealings Levi observed that most of the impressions seem to be from seals of a soft material, ivory, wood or steatite. Some, however, are clearly from seals cut in hard stone and already in the Mallia workshop there were stamp seals of rock crystal. This indicates that in MMII the Cretan engravers were beginning to try their hand at the engraving of materials which required more complicated equipment than the earlier hand-cut seals. The new stones are cornelian and jaspers, more rarely agate and amethyst. They may have been brought from Egypt or the east, but rock crystal was also used and this can be found in Crete. The drill had been used on earlier seals of ivory or soft stone, sometimes for their stringholes, rarely on the intaglio. It has to be used on hard stones for the perforation and, in common with the regular later practice, it could be used for most of the intaglio. Sometimes the drilling technique determined patterns or the style of figure devices, as we shall see, but it was the tubular drill which was to have an immediate effect on the appearance of Cretan seals. It had long been used for seals in the Near East, and in Egypt for hollowing out stone vessels. Cretans had learned its use for the latter purpose already in EM, but only later applied it for the decorative effect of neatly cut circles on seals. We have noted it already on soft stone prisms and button seals, but it may be that its properties were only first exploited when the gem engravers had to face the problems of cutting harder stone.

We may turn now to the main classes of decoration on the Phaistos sealings (examples in *Figs. 33–50*). These also tell us the outlines and contours of the faces of the gems, but for their whole form we have to appeal to the many surviving seals which show the same style on engraved faces of the same shape.

First, the primitives. A few impressions seem to be from seals like those of the Mesara Group, notably one with an all-over pattern of leaves, and another from the end of a half-cylinder (nos. 170, 171). There are no impressions from prisms of the main series represented at Mallia and in north Crete, but a few hieroglyphic signs appear on sealings which may be from prisms, in a rather different style (as no. 185).

The main group is dominated by technique—the use of a tubular drill and straight cuts—we might call it the Hoop and Line style. These produce a multiplicity of simple symmetrical patterns (*Figs. 33–36*). The shapes of the engraved faces are circular, square and rectangular, and since no stone seals executed in just this manner survive we may suspect that the originals were of wood, possibly cylinders, buttons, or some other type of stamp. Most had flat engraved faces.

Elaborations of the Hoop and Line style appear on other sealings also mainly circular and probably of the same shapes and material. They include several with star and interlace patterns which recall the far earlier sealings from Lerna. Variations, which abandon the Hoop and Line formula, introduce spirals in compositions which seem to derive from both Lerna and the Mesara Group. Some are elaborated with hatched or floral elements, such as are seen also on sealings from Knossos (*Fig. 51*) and contemporary vases. There are also one or two examples of a particularly fine pattern which relies wholly on straight cut lines of varying thickness (*Fig. 41*). These are arranged in patterns of friezes and panels which resemble elaborate basketry but are often described as 'architectural'. Here at last we have something easily matched on extant stone seals, which can tell us the probable shapes of the seals used at Phaistos. To these we shall return once the other sealing devices have been considered.

One long rectangular impression (no. 188) is clearly from a four-sided prism usually reserved for hieroglyphs at the end of the Early Palace period, but the hieroglyph-like signs on this example are not wholly canonical. Hieroglyphic seals and motifs seem at any rate to be exceptional in south Crete. Two small round stamps with finely detailed lions' heads (*Fig. 43* for one) and one with an owl (*Fig. 44*) can be immediately matched by devices on stone stamps, the loop-signets, of a familiar MM class. One (*Fig. 42*) is from an animal paw stamp (compare *Pl. 42*). The other sealings with figure devices present us with our first selection of fine individual animal studies on Minoan seals (*Figs. 46–48*). The style is smooth and assured, with the long sleek bodies stretched in the 'flying gallop' or standing posed in a setting of rocks and trees. There is no excessive detail here, of features or sinews, but all is grace and movement, untrammelled by any of the set iconographic conventions which bound the animal studies of Near Eastern and Egyptian artists. And there is no torsion. Occasionally technique and the drill suggest a more extreme stylisation, like an octopus infected with the Hoop and Line style. One sealing shows crossed lions' bodies set heraldically in the eastern manner. It is perhaps from an Anatolian seal, and in marked contrast with the freer Cretan compositions.

One motif, of a goat at bay on a rocky outcrop, worried by a dog (*Fig. 46*), is repeated on a rather later stone which has survived (*Pl. 61*). We see the already familiar minor wild life, spiders, a wasp, octopuses, birds, murex shells, but also dogs, goats, a boar and lions, some attacking other animals in schemes to be more freely developed later. Monsters too—the Egyptian griffin in Cretan form (*Fig. 45*) and an already translated version of the goddess Ta-urt (*Fig. 50*). The few human representations are a little more stylised (*Fig. 49*), but closely matched by the rare painted figures on MM vases. This is a period in which only the Minoan seal engraver has much to tell us of figurative art. These sealings are mainly round or oval, several from seals with convex faces. Very few are matched in stone, but the flat oval impressions come quite close to some hard stone prisms bearing both animal and hieroglyph devices

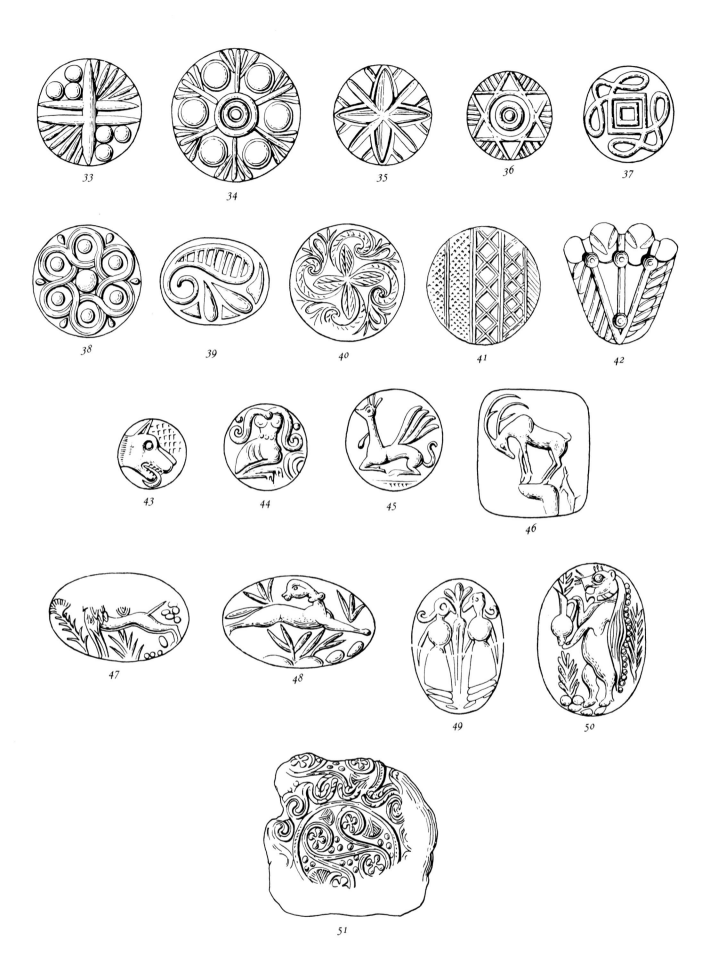

33

34

35

36

37

38

39

40

41

42

43

44

45

46

47

48

49

50

51

and there are various forms of stamp seals with carved backs which may be associated. Most of these have devices in a slightly more developed style, closer to that of a group of sealings from Knossos, which must be described before we can review the evidence for the shapes of seal used in the Early Palace period.

The Hieroglyphic Deposit at Knossos is a cache of sealings and inscribed bars and labels found beneath a stairway of the later palace. Evans dated it to MMII, but the tendency now is to propose a later date, based mainly on stylistic criteria. As Matz puts it, 'it is a matter of minor importance whether the Hieroglyphic Deposit is to be dated immediately before or shortly after the catastrophe which befell the old palace'. Its sealings show an advance on the style of those from Phaistos but there is not much that is positively new. We may take it that Phaistos gives the first inkling of the new pictorial style in Cretan gem engraving, of which the Hieroglyphic Deposit offers a more advanced although not much later phase in its rapid and brilliant development. There may also still be differences between north and south Crete to take into account, and perhaps between the materials commonly employed.

The most distinctive sealings from the Hieroglyphic Deposit were from what can be readily recognised as long four-sided rectangular prisms bearing hieroglyphic inscriptions (*Fig. 53*), and a few from the three-sided prisms with broader faces. There is one most intricate impression from a small circular stamp, showing stylised cats' heads around what may be musical instruments (*Fig. 52*). Others are circular, from stones with convex faces which may be discs, and one from a flattened cylinder. Some have the old spiral patterns of the Phaistos sealings, but the Hoop and Line style is largely forgotten. There are good animal studies, rather more detailed than those on the Phaistos sealings, with more deliberate modelling of the bodies, and in the field some more imaginative treatment of rocks and trees, even a submarine grotto with fish and octopuses (*Fig. 55*). Of the three with human heads, two are optimistically identified as portraits of a prince and his heir (*Pls. 14, 15*), but are really no more than an early statement of the Minoan convention for detailed human figure studies.

In the light of the evidence from these deposits of sealings, and with a few stones found in MMI–II contexts, we may now attempt to draw upon the many gems which own no excavated context and survey the range of shapes for hard stone gems which came into use in the Early Palace period.

Discs with flat edges and convex faces (*Pls. 16–21*) may derive from earlier flat discs in softer material. They bear some of the fine 'architectural' motifs, and others related to the Hoop and Line style sealings from Phaistos. From this shape derive the *lentoids,* which are the dominant shape in later periods, and it may be that they were already in use in our period, since three were found in a tomb at Mavrospelio near Knossos with late MMII pottery, and there are several known with devices closely resembling those seen on the discs, especially the 'architectural'.

Flattened cylinders, which rather resemble spacer beads but are only singly pierced, are alleged from the sealings at both Phaistos and Knossos. A few extant stones are carved in a comparable style (*Fig. 56*), but most are of the succeeding period.

Three-sided prisms have regular oval faces. They may carry basic Hoop and Line patterns, hieroglyphs, or animal devices, the more elaborate of which are probably MMIII (*Pls. 22, 27*). The *four-sided prisms* with long rectangular faces usually carry hieroglyphs only (*Pl. 26*) although there is one with Hoop and Line patterns and a Hoop and Line lion. There is also a unique eight-sided prism with hieroglyphs (*Pl. 24*).

The stamp seals offer a great variety of forms. There are a few examples of the older *pear-shaped* and *button* seals in hard stones (*Fig. 57*), but the most common form is the *loop-signet* (*Pls. 23, 25, 28–32, 34, 36, 37; colour, p. 29, 6–10*) which may owe something to both these earlier forms. They have neatly cut loops, ribbed stalks which may be enhanced with incised patterns, and a splaying base. The engraved surface is usually flat and circular, but some elaborate examples have lobed or scalloped edges. A few

52 53 54

55

56 57 58

examples, more like pendants than seals, have nearly hemispherical faces and very simple devices. There were soft stone examples in the latest Mesara tombs, but most are of harder materials, including the most colourful, one or two even of metal (*Fig. 58*), and they attract the most careful miniaturist engraving. The whole range of Early Palace devices appears on them—Hoop and Line patterns, whirls and rosettes, animals, hieroglyphic characters and single hieroglyphs with or without floral or hatched additions. With some of the animal and hieroglyphic studies the opportunity is presented of identifying the work of individual artists, who also carved other stamps and the hieroglyph prisms. They include some of the most intricate examples of gem and jewel carving in the whole history of Minoan glyptic.

Another common form of stamp, presenting the same range of devices as the loop-signets, but on a flat oval face, has the back carved in a raised, grooved S-pattern (*Pls. 33, 35 ; colour, p. 29, 12*). It is very likely that this is a simplified version of the two antithetic and twisted foreparts of animals carved in the round which are also seen on some stone stamps (*Pl. 39*), and which itself derives from the usually more explicit two-animal seals in ivory or soft stone in the Mesara Group. So the S-pattern stamps and those with the animal foreparts, sometimes barely recognisable, can be taken together, and seem to have a long history. Finally there is a wide selection of other subjects carved in the round as figure seals: monkey, birds, dogs, cats, ducks; human hand, animal paw; sea shell, vase (*Pls. 38, 40–42; colour, p.29. 11, 13, 14;39. 1–4*).

It should be noted that the style here attributed to the close of the Early Palace period has, at least since Evans' day, more generally been attributed to MMIII. Much depends on our view of the date of the

Hieroglyphic Deposit, but a high date is perhaps encouraged by the many advanced features exhibited by the Phaistos sealings which have only become known in recent years. We may be sure that the style has its origin in the Early Palace period. Whether its floruit began before or after they fell remains uncertain.

CRETE: THE LATE PALACES (MMIII–LMI)

The pottery phase MMIII sees the rebuilding of the Cretan palaces. Knossos was to suffer another shock before the end of the period; Mallia seems to have needed less drastic reconstruction; and the rebuilt Phaistos was to have its importance largely eclipsed by the palace at nearby A. Triada in LMI. There is more evidence too, especially for LMI, from other palatial or near-palatial structures elsewhere in Crete, at Zakro and Gournia in the east, at Tylissos and Nirou Khani nearer Knossos. The disasters that had occasioned the rebuilding had no serious effect on the arts of Crete and their rapid, indeed spectacular development. For this is the period of the first of the frescoes, the stone relief vases, the painted pottery with its elegant floral or marine motifs which come to replace the old polychrome patterns on black. We may suspect too that this is the finest period of gem engraving, in which the artist was able to bring full command of his technique to serve his vivid observation and sense of pattern. As before, he could let his technique dictate his composition, but he is still free from that formality of detail and pattern which characterises even the finest works of the succeeding period. We may suspect this only, for the masterpieces of this age are worn sealings, hard to decipher, or stones which have no dated context and can only be placed here on grounds, usually secure enough, of style.

The end of the period, for our purposes, is marked decisively by the disastrous earthquakes and flood which preceded and accompanied the volcanic disintegration of the island of Thera (Santorini) at or towards the end of LMIB, by around 1450 BC. Structures were overthrown, coastal sites overwhelmed and the soil of Crete polluted by ash perhaps for years. The ruins of the palaces yield a clear picture of the state of Cretan art at the time, and for our purposes the most informative are those in which clay sealings were found baked hard (A. Triada, Zakro, Sklavokampo). These are our prime sources for the end of LMI. For the earlier years there are cemeteries and sites in the east (Mochlos, Sphoungaras, Gournia), finds in and near Knossos in the palace and tombs, and another hoard of sealings at Knossos. This is from the Temple Repositories (MMIIIB), cists sunk in the floor of the west wing of the palace and containing what seem to be religious impedimenta from a shrine, including the famous faience Snake Goddess. In this period too we may begin to use, with caution, the evidence of the gems of possible Minoan workmanship found in mainland Greek sites, notably in the Grave Circles at Mycenae.

From MMIII on the commonest shapes for gems are the lentoid and amygdaloid—like a lens or like an almond. They have two convex faces, although usually only one is engraved, with sharp or rounded edges swelling to the blunt ends where the stone thickens to accommodate a string hole. These, and the flattened cylinders, which also have two convex faces but rectangular in outline, carry the main series of figure devices, which will be discussed later. The lentoid probably derives from the disc, as we have seen, and may have been invented already in MMII. Evans thought that amygdaloids had been used on sealings from the Hieroglyphic Deposit but this is not wholly clear and the shape may be a later development. Oval impressions might be from three-sided seals of a type yet to be described, or even from metal ring bezels. Some amygdaloids have neatly grooved backs, and in this they resemble the shape of LMI and later ring bezels. Others are elongated and plump, nearly circular in section. The flattened cylinder was attested in MMII and has been thought to derive from a rectangular tabloid. There

DISC FLATTENED CYLINDER LENTOID

AMYGDALOIDS

59

60

are certainly advantages to be got from carving a convex face since it leaves a far clearer impression and it is easier to cut, but, lacking handles, none of these shapes is easy to use. Whatever the apparent origin of each shape one cannot but observe that they seem to be versions of three basic bead shapes—sphere, barrel and cylinder—flattened to give a shallow convex face for engraving.

Some shapes continued in use from the period of the Early Palaces although they were to have little future. Loop signets are found still in graves at Mochlos, including one fine specimen with a hieroglyphic inscription and another with a strange horned demon. Discs were still used. One from beneath a stair in the Little Palace at Knossos, and so no later than LMI, shows a bull's head on one side and a bearded man's head on the other (*Fig. 60*)—the physiognomy quite different from that of the heads on the Hieroglyphic Deposit sealings (*Pls. 14, 15*). The latter are, however, recalled on a fine amethyst disc from Grave Circle B at Mycenae (early LHI) in Greece (*Pl. 44*). The four-sided prisms with hieroglyphs were still used in LMI to impress sealings found at A. Triada and Zakro. And in the Temple Repositories at Knossos there are sealings with careful 'architectural' motifs like those on MMII discs. It can readily be seen that for gems of these types no hard and fast distinctions between MMII and MMIII can be drawn. There are, however, a number of hieroglyph prisms extant which on purely stylistic grounds show an advance on what was represented in the Hieroglyphic deposit and which might therefore properly be attributed to the immediately following period, MMIII. Both the four-sided prisms with long rectangular faces, and the three-sided, with regular oval faces, are involved (*Pls. 43, 45–48*). On these the hieroglyphic signs are placed less often now in the combinations which we recognise (but cannot read) in the regular script, and they can be used to compose purely decorative or symmetrical patterns. They may be repeated for decorative effect, like the cats' heads on *Pl. 43*. Floral, spiral or figure patterns may be introduced beside or between them, as on *Pl. 45*. And on occasion an animal or human figure, borrowed from the

finer gems of the day, can appear (*Fig. 61*). Thus, both a four-sided and a three-sided prism admit an acrobat. Some three-sided prisms carry only animal devices in the new style. The atrophy or perversion of the hieroglyphs is understandable in this period when the new Linear A script was coming into general use.

For the development of the finest figure styles in Late Palace glyptic we turn first to the sealings from the Temple Repositories at Knossos, MMIIIB (*Pl. 49; Figs. 62–66*). The animal studies show some advance on those from the Hieroglyphic Deposit and the innovations are few. They include a return to the whirl and antithetic compositions of an earlier day, using whole bodies or separate heads, and there are some more realistic studies of flowers and trees. The important new themes involve human figures and they seem clearly inspired by monumental compositions which were becoming more familiar from fresco paintings now being executed for palace walls. Such scenes are shown in smaller works, as on the stone relief vases, and on the sealings too we find the bull-leapers, boxers (*Fig. 62*) and court officials or priests. Male bodies in action are treated with that elastic, vigorous disregard for anatomy which is the hallmark of the best contemporary work in stone relief, bronze and gold.

By the time of the sealings from the LMIB destruction deposits all these qualities have been further refined (*Figs. 67–79*). Superbly detailed animal studies are presented either in a purely decorative manner like the butterflies (compare *Pl. 65*), fish, some birds or hieratic monsters; or else with an ever fresh observation of natural forms and movement which is never stereotyped. The artist indulges a confident skill in representing the most involved poses—dogs twist and scratch (*Fig. 75*); bulls gallop or plunge with their heads turned away from the viewer, out of the field (compare *Pl. 67*); a lion leaps on its prey or twists in agony to claw an arrow from its side (*Fig. 73*); wild fowl fly or swim; cattle recline side by side, the second beast largely concealed or with its head turned away in a simple composition which successfully defies all the problems of perspective or foreshortening; sinewy hunters grapple with bulls and other creatures. Only on the works of minor artists are we conscious of technique and tools. The best are exquisite studies in miniature sculpture.

Some of the animal devices are heraldically composed—like the lions at an altar or the study of a bull's head and sacred double axe on a LMIA flattened cylinder from Knossos—and the other major class of representations on the seals is concerned with equally formal occasions. Most of these seem to be impressed by metal rings with oval bezels. From now on this is to be the normal shape for Bronze Age signet rings. There were few earlier, with round bezels, and even now their loops are too small for a finger and were clearly meant for suspension only, like the ring seals of the Mesara Group. The bezel is set across the axis of the hoop which, in the more primitive specimens, has its ends pushed through the face of the bezel and flattened on to it, while later it is more neatly fitted to the deep back of the bezel, which is either shaped to the line of the hoop or grooved like the more elaborate amygdaloids.

The finest rings used on the late sealings show running bulls, sometimes with leapers, and they include examples which have left impressions on different sites (*Figs. 67–70*). The semi-architectural ground lines, like the spiral frieze, provided for some of these scenes, remind us of their monumental counterparts in fresco. More common are what appear to be cult scenes involving priestesses (as *Fig. 70*), if not the goddess herself, with sacred trees, jars, enclosures and altars. The subject matter of these scenes has provoked a flood of speculation about Minoan religion, indeed they are a major source for the subject. With rare exceptions the figures were cut in a very simplified manner on the bezels, largely determined by the need to show several figures as well as the furniture of cult. A short-hand of dots and blobs serves to indicate heads, hair and breasts, and only the heavy flounced skirts encourage attention to decorative detail. They are rarely impressive on grounds of technique or composition and we are continually aware that they are reduced and perhaps abbreviated scenes designed for some larger medium.

38

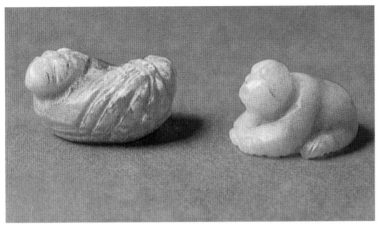

1 2 3 4

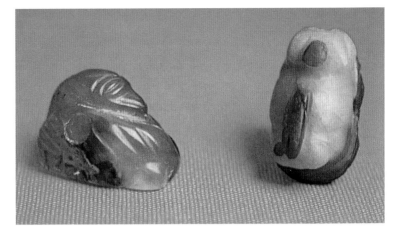

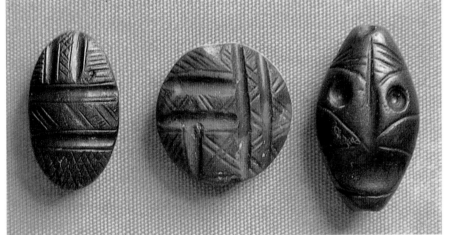

5 6 7

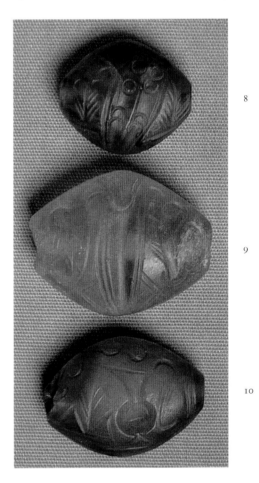

8

9

10

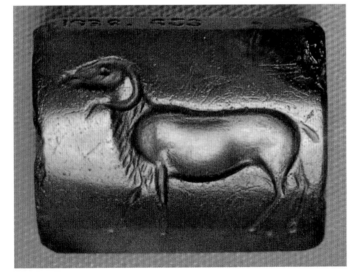

11

12 13

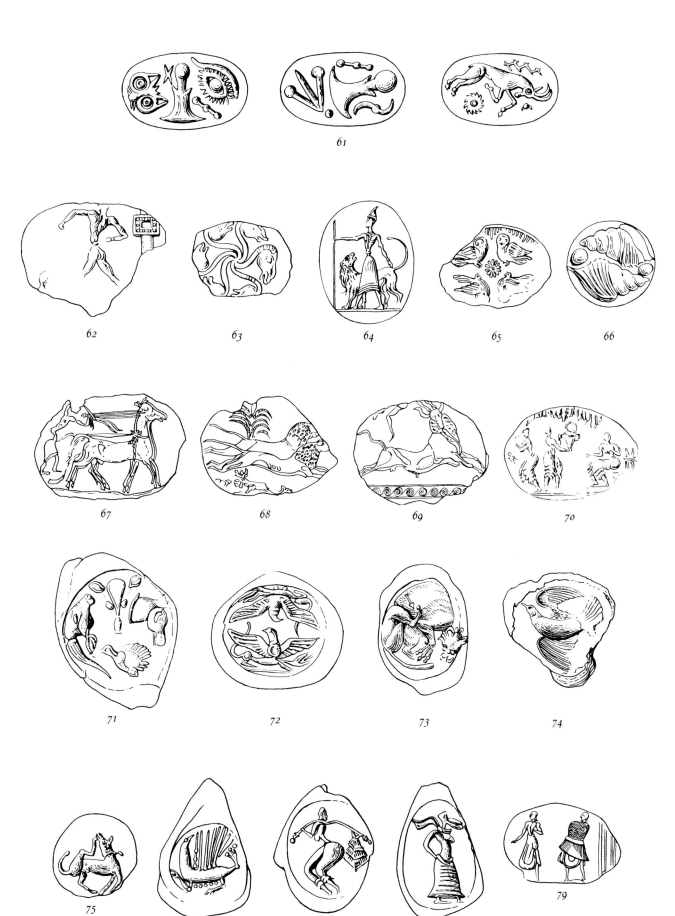

Special mention must be made of many of the Zakro impressions (*Pls. 51–56*), from gems which may probably be identified as the work of a single artist, of rare ability and imagination. The devices are grotesques composed of animal and human parts—heads, buttocks, breasts, tails, wings—with which Hieronymus Bosch could well have felt at home. Attempts to explain these in terms of eastern demons are quite futile. The Zakro Master created an idiom which goes far beyond anything we can find again in the history of Minoan, or indeed of Greek art. The technique is perfect; on, it seems, stone lentoids. The style is seen only on the Zakro sealings and no original stones by the master are extant, although there is a stone reel (*Fig. 80*) with motifs he created and some of his animal masks are seen on other lentoids. Presumably the artist was an East Cretan. The reader may judge how difficult it is to study the history of an art which can produce surprises like this.

For any assessment of the style of this period we have to rely heavily on the evidence of the sealings since regrettably few original stones of the finest style have been found in datable contexts. A few in the latest style have been excavated in recent years at Knossos near the Royal Road. However, many in collections can most plausibly be attributed to MMIII–LMI and some are illustrated here. Some flattened cylinders in Oxford are among the finest known (*Pls. 57–62; colour, p. 39. 11–13*). A bull drinking at a tank is leapt upon by a youth, on a stone whose banding makes it impossible to view the device other than in impression (*Pl. 58, colour, p. 49. 5*). A goat is worried by a dog (*Pl. 61*—a scene we have met already on the Phaistos sealings (*Fig. 46*), and, with the goat running, in the Hieroglyphic Deposit at Knossos and our *Fig. 56*. The rendering is so similar that we might suspect this stone of being another of the earliest flattened cylinders, even MMII. Acrobats doing handstands had intruded on to hieroglyphic prisms, and one is wrapped around the fine gold sword pommel from Mallia. The pair on *Pl. 60* perform a Homeric cabaret (*Iliad* 18, 605f.; *Odyssey* 4, 18f.).

There is one other important class of gems belonging to this period and yet to be considered. They are commonly nowadays called 'talismanic', a name first given them by Evans because the strange stylisation of their devices, in contrast with the brilliant realism of other and contemporary gems, suggested that their purpose was magical rather than sphragistic. Certainly, only very few examples of sealings from gems of this type are known, but since these few are from four different sites (Knossos; Gournia and Zakro in the north east; A. Triada in the south) it suggests that there was no compelling objection to their use as seals. We can understand a seal acquiring some magical significance by virtue of its function as a personal signet conveying authority or securing property, but there seems no strong reason why such a very large class of amuletic objects should take the form of seals. Perhaps the most that we can say is that there may have been a tendency for gems of this class to be used less as seals than as decorative or even magical amulets. While the usual explanation for them may be correct I do not stress it here since there is much about them which is explicable in terms of other trends in Minoan arts, glyptic included. Few are from excavated contexts, but it seems probable that the north and east of the island used them most. These were the areas where the Archaic Prisms too were most popular, and some amuletic significance has been attributed to these also.

One of the rarer seal shapes usually carries these devices. It is a three-sided prism (as *Pl. 73; Fig. 82*) with very regular convex faces, giving an impression like an amygdaloid. The latter is also a new shape and its introduction might have something to do with these new Plump Prisms. Amygdaloids, lentoids and flattened cylinders also bear these devices, in that order of frequency, and even an occasional cylinder.

Turning to the devices on these stones the first thing to notice is their technique, which derives directly from the Hoop and Line style of MMI–II, and whose immediate predecessor is that of the fine 'architectural' motifs on MMII discs. In other words the execution is with broad straight cuts, rounded in outline on the convex face of the stone, edged by or alternating with sharp narrow cuts, and embellished with cross

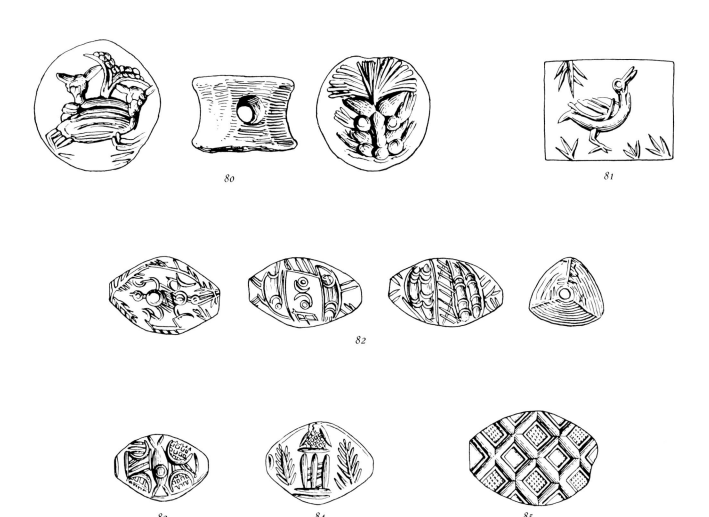

80

81

82

83 84 85

hatching and free use of the tubular drill. Apart from the drill work, the elements of the cutting are all apparent, in a more controlled manner, in the 'architectural' motifs. These, and in their finest style, were still current in this period—used on sealings in the Temple Repositories, although probably not after MMIII. A beautiful variant with a lattice (so-called 'ceiling pattern') is seen on amygdaloids, the new shape and so MMIII at earliest, from Kamilari (*Fig. 85*) and Episkopi, showing that the best tradition of this style was maintained, and several lentoids with the pattern must also belong here (*colour, p. 39. 6*). The 'architectural' motifs show the application of the technique to abstract or geometric pattern, but there were also MMII animal studies dominated by the Hoop and Line technique, and these too play their part in the early history of the gems. It is important to notice that for most of the 'talismanic' motifs no freehand cutting or 'modelling' with the cutting wheel was required and all could be done with a drill and possibly a straight-edged cutting instrument like a file (see below, p. 381). The length of the cuts was easily regulated on the very convex surface of the stone, but they occasionally run on to a different line or ridge at right angles to them. This cursory and economical technique suggests that we are dealing primarily with cheap gems. The material is usually cornelian (*colour, p. 39. 8–10*) or the commoner jaspers. It may be this, rather than any non-sphragistic properties which explains their absence from the palatial archives. If 'talismanic' devices were important to Minoans we might have expected more, or perhaps most, examples to be executed with the care devoted to other intaglios.

A number of the devices which defy explanation in terms of objects or animals seem to be disintegrated 'architectural' motifs, composed of the usual edged bars which are combined with areas of cross-hatching and arcs made with the tubular drill. The result may still seem broadly 'architectural' but some heart, triangle and diamond shaped compositions are favoured (*Pl. 70; Figs. 83, 86*). A prime intention seems to have been to create a composition which will effectively fill the field and which often, in common with the finer Minoan compositions on earlier gems and pottery, owns no top or bottom. The angularity of the 'architectural' patterns is lost on the more heavily curved convex surfaces, where a straight cut results in a curved line with rounded ends, and we often see single or double curved bars at either end of an amygdaloid, edged in the usual manner and joined by various sorts of hatching. Arcs cut over these patterns often give the appearance of eyes or scales, and it is a short step from this for the artist to make the natural appearance more explicit (*Figs. 82, 89*). It is usually thought that the odder devices are in fact natural forms or figures, stylised out of recognition—by us—for magical purposes. The alternative explanation, offered here, derives them from patterns dictated originally largely by technique, but which gradually were allowed to approximate to recognisable forms. These forms are ones which the technique most readily allowed—the long bodies of cuttle fish with arc arms (*Pls. 71, 75*), or the octopus with blob body and arc arms (*Pl. 79*); jugs with drilled blob bodies and arc handles (*Pls. 69, 72, 73; Figs. 87, 89*); the sacred double axe and bulls' heads are easily rendered (*Figs. 102, 82*) and anything from ships (*Figs. 98, 99*) to insects (*Figs. 100, 101*) can readily be composed from these basic elements. Stars, loose arcs or spiky shrubs are introduced in the field. Where no assimilation to another form was attempted scholars have been left to wrestle with explanations—sheaves, tied bundles, even the seed of an extinct North African plant, silphion. Evans demonstrated the translation of the old 'architectural' motif, with the addition of a 'gable', into the common 'talismanic' motif which is commonly called a 'rustic shrine' (*Pls. 73, 76; Figs. 84, 96*). But when arc patterns are added with the tubular drill it has to become a shrine with snakes, and when the arcs take the form of the jug handles it can only readily be matched with a far later vase form and any plausible explanation for all appearances of the pattern disappears. Another interesting invention is the 'lion mask' type which seems an independent creation, suggested by a floral pattern (*colour, p. 39. 7*) and not in any direct line of descent from the hieroglyphic cats' heads. Other motifs show a fragmentation of these devices. Whether this is to be regarded as a treatment alternative to that which assimilated the pattern to natural objects, or as a degeneration of the whole style, is by no means clear on either stylistic or stratigraphic grounds.

In some respects the 'talismanic' motifs come closer to the commoner patterns on contemporary painted vases than we are able to observe in other periods of Minoan glyptic. The 'bundles' look very like the more stylised shell patterns, while the triangles and heart-shaped motifs recall the common vase devices based on argonaut shells or ivy leaves. A painted papyrus with circles on the bloom (from a fresco) brings us straight to the gems with florals which led to the 'lion masks'. The fish, especially those swimming in parallel, are easily matched on vases, while the arcs of the tubular drill resemble nothing more than the rock patterns on Marine Style vases of LMI. The cuttlefish in this form become popular only later on vases, while other 'talismanic' motifs—the jugs, insects, ships, 'architectural' shrines—were already established in the gem engraver's repertory. If these observations have any weight they detract somewhat from any special quality attributed to the choice of 'talismanic' devices, and enhance the suggestion that technique was the dominant factor, and that the suitable subjects may be explained in terms of tradition or of contemporary fashions in other arts, which no student of gems can afford to ignore.

It is hardly surprising that some artists of merit turned this odd obsession with the bare elements of technique to good effect in composing more naturalistic motifs than are attempted in the main series.

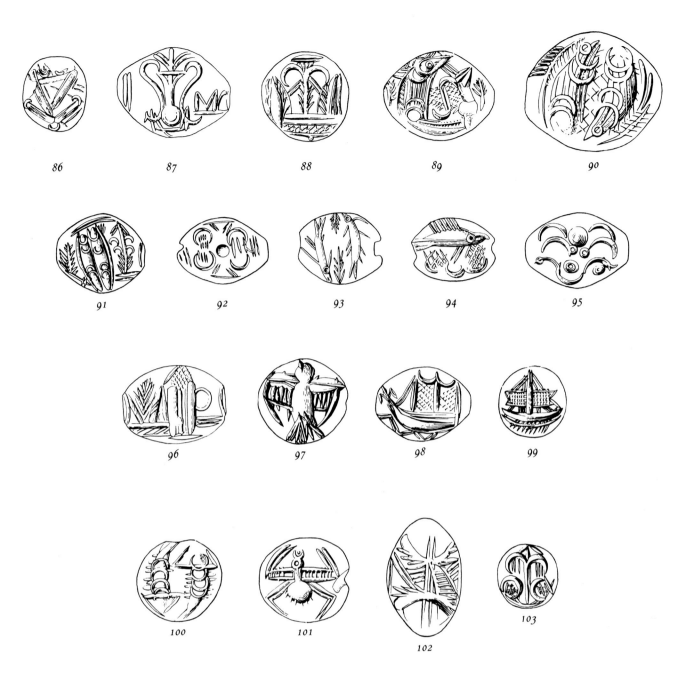

86 87 88 89 90

91 92 93 94 95

96 97 98 99

100 101 102 103

Thus, between the 'bundles' we find a crab, a fish swims in a spiky grotto or a bird spreads it wings (*Pls. 81–83*): the technique no more involved than that used for the 'talismanic' gems but now in the hands of an artist, not a hack. We shall meet this technical virtuosity again in the succeeding period, in a somewhat different style (the Cut Style).

The explanation for the 'talismanic' series suggested here would be supported if it could be proved that the more explicit devices are the later ones. Unfortunately this is not possible from the evidence of excavated examples or dated sealings, but we may observe that it is generally with the least explicit examples that we find the use of the cross-hatched filling, and that this derives immediately from the 'architectural' patterns of the preceding period. Later, a single or double zigzag seems to take its place. A further problem concerns the date of the 'talismanic' gems. The LMIA finds at Sphoungaras are important, and the two found in Grave Circle B at Mycenae, at least as early as the beginning of LHI.

45

It is likely that the main series begins in MMIII and the principal period of production was LMI. While they may appear in later contexts there is no strong reason to believe that the production of these provincial (we may perhaps use such a term here) gems survived the destruction of the provincial centres in Crete at the end of LMI, nor do any of them betray motifs which could only belong to a later period.

MYCENAEAN KNOSSOS (LMII–IIIA.1)

The palace centres of south and east Crete and of the northern coast did not survive the cataclysms of the earlier fifteenth century. Knossos, however, where the palace had suffered rather less serious damage, stood after 1450 BC as the sole major palatial site in Crete until it too was overwhelmed in about 1375 BC. In pottery terms this period of Knossian dominance is LMII and LMIIIA.1. The final destruction by fire baked many seal impressions (*Pls. 100, 101; Figs. 116–123*), which are one important source for our present enquiry, but also clay tablets inscribed in the Linear B script. These show that Knossos was in Mycenaean Greek hands at that time, receiving tribute from and managing affairs in the whole of the island. The period had seen architectural changes in the palace—like the installation of a Throne Room—consonant with Mycenaean rather than Minoan practice, and the distinctive change in the styles of frescoes and pottery (the 'Palace Style' par excellence) is probably to be attributed to the change in patrons. Not that Mycenaean Greece had any independent artistic tradition to offer. It learned from Crete, as we shall see, but even at this stage Greek taste was not inarticulate. It seems very probable that a Mycenaean Greek took advantage of the chaos in Crete to take over Knossos and with it control of the island, possibly not very long after 1450 BC. Minoan art of LMII–IIIA may therefore betray the influence of new masters. And we shall observe later how Mycenaean Greeks at home had received and reacted to Minoan art and artists.

In pottery the Palace Style of LMII–IIIA.1 shows a progressive stylisation of the more free natural forms of LMI combined with a real sense for the monumental, which may be characteristically Greek. Much the same seems true of fresco painting. All the grace and pattern of Minoan art are still in evidence, but now more tautly controlled. We must observe whether any similar tendency can be detected in the gem engraving.

There is on the whole more information about the end of this period than the beginning. The sealings from the palace at Knossos present some problems since they include many which we might judge to be from gems cut in a clearly earlier, LMI style. It is not always easy to decide whether these are in fact strays from a LMIB destruction, or evidence for the continued use of LMI seals, or evidence for the continued production of gems in the LMI style for at least part of the period. Other sources are graves in the Knossos area, both monumental built tombs, like the Royal Tomb, and warrior graves whose furnishing seems to reflect the new and troubled condition of Knossian life. Recent finds in the tholos tombs at Archanes south of Knossos seem to belong to the end of the period (*Figs. 106–7, 125–6*). Tombs at Sellopoulo are possibly all earlier than the destruction of the palace and they certainly contain gems and rings of the latest pre-destruction styles (*Figs. 108–110*). A similar style is represented in graves in the south of the island, at Kalyvia Mesara (as *Figs. 105, 111–2, 124*) and at Gournes Pedeada, which have been thought later in date than the Knossos destruction. But it is not possible to divorce them from the finds of the earlier period and it has been suggested that they are loot from the palace, especially since, at Kalyvia, they are accompanied by other palatial furniture. If so, the looter was discriminate and chose remarkably homogeneous groups of gems. It may be that at least some of these burials are of better class Minoan refugees from the destruction, who lived out their days in peace far from the ruins of the former

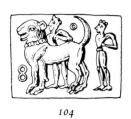
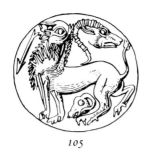
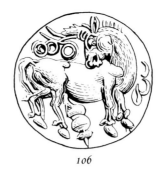
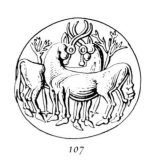

104 *105* *106* *107*

Mycenaean capital of Crete, and who took to their graves the last souvenirs of Knossos' palatial glory. But for Kalyvia at least the probability is that it is mainly a cemetery of the pre-destruction period, associated with a yet undiscovered villa dependent on Knossos and helping administer the south of the island. These are burials of gentry, not looters.

A tomb at Sellopoulo, near Knossos, and excavated only in 1968, is probably the most informative for the Knossos destruction period since its pottery dates it clearly to the years just before it, and it yielded a scarab of the Egyptian king Amenophis III (1405–1367 BC). The gems are in what we shall define as the Plain Palatial style, typical of the sealings from the palace. There is a gold ring with a Minoan cult scene, another with cloisons like an example from Kalyvia and possibly of mainland origin, and a third with a griffin in what one might more readily judge a mainland style.

The evidence for this period is, then, rich and varied and it is not easy to define clearly the development of Minoan gem engraving within it. We shall have occasion to revert to the problems of possible Mycenaean Greek intervention or taste in the next section, but it should be borne in mind here as a factor possibly influencing the course of the arts in Crete during these years of Mycenaean domination.

The principal shape for gems is now the lentoid, and by LMIIIA at least, as at Archanes, it may be found with a low conical back instead of the simple convex surface. A few are engraved on both sides and some are very large—up to 35 mm. across. Amygdaloids are still quite common, more often now with elegant grooved backs and a special variety is elongated and more barrel-shaped. There are flattened cylinders still, an occasional cylinder (*Pl. 144; Figs. 114, 127*) and a few three-sided prisms which usually now have round faces, like a lentoid, cut with ordinary animal motifs in the new style (*Fig. 115*) and not the more exotic subjects which the shape had entertained before. Quite possibly the 'talismanic' gems were still being cut and several are found in tombs of this period, but we shall see that their distinctive technique is employed rather for another group of gems, in the Cut Style, and it is possible that the main series had gone out of production. There is one fine all-stone ring (*Pl. 110; colour, p. 49. 9*). The materials are as before. Fine agates are particularly popular and haematite begins to become fashionable. In general, though, the range is far less colourful than it had been in MMIII–LMI. A new material, imported from Greece, is the mottled lapis lacedaemonius *(colour, p. 49. 10)* which was quarried near Sparta. The softer stones are used also—not the old greenish steatites but a grey or black, which becomes the dominant material in the post-palatial period. The gold rings are larger, often with strong convex faces and ornate beaded hoops *(colour, p. 49. 1; Figs. 124–6)*. Few rings are of silver or bronze. The technique and style of the gold rings of this period need not detain us. They show little advance on what had gone before, with only rare examples of single figure studies, like the bulls shown on the sealings, to match the finer stone gems. Most carry multi-figure scenes of a religious character, competently gouged in the metal and designed to be viewed in original not impression. The summary treatment of the heads of figures

47

involved in many of these scenes is notable since it is shared by some of the quasi-divine figures on stone gems (as *Pl. 145*) and seems almost strictly and deliberately aniconic.

On the stone gems there are significant stylistic changes from the normal treatment of animal and human figures in MMIII–LMI. Then they had been rendered with a vivid command of movement and composition which eschewed the bounds of mere anatomical accuracy, and yet they succeeded in offering some of the finest and truest animal studies in Minoan art. The measure of the change in the later period can perhaps best be taken by considering first the style which is farthest removed from the earlier, and which, to judge from its frequent occurrence in the latest contexts, can probably be taken to represent the favourite style of LMIIIA, the destruction period. We deal mainly with animal subjects. Bodies are smooth-cut with hardly any anatomical markings or modelling. The tubular drill marks the large eyes and a blunt drill models chin and jaw. The muzzles of goats in particular are meagre and beak-like. Limbs are attached as separate entities rather than an organic part of the body, the sinewy legs are often shown by two parallel cuts while joints and feet are rendered by drill holes. This we may call the Plain Palatial Style (*Pls. 122–142, 145; Figs. 107–113*).

Finer than these are the gems which show rather more detailed modelling of animal bodies, often with separate lines to define the edge of a belly or neck and shaping the almond eyes with their drilled pupils rather than reducing them to saucers. Legs are given mass instead of being an assemblage of sticks, and although the drill helps accentuate joints and feet it is often disguised by free cutting. On a number of these the artist uses the tubular drill for patterns in the field and even over the bodies of animals, and the blunt drill for figure-eight shield motifs. Some skill and invention is shown in the disposition of floral and other subsidiary patterns. Many devices in this, the Common Palatial Style (*Pls. 102–121; Figs. 104–106*), are careful and detailed, and their compositions may be skilled but the figures are lifeless by comparison with finer contemporary or earlier gems and there are many which lack both this finesse and the gusto of the Plain Style: such are the lions with dull hatched manes and straight claws.

The Fine Palatial Style (*Pls. 85–101*) makes a virtue of detail and thoroughly disguises its technique. Of these the least successful are the most complicated and ambitious, while the best capture something of the spontaneous charm of earlier gems, with studies of waterfowl or massive-bodied bulls. It is unlikely that the Fine Style survived to the destruction of the palace at Knossos.

This by no means exhausts the repertory of Palatial styles, and there are many poorer stones—and sealings—mainly of interest for their subjects since they exhibit no technical bravura and several are simply hand cut in softer stones. Others, with animals whose bodies are mainly drilled with little added detail, may also belong here. Only one class deserves notice—and a name: the Cut Style (*Pls. 143, 146, 147; Figs. 114, 115*)—for it derives technically from the treatment of many of the 'talismanic' gems. Everything is rendered in straight cuts or grooves which only acquire rounded edges or curved lines from the convex surface of the stone. There are some drilled details, especially on the better pieces, showing griffins with tubular drill eyes and wing markings. We observed a few successful and ambitious versions in this manner with the 'talismanic' gems. The later ones are careless by comparison, but it is sometimes difficult to distinguish the classes, among, for instance, the devices showing flying birds. Most of the Cut Style gems can be placed in this period because a cylinder in this style was found in a LMII grave at Knossos (*Fig. 114*) and it is represented in the sealings from the palace. Moreover, some motifs roughly recall the better contemporary stones. The style seems also to have been current in mainland Greece.

In their compositions the devices on the rings, gems and sealings develop themes already practised in the Minoan repertory. The Fine Style gems are on the whole the most conservative. The rings and

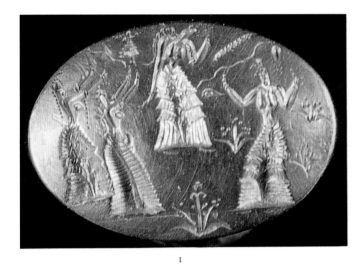

1

4 5

2 3

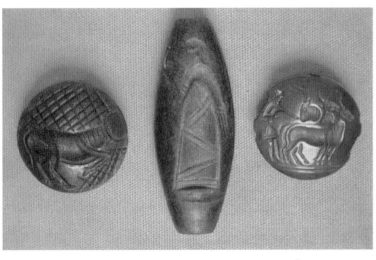

6 7 8

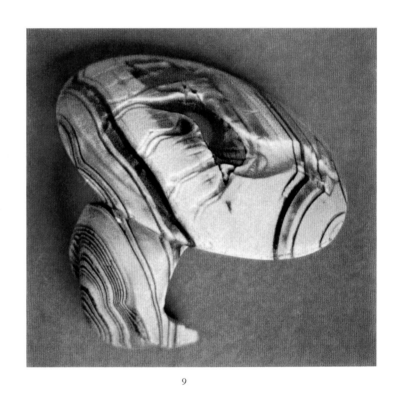

9

11 12

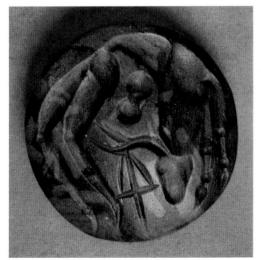

10

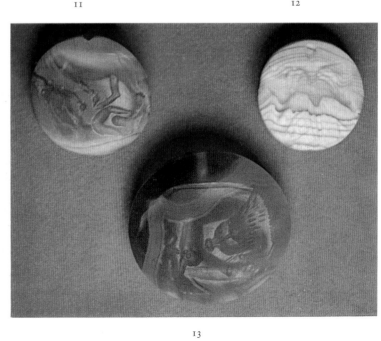

13

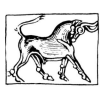

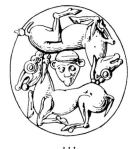

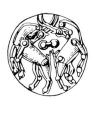

108　　　　　109　　　　　110　　　　　111　　　　　112

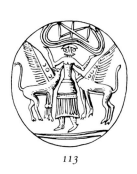

113　　　　　114　　　　　115

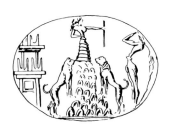

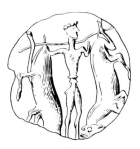

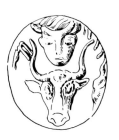

116　　　　　117　　　　　118

119　　　　　120　　　　　121　　　　　122

amygdaloids generally carry straightforward scenes or single subjects on their long fields, and we some-times see a ground line drawn to support them. On lentoids too there are plenty of simple studies of animals or groups, sometimes with a ground line, while there are a few with the creatures disposed in two registers. The older motif of a reclining or standing animal with one or more beyond, and some-times with the bodies opposed, is very popular and some skill is shown in disposing the extra heads in the field. More common now, and apparently in keeping with what we might expect of Mycenaean taste, are purely formal, heraldic groups involving deities or altars as centre pieces with attendant animals. In earlier days the characteristic Minoan compositions had been 'torsional' and these are not wholly forgotten. There are still a few whirls, with repeated figures of animals or fish, with or without a centre piece. Pairs of animals too may be set antithetically, usually back to back, or even two pairs. The most successful application of the torsional principle is seen in some animal groups, often of a lion attacking another beast, in which the body of the attacker curls around its prey. But even these are to some degree stereotyped, and the brilliant observation of pose revealed by earlier gems is replaced by a highly competent but formal composition of twisted bodies and limbs. Where one animal is shown we see sometimes the contorted bodies, twisted completely at the centre part, last noted in the Mesara Group. There has been occasion already to discuss this motif (p. 25) and it has been suggested that it may be no more than a rather awkward attempt to render a top view of a reclining beast. Now, however, different types of contortions are practised, as where the forepart of a lion seems folded back across and below its body (*Pls. 91, 114*). Here again it seems unnecessary to invoke special terminology to describe artistic licence with natural forms and poses, when all that is attempted is a near-realistic view of a recumbent animal, curled up with fore and rear legs lying close together. It is only a degree more involved than the common studies of animals with their necks and heads folded back, as it were, to attend to suckling young or to scratch their muzzles with a hind leg (compare *Pl. 133*).

The background to the figures is sometimes now supplied with various filling devices. The simplest are tubular drill marks (also rarely on the animals' bodies) and the shield patterns, especially on the Common Style, or linear devices resembling script (as on *Pls. 115, 125*), but we find also strange objects which are taken for 'sacral knots' and these may even form the main device (*Fig. 119*). Rarely there are detached animal heads, or bucrania, and these or other animal heads may also appear as the main device.

The repertory of subjects on the seals attains a richness and range to which full justice cannot be done in this chapter. Among the animals lions now become an important motif although it is on the main-land seals that we see the greatest variety in their treatment, and more interest in scenes showing them attacking other animals or being hunted. They pose a special problem in Bronze Age Greek iconography, best reserved for a later section. Bulls, goats and horned sheep are otherwise most popular, with a few pigs and dogs, some flying birds and waterfowl. The compositions of simpler groups of animals have already been described, as well as the contorted motifs, but there are a few special scenes worth listing. The bulls may be shown, as before, with the bull-leapers, or entangled in hunters' nets. Cows suckle calves, bulls throw their heads back in agony as they are struck by spears, horned sheep are tethered to columns—an odd motif. Other animals with a spear in their backs are shown as sitting targets. A few of the hunting scenes show the hunters themselves, grappling with the creatures (*Pls. 85, 92, 103*), striking them, or carrying them home from the chase. A unique scene on an all-stone ring has a goat cart (*Pl. 110*). The human figures are far less effectively rendered now than they had been in MMIII–LMI. The only individual studies of importance show men, usually taken for priests, dressed in a stiff enveloping cloak and sometimes shouldering Syrian axes (*Pl. 89*).

More novelties are monstrous creations, the commonest of which combine an animal forepart, or sometimes two, with human legs (*Pls. 128, 129, 132; colour, p. 49. 10*). That the bull-men thus created

123 124

125 126

recall the Greek story of the Minotaur may be quite fortuitous. The monsters are unlike the surrealist confections of the Zakro Master, but they have a certain organic plausibility, shared by Greek monsters of the Classical period. Sphinxes and in particular the griffin reappear, the latter perhaps being accorded some powers as demon-guardian to judge from its importance in the Knossos Throne Room fresco. But in many scenes griffins, sphinxes or lions seem interchangeable and particular powers may not have been generally attributed to different beasts. The Minoans had already in the Early Palace period naturalised and multiplied the Egyptian goddess Ta-urt (see *Fig. 50*). This new 'Minoan genius' is translated now into an animal standing on its hind legs, usually a lion, but sometimes a donkey or pig, dressed in a long stiff cape, rather like a massive wasp's body (*Pls. 118, 119*). Normally these genii are shown carrying jugs, sometimes in pairs grouped around a column, an altar or the horns of consecration. If they had any religious significance at all it may have been as weather spirits, but they also hunt and may be seen carrying animal bodies. They are well viewed on stones probably made on the Greek mainland (*Pls. 166, 175*). Minoan iconography gives no encouragement to attempts to identify the functions of particular demons, let alone name them or equate them with later Greek monsters. There are, however, a few religious scenes in glyptic. Those on the rings are the most explicit and involved, but it is rare to see excerpts from them—like the goddess with attendants or a single animal—on stone gems. Instead we have formal heraldic groups in which animals play an important role. The central figure may be the goddess or very rarely the young god. Sometimes there is only a column at the centre, as on the famous Lion Gate at Mycenae, and the creatures may be tethered to it, or, as at Mycenae, stand with their forelegs on an altar. The strangest form for the goddess shows her headless (or apparently so, but on the ring devices divine features are not made clear, as we have observed already), and crowned with a multiple horn structure which may be taken for some form of ritual headdress (*Pl. 145*). It has never been satisfactorily explained—'snake frames' has been one description of it. Finally, there are a few inanimate objects—ships, helmets, the ritual double axes and horns of consecration (seen already on the 'talismanic' gems).

This is a period of contact between Minoan and Cypriot glyptic, of which there will be more to say. The Minoan artist more often now attempts the eastern cylinder shape, once with a composition directly inspired by the east (*Fig. 127*) including some eastern motifs, but most of the figures are Minoan and the style is purely Plain Palatial. Eastern are the two registers (but not with one inverted, as here), the sun disc, horned goddess with lions and crossed lions in this pose: Minoan the rest—the griffin chariot is seen on the A. Triada sarcophagus. On the cylinder shown in *Pl. 144*, which is also of haematite, the common eastern material for the shape and one much used in Knossos at this period, the horned figure is a Minoan male and the 'Minoan genius' appears. The Cypro-Minoan counterpart to these is our *Pl. 206*.

In view of the popularity of floral and marine scenes in the immediately preceding period it is perhaps surprising that we see so few devices with fish, octopuses or purely floral patterns. But this is not the only respect in which the repertory of seal devices differs markedly from all the other and contemporary arts of Bronze Age Greece and Crete. It is a phenomenon which is particularly difficult to comprehend in the face of the remarkable unity of all the arts in the later Greek period. The gems and rings remain our richest single source of evidence for the figurative arts of Crete and never so rich as in this, the last palatial phase. Evans saw its importance but it is still too readily underestimated, and probably too little has been done to make the evidence easily accessible and comprehensible to other archaeologists and historians of art.

MYCENAEAN GREECE (LHI–IIIA)

Through the Early and Middle Bronze Ages the arts in mainland Greece developed in seeming isolation from the brilliance of Minoan Crete. In the Early Bronze Age, as we have seen, there was at least in seal usage some relationship with Crete, as yet not clearly definable, but, after the coming of the Greek-speakers, in the Middle Bronze Age, there is nothing. The opening of the Late Palace period in Crete saw the establishment of a number of Minoan settlements or trading stations on Aegean shores, at Miletus and on Rhodes in the east, on the Cyclades islands, and nearer the heart of Greece, on offshore Kythera and Keos. Crete was forcing herself upon the attention of the Greeks. Their own art seems to have been basically non-representational, so far as we can judge it from pottery decoration, and the impact of Minoan art worked a revolution. For the rest of the Bronze Age the story of Mycenaean art is told in terms of the import of Cretan works, the arrival of Cretan artists, the interaction of Greek patronage and Cretan style. From the end of the Middle Bronze Age too Greece enjoyed a sudden access of wealth and power, the political or dynastic origins of which remain obscure. It is exemplified for us in the finds from the famous Grave Circles at Mycenae, which was throughout this period to be the most rich and impressive of all the Greek citadel sites.

The earliest of the Mycenae graves are in a later enclosure known as Grave Circle B, and they belong to what ceramically we would regard as the transition between the Middle and Late Bronze Ages. The four gems found in the graves are all Cretan—a MMIII disc with the head of a bearded man (*Pl. 44*), a lentoid with a wounded bull, and two 'talismanic' amygdaloids. In Grave Circle A, whose burials immediately succeed those of Circle B, we straightaway observe devices and compositions which deviate in varying degrees from what is found in LMI Crete. Similar deviations can be observed in the gems found in Greece throughout this period, which for convenience we may take down to the end of LHIIIA, after the final dissolution of palatial life and arts in Crete. It is in fact not easy to discover clear criteria for stylistic development in the mainland gems of these years, even when given both the deduced

127

development of the Minoan series and the evidence of many contexts with datable pottery. Mycenaean artists seemed never able to make progress in the foreign idiom of the more sophisticated Minoan arts. But the question 'Mycenaean or Minoan?' has already been posed and must be faced.

The Mycenae Grave Circle B gems are Cretan. If the Circle A gems seem subtly different from the Cretan series this can only reflect the taste or instructions of their owners, since it is inconceivable that the first gems in this style cut in Greece could have been the works of other than Cretan artists. Common sense at any rate would suggest that the artists would move to satisfy the new demand and patronage. Once the studios are established in Greece the 'nationality' of the artists and apprentices becomes a problem of less than academic interest. The idiom is and remains Cretan, the subjects and compositions are determined in part by the tradition of the craft (wholly Cretan) and in part by the demands and taste of the patrons (wholly Greek). The differences in subject matter are easily observed. The difference in style is in many instances clear, when we compare home Cretan with Greek, but in most cases debatable. At any rate, it is questionable how much difference we should expect in the products of artists working in a Cretan idiom for Greek masters, on the one hand in Greece itself, on the other in a Crete dominated by Mycenaean Greeks, as in LMII–IIIA.1. What differences there are may admittedly stem from some basic temperamental difference between Minoan and Greek, and it is rather unlikely that there were Mycenaean-trained engravers in Knossos. But there may very well have been in Knossos gems or impressions made in the mainland. When criteria are sought broad principles can be agreed upon, and Biesantz has best defined what seem to be the basic torsional and interlocking compositions in Cretan work, and the basic architectonic compositions which better satisfied the Greeks. When the criteria are applied to individual pieces the possibilities of disagreement and error are total. They can lead to the attribution of different sides of the same stone to different artistic ambients, and they breed petty argument about problems best accepted as insoluble. The most that we can hope for is that some actual Cretan imports to Greece may be recognised through the attribution of gems to artists whose other work is from the island; and that—as seems to be the case—the mainland studios developed a style and tradition of their own, parallel to if subtly different from that of those serving a Mycenaean Knossos. Some mainland studios would also have tolerated work which is little better than a parody of the Minoan, and this can be observed in the finds. In the Notes to this chapter mainland finds are listed as Minoan only where a special type, like the 'talismanic', or hand make the attribution certain. Even this does less than justice to the travelling artist. If much that is left with Greece looks thoroughly Minoan this gives probably an accurate enough account of a society which was wholly conditioned to using objects in Minoan style, and to which place of manufacture meant nothing, except when it was a matter of ordering a particular device. Further progress in this study will lie mainly in the identification

of individual artists and studios, partly in more careful attention to iconographic detail. Neither can be attempted in the limits of this chapter. Before we return to considerations of the Mycenaean style it will be convenient to discuss sources, materials and shapes.

The important early sources for gems in Greece are the Mycenae Grave Circles, already mentioned. The finds from these early (LHI) royal tombs are not matched by finds in later, built tholoi or 'beehive' tombs which, at Mycenae, were all plundered in antiquity, but the site and lesser cemeteries near Mycenae have yielded gems, several in intelligible contexts (*Pls. 168–184*). Elsewhere in Greece the royal tholos tombs have been more productive. In LHII there is the great tomb at Vaphio in Laconia which yielded the famous gold cups with the scenes of the capture of bulls. Forty one gems and two rings were found (see *Pls. 154–167*), of which twenty three stones and one ring were observed in position within a pit burial overlooked by tomb-robbers. The gems were clustered at the wrists of the body, but it is unlikely that they were worn on wristlets (they are beautifully preserved) although this is how they are generally described. The excavator writes that they were found in piles and he noted traces of wood. They may have been in small boxes, but still possibly attached to the wrists or at least held in the hands. The number is exceptional and the suggestion has been made that their owner was a collector. The quality is mixed but several have good claim to be pure Minoan work and one is a 'talismanic' gem. The warrior who owned them may have served in Crete and took the gems to his grave with his other trophies of very mixed origin—the gold cups, foreign alabaster vases, an iron ring, Baltic amber. But most of the gems are probably of mainland manufacture (one is a very poor copy) and the collection may have been more a matter of display—he had eighty amethyst beads on a necklet or pectoral—than connoisseurship. Other royal tombs with gems and rings are at Dendra in the Argolid and several in the Pylos area (LHII–IIIA). Minor cemeteries with useful groups are at Prosymna (near the Argive Heraeum), Athens and in Rhodes at Ialysos.

Of the eight seals from Grave Circle A at Mycenae five are of gold, of which two are rings of the Minoan pattern and three are versions of the flattened cylinder which in Crete is known only in stone or bronze (and once gilt stone, *Pl. 59*). From near Pylos there is another gold seal of this shape (*Pl. 152*), even more elaborate, with a relief net pattern on the back, as well as two long amygdaloids (one on *Pl. 151*; the other with cloisons on its back). There are many other rings from Mycenae (*Pls. 148–150, 153*) and other sites, often with elaborately moulded and decorated hoops. A special type deserves attention here. It is represented by two examples from Mycenae, two from Asine, one from Kalyvia in Crete (*Fig. 124*), which may be of mainland manufacture, and, apparently, a Pylos sealing. Their bezels had been formed not out of a single sheet of metal but by two pieces clipped on to a core, so that the device is divided lengthways, which recalls the way that fresco backgrounds are treated in separate coloured bands. On one of the rings from Mycenae the join was a wavy line, as on frescoes. The cores of the bezels are described as bronze (Asine), silver (Mycenae), iron (Mycenae) and iron over bronze (Kalyvia). At Dendra the cores of three rings were said to be made of superimposed silver, lead, copper and iron, but the intaglio devices, which may have been on separate gold sheet, were not here preserved. In every other case only one half of the bezel has survived, and although it is generally assumed that the other half was of gold also, it is odd that it has always been lost or removed before interment. Possibly it was easily detachable, to be kept by a partner and only mounted on the hoop for joint use, as has been suggested by Platon for earlier ivories in Crete (see p. 24). But it may well have been of another material, probably silver, which has corroded away. Such bi-metal rings recall a later, Archaic and Classical Greek practice of mounting a gold stud in a silver ring (see p. 157). It is very doubtful whether any galvanic effect could have been observed from such juxtaposition of metals, although this might have been experienced with other metals. It could help explain the ring-kissing practices of later ages and the

128　　　　　*129*

sensation (an electric current passing between the metals) might have been hoped for when the bezel was licked in preparation for sealing.

The commonest materials for Mycenaean stone gems are as the Cretan, with perhaps a special preference for the banded agates and onyx. Spartan lapis lacedaemonius was used a little as it had been in Crete. There are some glass gems, but the intaglios are not cast with the shapes. A rarer material is amber from the Baltic, used for an amygdaloid at Mycenae; or lapis lazuli from Afghanistan, employed for several gems. A remarkable find at Thebes in 1964 throws light on the use of this eastern material. It comprises thirty eastern cylinder seals, of varying dates and proveniences. These may have been the gift of an eastern king to a Mycenaean whose palace, we know, housed studios for the cutting of ornamental stones.

Apart from the rings the other seal shapes used in mainland Greece are the same as the Minoan. Lentoids are rarely cut on both faces, and there are some very large examples of the shape. Amygdaloids are often elongated and have elaborately fluted backs. The flattened cylinders too may have carved backs, and all these shapes may be capped in gold at either end by the string holes. The only other stone shape of importance is the three-sided prism with round faces, which we met in LMII–IIIA Crete. There are rare cylinders, some of them barrel-shaped.

When we turn to a closer view of the style of the mainland gems we find that the main classes which could be distinguished and even approximately dated in Crete are of little service to us. There is in fact an overall homogeneity of style in Late Bronze Age Greece where even the devices of the gold rings have more in common with the style of the cut stones than they did in Crete, except where they are indistinguishable from the Minoan. In technique the Greek gems relate most closely to the Common and Plain Palatial styles of Crete, while the Fine naturalistic style, which in Crete was based on an earlier tradition, is absent. Even so there are differences. The devices on most of the gems found in Greece— and we might as well call them Mycenaean, however Minoan many may look—are more stylised than, and stylised in a different way to the Cretan, although in many instances they may admit more detail, as in the features, manes and anatomy of animals. This is well shown on the finer rings and seals (as *Figs. 128, 129*) where the detail may compare with that on the most naturalistic LMI gems, but the style is utterly different, as well as the subjects and compositions. Moreover, on the stone gems, the basic drilling or cutting techniques may remain as apparent as they are on Cretan gems, but they are never employed as subtly as they were by Minoan artists at home. We miss, for instance, the assurance with

which the Minoan artist could create brilliant animal studies from the very simplest of cut masses including completely undisguised drill marks.

In compositions we have already remarked on the more tectonic treatment on Mycenaean gems, with a structure of right angles and diagonals rather than the subtler Minoan whirls and fluid curvilinear movement. Even when the contorted creatures, alone or in fighting groups, are admitted, they are reduced to a pattern of parallels and angles rather than arcs (*Pl. 169*). The purely heraldic, symmetrical compositions of course express this feeling most completely (*Pls. 153, 171, 174, 177, 181*). They were well known in Crete too, but there the lines of the animal bodies create a composition of spirals while in Greece they are built into a more rigidly architectonic pattern. A symptom of the mainland approach is the popularity of ground lines for figures.

The fact that virtually all these basically non-Minoan features—the detailed stylisation, the compositions—are apparent already in the gems from Grave Circle A at Mycenae, seems to lend weight to the idea that mainland studios were well established early in the Late Bronze Age, and that they perhaps learned little new from Crete, since in LM/LHII Mycenaean interest in Crete is so strong that it is not easy to declare that any particular new motif, rather than style, was a purely Cretan innovation.

Within the period discussed in this section various stylistic groups can be detected. The criteria are partly technical—the degree of use of the drill for eyes, joints, feet; partly iconographic—peculiar lion types; partly compositional—predilection for heraldic or antithetic devices. Within the rich series of gold rings and seals similar groups can be found and broadly if not exactly related to the stone gem series. Some preliminary speculation on these groups is confined, in this book, to the Notes, but consideration of the motifs on the Mycenaean gems will provide the opportunity for some discussion of these matters.

While a great many of the devices on mainland gems derive directly from the Cretan, and differ from them perhaps only in details of composition, by no means all Minoan devices were adopted, and, of those that were, some enjoyed a popularity they had not known in Crete. In most details of dress, in the religious scenes and paraphernalia, the mainland artists depend on Cretan models, as may have Greek dress-makers and religious colleges. The same symbols and acts are shown, even if deployed differently: the same axes, horns of consecration, the Minoan 'genius' (*Pls. 166, 175*), goddess or god with animals (*Pls. 160, 161, 164*), worship of trees (*Pls. 149, 154*), the sacrificial animal on a table (*Pls. 184, 185*), the strange goddess on a dragon (*Fig. 128*). Among the monsters the griffin is preferred to the sphinx and we miss the rich fantasy of man-monsters from Cretan gems, as well as most of the 'talismanic' motifs. Scenes of fighting and hunting, however, form a special category. They were not unknown in Cretan art, but by no means common. In Greece the engravers shared with other artists an interest in these subjects, and while in Crete we may see the occasional boxing match or the dangerous bull-leaping, in Greece there are more scenes of men fighting together or hunting wild animals. We detect a more conscious interest in scenes of everyday life rather than the use of figure motifs for decorative effect, and this interest comes very close to that feeling for true narrative art which characterises later Greece, but is quite foreign to Minoan art.

The lion hunt is a case in point. In the LHI Grave Circle A at Mycenae it appears on a gold seal and the famous inlaid dagger, and it is repeated often later, but is almost unknown in Crete. The lion is the only real creature to appear in Aegean art of which the question must be asked whether Aegean artists had ever seen one alive. In Classical times there is evidence for lions in north Greece—the Persian invaders' camels were attacked by them in Thrace, and Herodotus says that there were many there—but nowhere else in Greece. There is no archaeological, and of course no literary evidence for them in Bronze Age Greece. In the eighth century Homer knew about lions, but not all about them—they never roar in his

poems. They are commonly shown in orientalising Greek art, but it can be clearly demonstrated that they are copied from eastern models, Hittite and Assyrian, and not from life. Indeed the artists made elementary mistakes like giving a lioness a mane and dugs all along the belly, or making the lion crouch like a dog, rump in air. The Bronze Age Aegean artist made exactly the same mistakes with the lioness (as *Pl. 91*), and although exact eastern models are not as easy to find as they are for the later period, we may safely assume that the lion, and the lion hunt motif, were inspired by foreign works and the creature's reputation, which may explain its special allure for the Greeks. Lions in Cretan art follow a set pattern, and usually have long, dog-like muzzles (as *Pls. 111, 114*). In the round there is the fine stone rhyton from Knossos. In Greece there is more variety. The Cretan type is normal (*Pl. 171*), but we find also on gems a type with a shorter, squarer and more realistic head (*Pl. 155*), just like the gold lion head rhyton from Mycenae, and there are some examples of a compromise between the types, combining the high arched forehead with a long muzzle. The square-headed lion, and its plausible behaviour in the lion-hunting scenes, leads one to suspect that the mainland artists profited either from more explicit foreign sources for the beast's appearance, or possibly from experience, real or reported, of its behaviour. The type appears early in Mycenaean art, at a time of remarkable prosperity and interest in overseas affairs, but it could be the creation of one artist who set the pattern to be followed by others.

THE END OF THE BRONZE AGE (LM/LH IIIB-C)

CRETE

Minoan art and economics were closely bound to palace life. In the period of Mycenaean domination Knossos and a few well appointed 'villas' in north Crete were the focus for the economic life of Crete, which seems rather an island of villages once the other palaces had been overthrown and abandoned. When Knossos and the villas also fell there was no longer any focus or patronage for the major arts, although this seems a period of relative quiet and prosperity to judge from the great number of sites and cemeteries of the thirteenth century BC which are found all over the island. Seal usage in Crete appears to have been much involved with its complicated bureaucratic and economic life, especially under Mycenaean Knossos, and the tradition had been long and strong. It is not surprising therefore to find both that seals continued to be cut in post-palatial Crete, and that their quality—in material, technique and artistry—declined sharply.

Unfortunately only a few post-palatial sites have yielded gems in datable contexts, and of these only a minority is published. The survival of fine gems from the palace period in some tombs has already been noticed. 'Talismanic' gems are found too, most of them probably old stones, especially where their material is good. They would have been more easily come by in LMIIIB than in the nineteenth century AD when Evans found them still worn as amulets. Gems which show a style appreciably different from that of earlier periods offer the old themes—lions and animals—rendered in a more stylised and summary manner, and generally hand cut in softer materials. A considerable number of gems which have no dated context can with some confidence be attributed to this period on clear grounds of style.

The commonest material is a 'steatite', black or grey in colour, and soft enough for many specimens to be so badly rubbed from wearing that their devices are indecipherable. Rarely harder stones are used, usually cornelian, rock crystal or jasper. In the soft material the intaglios are mainly hand cut, but a tubular drill may be used for eyes, and on other stones there is more haphazard use of the old Hoop and Line techniques to produce rough animal figures or more formal patterns. The lentoid is the usual shape, often with a low conical back, with few amygdaloids and flattened cylinders.

It has often been observed that in the other arts post-palatial Crete reverted to styles and motifs current before Mycenaean Greek intervention. If true, this is barely perceptible in the gems. Some of the subjects are those of LMII–IIIA, especially the figures of lions and bulls. And since so many of these are cut free-hand and lack any emphasis imparted by more mechanical means of cutting, the creatures look more like the poorer specimens of the Common Style of earlier gems. Certainly the lion type is just the same (*Pls. 191, 193, 194*). There are still animal groups (*Figs. 130, 132–3*) and pairs of antithetic animals in the old whirl form, but the more heraldic compositions and contorted figures of the preceding period seem to be avoided. The Minoan 'genius' and goddesses return, even a cult scene (*Pl. 188*), and occasional marine motifs—fish or shells. Spiky, sickle shaped wings are a feature of some gems, and there is a tendency to reduce figures to linear limbs, outline and detail, with little bulk to the bodies and no modelling. A new motif is the bird goddess (*Pl. 200*), her tail rendered as the flounced skirt and feet of a woman, her head human or bird-like. Subsidiary patterns—the shields, knots and trees—are rendered as the simplest linear forms. Irregular use of the tubular drill alone on some gems produces abstract patterns (*Fig. 131*) recalling the more controlled devices on the first Minoan gems to display the technique. The flying birds present a form which had persisted on poorer stones since the first main period of the 'talismanic' gems. It may be that 'talismanic' gems with the old motifs and on the old amygdaloid shape were now being cut again, in softer stones. Some from a late site (Episkopi Pedeada) are reported and may be taken with others without provenience. Versions with a ship or 'lion mask' may be explained in this way (*Pls. 196, 202*).

To the late period also may be attributed a number of plump lentoids made of either clear or blue glass, with animal devices of the usual type. The material had been employed long before in Crete, but its use for seals at this date may have something to do with the Mycenaean taste for mass-produced blue glass trinkets and beads.

THE ISLANDS

Apart from the basic question of Minoan or Mycenaean the existence of strongly distinctive local schools in Late Bronze Age Greece has not been considered, nor, in the present state of our knowledge, can one do more than speculate about the differing styles in, say, the Argolid or Messenia. The Greek islands that lay between the Greek mainland and Crete may prove more fruitful ground. Many seals have been found in the islands, and it was the 'Inselsteine'—most of which were later recognised as Archaic—which first stimulated interest in prehistoric seals during the last century. Melos and Thera had been closely involved in Minoan affairs at the end of the Middle and start of the Late Bronze Age. We may hope to learn more of Thera from beneath the lava level of the LMIB explosion. Melos has yielded several Cretan 'talismanic' gems of MMIII–LMI and a remarkable ivory ring showing a Minoan priestess (*Fig. 134*). In the Late Bronze Age the island looked rather to mainland Greece and the range of gems found is more varied. In LHIIIC the islands enjoyed a twilight prosperity denied the main Mycenaean centres and exploration of late sites, as on Naxos, has produced gems (as *Fig. 135*), but none demonstrably of post-IIIB manufacture.

Another approach is possible. In the Archaic period the distinctive island stone for gems is a pale green translucent 'steatite'. There are a very few Bronze Age gems in this material, most of them from the islands and probably made there. The rounded lumpy cutting of two antithetic goats on a big lentoid with a conical back, in the green stone, might indicate a local style, and there is an amygdaloid with similar creatures in the same material (*Pl. 198*): neither with certain provenience but both in the island stone.

60

130 131 132 133

134 135

136 137 138 139 140

GREECE

After the fall of Knossos, whatever its cause, Crete had ceased to be organised as a Mycenaean kingdom and there was no longer patronage for the luxury arts. The seal engravers of Mycenaean Knossos either turned to the land or emigrated and there were no longer any active studios in Crete to train artists of quality or to influence the taste of the rest of the Aegean world. For the last period of the Bronze Age Mycenaean Greece was on her own artistically, left with the idiom and tradition of a foreign art which, through import, instruction and imitation, had become the only figurative art it knew.

The demand for and the use of seals continued, but, as we might expect, there is no particular stylistic or technical advance to note. Motifs and compositions remain as before and some metal rings were possibly still being cut, while some were being cast with their intaglios. Generally speaking the more elaborate subjects were avoided and softer materials were more freely used. On these the simplified technique produced pieces not unlike the contemporary Cretan, with rather simply cut bodies relying on incised detail and little drill work, as for eyes (*Figs. 136–140*). Lions and griffins are popular subjects,

distinguished by their boldly and usually carelessly marked faces and wings. The sealings from the destruction level of the palace at Pylos (as *Figs. 141–143*) offer several utterly debased motifs, and impressions from a few finer, earlier rings and gems of LHIIIA style and presumably of LHIIIA date, which had continued in use.

The dissolution of the Mycenaean world is a long and complicated story. For our purposes we may observe simply that by about 1200 BC (the transition between LHIIIB and LHIIIC) the palace bureaucracies had been broken. As in Crete nearly two hundred years earlier, this meant the end of writing, at least for accounts, and the end of the more sophisticated arts which went with palace life and business. But, again as in Crete, the wearing and possibly the use of seals continued. An important cemetery of this period at Perati in Attica was well stocked with gems, most of which are obviously survivors from earlier days. There are, however, some from LHIIIC contexts which, taken with unstratified examples (several from Mycenae which remained occupied in this period), may suggest what seals were still being cut. All are lentoids in soft grey or black 'steatite'. Most have animal devices (as *Figs. 144–148*)—simple quadrupeds rendered without detail, with slim curving bodies and legs recalling the style of some of the latest painted figures on Mycenaean vases. The field is occupied by branchlike motifs—highly stylised versions of the shrubs and palms on earlier gems. Sometimes the animal form is barely recognisable, and we find also a simple pattern of opposed concentric arcs (hand cut) which again recall pottery patterns. With the final break up of Mycenean civilisation in Greece and the attendant depopulation of Greece in the years around 1100 BC, the craft of seal cutting disappeared, and no continuity whatever—in material, technique, shape or subject—can be observed in the following centuries or with the resumption of stone seal engraving in the eighth century, although, as we shall see in the next chapter, the Bronze Age gems of Crete and Greece had a part to play in the story of seventh-century Greek glyptic.

SEAL USE AND PRODUCTION

Our evidence for the use of seals in an age with no literary texts has to be taken wholly from the clay sealings which have survived through the accident of having been baked in a fire. The shapes and the markings on the backs of these sealings suggest sometimes how they were used. At Lerna (EHII) the lumps of clay had been applied around cords fastening wooden boxes or wicker baskets, while some are from the shoulders and mouths of jars. At Phaistos (MMII) the clay seems to have been pressed over the cords fastening boxes or cupboards, and wound around pegs. At Knossos the sealings in the Hieroglyphic Deposit (MMII/III), and the later palace sealings are usually hemispherical or prism-shaped, impressed around cords fastening boxes or possibly documents. Many of the earlier sealings were countermarked in Linear A, the later ones in Linear B script, and occasionally Linear signs were incised across the actual seal impression (as *Fig. 123*). Similar sealings were found at Mycenae and Pylos (LHIIIB), and at the former site the mouths of stirrup vases were found closed with sealed lumps of clay. It may be observed that the eastern practice of authenticating a written clay tablet with a seal impression was not followed in Greece. Admittedly, the Minoan and Greek tablets generally record accounts and none are letters or state documents of any importance, even so it is surprising that personal or official stamps were never used upon them. Only rarely are seal impressions found on clay vases to decorate or identify them. Most instances belong to EH Greece, with a few from MM Crete.

The most graphic evidence for how seals were worn is provided by the Cup-bearer fresco from Knossos which shows a youth with what appears to be a veined stone worn as a wristlet on his left arm. In burials in both Crete and Greece it has been noted that seals were found at the wrists of the dead,

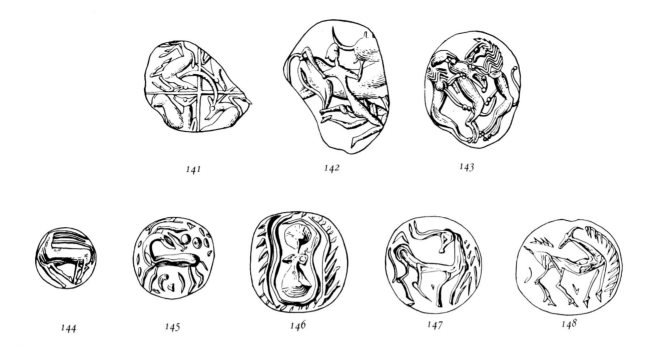

<p style="text-align:center">141 142 143</p>

<p style="text-align:center">144 145 146 147 148</p>

numbering between one and four, and we should recall the piles of gems at the wrists of the Vaphio warrior. They may have been in separate containers, but fastened to the wrists. At Prosymna it seems that a gold ring was fastened to the forearm. Its hoop was too small for a finger—which is true of most Bronze Age Greek rings. At Dendra the 'queen' had one gem at her left wrist. The left seems generally although not always preferred. That women carried seals is suggested too by the clay 'Dove Goddess' from LMIIIB Knossos, with one at each wrist, and this encourages the identification of seals shown on the wrists and arms of other clay figures from Crete and Mycenae. There is some evidence too that gems were worn with beads on necklaces, perhaps then as amulets.

Of the workshops for the seals and the engravers themselves we can know little. This was a specialist craft and had probably been so from an early date. The MMI studio at Mallia seems not to have yielded evidence for the practice there of any other craft. There is no need, for instance, to suspect that the seal engraver was also a jeweller, although the gold rings at least may always have been jeweller's work, including their intaglios. Their style seldom quite matches that of the stone seals. And the repertory of subjects and patterns on the stone seals seems very different from that of the jeweller or vase painter.

In the Mallia workshop were found a bronze file, burin and stone polishers. Unfinished stones showed that the shape of the seal was wholly fashioned before the engraving was done, and that the boring of the string hole came last. In a room at the south of the palace at Knossos (LMIIIA) Evans identified a 'Lapidary's workshop'. Here 'steatite' lentoids were found blocked out but without engraving, and already pierced, but we cannot be sure that they were meant for more than beads. The only stone intaglio there was cut on the prepared surface of a stone lump, but this looks more like a trial piece, and not a seal in the making. Clay nodules with impressions from unfinished gems were also reported. Other finds in the workshop were what Evans called 'chessmen'—cylinders or peg-like pieces of marble and steatite, which Hood has plausibly explained as the cores from stones being worked with a tubular drill. There are no unfinished stone vases from this area (as there were in the east wing of the palace) and it may be that it was recognised that these waste products could usefully provide raw material for the bead or seal maker. Slices cut from a cylinder core could easily be worked into lentoids. Possibly this is

the origin of the low conical backs to many LMII–III lentoids, and the peg-like tops to some of the pieces may be evidence for their treatment with this purpose in view, at least for beads if not for seals.

The presence of such a workshop within the palace at Knossos confirms what we have remarked already about gem engraving being a palace-centred art. There were also jewellers' workshops in palatial buildings at Thebes in LMIII, but there is no clear evidence that gems were cut there.

AEGEAN SEALS AND THE OUTSIDE WORLD

Not a great many seals from outside the Aegean world have been found on Greek or Cretan sites, and their immediate contribution to the development of Aegean glyptic seems to have been slight. We have observed the introduction of eastern stamp shapes to Greece and the islands in the Early Bronze Age, and of Egyptian shapes to Crete at the same time, but the characteristic eastern cylinder and Egyptian scarab were only rarely copied with compositions recalling their models, as the cylinders shown in *Fig. 127* and *Pl. 144*. Egyptian scarabs of faience and stone reached Crete from the Early Bronze Age on, and Greece in the Late Bronze Age. Some have provoked interesting problems of absolute chronology and at least one appears to have been reworked by a Cretan. From the Near East a number of cylinder seals reached Crete in the Middle Bronze Age, and both Greece and Crete in the Late Bronze Age. The earlier ones are Babylonian, the later from various eastern sources including Cyprus. The remarkable find of lapis lazuli cylinders at Thebes is a rather different matter, since they seem to be a bulk consignment whose worth was its precious material. Foreign seals in Greece may have been regarded as amulets, but they could on occasion be used. The impression of an Anatolian stamp was found at Phaistos, and of a Cypriot cylinder at Knossos. Finally, at the end of the Bronze Age there are found a few Anatolian 'bullae' with hieroglyphic inscriptions of Hittite type.

The brilliant and distinctive art of gem engraving in Crete might be expected to have had some influence on the work of overseas artists. This is not easy to detect since the transference of some motifs, like the spirals or the 'flying gallop', might have been effected in other media. But seals are the most portable of all works of art, and with a glyptic repertory as rich as that of Crete the appearance of Aegean motifs on foreign seals might reasonably be attributed to the positive influence of Cretan engravers and their art. The area which seems to have been most susceptible to this influence is Syria and Cyprus. A number of 'Old Syrian' cylinders include figures which appear to be in Minoan dress, scenes of bull leaping and animals in the flying gallop. There may certainly be some connection with Crete here but there are difficulties—details of dress are different and may indicate local practice. The Syrian style of cylinders with these motifs is dated very roughly to the Cretan periods MMIII–LMI, when there is evidence enough for Minoan activity in the eastern Mediterranean.

The Late Bronze Age cylinders of Cyprus owe much in their earlier and finer style to the so-called Mitannian seals of Syria. Some of the more elaborate examples carry inscriptions in the Cypro-Minoan script, which seems to have been derived from Cretan Linear A in LMI. These haematite cylinders and their immediate kin also admit some Aegean motifs, notably the Minoan 'genius' with his jug—who appears on other Cypriot works, but also some animals which in their style and posture are most closely matched in Crete and Greece. Other seals more frankly adapt Aegean subjects to fit a frieze composition, to which they are often ill-suited, and admit techniques closely related to the Plain Style of Crete. Here at least we may be dealing with immigrant Cretan artists. Generally the compositions are uncompromisingly hieratic or heraldic. These cylinders seem mainly contemporary with LM/LHII–IIIA, and related styles continue through LHIIIB. The Cypro-Minoan style is well shown in *Pl. 206*, one of the finest extant

149　　　　150

151

examples and hitherto unpublished. Eastern are the monsters with bull head and human body holding a lion, and with human body and lion legs; eastern the winged sun disc and facing horned head of a deity; mainly eastern the crossed lions, but they are not strictly symmetrical and the way that one trails a leg lends life and interest to the conventional pattern; Cypriot the four-character inscription above the sun disc and, apparently, a character in the field; Aegean the genii with their jugs (albeit not beaked, like the Cretan) who form the centre piece.

From the end of LHIIIB Cyprus received a large number of immigrants, whom we may probably more accurately call refugees, from Mycenaean Greece. They stimulated the Cypriot bronze industry, and a new fashion for stamp seals may also have something to do with the newcomers. The shape—a conoid with round back and oval face (*Pls. 203–205*; *Fig. 149*)—is not Greek, but the devices on many of the seals owe a great deal to Mycenaean models. The style, however, is on some specimens (as *Pl. 203*; *Fig. 150*) of a far higher quality than that shown by the latest Greek Bronze Age gems. It sometimes recalls the finer work of LM/LHI–II, as do some of the compositions, like the massive reclining bulls. It may be that this brief renaissance of the finer qualities of Aegean glyptic is due to artists who were not, by their homeland training, gem engravers, but engaged in the finer crafts of the end of the Bronze Age, metalwork, ivory-carving and jewellery. None of these Cypriot stamps seems certainly earlier than the last phase of LHIIIB, most are contemporary with LHIIIC and one was found in a LHIIIC grave at Perati in Attica. A closely comparable phenomenon in Cyprus at this time is the decoration of gold rings with either an intaglio on the metal bezel, or an inset stone intaglio, as *Fig. 151,* which shows a ring from a tomb of about 1200 BC at Kouklia. The style of these is that of the conoids. Different, and probably mainly earlier, are other Cypriot gold rings of Phoenician or Egyptian shape with the bezel in line with the hoop, and not across it as on Greek rings. Several of these carry eastern or Egyptian motifs but there are a few with animal devices of Aegean type.

Finally there is a group of lentoids of LMIIIB style in Oxford, said to be from near Gaza. These have been taken for evidence of a Cretan colony in the east. Similar finds from Aegean overseas settlements are, however, lacking, and the only seal which accompanied the considerable quantity of LHIIIB pottery found in the Near East was a poor glass lentoid, found at Tell abu Hawam in Palestine.

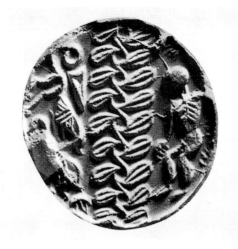

1 3:2 2 3:2 3 3:2

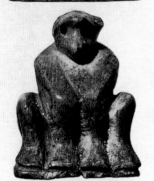

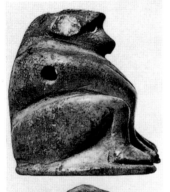

5 3:1

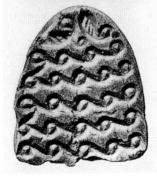

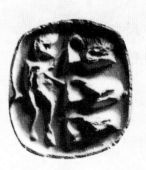

6 3:1

4 3:2

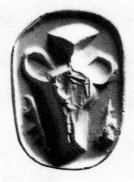

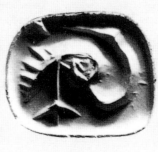

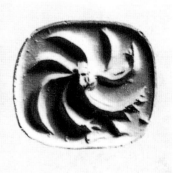

7 3:1

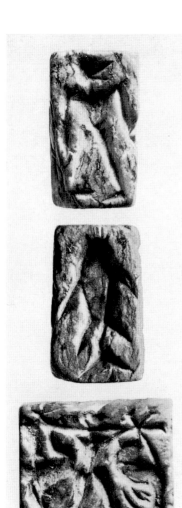

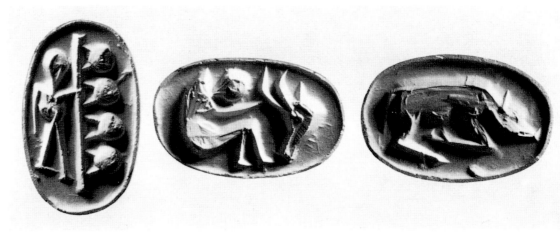

9 3:1

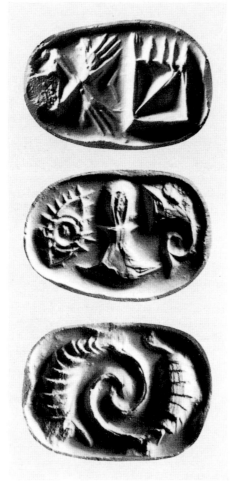

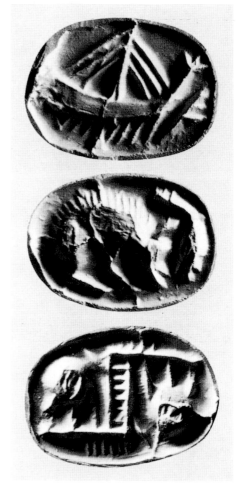

8 3:1

10 3:1 11 3:1

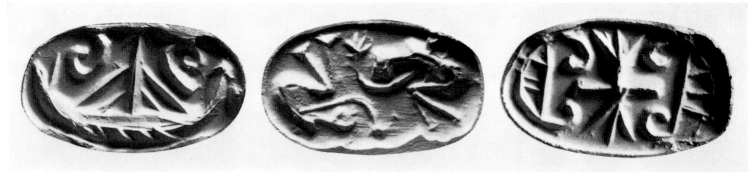

12 3:1

13

3:1

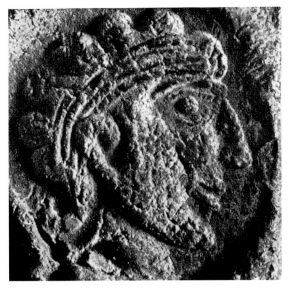

14

7:1

15

7:1

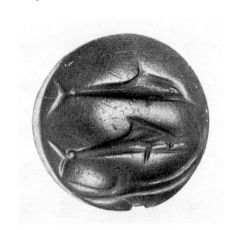

18

3:1

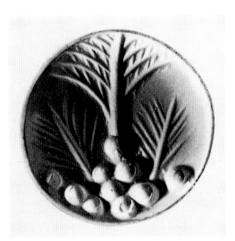

17

3:1

16

3:1

20

3:1

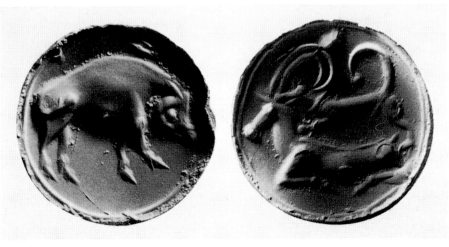

19

3:1

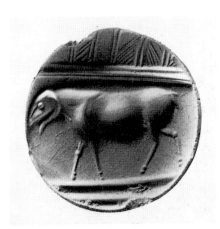

21

3:1

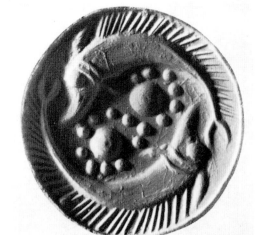

22

3:1

23 4:1

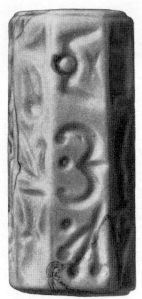

24 4:1

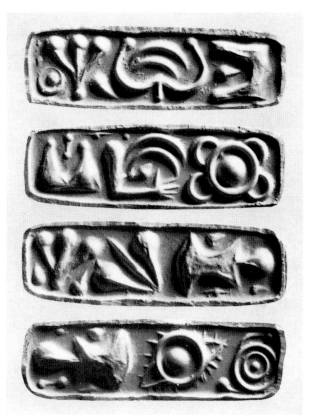

26 4:1

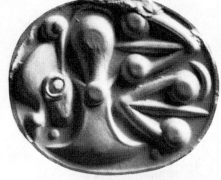

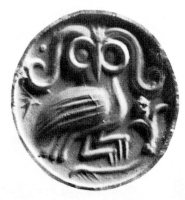

25 4:1

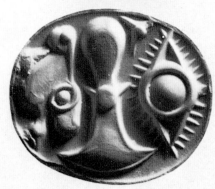

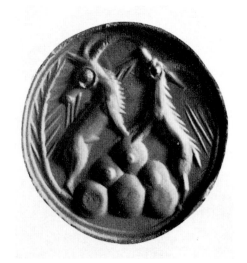

28 4:1 29 4:1

27 4:1

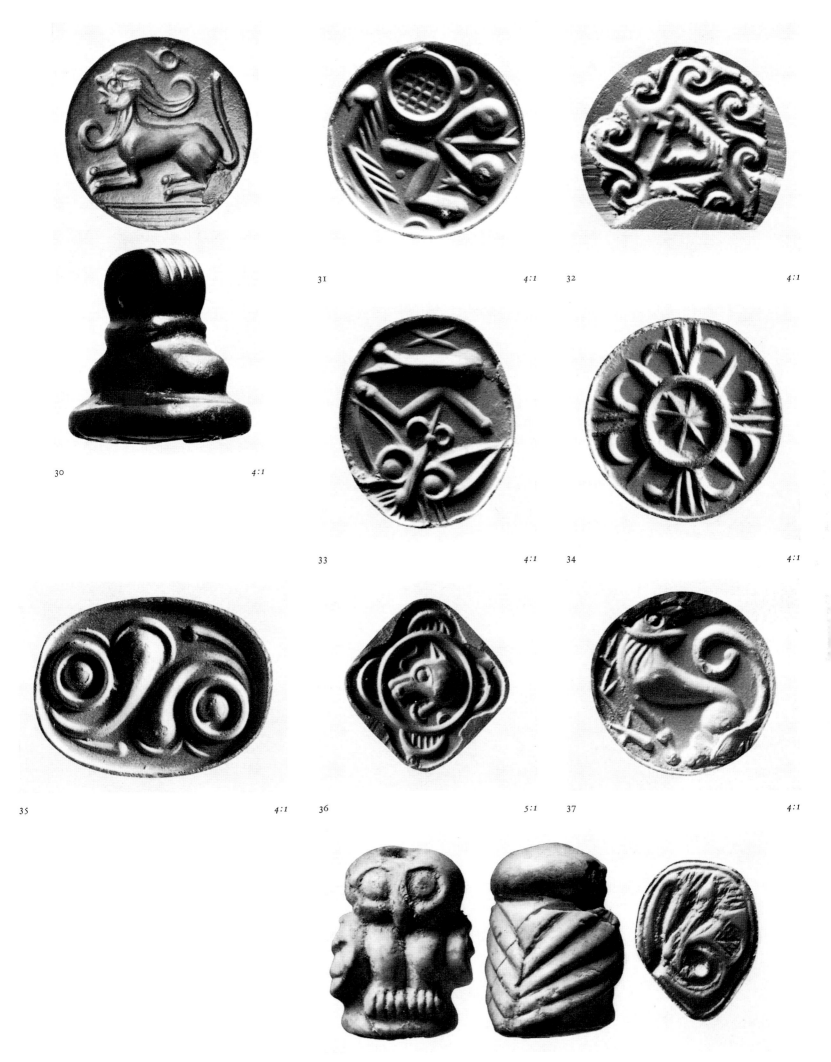

30 4:1

31 4:1 32 4:1

33 4:1 34 4:1

35 4:1 36 5:1 37 4:1

38 3:1

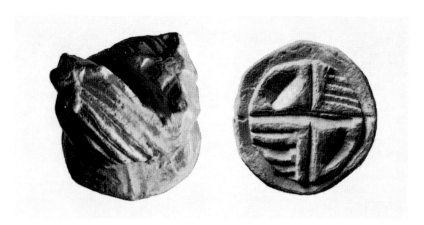

39 *4:1*

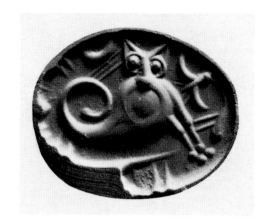

40 *4:1*

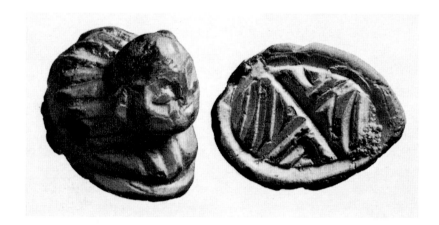

41 *4:1*

42 *3:1*

44 *8:1*

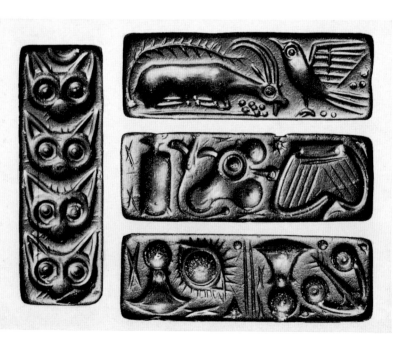

43 *4:1*

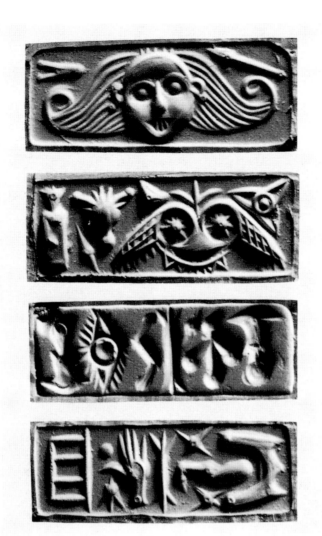

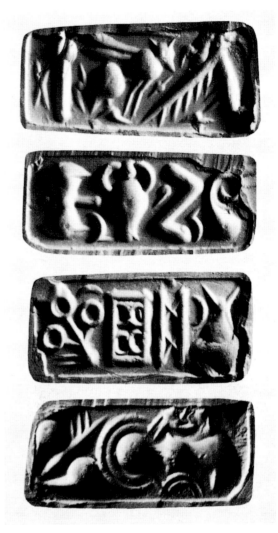

45 4:1 46 4:1

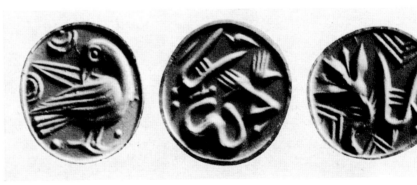

47

4:1

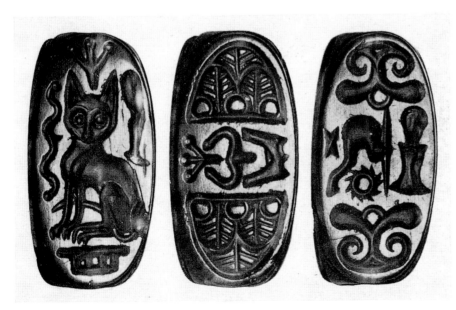

48 4:1

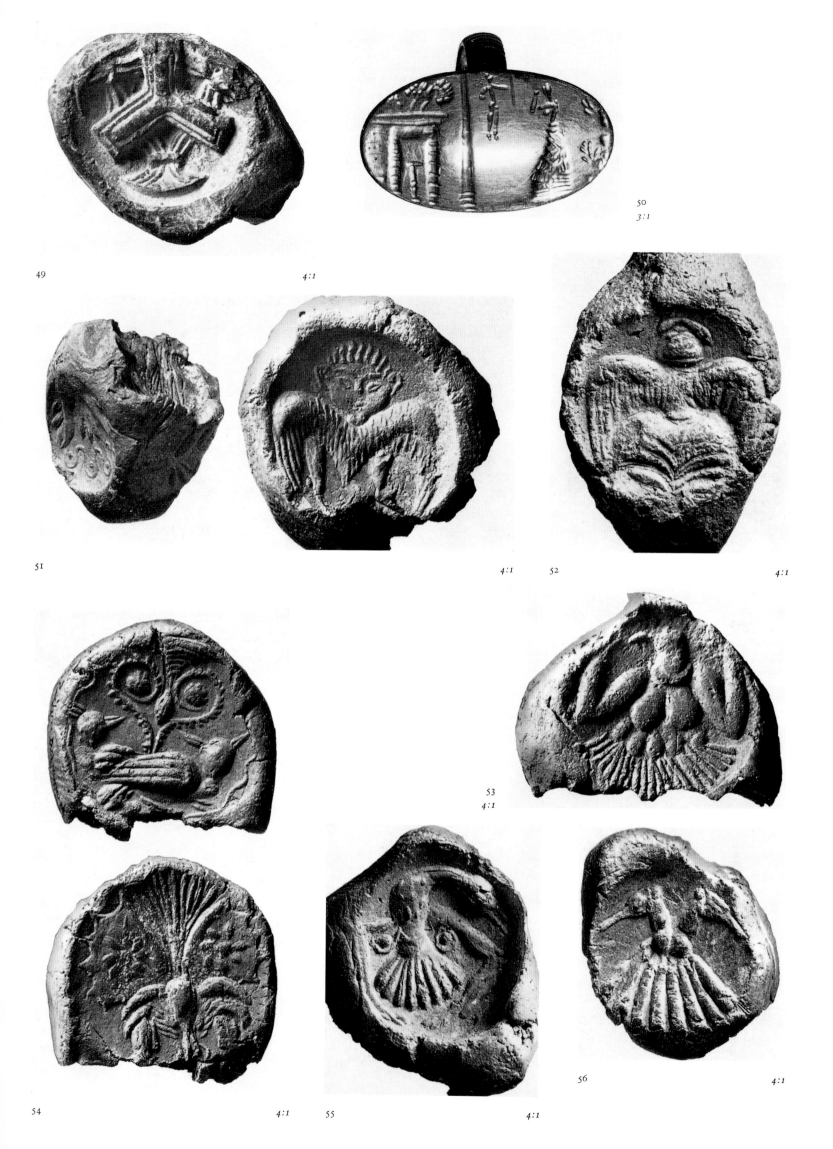

49

4:1

50
3:1

51

4:1 52 4:1

53
4:1

54 4:1 55 4:1 56 4:1

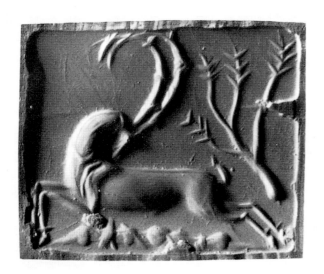

57

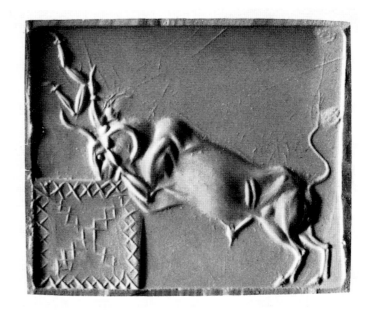

58

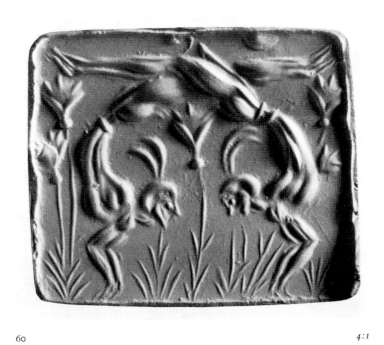

60

59

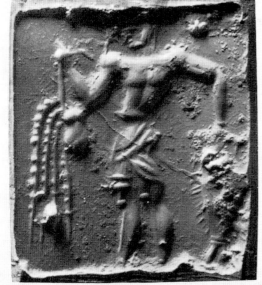

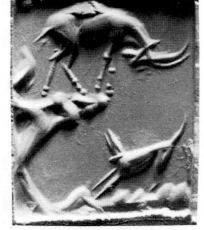

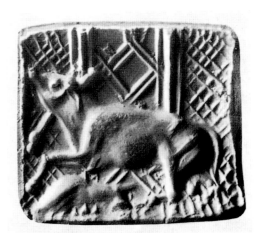

62

61

63

64

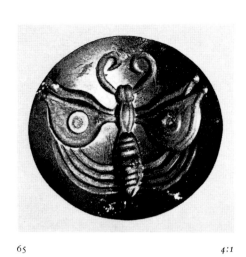

65 4:1

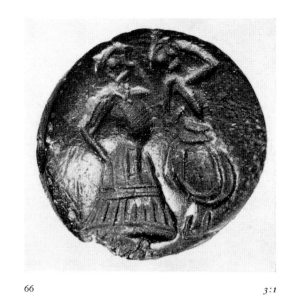

66 3:1

4:1

67 3:1

68 3:1

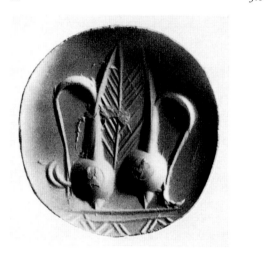

69 3:1

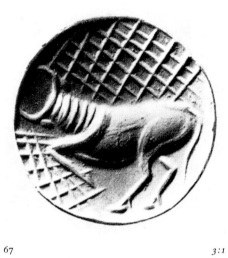

70 3:1

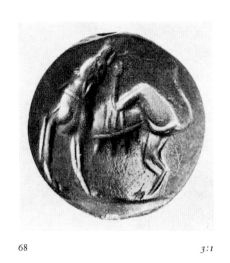

71 3:1

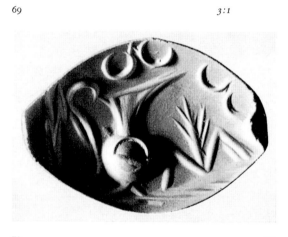

72 3:1

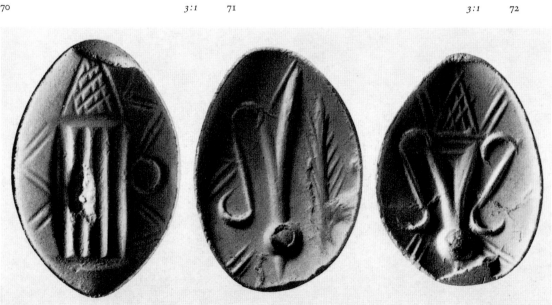

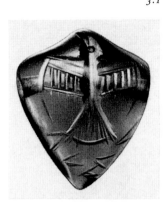

74 3:1

73

3:1

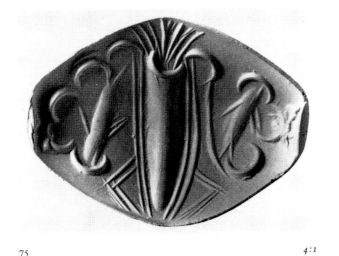

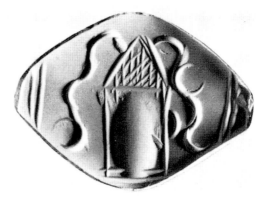

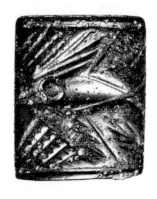

76 *3:1* 77 *4:1*

75 *4:1*

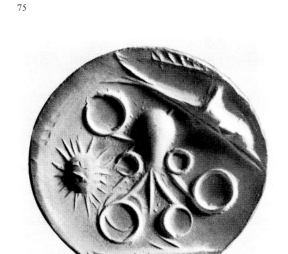

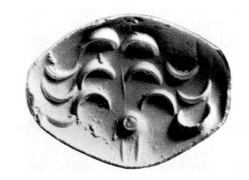

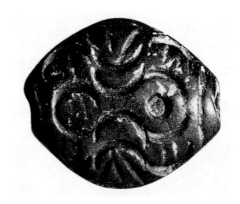

79 *3:1* 80 *3:1*

78 *3:1*

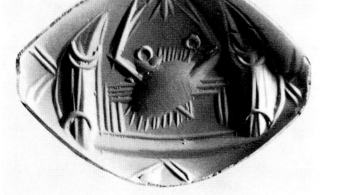

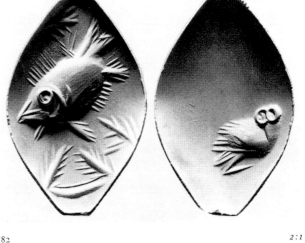

82 *2:1*

81 *3:1*

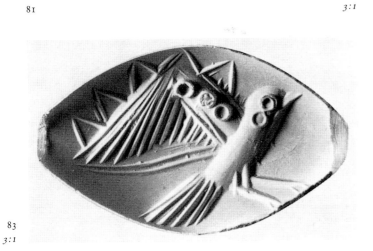

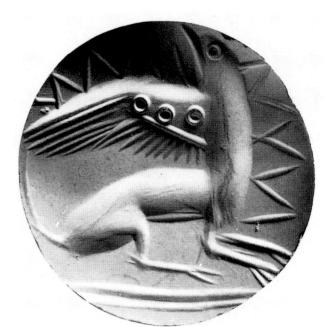

83 84
3:1 *3:1*

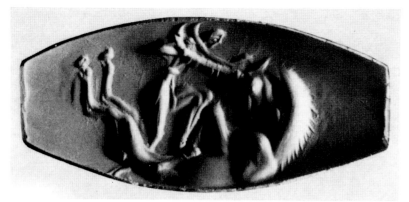

85 4:1

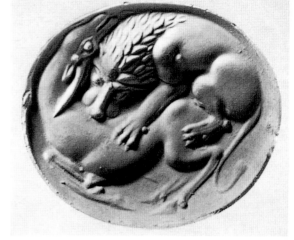

86 3:1

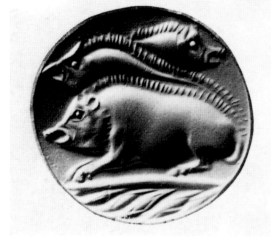

87 3:1

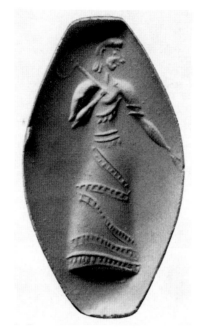

89 3:1

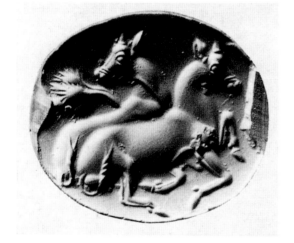

90 3:1

88 3:1

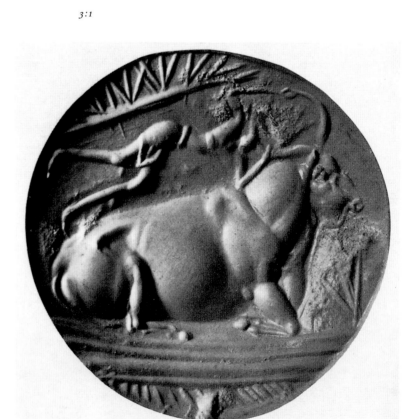

91 92

3:1 4:1

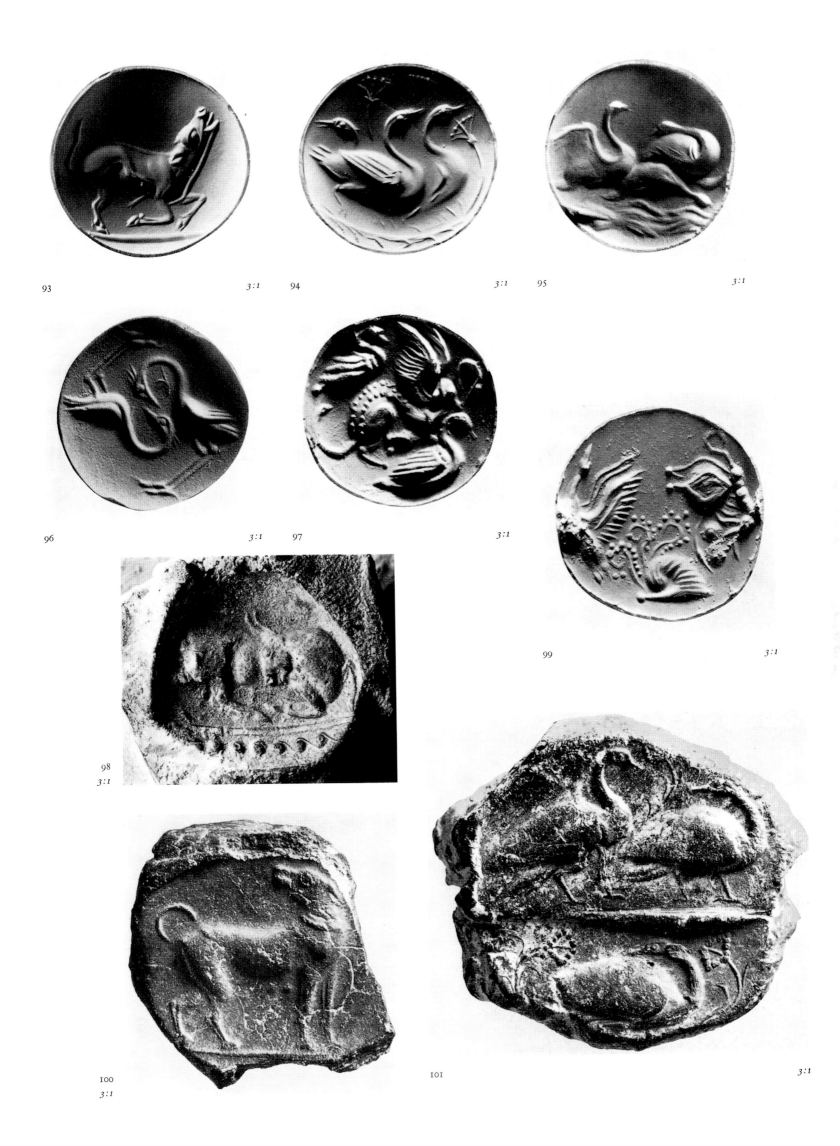

93 *3:1* 94 *3:1* 95 *3:1*

96 *3:1* 97 *3:1*

99 *3:1*

98
3:1

100
3:1

101 *3:1*

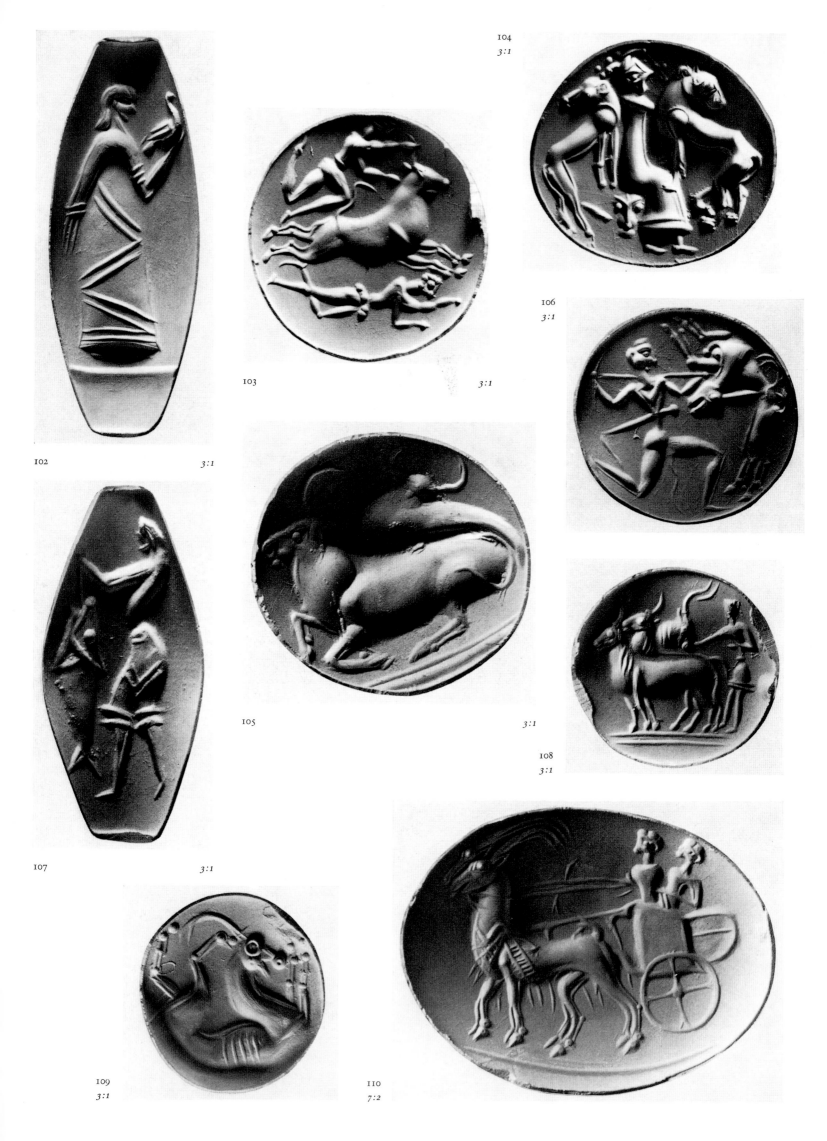

104
3:1

102 3:1

103 3:1

106
3:1

107 3:1

105

108
3:1

109
3:1

110
7:2

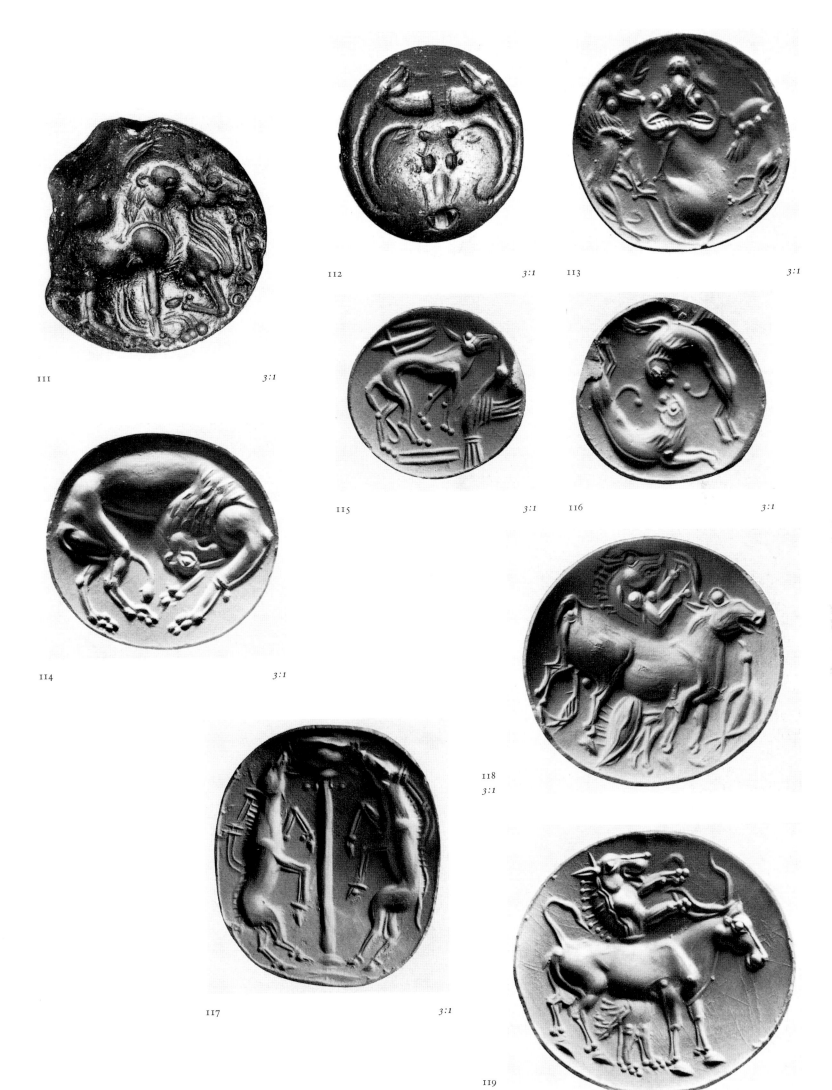

III 3:1

112 3:1 113 3:1

115 3:1 116 3:1

114 3:1

118
3:1

117 3:1

119
3:1

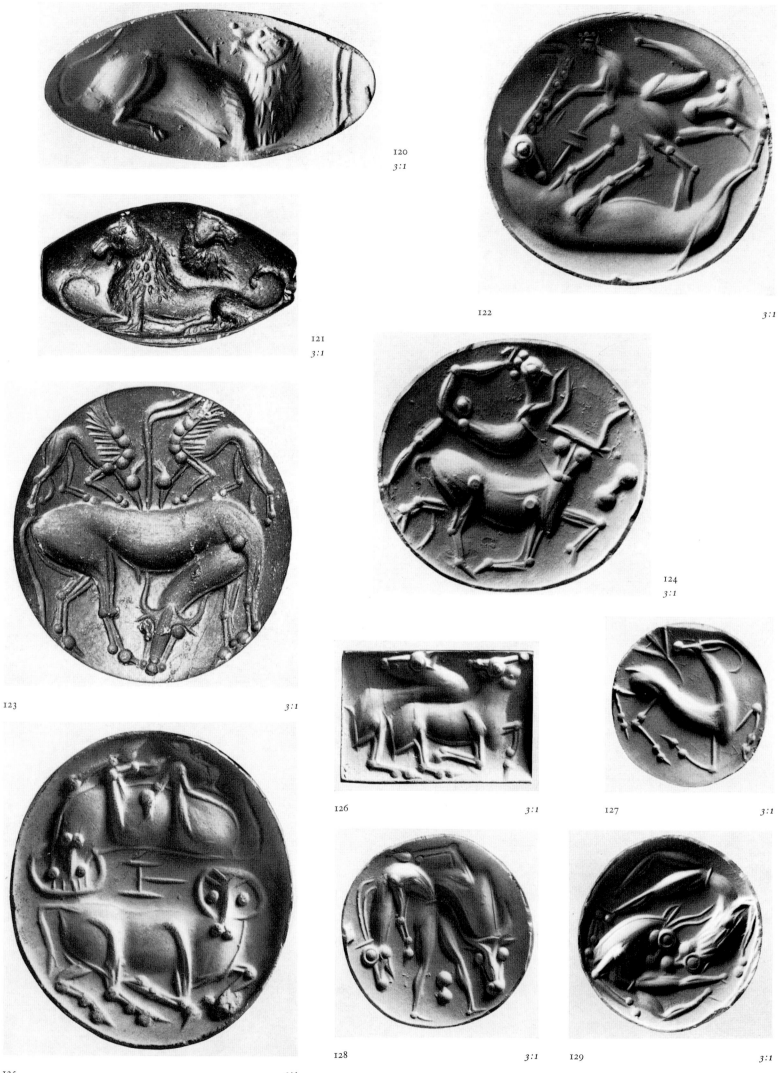

120
3:1

121
3:1

122
3:1

123
3:1

124
3:1

125
3:1

126
3:1

127
3:1

128
3:1

129
3:1

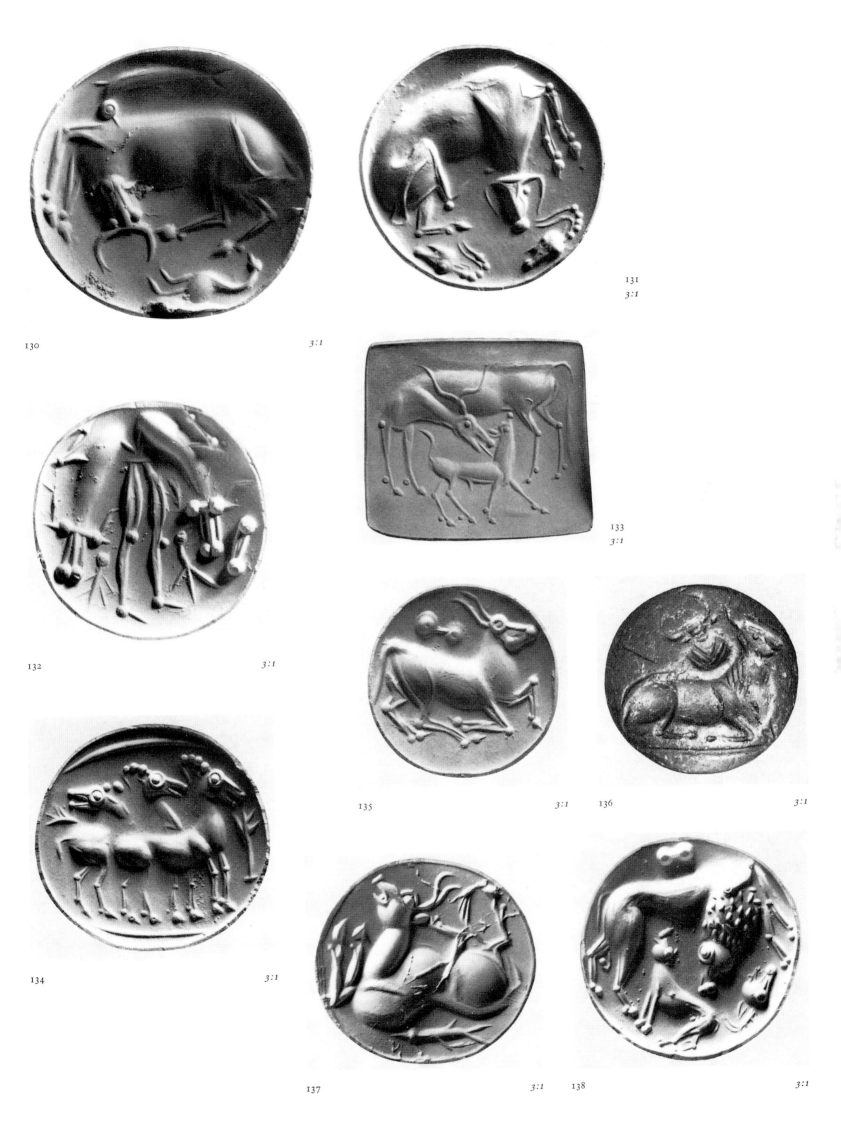

130

3:1

131

3:1

132

3:1

133

3:1

134

3:1

135

3:1

136

3:1

137

3:1

138

3:1

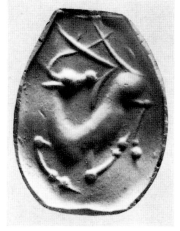

139 3:1

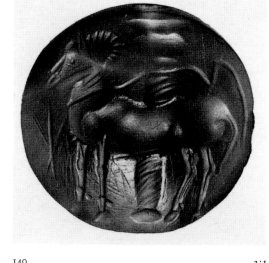

140 3:1

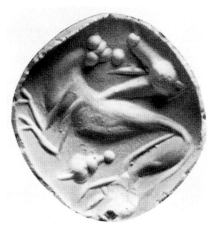

141 4:1

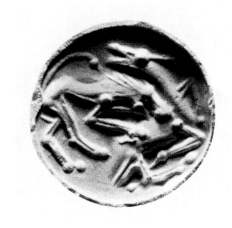

142 4:1

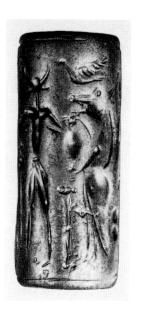

144 3:1

143 2:1

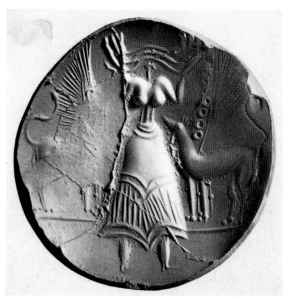

146 2:1

147 2:1

145

2:1

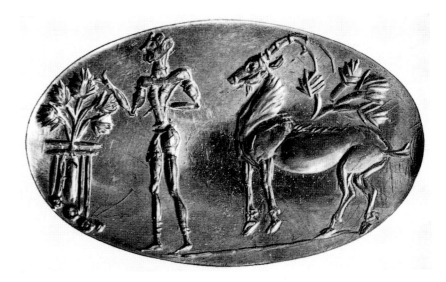

148 7:2

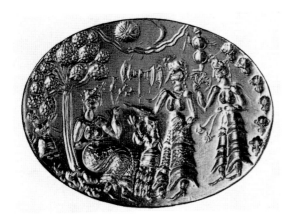

149 2:1 150 3:1

151 5:2

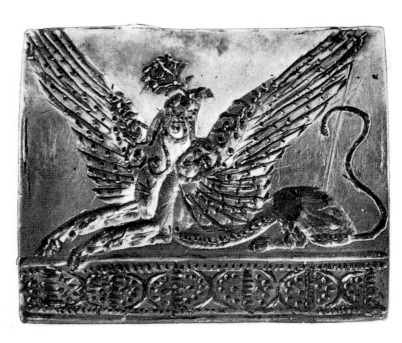

152
4:1

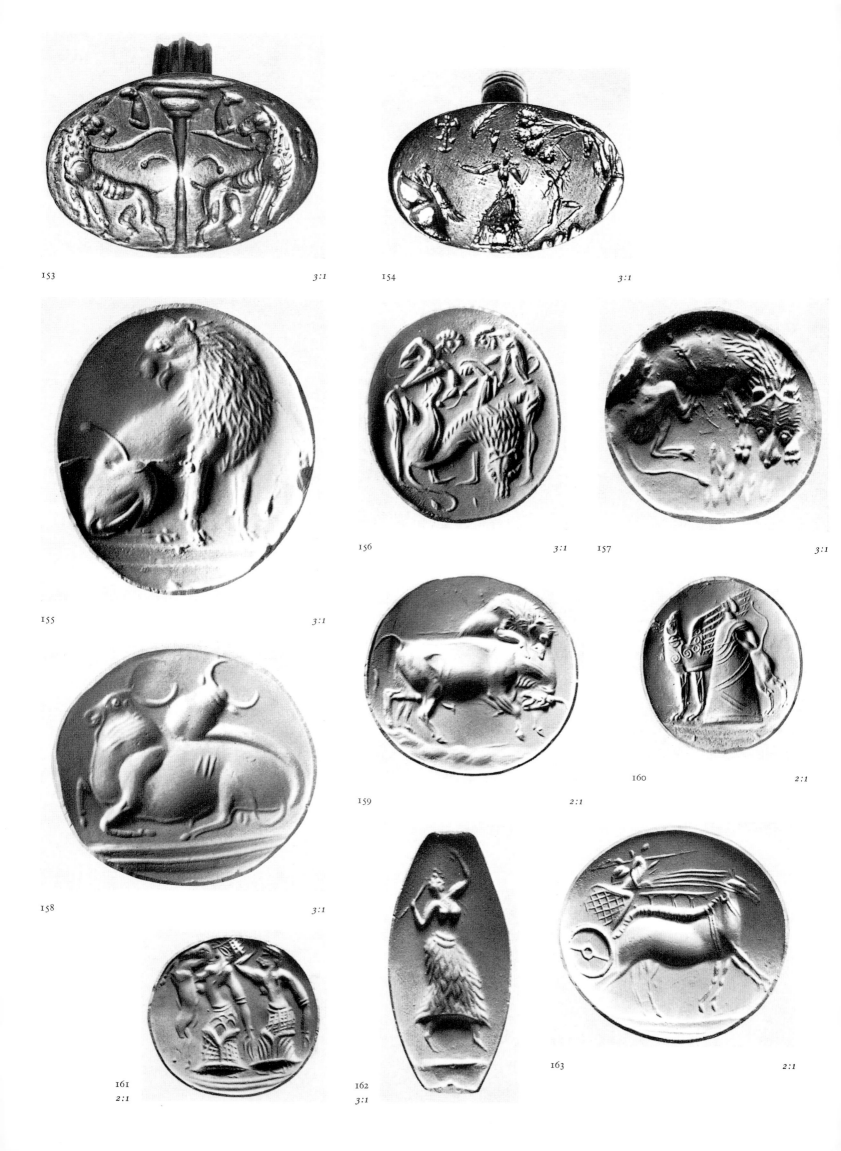

153 3:1

154 3:1

155 3:1

156 3:1

157 3:1

158 3:1

159 2:1

160 2:1

161
2:1

162
3:1

163 2:1

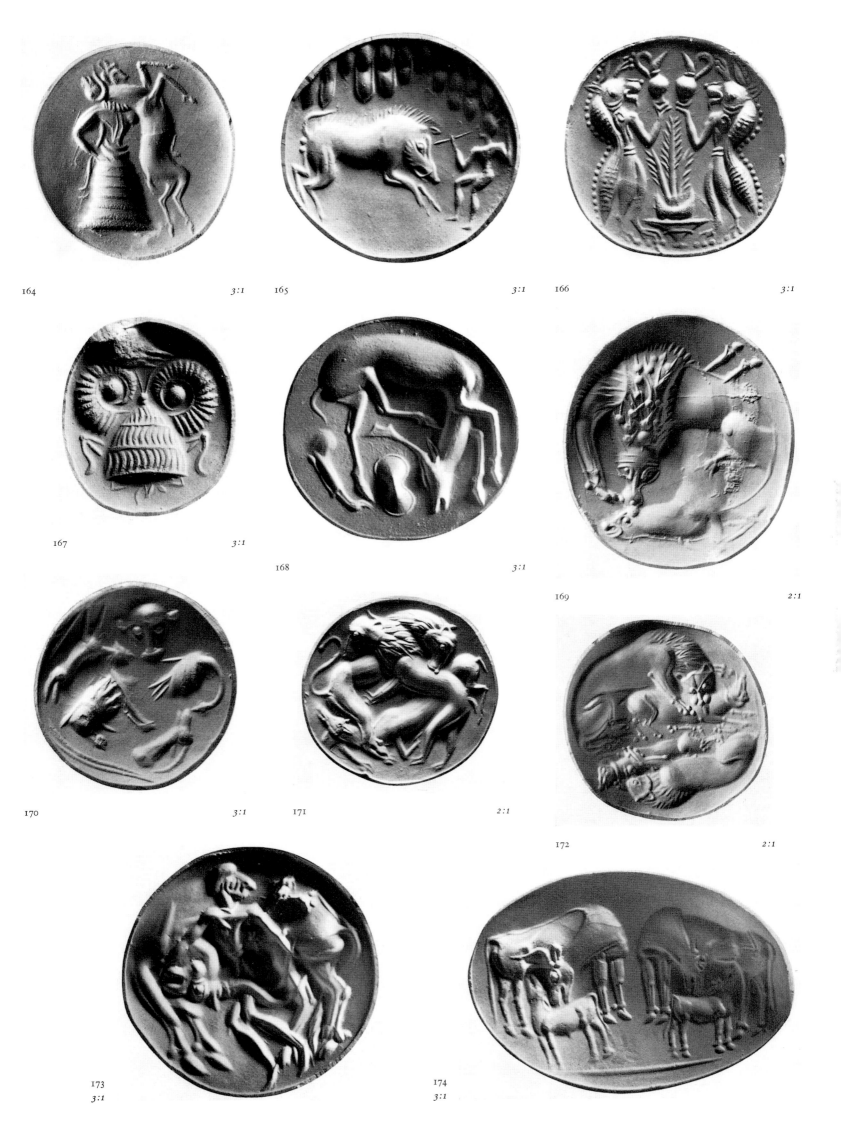

164 3:1 165 3:1 166 3:1

167 3:1

168 3:1

169 2:1

170 3:1 171 2:1

172 2:1

173
3:1

174
3:1

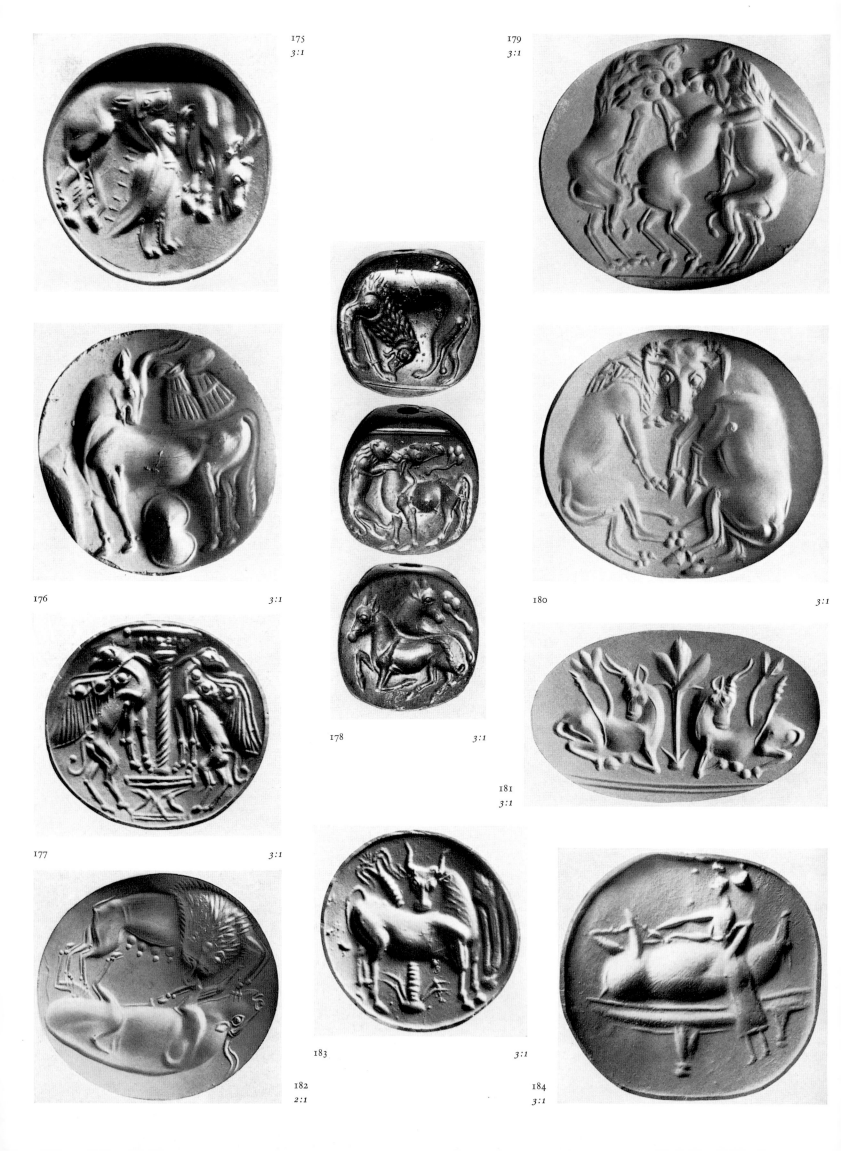

175
3:1

179
3:1

176
3:1

180
3:1

177
3:1

178
3:1

181
3:1

182
2:1

183
3:1

184
3:1

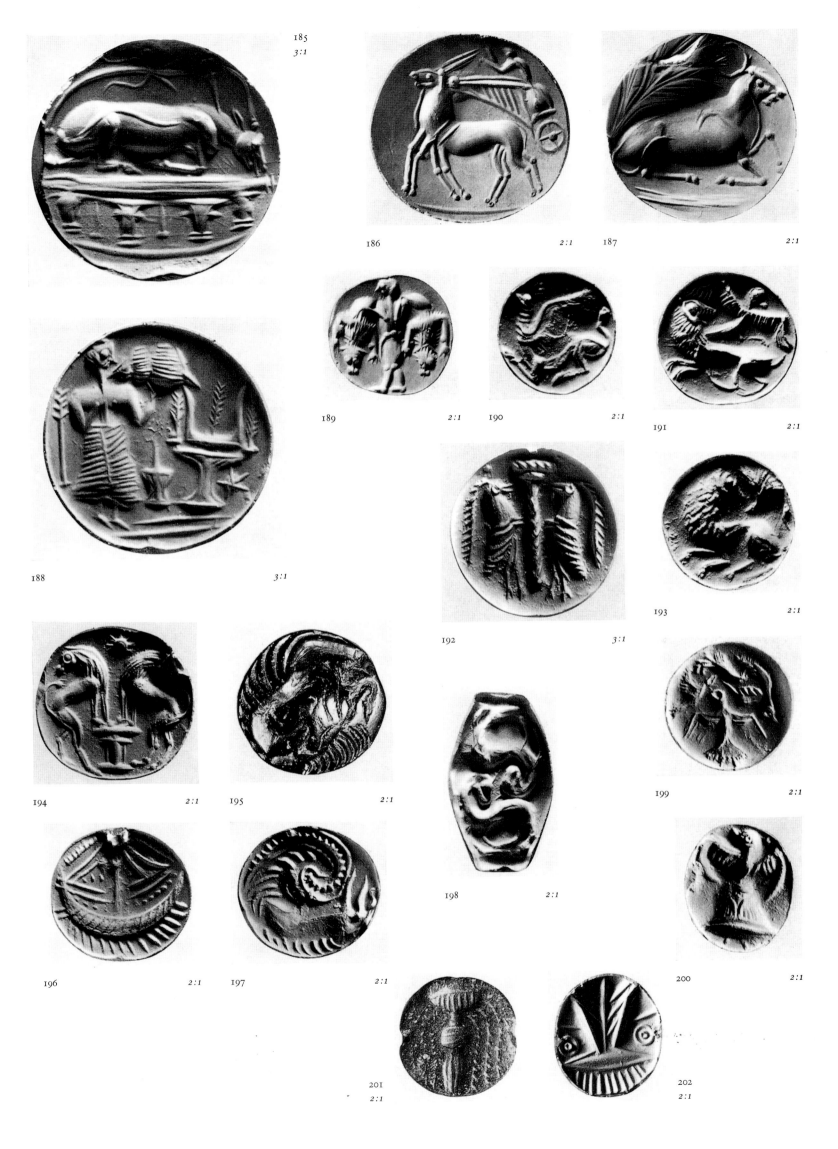

185
3:1

186 2:1

187 2:1

189 2:1

190 2:1

191 2:1

188 3:1

192 3:1

193 2:1

194 2:1

195 2:1

199 2:1

196 2:1

197 2:1

198 2:1

200 2:1

201 2:1

202 2:1

203

4:1

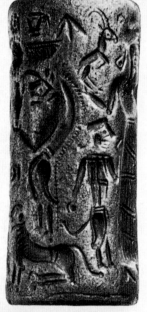

204

4:1

205

4:1

206

3:1

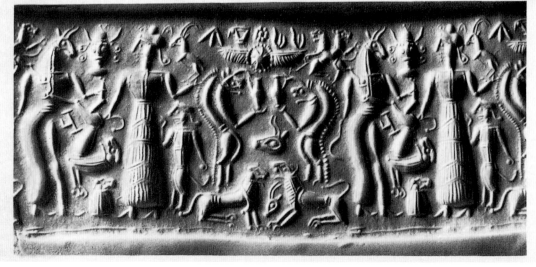

2:1

TEXT FIGURES

Fig. 30. Oxford *CS* 42, from Mallia. Black steatite prism. L.10. 1. A bird with turned head. 2. The same, stylised. 3. A boar (?).

Fig. 31 Unknown, from Mallia. Green steatite low prism. L.15. 1. Two men in a boat, with fish. 2. Hieroglyphs. 3. A man with two goats. *Mél. Dussaud* (Paris, 1939) i, 122, fig. 1.

Fig. 32 Heraklion, from Kamilari. Stone button seal. W.11. Florals and spiral. *Ann.* xxxix–xl, 98f., figs. 126.1, 128, N2. Compare *Pl. 13.*

Figs. 33–50 Clay sealings from Phaistos, in Heraklion. MMII. After the drawings in *Ann.* xxxv–xxxvi, the seal numbers of which are here cited after the Fig. numbers. Hoop and Line style—33–36 (75, 89, 109, 126). Spiral and loop patterns—37, 38 (138, 135). Florals and scrolls—39 (158) compare our *Fig. 32*, 40 (165). 'Architectural'—41 (44) from a disc. From hard stone stamps—42 (31) from a stamp in the form of an animal paw, as our *Pl. 42*, 43 (189) a lion's head, 44 (210) a crested owl, 45 (244) a griffin. From a flattened cylinder (?)—46 (237) a goat on a rock worried by a dog (compare our *Pl. 61*). From oval stamps—47 (231) a lion in a rocky grove, 48 (233) a collared dog in a rocky landscape, 49 (252) two women and a tree, the lower half restored (compare the figures painted on a vase from Phaistos, Schachermeyr, *Min. Kultur* (Stuttgart, 1964) pl. 48a–c), 50 (248; here after Gill's drawing in *Ath. Mitt.* lxxix, Beil. 1.1) a Minoan demon with a lion head holding a jug with branches and rocks. Scale c. 2:1.

Fig. 51 Heraklion, from Knossos. Clay sealing. W. of impression c. 30. From a large circular stamp with spirals and florals. Part of two impressions is preserved. *PM* i, fig. 151; *FKS* pl. 16.17; *BSA* lx, 85, Tb. The sealing is from late walls built in the Court of the Stone Spout; see Boardman, *Date of the Knossos Tablets* (Oxford, 1963) 51.

Fig. 52 Heraklion S.172, from Knossos, the Hieroglyphic Deposit. Clay impression. W.8. Circular stamp. In a border of cats' heads two stringed instruments, like lyres. MMII. *PM* i, fig. 205; *BSA* lx, 66, Hl. For the lyres see Platon in *Charisterion . . . Orlandon* iii, 208ff.; they may be taken for hieroglyphic signs, in which case the scheme, with a decorative border, resembles that of the inscribed Hittite hieroglyphic bullae.

Fig. 53 Heraklion S.179, from Knossos, the Hieroglyphic Deposit. L. of whole sealing 30. 1. Impression of prism with hieroglyphs. 2. Impression of disc with the head of a man (see *Pl. 14*). MMII. *PM* i, fig. 206; *BSA* lx, 67, P71; *Marburger Winckelmannsprogr.* 1958, pl. 10.1.

Fig. 54. Heraklion S.144, from Knossos, the Hieroglyphic Deposit. Clay sealing. W.18. Impression of a disc, with a goat. *PM* i, fig. 202d; *BSA* lx, 67, Pd.

Fig. 55. Heraklion S.128, from Knossos, the Hieroglyphic Deposit. Clay sealing. W.18. Impression of a disc, with a fish, octopus and rocks. *PM* i, fig. 202b; *BSA* lx, 67, Pb.

Fig. 56 *London* 3, pl. 1, from Crete. Agate flattened cylinder. L.17. 1. Hieroglyphs. 2. A running goat, worried by a dog, in a rocky setting. *CMS* vii, 35.

Fig. 57 Heraklion, from Kamilari. Stone pear-shaped stamp. W.11. Spirals. *Ann.* xxxix–xl, 98f., figs. 126.3, 130, N4.

Fig. 58 Heraklion, from Mallia. Gold loop signet with twisted handle and pointed oval face. H.15, W.11. Whirl. *BCH* lxx, 80, fig. 2d.

Fig. 59 Some seal shapes of Early and Late Palace periods.

Fig. 60 Heraklion 1419, from Knossos, the Little Palace. Black steatite disc. W.17. 1. A bearded head. 2. A bull's head. *PM.* iv figs. 167, 419 bis; *CS* figs. 78–9; *Marburger Winckelmannsprogr.* 1958, pl. 10.3; *Festschrift Matz* (Mainz, 1962) 6, pl. 1 (but not, I think, by the same hand as Heraklion 1329, 1579). For the bull's head cf. *CS* 206.

Fig. 61 Heraklion 1537. Green jasper prism. L.17. 1,2. Hieroglyphs including a cat's head. 3. A goat, star and hatching. *Kadmos* ii, 7ff., pl. 1.1.

Fig. 62 Heraklion S.336, from Knossos, the Temple Repositories. Clay sealing. W.30. Boxers by a column with rectangular capital. MMIIIB. *PM* i, fig. 509; iii, fig. 349 and ibid., 498ff. on the scene which appears in similar form on sealings and a relief steatite rhyton (Marinatos, *Crete and Mycenae* pls. 106–7) from A. Triada. *CS* fig. 70; *BSA* lx, 71, L50.

Fig. 63 Heraklion S.386, from Knossos, the Temple Repositories. Clay sealing. A whirl of horned sheep's heads. MMIIIB. *BSA* lx, pl. 5. L24.

Fig. 64 Heraklion S.383, 395, from Knossos, the Temple Repositories. Clay sealings. L.24. A figure with pointed cap, holding a sceptre. A lion beside him. MMIIIB. *PM* i, figs. 363a, 500a; ii, fig. 546; iii, fig. 325; *CS* fig. 63; *BSA* lx, 70, L46; *Kadmos* vi, 19.

Fig. 65 Heraklion S.391, from Knossos, the Temple Repositories. Clay sealing. L.23. Four owls and a rosette. MMIIIB. *PM* i, fig. 518f; *BSA* lx, 70, L38.

Fig. 66 Heraklion S.340, from Knossos, the Temple Repositories. Clay sealing. W.18. Two shells. MMIIIB. *PM* i, fig. 518h; *BSA* lx, 70, L43.

Fig. 67 Heraklion S.632–5, from Sklavokampo. Clay sealing from a ring. W.27. A two-horse chariot. LMIB. After Betts' composite drawing in *Kadmos* vi, 33, fig. 5. An impression of the same ring found at A. Triada.

Fig. 68 Heraklion, from Zakro. Clay sealing from a ring. W.25. Two lions running over rocks. A palm tree behind. LMIB. After Betts, ibid., 36, fig. 8. An impression of the same ring found at Knossos (*BSA* lx, 80, R37, pl. 14).

Fig. 69 Heraklion S.613–24, 626–7, from Sklavokampo. Clay sealing from a ring. W.24. A man leaping over a bull. Spiral ground line. LMIB. After Betts, ibid., 40, fig. 12a. For the spiral cf. our *Pl. 98*, and *Figs. 119, 124*.

Fig. 70 Heraklion S.277–82 and *CS* 41–2S, from Knossos. Clay sealings from a ring. W.25. A woman seated right, before a structure surmounted by horns of consecration. She is approached by a woman carrying a handled rhyton. Behind the latter and turned from her a third woman is occupied with some other object, possibly a tree. LMIB. *PM* ii, fig. 498; iv, figs. 331, 591; *Kadmos* vi, 38, fig. 10a and fig. 10b for an impression of the same ring from Zakro (*PM* ii, fig. 499). There is also a clay 'positive' from Knossos, *Kadmos* vi, 20; *BSA* lx, 98, iii.

Figs. 71–79 Heraklion, from A. Triada. Impressions from clay sealings. After *Ann.* viii–ix, 71ff., here distinguished by the fig. number alone. LMIB.

Fig. 71 Loc. cit., fig. 35. From a lentoid (?). Heads of a facing lion a bull and dog (?), with a bird.

Fig. 72 Loc. cit., fig. 112. From a lentoid (?). Two griffins with wings displayed, set antithetically.

Fig. 73 Loc. cit., fig. 69. From a lentoid (?). A contorted lion, its back pierced by an arrow. Compare our *Pl. 157* for the subject.

Fig. 74 Loc. cit., fig. 52. From a lentoid (?). A flying bird.

Fig. 75 Loc. cit., fig. 100. From a lentoid (?). A dog scratching.

Fig. 76 Loc. cit., fig. 116. From a lentoid (?). A griffin, rendered in a technique related to the Cut Style.

Fig. 77 Loc. cit., fig. 139. From a lentoid or ring (?). A woman carrying a pole over her shoulder from which hangs a flounced skirt.

Fig. 78 Loc. cit., fig. 135. From a lentoid (?). A woman.

Fig. 79 Loc. cit., fig. 141. From a ring (?). Two men, wearing baggy loin cloths, the second with a cloak wrapped around the upper body. To the right part of a building (?).

Fig. 80 Private. Reel-shaped seal. 1. Two small animals, seated head to tail and facing. Behind them a palm-like tree. 2. A facing lion's mask. For 1 compare our *Pl. 54*, *JHS* xxii, 85, no. 89 and *Ann.* viii–ix, fig. 171, pl. 15.89; for 2 compare ibid., fig. 205 and p. 17.167, *JHS* xxii, 82, nos. 56, 57. The motifs are those of the Zakro sealings but the faces of the stone are flat, not convex, and the style is rougher.

Fig. 81 London 1936. 7–21.6. Agate flattened cylinder. L.20. A bird with plants. *CMS* vii, 44.

Fig. 82 Heraklion, from Gournia. Agate plump prism. 'Talismanic' versions of—1. Two bucrania. 2. Two fish foreparts. 3. Two pairs of bundles. Hawes, *Gournia* (Philadelphia, 1908) 54, fig. 30.8. LMIB.

Fig. 83 Heraklion, from Sphoungaras. Cornelian amygdaloid. L.19. 'Talismanic' pattern of arcs and cross-hatching. LMIA. Hall, *Sphoungaras* (Philadelphia, 1912) 70, fig. 45e.

Fig. 84 Heraklion, from Sphoungaras. Cornelian amygdaloid. L.21. 'Talismanic' rustic shrine with branches. LMIA. *Sphoungaras* 70, fig. 45g.

Fig. 85 Heraklion, from Kamilari. Red jasper amygdaloid. L.18. 'Architectural' pattern. *Ann.* xxxix–xl, 100, fig. 141, N15. Compare Heraklion 1452, *Festschrift Matz* 7 (inaccurate drawing), pl. 1; *CS* fig. 153 (as MMIII; p. 42, n. 7, as LMI).

Fig. 86 Once Dawkins Coll. Green jasper lentoid. W.18. 'Talismanic' pattern of triangles and hoops. *CMS* viii, 71.

Fig. 87 Heraklion, *Giam.* 381, pls. 14, 29, from Mallia. Cornelian amygdaloid. L.21. 'Talismanic' kantharos with a branch in it. Horns of consecration to the right.

Fig. 88 Heraklion, *Giam.* 342, pls. 14, 29, from Knossos. Cornelian lentoid. W.13. 'Talismanic' horns of consecration with a palm between them.

Fig. 89 London, Mrs Russell Coll. Cornelian amygdaloid. L.22. 'Talismanic' forepart of a fish, jug and cross hatching, with a double zigzag. *CMS* viii, 153.

Fig. 90 Heraklion, *Giam.* 399, pls. 14, 30, from Siteia. Cornelian amygdaloid. L.17. 'Talismanic' foreparts of two fish or 'bundles', with cross hatching.

Fig. 91 Once Dawkins Coll. Cornelian amygdaloid. L.18. 'Talismanic' pair of 'bundles' with branches. *CMS* viii, 58.

Fig. 92 Athens 4615, from Crete. Green amygdaloid. L.18. 'Talismanic' pattern of verticals held by arcs. *CMS* i, 439.

Fig. 93 Athens 4613, from Crete. Rock crystal amygdaloid. L. 19. 'Talismanic' fish and branches. *CMS* i, 456.

Fig. 94 Athens 4642, from Crete. Agate amygdaloid. L.11. 'Talismanic' fish with arcs and cross hatching. *CMS* i, 460.

Fig. 95 *London 15*, pl. 1. Green jasper amygdaloid. L.18. 'Talismanic' pattern of arcs and hoops suggesting a crab (compare *Pl. 80*). *CMS* vii, 78.

Fig. 96 Heraklion, *Giam.* 356, pls. 14, 29. Cornelian amygdaloid. L.21. 'Talismanic rustic shrine' shown as a vessel with side handle (compare *Pl. 76*). Beside it horns of consecration with a branch.

Fig. 97 Liverpool B218. Cornelian lentoid. W.14. 'Talismanic' flying bird. *JHS* lxxxvi, pl. 10.5; *CMS* vii, 259. Compare *Pl. 74*; *Fig. 115*.

Fig. 98 *London 13*, pl. 1, from Crete. Cornelian amygdaloid. L.18. 'Talismanic' ship with cross-hatched sails and double zigzag suggesting water. *AG* pl. 4.2; *CMS* vii, 104.

Fig. 99 Colville Coll. Cornelian lentoid. W.15. 'Talismanic' sailed ship, with oars (?). *CMS* viii, 106.

Fig. 100 *London 28*, pl. 1, from Crete. Cornelian lentoid. W.16. Two 'talismanic' scorpions. *CMS* vii, 76.

Fig. 101 Heraklion, *Giam.* 332, pls. 14, 27, from Knossos. Cornelian lentoid. W.9. 'Talismanic' spider.

Fig. 102 Heraklion, *Giam.* 346, pls. 14, 29. Cornelian amygdaloid. L.14. 'Talismanic' double axe.

Fig. 103 Once Dawkins. 'Basalt' lentoid. W.12. 'Talismanic' lily pattern with arcs and cross hatching. *CMS* viii, 63.

Fig. 104 Heraklion 900, from Knossos, Isopata tomb 1. Blue chalcedony flattened cylinder with gold caps. L.26. Two men and a collared hound. *Tomb of the Double Axes* fig. 14; *Festschrift Matz* 9, pl. 1 (and ibid., Heraklion 839, for the motif, with a lion, but hardly the same hand). LMII.

Fig. 105 Heraklion, from Kalyvia Mesara. Agate lentoid. W.25. A lion, arrow and the heads of a goat and horned sheep. *Mon. Ant.* xiv, 622, fig. 95. LMIIIA.

Fig. 106 Heraklion, from Fourni, Archanes. Agate lentoid. W.20. A bull. The device below resembles a shell. *Archaeology* xx, 278, fig. 7r.; *BCH* xci, 791, fig. 16. LMIIIA. 1.

Fig. 107 Heraklion, from Fourni, Archanes. Cornelian lentoid. W.20. Two goats and trees. *Archaeology* xx, 278, fig. 7l.; *BCH* xci, 789, fig. 13. LMIIIA. 1.

Fig. 108 Heraklion, from Sellopoulo, grave 1. Flattened cylinder. A bull. *Arch. Reports for 1957* pl. 1h. LMIIIA. 1. See the following two.

Fig. 109 Heraklion 1865, from Sellopoulo, grave 1. Lentoid. Human legs and a bull forepart joined. For the device in the field, *Kadmos* v, 11ff., no. 15. *Arch. Reports for 1957*. pl. 1i. LMIIIA. 1. Compare our *colour, p. 49.10* for subject, style and symbol.

Fig. 110 Heraklion, from Sellopoulo, grave 1. Lentoid. Two men carrying (?) a stag. Ibid., pl. 1j. LMIIIA. 1.

Fig. 111 Heraklion, from Kalyvia Mesara. Cornelian lentoid. W.18. Two goats and a facing human head. *Mon. Ant.* xiv, 622, fig. 96. LMIIIA.

Fig. 112 Heraklion, from Kalyvia Mesara. Cornelian lentoid. W.17. Two goats and a shield device. Ibid., 620, fig. 92. LMIIIA. Compare the style of *Arch. Eph.* 1907, pl. 7.56.

Fig. 113 Heraklion, from Knossos, Hospital warrior grave III. Agate lentoid. W.34. A goddess crowned by sacral horns and a double axe, and flanked by griffins. *BSA* xlvii, 275, fig. 16, no. 20; Zervos, fig. 629. LMII. Compare *Pl. 145*.

Fig. 114 Heraklion, from Knossos, Hospital warrior grave III. Cornelian cylinder. H.19. Lions and goats. LMII. *BSA* xlvii, 275, fig. 16, no. 23.

Fig. 115 From Central Crete. Cornelian plump prism. 1. A goat struck by an arrow. 2. A flying bird. 3. Plain. *PM* iv, fig. 495.

Figs. 116–123 are clay sealings from the LMIIIA. 1 destruction level in the Palace at Knossos.

Fig. 116 Sealing from a ring. A goddess with staff on a rocky peak guarded by lions. To the right a male worshipper. To the left a structure surmounted by horns of consecration. *PM* iv, fig. 597, Ae.

Fig. 117 From the Little Palace. Sealing from a lentoid. A man carrying two goats (?) slung from a pole. *BSA* lx, pl. 9.650.

Fig. 118 From the Little Palace. Sealing from a lentoid. Facing heads of a man and a bull. Ibid., pl. 9.653.

Fig. 119 Sealing from a ring. Three 'sacral knots' between figure-eight shields. A spiral below. *PM* iv, fig. 597, Ak.

Fig. 120 Sealing from a ring (?). Pattern of double axes and rosettes. *PM* iv, fig. 597, Ad.

Fig. 121 Sealing from a lentoid. Antithetic pattern of four kneeling goats with an animal head in the field. *PM* iv, fig. 597, Bc. For the composition and style compare *CMS* viii, 90 (which must, then, be earlier than LMIIIB) and for the style with comparable subject, *Arch. Eph.* 1907, pl. 8.117.

Fig. 122 Sealing from a lentoid. Two hounds rampant on an altar. A star above. *PM* iv, fig. 597, Ag.

Fig. 123 Oxford *CS* 52S, from Knossos, Magazine VIII. Clay sealing from a lentoid, the face countermarked with a sign and the back with a Linear B inscription. A man grappling with a bull. *PM* iv, fig. 604b; *Kadmos* v, 4. For the subject compare our *Pl. 173* and *AG* figs. 27, 28.

Fig. 124 Heraklion, from Kalyvia Mesara. Gold ring with half the bezel preserved. Three figure-eight shields over a spiral. LMIIIA. *Mont. Ant.* xiv, 593, fig. 55.

Fig. 125 Heraklion, from Fourni, Archanes, tholos A. Gold ring. W.20. At the centre a woman. To the right a youth pulls down the branches of a tree, set over a shrine. To the left a kneeling man is looking into a vessel. In the field are symbols, including an eye, a pillar and two butterflies. LMIIA.I. *Archaeology* xx, 280, fig. 13.

Fig. 126 Heraklion, from Fourni, Archanes. Gold ring. A woman and a leaping griffin. *Ergon* 1967, 96, fig. 101; *BCH* xcii, 987, fig. 4.

Fig. 127 Heraklion 1460, from Astrakous, east of Knossos. Haematite cylinder. Upper register—crossed lions, woman, inverted goat (held by the woman?), man, chariot with a standard (?) overhead, man. Lower register—griffin chariot, man, vertical winged disc, horned goddess flanked by lions, man. *PM* iv, fig. 351; *CS* fig. 138.

Fig. 128 Athens 8718, from Mycenae, perhaps from the dromos of the Tomb of Klytaimnestra. Agate lentoid. W.27. A goddess riding a dragon over stylised rocks (compare the next). *CMS* i, 167; Gill, *BICS* x, 1ff., pl. 2a.

Fig. 129 Athens 7332, from Midea. Agate lentoid. W.40. A lion attacks a bull over rocky ground, represented as on frescoes (and cf. *CMS* i, 167). LHII–IIIA.I. *CMS* i, 185.

Fig. 130 Heraklion, from Olous. Black steatite lentoid. W.17. A lion attacks a bull. van Effenterre, *Necr. de Mirabello* pl. 47.0.122. LMIIIB.

Fig. 131 Athens 4623, from Crete. Lentoid. W.17. Hoops. *CMS* i, 431.

Fig. 132 Heraklion, from Maleme. Bronze flattened cylinder. A cow suckles a calf. LMIIIB. *Praktika* 1966, pl. 161a; *BCH* xci, 796, fig. 1.

Fig. 133 Heraklion, from Maleme. Agate flattened cylinder. Two deer. *Praktika* 1966, pl. 161b; *BCH* xci, 796, fig. 2. LMIIIB.

Fig. 134 Athens 5877A. Ivory ring from Phylakopi, Melos. W.15. A woman before a structure surmounted by horns of consecration. Behind her palm leaves and rocks. Hoop and bezel are made of a single piece, the hoop being broad, flat and ribbed. *CMS* i, 410.

Fig. 135 From Naxos, tomb B. Flattened cylinder. A man standing holding a staff. Beneath his arm a rhyton, sword, jug and basket over a table. Before him a palm tree. *Ergon* 1959, 127, fig. 135; Vermeule, *Greece in the Bronze Age* 290, fig. 4; *Praktika* 1959, pl. 155b. LHIIIC.

Fig. 136 Athens, from Pylos, Akona tomb 2. Chalcedony lentoid. A man leaping over a goat. *Praktika* 1963, pl. 89b; *BCH* lxxxviii, 749, fig. 7. LHIIIB. For the motif in this form with a bull cf. *CS* 248–9; *CMS* i, 408; *Munich* i, 45, pl. 6.

Fig. 137 Sparta, from the Menelaion. Clay sealing from a lentoid (with string). Bicorporate deer and branch. *BSA* xvi, 9–11, pls. 3, 17 top. LHIIIB.

Fig. 138 From Kea, the Temple. Agate lentoid. W.27. A lion and a floral. *Hesp.* xxxi, pl. 101f. For subject and style cf. Indiana 1.

Fig. 139 Athens 8084a, from Perati, grave 1, pit 2. Gold ring. L.25. Two goats and branches; badly worn. *CMS* i, 390. LHIIIC.

Fig. 140 Athens 8093, from Perati, grave 1, pit 2. Agate lentoid. W.20. A quadruped. Summary Cut Style. *CMS* i, 394. LHIIIC.

Figs. 141–143 are clay sealings from the LHIIIB destruction level in the Palace at Pylos.

Fig. 141 Athens 8524, from Pylos. Clay sealing. W.26. Quartered device with four deer. *CMS* i, 323. Compare Indiana 3 for the subject and possibly the hand on an agate lentoid from a 'tomb in Boeotia'.

Fig. 142 Athens 8505, from Pylos. Clay sealing. W.22. A man grappling a bull. *CMS* i, 342.

Fig. 143 Athens 8509, from Pylos. Clay sealing. W.22. Two lions attack a deer (?). *CMS* i, 368. Contrast our *Pl. 179* for treatment of the same subject.

Fig. 144 From Marathia, tomb 2. Lentoid. Stylised goat. *BCH* lxxxviii, 762, figs. 1, 2; *Praktika* 1963, pl. 167a, b. LHIIIC.

Fig. 145 Athens 1390, from Mycenae. Serpentine lentoid. W.16. A goat, with rough cut filling ornament. *CMS* i, 27.

Fig. 146 *London* 214, pl. 5. Black steatite lentoid. W.16. A figure-eight shield. *CMS* vii, 203.

Fig. 147 *London* 63, from Mycenae. Brown steatite lentoid. W.16. A goat. *CMS* vii, 205.

Fig. 148 Oxford 1967. 942. Brown steatite lentoid. W.21. A goat and branch. *CMS* viii, 98.

Fig. 149 Conoid seal shape.

Fig. 150 Nicosia, from Enkomi (with LHIIIB pottery). Conoid stamp. A 'Philistine' warrior with feather head-dress and round, bossed shield. *AA* 1962, 18, fig. 11; *BCH* xcii, 145, fig. 1.12; *Enkomi* iii, front., pls. 184, 187 (184).

Fig. 151 Nicosia, from Kouklia, Evreti tomb 8. Gold ring set with a lapis lazuli (?) ringstone. Diam. of hoop 25. Two bulls reclining. Cypro-Minoan characters in the field. *BCH* xcii, 157–61, fig. 1, 2; on the find, ibid., 162ff. For similar bulls on ringstones cf. *Hesp.* Suppl. viii, pl. 41.15; *London* 103, pl. 2; and on the ivory box, Karageorghis, *Myc. Art in Cyprus* (Nicosia, 1968) pl. 42.2. The type is common on conoid stamps.

BLACK AND WHITE PLATES

Asterisked numbers indicate that the piece is illustrated in original. All other photographs show impressions

PRE-PALATIAL CRETE
Pl. 1 Heraklion, from Platanos. Ivory cylinder. W.35. Lions and spiders. The other, smaller end shows three scorpions. *PM* i, fig. 87.4; *VTM* pl. 13.1039; *FKS* pls. 1.6a, 7.1.

Pl. 2 Heraklion, from Marathokephalo. Ivory cylinder. W.38. Lions and scorpions. *FKS* pl. 1.2.

Pl. 3 Heraklion 1201, from Marathokephalo. Ivory cylinder. W.37. A man and two lions on either side of a line of spirals with leaves. The other, smaller end shows spirals. *PM* i, fig. 87.6; *FKS* pl. 1.1; *CS* fig. 41.

Pl. 4* Heraklion, *Giam.* 2, pls. 1, 15. Ivory seal in the form of a monkey. H.32; 23 × 28. Two leaves and lines of spirals. Marinatos, *Crete and Mycenae* (London, 1960) pl. 12. Replica of the Platanos seal, *VTM* pl. 13.1040.

Pl. 5 Oxford *CS* 38, from Laske Turleti. Mottled green steatite prism. L.12. 1. A man seated before a marked table. 2. A man fashioning a large clay pithos with four side handles; to the left a small animal (?). 3. A whirl of goat and dog (?) heads, including two forelegs. *PM* i, fig. 93a; iv, fig. 464.

Pl. 6 Oxford *CS* 39, from Kastelli Pedeada. Grey-green steatite prism. L.12. 1. Two women and a star. 2. A man seated before a vase with a crescent device above; perhaps a kiln or oven. 3. A man and three jugs. *PM* i, fig. 93b.

Pl. 7 Oxford *CS* 41. Green steatite prism. L.15. 1. A handled jar. 2. A bird with turned head. 3. A star. See *colour, p. 29.1.*

Pl. 8* Oxford *CS* 36, from Mallia. Buff steatite tabloid. 14 × 12 × 8. 1. A man. 2. A fish. 3. A man carries two goats, slung from a pole. 4. A dog curled up. *PM* iv, fig. 466 (side 3).

EARLY PALACES
Pl. 9 Oxford *CS* 51. Dark green mottled steatite prism. L.16. 1. A man with four vessels suspended from a pole. 2. A seated man and a goat's head. 3. A recumbent bovine.

Pl. 10 Oxford *CS* 98, from Kritsa. Green steatite prism. L.16. Hieroglyphs on all three sides. *PM* i, fig. 143c,d; *Scripta Minoa* (London, 1909) i, P7. See *colour, p. 29.2.*

Pl. 11 Oxford *CS* 49, from Mallia. Buff steatite prism. L.17. 1. A ship. 2. A boar and a bird (?). 3. Two suspended vessels, set antithetically.

Pl. 12 Oxford *CS* 71. Grey-green steatite prism. L.20. 1. A ship, with spirals. 2. Two seated men, set antithetically. 3. A floral and spiral pattern.

Pl. 13* Oxford *CS* 74, from the Mesara area. Green steatite button. W.15. A cup spiral and floral pattern. *Scripta Minoa* i, fig. 78. Compare *Fig. 32.*

Pl. 41* Oxford *CS* 86, from A. Pelagia (?). Grey steatite stamp seal in the shape of the forepart of a monkey. H.12, W.12. Cross pattern. The patinated surface is rubbed, not glazed, it seems.

Pl. 42* Oxford 1967. 924. Mottled green steatite stamp seal in the shape of a cat's paw. H.13, W.8. Cross pattern. *CMS* viii, 32.

THE LATE PALACES
Pl. 43* Oxford *CS* 170. Green jasper prism. L.17. 1. Four cats' heads. 2. A goat, a bird and a tree. 3. Hieroglyphs, including a calf's head and lyre (cf. *Fig. 52*). 4. Hieroglyphs. *PM* i, fig. 204n. See *colour, p. 29.4*.

Pl. 44* Athens, from Mycenae, Grave Circle B, grave Gamma. Amethyst disc. W.9. Head of a man. Marinatos, *Crete and Mycenae* pl. 212 above; *CMS* i, 5; *Marburger Winckelmannsprogr.* 1958, pl. 10.4; Vermeule, *Greece in the Bronze Age* (Chicago, 1964) pl. 11c.

Pl. 45 Oxford *CS* 169. Chalcedony prism. L.18. 1. Facing head with flowing locks (compare the sphinx on *Pl. 30*). 2. Hieroglyphs including a device incorporating florals and recalling an animal mask. 3, 4. Hieroglyphs. *PM* i, fig. 207c.

Pl. 46 New York 26.31.157. Blue chalcedony prism. L.15. 1–4. Hieroglyphs including the representation of a flying ant or wasp. *AJA* lxviii, pls. 1.18, 2.4. Compare *Scripta Minoa* i, P51a and p. 212. Perhaps MMII, late.

Pl. 47 *Berlin* F 58, pl. 2, D 6, from Crete. Green jasper prism with circular faces. L.9. 1. A bird preening. 2, 3. Hieroglyphs. *Scripta Minoa* i, P31.

Pl. 48* Oxford *CS* 174, from Lasithi. Cornelian prism. L.18. 1. A seated cat with hieroglyphs, 2, 3. Hieroglyphs with formal patterns of buds and palmettes. *Scripta Minoa* i, P23; *PM* i, fig. 207a. See *colour, p. 29.5*.

Pl. 49* Oxford *CS* 9S, from Knossos, the Temple Repositories. Clay sealing. W.20. Y pattern over bound tendrils. MMIII. The motif is obscure and not obviously floral. *PM* i, fig. 518j; *BSA* lx, 70, L7, 40.

Pl. 50* Oxford *CS* 250, from Knossos. Gold ring. L. 22. A building with a large doorway showing a pillar within, and with trees on its roof. Before it a tapering column. On paving a woman, in flounced dress, naked above the waist, salutes a small male figure holding a staff who might be leaping from the building or pillar. *PM* i, fig. 115.

Pl. 51* Oxford CS 30S, from Zakro. Clay sealing. W.15. One view shows two of the three impressions, and the area striated by the cords onto which the clay nodule was pressed. The other view shows the third impression—a monster compounded of a facing head, two wings and feline (?) legs. LMIB. *JHS* xxii, 84, no. 78.

Pl. 52* Oxford *CS* 11S, from Zakro (?). Clay sealing. W.12. One of three impressions on the nodule. A monster with featureless head, wings and a woman's flounced skirt. LMIB. *JHS* xxii, 79, no. 21. The alleged provenience (Knossos, Harbour Town) is almost certainly wrong; see Pope, *BSA* lv, 205, n.10. The figure anticipates the later bird-goddesses (our *Pl. 200*) and cf. *Pl. 53*.

Pl. 53* Oxford *CS* 39S, from Zakro. Clay sealing. W.13. One of two impressions on the nodule. A monster compounded of a bird's head, woman's breasts and arms and a multiple fantail. LMIB. *JHS* xxii, 79, no. 23.

Pl. 54* Oxford *CS* 24S, from Zakro. Clay sealing. W.13, 15. Two impressions. 1. Two crested birds, or possibly two eared owls (a Cretan species—*skops*) with facing heads. Behind them a spiral-lily pattern. 2. The mask of a fox (?) joined to a fantail and butterfly wings decorated with rosettes. LMIB, *JHS* xxii, 83–5, nos. 89, 71. For 1 compare *Fig. 80*.

Pl. 55* Oxford *CS* 16S, from Zakro. Clay sealing. W.14. One of two impressions on the nodule. A bird, its wings replaced by bent limbs, apparently feline. LMIB. *JHS* xxii, 88, no. 129.

Pl. 56* Oxford *CS* 22S, from Zakro. Clay sealing. W.11. One of three impressions on the nodule. The heads and necks of two dogs or dragons (hardly birds) joined to a fantail. LMIB. *JHS* xxii, 82, no. 53.

Pl. 57 Oxford *CS* 201, from Rethymno. Agate flattened cylinder. L.19. A wild goat leaping over rocks; a tree behind. The stone is perforated twice (and a third attempted) for use as a spacer bead. *PM* i, fig. 204r,s; iv, fig. 439, Suppl. pl. 54a.

Pl. 58 Oxford *CS* 202, said to be from Priene. Agate flattened cylinder. L.21. A bull, apparently drinking at a tank decorated with crosses. A man is leaping on to its neck from above, grasping its foreleg. *PM* iii, fig. 129; iv, Suppl. pl. 54e. A recess at the edge of the central court of the Palace at Phaistos is painted in the same manner as the tank. This has suggested that the gem shows an episode in the bull-leaping games taking place in a palace court (Graham, *AJA* lxi, 255ff.; Ward, *Antiquity* xlii, 117ff.). See *colour, p. 49.5*.

Pl. 59* Oxford *CS* 203, from Palaikastro. Black steatite flattened cylinder, with heavy gold plate. L.16. Two dolphins in a rocky setting. *PM* iv, fig. 441, Suppl. 54b.

This is the only gilt steatite intaglio known, but there is some evidence for the gilding of relief steatite vases. See *colour, p. 39.12.*

Pl. 60 Oxford *CS* 204, from the Knossos area. Veined blue chalcedony flattened cylinder. L.21. Two acrobats with feather caps turning somersaults in a field of lilies. *PM* iv, fig. 443, Suppl. pl. 54j. For acrobats on other seals see *Arch. Eph.* 1907, pl. 6.38; *PM* iv, fig. 444 (*CMS* i, 131); *AJA* lxviii, pl. 2.1. The acrobats in Homer, Picard, *Rev. Arch.* 1947, 84f. See *colour, p. 39.13.*

Pl. 61 Oxford *CS* 227, from Archanes. Veined blue chalcedony flattened cylinder. L.15. A goat on a rocky ledge being worried by a dog. Possibly unfinished. *PM* iv, fig. 453, Suppl. pl. 54g. For the subject compare our *Fig. 46.*

Pl. 62. Oxford *CS* 205, from Knossos. Mottled chalcedony flattened cylinder. L.19. A man holding a fish and an octopus. *PM* i, fig. 497; iv, fig. 440, Suppl. pl. 54c. Compare our *Pl. 107* for the subject.

Pl. 63 Heraklion, from Gournia. Flattened cylinder. L.15. A bull, with 'architectural' pattern background. *Gournia* 54, fig. 27; Zervos, fig. 304c; *CS* fig. 52. In a MMIII deposit.

Pl. 64. Oxford *CS* 161. Agate lentoid. W.12. 'Architectural' pattern.

Pl. 65* Oxford *CS* 234. Haematite lentoid. W.13. A butterfly. The lines joining body and wings assimilate the motif to the cat's head. They appear also on the A. Triada sealing, *Ann.* viii–ix, fig. 58 and cf. *PM* iii, fig. 98 (*CS* 302; with the lines in 'profile'); iv, fig. 966; *Gournia* fig. 8.2; *CMS* vii, 71; viii, 152; *BSA* liii–liv, pl. 62. III. 4.

Pl. 66* Oxford *CS* 284. Grey steatite lentoid. W.20. A man with a baggy loincloth (cf. our *Fig. 79* and *CS* 15S) and a woman, making the gesture of adoration. Possibly later, but recalling the figures on A. Triada sealings.

Pl. 67 Oxford *CS* 236. Haematite lentoid. W.18. A bull caught in a net, its head turned away. For the motif cf. the A. Triada sealings, *PM* iv, figs. 553–4; a lentoid from Sunium (*Arch. Eph.* 1917, 196, fig. 8 centre below; Richter, *Engr. Gems* no. 67, as Archaic!); *CMS* viii, 52. Cretan hunters caught bulls in nets; compare the scene on one of the gold cups from Vaphio, Marinatos, *Crete and Mycenae* pl. 179. See *colour, p. 49.6.*

Pl. 68* Oxford *CS* 240, from Central Crete. Red jasper lentoid. W.17. A bitch scratching herself. For the subject cf. sealings from A. Triada, *Ann.* viii–ix, 110, fig. 100 (*Fig. 75*) and Zakro, fig. 176; and contrast the later, mainland

treatment, *CMS* i, 255–6. Notice the way the forelegs are twisted backwards, as with the contorted animals, where also the pose is in fact realistic.

Pl. 69 Oxford *CS* 262. Agate lentoid. W.17. Two 'talismanic' jugs and a branch.

Pl. 70 Heraklion. Cornelian lentoid. W.15. 'Talismanic' motif, heart-shaped, with florals and cross-hatching. *PM* i, fig. 219; *CS* fig. 144.

Pl. 71 Oxford *CS* 184. Cornelian amygdaloid. L.20. 'Talismanic' cuttlefish (not 'an insect'), with crosses in the field.

Pl. 72 Oxford *CS* 179, bought at Xero. Cornelian amygdaloid. L.22. 'Talismanic' jug beside horns of consecration. Hoops in the field. The jug and horns are commonly associated on these stones. *PM* iv, fig. 373b. See *colour, p. 39.10.*

Pl. 73. Heraklion 130. Cornelian plump prism. L.21. 'Talismanic' motifs: 1. A 'rustic shrine'. 2. A jug. 3. A kantharos. *Arch. Eph.* 1907, pl. 7. 47.

Pl. 74* Oxford *CS* 187, from Knossos. Amethyst claw- or tooth-shaped pendant. L.14. 'Talismanic' flying bird. *PM* iv, fig. 497. Other amulets of this shape are listed in *CS*, and see *Praktika* 1967, pl. 187b.

Pl. 75 Oxford 1967. 937. Cornelian amygdaloid. L.20. 'Talismanic' cuttlefish with two small fish. *CMS* viii, 62. See *colour, p. 39.9.*

Pl. 76 Oxford *CS* 254, from East Crete. Agate amygdaloid. L.22. 'Talismanic' rustic shrine with handles. Kenna describes this as a 'shrine surmounted by two snakes', but snakes seem not to have interested the 'talismanic' cutters, and the 'baetylic stone' in the shrine is a deep cut lending body and verisimilitude to the motif in its role as a vessel. There seems one small side handle too, recalling the handled and conical-lidded clay vessels of later date, which are more squat in profile.

Pl. 77* Oxford *CS* 229. Haematite flattened cylinder. L.10 'Talismanic' flying fish with weed and cross-hatching (net?).

Pl. 78. Heraklion 747, from Mochlos, tomb I. Rock crystal lentoid. W.23. A dolphin, fish, cuttlefish and starfish or sea-urchin. Hoops (rocks?) in the field and a branch (part missing in the impression shown) round half the device. Seager, *Mochlos* (Boston, 1912) fig. 6; Zervos, fig. 437; *CS* fig. 50. MMIII? Kenna may be right in associating this with the Early Palace discs, *CS* p. 36.

Pl. 79 Oxford *CS* 281. Green jasper amygdaloid. L.18. 'Talismanic' pattern suggesting an octopus.

Pl. 80* Oxford 1967.931. Green jasper amygdaloid. L.17. 'Talismanic' pattern of tubular drill lunettes suggesting two crabs or insects set antithetically. *CMS* viii, 54.

Pl. 81 Oxford *CS* 221. Mottled chalcedony amygdaloid. L.28. A crab between two fish-like motifs, linked by a cut which gives the appearance of horns of consecration to the assemblage.

Pl. 82 Oxford *CS* 220, from near Lappa. Agate amygdaloid. L.28. 1. A fish swimming past reeds. 2. A bird. *PM* i, fig. 498; iv, fig. 430, Suppl. pl. 54h. Perhaps 2 was started first, then abandoned. It is most unusual for an amygdaloid or lentoid to be cut on both sides in this period; it is rare in LMIII; common on Archaic Island gems. See *colour, p. 49.2*.

Pl. 83 Oxford *CS* 223, from Kritsa. Agate amygdaloid. L.27. A bird with spread wing.

Pl. 84 New York 14.104.1. Agate lentoid. W.27. A griffin. Compare the last. Richter, *Catalogue* (1920) pl. 1.9.

Mycenaean Knossos
Pl. 85 Oxford *CS* 285, from A. Pelagia. Agate amygdaloid with facetted back. L.25. A man grappling with a goat (not certainly stabbing it, nor does he wear a scabbard). *PM* iv, fig. 559.

Pl. 86 *Geneva Cat.* i, pl. 76, no. 197. Red jasper oval. L.21. A lion attacks a goat. Compare the last for both shape and style. The quality and compact composition suggest its inclusion here, rather than with mainland gems, with which it has been compared, but in technique and figure work it does resemble stones like our *Pl. 179*.

Pl. 87 Paris, BN, *Pauvert* pl. 1.6, from the Greek islands. Cornelian lentoid. W.20. Three swine. The motif below resembles ears of corn. *PM* iv, fig. 549; *AG* fig. 216. Cf. the swine on *Giam.* 302 (Marinatos, *Crete and Mycenae* pl. 118, bottom right), *Berlin* F 49, pl. 1, D 45.

Pl. 88 Oxford *CS* 296. Agate oval. L.23. Two recumbent calves by a tree. *PM* iv, fig. 541b. A very realistic rendering of the creatures at rest, leading to later compositions, as *Pls. 126, 178*; or *CS* 333, 383; *CMS* vii, 103; *Berlin* F 44, pl. 1, D 49.

Pl. 89 Heraklion, from Vathy Pediados. Haematite amygdaloid with grooved back. L.25. A man in a long dress shouldering a Syrian axe. *Arch. Eph.* 1907, pl. 7.85; *PM* iv, fig. 343a; Zervos, fig. 634; *CS* fig. 132; *BCH* lxx, 148–63.

Pl. 90 Paris, BN, *de Clercq* ii, pl. 7.97bis. Grey lentoid. W.21. Two bulls, crossed. *AG* fig. 39; *PM* iv, fig. 578, Suppl. pl. 55g.

Pl. 91* Oxford *CS* 314. Cornelian lentoid. W.25. A lioness. Kenna suggests that she is shown drinking at a river.

Pl. 92 Heraklion, from Praisos. Agate lentoid. W.25. A man leaps on to the back of a recumbent bull. *BSA* viii, 252, fig. 25; Zervos, fig. 644; *CS* fig. 134; Marinatos, *Crete and Mycenae* pl. 117 below.

Pl. 93 Oxford *CS* 301, from the Knossos area. Chalcedony lentoid. W.18. A calf, collapsing, trying to scratch out an arrow lodged in its belly. *PM* iv, Suppl. pl. 54f. For the style and subject see *CMS* vii, 105.

Pl. 94 Oxford *CS* 343, from Knossos. Green jasper lentoid. W.17. Three swans in a papyrus grove. *PM* iii, fig. 66a; iv, fig. 427.

Pl. 95 Oxford *CS* 297, from Mirabello. Green jasper lentoid. W.16. Three swans displaying. More subtly composed and probably earlier than the last (even LMI?). *PM* iv, fig. 426, Suppl. pl. 54m.

Pl. 96 New York, Velay Coll., from Knossos. Cornelian lentoid. W.16. Two waterbirds, set antithetically. Evans, *Selection* no. 25 ('outside a 'Geometrical' tomb north of Knossos').

Pl. 97 Oxford *CS* 344, from Archanes. Green jasper lentoid. W.18. A cat, its head upturned, has seized a waterbird by the neck and claws its body with a hind leg. Other fowl at either side. *PM* iv, fig. 582.

Pl. 98* Oxford *CS* 44S, from Knossos, Isopata, the entrance to the Royal Tomb. Clay sealing. W. of device 20. A recumbent bull over a spiral. One of several sealings with this motif. *PM* i, fig. 515; iv, fig. 530; *Kadmos* vi, 27, fig. 12b. LMIIB.

Pl. 99 Oxford *CS* 302, from Knossos. Haematite lentoid. W.18. A flying goose, an argonaut, a butterfly and flowers.

Pl. 100* Oxford *CS* 40S, from Knossos, Area of the Jewel Fresco. Clay sealing. L.25. A collared bitch. Examples of this impression appear on sealings from various parts of the palace (*BSA* lx, 98, i). *PM* ii, fig. 493; iv, fig. 567, 597 Bj. LMIIIA. 1 (the stone probably LMII).

Pl. 101* Oxford *CS* 51S, from Knossos, the Arsenal Deposit. Clay sealing from a ring (?). W.34. Water birds

with papyri. Set in two registers. Other examples from the same deposit. *PM* iii, fig. 67; iv, fig. 602. LMIIIA. 1 (the stone probably LMII).

Pl. 102 Oxford *CS* 293, from Knossos. Green jasper amygdaloid with grooved back. L.34. A man wearing a long heavy garment and shawl, holds a bird. *PM* iv, fig. 336. See *colour, p. 49.7.*

Pl. 103 Oxford *CS* 249. Agate lentoid. W.21. A leaping bull with a man grasping its horns, another prostrate below. See *colour, p. 49.4.*

Pl. 104 *London* 83, pl. 2. Cornelian lentoid. W.20. A woman, holding flowers over her head (?), seated on a lion's head, between two lions. *CMS* vii, 118.

Pl. 105 Oxford *CS* 311. Agate lentoid. W.25. Two recumbent oxen, the farther one facing away. Compare the finer rendering on *Pl. 88.* See *colour, p. 49.3.*

Pl. 106. *London* 76, pl. 2. Agate lentoid. W.22. A huntsman, wearing a sword, spears a goat. *AG* pl. 2.15; *CS* fig. 163; *CMS* vii, 131.

Pl. 107 *London* 40, pl. 1 (as 39). Black jasper amygdaloid with grooved back. L.28. A man, wearing a long kilt, carrying a fish. *CMS* vii, 88. For the subject compare our *Pl. 62* and the Phylakopi vase, Zervos, *L'Art des Cyclades* figs. 312–5.

Pl. 108 Oxford *CS* 300. Red jasper lentoid. W.18. A kilted man with three bulls. *AG* pl. 6.11; *PM* iv, fig. 535. See *colour, p. 49.8.*

Pl. 109 *London* 62, pl. 2. Lapis lacedaemonius lentoid. W.17. A contorted goat. *CMS* vii, 124; *AG* pl. 3.36.

Pl. 110 Oxford *CS* 308, from Avdou, near Lyttos. All-stone agate ring. L.28. Two men in a chariot drawn by two goats. *Arch. Eph.* 1907, pl. 8.166; *PM* iv, fig. 803. Other all-stone rings of Bronze Age date are *CMS* i, 89, 383 and our *Pls. 174, 181.* Another goat chariot on the A. Triada sarcophagus, Marinatos, *Crete and Mycenae* pl. XXIXB. See *colour, p. 49.9.*

Pl. 111* Oxford *CS* 318. Green jasper lentoid. W.22. A lion and a bull with a tree beyond (one branch and the curling trunk preserved). The creatures are not obviously fighting. For the style compare *Pl. 114.*

Pl. 112* Oxford *CS* 292, from Psychro Cave. Haematite lentoid. W.18. The facing head of a horned sheep (?) and two profile heads and necks of goats. *PM* iv, fig. 581.

Pl. 113 *London* 65, pl. 2. Haematite lentoid. W.19. A griffin and a lion attack a bull, spreadeagled. *AG* pl. 3.5; *CMS* vii, 116.

Pl. 114 Oxford *CS* 315, from Knossos, 'with mature LMII pottery'. Rock crystal lentoid. W.20. A twisted lion. *PM* iv, fig. 583, Suppl. pl. 55j. Compare *Pl. 111*; possibly the same hand.

Pl. 115 Once Evans. Haematite lentoid. W.15. A dog, bird and linear sign. *PM* iv, fig. 568; *Kadmos* v, 16, no. 24.

Pl. 116. London, Victoria and Albert 8793–1863. Red jasper lentoid. W.16. Two lions, set antithetically. Compare for style and motif *CS* 244; *CMS* vii, 90.

Pl. 117 *Munich* i, 58, pl. 7. Agate lentoid. W.23. Two goats with bristling backs rear up at either side of a column. Compare the style and subject of *CS* 339.

Pl. 118 Oxford *CS* 307, from Taygetos. Lapis lacedaemonius lentoid. W.22. A 'Minoan genius' with boar's head leading a bull. Summary flying bird in the field. *AG* pl. 2.33; *PM* iv, fig. 368a. The material, together with the alleged provenience, might suggest mainland Greek work, related to our Group Q (Notes, p. 396).

Pl. 119 Oxford *CS* 306, from Crete. Agate lentoid. W.23. A 'Minoan genius' with lion head leading a bull. *PM* iv, fig. 368b. Compare the style of *Pls. 111, 114.*

Pl. 120 Boston. Amygdaloid. L.30. A lion struck by an arrow.

Pl. 121* Oxford *CS* 329, from Central Crete. Haematite amygdaloid with grooved back. L.24. Two lions. *PM* iv, fig. 570.

Pl. 122 Oxford *CS* 320, from Mirabello. Agate lentoid. W.25. A hunter killing a goat. Between his legs an animal head. *PM* iv, figs. 428, 558. See *colour, p. 49.11.*

Pl. 123* Oxford *CS* 342, from Crete. Haematite lentoid. W.25. Two griffins attack a twisting bull. *PM* iv, fig. 611. It is unusual to find griffins rather than lions, hunting on Bronze Age seals.

Pl. 124 Oxford *CS* 341. Lapis lacedaemonius lentoid. W.24. A man leaping over a bull. Shield motif in the field. Some gems in comparable style and subject are *CS* 246, 249; *CMS* vii, 108–9; cf *AA* 1959, 106, fig. 25.

Pl. 125 Heraklion 131, from Siteia. Lapis lacedaemonius lentoid. W.26. Two bulls, set antithetically, a linear sign between them. *Arch. Eph.* 1907, pl. 7.103; *PM* iv, fig. 544b;

Zervos, fig. 643; *Kadmos* v, 16, no. 27. For the composition and device cf. *AJA* lxviii, pl. 4.16.

Pl. 126 New York 11.195.1. Agate flattened cylinder. L.17. Two recumbent calves. Richter, *Catalogue* (1920) pl. 1.5.

Pl. 127 Manchester University, Finlay 5. Pink quartz lentoid. W.16. A goat and a branch. *CMS* vii, 250.

Pl. 128 *London* 86, pl. 2 (as 78), from Crete. Lapis lacedaemonius lentoid. W. 18. Human legs joined to the foreparts of a goat and a bull. A shield device in the field. *AG* pl. 2.41; *CMS* vii, 123.

Pl. 129 Oxford *CS* 321. Agate lentoid. W.15. Two demons with human legs, and the foreparts of a lion and a goat, in an antithetic scheme, as though fighting. *PM* iv, fig. 586.

Pl. 130 Oxford *CS* 345. Agate lentoid. W.25. A contorted bull. A bird below, and the fish-like creature may also be intended for a bird, picking at the bull. For the subject compare *ADelt* iv, pl. 5.5 (Gournes).

Pl 131 Manchester University, Finlay 3. Green jasper lentoid. W.21. A contorted bull with two goats' heads in the field. *CMS* vii, 248.

Pl. 132 Oxford *CS* 323, from Milatos. Haematite lentoid. W.20. Human legs joined to the foreparts of two bulls. A shield device and florals in the field. A stylised version of *Pl. 128*. Compare Zervos, fig. 630, with foreparts of a goat and a lion. It is commoner with the single forepart as our *Pl. 129*.

Pl. 133 Boston, *LHG* 5, pl. 1, from Crete. Agate flattened cylinder. L.20. A cow suckles a calf.

Pl. 134 Oxford *CS* 286, from Goulas. Agate lentoid. W.20. Three goats or horned sheep and florals.

Pl. 135 Once *Evans* 14, pl. 2. Green jasper lentoid. W.16. A bull, with a shield device in the field.

Pl. 136* Oxford *CS* 312, from the Heraklion area. Haematite lentoid. W.18. Two recumbent bulls, one struck by a spear. *PM* iv, fig. 540.

Pl. 137 Paris, BN, *Pauvert* pl. 1.4, from Crete. Green jasper lentoid. W.20. A contorted bull and a fish (or bird?; see *Pl. 130*). *AG* pl. 3.39.

Pl. 138 Oxford *CS* 298, from Gortyn. Haematite lentoid. W.19. A contorted lioness suckling a cub. A shield motif

and goat's head in the field. *PM* iv, fig. 522a (cf. ibid., b, for the motif).

Pl. 139 Naples 1404. Cornelian amygdaloid with a flat back. L.19. A goat and branch. See *Pl. 127*.

Pl. 140* Oxford *CS* 7P, from Knossos, Zapher Papoura, tomb 36. Agate lentoid. W.21. A horned sheep tied to a pillar. Awkward work. *PTK* fig. 61; *PM* iii, fig. 209; *CS* fig. 126. A 'branch' before the sheep is omitted on the published drawings, is lightly incised, and may not be original. The motif reappears on Knossos sealings, as *CS* fig. 125; *PM* iii, fig. 208.

Pl. 141 Manchester University, Finlay 4. Cornelian lentoid. W.14. A dog and a bird. The device below may be a shell or a head. *CMS* vii, 249.

Pl. 142 Heraklion, from Lyttos. Cornelian lentoid with a conical back. W.12. A lion attacks a goat. *Arch. Eph.* 1907, pl. 7.56. For the subject and style (rather better) cf. *CS* 349, 350.

Pl. 143 Oxford *CS* 15P, from A.Pelagia. Cornelian lentoid. W.25. A griffin.

Pl. 144* Oxford *CS* 358, from Crete. Haematite cylinder. H.22. A 'Minoan genius' with jug, a pillar before it and a bird overhead, a horned man, and on the rest of the cylinder (not shown) two goats, a man, a kilted man with a jug, and another pillar (?). *PM* iv, fig. 383.

Pl. 145 Oxford *CS* 351, from the Psychro Cave. Cornelian lentoid. W.34. Part of the intaglio is broken away. A goddess with the sacral horns on her head, flanked by griffins. This is not an uncommon motif. In this style it appears on our *Fig. 113*.

Pl. 146 Liverpool City Museum 217. Cornelian amygdaloid. L.26. A griffin. *CMS* vii, 258; *JHS* lxxxvi, pl. 12j.

Pl. 147 Paris, BN N3436, from Mycenae. Chalcedony amygdaloid. L.27. A griffin with spread wings. *AG* fig. 19. Possibly mainland Greek work; see Notes, p. 412.

MYCENAEAN GREECE
Pl. 148* Athens 3148, from Mycenae, grave 84. Gold ring. L.30. A goat and tree preceded by a man who approaches a structure from which a tree is growing. *CMS* i, 119; Marinatos, op. cit., pl. 206.2. This looks more like a combination of motifs—animals with a tree; 'adoration' of a tree—than a cult act involving the goat; but cf. *CMS* i, 292.

Pl. 149* Athens 992, from Mycenae, the Acropolis Treasure. Gold ring. L.34. Three large figures of women in a garden, holding lilies and poppies. Two smaller figures appear, one before the seated woman, holding flowers, and the other behind her, plucking fruit (?) from a tree. In the field above is a small male warrior, with spear and figure-eight shield, and at the centre a double axe. At the top two wavy lines, suggesting clouds, enclose a crescent moon and a full disc (sun or full moon). At one border six lion heads are set decoratively. *CMS* i, 17; Marinatos, *Crete and Mycenae* pl. 207 below.

Pl. 150* Athens 3180, from Mycenae, grave 91. Gold ring. L.26. Two women make a gesture of adoration at either side of a shrine, which seems to be topped by plants and to be approached through a gated, walled enclosure. Trees and plants in the field; at the left a tree or pillar. 'Paving' in the exergue. *CMS* i, 127; Marinatos, op. cit., pl. 206.4.

Pl. 151* Athens 8324, from Pylos, Rutsi, grave 2. Gold amygdaloid with grooved back. L.28. A bull, caught in a net and grappled by a hunter who clings to its horns. Rocks and a tree are shown. Cf. *Fig. 123*. *CMS* i, 274; Marinatos, op. cit., pl. 209 below.

Pl. 152* Athens 7986, from Pylos, grave Δ. Gold flattened cylinder. L.27. A griffin with floral crown and spread wings. Below, an architectural frieze. The back of the seal is worked with a net pattern in relief. *CMS* i, 293; Marinatos, op. cit., pl. 209 top.

Pl. 153* Oxford CS 340, from Mycenae. Gold ring. L.24. Two lions tethered to a column. Above them 'sacral knots'. *PM* i, fig. 310b; iv, fig. 598a.

Pls. 154–167 are from the Vaphio tomb in Laconia. LHII. See Notes, p. 413.

Pl. 154* Athens 1801. Gold ring. L.22. At the right a youth steps over rocky ground to pull down the heavy branches of a tree, at the foot of which stands a storage jar (an olive tree?). At the centre is a woman in a dancing pose. At the right a figure-eight shield is shown in profile with a 'sacral knot' or dress attached to it. In the field above is a decorated double axe, an ear of corn (?) and an insect or chrysalis. *CMS* i, 219.

Pl. 155. Athens 1768. Agate lentoid. W.24. A seated lion. *CMS* i, 243.

Pl. 156 Athens 1775. Jasper lentoid. W.20. Two men tie up a lion by its legs. *CMS* i, 225.

Pl. 157 Athens 1774. Agate lentoid. W.19. A lion crouching, trying to scratch out an arrow lodged in its flank, in a

rocky setting. *CMS* i, 248. For the subject compare *CMS* i, 277; *PM* iv, 545.

Pl. 158 Athens 1763. Agate lentoid. W.24. Two recumbent bulls, the farther one with its head turned away. *CMS* i, 240. Compare our *Pls. 105, 136*, for the subject in this form.

Pl. 159 Athens 1774. Agate lentoid. W.28. A lion attacks a bull over rocky ground. *CMS* i, 252.

Pl. 160 Athens 1761. Jasper lentoid. W.23. A man in a heavy long cloak, with a griffin. *CMS* i, 223. Compare the Cretan figures, our *Pls. 89, 102*.

Pl. 161. Athens 1760. Chalcedony lentoid. W.22. Two women, both crowned, naked above the waist, and wearing skirt and apron. They turn their backs to the viewer. Before them a rearing goat. *CMS* i, 220. Compare *Pl. 164* for the subject.

Pl. 162 Athens 1789. Agate amygdaloid with grooved back. L.22. A dancing woman, naked above the waist, wearing a fleecy skirt. She holds a short staff (or is this a lock of hair?). *CMS* i, 226. Compare the dress on *CMS* viii, 146.

Pl. 163 Athens 1770. Agate lentoid. W.31. A two-horse chariot carrying charioteer and spearman. *CMS* i, 229. For chariots in Bronze Age Greece see now Wiesner, *Reiten und Fahren* (Göttingen, 1968).

Pl. 164 Athens 1765. Cornelian lentoid. W.18. A woman, wearing necklet, bodice and skirt, with a ram which seems to leap before her, throwing its head back on to her shoulder. *CMS* i, 221. This very odd group is repeated on other gems (*CS* figs. 106–7; *CMS* viii, 144, cf. 146); its intention is obscure.

Pl. 165 Athens 1772. Chalcedony lentoid. W.20. A hunter confronts a charging boar in a cave or rocky setting. *CMS* i, 227.

Pl. 166 Athens 1776. Agate lentoid. W.20. Two 'genii' with lion heads, slim feline legs and 'wasp' cloaks, hold jugs over horns of consecration which have branches between them, and which stand on a low altar. *CMS* i, 231.

Pl. 167 Athens 1781. Agate lentoid. W.16. A helmet formed of rows of boars' tusks, of a type represented by Bronze Age finds and described by Homer. From its crown rise a floral and at either side two crests like horns. The helmet straps are shown at either side. *CMS* i, 260; *Arch. Eph.* 1966, 119ff., fig. 1.

Pl. 168. Athens 4533, from Mycenae, the Acropolis. Green jasper lentoid. W.20. A stag, twisting to scratch its neck. In the field a figure-eight shield and a lion's leg. *CMS* i, 41.

Pl. 169 Athens 3137, from Mycenae, tomb 83. Agate lentoid. W.32. A lion attacks a bull. *CMS* i, 116. The pose is a common one on seals but appears also in an ivory relief from Thebes, *ADelt* xxii, Chr. pl. 162γ.

Pl. 170 Athens 3089, from Mycenae, tomb 78. Agate lentoid. W.18. The head of a lion, forepart of a lion, head and neck of a goat, a waterbird and a quadruped. *CMS* i, 110.

Pl. 171 Athens 3138, from Mycenae, tomb 83. Agate lentoid. W.26. Two lions, crossed and apparently fighting, over the body of a deer. *CMS* i, 117.

Pl. 172 Athens 2973, from Mycenae, tomb 68. Agate lentoid. W.26. Two lions attacking rams, the groups set antithetically, but one lion head frontal. *CMS* i, 103.

Pl. 173 Athens 2863, from Mycenae, tomb 58. Lapis lacedaemonius lentoid. W.22. A man grapples with a fallen bull. *CMS* i, 95.

Pl. 174 Athens 1376, from Mycenae, the Acropolis. Chalcedony all-stone ring. L.29. Two cows suckle calves. *CMS* i, 20.

Pl. 175. Paris, BN, ex Louvre A1167. Chalcedony lentoid. W.21. A 'Minoan genius' with lion's head supports the body of a bull. Delaporte, *Louvre* pl. 105; *PM* iv, figs. 354, 358b; *Ath. Mitt.* lxxix, 19, Beil. 5.4.

Pl. 176 Boston. Chalcedony lentoid. W.22. A bull. In the field are a figure-eight shield and two sacral knots. For the subject, with the shield, see *CMS* vii, 113.

Pl. 177 Athens 2875, from Mycenae, tomb 58. Agate lentoid. W.20. Two griffins stand with their forelegs on an altar which supports a Mycenaean column with spiral fluted shaft. *CMS* i, 98.

Pl. 178* *London* 89, pl. 2, from the Peloponnese. Red jasper prism. W.13. 1. A contorted lion. 2. A lion attacks a bull. 3. Two recumbent calves. *CMS* vii, 115.

Pl. 179. Boston, *LHG* pl. 1.1, from Mycenae. Cornelian lentoid. W.25. Two lions tear at the throat of a stag. *PM* iv, fig. 579. Contrast the later treatment of the theme on a Pylos sealing, our *Fig. 143*.

Pl. 180 Boston, *LHG* pl. 1.2. Cornelian lentoid. W.24. A lion attacks a bull. The bodies are set upright and the lion's head obscured by the bull's, which is frontal, giving the impression of a bicorporate beast. *PM* iv, fig. 575.

Pl. 181. Boston, *LHG* pl. 1.4, from Mycenae. Rock crystal all-stone ring. L.24. Two recumbent calves, with trees.

Pl. 182 Boston, *LHG* pl. 1.3. Cornelian lentoid. W.31. A lioness attacks a bull.

Pl. 183 Athens 2319, from Mycenae, tomb 10. Agate lentoid. W.19. A bull, with a palm tree and floral. *CMS* i, 52. Compare for style and subject *CMS* vii, 113, from Ialysos.

Pl. 184 Athens 2423, from Mycenae, tomb 47. Agate lentoid. W.23. A man disembowels or skins a dead deer, laid out on a low table. *CMS* i, 80. Compare our *Pl. 185*.

Pl. 185 *Berlin* F 22, pl. 1, D 44, from Abrosine in Achaia. Agate lentoid. W.21. A dead goat, laid out on a low table between the legs of which appear bucrania. A dagger stuck in the creature's neck. Behind is a limp palm. *PM* iv, fig. 542b.

Pl. 186. Once Arndt. Lentoid. W.25. A two-horse chariot. Hitherto unpublished. On chariot scenes see on *Pl. 163* and for a later Cretan representation, *AA* 1964, 803.

Pl. 187 New York 14.104.2. Agate lentoid. W.27. A recumbent bull and a tree. Richter, *Catalogue* (1920) pl. 1.2.

The End of The Bronze Age

Pl. 188 Heraklion 24, from the Idaean Cave. Rock crystal lentoid. W.20. A woman holding a large conch shell (to blow it?) before an altar surmounted by horns of consecration and branches. In the field a tree, a stand (?) and a star. *PM* iv, fig. 162; Zervos, fig. 665; *CS* fig. 140.

Pl. 189 Vienna 1357. Cornelian lentoid with conoid back. W.18. A man carrying two lions. Possibly LHIIIB, not Cretan. The man probably carries the lions from a pole; cf. the 'genius' with lions, *Berlin* F 11, pl. 1, D 28, from Crete. Compare for style and subject *Munich* i, 57, pl. 7.

Pl. 190 Heraklion. Black steatite lentoid. W.15. A griffin. *Arch. Eph.* 1907, pl. 7.75.

Pl. 191 *London* 181, pl. 4, from Crete. Black steatite lentoid. W.18. A lion and a flying bird. *CMS* vii, 198. For subject and style cf. ibid., 197 (from Crete); *CMS* viii, 80; *Berlin* F 30, pl. 1, D 42, from Crete; *Giam.* 288.

Pl. 192. Oxford 1967. 138. Green stone lentoid. W.15. Demons with goats' heads, birds' legs and bodies recalling

the cloaks of the 'Minoan genius', at either side of a column marked with chevrons. *CMS* vii, 65. Possibly inspired by the compositions with 'genii'.

Pl. 193 Oxford *CS* 373. Grey steatite lentoid. W.17. A lion and a tree.

Pl. 194 *Berlin* F 34, pl. 1, D 39, from Crete. Red jasper lentoid. W.21. Two lions with their fore paws on an altar. A star above.

Pl. 195* Oxford *CS* 395. Black steatite lentoid. W.20. Twisted body of a deer with filling arcs (rather than lion attacking bull, as *CS*). Compare the last.

Pl. 196 Oxford *CS* 106, from Central Crete. Black steatite lentoid with a conoid back. W.20. An oared sailing ship. *CS* proposes a MMI date (also for *CS* 107) and Evans MMII, but the combination of shape and material only wholly suit LMIIIB and the style is appropriate.

Pl. 197 Oxford *CS* 394, from Archanes. Black steatite lentoid. W.20. Twisted, fragmented body of a goat (rather than an argonaut, as *CS*). This, and the next, correspond broadly to the mainland LHIIIC style.

Pl. 198 Basel, Erlenmeyr Coll. Green steatite amygdaloid. L.23. Two goats set antithetically. Probably island work.

Pl. 199. *Berlin* F 36, pl. 1, D 58, from Syra. Black steatite disc. W.17. Four birds, two flying in profile, one displayed, one standing. The shape is that of the Early Palace discs, but the stone seems not to have been recut, and the style and subject seem late, so this may be a deliberate imitation of an outdated form. Compare the style of *CMS* vii, 134.

Pl. 200 Oxford *CS* 374. Grey steatite lentoid. W.14. A bird goddess.

Pl. 201* Oxford *CS* 382. Green steatite lentoid. W.16. An octopus (?). *CS* suggests a fountain.

Pl. 202 Oxford *CS* 353, from Knossos. Grey steatite lentoid. W.14. A floral with horns (?) and hoops, approximating to a lion's mask. Taken for LMII in *CS* but perhaps later and related to other 'sub-talismanic' devices, like *Pl. 196*.

CYPRUS

Pl. 203* Nicosia 1938. III–25.1, from Trikomo. Black steatite conoid. L.16. Head of a man wearing a helmet with horns. *Rept. Dept. Ant. Cyprus* xxxvii–xxxix, 202 and pl. 43.1.

Pl. 204* Nicosia E.24. Green steatite conoid. W.13. A griffin. *BCH* xcii, 151, 35.

Pl. 205* Nicosia 1955. VI–17.1. Steatite conoid. W.19. Goat and scorpion. *BCH* xcii, 151, 31.

Pl. 206* Private Coll. Haematite cylinder. H.27. The centre piece is two genii holding jugs with a bull's head between. Below them two lions and a goat's head; above, a winged disc and a four-character Cypro-Minoan inscription with central rosette. To the right above, two crossed lions. The other two main figures are a bull-headed human in a long dress, opening to show one leg, holding a long handled sickle and a lion, upside down. Between them is another Cypro-Minoan character. He is faced by a woman in a long dress who seems to grasp his lion's tail and to support a goat with her other hand. Between them, above there is the facing head of a horned deity, with long ringlets, and below, the head and neck of a lion. Behind the woman is a small human figure with lion's legs and tail. This general class of Cypriot cylinder, deriving its style and subject matter from both the Aegean and Syria, is well known (see Notes, p. 416). It is represented by Porada's Groups II and III as defined in *AJA* lii, 184ff. Several are inscribed in Cypro-Minoan script, some in cuneiform. For the genii see Gill, *Ath. Mitt.* lxxix, 1ff., and another example on a Cypriot cylinder now is Karageorghis, *Myc. Art in Cyprus* (Nicosia, 1968) pl. 38.4. Stylistically ours is closest to a cylinder in Boston (33.1006; Frankfort, *Cylinder Seals* (London, 1939) pl. 45g) where the demons are, however, winged. But there are the same crossed lions, headdress and skirt, bull-man with lion and a similar bared forward leg. Rather similar are *London* 111, 116, pl. 2 (Porada, figs. 11, 18). The bared leg, winged disc with a star upon it, crossed lions and the sickle carried by the bull-man derive from earlier Syrian and Mitannian cylinders and are not very common on the Cypriot. For the sickle see now Makkay in *Acta Arch. Acad. Hung.* xvi, 36ff. Another Cypriot cylinder similar to ours in subject matter but not style is in Yale (*Newell* pl. 24.354) where we see the winged disc (vertical, as on our *Fig. 127*), bared leg and bull-man with sickle and a goat held upside down. The form of the characters in the inscription (which will be further studied by Dr Masson) is involved and not wholly canonical, but this is true of other inscribed cylinders. This feature, the accomplished style, and details of the subject matter, suggest that the piece may be quite early in this Cypriot series, which is generally dated to the earlier fourteenth century BC.

Chapter III
THE GEOMETRIC AND EARLY ARCHAIC PERIODS

The fall of the Mycenaean palaces had spelled the end of the palatial arts of the Bronze Age, including gem engraving. For a hundred years or more the survivors of the old kingdoms went on living in Greece but there were further incursions from the north and considerable depopulation, all of which can hardly be due to man-made violence without the aid of pestilence and drought. These are the Dark Ages.

Gradually, however, the country of Greece and its peoples can be recognised in a form close to that which we know in the full Classical period. On the Greek mainland and the southern islands Dorian Greeks had occupied the desolate land and towns. Here and there continuity of occupation and culture can be observed, especially in Athens and Crete, just as there was certainly continuity of language. The Greek islands had survived the troubles at the passing of the Bronze Age better than most of Greece, and were to serve as stepping stones across the Aegean to the coastline of Anatolia where, on the offshore islands and the mainland itself, new Greek communities were formed where before Minoans or Mycenaean Greeks had barely visited, rarely settled: Aeolic in the north and in the island of Lesbos; Ionian in the centre and on Chios and Samos; Dorians to the south and on Rhodes and its attendant islands.

We can best observe the renaissance of the arts in Greece in the developing skills of the Protogeometric and Geometric Greek potters of Athens from the mid eleventh century to the end of the eighth. But these are years in which material wealth must have been reckoned in land and iron, and it was not until the arts of the foreigners were brought again into the Greek world to inspire and teach new styles, that the conditions were right for the resumption of crafts like jewellery or seal engraving.

If, however, there was no continuity in production, we may still enquire what the Greeks of those centuries could have understood of the glyptic of their own past or of others. We have already remarked how, in the nineteenth century, Greek Bronze Age seals were being worn by peasants in Crete: the 'milk-stones' bought by visitors and collectors like Arthur Evans. The stones had been found in fields which marked the sites of ancient towns or cemeteries, or had been taken from tombs casually uncovered and robbed. Three thousand years earlier the opportunities for such discoveries must have been far greater, and we may be sure that the gems were handled and worn as amulets by folk to whom the near-realistic arts of the Bronze Age were as strange as the use of the seals themselves. And these were but the minor souvenirs of a heroic past which they saw about them in the walls, built by the giant Cyclopes, the 'treasury' tombs they robbed, and the labyrinthine ruins of palaces. Of the seals they picked up we find several in eighth- and seventh-century tombs or votive deposits in Greece and Crete. In Crete one was reused in a Classical setting. Another Cretan took a Minoan gem with him to a new colony in North Africa and dedicated it at a sanctuary of Demeter and Kore at Taucheira in the sixth century. There are many similar instances of the reuse of such finds, from the Bronze Age clay head installed in a shrine of Dionysos in Keos, to the Minoan stone bowl set as a rhyton over the head of a burial in the Christian basilica church at Knossos.

It is clear that this casual familiarity with Bronze Age seals did not inspire emulation by Greek artists until a period in which seal use had already become again a regular practice, but inspired by other sources

(the Island gems, see below). These new sources are the same as those which initiated the whole orientalising phase of Greek art. Although we are most familiar with these new styles in the seventh century BC we have to look for their beginnings, and some abortive experiments with the new patterns and techniques, far earlier. The Greeks, and even the East Greeks on the coast of Anatolia, had lost contact with the countries of the Near East and Egypt in and after the Dark Ages. In Crete especially relations of some sort seem to have been maintained with Cyprus, which had given shelter to Mycenaean Greek refugees, and it was probably from or via Cyprus that a Phoenician bronze bowl and gold jewellery arrived in Athens in the ninth century. By the end of that century Greek islanders, led by Euboeans and probably guided by Cypriots, went themselves to tap the resources of the east, and established a trading post at the mouth of the River Orontes in North Syria, at a site we know as Al Mina. At about this time and soon afterwards eastern craftsmen were travelling west, especially to Crete and Attica, to practise and teach advanced techniques in working bronze, gold and ivory. In this way Greece acquired not only the new techniques which its developing society could use, but also a route for the import of eastern materials and objets d'art.

The finds of foreign seals in the eighth century are dominantly Egyptian, but Egypt was clearly not the source of inspiration for the first new seals cut in Greece, as we shall see. This very fact suggests that it was the arrival of craftsmen rather than simply objects which may have been responsible for many of the changes in Greek art in these years.

THE GEOMETRIC SEALS

The earliest evidence for Greek Geometric seals is provided by the recent excavation of a mid-ninth century grave on the north slopes of the Areopagus hill at Athens. In it were two ivory seals, with roughly square faces and pyramidal in form, their sides decorated with lines of notches and their devices, so far as they are preserved, the simplest of geometric patterns (*Fig. 152*). They teach us two important things: first, that ivory was already being worked in Geometric Greece, for there can be no question of their being imports, although in the same grave there is a fine piece of eastern (probably Cypriot) gold jewellery; and secondly, that since seal use was already current in about 850 BC we should probably assume the existence of seals in other materials which have not survived, such as wood, because there is no other physical evidence for seals until the stone series beginning nearly a century later.

Ivory was a new material for the Greeks of the Iron Age. Worked objects from the east arrived in Crete, Rhodes and Athens, some perhaps already in the ninth century, and in time eastern craftsmen were to come to practise and teach the finer techniques of cutting. The material was still available from the elephant herds in Syria and apparently continued to reach Greece until the end of the seventh century, when there is a marked falling off in ivory work, and for some types of objects bone took its place. Al Mina may have been a shipping port for ivory, and marked tusks were found there, but the Athens ivory seals are earlier than Greek activity at Al Mina.

Although most of the ivories to be discussed later seem to be from Peloponnesian centres, it is in eighth-century Athens that we find the earliest evidence for Greek craftsmen working this material for statuettes. These copy eastern figures of the naked goddess Astarte but translate her into a geometricised Greek form. There has been another recent find in Athens of an ivory seal in what seems to be an eighth-century context (*Fig. 153*). It resembles the early stone seals which we have yet to discuss in its rectangular shape and the arrangement of three pegs set in its back to provide a handle. Only one of these pegs is preserved, in the form of a bird on a pillar. The other decoration is common to much other work in ivory, including

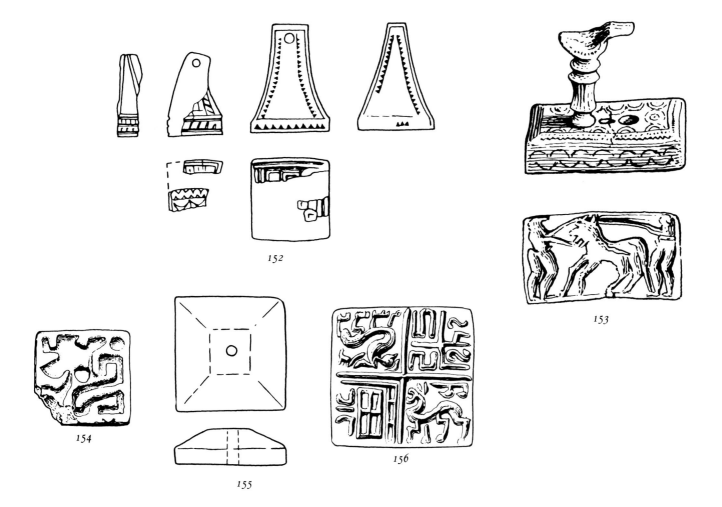

152

153

154

155

156

the later Peloponnesian, and the intaglio is a poor study of two men and a horse, in an orientalising rather than a Geometric form.

There has been occasion already to discuss the probable use of wooden seals in Bronze Age Greece. There was a later Greek tradition that their earliest seals were of worm-eaten wood (see p.379) which provided a distinctive and irregular intaglio pattern. This should perhaps be taken seriously, although none have, of course, survived, but there may be good circumstantial evidence for them in the shapes of the earliest Greek stone seals, to which we must now turn.

These are large, roughly square plaques. Most are pierced through to their faces, presumably for a wooden handle, and many have bevelled edges to their backs (*Fig. 155*). They are cut in soft white stone, but occasionally even in hard white island marble, and it seems that early centres of production were in the islands, perhaps on Melos, and at Argos in the Peloponnese. A find at Perachora proves that they were being made by about the mid eighth century. Some of the intaglio devices are crudely gouged, irregular patterns, resembling worm-eaten wood (*Fig. 154*), and it is very probable that they imitate similar wooden stamps. This would indicate that all-wooden seals, probably of this shape and with separate peg handles, were already in use.

The other square seals carry simple geometric patterns, with the whole field quartered, and a few simple representation of men and women (*colour, p. 115. 1*). One seal, in New York, admits animals to two of the quarters (*Fig. 156*), and although this style may seem advanced for Geometric Greece, they have to be viewed in the light of other figures on objects in Greece of eastern form which are demonstrably

of the eighth century, like the gold bands from Attica which must have been impressed on intaglio matrices rather similar to the stone seals, but smaller, finer and possibly of fired clay. Square seals of this form are found in the Near East, especially in North Syria, in stone and bronze. They often have Geometric devices, but usually better handles, sometimes even in the form of an animal, although one is pierced through to the face, like the Greek.

The mention of bronze, and of animal handles, obliges us to consider briefly a very common class of Greek Geometric bronzes which have sometimes been thought to have served as seals. These are figurines, usually of horses, but occasionally of other animals and rarely of groups involving human figures, which stand upon rectangular or round flat bases. The bases are often made in an openwork pattern, like a grid, but sometimes they are solid, with patterns in relief or intaglio beneath (*Pl. 207*). These examples certainly seem to be influenced by the form of seals even though we may doubt whether any were ever so used. It is only a very small minority which have figure devices in intaglio beneath, the best known being the 'twins' beneath a fine bronze horse from Phigaleia, in London (*Fig. 157*). There are a few bronze pyramidal stamps too which look more like seals, but only one or two have intaglios beneath. We know these bronzes best from finds in the big sanctuaries of mainland Greece, especially at Olympia. From Sparta comes a bronze counterpart to the ivory, *Fig. 153*.

No imports of eastern seals of the type which must have inspired the square seals have been identified so far in Greece, and when eastern seals do begin to arrive in the later eighth century they are of forms which have no immediate influence on Greek studios. The most notable imports are stone seals, usually scaraboids, of the Lyre-Player group, which seems to have had its home in Cilicia in the second half of the eighth century. Its eastern origin is assured both for the purely eastern iconography of the subjects (*Fig. 158*), which are related to the so-called Syro-Hittite or neo-Hittite monuments but in no serious respect to Greek Geometric art, and for their distribution in the east which, although slight beside their distribution in the Greek world, is more than could ever be expected of Greek artefacts at this time. The main concentration of finds has been in sanctuaries on Cyprus (A. Irini) and Rhodes (Kameiros and Lindos), but they are also represented all over East Greece, the islands, Crete and the Peloponnese, again normally in sanctuaries. The other major find has been in the west, at Ischia, where the Euboeans, who had visited Al Mina in the east at the end of the ninth century, were the first Greeks to found a colony in the west. Here, however, they appear in children's graves, often with Egyptian or Egyptianising scarabs, and they seem to have been worn as amulets. The practice is unique at this period in Greek lands, especially on this scale—nearly 90 have already been found on Ischia out of a total of little over 200 from all sites.

The second class of import is of glass scaraboids of Phoenician type which seem to belong to the earlier seventh century and have been found in Greece in votive deposits on Rhodes and Chios, but also in mainland Greece at Sparta, Eleusis, the Argive Heraeum and perhaps Tanagra; and in graves on Rhodes and at Athens. These carry straightforward Phoenician devices with sphinxes, griffins, winged beetles and uraei (Egyptian sacred snakes). An example is shown in *Fig. 159*.

A third class comprises faience seals, mainly scarabs, which reached the Greek world in hundreds from the end of the eighth century on, and are again usually found in sanctuaries although some appear in graves in Athens and Ischia. These have garbled Egyptian devices, with hieroglyphs or animals. Their place of origin is not certain, but it seems not to be either Rhodes or Cyprus, and may be somewhere on the Phoenician coast.

All these exotic little eastern trinkets seem to have been admired by the Greeks, but totally ignored by Greek artists. The finds in Greece tell us about how the Greeks regarded them as valuable for dedication, or as amulets to protect the young, but nothing about seal usage or production in Greece itself.

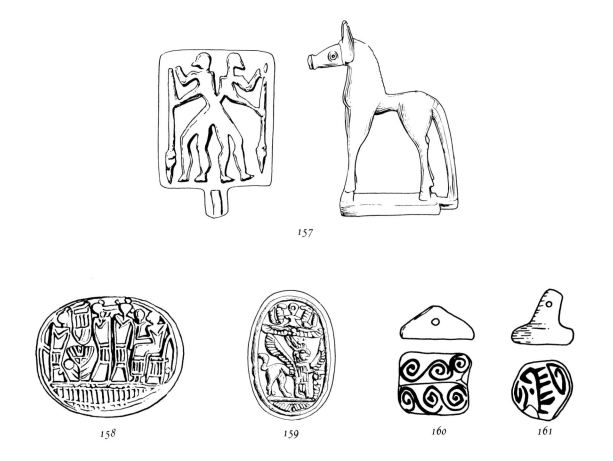

157

158 159 160 161

EARLY ARCHAIC STONE SEALS

The most that the import of these eastern seals may have accomplished in Greece was to stimulate the production there of seals in other shapes and other materials. These proliferate from the end of the eighth century on. The full range of stamp seals current in Cyprus and North Syria is copied in Rhodes in a series of stones which have such poorly cut devices that they can be called nothing better than Amulet Seals (*Fig. 160-1*). Lumpy ornaments like this are found in Crete too, and are very difficult to date, but in Rhodes they appear in votive deposits at Kameiros which were closed in about the mid seventh century. Rhodes may have been an active customer for eastern seals and other objects, and her cemeteries and sanctuaries are important sources for us in this period, but her own contribution to the early orientalising arts of Greece, in seals, vase painting or jewellery, is unenterprising.

We have already noticed Argos as one possible centre for the Geometric square seals, and the deposit at the Argive Heraeum shows that many other shapes of seals were current there from about 700 BC on. It may be just the accident of excavation which leaves the impression that the Argolid was the main centre for stone seals of this type. Certainly, most seals from other sites or with no provenience can be explained in terms of the Argos finds, and in this account of the main shapes and devices provenience is ignored.

Rectangular tabloid seals (*Pl. 208, Figs. 162-164*), with devices on the two broad sides and sometimes on the narrow sides also, seem to keep up the tradition of the old square seals. They are pierced for

suspension or stringing. The devices are still often simply Geometric, but there are more elaborate figure scenes too, with men, women and animals. On a fine example in Paris a bowman attacks a centaur, and we naturally think of Herakles and Nessos (*Pl. 208*). A poorer tabloid in Munich has the same centaur and bowman but adds a woman, in whom it is tempting to recognise Deianira, rescued from Nessos by Herakles. Mythological scenes are beginning to appear on other works of art at this time, so we should not be too sceptical about identifying them on seals. An example from Brauron in Attica (*Fig. 162*) shows two warriors fighting over a tripod which could be a prize, or possibly the Delphic tripod, and this would mean that the warriors are Herakles and Apollo disputing possession of it. The same scene appears on a bronze tripod leg from Olympia of about the the same date.

Another popular shape is the hemisphere. On this simpler devices are preferred, single animals or figures with the background filled with linear patterns (*Fig. 165*). Discs (*Pls. 209–211*) may be decorated on both sides, with one face slightly larger than the other and the profile stepped, and there are some slim pyramidal stamps. A very few have their backs roughly shaped as animals, a commoner practice in ivory. One seal in Oxford is remarkable for its shape and material. It is of shell, and ogival in outline, with Geometric figures on either side and the base (*Pl. 212*). This shape, like the others mentioned here, has its counterpart in the Near East and Cyprus, but we can see that in Greece the forms are quickly reduced to a very simple geometric pattern and the flat disc in particular is developed as a seal in a manner not readily paralleled in the east.

The material of these seals is generally a fairly soft serpentine—in the Argolid a reddish grey variety is popular but otherwise various shades of green, often very mottled, are met. The devices are cut rather crudely, rarely attempting to give volume to the figures by hollowing broad areas, and generally satisfied with simple stick figures. The stones themselves are seldom very carefully cut, but occasionally the back of a hemisphere or tabloid is elaborated with a simple incised pattern. These seals were probably worn as pendants, perhaps on necklaces but nearly all that we know are from sanctuaries and we lack the evidence of location within a grave.

Even less can be said about usage. The shapes are derived from areas of the ancient world where there had been a long tradition in the use of seals. Many of the early Greek seals produce such poor or meaningless impressions that we might suspect that most were used decoratively or as amulets rather than as personal seals to safeguard or identify possessions. But the irregular intaglios of the earliest Geometric seals do suggest that they were intended for individual identification, especially if they can be taken as evidence for the use of wooden seals at an earlier date. We can be sure that the early stone seals were used to make impressions since only thus could an intaglio with a figure device or pattern be properly viewed, but the surviving evidence is on fired clay and the purpose purely decorative. A clay whorl from an eighth-century tomb in Athens bore the impression of a foreign scarab. In Crete rectangular stamps with early orientalising devices were used to decorate clay storage jars (pithoi), the impression being repeated in rows. A similar rectangular stamp showing Ajax carrying the dead Achilles was used to decorate a clay plaque dedicated on Samos, and also impressed on the neck of a clay jar found on Ischia (*Fig. 166*). All these examples are datable to the years just before or after 700 BC.

Stamps continued to be used for decorating clay plaques and pithoi into the sixth century, but more commonly cylinders are used. Cylinder seals were, of course, the standard seal type in Mesopotamia and it is a little odd that Greek artists were prepared to make cylinders, perhaps in wood, for the decoration of clay vases, but not in stone for ordinary use as seals. Some of the patterns on the cylinders used on pithoi are quite elaborate but I know only one Greek stone cylinder big enough (5 cm. high) to be used thus, and this is already sixth-century and not in a style met on the vases.

Another cognate use of objects with intaglio devices was for the production of matrices on to which

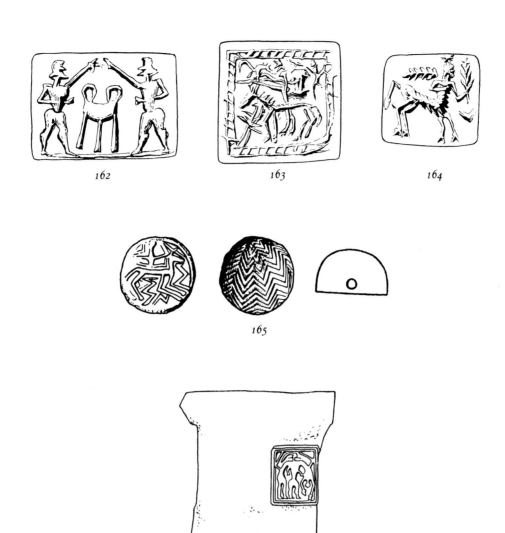

162 163 164

165

166

gold bands were beaten or impressed. The bands themselves are known already in Crete by 800 BC and best represented in eighth-century Attica. Later usage, in the islands and East Greece, included the production of minor jewellery, like earring pendants, impressed in similar matrices. We do not know what these were made of but soft stone moulds were used for casting gold ornaments. Some of the Geometric gold may have been made on fired clay matrices since the same device seems to have been impressed on to a single matrix: but the original might have been of stone or wood. A unique rectangular bronze bar in Oxford, said to be from Corfu, has shallow intaglio figures on it, mainly animals but also a scene of Ajax committing suicide. It may have served as a jeweller's matrix although no ornaments have so far been found in quite this style. It was perhaps also metal matrices that were used in making the beaten bronze reliefs which decorated the arm bands on the inside of hoplite shields. All these are examples of the use of objects with intaglio-cut patterns in early Archaic Greece which we might expect to have some bearing on the cutting of intaglios on seals.

The devices on the seals so far discussed have been generally dull or careless, but there are two other series of seals which belong mainly to the seventh century on which far more sophisticated patterns were admitted. The first are of ivory and were made principally in the Peloponnese. The second are of stone and are made on the Greek islands. Their origin and development are by now fairly clear, and they afford interesting studies in seal production with comparatively restricted types and restricted distribution. It will be noticed straightaway that they hail from exactly the areas in which the first new essays in seal cutting in Greece were identified.

The little sanctuary of Artemis Orthia in Sparta was probably not the most important in the city, but its deposits of Archaic votives were neatly covered by sand from a flooding river, they were not further seriously disturbed by temple building, and they have been fully excavated. This is the most prolific single source for Peloponnesian ivories and as a result there is a tendency to believe that Sparta was the main centre for their production. However, finds at the Argive Heraeum and Perachora, both important sources for the early stone seals, which Sparta is not, are on the whole of higher quality and better representative of the early phases. They may have been made in several places, possibly including Sparta, especially for the later types in which bone was sometimes employed instead of ivory. From the style of the figures on them and from what we know of Corinthian vase painting it may be that Corinth was the main and earliest source.

The earliest have their backs cut in the round with figures of recumbent animals, usually lions or rams (*Fig. 172*), sometimes bulls, dogs or sphinxes. The lions may attack another animal, or be attacked themselves by a man. The general type of the couchant animal resembles examples from the east, as at Nimrud, but there they are decorative attachments and not seals. The Greek animals lie on flat rectangular bases with intaglio devices beneath. The finds at Perachora and Sparta suggest that they were being made already at the end of the eighth century and continue to be made at least to the mid seventh century. A few have crude subgeometric devices, but most have better animal studies on them, in a style comparable with that on the commoner shapes of ivory seal. Of these the most popular are discs (*Fig. 167*)—some 200 were found at Sparta, 100 at Perachora. Many of the devices on the discs are cut with far greater finesse and detail than we have met hitherto. The material was more tractable than stone, and being handled by artists familiar with the meticulous engraving required for the best black figure painting on Protocorinthian vases. Some are quite deep cut—usually the more summary, but many have such a shallow intaglio that they make a very poor impression. Sometimes body masses seem barely more than impressed on the surface of the ivory, with the details picked out in lines or flicked with the tip of a knife. We may suspect that most were used for purely decorative purposes and this was certainly true of those with relief devices. Someone took a clay impression from an ivory disc, fired it and offered it at Perachora as a cheap dedication. But it might also be argued that this was the offering of a seal engraver, or even that the dedication of an impression from a personal seal might guarantee or ensure its effective use.

Single figures of animals or monsters are popular themes (*Pls. 213–217*), especially winged lions and panthers, which are not otherwise commonly seen in Greek art. It could be that the wing helped the artist fill the circle. Mythological scenes are rare since they generally require too many figures, but there is the occasional centaur, chimaera or Gorgon-like monster, a duel and what appears to be Ajax carrying Achilles, whom we have already seen in impressions on fired clay. In time too the idea that the circle

1

2

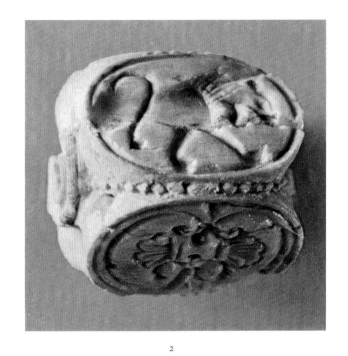

3

4

5

6

167 168 169 170 171

should conform more to the rectangular or frieze-like composition of painting is answered by the introduction of a ground line, decorated with hatching or a wavy line, on which the figure or figures may appear to stand instead of being set free in the field. The devices are often framed in borders of hatching or notches.

Many of the discs are engraved on both faces, some with only a simple rosette pattern for purely decorative effect on one side. They are usually pierced from side to side so that they could have been worn on a necklace or possibly a wristlet, but one from Sparta has links attached to its centre back, rather like a bath plug, and must have been a pendant (*Fig. 168*). Some discs have stepped edges, giving two unequal faces, like some of the stone disc seals.

There are not many other shapes for seals in ivory. Some small figures other than couchant animals are cut with devices on their backs or bases, like a seated woman or frontal heads of women or animals. These are known at Sparta and may be late variants. A few discs compromise with the eastern scarab form by having the beetle cut in shallow relief on their backs, but enlarged to fit the circle (*Fig. 169*), and the most elaborate have four faces, like four scarabs pushed together back to back (*colour, p. 115.2*). This has eastern counterparts too, but survived long in Greece, and in Sparta there are late examples in bone, the edges cut flat and the ends plugged (*Figs. 170, 171; Pl. 218*).

The Sparta deposits with ivories terminate with the flood which overwhelmed the sanctuary in about 580–570 BC, but it is likely that the ivory seals were no longer being made by then, that the Peloponnesian workshops were using bone rather than ivory, and kept up production only of some trivial ornaments like the so-called 'spectacle' fibulae. Al Mina seems to have been abandoned for the period of Babylonian domination, from the end of the seventh century, and its fortunes seem reflected in the ivory trade with Greece.

One last feature of the Peloponnesian ivory seals may be mentioned, since it serves to introduce the Island gems. It is possible that the Peloponnesian artists who cut the seals were aware of Greek Bronze Age seals and on occasion copied them. The Archaic deposits at the major sites include some Bronze Age gems, so they were being handled then. Some shapes and some patterns on the ivories strongly recall much earlier Cretan seals, but of types never seen in the Peloponnese. In Minoan glyptic, as we have seen, animal seals, discs, and three- or four-sided seals were known in ivory, and on stone prisms there appear ostrich-like birds and S-patterns very like those on the Archaic ivories. If there is any connection it should be through the handling of Cretan seals of the types mentioned, and these could not have been come by locally. But there are two ivory discs also, cut rather like lentoids, and with animal devices more Mycenaean than Archaic Greek. Indeed one has been republished recently as Mycenaean although I have no doubt about its seventh-century date. The other was from the Sparta deposit.

There seem to have been no important counterparts to these ivory seals in the Greek islands, although a few examples, probably from the Peloponnese, arrived there. In East Greece the deposits on Rhodes which have already been noted, and votive deposits at Ephesus and on Samos and Chios, have given evidence for local orientalising workshops for ivory. There are very few ivory seals, however, and these are mainly from East Greek sites and the islands, possibly all made in Rhodes since a strong sub-geometric style is evident, which is well in keeping with what we know otherwise of Rhodes' artistic record in the earlier seventh century. The most important group of these have rather poor figures of lions on their backs (*Fig. 173*), heads to the front and paws outstretched, unlike the Peloponnesian lion seals. There are also a few simple oval seals and a hemicylinder, with the device on the flat face.

ISLAND GEMS

The islands have a special role in the history of Archaic Greek gems. We have seen already how they played a part, perhaps a primary one, in the production of the earliest of the Geometric square seals. One or two of these are cut in the islands' white marble, a first use of this difficult material for works of art in the Iron Age; the first, in fact, since the time of the Cycladic idols. The other seals were cut in a softer stone, usually white or grey, which seems to be generally an altered rock or comparatively soft serpentine, generally called 'steatite'—a term better reserved for a different and softer material never used for seals. The white or grey stone was still used in the seventh century in the islands, but very much more popular was a pale green serpentine, often partly translucent, which must have been accessible locally (see *colour, p. 115.5, 6*). It was used in the Bronze Age for a few gems which were probably made in the islands (see p. 60).

After the square seals island engravers experimented with a number of different shapes, not all of which are commonly found among the Peloponnesian stone seals. We find pyramidal stamps, various discs (*Fig. 174*), oval and hemispherical forms. There is a copy of one of the ivory animal seals, with the back in the form of a dog curled up and the device a griffin-bird with snake (*Pl. 219*), as on many ivories; and one signet ring with its loop and rectangular bezel cut out of a single piece of stone (*Pl. 220*)—a show of virtuosity matched rarely in the Bronze Age and Classical period. Two seal shapes hint at an unexpected source of inspiration. One is a three-sided prism (*Pls. 221, 222*), exactly the form of the Minoan Archaic Prisms and the other a bell-shaped stamp with spiral markings, which resembles Minoan seals of the same period. Neither have close contemporary kin in Greece or the east, and the Cretan prisms are the very ones which have devices mysteriously recalled on some of the Peloponnesian ivories already discussed.

These assorted shapes are decorated with devices which range from the subgeometric to the fully Archaic of the sixth century BC, usually with animal and rarely with human subjects. They show that island artists were well aware of the varied seal forms current in the Peloponnese and in ivory, but the main contribution of the island studios was a series of gems which had quite a different origin and history. Against the twenty odd seals of shapes just mentioned there are nearly four hundred which are all either lentoids or amygdaloids—the old and very popular Bronze Age forms. These are the 'Island Gems', the *Inselsteine* collected assiduously in the last century, especially on Melos. Only after the major finds of gems of a similar shape in Greece and Crete did it become clear that they belonged to two very different periods. The Bronze Age seals can now be assigned to Crete or the mainland and broadly classified, as we have seen in the last chapter. The Archaic gems, for which the old title is retained, are the ones we have here to discuss.

118

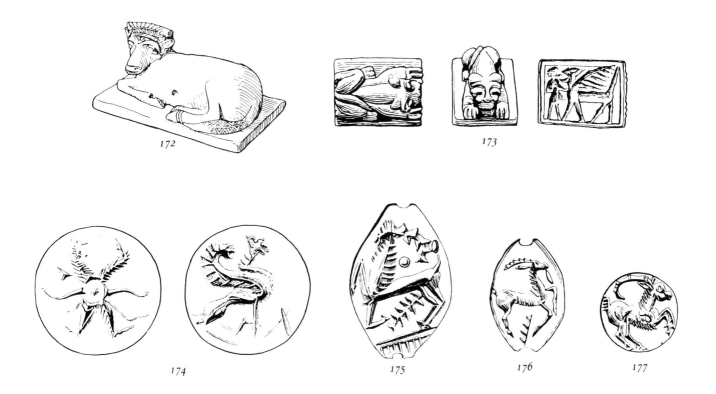

172

173

174 175 176 177

The use of the lentoid and amygdaloid shapes could only have been inspired by the casual discovery of Bronze Age seals, in the manner described at the start of this chapter. Melos had been an important Bronze Age centre and would have provided opportunity enough for such finds, and there had been flourishing Minoan and Mycenaean settlements on several other islands. Once these stones had attracted the attention of artists it is possible that they supplemented their collection of models with examples from elsewhere, perhaps from Crete. This seems a reasonable enough procedure and might explain the imitation of shapes and motifs in the islands and the Peloponnese from Cretan models such as never reached these areas in the Bronze Age. At first they did not attempt to work the harder materials of the early seals, nor did they command the techniques for doing so. Nor, at first, did they copy the motifs which were in a style even more foreign to them than the eastern and orientalising arts current in Greece. Instead they used the opaque serpentines already being cut for seals, adding to them the distinctive and most popular pale green translucent variety, which the translucent Bronze Age seals, of cornelian or agate, may have encouraged them to seek out. They used the simple cutting techniques already practised, and the devices were drawn from the current subgeometric or early orientalising repertory.

This first phase of the Island gems seems to belong mainly to the third quarter of the seventh century, having started earlier. In the last quarter they generally admitted more advanced technique and subjects. The development is a steady one with no startling changes. In an earlier study I distinguished three main phases by technique. In the first the cutting is angular and the bodies of the animals—which are the commonest devices—have no volume and little detail, cut in bold straight lines for ribs or manes (*Fig.* *175*). In the next phase, belonging to the later part of the seventh century and the years around 600, the bodies fill out and the linear detail is more carefully applied (*Fig. 176*). In the last phase, of the early sixth century, full mastery of the hand-cutting technique results in more ambitious and successful compositions and a more realistic, modelled style (*Fig. 177*) making full use of devices like hatching and stippling on

119

the stone for details of manes or bodies. The transition to this last phase was effected mainly by two artists, whose work can readily be distinguished. In the following account of the devices on the gems I take first what were made before these artists began their careers, and then the products of their studios and their contemporaries.

In the early phase (*Pls. 223–234*), wholly seventh-century, the range of subjects is limited, with rare introduction of the mythological or archaising devices—if we may so call the throw-backs to Bronze Age patterns—of later years. Goats, stags and horses are shown, generally with their forelegs splayed and bent in a skipping position which may resemble the act of kneeling but was probably intended to suggest motion. We have seen this position used commonly for animals on Bronze Age gems, but when it appears in the seventh century it is not necessarily a copy of the earlier motifs. Less common animals shown are hares, birds and dolphins—long a favourite island motif. Lions were always popular, and in the early phase they are shown standing. Feline monsters with wings are not always winged lions— which are uncommon in Greek art—rather than griffins, but there are one or two obvious chimaeras, sphinxes and a siren. Winged horses (*Pl. 231*) become more popular later, and we are not obliged to recognise them all as Pegasus since teams of them are often shown on island vases pulling divine chariots, and on several gems foreparts are combined to make a whirligig (*Pl. 233*). Centaurs had been popular on the Geometric stones and they continue on the Island gems, usually 'skipping' and shown in the developed form, with equine, not human forelegs (*Pl. 230*). There are rare representations of the human figure, including one winged man (*Pl. 226*). On these early stones the artist does not attempt to combine motifs. The device is set centrally on the stone, and already we can detect some skill in fitting limbs and bodies to the odd shapes of the gems. Where empty space is to be filled branches or 'saw patterns' are used, or gouged holes which produce blobs on the impression. The way the saw pattern is placed sometimes comes close to that use of a real ground line on which the figures stand which we observed on the later ivory seals.

By the end of the seventh century (for the dating of these gems we have to rely on stylistic comparisons with island vases) we reach the most productive period for Island gems, in which the work of two artists seems to dominate. To the first some thirty gems can be attributed, to the second, over forty. This is a remarkable number of attributions to individual gem cutters for any period, and it suggests that we have a higher proportion of the whole original output of Island gems surviving than we have of most other series. This may be due to various factors: the comparative ease of working the soft stone which could have led to rapid and mass production, and their restricted distribution on sites which have been well plundered.

The first artist (*Pls. 235–242; colour, p. 115.5, 6*) likes fine, feathery incision for his creatures' tails and manes, and close set stippling on parts of necks and bodies. Eyes are bold and rimmed, except on the dolphins which are often eyeless. He deserves a name—the Blind Dolphin Master. The second artist (*Pls. 243–252; colour, p. 115.4*) seems more aware of his Bronze Age models. His animals are particularly fine, with neat patterned stippling on their necks. He regularly shows the farther rear leg as a simple outline following the near leg, where his companion details both. This is a trick practised well by contemporary vase painters in the islands. It was never a feature of the Bronze Age seals. He cuts wings with thicker detail and with a separate line as a leading edge, and the tails of his sea creatures are notched. We may call him the Serpent Master for the monster which swims by a boat on a fine seal in New York (*Pl. 244*).

These two artists seem close contemporaries. There are other minor groups of gems which can be picked out and may represent the work of their fellows. They use the fuller modelling and more careful detailed incision for a wider range of subjects than have been met hitherto on gems, and these may be

considered all together. It is noticeable that it is only with this new confidence in technique that the island artists felt able to imitate some of the devices on their Bronze Age models and not simply the shape of the stones; and among the amygdaloids we even find for the first time stray examples imitating the refined Minoan form with a grooved back. Rather more stones are now engraved on both faces, but this was still a rare practice and was only slightly more common on Island gems than it had been in the Bronze Age.

The animals chosen for most of the devices are as before. It is in the treatment of the same creatures in different periods that the artists' growing control of technique and developing style can best be judged. There are some new subjects, though. Bulls only become popular now. They were common on Bronze Age seals and the beast was often shown struck in the back with a spear and with its head thrown back in agony. The pose is not seen in the ordinary Archaic Greek repertory for vase painting or bronzes, but it was copied on an Island gem (*Pl. 245*), without the spear. A new lion type shows the creature in a crouching position, often with head turned back (*Pl. 256; colour, p.115.3*). The two popular types for birds show them standing or flying with a snake in their mouths (*Pl. 237; colour, p.115. 6*). There are some studies of octopuses now, and more of dolphins, with decoratively antithetic compositions (*Pls. 239, 240, 258, 262*). They are joined by tunny fish and the severed heads and tails of fish appear beside the whole creatures in many devices (*Pl. 261*). This apparent interest in butchery applies to quadrupeds also. There is a study of limbs alone, and a cylinder by the Serpent Master shows a severed bull's head and limbs beside a carcase. This jointing of fish and flesh, and the dolphin and octopus motifs, were to be found on Minoan seals, but the whole creatures are seen on other works in the Archaic period, and the island vase painters, for example, seemed fond of truncated or grotesque figures. The sliced fish at least recall the subjects if not the style of Minoan 'talismanic' gems, several of which have been found on Melos.

There is a better display of monsters now. The winged horses are combined in whirligigs but they are joined by winged goats (*Pl. 251*). These are odd beasts for Greece although there are examples on two Attic Geometric vases. Odder still is the way both the winged horses and winged goats are grafted on to fish bodies (*Pls. 235, 250; colour, p. 115. 4*). With the horses we have the appearance of the favourite Archaic and Classical hippocamps, which are usually wingless and may owe something to real 'sea-horses'. Foreparts of the monsters are shown and there are some strange combinations of heads, necks and wings (*Pl. 248*). The Greek sea serpent (*ketos*) is a dragon-like monster with pointed muzzle and sometimes lion legs. Island gems offer a forepart with the lion leg (*Pl. 259*) and, on the Serpent Master's name piece (*Pl. 244*), the whole creature swims by the prow of a ship. Other monsters are more canonical—centaurs, chimaeras, sphinxes (*Pls. 241, 257*). Only the griffin seems odd for it lacks the long ears and forehead knob of the Archaic Greek variety and with its bird-like head is closer to the Minoan form.

A number of new compositions involving the animals seem also to derive from study of Bronze Age models. Fish and parts of fish are used as space fillers with other animals, or sometimes as a major part of the composition, as in the studies of a lion over a dolphin (*Pl. 256*). There are examples too of both types of torsion which appear for creatures on Minoan seals—both the curled-up top view of a beast, and the abrupt twist of the body at the shoulders (*Pls. 247; 225, 235, 242*). Neither were otherwise admitted in Archaic Greek art. With devices like these the Island gems approach the freely composed patterns of Bronze Age gems, but in general Archaic Greek artists, including the engravers of Island gems, preferred to make a more explicit statement of each subject, and to keep their creatures' feet firmly planted on the ground.

There are a few more mythological figures and scenes on the later gems, but they were clearly never a major interest and they reflect merely the growing Greek competence in narrative art. Ajax falling on

his sword was a common seventh-century theme. On an Island gem the manner of the suicide is the usual one in Greek art (*Pl. 264*). The artist shows the outline of the human body well enough but attempts no subtlety of modelling. The way the farther leg is shown by outline recalls the Serpent Master, and this could be his work. This piece is said to have been found at Perachora, the important sanctuary site near Corinth. It is the only Island gem to be inscribed, but the form of the inscription and its letters show that it was cut by or for an Etruscan, giving what seems an Etruscan form of Ajax's name, *Hahivas*. If so, this might be a dedication bought and inscribed locally by a visitor from the west. The same site has yielded a little Etruscan pottery of this period, but whether brought by Etruscans or Greeks we cannot say.

In the same style and possibly by the same artist is a study of Prometheus being attacked by Zeus' eagle (*Pl. 267*). Rather later a Herakles wrestles with a merman (*Pl. 266*), Nereus or Triton. Other mermen on Island gems are given wings. There are some strange Gorgons (*Pl. 265*), and part-human monsters, of which the oddest has two serpents instead of a human torso above the waist (*Pl. 269*). This too recalls Minoan monsters (*Pls. 128, 132*). One of the largest gems has a canonical chimaera on one side, and on the other, which is markedly more convex, a scene of love-making (*Pl. 270*). The posture is the usual one for such representations in this period, from behind, but the figures are unusually upright, and with his arm round her shoulder and her head turned back, the scene has a touch of life. The engraving on this side has been doubted, unreasonably. The filling swastika is as on Island vases.

The main series of the Island lentoids and amygdaloids probably does not survive the first quarter of the sixth century, but there are a few examples of these shapes and others with devices in an appreciably later style (*Pls. 263, 271–3*), and it is clear that the studios were not closed. Their survival is shown in various ways, the most important of which will be studied in the next chapter. A new series of Greek gems was beginning, in which Island artists were to play an important part. It involved the use of harder materials and an early intimation of the new fashion is seen in a few Island stones of the old shapes, or approximations to them, but in the new materials (*Pls. 274–276*). Rock crystal and chalcedony were used for seals with devices of animals and monsters in the old manner, but soon the Island artists either adopted wholeheartedly the new techniques, materials and shapes, or practised the new styles in scarab carving in their old softer material with the old technique of hand-cutting which suited it.

The Island gems were probably made on Melos. Some reached the other islands and mainland Greece, and several Crete. We have no reason to suppose that only islanders wished to use seals in this period, so this comparatively local phenomenon is probably best explained in terms of the production of objects to be admired as jewellery rather than to be used.

THE SUNIUM GROUP AND CRETE

There are a few other stone seals in Greece which are roughly contemporary with the Island gems and in various ways related to them. The Sunium Group is the closest we come to evidence for the use or production of seals in Attica. It is best represented in finds from the sanctuaries of Athena and Poseidon at Sunium, and of Artemis at Brauron. The common shape is a disc with lightly convex back and low straight sides (*Fig. 178*). Motifs are very simply cut and resemble the island repertory, with centaurs, winged horse foreparts and a hybrid human monster, but the execution is far less accomplished (*Figs. 179–182*). The earliest, in a dark serpentine, are cut like the earlier island lentoids; on other coloured stones the devices are more like the main run of Island gems; and finally, two in rock crystal show experiments with harder material, like those in the islands. Other examples of the shape from other

178 179 180 181 182

183

184

sites may be related and there are several in rock crystal—one from distant Dodona, another with only an inscription, in Euboean letters, set in separate lines as on many a Near Eastern seal. On the rock crystals we see the use of both hatching and a cable border to the device, both commonly to be used on later gems. These gems cannot compare with the Island gems in numbers or quality, but they had a long life and an island or Attic home for them is possible. The Acropolis at Athens has yielded only a tiny cube, with scenes related to the Sunium Group and the islands, and the shape is matched at Sunium, so these are possibly another Attic speciality (*Figs. 183, 184, Pl. 277*).

The other gems which show a similar range in date and style are discs (*Pls. 278–280*), often engraved on both faces and mainly from Crete. No clear series can be established here. The earliest might as easily have been included with the subgeometric groups earlier in this chapter, but there are several in a more advanced style, like the islanders, and it is very probable that Crete, as a flourishing centre for Archaic Greek art and with its Bronze Age record in gem engraving ready at hand in casual finds, should also have been a centre for making seals. None, however, ape Minoan patterns as the Island gems do, with the possible exception of a puzzling disc from Central Crete, now in New York, which Evans at first took for prehistoric (*Pl. 279*). One side shows goats mating. Subjects like this with animals are virtually unknown in Archaic Greek art. Any sort of erotic subject was, of course, anathema in Bronze Age Greece with the solitary and significant exception of goats' mating, which appears on a fine gold ring in London and on a much later vase from Lefkandi. The other side of the gem shows a seated man and a standing woman. Their excited gestures and the positions of their hands on each other's bodies suggests an activity related to that of the goats. But while human love-making is not an uncommon subject in early Archaic art, its significance was probably serious and religious, nothing like the playful assault which seems depicted here. Finally, behind the woman is a beaked jug like many on Minoan seals, and the big-headed figures look as much Middle Minoan as Archaic. There is no reason to doubt the authenticity of the gem, and no good reason for believing it Bronze Age work. In common with much else in seventh-century Cretan art, it must be taken as a local product, inspired by varied, but none too easily specified sources.

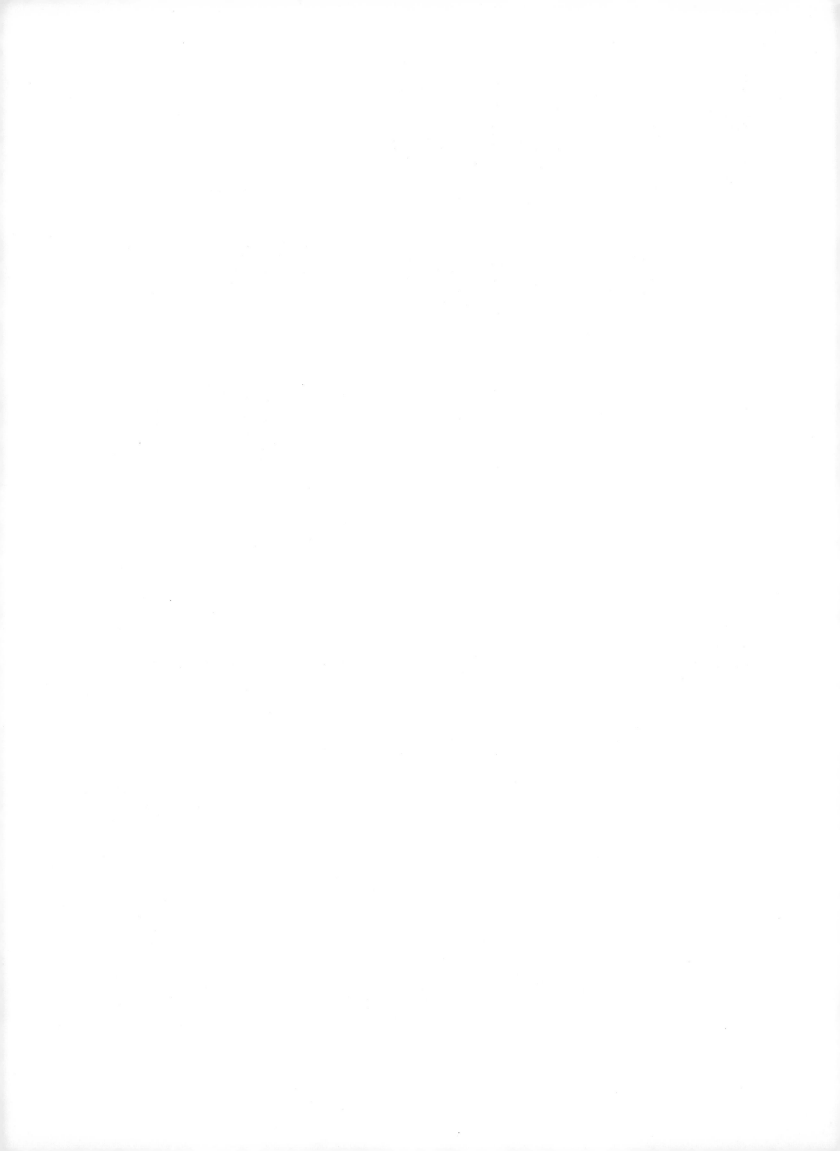

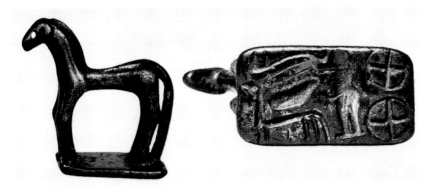

207

2:3 | 1:1

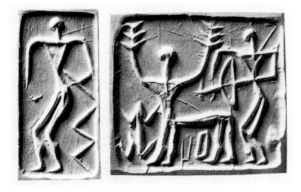

208

2:1

209

3:2

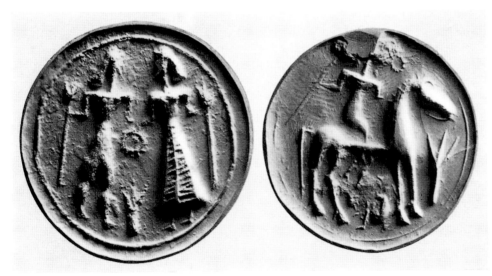

210

3:2

211

3:2

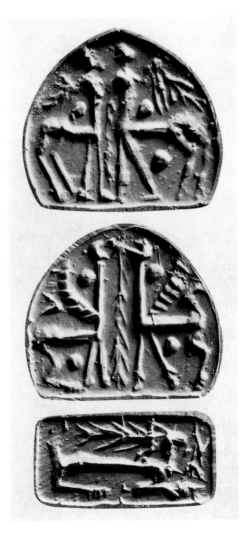

212

3:1

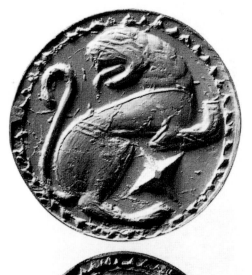

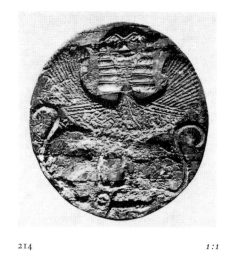

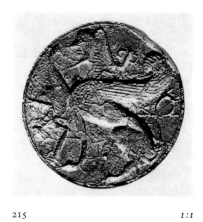

214 *1:1* 215 *1:1*

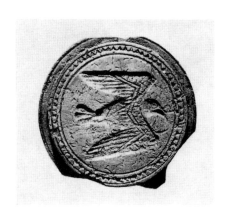

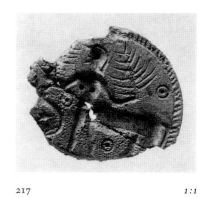

213 *2:1* 216 *1:1* 217 *1:1*

218 *1:1*

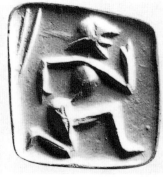

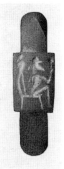

221 *1:1*

220

3:2

219 *2:1*

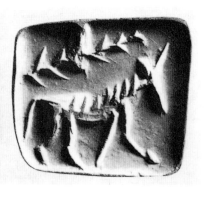

222 *3:1* 223 *2:1*

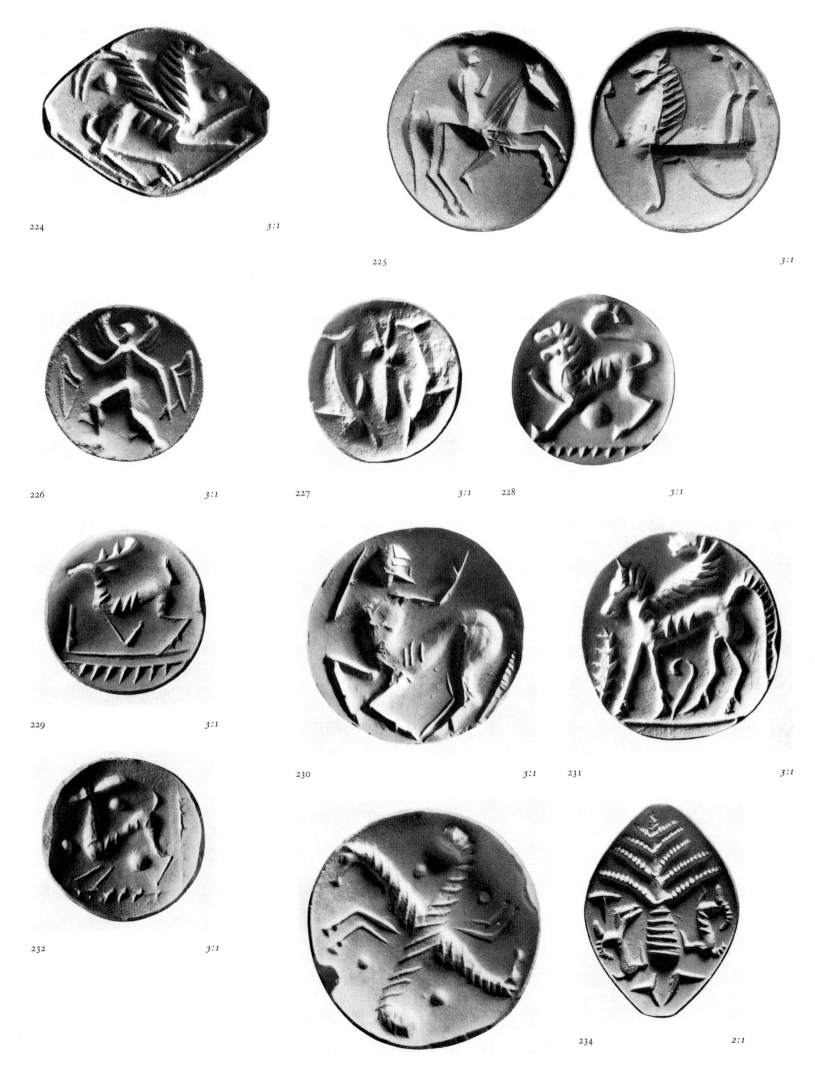

224 3:1

225 3:1

226 3:1 227 3:1 228 3:1

229 3:1

230 3:1 231 3:1

232 3:1

233 3:1 234 2:1

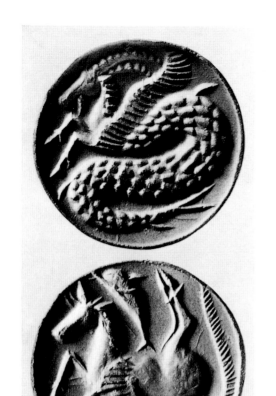

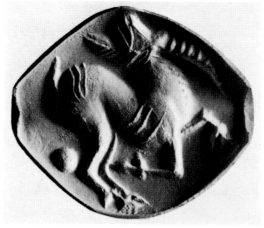

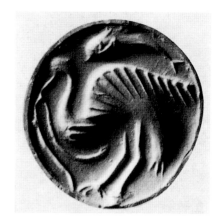

236 3:1 237 3:1

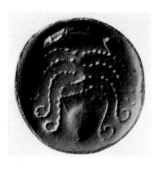

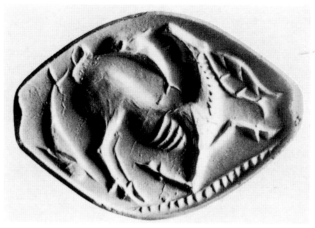

235 3:1

238 3:1 239 3:1

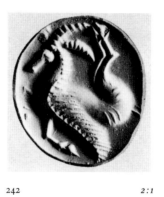

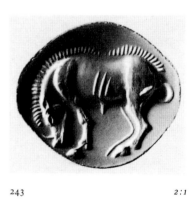

240 2:1 241 2:1 242 2:1 243 2:1

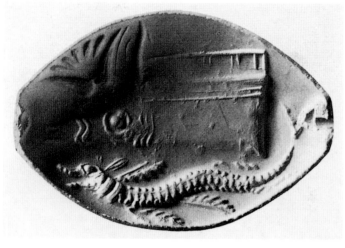

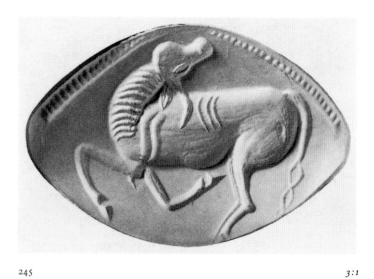

244 3:1 245 3:1

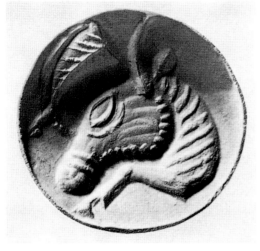

246 *3:1* 247

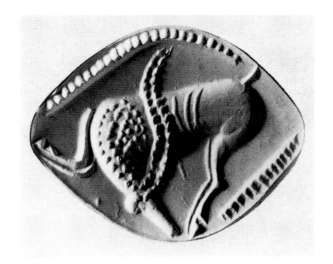

 3:1

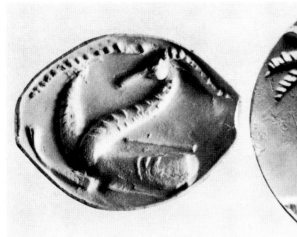

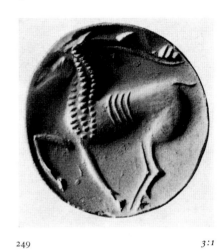

249 *3:1*

248 *3:1*

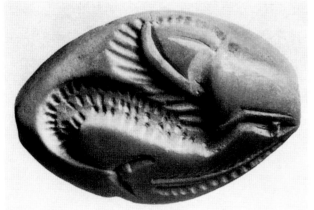

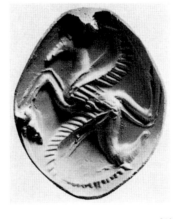

 251 *2:1*

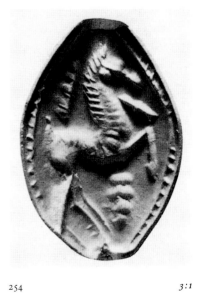

250 *3:1*

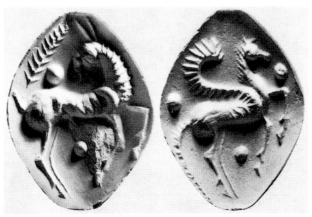

252 *2:1* 254 *3:1*

253 *2:1*

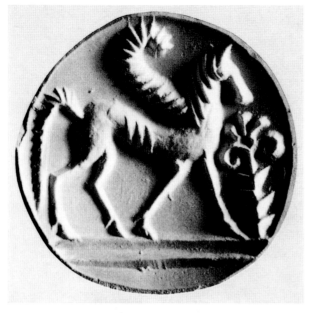

255 3:1

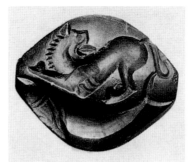

256 2:1

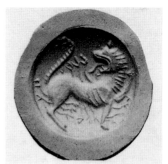

257 3:2

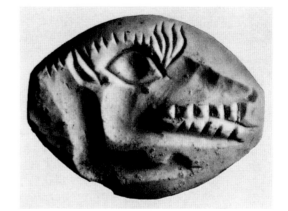

259 3:1

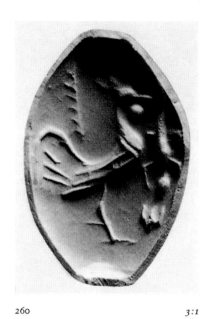

260 3:1

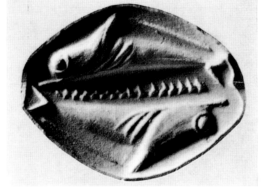

258 3:1

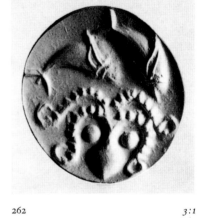

262 3:1

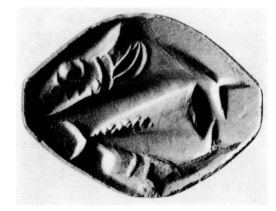

261 3:1

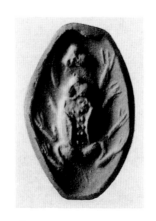

263 3:1

264 3:1

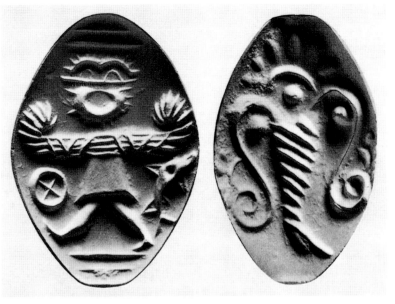

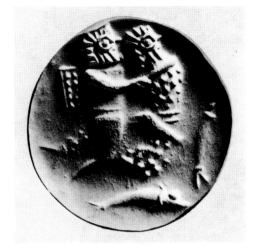

265 A *3:1* 265 B *3:1* 266 *3:1*

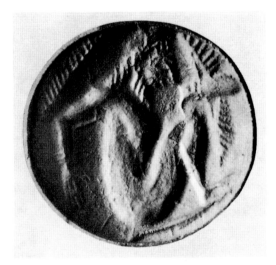

267 *3:1* 268 *3:1* 269 *3:1*

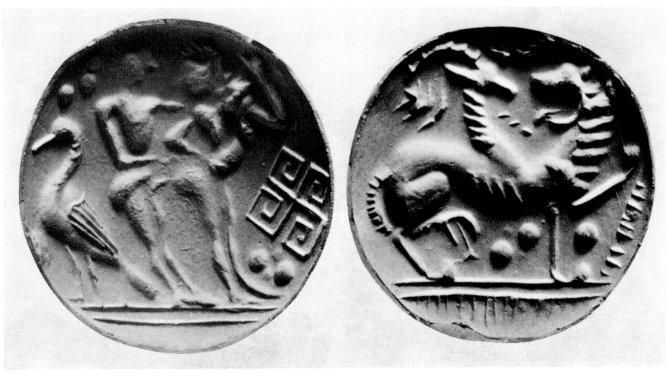

270 *2:1*

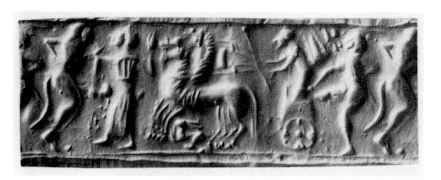

271

272 3:1

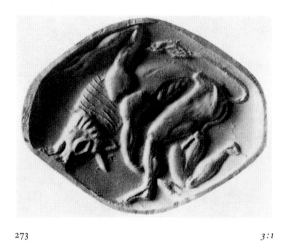

273 3:1

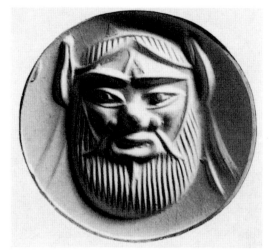

274 3:1

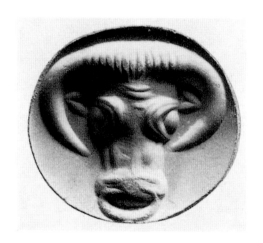

275 3:1

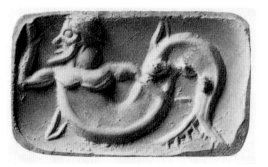

276 3:1

277 4:1

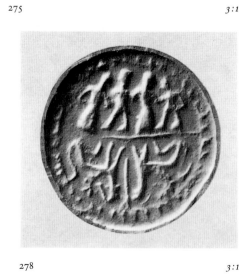

278 3:1

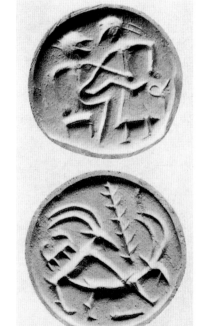

279
2:1

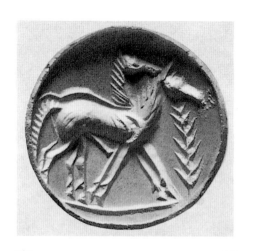

280 3:1

LIST OF ILLUSTRATIONS TO CHAPTER III

Measurements are given of the maximum dimension of the intaglio face, in millimetres

COLOUR PLATES

TEXT FIGURES

Fig. 167 Profile shapes of Peloponnesian ivory disc seals. *IGems* 146, fig. 15.

Fig. 168 Ivory disc seal from Sparta, with an iron loop and ring. *Artemis Orthia* pl. 141.1; *IGems* 146, fig. 15.

Fig. 169 Once Dawkins, probably from Sparta. Ivory round scarab.

Fig. 170 Oxford 1957. 49. Shape of the ivory four-sided seal shown in *colour, p. 115.2.*

Fig. 171 Shape of a typical four-sided bone seal from Sparta.

Fig. 172 Back of an ivory seal from Sparta in the shape of a reclining ram. *Artemis Orthia* pl. 153.3.

Fig. 173 Chios, from Phanai. Ivory lion seal. L.22. A man and a sphinx. *BSA* xxxv, pl. 33.1–4; *IGems* 154; *JHS* lxxxviii, 11.

Fig. 174 London 1934. 1–19.4. Green steatite disc with ribbed edge. W.19. 1. From a centre disc spring the fore parts of two horses, two snakes and two lions. 2. A sphinx. *IGems* no. 331, pl. 11, fig. 6.

Fig. 175 Once Dawkins. Green steatite amygdaloid. L.30. A goat (the other side shows four dolphins). *IGems* no. 19, pl. 1, fig. 1.

Fig. 176 Once Dawkins. Green steatite amygdaloid. L.21.5. A goat. *IGems* no. 22, pl. 2, fig. 1.

Fig. 177 Leningrad 519, from Melos. Black steatite lentoid. W.16. A goat. *IGems* no. 37, pl. 2, fig. 1.

Fig. 178 The shape of a typical Sunium Group disc.

Fig. 179 Athens, from Sunium. Grey steatite disc. W.10. A seated figure. *IGems* F3, pl. 14.

Fig. 180 Athens, from Sunium. Grey steatite disc. W.14. Foreparts of winged horses joined. *IGems* F5, pl. 15.

Fig. 181 Athens, from Sunium. White steatite disc. W.15. A tripod with zigzags at either side. *IGems* F10, pl. 15.

Fig. 182 Athens, from Sunium. White steatite disc. W.12. A monstrous figure including a human leg. *IGems* F11, pl. 15; compare our *Pl. 269.*

Fig. 183 Athens, from Sunium. Blue stone tabloid. 9 × 8 × 5. 1. A crouching human figure. 2. A hare. 3. A winged man. 4. A sphinx. *IGems* F28, pl. 15.

Fig. 184 Athens, Acropolis 7237. Green steatite tabloid. See *Pl. 277.*

BLACK AND WHITE PLATES

**Asterisked numbers indicate that the piece is illustrated in original. All other photographs show impressions.*

GEOMETRIC SEALS

Pl. 207* New York, Baker Coll. Bronze horse on a stand. H.65. Intaglio device beneath, with a chariot, the horse, charioteer and wheels being detached and shown separately. Von Bothmer, *Ancient Art in American Private Collections* (New York, 1961) pl. 43.124; *IGems* 114.

Pl. 208 Paris, BN M5837, from Crete (?). Black serpentine tabloid. 22 × 20 × 10. 1. A man with a stick. 2. A bowman, centaur and lizard. (3, 4. Geometric patterns.) *IGems* C13, pl. 14. The scene on 2 could be Herakles and Nessos. Cf. *Munich* i, 101, pl. 12 (*IGems* C14), which may show Nessos and Deianira, in a slightly later and looser style. For these two seals see Zazoff in *Opus Nobile* (Wiesbaden, 1969) 181ff., who takes the latter for Attic, but the only distinctive feature seems to be Deianira's girdle ends, shown as on Argive vases. See the next.

Pl. 209 Athens, *Argive Heraeum* ii, pl. 138.22. Grey-red serpentine disc. W.35. 1. Two women with branches, a bird, a snake and a notched border pattern. 2. Geometric pattern resembling a quadruped. *IGems* G12, pl. 15. The women have long girdle ends, as on Argive vases.

Pl. 210 Athens 11750, from Megara. Disc. W.40. 1. A man and a woman holding a wreath between them and a branch in the free hand. A shrub below. 2. A horseman. A rosette above, shrub before, and a squatting figure below. *IGems* G14, pl. 16.

Pl. 211* London, Mrs Russell's Collection. Blue-grey serpentine disc. W.21. 1. A winged horse and reins (?). 2. A centaur with a branch, and a small animal. *IGems* G33, pl. 16 (impressions).

Pl. 212 Oxford 1894. 5A (xxvii), from Melos. Shell ogival seal, pierced laterally. 19.5 × 17 × 9. 1. Two centaurs with branches. 2. Two sphinxes face over a branch. Pellets in the field. On the base a stag and small animal. *IGems* L1, pl. 17.

IVORIES

Pl. 213 *New York* 5, pl. 2, 'from Mykonos'. Ivory disc. W.33. 1. A lion and star. 2. A flying bird.

Pl. 214* Athens, from the Argive Heraeum. Ivory disc. W.49. A facing bicorporate sphinx. Impression shown in *IGems* pl. 18a. Possibly the earliest representation of this monster in Archaic Greek art. Closest in date is the one painted on the Chigi Vase, Payne, *Protokor. Vasemalerei* (Berlin, 1933) pl. 27.

Pl. 215* Athens, from the Argive Heraeum. Ivory disc. W.44. A seated male sphinx with a bird in front. Impression shown in *IGems* pl. 18c.

Pl. 216* Athens, from the Argive Heraeum. Ivory disc (back). W.44. A flying bird. Impression shown in *JHS* lxviii, pl. 7.

Pl. 217* From Siphnos. Ivory disc. W.43. A centaur, apparently helmeted, holding branches. Before him a bird. Impression shown in *IGems* pl. 17b.

Pl. 218 Athens, from Sparta. Bone four-sided seal. 19 × 17. 1. A siren. 2. A floral pattern. 3. A flying bird. 4. A double crest or wing. D.Inst. NM 3640.

ISLAND GEMS

Pl. 219 *Berlin* F 132, pl. 3, D 106. Green steatite animal seal, the back in the form of a dog curled up. W.16. A crested bird (? a griffin bird) with a snake. *IGems* no. 352, pl. 13.

Pl. 220* Athens 1095, from Siphnos. Green steatite finger ring with a rectangular bezel. 11 × 8. A seated man holding a staff. *BSA* xliv, pl. 9.1; *IGems* no. 351, pl. 13.

Pl. 221* Athens, from Siphnos (a Roman grave). Green steatite prism with a loop handle. L.27. (1. A centaur with branch.) 2. A ship. (3. A horse.) *BSA* xliv, pl. 9.3; *IGems* no. 316, pl. 11.

Pl. 222 Oxford 1873. 136, bought in Smyrna. Green steatite prism. 14.5 × 15.4, 14, 17. 1. A human bust holding a branch. 2. A running figure. 3. A horse and branch. *IGems* no. 315, pl. 10. Evans (at first), and Matz have taken this for prehistoric but the style is decisively Archaic, and busts and head like that on side 1 are easily matched on island vases of the seventh century.

Pl. 223 Basel, Erlenmeyr Coll. Green steatite disc. W.18. 1. A man with two branches. 2. Two naked human figures, one apparently carrying the other.

Pl. 224 Athens, British School, probably from Melos. Green steatite amygdaloid. L.21. A chimaera. *IGems* no. 201, pl. 8.

Pl. 225 Solothurn, Schmidt. Lentoid. W.17. 1. A horseman. 2. A contorted lion. *IGems* no. 64, pl. 3.

Pl. 226 Bowdoin Coll. 64. Grey steatite lentoid. W.14.5. A winged man with winged boots. *IGems* no. 188, pl. 7. Possibly a wind.

Pl. 227 Athens, British School, probably from Melos. Green steatite lentoid. W.14. A cuttlefish between two dolphins. *IGems* no. 134, pl. 5.

Pl. 228 London, Bard Coll. Green steatite lentoid. W.15. A lion. *IGems* no. 68, pl. 3.

Pl. 229 London 1934. 1–20.8. Green steatite lentoid. W.14. A stag. *IGems* no. 103, pl. 4.

Pl. 230 Paris, BN M6252, from Melos. Green steatite lentoid. W.20. A centaur. *IGems* no. 194, pl. 7.

Pl. 231 Athens, British School, probably from Melos. Green steatite lentoid. W.18. A winged horse. *IGems* no. 267, pl. 9. This need not be Pegasus since winged horses are commonly shown in island art, drawing chariots for deities, and pairs may be combined in whirls, as on *Pl. 233*.

Pl. 232 Once Dawkins Coll. Green steatite lentoid. W.14. A hare. *IGems* no. 55, pl. 3.

Pl. 233 Once Dawkins Coll. White steatite lentoid. W.19.5. The foreparts of winged horses joined in a whirl. *IGems* no. 281, pl. 10.

Pl. 234 London 1934. 1–20.7. Green steatite amygdaloid. L.29. A palm tree with goats at either side. *IGems* no. 296, pl. 10. The motif is an oriental one occasionally copied in Greek art (*IGems* 26).

Pls. 235–242 are by the Blind Dolphin Master.

Pl. 235 *New York* 10, pl. 3. Green steatite lentoid. W.18. 1. A winged goat fish. 2. A contorted winged horse and dolphin. *IGems* no. 253, pl. 9.

Pl. 236 *London* 161, pl. 4. Grey steatite amygdaloid. L.22. A goat. *IGems* no. 44, pl. 2.

Pl. 237 *London* 178, pl. 4, from Galaxidi. Green steatite lentoid. W.16. A water bird with a snake, and a dolphin above. *IGems* no. 126, pl. 5.

Pl. 238 Oxford 1921. 1225. White steatite amygdaloid. L.26. A stag with two dolphins. *IGems* no. 108, pl. 4.

Pl. 239 Manchester University. Green steatite lentoid. W.13. Three dolphins and three small fish. *IGems* no. 136, pl. 5.

Pl. 240 *London* 177, pl. 4. Green steatite lentoid. W.19. An octopus and dolphin. The two blobs suggest the eyes. *IGems* no. 162, pl. 6; *BSA* lxiii, 43, fig. 4b.

Pl. 241 *Berlin* F 93, pl. 3, D 111, from Melos. Green steatite amygdaloid. L.24. A centaur holding a branch and a stone. *IGems* no. 198, pl. 7.

Pl. 242 *London* 203, pl. 4. Grey stone lentoid. W.15. A contorted winged goat. *IGems* no. 237, pl. 9. The winged goats, like the winged goat fish, are suggested by the divine winged horses and the sea horses on the gems. Goats are twice shown winged on Late Geometric Athenian vases and occasionally in Achaemenid art (compare our *Pl. 923*).

Pls. 243–252 are by the Serpent Master.

Pl. 243 *Berlin* F 92, pl. 3, D 115. Green steatite amygdaloid. L.22. A boar. *IGems* no. 2, pl. 1.

Pl. 244 *New York* 14, pl. 3, from Epidaurus Limera. Green steatite amygdaloid. L.27. The forepart of a ship with animal head prow. Above is a floral and below, a sea serpent. *IGems* no. 293, pl. 10. For the type of serpent see *AFRings* 21 and cf. our *Pl. 259*.

Pl. 245 Unknown. Amygdaloid. L.30. A bull with its head thrown back. *IGems* no. 13, pl. 1.

Pl. 246 London 1930. 4–16.4. Pale green steatite lentoid. W.20.5. The forepart of a bull and tail of a fish. *IGems* no. 15, pl. 1.

Pl. 247 *London* 162, pl. 4. Grey steatite amygdaloid. L.25. A contorted goat. *IGems* no. 45, pl. 2. This is the more natural 'contortion' of a reclining animal, such as appears on many Bronze Age gems (as our *Pl. 138*) and not the more brutal twist, as *Pl. 242*.

Pl. 248 Athens, British School, probably from Melos. Green steatite amygdaloid. L.20. 1. The forepart of an animal with two necks and one goat head. Possibly a winged goat was intended and the head misplaced. 2. A palm tree. *IGems* no. 242, pl. 9.

Pl. 249 Unknown, from Melos. White steatite lentoid. W.16. A stag. *IGems* no. 109, pl. 4.

Pl. 250* *London* 171, pl. 4, from Melos. White steatite amygdaloid. L.25. A winged goat fish. *IGems* no. 250. See *colour, p. 115.4*.

Pl. 251 *London* 167, pl. 4, from Melos. Green steatite amygdaloid. L.24. The foreparts of two winged goats joined in a whirl. *IGems* no. 244, pl. 9.

Pl. 252 London, Mrs Russell Coll. Green steatite lentoid. W.16. The forepart of a winged horse. *IGems* no. 275, pl. 10.

Pl. 253 Leningrad 517. Amygdaloid. L.26. 1. A goat without horns. 2. A winged horse. *IGems* no. 33, pl. 2.

Pl. 254 Once Dawkins Coll. Green steatite amygdaloid. L.20. A rearing horse. *IGems* no. 60, pl. 3.

Pl. 255 Dresden 1614. White steatite lentoid. W.25. A winged horse and palmette flower. *AG* pl. 61.5; *IGems* no. 268.

Pl. 256* Paris, BN N6. Amygdaloid. L.22. A lion over a dolphin. *IGems* no. 84, pl. 3. The anticipation of the device on the later ring, our *Pl. 693*, is without significance.

Pl. 257 Athens, *Perachora* ii, B20, pl. 191. Green steatite lentoid. W.19. A chimaera lacking the goat's head but with sixteen small snake heads springing from the body. *IGems* no. 207, pl. 8. The small snakes are sometimes attached to the monster Kerberos in Greek art.

Pl. 258 Once Dawkins Coll. Green steatite amygdaloid. L.21. Two dolphins. *IGems* no. 139, pl. 5.

Pl. 259* *London* 164, pl. 4, from Melos. White steatite amygdaloid. L.22. The forepart of a monster with a leonine foreleg. *IGems* no. 101, pl. 4. Possibly this is meant for the forepart of a sea serpent, since the pointed muzzle is an admissible variety, and the lion leg is to be found (as on our *Pl. 433*), but this is not the type on other Island gems (our *Pl. 244* and *JHS* lxxxviii, pl. 2.222).

Pl. 260 *Munich* i, 113, pl. 13, from Melos. Green steatite amygdaloid. L.20. A cock with a lizard. *IGems* no. 131. Cf. *Ann. Rept. Friends Fitzwilliam Museum* 1934, fig. 3 (black-figure vase).

Pl. 261 *Munich* i, 130, pl. 15, bought in Athens. Grey steatite amygdaloid. L.21. A tunny fish, a tunny tail and a dolphin. *IGems* no. 155, pl. 6.

Pl. 262 *London* 176, pl. 4, Green steatite lentoid. W.16. A four-armed octopus and two dolphins. *IGems* no. 167, pl. 6.

Pl. 263 Bonn, Müller Coll. Green steatite amygdaloid with grooved back. L.14. Toads coupling, seen from above. *JHS* lxxxviii, pl. 2. 160 *bis*.

Pl. 264 *New York* 13, pl. 3, from Perachora. Green steatite lentoid. W.19. Ajax committing suicide by falling on his sword which is fixed into a mound of earth. Inscribed *Hahiwas*, probably Etruscan. *IGems* 178, pl. 7.

Pl. 265A Athens, British School, probably from Melos. Green steatite amygdaloid. L.24. An armless Gorgon with a dolphin and a wheel. *IGems* no. 180A, pl. 7. Gorgons are sometimes shown with dolphins (with a Gorgoneion on the ring, our *Pl. 731*) to suggest their pursuit of Perseus over sea; perhaps the wheel indicated overland pursuit.

Pl. 265B Athens, British School, probably from Melos. Green steatite amygdaloid. L.24. A palmette scroll and horn. *IGems* no. 180B, pl. 7.

Pl. 266 *London* 212, pl. 5. Yellow mottled steatite lentoid. W.19. Herakles wrestles with a merman. Two dolphins in the field. *IGems* no. 181, pl. 7. On the iconography of these scenes see *BICS* v, 7–9.

Pl. 267 Unknown, from Crete. Lentoid. W.21. Prometheus bound and the eagle of Zeus. *IGems* no. 186, pl. 7.

Pl. 268 Bonn, Müller Coll. Green steatite lentoid. W.13. A satyr. The only other certain satyr on an Island gem is seen on the later cylinder and scarab, our *Pls. 271, 351*. It is surprising to find a satyr at all on an Island gem and this can be hardly earlier than the second quarter of the sixth century, and so one of the latest of the steatite lentoids.

Pl. 269 Dresden 1616, from Melos. Brown steatite lentoid. W.19. A monster with human legs, the upper part formed by two serpents. *IGems* no. 191. The composition recalls that of some monsters on Minoan seals (as our *Pls. 128, 132*) and this should perhaps be taken for another example of the imitation of a Bronze Age motif.

Pl. 270 *Berlin* 96, pl. 3, D 110, from Melos. White steatite lentoid. W.37. 1. Love making, with a swan in attendance and a swastika. This side is heavily convex. 2. A chimaera. *IGems* no. 177, pl. 6. The swan can hardly be a reference to Leda, as suggested by Koch (*Gnomon* xxxvi, 814). The swastika appears only here on Island gems but is a common device on island vases. The woman's interested backward glance is unexpected but is seen on black figure vases and compare our *Pl. 906* and *Fig. 298*.

Pl. 271 *Berlin* F 131, pl. 3, D 118, from Aegina. Green steatite cylinder. H.12. A nymph assaults a satyr who ejaculates. A warrior mounts a four-horse chariot, which is already occupied by its charioteer. A hare runs below. *IGems* no. 334, pl. 11; *AGGems* no. 360 and p. 118. The style is close to that of the Island Scarabs (see *Pls. 350–354*).

Pl. 272 Unknown, from the Peloponnese. Yellowish

steatite lentoid. W.16. A lotus with palmette and scrolls. *IGems* no. 304, pl. 10.

Pl. 273 Athens, from Sunium. Green steatite amygdaloid-scaraboid. L.20. A contorted bull-headed man, like the Minotaur. *IGems* no. 350, pl. 13; *JHS* lxxxviii, pl. 1.ii.

Pl. 274 Boston 27.678. Chalcedony lentoid with very convex back and shallow face (compare the shape of our *Pl. 273*). W.21. The facing head of a satyr. *JHS* lxxxviii, pl. 1.iv.

Pl. 275 New York 22.139.40. Chalcedony lentoid with flat sides, rather oval in outline. W.19.5. Frontal bull's head. *IGems* no. 17, pl. 1; *JHS* lxxxviii, pl. 1.vii.

Pl. 276 Boston 01.7594. Rock crystal prism, a piece of natural crystal with one face roughly cut back to provide the surface for the device. L.21. Triton. Lippold, pl. 6.1; *JHS* lxxxviii, pl. 2.xiii.

THE SUNIUM GROUP AND CRETE

Pl 277* Athens, Acropolis 7237. Green steatite tabloid. 10×8×9. (1. Love making.) 2. Joined foreparts of goats with a lizard and bird in the field. (3. A woman playing pipes and another with a jar. 4. Two goats at a tree.) *IGems* F29, pl. 15. See *Fig. 184* for sides 1, 3, 4. There is a similar tiny cuboid seal from Sunium, our *Fig. 183*. For the goats compare our *Pl. 234*.

Pl. 278 Basel, Erlenmeyr Coll. White stone disc. W.14. In one half, sphinxes; in the other, two couples. In a hatched border.

Pl 279 *New York* 3, pl. 1, from Central Crete. Green steatite disc, with concave sides. W.19. 1. A seated man and a standing woman. 2. Goats mating. *IGems* G6, pl. 15. Bronze Age scenes of mating goats on the gold ring, *CMS* vii, no. 68, and a LHIIIC vase from Lefkandi, *Arch.Delt.* xxii, Chr., pl. 175f. Davies has made the interesting suggestion (*BCH* xciii, 224ff., with figs. 6–8) that 1 shows Klytaimnestra killing Agamemnon. He argues that the woman is holding a sword, shown by a light cut running within the outline of the man's body, but any artist at this date would have been far more explicit about the use of a sword. Given the scale and the rough style, it is clear that the artist meant to convey some sort of bodily contact with the man and it might be argued that arm + sword was intended.

Pl. 280 New York, Velay Coll., from Crete. Grey steatite lentoid. W.18. Two horses and a branch. *IGems* G7, pl. 15; *Proc.Brit.Acad.* xv, pl. 10.7 (as LMIIIB).

Chapter IV

ARCHAIC GEMS AND FINGER RINGS

The main series of Archaic Greek gems begins in the second quarter of the sixth century. This must be the starting point for any account of the history of Classical Greek gem engraving, and of the tradition which continued through the Roman period, down virtually to the present day. The arts of Greece had been exposed to various forms of orientalising influence since the eighth century BC, and these had been absorbed and translated to contribute to what we recognise as the Archaic idiom in Greek art. The renewed interest in the carving of seals in Iron Age Greece was one of the earliest results of this influence, and it was in gem engraving also that one of the latest can be observed. Already by the end of the seventh century the Greeks had been moved by foreign example to attempt monumental architecture and sculpture, and earlier still their styles of drawing had been set on a course which was to lead to red figure vases and the achievements of the fifth-century muralists. We may wonder why this second and decisive step forward in the art of gem engraving should have come so late. To understand this it is necessary to describe first what was in fact novel in the new series, and secondly the nature of the eastern sources.

The new gems are generally scarabs, their backs carved in the round in the form of the sacred beetle long familiar on Egyptian seals and amulets. The new materials were far harder than the ivory and serpentines which had served before, and these stones—usually cornelian and other members of the chalcedony family, or the native rock crystal—required new techniques for working them. Greek artists had to learn again how to use the drill to shape these tiny stones. A similar lesson had been learnt in Minoan Crete of the Early Palaces, but then the change effected no radical alterations in styles or shapes, as it did in the sixth century.

The immediate source of influence is not so readily determined. The scarab was the regular seal shape in Egypt, but although Greeks had much to do with Egypt at this time there is nothing there in these years to suggest that this was the source. The Egyptian scarab shape, and the 'scaraboid' which has the same oval, flat engraved base but with its back only blocked out, had been in use in Phoenicia and as far north as Syria for some time. An apparently eighth-century Syrian group of scarabs, mainly of haematite, seems to have been ignored in Greece although the cheaper Cilician 'Lyre-Player Group' —mainly scaraboids—had been freely imported (see above, p.110). In Phoenicia at this time the scarabs and scaraboids carried simple animal or sacred figure devices, often inscribed, or inscriptions alone. These too had virtually no effect and at any rate even the native Greek jewellers of the seventh century were unwilling or unable to cut and polish hard stones for beads or inlays. The dating of Near Eastern seals in this period is very difficult, but it seems that it was only in the seventh and sixth centuries that Phoenician engravers regularly produced scarabs and scaraboids in the variety of hard stones the Greeks were to favour, and with the carefully cut and elaborately composed devices which were bound to appeal to a Greek artist. Many of these carry heraldic groups of animals at a sacred tree in a highly Egyptianising style, such as had been familiar in the earlier orientalising phase of Greek art on eastern bronzes and ivories. So both the technique and the most agreeable of the Near Eastern styles in gems

came late to the attention of Greeks. That Phoenicia was the source is indicated also by the regular Greek use of a hatched border to the intaglio device, their occasional use of a cross-hatched exergue to provide a ground line for the figures, and their common method of carving the beetle with an anatomically inaccurate ridge or spine running along its back where the wing cases join (carination). This is seen otherwise only on some Phoenician scarabs, of the materials and style already described, but they can be dated closely only with reference to the Greek stones which they inspired.

'Phoenicia', however, is an agreeably vague term. Since the influence on Greek gem engraving was not a matter of mere imitation, but involved the learning of new techniques, it could not have been effected simply through the import of Phoenician models, and indeed there are none found in Greece of just this style and date. Somewhere in the east, then, Greek artists must have been able to learn from Phoenician studios. The obvious place is Cyprus, since Greeks, and Greek artists, were by this time established in the island, where there were also a number of prosperous Phoenician cities with workshops producing bronzes and, it seems, scarabs, in the homeland styles. The carinated beetles are met in Cyprus, and all the other necessary criteria which we seek. Indeed there also seems to have been a fashion there for a zigzag rather than cross-hatching in the exergue below figure devices, and this appears on some of the earlier Greek scarabs (as *Pls. 282, 284*). These bear some odd versions, even perversions of Greek myth (as *Fig. 187*), such as we see on other Greek Cypriot works. And when we find that Cyprus remains an important centre for Greek gem engraving throughout the Archaic period, its claim as the birth place of the whole new series might seem confirmed.

There is little more that need be said about the form and materials of the Greek scarabs and scaraboids. The beetle backs are seldom very carefully cut or elaborated (*Fig. 185*). The carination may appear as a ridge, a sharp spine or simply a gabled back; and it is not ubiquitous. There may be a hatched border to the thorax or wing cases, and occasionally the legs are marked or whiskered. The vertical border or edges of the plinth below the beetle are plain. There are a few other eccentricities or attempts at detailed carving. The V markings which appear at the front of the wing cases on Egyptian and Phoenician scarabs are sometimes copied, or even rendered in relief, but it seems to have been left to Greek workshops in Etruria to translate them into tiny incised winglets. Sometimes there are spirals or palmettes incised on the backs. The intaglio device is usually edged with a hatched border, but a line of pellets or cable may be found. If there is an exergue it is filled, as in the east, with cross-hatching or zigzag, but also rarely with alternate hatching. The engraved surface and background are not highly polished. The minor elaborations mentioned here become regular features in Etruscan studios, which had been inspired and probably established by immigrant Greeks by about 500 BC. The scaraboids in this period usually have high straight sides with shallow domed backs, and there are some 'pseudo-scarabs' with their backs carved with heads or figures in the half round or relief. This is another practice derived from Egypt and Phoenicia. In Cyprus there are a number with negro heads carved on the back, and the type was popular in Naukratis, the Greek trading town on the Nile. Cypriot too is a small group, closer to the early Greek scarabs in style, with summary heads carved on the back (as *Pl. 281*).

Cornelian is the commonest material in this period, followed by agates and other chalcedonies. Rock crystal was usually reserved for scaraboids—the detailing of a beetle is almost invisible in the clear colourless stone. Green jasper is typical of the Greco-Phoenician stones, which will be discussed briefly below, but is also used for some purely Greek works. All softer stones seem to have been abjured except for some thoroughly provincial black serpentines in Cyprus and the exceptional Island scarabs.

The subject matter of the intaglios on Archaic gems is varied, and their iconography sometimes goes beyond what we might expect from study of the hitherto better known Archaic Greek vases and bronzes. This is partly because gem engraving must have been an art which, with the jeweller's, could

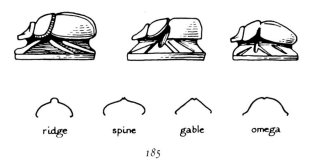

ridge spine gable omega

186

185

claim some independence of tradition, and partly because in this period it is a major source for the figurative art of an area whose artists seem to have been shy of expressing such themes in other media, like vase painting. Of the Archaic gems with recorded provenience nearly one third are from Cyprus, and about as many from other East Greek sites. The rest are accounted for by finds in Etruria, where emigrant Greek studios were at work, and mainland Greece. The few inscriptions on the gems are all either Cypriot or epigraphically attributable to the East Greek area and the Aegean islands. Stylistically there are a number of East Greek preferences to be detected also—for instance the satyrs with horse feet, lions with back manes, and a range of monster creations, usually winged, to name only the most obvious. It looks very much as though gem engraving in Archaic Greece was a dominantly island, East Greek and Cypriot phenomenon. It is hard to believe that Athens, which learnt so much else from East Greece, and especially Ionian artists at this time, had not studios of her own, but there is as yet no evidence for them, unless it lurks in the still unpublished find of Archaic gems made in 1961 at Brauron in Attica. If this seems a strangely restricted usage we have only to recall what went immediately before —the extremely narrow distribution of the Island gems or the Peloponnesian ivories. It was to be some time still before seal use was general in Greek lands. Such other evidence as there is for their use in the Archaic period is reserved for the discussion of the Classical gems and rings, in Chapter V, but we may briefly review the inscriptions on the Archaic stones, since this is the first series on which they have appeared at all commonly. A few are wholly explicit, declaring ownership, as *Fig. 186* where the letters of the name are set in two lines as on the earlier Phoenician stones, or a scarab which adds a tiny dolphin as device beside the clear injunction 'I am the seal of Thersis. Do not open me.' Others find the genitive of the name ('I am (of) . . .') sufficient. Only two artists declare themselves clearly by adding the word 'made' (Epimenes and Syries). On other stones where we see a name in the genitive alone we may suspect the owner, and where a nominative alone, the artist; but this rule of thumb does not always correspond neatly with another declared criterion, that artists' names are small and unobtrusive, being cut at the same time as the device, while owners' names are bolder and more easily read, possibly being cut after the device. No Archaic gems label or describe the device. They are to be read sometimes forwards, sometimes backwards in impression, in common with the varying practice with inscriptions on other objects at this time, but the artists are careful to see that all human figures appear right-handed in the impression.

For the devices themselves the artists preferred single figure subjects. The oval field was satisfactorily filled by a human figure in the 'kneeling-running' position. This was a common Archaic convention in other arts and called for no ground line. On gems it came to be used for static as well as for moving figures—for youths with lyres or flowers, for warriors testing arrows or a Herakles threatening—and we may sometimes be at a loss to describe a figure's action, or inaction, satisfactorily. In the later Archaic period of the early fifth century, when the pose had already been abandoned in the other arts, it is commonly replaced by standing, stooping figures who are picking up armour, patting a dog or similarly

occupied. These too fill the field well, but they also reproduce a more complicated pose which is shown in vase painting and relief sculpture of the day.

The figures might be human or mythical, but this preference for single subjects inhibited the display of the sort of mythological scenes common on vases. Simple groups like that of a satyr carrying off a woman were common enough, but more involved compositions with more figures are rare and generally early. This was not a medium in which the artist could indulge his native love of narrative art and it is the more remarkable that the few such scenes which do survive offer so much that is fresh and unexpected.

Single animal figures also fit the oval well and for many we see the same splayed forelegs which appeared on the Island gems. This seems the animal equivalent of the human 'kneeling-running' position, and often just as ambiguous. Lions are the commonest subject, often shown with heads turned frontal. In this position archaeological jargon describes the beasts as 'panthers', an unnecessary misnomer, by now best abandoned. The lion was as little known to the sixth-century Greek as it had been in the Bronze Age (see p. 58f.) and we find the same mistakes, giving manes and lines of dugs to lionesses, or admitting dog-like anatomy and behaviour, especially the rump-in-air position. The closest knit and most popular animal groups show lions attacking other animals—usually bulls or stags, sometimes boars or goats. The motif becomes remarkably common in Greek art about the same time as the new scarabs appear and it may be that this should be attributed to the same source of inspiration. In vase friezes or pediments the beasts are usually grouped in pairs over the victim but the gems demanded a more compact composition of only two creatures (a rare exception, *Pl. 295*) and we find a few stock poses—attack from the rear, attack from the front, attack from the front crossing the body, or attack from above a prostrate victim. The gem artists also created a new antithetic composition of lion attacking lion (*Pl. 384*) which recalls the Bronze Age, but had not been used on Island gems.

All degrees of detail may be observed on the gems. The use of the drill is never obtrusive in the blocking out of the main body masses. The artists so subordinated technique to design that there are no classes in which the drill technique dictated the style, as happened so often in other periods—the Bronze Age 'talismanic' and Cut Style or the later 'a globolo'. Finer drill work could be used for eyes, hair curls or paws and joints, but a great deal is expressed in simple linear cuts. A more deeply modelled sculptural style is rarely attempted except by the finest of the Archaic artists, Epimenes (*Pls. 355–357*), or on the Island scarabs where softer stone was used and the drill not required (*Pls. 350–354*). The best examples will bear comparison with the finest surviving relief sculpture of the day and, for the first time in the Greek Iron Age, gem engraving can claim its place as a major art.

THE ORIENTALISING STYLE

The earliest groups are also technically the simplest and they exhibit most clearly the influence of eastern styles or subjects. In terms of Archaic Greek art they should begin before the middle of the sixth century and the style probably persists until its end. At the head is the Gorgon-horse Group, with slim, slightly detailed figures which offer several strange mixtures of Greek myth and eastern convention. The gorgon-horses on three of the scarabs are the Greek Medusa, but provided with a horse's body (*Pl. 282*). This is correct enough since the horse-god Poseidon fathered the winged horse Pegasus upon her, but she had been shown thus only once otherwise in Greek art. Moreover the detail of her dress is eastern (the curving hem line), she handles a lion like any eastern hero, and stands on what we should probably regard as a Cypro-Phoenician zigzag exergue. Other monsters created for the group are a form of winged centaur holding a piglet upside down (*Pl. 283*) in exactly the manner of the naturalised Phoenician

187

deity Bes, and a similar figure with a lion body holding a goat (*Pl. 284; colour, p. 149. 1*). More canonical in appearance if not behaviour is the centaur fighting a lion (*Pl. 285*). When it comes to Greek myth a Perseus beheading the Gorgon is shown dressed like Herakles (*Fig. 187*) of whom the Cypriots, and Phoenicians, were inordinately fond.

Other subjects are eastern in inspiration. The sun god carried by a winged sun disc was a common motif, but the winged disc was not one of the eastern decorative features which Greeks copied. They preferred to add the wings to the deity, who then has to carry the disc in his arms. In the strange version on *Pl. 287* the disc seems incorporated in his body and he can fly—'no hands'. On *Pl. 286* the god, identified as a long-dressed Hermes or Iris by the caduceus, is provided with six wings, a wing-cap and winged feet, but has to carry the disc. A comparable translation of the eastern sun god in a winged disc into a Greek Iris carrying a disc-phiale can be traced in the series of coins from Mallos, in Cilicia, from the Archaic period through to the fourth century.

There are a few other strange, mixed motifs, but most are commonplace like the more canonical Greek Gorgons (*Pl. 288*), or the Gorgon head (*Pl. 289*). Once again, though, there is an example of a Gorgon given a whole horse's body, including front legs this time (*Pl. 290*). Animal studies (*Pls. 291–297*) include several Common Style versions of bulls and a few of the better lion-fights, which may be late in the series. The lion forepart attached to a cock (*Pl. 298*) makes an odd combination, but there will be other examples of such surgery, and the Greeks admired the fighting qualities of both animals. There are other, more summary animals, and some in a more deeply cut style, although lacking in detail, which also seem part oriental—like the winged lioness (*Pl. 299*).

This style should probably be traced to Cyprus in the first instance, although it might later have been practised in different parts of East Greece. It remained for the most part outside the main tradition of the development of Archaic Greek gem engraving, and it is not surprising that it has a great deal in common with the earlier Greco-Phoenician scarabs of green jasper. These are the most pedestrian of the Archaic gems, although the most informative about the origins of the whole series.

THE ROBUST STYLE

More ambitious in content and style are a number of groups where we may recognise the characteristics which in other arts are attributed to the hands of Ionian artists. Freer and more effective use of the drill produces more fully rounded figures and there is a real attempt to render details of anatomy either by the drilled masses or by skilfully applied linear detail along sinews and muscles. The Satyr Groups show the development most clearly. The Plump Satyrs are the earliest, of the mid century, with massive heads, broad thighs, no attempt to disguise the transition from frontal chest to profile hips. Several are shown kneeling-running with pots and cups *(Pl. 300; colour, p. 149. 2)*. The Slim Satyrs are later, and the latest may bring us towards the end of the century. The same pose is seen, but now belly markings suggest the torso twist, while for a fine reclining figure (*Pl. 301*) there is a detailing of stomach muscles which recalls contemporary anatomical experiments in major sculpture. There will be more to say about this artist, the Master of the London Satyr. Where a youth replaces the satyr, on *Pl. 302*, which is one of the finest of the whole series, we can see that his head and hair are treated just as any Ionian kouros,

and can now admire the loving detail accorded to wrinkles at his forehead and neck or to his feet. In all but size this is a monumental study. The satyrs are not mere wine-bibbers and they may carry women (*Pls. 303, 305*) as often as cups. Closely related is the superb centaur, similarly occupied, on *Pl. 306*. He is wreathed, and so probably one of the beasts invited to the Lapith wedding who, in their cups, broke up the party and carried off the women. He and most of the satyrs have human legs with horses' feet, which in Greek art is only normal for these creatures in East Greece.

It is a similar satyr who is assaulting a sphinx by pulling her hair (*Pl. 307*) with a gesture only closely matched by another gem in the same style, which shows a youth similarly maltreating a girl and holding a stick (*Pl. 308*). Satyrs have little enough to do with sphinxes at the best of times, but they are amorously occupied with them at least once on a vase, while for the youth and his girl a far more explicit version of the group on a slightly later vase makes it clear that the context is erotic. Such scenes are very rare in the otherwise rich repertory of private scenes in Greek art, and it is surprising to find one on a gem. These belong to a small group of gems in a meaner style, which admits some more wiry satyr studies, as *Pl. 309*.

Very like the Satyr Groups in style is Sphinx and Youth Group I, which, however, offers few direct points for comparison since the range of subjects is so different. But a link can also be made through the beetle backs, since the scarab of the fine London satyr, *Pl. 301*, is large and uncommonly detailed, in exactly the manner of a scarab in Leningrad showing a contorted winged horseman (*Pl. 311*) which can in turn be related to the group with the sphinxes, and particularly to the lyre player, *Pl. 312*. The sphinxes appear in various poses—alone, with animals or bicorporate—but on two examples it is the Theban sphinx carrying off a youth (*Pl. 310*). We should probably identify the figures specifically in this manner, rather than regard the sphinx as a nameless death demon, for which there is little enough evidence in Greece. We shall meet the group again. The features, fine stippling, spiky wings and plump bodies encourage the addition of other gems here, including some human figures (*Pl. 316; Fig. 188*) and plump sirens who are provided with human arms when they need to handle musical instruments or jewellery (*Pls. 317, 318*). There are some monsters too. Some are simply winged foreparts, like the griffin (*Pl. 313*) or the man bull (*Pl. 314*), a fuller version of which (*Pl. 364*) we shall discuss later. Others are compounded of cock's legs and bodies with animal or human foreparts. These are popular inventions in various periods of Greek art and no special names or myths need be sought for them. The only one with a record is the cock horse, hippalektryon, ridden by a youth on Greek vases and sculpture, but not on gems. The winged beetle, *Pl. 320*, is a rare example of Greek acceptance of the Phoenician motif.

The fine ram with Mandronax's name beside it, *Pl. 315*, seems to go with the sphinxes, and with them too may be placed several gems with lions. One, on a finely detailed scarab, attacks a bull from its far side in the eastern manner (see *Pl. 321*) not met again on Greek gems. This has the cable border which has appeared already on these 'Ionian' stones. On *Pl. 322* the lion forms the main part of a sturdy chimaera. A further whole group can be associated—the Group of the Munich Protomes. On the name piece, *Pl. 323*, a very tame Phoenician lion sits in a papyrus grove, but beside him are the foreparts of a bull and a lion, whose whole bodies are seen on another gem, in close combat (*Pl. 324*). This scarab is of exactly the type observed already for the satyr (*Pl. 301*) and the contorted horseman (*Pl. 311*). Here too we see fine stippling and long bristling back manes. The shoulders of these lions are regularly shown humped in a realistic pose which is met in vases and sculpture in the later sixth century. That these gems belong late in the century is shown too by the dog-like modelling of the lions' bodies and the careful detailing of the bulls' heavy dewlaps, where before bellies were straight and necks slim.

The groups distinguished here depend for their unity on similar treatment of similar motifs, but they are linked together for an overall unity of style, which is confirmed by the identical scarab backs which

are used in the finest examples from the three main groups (for *Pls. 301, 311, 324*). This strongly suggests a single workshop for the principal gems in all the groups, and a single artist for at least the three scarabs mentioned—our Master of the London Satyr. It is seldom possible to demonstrate so clearly the relationship of groups or to detect a master hand in this period.

The detailing of some of the scarab backs has already been noticed and there are also some pseudo-scarabs to record. These have their backs carved with the figures of sirens in low relief, seen from below, with their wings spread (*colour, p. 149. 4*).

There has been little in the Robust Style groups to recall the east and Phoenicia, but for the cross-hatched exergue below Mandronax's ram, or the lion in the papyrus grove on the Munich gem, and although some of the subjects are broadly orientalising, most are far closer to what we look for in Archaic Greek art. The generally East Greek or Ionian character seems clear, but a great many of these gems have been found in Etruria, and it seems very likely that some were made there in emigrant Greek studios. We shall have to return to this point later in the chapter.

THE DRY STYLE

Other groups of Archaic gems, belonging mainly to the second half of the sixth century but with followers in the early fifth century, are executed in a style which is more detailed than the Orientalising, less modelled than the Robust. The distinctions between these basic styles are not easy to define and the composition of groups has often to be helped by criteria of motif alone. Sometimes the distinction may seem too fine to have meaning, but there is not evidence enough for closer definition by artists and schools and the broader trends distinguished here probably do reflect slightly differing traditions. If the Robust are Ionian, then the Dry perhaps belong to the islands, but their close kinship to what is more readily recognised as East Greek work is unquestionable and this may be idle speculation.

The Dry Style in its clearest and earliest form is represented by some rather angular figure studies, fairly shallow cut and relying a lot on simple linear detail. We may notice a tendency to summarise or reduce subsidiary detail (as the lyre on *Pl. 325*, the wash basin on *Fig. 189*). The style lends itself also to summary treatment of commoner motifs from the later repertory—youths kneeling to test arrows, with lyres or strigils. The young man with lyre and cock, *Pl. 325*, is commonplace, but his wearing a helmet is not. The girl kneeling to wash her hair, *Fig. 189*, is the first example of a motif which will be popular later on Etruscan gems and in Greek art.

There are a few other minor groups to be distinguished here: one, for its use of a facing lion head as exergual device. On two gems we see over the head a horseman jumping from his horse, an *anabates* practising a popular exercise (*Pl. 328*). The bitch coursing below the horse is a conventional co-runner. On another the device is a grotesque frontal sphinx with, over its head, one of the very rare Greek copies of an eastern winged sun disc (*Fig. 190*).

More ambitious are some narrative scenes with the small neat figures which this style seems to favour. *Pl. 329* is very Cypro-Phoenician with its cross-hatched exergue, Egyptian ankh and falcon, but the

scene is purely Greek with a Herakles rescuing Deianira from the centaur Nessos. Herakles' acquisition of the girl is told on two other gems, by one hand. He fights the river god Acheloos, whose sea serpent mutation rears over his back (*Pl. 330*), and having broken off the magic horn he receives the creature's submission and the hero's prize (*Pl. 331*).

The fact that the sphinx and youth motif appears several times in this style serves further to illustrate the close relationship of the two series. Here it is rendered in a scratchy, angular manner (*Pl. 332*) and there are several other stones on which the same treatment of the same human features can be seen. One is a rather awkward running-flying Eros, with a winged head and heels (*Pl. 333*). The motif, managed differently, will be a popular one. The beetle on *Fig. 191* is the Phoenician motif again, without wings but with a human head and raised arms which, in the east, would be holding the sun disc. Similar but later are some studies of winged female deities. The curved, splaying folds of their dress recall vase painting, and is a realistic rendering hitherto ignored on gems. One has the Archaic sickle wings, perhaps an Iris (*Pl. 334*). Two others (one on *Pl. 335*) turn their wings down in the later manner and carry snakes. They might be avenging demons, Erinyes (as Beazley suggested), but there is no clear iconography for them at this date in Greek art. There are other rather summary and lumpy figures (*Pl. 336*) and helmeted heads (*Pl. 337*) which can be associated, and joined heads of a satyr and maenad (*Pl. 338*) which are found also as a coin motif. This series has its monsters too, compounded of human figures and animal heads (*Pl. 339*), or as *Fig. 192*, which resemble the results of Circe's work on Odysseus' companions, as they appear on some vases. It is likely, however, that they have some other significance here, for their kin are to be found on East Greek vases, and some seem meaningfully employed, or at least armed. A dog-headed man fights a lion on a beautiful gold seal shaped like a sheep's head (*Pl. 341*), and we shall soon see two such monsters in a duel (*Pl. 342*). Aesop had been composing his Fables in Samos or Anatolia little before these were cut, and the possibility that such animal-men were common actors in East Greek myth, as they were in the east and Egypt, cannot be dismissed.

In so far as the Dry Style can be treated as a separate tradition in Archaic gem engraving, it is fair to look for its continuance in certain other Late Archaic groups. Here the figures are generally smaller than hitherto, and more accurately proportioned, without the Archaic exaggeration of heads and limbs. The Group of the Tzivanopoulos Satyr is headed by a stone bearing a neat, athletic satyr lifting a jar (*Pl. 340*). This was owned by a Cypriot, whose name appears twice in the field. The monster duel already mentioned involves Brer Dog and Brer Donkey who fight it out like Greek hoplites with spear and shield, while a small donkey rolls in the background (*Pl. 342*). The last is seen as a separate motif on several gems, and it is an odd choice in this situation. There are still some eastern traits which bring us close to Greco-Phoenician work. Thus, the Herakles on *Pl. 343* is beardless and holding a lion inverted. This is not the Nemean lion, obviously, and the hero is acting like an eastern master of animals. The same figure with the lion is seen on Phoenician coins and on some Greco-Phoenician seals the lone fox behind is added too, so it must have some significance which may not have been immediately apparent to a homeland Greek. The gem from Cyprus with a footprint, *Pl. 344*, may also go here for its date, inscription and what little can be judged of its style, which is mannered and not wholly realistic. A foot impression seems a very natural motif but recurs only once on Greek gems.

The Group of the Beazley Europa brings us close to the Early Classical. The slim, small figures are set more freely in the field and the artist feels less constrained to fill the available space. This encourages more two-figure scenes or myths. Gone is the Archaic kneeling-running and instead there are the stooping figures, with a dog or arming, or as the pair on *Pl. 348*. The name piece is a spirited study of Europa carried by the Zeus bull over the sea, *Pl. 345*. In the bull itself we see a new realism and massiveness which will be well expressed in other Late Archaic groups, but Europa is a slight figure, her dress

189 *190* *191* *192*

simply marked with folds, more like the figures from Melian clay reliefs of about this date than the drawn or carved figures of the Greek mainland. The satyr who tries to lift a burly maenad on *Pl. 346* is a very different breed from his predecessors who found no difficulty with their compliant victims (as *Pl. 303*). His senior on *Pl. 347* has stolen the lion chariot of his master Dionysos, or is perhaps his charioteer in the battle against the Giants.

The unity of these Dry Style groups is not easy to grasp, and could be illusory, but the contrast with the general aspect of what is here assigned to the Robust Style seems real enough, and the two late groups are easily separable from others of the same period, yet to be described. Cyprus and East Greece or the islands seem mainly involved. Some of the earlier stones, at least in their subject matter or treatment of narrative, may have had something to contribute to Etruria, while the latest have most to do with later, Classical developments in the art.

ISLAND SCARABS

The translucent green 'steatite' which had been employed for the Island gems was the only soft stone still used by an important studio of Archaic gem engravers. The source of the stone must have been the same, and so the home of the studio may be in Melos, as for the earlier gems, but we cannot be sure of this, and the letter forms used by the two artists who sign their work point rather to Euboea. There is a further connection or hint of continuity with the older workshops in the evidence already discussed for their experiments in harder stones or with shapes approximating to the new scaraboids (see p.122). But the most important work is done in the old material and in the old technique, producing a rugged and individual style, allowing considerable detail and depth of modelling. The style of the best examples is Late Archaic, of about 500 BC or little after. Syries signs one fine pseudo-scarab (*Pl. 350*), its back carved as a facing satyr's head. The device shows a man mounting a stepped platform or *bema* to play a kithara. His body is carefully modelled beneath the intricate pattern of folds on his clothes. The artist's signature is discrete and barely legible. Onesimos signs three stones. His best—almost the best of all Archaic gems—has a satyr tuning his lyre, his head thrown back to catch the tone, his shaggy body and tail bristling with an attention which he will divide only between music and love (*Pl. 351*). Onesimos' other scarabs also seem to add something to the stock Archaic motifs of warriors or animals (*Pl. 352* and perhaps *353*). The scarab backs are without exception meagre and roughly cut, but we can see that Syries could carve in the round if he wished. If these artists ever worked in the harder materials it is not possible to detect their hands among extant gems, for no other groups display comparable inventiveness and verve.

147

The fullest achievement of Archaic Greek gem engraving was realised by artists and studios working around 500 BC and in the following generation. This was too, in its way, the end of a tradition, since the new styles of Classical engraving evolved less from this ultimate and fullest statement of the Archaic idiom than from the less emphatic work of the latest Dry Style groups. But there is certainly no abrupt break and it is possible to detect already some of the traits of the later style—a growing preference for scaraboids and for chalcedony, an attenuation or elimination of the hatched border to devices.

The works of two artists dominate this period, although there are many other individual works of the highest merit. Epimenes signs a scaraboid on which a youth is shown restraining a restive horse (*Pl. 355*). The animal is beautifully carved with the utmost attention paid to detail of anatomy and harness. The youth is a minor sculptural tour de force. The twisting three-quarter view of his back is successfully rendered, while but a generation earlier engravers were satisfied with the uncompromising and abrupt transition from frontal to profile in the torso. The head is still a simple profile, with the Archaic frontal eye, and the legs, one profile, one seen from behind, show a pose which, with the three-quarter back view, becomes very popular about 500 BC in works of red figure vase painting or relief sculpture in Athens. But Epimenes is no Athenian, and the spelling and letter forms of his signature, in common with those of several other gem inscriptions of these years, points rather to the Greek islands. The same youth is seen on a New York scaraboid, kneeling to test the tip and straightness of his arrow (*Pl. 357*) another pose popular with the vase painters at this time. Here there is the same twisting back, and the anatomy on the larger single figure is even more carefully and realistically observed. Like the latest marble kouroi the hair style of this youth shows the locks radiating from the crown in waves, with a cluster of drilled curls gathered over his forehead and the nape of his neck. A bowman, in somewhat poorer style but with the same accomplished treatment of the back (*Pl. 356*) completes the trio to be associated with Epimenes.

A scarab in Berlin has a fairly detailed beetle back with faint relief winglets. The device shows a naked girl kneeling to fill her jug at a lion-head spout (*Pl. 358*). The inscription gives a man's name, Semon, in the genitive. This might be the artist, for the letters are small and neat, but we cannot be sure, so it is better to call him the Semon Master. His style is more readily seized than is Epimenes', for which we rely largely on his skill with anatomy, since the Semon Master favours a most distinctive head type for men, girls or sphinxes, and one attribution leads to another to create a considerable and homogeneous oeuvre. The girl reappears in a simpler version on *Pl. 360* but the artist is at his best with winged beasts and deities. Eros flies off with a girl (*Pl. 359*) too startled to drop her lyre. Instead of the sphinx seen on earlier gems a griffin carries off a dead or moribund youth (*Pl. 361*). The monster is of the fifth-century breed with fishy mane and bent wings. But the older motif is not forgotten, though treated in a different manner, and the sphinx on *Pl. 362* finds that she has an armed youth in her grasp who twists and fights her. This is the way the group will be shown in Classical Greek art, as by Phidias on the throne of his Zeus at Olympia. The young warrior's stretched frontal leg and bent profile one recall the pose of Epimenes' groom and will be seen again for fighting and standing figures, and for the bowman on *Pl. 363*. The winged man bull on *Pl. 364* matches exactly no Greek monster, since the river god Acheloos should have no wings. We might take this, however, as a hellenised version of the common Persian monster (as *Pl. 837*), remembering that if, for instance, it had been cut in Cyprus, this was then part of the Persian empire. We have met the forepart already (*Pl. 314*) and it appears on an Ionian electrum coin.

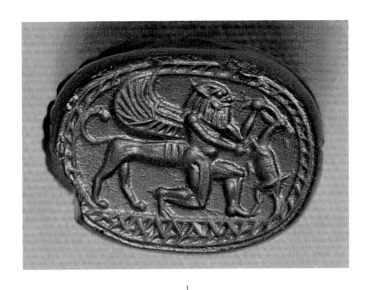

1

2

3

4

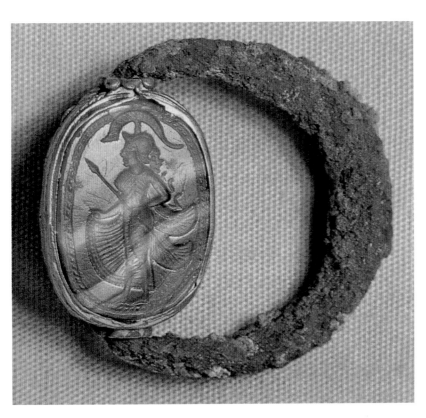

5

6

The crouching position used for Epimenes' youth with an arrow or the Semon Master's girl on his name piece, serves a passive Hermes less satisfactorily (*Pl. 365*). This too is from Cyprus. Finally, Herakles throws the lion, on *Pl. 366*. The action is one more often seen on gems than vases in this period and the artist is at pains that we should not take this for the commoner group with hero and beast wrestling on the ground, by straightening the border to serve as ground line. More important here is the shape, for this is the first ringstone we have met, with convex face and flat back, not pierced but to be set immobile in a finger ring. There are a few other Archaic examples, all of cornelian. The origin of the shape is not immediately obvious. The outline and convex face recall the Island amygdaloids, but also the face of Persian stamp seals which were by now becoming known to Greeks. With the ring hoop replacing the high conoid shaft of the eastern seal there can be seen to be some similarity between the shapes. But these stones are set on stirrup-shaped hoops, which copy all-metal finger rings with engraved bezels already current in Greece (see below).

There are a number of other Late Archaic gems of high quality which closely resemble the work of Epimenes and the Semon Master. Athletes and warriors arming are popular subjects (*Pl. 367*). *Pl. 368* shows the impression from another ringstone, with Herakles and an owl on his shoulder to signify the presence or interest of his patron goddess Athena. The twisting body of the warrior on *Pl. 369* exploits well the engraver's new command of anatomy. There is a replica of this stone bearing a Cypriot inscription. Eros flying, as on *Pl. 371*, with his head turned back and body twisted, holding flowers, a wreath or a lyre, becomes popular now and will remain so, especially on finger rings in the fifth century. There are still problems of identity, however. On *Pl. 372* there is only the club to suggest that the figure could be Herakles. The hero has to face a single snake, as here, when he steals the apples of the Hesperides. He had dealt with two when in his cradle and faced a multiple serpent in the hydra, but this might well be some other hero in some other encounter.

A very few gems of the highest quality and stylistically more advanced than the work of Epimenes or the Semon Master represent the last phase of the true Archaic tradition in gem engraving. This is the Anakles Group, at whose head is a scaraboid, signed by Anakles, showing a satyr reclining on a wineskin and holding a kantharos (*Pl. 373*). We have come far now from the figures of the sixth-century Satyr Groups. The strong torso is treated with sympathy and accuracy; the left leg is doubled up, showing the thigh frontal, in another of the familiar Late Archaic poses; the head, though of a satyr and with animal ears, has the dignity and presence of a Zeus. Markedly similar is a broken scarab showing a lyre player (*Pl. 374*). Two other gems shown here also carry satyrs, but of the normal breed, with bald heads and snub noses, albeit with the physique of athletes. One draws a bow, his back twisted in the pose of Epimenes' youth, but executed now with complete assurance (*Pl. 376*). There is a kantharos before him. A satyr play in Athens told how satyrs robbed a drunken Herakles, and if this device is influenced by the play we have a rare example of Athenian interest in gem engraving. The satyr himself could be easily matched on Athenian vases, by the painter Douris. On the other gem, perhaps by the same artist, the satyr stoops beneath the load of a full wineskin (*Pl. 377*), a slippery burden which he keeps from sliding off his back by a cord passed round it.

The subjects so far have been principally male nudes. There are other Late Archaic gems with studies of clothed figures. At their head is the Leningrad Gorgon (*Pl. 378*), for the fine-set lines of her dress and carefully modelled body, yet in some ways this is not a wholly typical piece. Its shape and material, a heavy scaraboid of blue chalcedony without a hatched border to the stone, looks forward to Classical works of East Greek or even Greco-Persian workshops. Her long sickle wings are the eastern form also favoured in the Persian Empire, and the pattern of her hem and skirt can be matched on early Achaemenid work. Although it is wholly Greek, and still Archaic, it affords a rare link with works to be discussed in

a later chapter. Related is a queer Athena, on *Pl. 379*, her aegis slung at her back and its mask—a satyr head and not a gorgoneion—showing in profile at her neck. She is winged too, an East Greek fashion originally, and the wings spring from her waist not her shoulders, as they would in mainland Greek art. But, unlike the Leningrad Gorgon's stone, this is a small onyx scarab from Cyprus, of the usual Archaic pattern. An Iris on *Pl. 380* and Athena on *Pl. 381* show the folds on their dress more realistically, and the latter is in this respect close to the figures of vase painting. Her aegis is suggested in an odd way by the snakes which fringe her himation cloak, while its mask is this time a serpent head, rearing at the back of her neck. This is a larger stone, with the slim hatched border which becomes increasingly popular in the fifth century. We see her head alone on *Pl. 382*, and finally, on *Pl. 383* there is a stumpy Dionysos with his chiton oddly marked in zigzag folds.

The animal studies of this period are easily related to the figures already discussed. The Group of the Cyprus Lions presents a number of fine beasts with whiskery manes (*Pls. 384–386; Fig. 193*). The pair fighting on *Pl. 384* are a new motif, invented by the gem engraver but already shown on sixth-century stones. On *Pl. 385* a lion scratches his nose while a cock pecks at his back. Lion and cock, the strongest of beast and fowl, are several times associated on gems (see *Pl. 298*), but the monkey here, who appears to be helping the lion, seems a gratuitous addition and the whole group may be a mere conceit of the artist's, like an animated hieroglyph. The same lion in the same pose is seen on *Pl. 386*, over a murex shell and on a ringstone here preserved with its original gold setting and hoop. There are related scarabs in green jasper, the Phoenician material, but Greek in style, like the fine lion and goat on *Pl. 387*.

Aristoteiches' magnificent lioness, *Pl. 388*, calls to mind the feline studies on the Semon Master's gems, but is probably a little later. This is a most careful study, with the dugs now properly placed in the loins and the other markings and whiskers carefully shown, although the mane for the lioness is not correct. This is a lion type (again on *Pl. 389*) which can be easily matched in East Greece and which remains familiar in Greek art into the Classical period. Among the other animals the farmyard beasts seem particularly popular. Hermotimos claims ownership of a fine scaraboid with an ewe (*Pl. 394*), and Bryesis signs, perhaps as artist, a ram (*Pl. 395*). The bulls are sometimes still shown with the 'skipping' forelegs but there are also more natural poses (as *Pls. 397, 398*), and some turn to scratch a muzzle or a cow suckles a calf—motifs familiar on contemporary coins but not seen on gems since the Bronze Age. The bull on *Pl. 401* is being attacked by a gadfly, and on another stone (*Fig. 194*) the assailant is shown more clearly. Unless this is Io, mis-sexed (as she is on a Greek vase), it could be the Zeus bull who abducted Europa and who is being harried by Hera's insect agents. There are some fine sows and porkers (*Pls. 402, 403*) and some horses (*Pls. 404, 405*) and dogs. This interest in animal devices remains strong in the Classical period but either with different creatures (stags, waterbirds) or with different poses (the plunging bulls, racing horses). There are a few monster devices in the fine animal style, notably foreparts of winged boars (*Pl. 399*), such as appear on various East Greek coins, or one attached to a human leg (*Fig. 196*, and compare *Pl. 429*), and even a contorted boar (*Fig. 195*), recalling the old Minoanising Island gem devices. The tree with its wild life (*Fig. 197*) seems a Greek version of a common Phoenician subject and carries a good Ionian name, Bion.

GREEKS IN ETRURIA

A higher than average proportion of the alleged proveniences for gems of the Robust Style name Etruria. This is not of itself enough to demonstrate that some of the stones were cut there, but it is necessary to postulate some such production to explain both the inception of Etruscan gem engraving and some of its characteristic features. From the mid sixth century on there was a considerable movement of artists

193 194 195 196 197

in the Greek world, and in particular it is not difficult to map the diaspora of East Greek artists whose skills found patronage and markets in mainland Greece and in Italy. That there should have been gem engravers among them is a highly reasonable assumption. We may suppose then that some examples from the Robust Style groups were cut by Greeks in Eturia, possibly including the Master of the London Satyr. Their style certainly has a great deal in common with the work of other East Greek artists who were demonstrably working in Italy at just this time, especially the master of the Caeretan hydriae. It may not be too much to claim that it was in this half century that immigrant Greek artists determined the appearance and principal features of Archaic Etruscan art.

Distinctive studios which we might call purely Etruscan were working by about 500 BC. They might still have been staffed by Greeks, but their style had diverged considerably from what was then being practised by engravers in Greece itself. Other signs of loosened ties with metropolitan fashion are seen in the use of inscriptions (in Etruscan) to label figures, and these may betray false identifications of stock scenes from Greek myth. Other features derive from the heritage of the sixth-century Greek studios in Etruria. The treatment of the beetle is one: it often has incised winglets, stippled head and decorated plinth—all of them elaborations met on the Greek stones but never regularly applied or usually applied all together. The beetle is accorded far more attention in Etruria, where the scarab is treated rather as a jewel than a seal. We met pseudo-scarabs in the Robust Style, especially with relief sirens on their backs. A group of relief gems with sirens and Gorgoneia (*Pls. 406, 407; colour, p. 149. 6*) was probably the work of Greeks in Etruria, and they are stylistically close to the most hellenised of the carved ambers in Italy. The relief siren on the back of a pseudo-scarab becomes quite common in Etruria (as *Pl. 413*), and other simple versions derived from Greek pseudo-scarabs show the heads of satyrs or women.

One fine pseudo-scarab of late sixth-century date shows Dionysos with his vine in relief on the back, while the device is a four-figure scene with Herakles, supported by Athena, fighting an old man, with a second woman beyond him (*Pl. 408*). Other gems by the same artist (Master of the Boston Dionysos) have their backs detailed in an 'Etruscan' manner, and the style of the figures—stocky, big-headed, flat-footed in stance (*Pls. 409, 410*)—is very close to that of peripheral Etruscan work in bronze and stone (as the Volterra stelai). This does not mean that the artist was not a Greek, since we may only be witnessing the establishment in Etruria of an immigrant and highly individual Greek style. But it is not one as yet well attested in the west so, whatever his nationality, the artist might be considered the first of the 'Etruscan' gem engravers. There are later and still purely Greek works made in the west which contributed to the development of the local studios. Such are the Hermes and the athlete of *Pls. 411, 412*.

GREEKS AND PHOENICIANS

The relations between Greek and Phoenician gem engraving go far beyond the circumstances which gave rise to the new Greek series of scarabs. At about the same time a new series of Phoenician gems begins. Its precise origins and course vis-à-vis the Greek will have to be explored elsewhere, but a simple description of what is involved will reveal the problems. The characteristic new material for the scarabs

is green jasper, and although cornelian scarabs may be found nearly as often in the same contexts and with similar devices, still it is the jaspers which unfailingly carry all the significant motifs and details of scarab shape. The beetle is generally large, with little detailing, but often with two cuts at either side of the 'tail' giving a pinched effect. Some of the scarabs are from Cyprus and from the Phoenician mainland but most are from the west. The preponderance there may be due to the common practice of putting them in graves and the many Punic cemeteries which have been excavated. Examples from Tharros in Sardinia first attracted attention and there is still a tendency to believe that they were made there, but they are just as common in Carthage, Ibiza or Gibraltar, sharing the same characteristics of shape, style and motif. No serious attempt to define differences between the western and the eastern Phoenician scarabs has yet been made, so it would be premature even to argue that any were made in the west (although this is the usual assumption), especially when we remember how many Cilician seals could reach Ischia in the eighth century BC (the Lyre-Player Group).

Most of the scarabs carry careful Egyptianising motifs in a style close to that of the earlier Phoenician gems in other materials. Closest to the early Greek are those with the scene of two lions attacking a bull (as *Pls. 414, 415*), which the Greeks regularly abbreviated to a two-figure group. There are a number, however, with purely Greek devices, or orientalising devices which at this date are otherwise met only on the Greek gems. Most are Late Archaic, and include familiar athlete studies or warriors, even some satyrs—the commonest of the late sixth-century Greek motifs. The style of these is generally close to that of the purely Phoenician but some of the finer devices are wholly Greek, or offer rare but quite intelligible Greek subjects, so that the intervention of Greek artists seems probable, and there must be some question how far their example may have influenced the whole jasper scarab series. There are a few examples in the material, not used in Greece since the Bronze Age nor much in the east, which one would unhesitatingly attribute to some of the Archaic Greek studios already discussed. I illustrate one or two with Greek subjects treated in a different style, typical of the 'Greco-Phoenician' or 'Greco-Punic', but for which it is difficult to conceive other than a Greek hand. The youth with a lyre on *Pl. 416* is in a harder, more mannered style than most, and his lyre is oddly fashioned with its round sound box. But this is accomplished work showing a full understanding of Greek composition and anatomical conventions. The engaging hybrid on *Pl. 417* is a popular motif in this class, and leads to some similar but less subtle compositions on later gems and even on Achaemenid finger rings. It is compounded of a man's and a woman's head, a satyr mask, the forepart of a boar, and a bird, but it is not a mere grafting together of parts since the bird serves as the beard and ear of the human head. On *Pl. 418* the Athena head beside her owl recalls the Group of the Leningrad Gorgon, but is a duller work for all its precise miniaturist detail, and the owl is on the way to being an Egyptian or eastern falcon. The stricken warrior on *Pl. 420* is a forceful study, but contrast the purely Greek *Pl. 369*; and finally, the lioness with cub is a rare motif in Greece or the east (*Pl. 419*).

FINGER RINGS

Although the art of stone seal engraving had died at the end of the Bronze Age the traditional shape for all-metal rings survived, albeit without figure devices and actually worn on the fingers, unlike the engraved Bronze Age rings which were usually worn as pendants. There is one gold ring with a sub-geometric intaglio device on a bezel set across the hoop in the Bronze Age manner, but it is from Melos and may be explicable in the same terms as the Island Gems (*Pl. 421*).

All-metal rings with intaglio devices are made again in Greece from the end of the seventh century on. Unlike the scarabs, they seem not to be an exclusively East Greek fashion, but are well represented in the

Peloponnese too. Like the scarabs, however, the ring forms were introduced to Etruria, and in a land where gold was plentiful and jewellery regularly worn and deposited in graves, some of the series are better represented there than they are in Greece, where bronze or silver rings are commoner. The engraving techniques are simple, with direct free-hand cutting in the soft metal with no use of the drill, but no intaglios are cast, and on occasion all the goldsmith's skill was lavished on the hoop. The same smiths must have made the swivels on which the stone scarabs were set, and we are reminded of the close connection between the crafts, which may well have been exercised by the same artists. The devices are usually of animals, or pairs of animals, and only on some of the larger and more elaborate rings made in Etruria are more ambitious scenes attempted.

There is some variety in the shapes of the rings, summarised in *Fig. 198* according to the principal types. One important model was the Egyptian cartouche ring with its long oval bezel in line with the hoop. It was copied in Phoenicia and Cyprus, where it is sometimes given a double bezel (*Pl. 423*). The form is either directly copied by Greek artists (A,B) or rendered in more angular forms (C,D and perhaps E). Another basic type derives simply from beating flat part of a plain hoop to give a diamond-shaped bezel (F). This we may see to be related to other types of rather different construction which give bezels of the same shape (K,M and perhaps N). The oval bezels of the others are probably inspired by the shape of a scarab base, and one finely worked type of hoop, with lions gripping the bezel, was used for both metal bezels and for holding stone scarabs (G). The Boeotian-shield shape for a bezel (J) was probably suggested by the similar functions of a shield blazon and a seal blazon.

The basic cartouche type (A) is found in Cyprus with pseudo-hieroglyphs and orientalising devices (*Pls. 422, 423*), and in East Greece where, in Rhodes and in a context of about 600 BC, there is an example inscribed simply with the name of its owner—'I am of Elephantis'. The type from studios in Etruria (B) may have been introduced by Greeks, but it has an involved and individual career, parallel to that of the Greek scarab workshops in the west, and, in style, to Greek-inspired vase painting in Etruria. It cannot be treated in detail here. The large bezels are usually of gold, and hollow, with elaboration of filigree and granulation. The devices may be designed in three or four registers, following a Phoenician fashion (*Pls. 424, 425*), or disposed along the length of the bezel (*Pls. 426, 427*). Some are in relief (*Pl. 428*), and none are robust enough to be much use for sealing. The series belongs mainly to the second half of the sixth century.

The cartouche form with pinched sides (C) seems wholly Greek and mainly of the first half of the century. The heavier rectangular bezels (D) are usually of silver or bronze, and although there are examples from Greece and Cyprus, it is met most often in fifth-century Etruria. The lighter type with the ends moulded (E) is mainly Greek of the third quarter of the sixth century.

Rings of group F (*Pls. 429–431*) are made in a different fashion, from bars of circular section, hammered flat to give a diamond-shaped bezel, then bent round on themselves and the ends soldered or sometimes left open. It is a popular type, but none seem earlier than the mid sixth century and the form persists in the fifth. The finest are a group, probably Greek work in Etruria of around 500 BC, with elaborate and detailed animal devices (*Pl. 431*).

The exquisite gold lion rings (G) are purely Greek, wherever made, and there are several examples serving to hold Archaic Greek scarabs. Of those with a metal bezel shown, *Pl. 433* has a Greek sea serpent device—with pointed muzzle, mane and leonine forelegs; and *Pl. 432* Hyakinthos, riding Apollo's swan.

The flat, spreading hoop with oval bezel (H) may be fifth century and western work, but the shield rings (J; *Pl. 436*) are wholly Archaic and begin in Greece, appearing also, with extra elaboration, in Etruria. In Greece itself the type survives with relief gorgoneion devices. Some diamond-shaped bezels

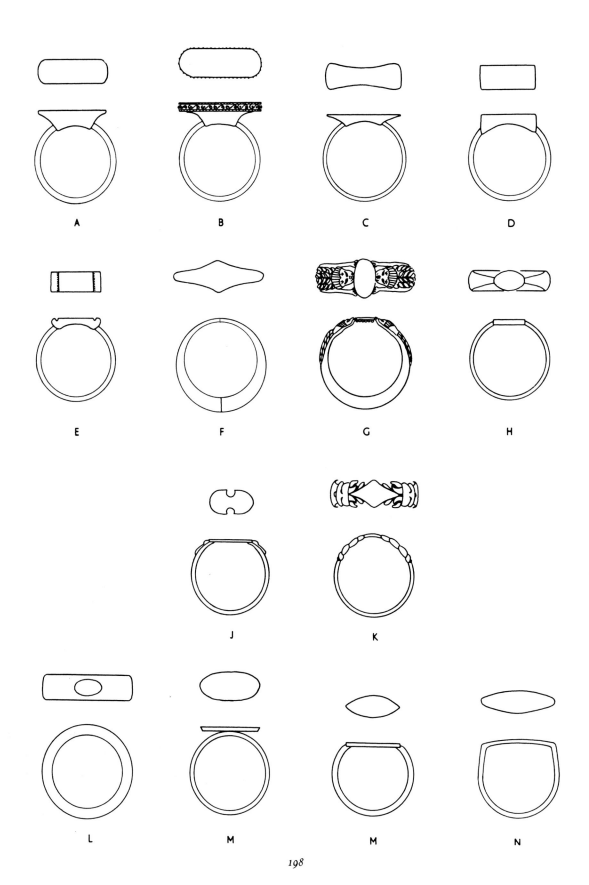

A B C D

E F G H

J K

L M M N

199

are flanked by summary lion heads or florals (K; *Pl. 435*). Most are Late Archaic and from Etruria but some elaborate also the outer corners of the bezel and these are Greek. The heavy hoops which appear to embrace the oval bezel (L) are less readily placed, but the devices include some which vividly recall some of the odder motifs on East Greek scarabs, and there is an example from Cyprus. Thus, we find a boar-bird, a bull-cock, and a Herakles chasing a monster which has a human body and hare's head (*Fig. 199*). Various Late Archaic rings have oval or leaf-shaped bezels which are conceived as separate entities, fastened to a light hoop (M). These do not really constitute a distinct type, but most seem Greek.

Type N, with the long, flat, leaf-shaped bezel and stirrup hoop, is important since from it stems the whole series of Classical finger rings. It is mainly Late Archaic, with a long history in Cyprus, where it will be favoured for simple devices of a flying Eros, and with some currency in Etruria, with devices of the type best familiar on the larger cartouche rings. One, with an unusually heavy hoop and relatively small bezel, has an excellent study of a young archer, squatting on rocks (*Pl. 442*). Another, with its lion (*Pl. 439*), has far more in common with the ordinary scarab devices. A third is more readily comparable with the best Late Archaic gem stones, with its study of a light-armed warrior poised with one leg frontal, one in profile (*Pl. 440*). A fourth is rather mysterious, known to me only from a photograph, apparently from a ring of this class to judge from its shape, and the style and pose of the Herakles upon it (*Pl. 441*). What is odd is the tremolo border (see p. 378) and the inscription, first for naming the subject by his epithet—*soter*, 'saviour'—and secondly for attesting a Herakles Soter at this date, since there is no other evidence for his quite reasonable claim to the epithet until the Hellenistic period.

Finally there are a few metal bezels designed to be set in swivels, like the engraved stones. Circular, square and hexagonal shapes are met at Perachora and in the Peloponnese. A gold box bezel has a fine griffin on it and is inscribed *damo* (*Pl. 443*). It would be tempting to take this for a public seal but for its extreme impracticability for regular use.

It may be noted that there are silver examples of types A, C, D, E, F and N which have their bezels pierced with a gold stud, and on occasion even with two or four gold studs. Most are Greek in origin. There will be call to mention this phenomenon later (p. 215).

CONCLUSION

There are a few general considerations best reviewed now that the main series of Archaic gems have been discussed and displayed. They concern their origins and their relationship with other Archaic Greek arts and practices.

The importance of Cyprus as a source and the probable existence of Greek workshops in Etruria need no further discussion. 'East Greece and the island area' is a vague enough term to embrace the other main centres of production, especially since it seems that we might have to include Aegina and Euboea, but not, apparently, Crete. Cycladic participation seems assured on epigraphic grounds. One place which may be claimed as an important centre is Samos. We may judge this from the alleged proveniences of several stones, stylistic and subject comparisons which can be drawn between many gems and Samian sculpture and metalwork, and the fact that the only Archaic gem engravers to be mentioned by ancient authors are Samian—Mnesarchos, father of the philosopher Pythagoras, and Theodoros who made

the famous ring for the tyrant Polykrates and won renown also as sculptor and architect. For Athens we await evidence still, perhaps from the finds at Brauron in the Attic countryside, but Attic Sunium in earlier days seemed to look to the islands for its glyptic. Solon, the Athenian lawgiver of the early sixth century, is said to have laid down that, for security reasons, engravers should not keep impressions of seals cut for customers, but there seems no good reason to credit Athens with a seal usage so early, so this may be another of those later ordinances attributed to Solon. If we have so often to turn to Athenian vases for comparisons of subjects and style this is due to Athens' near-monopoly in figure-decorated vases and their high survival rate. It is hard, but not impossible, to detect what is originally or basically non-Athenian.

Before the scarab series the choice of devices for Greek seals seems to have been mainly determined by decorative considerations. Now, however, there seems to be more feeling for the idea of a personal blazon, whether or not the owner is also identified by inscription. We are inevitably led to draw comparisons with shield blazons and coin devices. There is, in fact, little enough evidence for the use of personal blazons on shields in the Archaic period, and study of the blazons shown in vase paintings seems, in this respect, unrewarding. But the Greeks used similar words to describe the devices on shields, coins and gems, and on coins certainly it is personal and state devices that we see. In subject matter the shield blazons offer very little for comparison with the gems. There is more of relevance to be found on coins, especially in the East Greek area and Cyprus, as we have seen, although it is not possible to determine the existence of, let alone identify, state seals in this period. We might also expect close correspondence in subjects and styles between the gems and coins, which are both mainly miniaturist work. It is not yet clear whether the technique of cutting a metal die for a coin was the same as that for a stone gem, but even if it were not this need not mean that they had to be the work of different artists. Coin devices, although generally larger, lack the finer detail of the best stone gems, so it seems probable that the dies were hand-cut in the metal without the help of drill and cutting wheel. If so comparisons should be drawn rather with the techniques of cutting intaglios in all-metal rings, and for the Archaic period such comparisons are fruitless.

The use of seals in the Archaic and Classical periods will be considered at the end of Chapter V. For the manner in which Archaic seals were worn we have only the evidence of the objects themselves. The wearing of signet rings upon the fingers was obviously the normal method, although it had not been so in the Bronze Age. Scarabs were set in metal swivel hoops, and occasionally the stone itself is given a decorated or plain band of metal around the plinth which engaged with the swivel ends. Gold and silver swivel hoops are preserved, usually circular in section with cup-shaped finials. The scarab turns on wire, the ends of which are bound in a spiral around the ends of the hoop. The setting is rarely elaborated, as it is for later scarabs in Etruria. These hoops can be worn on the finger, beetle on the outside, and taken off, the scarab turned, for use as seals, but they are as easily worn as pendants. Larger silver hoops are commoner in Cyprus and these must have been worn as pendants. The Leningrad Gorgon gem has a short gold chain attached which could have encircled neck or forearm (*Pl. 378*). Rarely a scarab is set immobile in a finger ring hoop, like the fine lion rings (type G). The few Archaic ringstones are set on stirrup-shaped hoops, again for use as finger rings.

The ringstones, pendants, and great variety of metal finger rings are symptomatic of a period of experiment. Once satisfactory shapes, sizes and settings were determined further change came only slowly. By the end of the Archaic period most of the characteristic features of Classical gem engraving had been introduced.

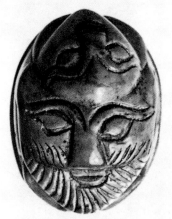
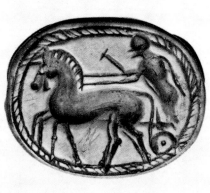

281

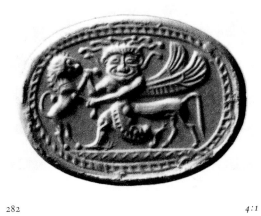

4:1　282　　　　　　　　　4:1

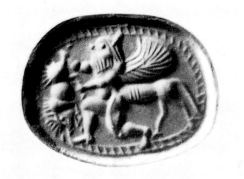

283　　　　　　　　　4:1

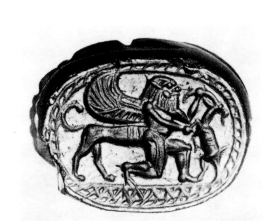

284　　　　　　　　　4:1

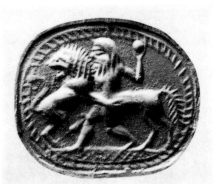

285　　　　　　　　　4:1

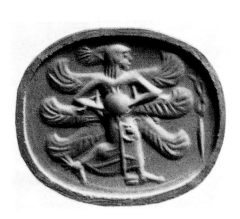

286　　　　　　　　　4:1

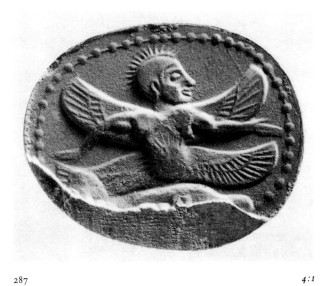

287　　　　　　　　　4:1

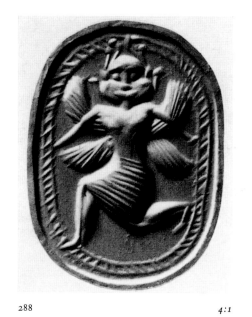

288 4:1

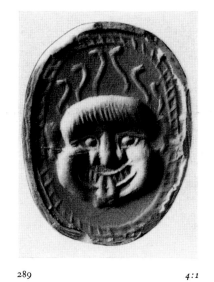

289 4:1

290 4:1

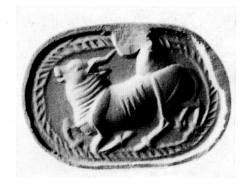

291 4:1

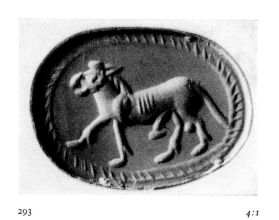

293 4:1

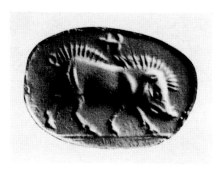

292 4:1

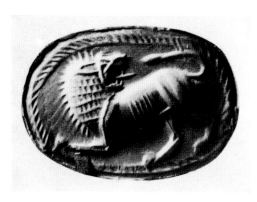

294 4:1

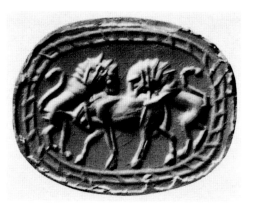

295 4:1

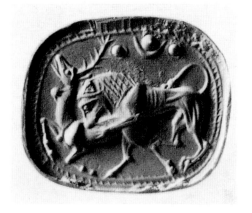

296 4:1

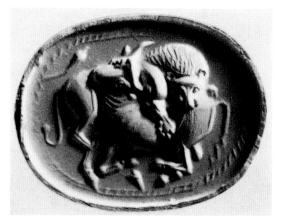

297 4:1

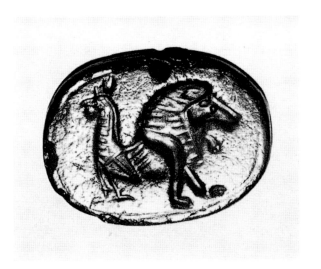

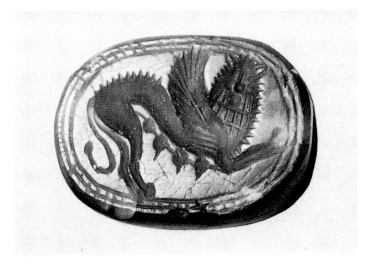

298 4:1 299 4:1

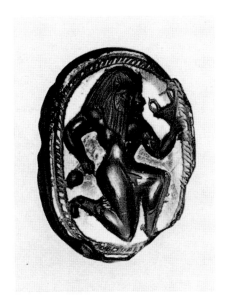

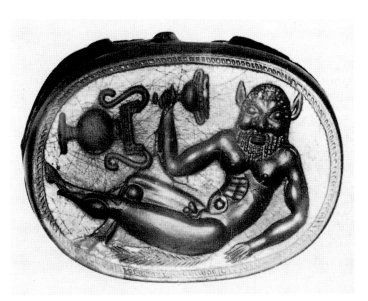

300 4:1 301 4:1

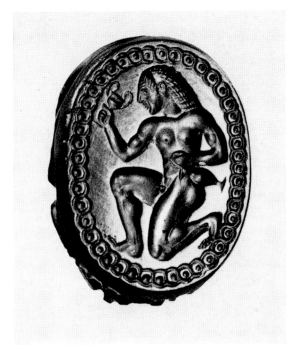

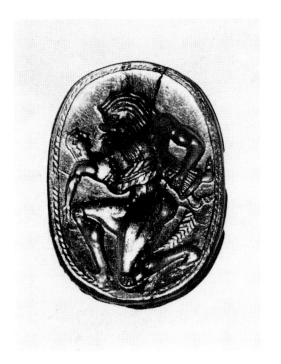

302 4:1 303 4:1

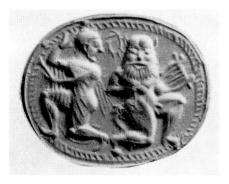

304 4:1

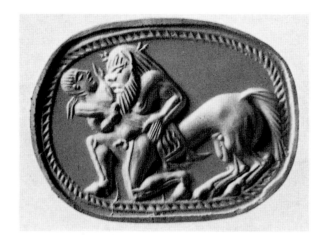

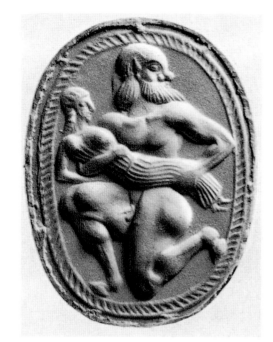

305 4:1

306 4:1

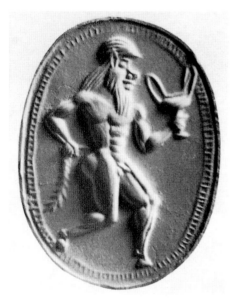

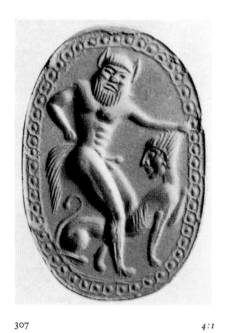

309 4:1

308 4:1

307 4:1

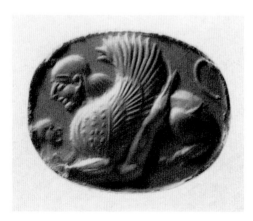

310 4:1

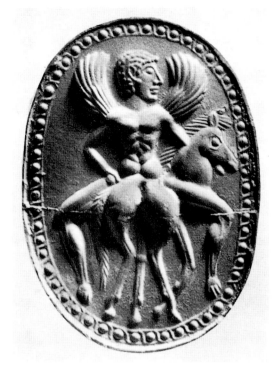

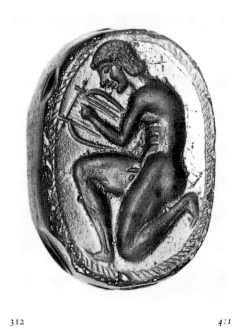

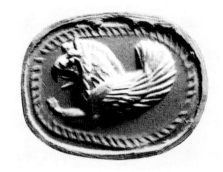

311 *4:1*

312 *4:1*

313 *4:1*

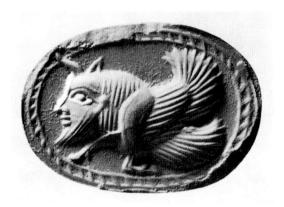

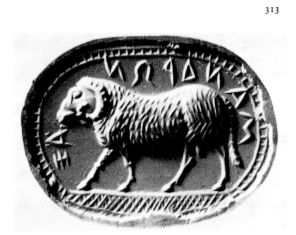

314 *4:1*

315 *4:1*

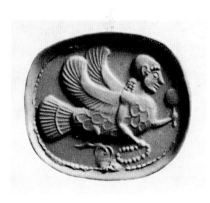

316 *4:1* 317 *4:1*

318 *4:1* 319 *4:1*

320

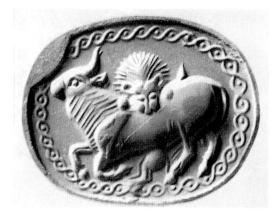

321 *4:1*

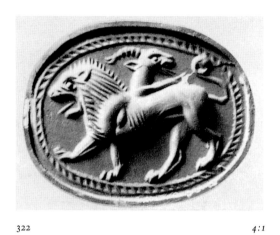

322 *4:1*

323 *4:1*

325 *4:1*

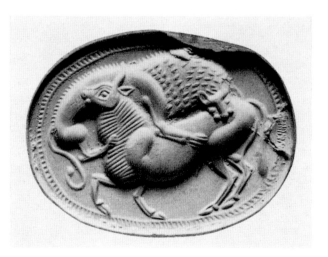

324 *4:1*

326 *4:1*

327
4:1

328 4:1

329 4:1

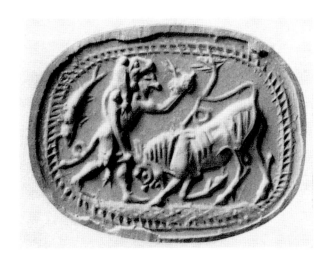

330 4:1

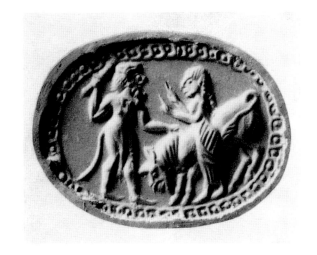

331 4:1

332 4:1

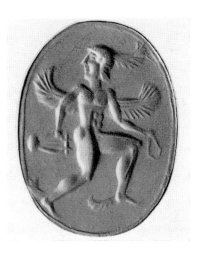

333
4:1

334
4:1

335 *4:1*

336 *4:1*

337 *4:1*

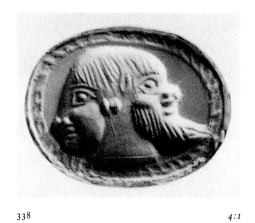

338 *4:1*

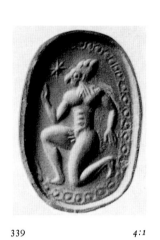

339 *4:1*

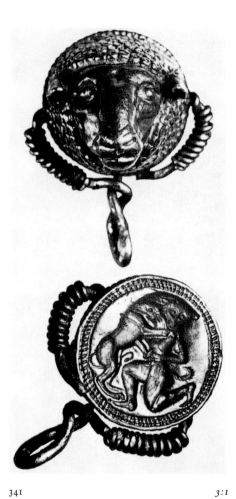

341 *3:1*

340 *4:1*

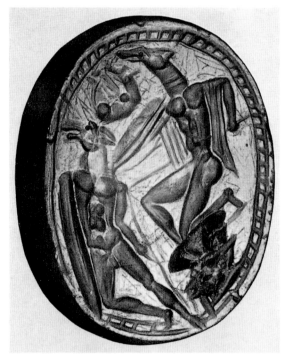

342 *4:1*

343 *4:1*

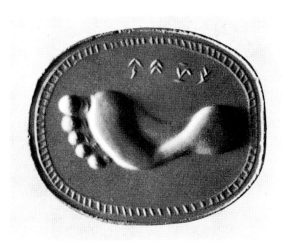

344 4:1

346 4:1

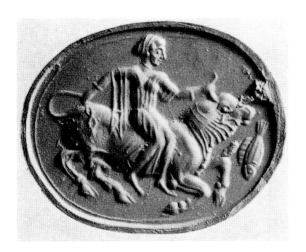

345 4:1

347 4:1

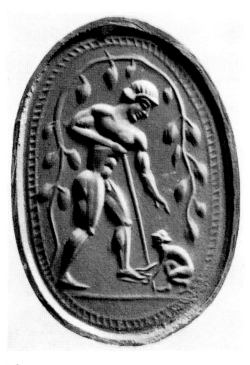

348 4:1

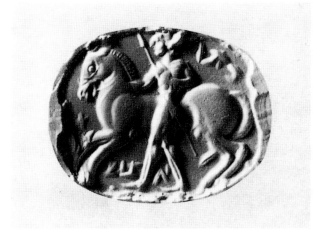

349 4:1

350

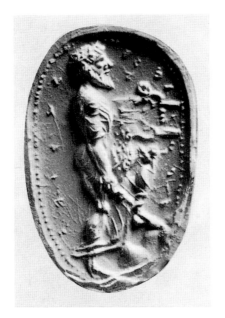

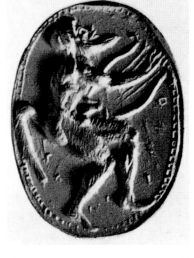

350 2:1

350 4:1

351 4:1

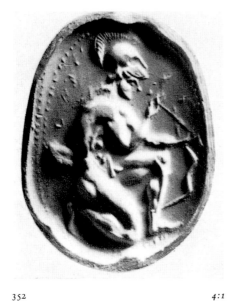

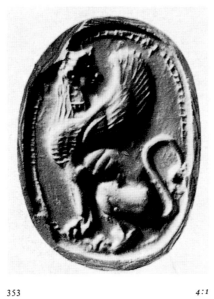

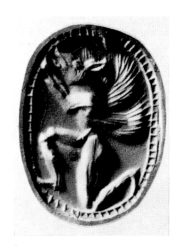

352 4:1 353 4:1

354 4:1

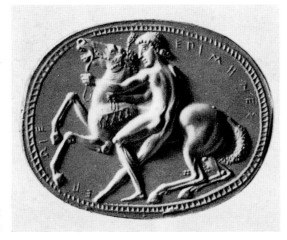

355

4:1

356

4:1

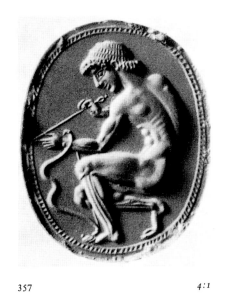

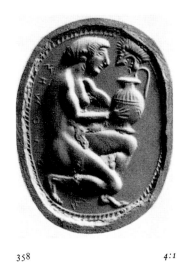

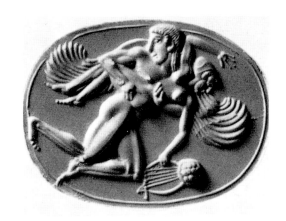

357 4:1 358 4:1

359 4:1

360 4:1

361 4:1

363 4:1

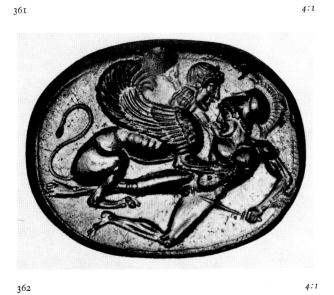

362 4:1

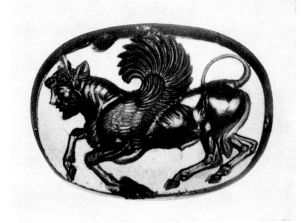

364
4:1

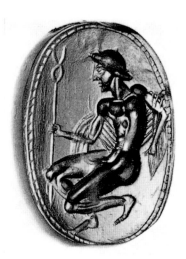

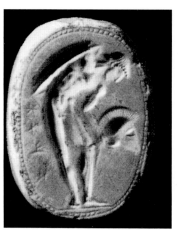

365 4:1 366 4:1 367 4:1

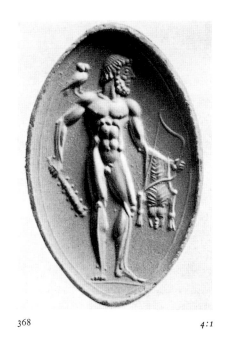

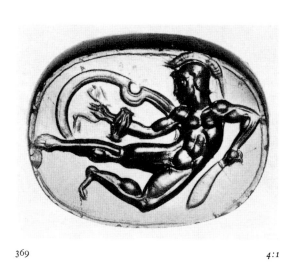

368 4:1 369 4:1

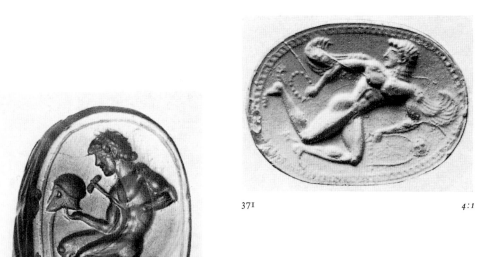

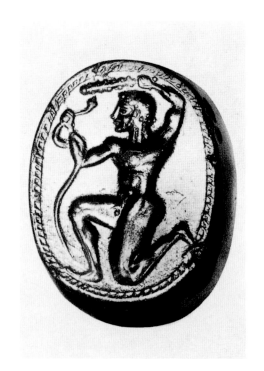

371 4:1

370 4:1 372 4:1

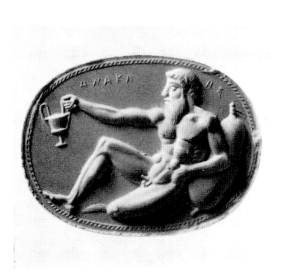

373

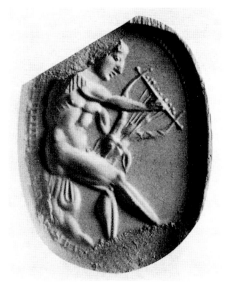

374 *4:1*

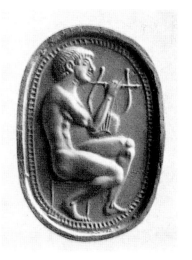

375 *4:1*

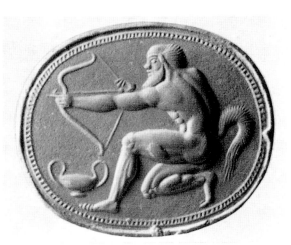

376

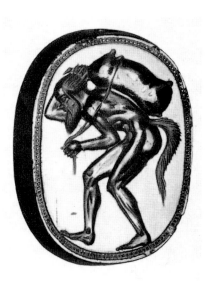

377 *4:1*

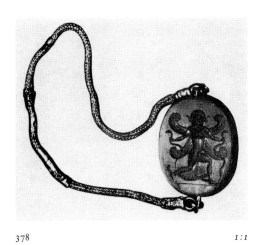

378 *1:1*

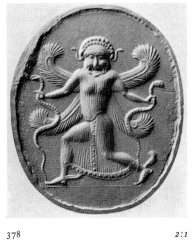

378 *2:1*

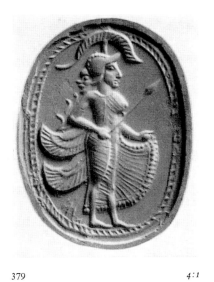

379 *4:1*

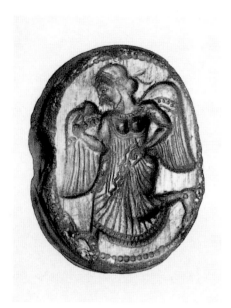

380

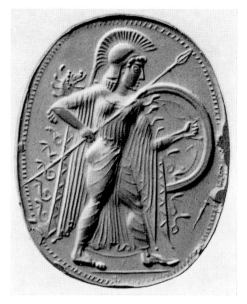

381 4:1

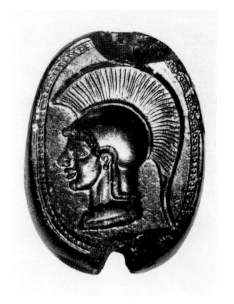

382 4:1

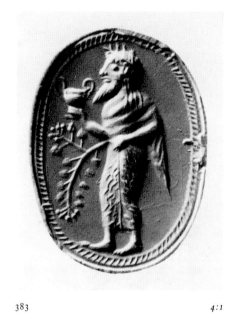

383 4:1

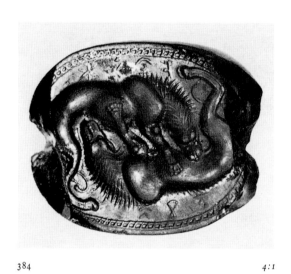

384 4:1

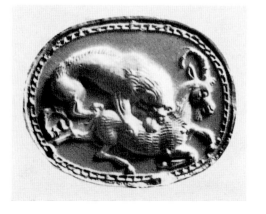

385 4:1

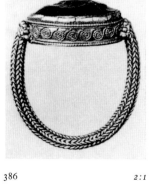

386 2:1

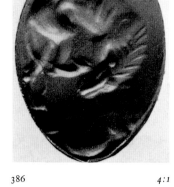

386 4:1

387
4:1

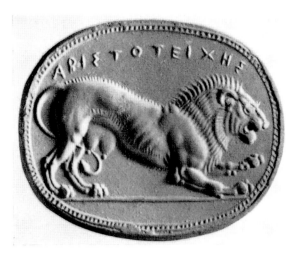

388 4:1

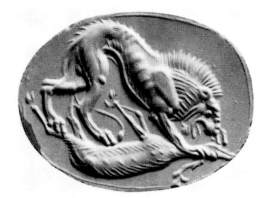

389
4:1

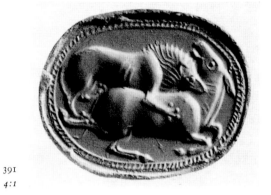

391
4:1

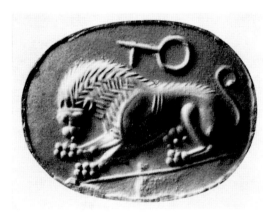

390 4:1

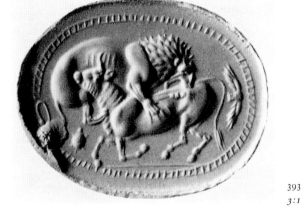

393
3:1

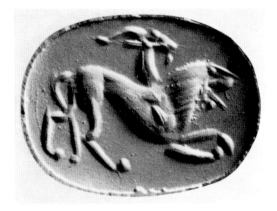

392 4:1

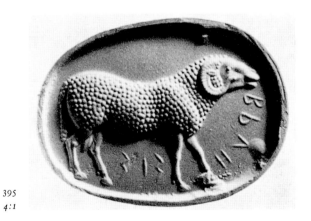

395
4:1

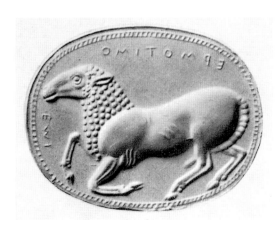

394 4:1

396
4:1

397　　　　　　　　　　　　　　　4:1

398　　　　　　　　　　　4:1

399　　　　　　　　4:1

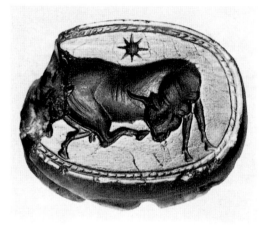

400　　　　　　　　　　　4:1

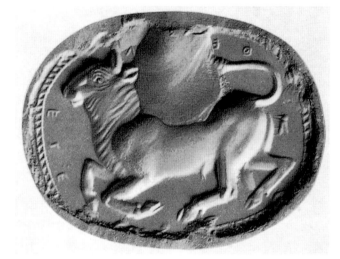

401　　　　　　　　　　　　　　4:1

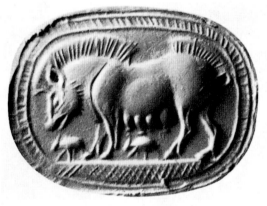

402　　　　　　　　　　　4:1

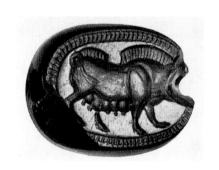

403　　　　　　　　　4:1

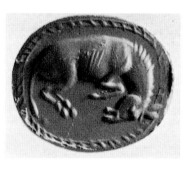

404　　　　　　　　4:1

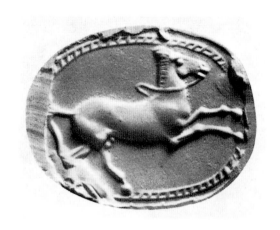

405　　　　　　　　　　　4:1

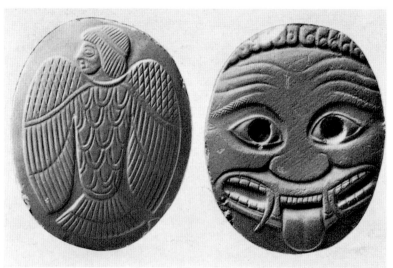

406　　　　　　　　　　　　　　3:1

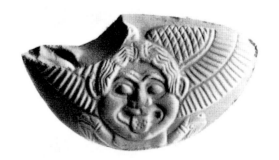

407

3:1

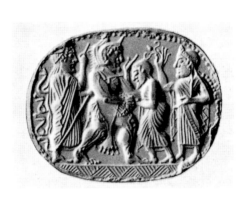

408　　　*3:1*　　408　　　*3:1*　　408　　　*3:1*　　408　　　　　　　　*4:1*

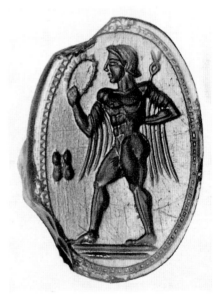

409　　　　　　*4:1*

410　　　　*4:1*　411　　　　　　　　*4:1*

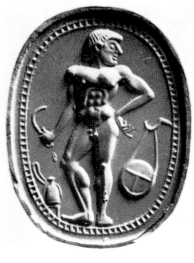

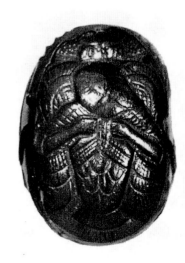

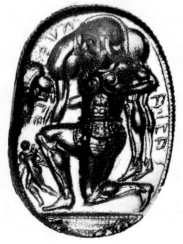

412　　　　　　　　*4:1*　413　　　　　　　　　　　*4:1*

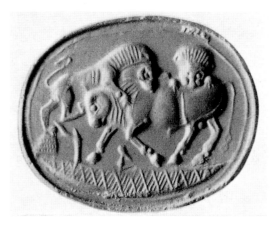

414 4:1

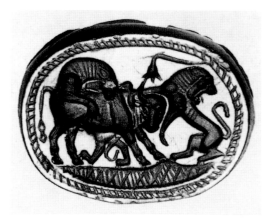

415 4:1

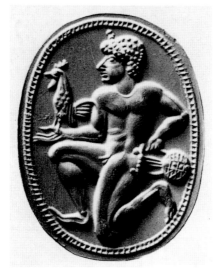

416 4:1

418
4:1

417 4:1

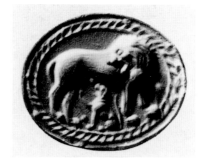

419 4:1

418 4:1

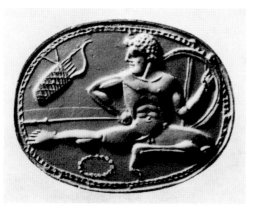

420 4:1

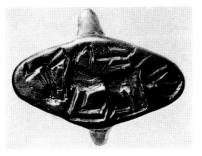

421

2:1

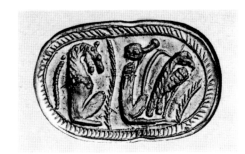

422

3:1

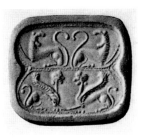

423

2:1

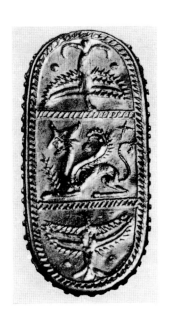

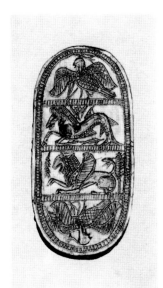

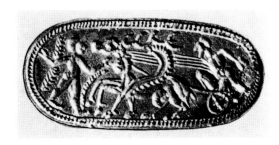

426

3:1

424

3:1

425

2:1

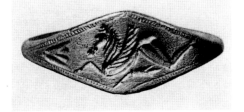

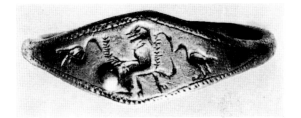

427

2:1

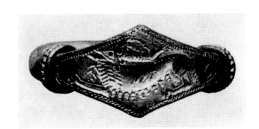

428

2:1

429

3:1

430

3:1

431

3:1

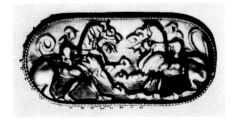

432

3:1

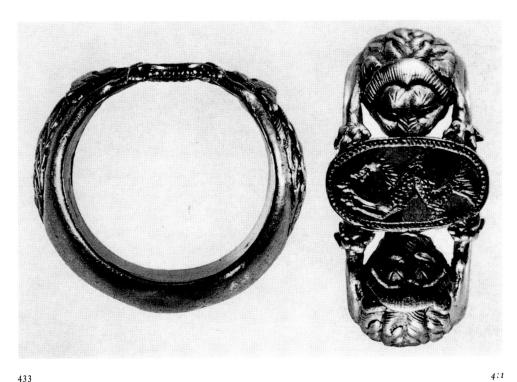

433

4:1

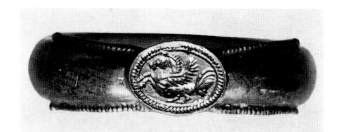

434 4:1

435 2:1

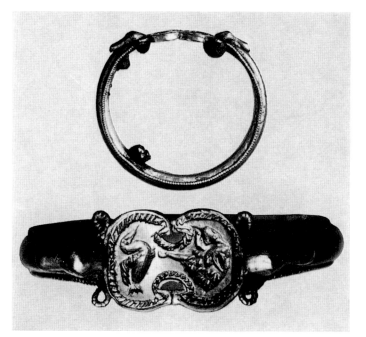

436 2:1 / 4:1

437 4:1

438 4:1

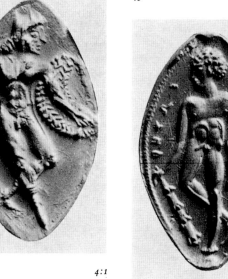

439 2:1

440 4:1

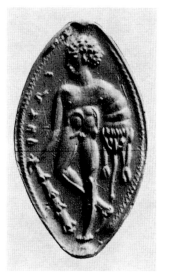

441 3:1

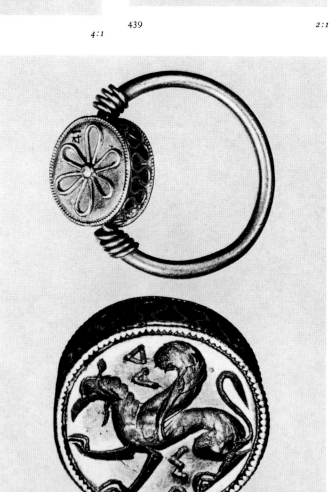

442 3:1

443 2:1 / 4:1

LIST OF ILLUSTRATIONS TO CHAPTER IV

Measurements are given of the maximum dimension of the intaglio face, in millimetres

COLOUR PLATES

TEXT FIGURES

BLACK AND WHITE PLATES

Asterisked numbers indicate that the piece is illustrated in original. All other photographs show impressions

Pl. 281* *London* 480, fig. 29, pl. 8. Pale green steatite pseudo-scarab. L.14. On the back two heads, crown to crown, one bearded. The device is a biga. *AGGems* no. 591, pl. 38. Others of this group are ibid., nos. 590, 592, 593, pl. 38, which are in the same material as the stone shown here (no. 590 is black). It is very soft, easily polished by wear, and commonly used for stamp seals in Bronze Age Cyprus.

THE ORIENTALISING STYLE

Pl. 282 Unknown. Cornelian scarab. L.14. A winged Gorgon with a horse's body and winged fore feet holds a rearing lion by its forelegs. Zigzag ground line. *AG* pl. 7.40; Lippold, pl. 76.3; *AGGems* no. 31, pl. 2. Animal genitals are shown, not obviously male, and the lumpy treatment might be a deliberate attempt to show dugs.

Pl. 283 Paris, BN, *Pauvert* 41, pl. 5. Cornelian scarab (carinated). L.15. A centaur-like monster with wings attached to the human back holds a boar upside down. *AG* fig. 220; *AGGems* no. 34, pl. 2. For figures of Bes with a boar on Greco-Phoenician gems see *Budapest Mus.Bull.* 1969, 9ff.

Pl. 284* *London* 317, pl. 6. Cornelian scarab (carinated). L.15. As the last but the monster's animal body is a lion's and it holds a goat, upright. Zigzag exergue. *AG* pl. 7.41; *AGGems* no. 35, pl. 2. Very close in style to the last, perhaps by the same hand. And compare the style of some Satyr Group gems, *AGGems* nos. 86, 87, 98, pl. 6, which are rather more fully modelled but must be close contemporaries. See *colour, p. 149.1*.

Pl. 285 Bowdoin College 1915. 68. Cornelian scarab. L.12. A centaur holding a rock fights a lion. *AG* pl. 6.45; Herbert, *Ancient Art in Bowdoin College* (Cambridge, 1964) no. 485; *AGGems* no. 39. Ordinary centaurs never fight lions in Greek art, but a Proto-attic Chiron caught a cub, *CVA* Berlin i, pl. 5.2.

Pl. 286 Oxford 1966. 595, from Cyprus. Chalcedony scarab. L.15. A six-winged deity with a winged cap and winged feet runs holding a disc. In front a caduceus. *AGGems* no. 40, pl. 3. The head wing is discussed ibid., 32; add, perhaps, the four-winged goddess on a Clazomenian sarcophagus, *Acta Arch.* xiii, 54, fig. 33; *BCH* xix, pl. 1; the Greco-Punic ring, *Arch.Viva* i.2, pl. xv.

Pl. 287 Péronne, Danicourt Coll., from Italy. Cornelian scarab (carinated). L.19. The bust of a four-winged deity wearing a radiate cap and with arms outstretched. At his waist is set a rayed disc. *AGGems* no. 43, pls. 2, 40. A near replica is Toronto 926.7.3 (ibid., no. 42, pl. 3), where the palms of the figure's hands are turned down in what looks less like a running position. The mass below, which appears on both, might be atrophied wings. The crossed cords on the chest rather suggest attached wings, in which case the 'flying' hands, sun disc and indistinct mass below might support the identification of an Icarus. But this would be an odd convention for him, while sun deities on these gems are well attested.

Pl. 288 *London* 471, pl. 8. Chalcedony scarab (carinated). L.20. A running Gorgon in a short skirt. *AGGems* no. 47, pls. 3, 40.

Pl. 289 *London* 473, pl. 8. Cornelian scarab (carinated). L.15. A gorgoneion. *AGGems* no. 68, pl. 4; no. 67, *London* 471, is a replica by the same hand.

Pl. 290 Basel, Dreyfus Coll. Cornelian scarab. L.7. A gorgon-horse, like that in *Pl. 282*, but here the forelegs are equine.

Pl. 291 Paris, BN F1007. Cornelian scarab (carinated, spine). L.13. A bull. *AGGems* no. 479, pl. 33.

Pl. 292 Istanbul, from Sardis, tomb 722. Cornelian scarab. L.13. A boar. *Sardis* xiii. 1 pls. 9, 11, no. 98; *AGGems* no. 497. The device over the boar's back is a personal blazon of a type which appears on many Achaemenid Lydian stamp seals, especially at Sardis. Here it is added to a Greek gem. See *Iran* viii, 19ff., pl. 8.195.

Pl. 293 Switzerland, Private. Rock crystal scaraboid. L.16. An ithyphallic mule. *AGGems* no. 506, pl. 33. The subject, in this form, is not seen again on Archaic gems.

Pl. 294 Naples 1188. Cornelian scarab (carinated, spine). L.15. A lion with its head turned back.

Pl. 295 Bonn, Müller Coll. Cornelian scarab. L.17. Two lions attack a bull. The scheme is that of Archaic Greek pediments, or some Phoenician gems (*AGGems* 123f., with n. 16).

Pl. 296 Paris, BN, *Pauvert* 58, pl. 5, from Etruria. Agate scarab (carinated). L.15. A lion attacks a stag. Above are three blobs, one with a crescent, like the common eastern symbol. *AGGems* no. 384, pl. 28.

Pl. 297 *London* 483, pl. 8, from Greece. Green jasper scarab. L.16. A lion attacks a bull. *AGGems* no. 391, pl. 28. An oddly compressed group, with the bull's legs drawn up and its head turned frontal. The last feature is rare on these stones but seen on Phoenician (as ibid., no. 368, pl. 27). From its material, this might be work by a Greek in a Phoenician studio.

Pl. 298* Leningrad 572. Cornelian scarab. L.15. A lion forepart joined to a cock. Micali, *Storia* iv, pl. 117.13; *AGGems* 125, as Etruscan, and cf. 71 with n. 34. On the lion's fear of the cock see Aesop 210, 269.

Pl. 299* Oxford 1892. 1355, from Demanhur. Cornelian scaraboid. L.17. A winged lioness with facing head. *AGGems* no. 462, pl. 32. The odd pose makes the mane look like a beard, and the whole figure rather like a Bes-sphinx. The dugs are misplaced, all along the belly.

THE ROBUST STYLE

Pl. 300* *London 466*, pl. 8. Cornelian scarab (carinated). L.20. A satyr with no tail but equine feet, runs with a kantharos and jug. *AG* pl. 8.20; *AGGems* no. 84, pls. 6, 40. By the same hand are ibid., nos. 85–87, 94, perhaps 102, pls. 6, 7. A related pair are nos. 101, 103, pl. 7. See *colour, p. 149.2.*

Pl. 301* *London 465*, pl. 8. Agate scarab (carinated and finely detailed). L.22. A satyr reclines, his head facing, his feet equine. He holds an empty kantharos and before him is a crater turned on its side. *AG* pl. 8.4; Lippold, pl. 14.8; Boardman, *Greek Art* (London, 1964) fig. 104; *AGGems* no. 93, pls. 6, 40, p. 55. There has been discussion whether this should be viewed 'feet down' with the satyr dancing. Iconographic criteria are contradictory. Aesthetically the upright head, as shown here, has more effect. This is the name piece of the Master of the London Satyr; for whom see *Burlington Mag.* 1969, 587f., figs. 10, 11, 15.

Pl. 302* London, Ionides Coll. Cornelian scarab (carinated, with V winglets). L.16.5. A youth runs with a jug and kantharos. *AG* pl. 8.19; Lippold, pl. 59.1; *Ionides* 1, pls. 1, 3; *AGGems* no. 97, pls. 7, 40. The head and hair type is matched on Ionian kouroi, and bronzes, especially from Samos, where the physique is generally rather less robust. It recurs in Italy, as on Caeretan vases, and the elaborate beetle suggests a Greek workshop in Etruria.

Pl. 303* Leningrad 553, from South Russia. Amethyst (not agate) scarab. L.14. A satyr carries a woman. His feet are equine. A more brutal version of *Pl. 305*. Maximova, *Kat.* pl. 1.4; *AGGems* no. 105.

Pl. 304 Boston, *LHG* 15, pl. 2. Black and red jasper scarab (carinated, with a palmette on the wing cases). L.12.5. A nymph and satyr dance. She is wearing a chiton; he holds a lyre and his feet are equine. Between them is a wreath. *AGGems* no. 88, pl. 6.

Pl. 305 Hanover 1965. 6. Rock crystal scarab. L.21. As *Pl. 303* but the satyr's tail is not shown. *AGGems* no. 107, pl. 7.

Pl. 306 *London 470*, pl. 8, from Sicily. Onyx scarab. L.20. A centaur carries off a woman. He is wreathed, has human forelegs with equine feet, in the common East Greek manner. *AG* pl. 8.5; Lippold, pl. 75.13; *AGGems* no. 108, pls. 7, 40, p. 55.

Pl. 307 Boston, *LHG* 17, pl. 2. Cornelian scarab (carinated). L.17. A satyr, with equine feet, is seizing a sphinx by her hair. *AG* pl. 63.1 and fig. 69; Lippold, pl. 14.1; *AGGems* no. 110, pl. 8.

Pl. 308 *New York* 29, pl. 5, from Cyprus. Cornelian. L.12. A youth with a crouching naked girl. He holds a stick and appears to be pulling her hair. *LHG* pl. A.1; *AGGems* no. 111, pl. 8. A similar erotic group, the man ithyphallic (it is odd that the youth's genitals are not shown on the gem), is seen on a red figure cup by the Brygos Painter (Vorberg, *Glossarium Eroticum* (Stuttgart, 1932) 187; Bloesch, *Formen* (Bern, 1940) pl. 23.2). For a man slippering a girl while making love, and vice versa, Vorberg, 188, 190 and 538 (*CVA* Berlin ii, pl. 59.4) and cf. the pursuit with a slipper, Vorberg, 38 and Gerhard, *Etr.Spiegel* (Berlin, 1840-67) pl. 423.2.

Pl. 309 Péronne, Danicourt Coll., from Sparta. Chalcedony scaraboid. L.18. A satyr with a cup. *AGGems* no. 121.

Pl. 310 Paris, BN, *Pauvert* 47, pl. 5, from Orvieto. Cornelian scarab (carinated, with a palmette on the thorax). L.12. A sphinx carries the body of a youth. *AG* fig. 217; *AGGems* no. 122, pl. 9.

Pl. 311 Leningrad 416. Burnt scarab, like that of *Pl. 301.* L.22. A winged youth, twisted at the waist, sits on a horse, seen from behind. Cable border. By the Master of the London Satyr. See *Burlington Mag.* 1969, 588, figs. 12, 13, 16.

Pl. 312* London 493, pl. 8. Cornelian scaraboid. L.17. A kneeling youth is playing a lyre. *AG* pl. 8.35; Lippold, pl. 59.3; *AGGems* no. 133, pl. 9. By the Master of the London Satyr. See *Burlington Mag.* 1969, 588, fig. 14.

Pl. 313 *Munich* i, 159, pl. 19, from Epidauros. Cornelian scaraboid. L.11.5. The forepart of a griffin. *AG* fig. 72; *AGGems* no. 130, pl. 9. Griffins are only commonly shown with manes after about 500 B.C. (cf. Boardman, *Greek Emporio* (London, 1967) 203). This is like a horse's mane, where later it is spined like a fin (as *Pl. 512*).

Pl. 314 Rome, Villa Giulia. Cornelian scarab. Forepart of a winged bull with human features. For the whole creature see *Pl. 364.* This device on coins of King Uvug of Lycia, *AGGems* 101, n. 16.

Pl. 315 *London* 445, pl. 8. Plasma scarab (carinated). L.18. A ram walking. Inscribed *Mandronax*, which is a good Ionian name. *AG* pl. 9.17; Lippold, pl. 91.11; *AGGems* no. 131, pls. 9, 40.

Pl. 316 *London* 459, fig. 28, pl. 8. Cornelian pseudo-scarab. L.11. On the back a capped siren is seen from the back, her head in profile. The device is a youth running with a lyre and flower. *AG* pl. 8.23; *AGGems* no. 128, pls. 9, 38, p. 55; Zazoff, *ES* no. 929. An early example of the pseudo-scarabs with a siren on the back, but it is simply imposed on the wing cases and does not replace them as on later specimens (cf. *Pl. 413*). See colour, *p. 149.4*.

Pl. 317 Hague. Cornelian. L.10. A siren holding a mirror and necklace. *AG* pl. 8.26; *Bull.Vereen.* xli, 50, fig. 1; *AGGems* no. 140. Sirens with human arms are mainly East Greek. They are shown with lyres, wreathes and neck-laces, which could suit their function as creatures of death and mourning; and on the Harpy Tomb from Xanthos, and *AGGems* no. 168 (*AG* fig. 70) carrying bodies. But the mirror and other attributes mentioned also recall their powers to charm, and not by song alone.

Pl. 318* *London* 487, fig. 30, pl. 8. Cornelian pseudo-scarab. L.11. On the back is a profile negro head. The device is a siren holding a wreath. *AG* pl. 8.30; Lippold, pl. 79.8; *AGGems* no. 143, pls. 10, 38, p. 55. Facing negro heads appear on the backs of Egyptian, Phoenician and Cypriot seals. This profile treatment is unusual.

Pl. 319* Oxford 1925. 130. Cornelian scarab. L.10. An owl or falcon displayed. *AGGems* no. 144, pl. 10. The long tail and legs make the bird more like the Egyptian or eastern falcon than the displayed owl as on slightly later Athenian coins (Kraay-Hirmer, figs. 357, 358). See *colour, p.149.3*

Pl. 320 Vienna 207. Cornelian scarab (carinated). L.15. A two-winged beetle. *AG* pl. 7.65; Lippold, pl. 97.17; *AGGems* no. 148, pl. 10. The Phoenician version of the Egyptian winged beetle normally has four wings, as on the Greek scarab, *AGGems* no. 175, pl. 11. Ibid., no. 147, pl. 11, is a simpler version of the Vienna device, with two wings.

Pl. 321 Cambridge. Cornelian scarab (elaborate, with tongues on the vertical border and incised winglets). L.15. A lion attacks a bull. Cable border. *AG* pl. 6.52; Lippold, pl. 85.3; *AGGems* no. 371, pl. 27; Zazoff, *ES* no. 2. This is unusual in having winglets of 'Etruscan' type on the beetle and for the attack from beyond the bull, which is an eastern trait. It was probably made in Etruria.

Pl. 322 London, Mrs Russell Coll., from Crete. Black jasper scaraboid. L.15. A chimaera. *AGGems* no. 374, pl. 27; Boardman, *Preclassical* (London, 1967) fig. 81a.

Pl. 323 *Munich* i, 189, pl. 21. Agate scarab. L.18. The foreparts of a bull and a lion; beside them a facing lion seated in a papyrus thicket. Lippold, pl. 84.5; *AGGems* no. 406, pl. 29. The scarab is detailed as those of *Pls. 301, 311, 324. Burl. Mag.* 1969, 588, fig. 20. By the Master of the London Satyr.

Pl. 324 *New York* 51, pl. 9, from Gela (a tomb with black-figure vases). Cornelian scarab. L.25. A lion attacks a bull. *AG* pl. 6.51; Lippold, pl. 85.14; *AGGems* no. 407, pl. 29; *Burl. Mag.* 1969, 588, fig. 18. By the Master of the London Satyr.

THE DRY STYLE

Pl. 325 Oxford 1892. 1479. Rock crystal scaraboid. L.21. A youth wearing a helmet runs with a lyre and cock in his hands. *AG* pl. 6.38; Lippold, pl. 58.13; *AGGems* no. 178, pl. 12. By the same hand are our *Pl. 326, Fig. 189*, and *AGGems* no. 180, pl. 12; cf. also our *Pl. 337*.

Pl. 326 *Berlin* F 139, pl. 4, D 76. Cornelian scarab. L.17. A seated satyr with human feet, holds a wreath, and extends a hand to a cock standing on his legs. *AG* pl. 8.2; Lippold, pl. 13.10; *AGGems* no. 179, pl. 12. See the last.

Pl. 327 Nicosia D.56. Cornelian scarab. L.9.5. A kneeling youth. *AGGems* no. 181, pl. 12.

Pl. 328* Leningrad 557. Cornelian scarab (carinated). L.14. A youth with helmet and shield jumps from the back of a galloping horse. Beneath the horse a bitch runs, and in the exergue is a lion mask, which also appears as the shield device. *AGGems* no. 201. A replica is *London* 442 (*AGGems* no. 200, pl. 13) and by the same hand ibid., no. 203 and our *Fig. 190*.

Pl. 329. Once Kammitsis, Nicosia, from Marion. Cornelian scarab. L.16. Herakles kneels to shoot at Nessos, who is trying to pull an arrow from his back. Deianira runs between them, looking back at her attacker. Overhead is the Egyptian ankh sign and a hovering falcon. Cross-hatched exergue. *BCH* lxxxv, 299f., fig. 52; *AGGems* no. 72, pl. 5.

Pl. 330 *Berlin* F 136, pl. 4, D 79, from Falerii. Plasma scarab (carinated). L.19. Herakles fights with Acheloos, seizing his horn and tail. One of Acheloos' mutations is shown by a serpent rising from his back. The fish probably indicates the river setting for the fight. Cross-hatched exergue. *AG* pl. 8.3; *AGGems* no. 74, pl. 5.

Pl. 331 *London* 489, pl. 8. Plasma. L.19. Herakles receives Acheloos' submission (see the last gem illustrated) and Deianira's thanks, holding aloft the horn he has broken from the beast. Cable border. *AG* pl. 6.39; *AGGems* no.

75, pl. 5. By the same hand as the last. The breaking off of the horn was an important feature of the encounter but is nowhere else shown as here.

Pl. 332 Paris BN 1812 bis, from Korkyra. Cornelian scarab. L.20. A sphinx carrying a youth. *AG* pl. 6.32; Lippold, pl. 79.4; *AGGems* no. 155, pl. 11. Contrast the style of *Pl. 310*.

Pl. 333 Boston, *LHG* 20, pl. 2. Chalcedony scaraboid. L.14. Eros holding a lyre and wreath. His head and heels are winged. *AGGems* no. 172, pl. 11.

Pl. 334* *London* 467, pl. 8, from Marion. Cornelian scarab (carinated). L.14. A winged goddess, with winged feet, runs holding a bowl. *AG* pl. 6.55; Lippold, pl. 32.1; *AGGems* no. 206, pl. 13.

Pl. 335 Boston, *LHG* 19, pl. 2. Chalcedony scaraboid. L.18. A winged goddess running, holding a snake. *AGGems* no. 204, pl. 13. The dress is probably a peplos over a chiton, for added warmth. Ibid., no. 205, pl. 14, is a replica, slightly plumper. By the same hand may be no. 210, pl. 13 and no. 212, pl. 14.

Pl. 336* *London* 481, pl. 8, from Amathus, tomb 256. Cornelian scarab (carinated, with V winglets). L.17. A youth is stooping to pick up a discus. Behind him is a strigil. *AG* pl. 9.6; Lippold, pl. 55.8; *AGGems* no. 215, pl. 14 and frontispiece.

Pl. 337* *London* 462, pl. 8. Cornelian scarab. L.10. A helmeted head. *AG* pl. 8.73; *AGGems* no. 221, pl. 14. See on *Pl. 325*. The type is met on East Greek coins.

Pl. 338 Switzerland, Private. Rock crystal scaraboid. L.14. Joined heads of a satyr and maenad. *AGGems* no. 228, pl. 14. The type is met on East Greek coins.

Pl. 339 Paris, BN, *Pauvert* 28, pl. 4. Cornelian scarab (carinated, with diamond winglets). L.13. A human figure with a bird's head and a pointed cap. A star in the field. *AGGems* no. 581, pl. 37. A replica is no. 582, and no. 577, pl. 37, may be by the same artist.

Pl. 340 Athens, Num. Mus., *Tzivanopoulos* 6, pl. 6. Red-brown limestone scaraboid. L.15. A satyr, with equine feet, lifts an amphora on to his shoulder. Inscribed twice in Cypriot *o-na-sa-to-se*, 'of Onasas'. Masson, *Inscr.Chypr.* (Paris, 1961) no. 362; *Syria* xliv, pl. 20.1, 2; *AGGems* no. 292, pl. 20.

Pl. 341 London, *BMC Jewellery* 1599, fig. 49, pl. 26, from Marion. Gold pendant in the shape of a sheep's head. W.12. A dog-headed man with a sword fights a lion. *AG*

pl. 64.7; *AGGems* no. 589, pl. 37, p. 155. There are dog- (or donkey-) headed men with swords on *AGGems* nos. 578, pl. 37, no. 579. See also our *Pl. 342* and a Fikellura vase, where the figure is also winged: *AA* 1929, 250, fig. 13.

Pl. 342* London 1929. 6–10.3. Chalcedony scaraboid. L.19.5. A dog-headed man fights a donkey-headed man, each with shield and spear, the former with a cloak over his shoulders and kneeling on an object, now largely broken away. Above is a small donkey rolling. *AGGems* no. 293, pl. 20. See the last.

Pl. 343 *New York* 31, pl. 5. Cornelian scarab. L.15. Herakles brandishes his club and holds a lion upside down by its tail. Behind him is a fox. *AG* pl. 7.54; Lippold, pl. 37.7; *AGGems* no. 297, pl. 20. The whole group, with the fox, appears also on Greco-Phoenician gems; and without the fox on Phoenician coins. Herakles is rarely beardless in Archaic Greek art; see *AGGems* 105 with n. 9.

Pl. 344 Oxford 1896–08.O.14, from Cyprus (once Tyszkiewicz and Warren). Chalcedony scaraboid. L.15.5. A footprint, and the Cypriot inscription *pi-ki-re-wo*, 'Pigrewos'. *AG* pl. 9.18; Masson, *Inscr. Chypr.* no. 360. A footprint on a Late Classical silver ring (Notes to Ch. V, no. 881) and with other motifs on Greco-Punic scarabs as *London* 430, 431, pl. 7.

Pl. 345 Oxford 1966. 596. Moss agate cut scaraboid. L.18. Europa riding the Zeus-bull, holding on to its horn and tail. In front is a tunny fish. *AGGems* no. 305, pl. 20.

Pl. 346 *London* 495, pl. 9. Agate scaraboid. L.22. A small satyr lifts from the ground a maenad who is carrying a thyrsos. *AG* pl. 10.9; *AGGems* no. 306, pl. 21.

Pl. 347 Unknown. Cornelian scarab. L.17. A satyr drives a chariot drawn by two lions. *AG* pl. 8.42; Lippold, pl. 13.9; *AGGems* no. 328, pl. 23. Dionysos may drive a lion chariot and he is sometimes attended by a satyr in the fight against the Giants: e.g., Lullies, *Gr. Kunstwerke* (Sammlung Ludwig: Düsseldorf, 1968) 114, no. 46, on a red figure vase.

Pl. 348 Paris, BN, *Pauvert* 84, pl. 6, from Asia Minor. Chalcedony scarab (carinated, with V winglets). A crouching boy adjusts the sandal of a youth who is leaning on a stick. A vine grows around them. *AG* fig. 223; Lippold, pl. 56.15; *AGGems* no. 309, pl. 21.

Pl. 349 Péronne, Danicourt Coll. Cornelian scaraboid. L.14. A youth with a spear is leading a horse. *AGGems* no. 330. The inscription seems ancient but meaningless, the characters being more like Aramaic than Cypriot.

Pl. 371 Boston, *LHG* 33, pl. 2, from Caria. Cornelian scaraboid. L.14. Eros flies with wreath and lyre. His heels are winged. *AGGems* no. 272, pl. 19.

Pl. 372* Leningrad 551. Cornelian scaraboid. L.15. A kneeling Herakles with a club grapples with a snake.

Pl. 373 *New York* 46, pl. 7, from near Heraklion, or, as Mr T. H. G. Ward tells me, found in Samos. Black jasper scaraboid. L.16. A satyr reclines on a wine skin holding a kantharos. Inscribed *Anakles*. *AGGems* no. 333, pl. 23.

Pl. 374 Boston 98.734. Cornelian scarab (with decorated vertical border). L.15. A youth seated on a rock is tuning a lyre. *AGGems* no. 334, pl. 23. The goat horns of the lyre are clearly marked.

Pl. 375 Berlin 11.863.66, D91, Cornelian scarab. L.17. A young man on a stool is tuning his lyre. *AGGems* no. 335, pl. 24.

Pl. 376 Baltimore 42.461. Cornelian scaraboid. L.17. A kneeling satyr draws a bow. A kantharos on the ground before him. *AGGems* no. 336, pl. 24. On armed satyrs see Corbett, *JHS* lxxxv, 17; for their theft of Herakles' arms, Brommer, *Satyrspiele* (Berlin, 1959) 34ff.

Pl. 377* *London* 516, pl. 9, from Athens (?). Cornelian scaraboid. L.17. A satyr carries a full wine skin on his back, supported by a cord. *AG* pl. 9.27; Lippold, pl. 13.6; *AGGems* no. 337, pl. 24, frontispiece. By the same hand as the last.

Pl. 378 Leningrad, from Kerch. Chalcedony scaraboid. L.27. A four-winged Gorgon with winged heels and holding a snake in each hand. Set on a gold chain. *AG* pl. 8.52; Lippold, pl. 76.9; Maximova, pl. 2.5; *AGGems* no. 236, pl. 15.

Pl. 379 *London* 437, pl. 8, from Amathus. Agate scarab. L.17. A winged Athena. Her aegis is slung at her back and the mask, which is normally a gorgoneion, is shown as a satyr head in profile at the back of her neck. *AG* pl. 6.56; Lippold, pl. 20.5; *AGGems* no. 237, pl. 15. The wings attached at the waist or lower are an East Greek or Etruscan feature, and in Etruria too we see the mask translated and set at the back of the neck. Wings for Athena, and some other deities, seem an East Greek speciality but are on rare occasions shown in late sixth-century Athens. See *colour, p. 149.5*.

Pl. 380* *London* 468, pl. 8. Rock crystal scarab (carinated). L.15. A winged woman running, holding a flower. *AG* pl. 8.27; *AGGems* no. 238, pl. 15.

Pl. 381 Boston, *LHG* 26, pl. 2. Chalcedony. L.17.5. Athena. *AGGems* no. 239, pl. 15. The aegis snakes are

here shown fringing the himation, as occasionally on Athenian vases. As on *Pl. 379* the aegis mask is at the back of the neck, here like a serpent.

Pl. 382* Leningrad 548. Moss agate scaraboid. L.14. A helmeted head. Compare the Kyzikos coin, Kraay-Hirmer, fig. 701.

Pl. 383 Cambridge. Rock crystal scarab (carinated, with V winglets). L.15. Dionysos, wreathed, holding a kantharos and ivy branch. *AGGems* no. 242, pl. 15. A very rare example of a rock crystal scarab. Etruscan versions of the Dionysos, *AG*, pl. 16.15, 16.

Pl. 384* *London* 450, pl. 8, from Cyprus. Black jasper scaraboid. L.15. Two lions fighting. Cypriot inscription, *a-ri-si-to-ke-le-o*, 'of Aristokles'. Masson, *Inscr. Chypr.* no. 359; *AGGems* no. 423, pl. 30. Another example of the motif on a gem is ibid., no. 400, pl. 29. By the same hand as *London* 450 are *AGGems* no. 422 (Masson, no. 259) and our *Pls. 385, 386*.

Pl. 385* Paris, *de Clercq* 2794, pl. 19, from Beirut. Chalcedony scaraboid. L.14. A lion scratches its nose with a hind leg. On its back is a cock and before it a monkey. Cypriot inscription *ka-pa-sa*. Masson, *Inscr. Chypr.* no. 365; *AGGems* no. 424, pl. 30. The animal mixture might be taken to be inspired by hieroglyph devices, as that on *Pl. 422*, which has also been 'translated' by a Cypriot. Compare also the falcon over a basket on the situla fragment, *CVA* London viii, pl. 2.2. For the monkey and lion see the Etruscan ring, *AFRings* B.I.32. There are eagles on lions' backs on Cypriot coins, as Kraay-Hirmer, fig. 679.

Pl. 386 Nicosia 1960. VI-21.1. Cornelian ringstone. L.13. A lion scratching its nose. Below is a murex shell. *BCH* lxxxv, 259, fig. 2, pl. 5.2, 3; *AGGems* no. 425, pl. 30. By the same hand as the last. Phoenicians extracted the valuable purple dye from murex shells, and they are sometimes found as offerings or decoration in Greek sanctuaries.

Pl. 387 Péronne, Danicourt Coll. Green jasper scarab (pinched back). L.14. A lion attacks a goat.

Pl. 388 Unknown, from near Pergamon. Plasma scarab. L.18. A lioness. Inscribed *Aristoteiches*. *AG* pl. 8.43; Lippold, pl. 84.7; *AGGems* no. 427, pl. 31. The dugs are here correctly placed.

Pl. 389 *London* 539, pl. 9, from Kourion. Chalcedony scaraboid. L.19. A lion dragging a dead stag by its throat. *LondonR* 295, pl. 8; *AGGems* 436, pl. 31. The action of the lion with its prey is correct.

Pl. 390 Istanbul, from Sardis, tomb 701. Haematite scaraboid. L.17. A lioness. Sardis xiii.1 pls. 9, 11, no. 99;

AGGems no. 431; *Iran* viii, pl. 8.194. The symbol over the lioness' back was added in Sardis. See on *Pl. 292*. In this style are *AGGems* nos. 432, 433, pl. 31 and compare the next.

Pl. 391 Boston, from Cyprus. Chalcedony scarab. L.14. A lion attacks a horse. *AG* pl. 31.2; *AGGems* no. 440, pl. 31.

Pl. 392 Leningrad 582, from Aegina. Black jasper scaraboid. L.16. A chimaera. Lajard, *Mithra* pl. 46.2; *AGGems* no. 456.

Pl. 393 Boston, from Thebes. Chalcedony scaraboid. L.22. A lion attacks a bull. In the field is a winged sun disc and a tortoise. *AG* pl. 6.44; Lippold, pl. 85.12; *AGGems* no. 450, pl. 32. The tortoise recalls the tiny devices seen in the field on coins, possibly the personal blazons of officials. The eastern sun disc is here strangely subordinated to the device.

Pl. 394 Boston, *LHG* 35 bis, pls. 2, 9, from near Dimitsana. Chalcedony scaraboid. L.16. A ewe. Inscribed *Ermotimo emi*, 'I am of Hermotimos'. *AGGems* no. 516, pl. 34.

Pl. 395 Paris, BN, *Pauvert* 67, pl. 6, from the 'Ionian Islands'. White jasper scaraboid. L.17. A ram. Inscribed *Bryesis*. *AG* pl. 9.11; Lippold, pl. 91.9; *AGGems* no. 518, pl. 34.

Pl. 396 *London* 506, pl. 9, from Greece. L.14. A ram's head. *AGGems* no. 519, pl. 34.

Pl. 397 *Berlin* F 302, pl. 6, D 169, from Tanagra. Cornelian scaraboid. L.19. A bull. Inscribed . . *dos*. *AG* pl. 8.41; *AGGems* no. 526. The border of dotted squares appears only here on Greek gems, except for the dress pattern on *Pl. 378*.

Pl. 398 Leningrad 561. Cornelian scaraboid. L.15. A bull. Close in style to the last, but probably later.

Pl. 399 Basel, Dreyfus Coll. Cornelian scarab. L.7. Forepart of a winged boar. The motif is seen on other Archaic gems, on Phoenician gems and on coins of North Greece, Ialysos, Samos, Chersonesos and Klazomenai.

Pl. 400* Nicosia 1964. XII–4.10, from Marion. Cornelian. scarab (carinated). L.15. A bull scratching its muzzle. In the field is a star. *BCH* lxxxix, 237, fig. 8; *AGGems* no. 529, pl. 35.

Pl. 401 Boston 01.7545. Rock crystal scaraboid. L.19. A bull with a gadfly on its rump. Inscribed *the . . lese. LHG* pl. A.15; *AGGems* no. 524, pl. 35. A Zeus-bull is attacked by a gadfly on coins of Gortyn, where, on the obverse, a figure

in a tree is usually identified as Europa. See also our *Fig. 194*.

Pl. 402 Leningrad 567. Chalcedony cut scarab. L.17. A sow with two piglets. Cross-hatched exergue. *AG* iii, 105; *AGGems* no. 542. Replica of no. 541.

Pl. 403* Oxford 1925. 132. Cornelian scaraboid. L.11. A sow. *AGGems* no. 547.

Pl. 404 Paris, BN M 6468. Cornelian scarab. L.11. A rolling horse. *AGGems* no. 565, pl. 36.

Pl. 405 Paris, BN, *Pauvert* 65, pl. 6. Cornelian scaraboid. L.13. A horse with loose reins. *AGGems* no. 566. A motif which becomes very popular in the Classical period, see *Pls. 473, 475–477*.

GREEKS IN ETRURIA

Pl. 406 *London* 455, pl. 8. Cornelian biconvex. L.22. On one side a displayed siren. On the other a gorgoneion. Both in relief. *AGGems* no. 596, pl. 39; Zazoff, *ES* no. 20. The alternate-hatched eyebrows are seen on contemporary Cypriot sculpture.

Pl. 407 *London* 454, pl. 8. Cornelian half-oval convex. L.24. A gorgoneion set in two wings. Two snakes at the neck. In relief. *AGGems* no. 600, pl. 39; Zazoff, *ES* no. 518. There is a gorgoneion with four wings on another relief gem of this set, ibid., no. 599, pl. 39 (our *colour*, p. 149.6). The addition of wings becomes usual later, though they are usually reduced in size and set in the hair.

Pl. 408 Boston, *LHG* 35 ter, pls. 2, 8, 9. Cornelian pseudoscarab. L.14. On the back in relief is a Dionysos holding a drinking horn and vine. The device shows Herakles fighting a shorter, bald man. To the left is Athena, to the right a woman with a flower. Nereus or Geras have been suggested as Herakles' opponents. *AGGems* no. 77, pls. 5, 38; Zazoff, *ES* no. 18 and *JdI* lxxxi, 63ff. and fig, 4, where works by the same hand (Master of the Berlin Dionysos) are listed. See also the next.

Pl. 409* Oxford F.74. Agate scarab. L.9. A youth holding a necklace. Attributed to the Master of the Boston Dionysos (our last) by Zazoff, op. cit., with fig. 1, and *ES* no. 15.

Pl. 410 Paris, Louvre, Bj.1193. Cornelian scarab (simple, with winglets). L.7.5. A woman, possibly helmeted, holding a necklace and flower. By the Master of the Boston Dionysos.

Pl. 411* Oxford 1953. 133. Cornelian scarab (carinated, with V winglets). L.17. Hermes, with caduceus and wreath. A knucklebone in the field. *AGGems* no. 338, pls. 24, 40, frontispiece; Zazoff, *ES* no. 730.

Pl. 412 *London* 490, pl. 8. Chalcedony. L.16. An athlete holding a strigil. On a box before him a Columbus alabastron and a discus hanging behind him. *AG* pl. 8.53; *AGGems* no. 340, pl. 24.

Pl. 413* Leningrad 676. Cornelian pseudo-scarab. L.14. On the back a siren in relief. The device shows Ajax carrying the dead Achilles. In front of them is a small winged figure, a soul (?). Inscribed *Aiwas, Achele. AG* pl. 16.19 and ii, 76; *AGGems* no. 605; Zazoff, *ES* no. 11.

GREEKS AND PHOENICIANS
Pl. 414 *London* 416, pl. 7, from Tharros, tomb 8. Green jasper scarab. L.17. Two lions attack a bull. One lion stands on a basket (?). Phoenician letter in the field (?). *AGGems* no. 365, pl. 27.

Pl. 415* *London* 334, pl. 6. Green jasper scarab. L.17. Two lions attack a bull. *AGGems* no. 367, p. 155.

Pl. 416 Cambridge. Green jasper scarab. L.16. A youth with a cock and a lyre. *LHG* p. 115.

Pl. 417 *London* 428, pl. 7, from Tharros. Green jasper scarab. L.14. A grotesque composed of two human heads, one bearded, a satyr mask, a boar forepart and a bird. *AG* pl. 15.89; *Syria* xliv, 370, fig. 2. On the subject see *AGGems* 84, *Ionides* p. 35.

Pl. 418 Leningrad 549. Green jasper scarab (carinated, ridge). L.12. Helmeted head (of Athena) and an owl. *AG* pl. 6.59; *AGGems* no. 243.

Pl. 419 Bonn, Müller Coll. Green jasper scarab. L.11. A lioness suckling a cub.

Pl. 420 Paris, BN 1082 bis. Green jasper scarab. L.15. A falling warrior, struck in the back by a spear. A bowcase and wreath in the field. *AG* pl. 9.24; Lippold, pl. 51.11.

FINGER RINGS
Pl. 421* Oxford F.91, from the Greek islands. Gold. L.24. Two kneeling quadrupeds. *IGems* 157, pl. 20h; *AFRings* 5, pl. 1a.

Pl. 422* Nicosia J.370, from Marion. Electrum. L.20. Mock hieroglyphs. *AFRings* A.1. The hieroglyphs are translated into more natural animal forms.

Pl. 423 *New York* 24, pl. 5, from Cyprus. Gold. L.15. Double bezel. Two lions and two sphinxes. *AFRings* A.3, pl. 1. For other Cypriot double bezels see *AFRings* A.2, which is inscribed; Nicosia J.796, with two lions and two goats, and Nicosia J.767, with a lion and sphinx.

Pl. 424* Boston 98.775. Gold. L.23. Flying birds in the outer panels, a sphinx, cross and branch in the centre. *AFRings* B.I.17, pl. 2 (16 is a replica).

Pl. 425* *LondonR* 20, fig. 6, pl. 1. Gold. L.27. A siren and branch in each outer panel. A hippocamp and fish, and a winged lion in the centre panels. *AG* pl. 65.2; *AFRings* B.I.31, pl. 2.

Pl. 426* Paris, BN 2615. Gold. L.21.5. Chariot drawn by a sphinx and a stag, approached by a man. *AG* fig. 60; *AFRings* B.II.8, pl. 2.

Pl. 427* *LondonR* 23, pl. 1. Gold. L.24. A sphinx and winged horse. *AFRings* B.II.36, pl. 3. By the same hand is ibid., B.II.27, pl. 3.

Pl. 428* London, Victoria and Albert. Gilt silver. L.29. Relief device of two men holding two lions. *AG* fig. 62; Oman, 40, pl. 3; *AFRings* B.IV.15, pl. 4.

Pl. 429* Paris, Louvre Bj. 1346. Silver. Forepart of a winged horse joined to a human leg. A flower and palmette in the field. *AFRings* F.8, pl. 5. The same device on a ring from Chios (*AFRings* C.2) and cf. *AGGems* p. 152 for gems (as our *Fig. 196*).

Pl. 430* Switzerland, Private. Silver, with a gold stud. A man seated holding a branch, between two birds. Soldered hoop to a ring of Type F.

Pl. 431* Paris, Louvre Bj.1340. Silver. A lioness carries a stag in her jaws, over her back. *AFRings* F.33, pl. 5. Lions are shown carrying their prey like this in Greek art, including a gem; see *AGGems* no. 413, pl. 29 and p. 129.

Pl. 432 Switzerland, Private. Gold lion ring. L.9. Hyakinthos.

Pl. 433* Munich, Ant.Kl. 2409, from Etruria. Gold lion ring. L.12. A sea serpent with pointed muzzle and lion forelegs. *AG* pl. 6.27; *AFRings* G.1, pl. 6. The animal features of the Greek monster distinguish it from the commoner Greek or Etruscan hippocamp. The type is discussed in *AFRings* 21, n. 66; and add serpent representations on the Cretan bronze helmet, Mitten and Doeringer, *Master Bronzes*, (Harvard, 1967) 47.

Pl. 434* *LondonR* 33, pl. 1. Gold. L.6.5. A cock horse, *AFRings* H.1, pl. 6.

Pl. 435* *LondonR* 34, fig. 8, pl. 1. Gold L.5.5. Lion mask at each end of the bezel. The device is a kneeling archer. *AFRings* K.8, pl. 6.

Chapter V

CLASSICAL GEMS AND FINGER RINGS

This chapter deals with the engraved gems and finger rings made in the Greek world in the fifth and fourth centuries BC. It is not a period which, for our purposes, can be defined by precise dates. What went before is Archaic. What comes afterwards is Hellenistic. And inasmuch as the Archaic and the Hellenistic offer distinctive styles this is definition enough. The main characteristics of the Classical will be the dominance of the scaraboid shape and the growth in popularity of finger rings with either metal or inset stone bezels; the spread of an art and usage from what was almost exclusively East Greek in the Archaic period to the whole Greek world, from Italy to the Persian Empire; new subjects; and a very few but important artists' names.

The subjects and purpose of the engraved metal finger rings are sufficiently like those of the engraved gemstones for them to be considered together in one chapter, but not sufficiently alike for schools or, I believe, artists dealing with both stone and metal to be certainly identified. The techniques were different, since the drill was not used on the metal bezels, so direct comparisons are difficult even though the same artists could have been at work. The groups of gemstones have therefore been composed and will be discussed independently of the groups of finger rings, although there will be some occasion for comparisons to be drawn between them, and their sources and use can be considered together.

The sources for Classical gems and rings are quite different from those which serve us in the Archaic period, except for the many which have reached collections without known provenience. More have been excavated, usually in tombs, and on the periphery of the Greek world. These circumstances might seem to give promise of good evidence for dating, but this has rarely proved the case. By their nature the gems and rings had a long life above ground, and we are generally able to suggest closer dates on purely stylistic grounds than anything offered by a tomb context with pottery or coins. What is of value, however, is the certainty of provenience, and the knowledge that the pieces were worn, used and buried in a particular place.

One of the most important sources lies far from the Greek homeland, in South Russia. East Greeks, principally from Miletus, had founded colonies on the shores of the Black Sea and in the Crimea from the end of the seventh century on. They prospered on the adjacent corn lands and fisheries and had much to do with the Scythian kingdoms which controlled the mainland. Greek artists worked for Scythians on objects of Scythian type and at first in an unhappy approximation to the Scythians' own 'animal style' of decoration. In the Classical period the Greek work there makes concessions only to native shapes, not to native styles, and the question must arise whether, beside the other work of high quality in precious metals, some of the gold finger rings found in South Russia could also have been made in the colonies. The finds have been made in both Scythian tombs, massive tumuli characterised by their built burial chambers and sacrifices of horses, and in Greek tombs near the colonies. Of the first class we may mention the great Chertomlyk (Nikopol) tomb, over one hundred miles up the Dniepr from the sea, and the so-called Seven Brothers Tumulus in the Kuban, behind the Taman peninsula east of the Crimea. Of the second class, the Greek tombs, the most important are those in the cemeteries of Kerch, ancient Panti-

capaeum, and Nymphaeum, on the east coast of the Crimea, and others on the Taman peninsula facing them, near the cities of Phanagoria and Gorgippia. In the great Chertomlyk tomb the debris of the 'king's' tomb yielded two engraved gold rings, while the 'queen' in one of the chambers wore a gold ring on every finger, including one engraved. In the Great Bliznitsa tomb, near Phanagoria, the 'priestess of Demeter' had four engraved gold rings, and not far away a broken sarcophagus contained one of Dexamenos' signed gems and a gold ring. All these burials were richly furnished with other jewellery and vases, sometimes with coins, and these finds make it possible to fix fairly closely the date of interment. The gems and rings, however, are almost without exception of much earlier date, sometimes by as much as a hundred years. Thus, the Leningrad Gorgon gem (*Pl. 378*), still Late Archaic in style, was found with a fully Classical gold ring (*Pl. 703*), with a gem which can be associated with Dexamenos (*Pl. 475*), and with jewellery and vases of the early fourth century, which indicate the date of the burial. Beside the Greek gems and rings a number of Achaemenid seals were found in South Russian tombs, usually from Asia Minor and almost always in very much later contexts. The engraved stones from these sites have often suffered from exposure to the flames of the cremation pyre. This discolours the stone, rendering the translucent opaque and usually a dull grey colour, severely cracking the stones which have often not survived complete. The results of this ordeal by fire are easily distinguished from the results of patination through long burial.

The East Greek world still yields us some gem stones, although not generally from controlled excavation. In Cyprus the cemeteries have offered fewer Classical gems than Archaic, but there are a number of engraved rings, continuing an Archaic tradition. Usually the tomb contexts are too mixed to be informative. In the fifth and fourth century Asia Minor, the Near East and Egypt were part of the Persian Empire. Greek artists worked for Persians, while Persian and other local artists were profoundly influenced by Greek art. Gems and rings of Greek origin and style are reported from all over the Persian Empire, from the excavated cemetery of Sardis, the Persian capital in Lydia, to the Treasure of the Oxus, in Afghanistan. Even India contributes specimens, carried east by Persians or by Alexander's courtiers.

One rather unusual source of evidence is the find of a collection of fired clay impressions in a partly plundered tomb of the earlier fourth century at Ur. They include casts and impressions of Greek coins, several impressions of Greek gems and rings of high quality (*Figs. 276–279*), and many impressions of engraved Achaemenid rings (see below, *Figs. 313–315*). They show what was accessible and admired in lower Mesopotamia, and may be the 'cabinet' of a collector, possibly himself an engraver. The problems of Greek work in the Persian Empire are considered here in Chapter VI.

In the Greek homeland gemstones are most commonly reported from mainland sites, notably Sparta, whose political associations with East Greece and Persia in the later fifth and fourth centuries may have something to do with it. A very few rings in precious metal from North Greece belong to the end of our period, and reflect the attraction of artists to the courts of the Macedonian kings. In far more common use throughout Greece, however, are bronze finger rings. Important finds have been made both in cities like Olynthus (destroyed in 348 BC) and in sanctuary sites, as at Dodona, Olympia, Perachora. A prolific source of information about the engraved rings results from the common practice of impressing a ring device on clay loomweights, which are well preserved since they were fired. The impressions are not always very clear and they tell more about subject than style. Their great value is that they give clear evidence for the existence and use of particular types in particular places, and they are often in useful contexts for dating. Occasionally gems or rings were used to impress clay roundels or tokens, best known in later fifth- and fourth-century Athens, but most of these were made from special circular stamps, which may have been made from clay, wood or metal; none survive. Related are the lead tokens, also from Athens, which are of the fourth century and later.

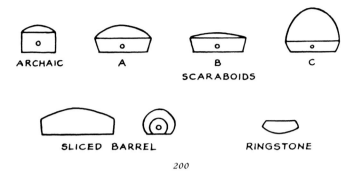

ARCHAIC A B C

SCARABOIDS

SLICED BARREL RINGSTONE

200

In Italy and Sicily the sources are quite different from those for the Archaic period. Etruria has its own flourishing studios and hardly any Greek gems were received. The Greek cities of South Italy, however, have yielded a number of gems, and the possibility of local production has to be taken seriously. Even more common are gold and silver finger rings, and the use of metal finger rings is even more fully attested by impressions on clay weights and similar objects than it is in Greece itself. Tarentum is the most important single source for the rings.

For the dating of the Classical gems and rings we have to rely very much on stylistic comparisons with other works of art. This is not too difficult in the fifth century and early fourth, but becomes increasingly difficult as the Hellenistic period is approached. For the rings at least the shapes can sometimes prove a useful but not decisive criterion. We have seen that the find contexts are generally unhelpful, but the pieces from fourth-century tombs in South Russia do at least indicate that before the Hellenistic period ringstones and metal rings with circular bezels were still comparatively rare, and this is of some value in determining the end of the main Classical series.

CLASSICAL GEM STONES

SHAPES AND MATERIALS

The shapes of Classical gems are readily defined. They do not offer particularly valuable criteria for details of dating or origin but they are distinctive for the period, and only with the ringstones is there possibility of confusion with later work on grounds of shape alone.

Scarabs are still being cut throughout the fifth and fourth centuries although they are now a minority. Cornelian is the normal material for these and the beetle backs are cut with care but without any great elaboration. The thorax border may be hatched and there are occasionally V winglets, but the Archaic carination is soon forgotten and the legs and head are often simply incised and not modelled in the round. There is no serious possibility of confusion with Etruscan scarab beetles, since these are more elaborate and better finished, although by the fourth century many Etruscan beetles have been translated into a less modelled form with angle winglets and incised legs. One unusual scarab may be mentioned here, bearing a fine flying goose in the style of Dexamenos (*Pl. 489*). It is of onyx and the banding of the stone has been carefully observed by the artist so that the beetle's head is brown, there is a black stripe exactly across its thorax, and the tail is black; the rest is white (*colour, p. 203.6*). This anticipates the exploitation of banded stones for cameos.

Scaraboids are the commonest shape, rather larger than hitherto. Considering how simple the form is it is remarkable that such variety of profile can be found. The Archaic scaraboid had straight walls with a shallow rounded back, and this survives for a while, although not for long, into the second half of the fifth century. Of the other scaraboids three main varieties of shape can be distinguished (*Fig. 200*), and

although there are a number of borderline cases the distinction does seem to be a real one. Type A can be regarded as the normal Greek form and it remains popular throughout the period. Its walls are roughly half the height of the whole stone and they often slope in slightly towards the engraved face. This makes for impressions with cleaner edges. The material is usually chalcedony or cornelian, more often the former. The chalcedony is usually a clear grey or white, often passed as 'white jasper' when opaque, but the blue 'sapphirine' or 'amethystine', which is most characteristic of the Greco-Persian gems, is not uncommon (*colour, p. 203.7*). Minor varieties of Type A include some with a lightly convex engraved face, and a number carved on the convex backs instead of (rarely as well as) the flat face. These are current throughout the period, but become more popular in the fourth century, and reflect either the growing popularity of the convex-faced ringstones, or the eastern preference for stamp seals with convex faces. Since the ringstone form was established before the practice of carving the backs of scaraboids it is not likely that the latter practice is responsible for the eventual success of the ringstone. It is very much easier to make a good impression if the engraved face of the seal is lightly convex.

Scaraboids of Type B have very shallow convex backs, like the Archaic scaraboids, but they are very much flatter in their proportions. Their walls are more often straight than in-sloping. It is not a very common variety, but found in the fifth century and, more often, in the fourth. When the back only is engraved, as with some of Type A, it closely resembles the larger ringstones and is only distinguished from them by being perforated. Even then, they may have been mounted as ringstones. The materials are as for Type A. Glass scaraboids are this shape, but for a special reason, as we shall see.

Type C scaraboids have very high domed backs, up to three or four times the height of the walls, which often slope in sharply. They are much more like pebbles with a flattened side than Type A, which recalls the scarab more nearly, or Type B, which is like a flat plaque. They begin to be popular in the later part of the fifth century. Chalcedony is the normal material and a high proportion are in the 'sapphirine' blue. Type C scaraboids, and to a lesser extent Type B, are often related in motif or style to the Greco-Persian gems made in the Greek east and within the Persian Empire, where Type C is especially common. But there is a small fourth-century group of Type C scaraboids in black jasper which are purely Greek. Other materials used for Classical gems are agate, rock crystal, and twice lapis lazuli.

Other shapes with eastern connections are the tabloid with facetted back which is rarely found with a purely Greek device; the cylinder, which is attempted occasionally in the fourth century although not with the usual eastern frieze-like development of the device; and various pendants. Lion seals of cornelian and sliced cylinders or barrels of agate will be considered separately below.

The few Late Archaic ringstones were long ovals with convex faces. They increase in popularity in the fourth century, and the larger stones with shallow convex faces come very close in shape to the Type B scaraboids. The shape becomes a broader oval and one or two are circular. The ringstones with flat faces are more difficult to place. They are more at home later in Italy, and some with what seem to be fourth-century Greek devices perhaps belong there, especially those with rather straight outlines. We might expect them to have become popular in an area where scarabs were usual, and it is the same material, cornelian, that is used for them. Metal finger rings with flat engraved faces might seem another possible source of inspiration but there is no close correspondence in shape or setting. No flat ringstones seem earlier than about 400 BC and they should probably be regarded as exceptional for the fourth century.

For the subsidiary decoration of the gems we shall see that the hatched border to devices is attenuated and increasingly often omitted on scaraboids (entirely so on the Greco-Persian), but it persists on oval ringstones and is seen on several sliced barrels and cylinders and on the lion seals. A ground line is often omitted now, or on later gems is reduced to a short line not reaching the edge of the field. Occasionally gouged dashes at irregular levels suggest a rocky ground. Some ground lines have a row of spaced dots

or squares attached beneath. These then resemble the dentils moulding on stone bases and lend an air of monumentality to the device.

The rest of the first half of this chapter is devoted to an analysis of the style and subject matter of Greek gems engraved between the Persian Wars and the time of Alexander. In this, the 'Classical' period in the broad sense of the word, regional peculiarities of style are even less readily discerned than they were in the Archaic period. This is as true of gem engraving as it is of sculpture, and the scale of the gems effectively disguises nuances of the type which students of major sculpture may detect between different schools. We rely, therefore, more on the evidence of find place and subject, and the divisions have to be mainly chronological. Only when we come to deal with Greek work in the Persian Empire in the next chapter do clear criteria of subject and style help to determine the main groups, but they do not in fact make the problems of defining and classifying Greco-Persian gems any easier. A further complication and difficulty is the relative scarcity of the material. In comparison with the Archaic period, and including engraved finger rings, there are no more pieces to show for the years from about 480 to 320 BC than there were for the years from about 560 to 480 BC. This means that while fairly large groups of Archaic gems could be assigned to studios or even hands, there is far less chance of doing this with Classical gems. We have no reason for believing that production was less intense, and in fact there were a number of new centres for gem engraving. The fewer signatures and slighter differences in regional styles are the final stumbling blocks. The following groups, accordingly, observe differences in date and sometimes differences in shape, but differences in style are often a matter of quality rather than location or hand.

EARLY CLASSICAL

The latest of the Archaic gems showed a preference for the larger scaraboids over scarabs, and after the middle of the fifth century scarabs become very rare. In the Early Classical period, roughly the years between 480 and 450 BC, which in Greek art we would define in terms of the Olympia sculptures or the Niobid Painter, gems were still being made with subjects long popular in the Archaic period and with only slight development in style, generally towards the more naturalistic. The best examples of these were gems with animal devices from East Greek and probably Cypriot workshops, which found their place in the last chapter.

Other subjects winning popularity on the latest Archaic gems were figure groups and single figure studies which did not try to fill the field in the old Archaic manner, but which stood freely within it. This trait in particular is to be developed in the fifth century.

A few gems, all still scarabs, offer head studies, of which the best (*Pls. 444–448*) capture much of the sober charm of contemporary major sculpture. None are obviously of deities although the crescent beside a woman's head on a London scarab might indicate Selene (*Pl. 447*). A poorer frontal version of the head (*Pl. 448*) has the same odd topknot of hair, closely paralleled on coins of Syracuse of just before the mid century. I do not think that these stones need be dated late in the century, as has been done by others, although a version of the topknot regains great popularity later.

Draped figures have their clothes simply rendered in close set parallel lines which avoid the zigzag patterns of Archaic folds. Danae stands by her bed to receive Zeus as a golden shower, in the folds of her himation (*Pl. 449*). She is shown standing again on rings, rather later (*Pl. 667*), but elsewhere in Greek art she normally appears seated on the edge of her couch. This is another instance of what seems to be a distinct iconographic tradition among engravers. On a New York gem from Cyprus Hades abducts Persephone (*Pl. 451*) who drops her torch as he carries her gently off her feet. This is a very rare scene for the period, and is rendered in a successful variant on the old satyr and maenad motif, still not forgotten.

Three gems (one of glass) show the monster Skylla, with a clothed female torso, a dog springing from her loins and a fishy tail (*Pl. 453*). This is the type met first otherwise on Melian clay reliefs about 460 BC, and the gems need be no later. Sphinxes have long been familiar on gems, but on a rock crystal in Paris (*Pl. 454*) we see a new head type and hair style, and the whole figure closely resembles that on Chian coins of the mid century (before the Coinage decree). On a New York gem is another monster: the centaur-bowman, Sagittarius, with stars around him (*Fig. 201*). This seems to be the earliest Greek representation of the zodiacal figure, and his eastern origin is suggested by the dressing of his tail like a Persian stallion (compare *Pl. 881*).

Among the figure studies of standing men we find no less than three of Apollo with attributes— bow and tripod (*Pl. 452*); bow and fawn; laurel, hawk and fawn (*Pl. 455*). The type for the frontal figure is the new Classical one with the weight shifted onto one leg. The Amazon, here resting on her battle axe (*Pl. 456*), is now a popular figure on vases. Other subjects which may be placed here are the warship (*Pl. 457*) and a Gorgoneion (*Pl. 458*), whose monstrous mask is already softened in an approach to the more human Classical treatment of the features (contrast *Pls. 289* and *602*).

Some animal devices offer variants on the old Archaic subjects, with good studies of dogs and cattle (*Pls. 459–462*). Timodemos has a fine hound on his scaraboid (*Pl. 459*) and the shaggy Maltese dogs begin to be seen on other stones. A scaraboid from one of the Crimea graves, showing a cow suckling a calf (*Pl. 461*), betrays its origin in some Greek corner of the Persian Empire by the winged sun disc of Achaemenid type cut on its back. The griffin is seen too in its new fifth-century form (*Pls. 464, 465*), with long serpentine neck and a spiky mane of the sort met otherwise only on sea monsters. It has lost the Archaic forehead knob but keeps the long ears and gaping eagle's head. Its slim, greyhound body is lightly marked, the wings patterned still with neat close set parallel lines. The pose is to be its usual one, like that of the Late Archaic lions, bottom in air, one forepaw lightly raised. Later it will fight, like a lion.

The gems with human heads as devices were scarabs, their backs and legs fairly well cut, but, with one exception, abandoning the Archaic carination. Only *Pl. 444* has a rougher beetle and is of green jasper, not cornelian, but its style is purely Greek. They keep the hatched borders, as do most of the other stones, which are scaraboids. Four of these are carved on the convex back, not the flat base, and one has a lightly convex face, new features which will be met more often later in this and in the succeeding century. Chalcedony is the favourite material already, but cornelian and rock crystal are still in regular use. Find places are uninformative and the one said to be from Sparta is inscribed in a non-Spartan manner, so it is possible that in this period it is the same East Greek or island studios at work which had been active at the start of the fifth century. The figures have much in common too with those on Melian clay reliefs, and the figure style in general derives most directly from that of the Archaic Dry Style groups.

DEXAMENOS AND HIS CONTEMPORARIES

By the middle of the fifth century very little of the tradition of the Archaic schools of gem engraving in Greece can be seen to have survived. The larger scaraboids are now normal and there are few scarabs, their backs treated in various ways, none of them distinctive of place or period, except for some Greco-Persian. Most of the scaraboids are of standard proportions (Type A), their backs no higher than their walls, but a few have either the flat or domed backs, of Types B or C, which are characteristic of the Greco-Persian gems. These appear with devices, like the animal fights, which were popular in the east, and there is one tabloid, which was another familiar shape in this quarter. The hatched border persists for many devices, but it is generally thinner and more carefully and closely marked. Often there is no border at all, or just a line. A full ground line is added where called for. Chalcedony is the commonest material, white as well as blue, with about half as many cornelian and some rock crystal and agate. Gaily mottled

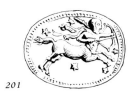

jaspers have a short vogue. Cornelian is usually kept for the smaller gems and the few scarabs still being made. It is not in fact much less popular than chalcedony in the second half of the fifth century, but it does seem less popular for those works associated with Dexamenos. The blue chalcedony is much used in Greek workshops but not dominantly so, as in the Greco-Persian. The writer's wife has picked up a raw nodule of blue chalcedony in South Chios, Dexamenos' island. New subjects account for most of the devices—a new range of animal studies, some domestic scenes, even still life.

The gems discussed under this heading are all of high quality. Most of them belong to the third quarter of the fifth century, although there are some in the same manner which may be later. No less than four are signed by the Chian artist Dexamenos, and since these include some of the very finest specimens, it is right that his name should stand at the head of any discussion of gem engraving in this, the High Classical period of Pheidias and the Parthenon sculptures. The one other artist's name preserved on a stone, Sosias, enables us to give another fine artist his due, but it is not possible from the one gem to assemble a group of plausible attributions. Even the four stones signed by Dexamenos offer some variety—a man's head, a domestic scene, and studies of water birds (*Pls. 466–469*). These give some scope for further attributions to his hand and scholars have not been slow to attempt this. But the qualities of the master are not easy to define in terms which allow of sure attributions where the subjects are different from those he signed. The tendency has been to give him all the best of this period, stamped by a common quality and finesse of detail, but it is possible that these derive as much from the period and workshop in which they were made as from the genius of an individual artist. I have not attempted to improve the lists although I note what seem to me safe attributions.

The finest of the signed stones is the one with the man's head, in Boston (*Pl. 466*): a middle-aged man, balding, intelligent. The delicacy of detail, especially the treatment of eyes, lashes and beard, take nothing from the broad and individual effect. There had been character studies of aging men in Greek art before but scholars have generally agreed that this is perhaps the earliest of which it might be said that a particular person was intended. If true, this means that he must have 'sat', at least for a drawing on which the intaglio is based. This in itself would be novel, since hitherto advances in naturalism in Greek art had been won by observation and copying of postures and details, composed on generalised or idealised figures. The new approach would have led to a closer observation of forms, artificial and natural—such as the animal and still-life studies we have yet to discuss. But we must return in a moment to the question of whether this is a real portrait. Two other signed gems, these from South Russia, show herons, one flying (*Pl. 468*), the other preening (*Pl. 469*), with a locust beside it. Their downy bodies are rendered with the same nervous, meticulous incision as the hair of the 'portrait' head. These are accurate studies, and the water bird motif—with opposed curves of wings and body, the sinuous neck and angular legs—is to be a favourite with engravers. The creatures had appeared before in Greek art, but, to judge from Athenian vases, at about this time they were being kept as household pets.

The fourth signed gem also carries the name of its owner, the lady Mika, in Ionic form (*Mikes*). It shows a mistress seated with her maid standing before her, holding a mirror and a wreath (*Pl. 467*). The composition calls to mind immediately grave reliefs of the type beginning to be made for Athenian cemeteries after the middle of the fifth century. This is less detailed than the other three stones, and although there may seem something still of the Early Classical about it, this is illusory. The women's

bodies are carefully modelled while the folds of their dress accentuate the contours and a transparent effect is achieved. This is, in a way, easier in glyptic since it involves no more than incising the fold lines deeper on the intaglio of a naked body, rather like painting the clothes over a nude outline on white ground vases. If there is something stiff in the composition it is because such a two-figure group is bound to compare unfavourably with the other single subjects on his gems, and perhaps he was not at his best with these stock draped figures. He also turns his hand to linear perspective here, by showing the underside of the stool as a triangle. Simple attempts at perspective and foreshortening with bodies had been tried before, and it is in this group of gems that we shall find examples of animals' heads turned slightly towards the viewer in three-quarters view.

Several other gems are related in various ways to Dexamenos' signed work, and some may be by him, but there is one which claims a special connection for a rather unusual reason. Dexamenos has told us in one signature that he is from the Ionian island of Chios, and the way he writes his *x* suggests that he learned his letters there. That he mentions his birthplace at all does not necessarily mean that he was working away from home, since an Athenian sculptor could sign his work for his own city acropolis as an 'Athenian', but the case is not quite the same and this is the only gem signature we know with an ethnic. Furtwängler had attributed to Dexamenos' studio a gem in Leningrad showing an amphora (*Pl. 470*), because it was cut in the distinctive mottled jasper used by him for two of his signed works. But we can now recognise from this careful study of the vase that it is a characteristic Chian type, which can, moreover, be closely dated to the middle years of the fifth century. This is the form which appears in clear excavated contexts and is repeated on the latest of the Chian silver didrachms. I have little doubt that it is Dexamenos' work.

The attribution of the amphora gem involved no consideration of style. The fine horse with loose reins on a Boston gem (*Pl. 473*) has been associated with Dexamenos for its careful and detailed observation of natural form and dignity of composition. The neat small letters, presumably naming the owner, also resemble those of his signatures. There are other gems with riders and horses, including another in the mottled jasper with a riderless horse, tossing its head as it races past the post (*Pl. 475*), which could well be his work. A mounted Amazon with her companion (*Pl. 474*), and a fine centaur, struck in the back (*Pl. 478*), are in a comparably delicate style. On the latter some other hand added the letters *chi*: hardly for Chi(os) or Chi(ron)—since the centaur Chiron was struck by Herakles in the leg, not the back—but perhaps the start of the owner's name. There may have been more of the name on the missing part of the stone. Other equine subjects are well rendered on stones of this period, but lack the master's finesse *(Pls. 476, 477)*.

We must return now to the signed 'portrait' head, *Pl. 466*. A youth's head, on a rock crystal in Berlin (*Pl. 471*), has recently been published and very reasonably attributed to Dexamenos by Miss Diehl. Although a slighter work than the Boston head it shows the same detailing of hair and eyes, the same profile. Indeed, so similar are the heads that one is bound to ask whether they are not the same man at different ages. The matter is complicated when it is observed that on an agate barrel in London (*Pl. 516*), which has been associated with Dexamenos, the head of the young boxer exhibits just these features of hair and profile, although on a very considerably reduced scale. Portraits of different people by the same artist are often strikingly alike and this would perhaps be even more true in the early days of portraiture. But when the same features are seen on the boxer we may wonder whether Dexamenos had not simply created a generalised portrait, a realistic type which may have appealed to his Ionian blood more than the idealising heads of the mainland Greek artists. If the heads are as early as they seem, around the mid century or just after, this might be a more satisfactory explanation than to believe that they anticipate major stone portraiture by so long. And an exactly similar phenomenon can be observed on gold rings

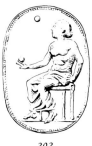
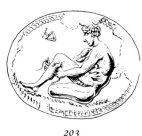

202 203

very little later, where a different male head type, leaner and meaner, is repeated (*Fig. 220, Pl. 670*). If we look for these generalised types elsewhere, that of the Dexamenos gems may perhaps be seen in the Pythagoras 'portrait' on coins of Abdera, and that of the gold rings in some of the coin 'portraits' of satraps. The discovery of a second Dexamenos 'portrait' has complicated the study of early Greek portraiture rather than elucidated it.

There are two idealised heads of women on scaraboids of these years. The first, and finer, is signed by Sosias (*Pl. 480*). The delicacy and detail in the treatment of the hair recalls Dexamenos' head of a man. The obvious comparison for a woman's head of this type is on the series of fine Syracusan coins of the later fifth century, but this can be no reason for believing that Sosias worked in the west. The type of head and hair style originated in the art of Greece, and Sosias' gem makes even the best Syracusan coins look provincial. The difference lies both in details, like the delicate curve of the upper eyelid and the working of the nostril, and in the general set and proportions of the head, with its softer chin and less emphatic features. Sosias' gem need be no later than the 420's. Simpler, and earlier, is the head of Dawn on another scaraboid (*Pl. 481*).

The ladies on Mika's gem are matched by no others on stones of the same date, but there are some slightly later studies, usually of naked or partly draped girls, of a quality and originality which remind one of Dexamenos. A variant on the seated woman motif shows Aphrodite, nearly frontal, suckling Eros who is grown enough to stand at her knee—perhaps the earliest representation of this rare scene in Greek art. Another gem from South Russia shows a half-naked girl juggling with balls (*Fig. 202*), like some ladies on mid-century Athenian vases and particularly the nymph seen on coins of Terina who is also adept at balancing a ball on the back of her hand. Another naked lady reclines to play with a heron while a flying ant hovers overhead (*Pl. 482*). The carefully engraved insect and its position recall the locust on Dexamenos' gem. Other girls kneel to dress or to dry their hair (*Pl. 483*)—a popular motif also on later stones. Perhaps all these undressed ladies should be taken for nymphs or goddesses rather than mortals.

One other study of a woman must be included here because it has so often been associated with Dexamenos. She is seated, playing a harp (*Pl. 472*). The delicate cutting on the drapery very closely resembles the engraving on the herons' bodies on the signed stones, and details of the head on the Boston gem, but what a world of difference there is between this figure and the seated lady on Mika's gem (*Pl. 467*)! If this is really the same artist his career must have been a very long one indeed, and far from conservative if styles of rendering bodies and drapery could be so profoundly revised.

There are a few male figure studies, frontal, relaxed (as *Pl. 484*), showing some advance on the Early Classical and already something of the spirit of Polyclitus' athlete statues. A stock figure of this type is the Herakles which in sculpture we know best from copies of what is probably Myron's work of the mid century. This showed the hero with his hand on his club, which is resting on the ground, rather in the pose taken by Athena with her shield in Pheidian studies, and with a bow in his left hand, his lion skin draped over the extended arm. There is one version of this figure on a gem of our period, but

197

the hero is beardless and wearing his lion skin. A far stranger version is seen on a gem recently found in Taranto (*Pl. 485*) which is canonic save that Herakles has a cloak fastened at his neck and his whole head is that of a lion! It is as though the lion skin (lying innocently over his arm) had partly taken over his human frame. The artist may have had some specific message in mind, but it escapes us.

A youth fastening a boot or sandal (*Fig. 203*) is nameless, but recalls later studies of the wounded Philoktetes tending his leg. There are not as yet many studies of deities alone but there is a fine and rather unusual Athena (*Pl. 486*). Her pose with spear and shield is broadly Pheidian, and the coiled snake beside her legs brings to mind the Parthenon statue, but her dress does not have the usual long Athenian over-fall, held in by the belt. She is holding an *aphlaston*, the stern of a ship, indicating her concern with the welfare at sea of her clients or recording a victory. It is tempting to think that this was cut in Athens, or for an Athenian, but it was found in Cyprus and it is on coins of Cyprus of the later fifth century that we find one of the other rare representations of Athena with an *aphlaston*, now seated on a ship. The coin must celebrate a naval victory, and the gem may have been cut for a victory. The size of the figure relative to the field suggests that the gem is of the Dexamenos period rather than later.

Two gems by one artist, showing a sphinx and a griffin, give the creatures finely feathered wings. The sphinx's body and head (*Pl. 487*) resemble the Chian coins of later in the fifth century, but on the coins the old-fashioned sickle wing was retained. The griffin (*Pl. 491*) is given a sea serpent's neck and crest, with delicate fan-like spines. Another gem, with a whole sea serpent (*Pl. 488*), can probably be placed here too.

The other animal devices can be related immediately to Dexamenos' work. A superb flying goose might be the master's (*Pl. 489*). There are herons (*Pls. 490, 492, Fig. 204*) preening or pecking at an emaciated silphion plant (if such it be), even a quail and a carrier pigeon. Eagles carrying snakes or tearing their prey (*Pls. 493–495*) recall the motifs on fine contemporary coins of Greece and the west. Dogs have been seen on Late Archaic gems, but now we have careful anatomical studies of them (*Pl. 496*). There is even one of the 'foxes, the little foxes that spoil the vines' climbing over the rocky ground towards a tempting bunch of grapes (*Pl. 497*). This need have nothing to do with the fable, since the fox seems likely to be successful. The motif had appeared as a shield device on a red figure vase, and is repeated on a later ring (*Fig. 237*). Bulls, such popular subjects in the sixth century, are represented now walking or in the Classical plunging pose (*Pls. 498, 499*). These types are very close to those appearing on coins of Thurium in the third quarter of the fifth century. There are also two gems with bull foreparts (*Pls. 500, 501*)—massive shoulders, tiny heads—one with the head turned to a three-quarter view, the other in profile and very like the devices on coins of Samos minted in the second half of the fifth century. The locust was introduced on one of Dexamenos' gems and occupies the whole field on others, once with a moth and a corn stalk (*Pl. 502*), and there is a carefully detailed wasp (*Pl. 505*). A snake and a dolphin (*Pls. 503, 506*) complete the zoo, but there are new versions too of the old lion fights (*Pls. 507, 508*), and dogs attacking a boar (*Pl. 510*). The aggressor is sometimes now the griffin (*Pl. 511*) which can also appear in its usual heraldic pose (*Pl. 512*). The new fighting role for the griffin is to be an important one in Classical art. When the Greeks first learned of the monster from Near Eastern art they gave it a sinuous, scaly neck and let it serve as an ornamental handle. The Classical beast retains the serpentine neck, with a fishy mane, and with its sleek leonine body and spread wings it is the most graceful of the fictional beasts which served Greek decorative art. Again on the gems we see examples of animal heads turned slightly to the viewer with successful foreshortening.

Almost more still-life is the study of a peacock with two snakes (*Pl. 509*). The bird looks stuffed, and the snakes are neatly arranged to make a heraldic pattern of the three creatures. There is no doubt of its authenticity, and the material, shape and delicacy of the cutting suggest its inclusion at this point. This

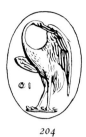

204 205 206

must be the earliest Greek representation of a peacock—an eastern bird introduced from Persia in the fifth century and especially at home in Samos where it became the familiar of Hera. On the gem it outdoes Zeus' eagle by holding two snakes, but it is not flying. One of the snakes is bearded and perhaps crested; the other is not. Snakes shown with little goatee beards are one of the mysteries of Greek art. Where a pair is shown and one is clean-shaven, as here, we may suspect that the beard was intended to indicate sex, and it might be that this was the original meaning of this convention.

There is also an interesting range of real still-life subjects. Two gems with drinking cups, kantharoi (one on *Fig. 205*), are complementary to Dexamenos' wine amphora. Odder are the meticulous engravings of a sandal, a hazel nut, and of the mouth pieces for double pipes (*Pls. 513, 514; Fig. 206*). And finally, on a cornelian tabloid, there is the frontal view of a herm (*Pl. 515*). The pillar is topped with the head of Hermes, wearing a flat cap. This headgear is sometimes shown on the herms drawn on Classical vases, where also we see the god's caduceus beside the pillar, as here, and the customary erection.

Out of all the gems mentioned in this section there are barely six which bear comparison with the high quality of Dexamenos' or Sosias' signed work. We cannot say that these artists led the schools of Classical engraving rather than that they are the most gifted exponents of the new style, which is well represented by the other stones listed here. These works display a confident command of style to which technical difficulties are completely subordinated. Later works may introduce new compositions or poses, but they are more consciously miniaturist versions of an idiom developed in larger works of sculpture, and in this respect the independent tradition of the engraver's art becomes impaired.

SLICED CYLINDERS AND BARRELS

Of all the less common shapes used for Classical gems only these, and the lion gems, seem worth keeping separate from the other groups. This is not because they could not easily be fitted into them on grounds of style, as we shall see, nor because they are wholly attributable to a restricted period or place, but because they each have some special characteristics which are best considered on their own.

Sliced cylinders and barrels are usually of agate, occasionally cornelian. The bead which is sliced to provide a flat area for the intaglio has various proportions, from the slim swelling to the plump and almost purely cylindrical (*colour, p. 203.4, 5*). Four are not sliced at all, but cut on the curved surface of a barrel-shaped bead, as on a cylinder, but with a single device (always a heron) meant to be impressed and not rolled like a cylinder. The hatched border is kept for several of the devices. There are three examples among the Archaic gems of the early fifth century but the majority belong to the third quarter of the fifth century and can be associated with Dexamenos' work. The boxer (*Pl. 516*) we have already seen to be certainly his. The figure stands on what looks like a base and Furtwängler thought that the artist was representing a statue. On a broader field there is a seated youth playing a *trigonon* (*Pl. 517*). This is a harp of triangular form, of a variety with distinctive spindle-shaped upper arm. Two other varieties appear on later gems, one of which has been met already (*Pl. 472*). This superficial similarity and the

comparative rarity of representations of the instrument may have induced scholars to attribute them all to the same hand and date—Dexamenos'—but the style of the head and figure here are quite different. The commonest motif, and one well adapted to the slim field, is a standing heron, much like Dexamenos' birds, but less finely carved, except for one in Bowdoin College. Animals also fit well and we have a lioness, as *Pl. 520*, a griffin and dogs, scratching or gnawing bones (*Pls. 521, 522*). The locust reappears (*Pl. 523*) and, for the still life, another sandal (*Pl. 524*).

In a rather different style but probably no later are stones with a slim camel (*Pl. 526*) and with a study of a Persian, standing nonchalantly, his features and padded costume almost caricatured (*Pl. 525*). These two subjects have an eastern flavour, and other sliced barrels, summarily cut, hail from Cyprus.

After Dexamenos

Some of the gems assembled in this section may be contemporary with the work of Dexamenos, but they are generally inferior in style to those associated with the master. Most are probably rather later, of the end of the fifth century and the beginning of the fourth. The general style is very much the same, with a similar range of subjects, but more naked women, and, among the animals, more deer. Although the figure and animal compositions are fluent there is a tendency to summarise details and features where a Dexamenos would have tried to be quite explicit, despite the scale. This is a characteristic also of the Greco-Persian series, and many of the stones collected here are probably from East Greek studios in touch with the more provincial workshops in the Persian empire. Scarabs remain rare, their backs treated ornately or summarily—there are not enough surviving to give clear criteria in the Greek world now. There are more examples of scaraboids cut on their convex backs, one or two engraved on both sides, and a number of unpierced ringstones. Of the scaraboids there are more with either the humped or the almost flat back (Types C and B) usually with devices related to the Greco-Persian in all but purity of style. Cornelian is as popular as chalcedony for all but the animal devices, where chalcedony is preferred, including the blue—another eastern trait.

This is the period in which the activity of Greek studios in Sicily or South Italy has been suspected. We have met a similar problem already in the Archaic period, and with Sosias, where it was a matter of misleading comparisons with western coins. The points at issue now are rather different. Reliable proveniences for the stones are hard to find, but a few from western cities which seem to have some common features in style are, albeit diffidently, grouped below (p. 206). For the gems of higher quality the problem is more acute since no division can be made purely on grounds of style. It is therefore worth while considering closely two pieces which could offer less equivocal evidence. One—known now only from impressions—shows a crawling Eros in a broadly Classical style (*Pl. 529*). Behind him an open sea shell refers to his mother's birth rather than his own, but seems original. Below is the name Phrygillos, presumably the artist. A Phrygillos signed in full, or with initials, a number of coin dies for western Greek cities (Syracuse, Thurium, Terina) in the later fifth century. The lettering is similar but the eye of faith is needed to support any declaration that the styles of the gem and the coins are identical. At least they are not wholly incompatible. If the inscription on the gem is ancient it does seem quite possible that the same artist is in question, although we cannot say whether he cut the gem and the coin dies in the same place.

The second piece is a cornelian ringstone, said to have been found near Catania (*Pl. 528*). The device is an almost exact replica of the coin type of Syracuse of the beginning of the fourth century—Herakles wrestling the lion, bearded here, but beardless on the coins. The stone is unique among purely Greek gems of this period in being circular. If this is in fact not against such an early date it does suggest that it was cut in deliberate imitation of both the style and device of the coins, and perhaps by the same master,

Euainetos. It has been suggested that the stone was an official city seal. This seems more plausible when we see that in Athens at this time the official seals on measures were circular stamps copying coin devices (see p.237). But in any case the Catania gem has no necessary connection with the production of engraved gems of the usual shape. For those that we have now to discuss all we can say is that very few have been found in the west and none need have been made there.

One scarab continues the tradition of the Dexamenos 'portrait' by presenting a fine study of the head of a negro girl, her locks and jewellery most carefully engraved (Pl. 530). It is on coins of about 400 BC that we see similar, full features, but allowance must be made for the appropriate physiognomy of the subject, and it could be that this piece is as early as Dexamenos. Another head study, of a youth wearing a Phrygian cap, is inscribed *Perga*, in letters discretely hidden on the neck of the cap (Pl. 531). This probably gives the name of the artist, Pergamos. It has been dated earlier by some scholars but the treatment of the eye is late fifth-century at the earliest. The name can have nothing to do with Pergamon, the city, and the lettering indicates Athens or one of the islands.

Studies of single standing figures begin to become more common from the later fifth century on and the artist has no qualms that so much of the field is left unoccupied. The fine Persian on Pl. 532 is so thoroughly Greek in style that we might suspect a Greek dressing up. The contrast with Persians on the Greco-Persian stones is clear (compare Pl. 884) yet the shape and material of this and other stones cut in a purely Greek style—humped scaraboids of blue chalcedony—are characteristic of the Greco-Persian series, as we shall see. This, then, is East Greek work in a Greek studio and probably for a Greek master, while the Greco-Persian are for customers within the Persian empire. The gracious Artemis on Pl. 533 is on a stone of the same type as that with the Persian, also found in South Russia.

The popular warrior type now is naked, but for chlamys and pilos or the similarly shaped 'Thracian' helmet. The dress serves for Odysseus, who may be shown on Pls. 535, 537, pensive or waiting. For a warrior the common pose is crouching, behind his shield, which we see on Pl. 534, and on coins and sculpture from the Early Classical period on. There is a beautifully cut study of defiance on Pl. 538. Of the heroic scenes there is a Herakles fighting the lion (Pl. 536) in a pose less compressed than that of the Catania gem (Pl. 528) but often copied in the east. Theseus with the sow of Crommyon, on Pl. 539, is cut on the convex back of a scaraboid, and is a version of the encounter which seems unique in Greek art. He is withdrawing a trident boar-spear from its neck. Philoktetes fans his noisome wound on another scaraboid (Pl. 540) in what is to be a characteristic pose for the stricken hero on Lemnos. The satyr shouldering a wine jar (Pl. 541) recalls the popular Archaic motif.

Some oval cornelian ringstones go here. River gods shown as the foreparts of bulls with human features are seen on many West Greek coins (and a few East Greek, as at Kyzikos), and our Pl. 542 is said to be from Sicily, but nowhere else do we find such a grotesque truncation, which the artist has sought to improve by adding a helmet. Pl. 543 is puzzling, with two youths playing knucklebones. They are named, the Dioskouroi. According to Pliny Polyclitus made a group of two youths playing knucklebones, but they were naked. This is not an expected pursuit for Kastor and Polydeukes.

The mantle-dancer of Pl. 544 is not wholly characteristic of the devices showing women, who are generally only partly dressed, or, and this is new, completely naked. The other studies include the seated Aphrodite or woman with Eros, most popular on vases, gems and rings from the later fifth century on, and other, stranger groups and figures. The complete nudity of the girl with the heron on Pl. 547 is a little surprising at this date, yet the piece can be no later than the end of the fifth century, for the treatment of the body and features, which match other gems grouped here. A problematic scene on Pl. 546 shows a half-naked girl seated disconsolately at the foot of what seems to be a gravestone, but being crowned by Nike.

Representations of the mainly human monsters of Greek mythology did not admit their female counterparts until the Classical period. Pan was an individual goat deity who became particularly popular in the fifth century. Probably through some assimilation to the race of satyrs it became possible to show several Pans, or Pan-like demons, but the earliest girl Pan is found on a gem, our *Pl. 548*, identified by her tiny goat's tail and horns. The artist Zeuxis had painted a famous family of centaurs in the later fifth century but the earliest representation of a centauress is again on a gem, our *Fig. 207*. The wholly human forepart matches the way in which the centaur Chiron is shown, as Furtwängler observed, so this could be his daughter Hippe, pouring herself a drink from a rhyton. For a realistic figure like this the human legs are grotesque and her pose is very strange.

An interesting group of gems, probably by one artist, seem to tell a story of their own. On two (one in *Pl. 550*), a girl crouches, climbing into her clothes. But on a third (*Pl. 551*) she has lost her clothes again, to a young man who holds them high over her head. She cannot reach them and grabs at his cloak instead. The girl disturbed at her bath is an age-old theme. Impressions of another gem with exactly this motif were found at Persepolis (restored from two incomplete impressions in *Fig. 208*).

Other ladies are more conventionally occupied—with a heron, a dog, or standing by a wash basin. Any could be Aphrodite but they are probably better taken for mortals. This is certainly true of the girl being made love to so intently in *Pl. 552*—a rare erotic motif at this time.

The lady by the basin was engraved on the back of a scaraboid on whose base is a study of a heron (*Pl. 549*), a poorer bird than Dexamenos' but still a charming motif and often to be repeated. Two deviants may be noted—on one the bird draws a bow (*Pl. 554*), recalling the snake's similar feat on a ring (*Pl. 699*) and a Greco-Persian lion-hoplite (*Fig. 286*); and on the other it grows antlers (*Pl. 557*), a reversal of the eastern and 'animal style' rendering of animal horns as birds' heads and necks. Other herons stand, preen, fly, catch frogs or flies (*Pls. 555, 556; Fig. 209*).

Among the quadrupeds there are still some spirited loose horses (*Pls. 559, 560*) and wheeling chariot pairs (*Pls. 561, 563*) showing some advance on the earlier versions in use of perspective and three-quarter views of heads and wheels. The studies of stags are, however, the most typical of this group, with heavy smooth bodies and slim brittle legs, usually grazing (*Pls. 564–567*), but some with head raised, or scratching their bellies, and one struck in the back with a spear (*Pl. 568*). These, with the dogs (*Pl. 572*) and cattle (*Pls. 573, 574*), brings us very close to the work of Greeks for Persians within their empire. Both these subjects were popular on coins in different parts of the Greek world. The lions, with small heads and neat manes, also resemble the easterners, but without the exaggerated patterns of muscles (as *Pls. 575, 576*). Lithe griffins again join the animal fights, their wings more elaborately feathered (*Pl. 579*), with more verve than before, but less dignity (cf. *Pl. 511*). And there are still sphinxes (*Pl. 580*) and insects (*Pls. 581, 582*).

Finally, we have to revert to the problem of the possible identification of a public seal, with the scaraboid shown in *Pl. 583*. It is of bronze, which is unusual but perhaps appropriate for official use. Beazley's description of the device—the seated griffin, club and horse's head symbol, supports his suggestion that it is 'conceivable that the scaraboid was the official or semi-official seal of an Abderite magistrate: but to assert this would be unwise, for here as elsewhere individual caprice must be taken into account. Whatever the exact explanation may be, it seems probable that the person who ordered the seal had the coinage, if no particular coin, of Abdera in mind'. The problem may be reconsidered. The griffin is not especially like the Abdera coin devices, and the club is seen extremely rarely and only on late coins. Is this a club? The ground line, especially on finger rings, is sometimes given a near-monumental character—like a row of dentils. Indeed, the Abdera griffin sometimes sits on an explicitly architectural base. Then, the horse's head before the griffin is very little like any magistrate's symbol on a coin. We may remember that griffins fight horses, that in Achaemenid art the subjection of a creature may be shown by putting

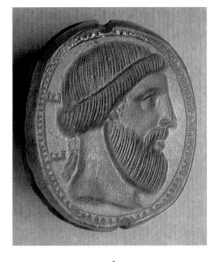

1

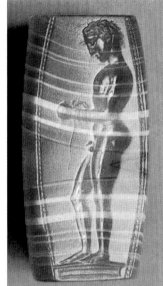

2

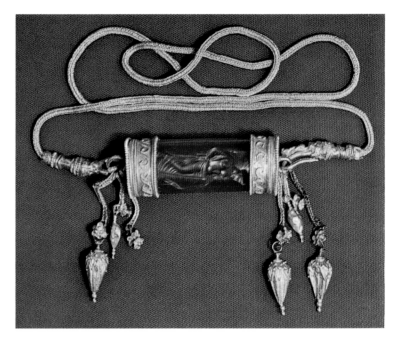

3

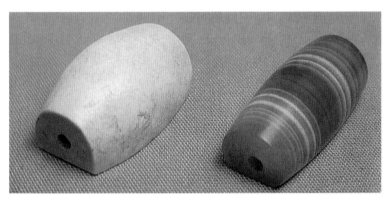

4 5

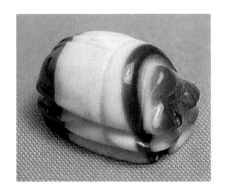

6

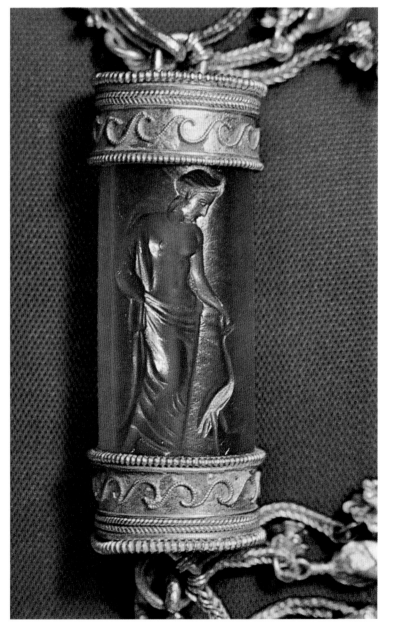

3

7

207 208 209 210

211 212

its forepart between the legs of its victor, and in Greek art griffins, lions and sphinxes register domination by putting a paw on an animal head. The engraver seems to have treated the motif in a more formal, heraldic fashion. The device no doubt held a message, even if now it is unintelligible.

LION GEMS

Engraved gems with their backs cut in the form of animals had been common enough in earlier periods, but the only type to survive was the lion gem. There is one Late Archaic example, unfortunately incomplete. Its successors are all cut in cornelian, and have long oval bases, recalling some elongated scarabs, but for one which has a rectangular plinth below the lion (*Fig. 212*). The lions are of the same basic Egyptian type, with heads turned, but they differ considerably in execution. Most of the Classical examples can be fairly closely related to the other gems we have considered 'after Dexamenos' although some might be contemporary with the master's work. None are of the quality of the sliced barrels, however, and we should look for a different centre of production. Proveniences are of no help, but clearly none were made in Italy.

The best has a study of a naked crouching woman (*Pl. 585*) of the usual type. A flying Eros might be earlier, as also a graceful eagle with a wreath (*Fig. 211*). Commoner are animals. Three with bulls, standing or plunging. The latter is a motif seen on Greco-Persian stones as well as Classical, and the lion device on another lion gem shows the beast in the eastern flying gallop. Another lion, tearing at a limb (*Fig. 212*), recalls the dogs with bones on the sliced barrels, but this is again a motif seen in the east (compare *Pls. 970, 984*; *Figs. 285, 312*).

The type survives, or is revived, in the fourth century, since we find a half-naked woman by a basin (*Pl. 584*) and a trophy, both in a style which can be no earlier. It is in this period too that we may place a fine example in gold, with the device showing a statue of Artemis, from one of the South Russian tombs (*Pl. 819*).

These gems are not too long to be set on swivels and worn as finger rings, and there are some cornelian (and one chalcedony) lions of exactly this type lacking the intaglios completely, and made simply as ring ornaments.

SOME PLAIN WESTERN GEMS

A few gems of the middle and second half of the fifth century come from western Greek sites and may have been made in the west. There is no very striking congruity in style, but in general they are very simply although competently cut, and only differ from others discussed in this chapter by the lack of incised detail. It would have been comparatively easy to assign them to other groups but their proveniences and some slightly unusual motifs suggest that there may be some point in keeping them together. Taranto, Lecce (twice each), Sicily and Patras (in western Greece) are given as proveniences. A kneeling warrior behind a shield (*Fig. 213*) in the Sir John Soanes museum in London repeats a popular Early Classical motif. Others show animals, including an odd study of a prancing lioness (*Pl. 586*), a goat (*Pl. 587*), a bucranium (*Pl. 588*) and a fly (*Pl. 589*). Here we may perhaps also place a scaraboid in Berlin which is distinguished for the way in which not only the face and back but also the sides carry intaglio devices.

FOURTH CENTURY: THE FINE STYLE

These are the best of the fourth-century gems. Most are still scaraboids but there are also one or two of the larger ringstones with convex faces. Chalcedony (especially the blue), cornelian and rock crystal are used, and there is one example in the rare lapis lazuli. Some of the motifs are still in the fifth-century tradition, but others, notably the figure studies of men and women, display the full competence of the Late Classical, without yet the languid prettiness of the Praxitelean. On the best stones too the compositions neatly fill the oval with less free field than has been observed on most Classical gems. There is also more attention to circumstantial detail of dress or properties although not the miniaturist treatment of a Dexa-menos. These are all features which are soon to be ignored again. The gems apparently belong to the first half of the fourth century, but the stylistic criteria are not easily defined except in terms of the overall sequence and development within the art, and we have to some extent to rely upon figure types and poses for dating.

One artist's name is read, with the eye of faith only, as Onatas, on one of the finest gems of this date (*Pl. 590*). The artist deserves a name and may better continue with the wrong one than none at all. Nike is shown putting the finishing touches to a trophy, and two letters, NΔ (which have been misread, together with the decorative squiggles, into a whole name) are inscribed on the fillet or pennant hanging from the spear planted beside it. The letters are probably an abbreviated signature and their discrete placing can be matched by the *Perga* on *Pl. 531* and the two letters on the statue base on *Pl. 599*. Nike is shown half-naked now, her himation gathered around her legs in a pose and state of undress which is long to be popular for goddesses. We have seen a yet earlier half-dressed Nike on another gem (*Pl. 546*). She kneels to a trophy on an electrum coin of Lampsakos and stands to it on a late fourth-century coin of Agathokles of Syracuse, which is a poor thing beside the 'Onatas' stone.

On some other gems of this date we see rather similar treatment of features, plump bodies and realistic but not theatrical drapery. A ringstone shows Kassandra taking refuge at the statue of Athena from the Greeks sacking her home Troy (*Pl. 591*). Her half-nakedness is an older theme, part erotic, for this is an excerpt from the fuller scene where Ajax moves to drag her from sanctuary. The treatment of the body is less assured than that of the Nike.

Ladies bathing are shown in the same new manner, closer to a Praxitelean view of the body, and certainly with a more sensual appeal, especially where the body is partly turned to the viewer. One example of this is on a rare all-stone cornelian ring—bezel and hoop of stone (*Pl. 592*). The Classical motif of a girl dressing is shown more realistically on *Pl. 594*. These half-naked girls may appear standing with a mirror or seated. On *Pl. 593* the girl is balancing a stick on her hand. The point of the game is lost to us, but it is shown on other gems and a stick is needed for the game of *morra* which is also shown on

213

gems and rings. Balancing tricks with rods, balls, amphorae, cups and even children have appeared sporadically in Greek art since the Late Archaic period.

The cornelian cylinder showing a woman with a heron (*Pl. 595* and *colour*, *p. 203.3*), in the Victoria and Albert Museum, is a masterpiece, too long overlooked—although, of course, Furtwängler knew it and admired it. The Greeks usually avoided the cylinder shape and when they did use it they often, as here, cut a single figure device so that it could be impressed without rolling the whole circumference. Not the least remarkable feature of this piece is its superb gold setting.

There are a few male figures. One gem has a superb Diomedes carrying the palladion, stolen from Troy (*Pl. 596*). A rather stiff seated Dionysos (*Pl. 597*) is said to be from Chios, Dexamenos' island. *Pl. 598* offers a moving, although still strongly idealised study of an old man carrying home the spoils of the hunt. It anticipates the Hellenistic sculptor's treatment of, for instance, old fishermen, but this fellow's physique could suit a deity and it is his pose and bowed head which convey the mood of the figure.

A few other representations of deities are of a quality to recommend their inclusion here. The Athena statue shown on *Pl. 599* has another of the cryptic two-letter signatures at the corner of the base (AΔ). The youth with another version of the triangular harp (*Pl. 600*), who is seated on a panther skin, is shown still very much in the fifth-century manner. The tiny figures on the much damaged gem in *Pl. 601* depict the popular story of Apollo and Marsyas. The god, naked, stands by his kithara and stretches his hand in victory and with a shade of condescension over the cowering figure of the defeated and bound silen Marsyas, who had challenged him to a musical contest and now awaits the loser's penalty—flaying.

We have seen Gorgon heads already. On *Pl. 602* her features are wholly human, feminine, and more subtly menacing than the monster masks of Archaic art. Her hair is still wild but the snakes are knotted in a neat cravat and there are tiny wings in her hair. Classical art has reduced the demon to a basically human aspect without lessening the image's power and threat.

Finally, a ringstone, showing a sphinx scratching herself (*Pl. 603*). This has been much discussed and often assigned to the early Roman period, but the shape of the stone and its style better suit the fourth century. The inscription sets the problem—*Thamypou*. This I judge either modern, inspired by the name which appears on later gems, Thamyras, or at least later than the engraved device.

FOURTH CENTURY: THE COMMON STYLE

A number of gems of varied quality, belonging mainly to the middle quarters of the fourth century, to judge from their style, fall into fairly readily defined groups. They show some of the characteristics of the finer gems of the period, but for the most part derive in subject and style from the earlier stones we have considered, with some concession to the newer languid poses for figure studies. The proportions of the figures are more appropriate to a late date. Drapery is treated in a fairly summary manner and the folds are reduced to simple linear patterns. Wings have a looser, more feathery structure and some bodies are leaner although there are still some robust felines. There are no western Greek proveniences.

The stones are most easily presented as a series of groups but these are not always stylistic entities.

207

There are several scaraboids with figures, still life and animal subjects, among which a distinct group made of black jasper can be singled out. Other shapes are well represented too—pendants, several scarabs, and ringstones with convex faces, as well as some with flat faces which are perhaps to be placed here.

For the scaraboids chalcedony and cornelian are still equally popular. The figure devices include crawling Erotes (*Pl. 604*) in the manner of the Phrygillos gem, and some musicians (*Pl. 605*) and seated women (*Pl. 606*). The last are less popular and less stereotyped than we shall find them on contemporary gold rings. The domed back of the stone is used for two lithe centaurs (one on *Pl. 607*). The demon on *Fig. 214* combines elements of Priapus, Pan, and satyrs, plus wings, and as successfully challenges our knowledge of Greek religion as it might have done a contemporary Greek. It is probably to be taken as an animated and improved version of a Priapic cult figure set on a rocky base. The usual type is legless, in the form of a herm, but with the same military and militant bearing.

One group of scaraboids can be distinguished for its material—black jasper (and once dark green)— which is not otherwise met in the Classical period. All are high domed, with shallow, inward-sloping walls. The style is fairly uniform, and not of the best, but competent, and there is a good variety of subjects, some of them original. We may single out the figure with thyrsos and mask (*Pl. 608*), our first obviously theatrical subject, and a three-quarter back study of a naked girl (*Pl. 609*). A boy with a horse (*Pl. 611*) presents a group seen on fourth-century Athenian reliefs. Still-lifes include a tripod, and a composition of a herm, strigil and oil bottle (*Pl. 610*)—all appropriate to a palaestra—but accompanied by an as yet unidentified object. The material of these scaraboids is fairly soft and the intaglios have not survived very well. The only alleged provenience, apart from 'Greece', is Tanagra.

The scaraboids with still lifes include studies of fourth-century vases—a calyx crater (*Pl. 613*) and a lidded amphora. The latter is on a mottled jasper stone like that used by Dexamenos and the same material, or similar, is used for the representation of a lidded tripod cauldron (*Fig. 215*), a kithara (*Pl. 614*) and a heron of rather poorer style. This persistent use of such distinctive material may argue a common origin for these gems.

Two examples of rather irregular pendant shapes may have been inspired by the pear-shaped pendants favoured in the Greco-Persian studios. The piece shown in *Pl. 615* is roughly heart-shaped, divided vertically, and useless for the purpose of sealing. We have met figures like the crawling babies on one side already, but the unusual sirens are borrowed from Greek funerary art.

The scaraboids with animals give a good range of the now familiar griffins, some with thinning bodies and wispy wings (*Pls. 616–618*). The lions are heavier creatures (*Pl. 619*) with more bristling manes than on the earlier Classical stones. We meet too a lion fight (*Pl. 620*) and the motif of a lion breaking a spear in its mouth, appearing now on gems and coins for the first time. Some cornelian scarabs carry comparable animal motifs (*Pl. 622*) but the best of this shape is in blue chalcedony and shows a fine maned lioness (*Pl. 621*). There are several scarabs from South Russia, some with very summary animals rendered 'a globolo' with undisguised use of the drill, rather like the contemporary Etruscan, but their find places— South Russia and Patras—suggest that they are Greek, if provincial.

With the ringstones (*Pls. 623–625*) there is considerable difficulty in isolating the truly fourth-century from later stones or copies of the Classical. Lions with spears, griffins fighting, even herons, represent Classical types which must still have been current, although there is no clear evidence for date from style or excavated context. All are quite small stones. Some are long ovals, with convex faces, and close enough to fifth-century ringstones for us to be reasonably sure of their date. Some of the others, with flat faces, tend to rather more rectangular forms and might be Hellenistic or even Italic, although they are usually assigned to the fourth century and Greece.

214 215

SOME PLAIN EASTERN GEMS

There are a number of gems in a summary style with proveniences given as Cyprus and farther east. They belong, then, to the Persian empire but I have not included them with the Greco-Persian stones because although there are some eastern motifs (zebu and camel) there are none which are specifically Persian. A few stones show free drill work, which is characteristic of some Greco-Persian stones, especially their 'a globolo' style (see p.322) but the stylistic similarity is slight and the subjects are Greek, like satyrs (*Pls. 626, 629*) or Pan (*Pl. 627*) and various animals (*Pls. 628, 630, 631*). Others are very summarily cut, without detail. If at least most are from a single centre, it is one removed from those producing the Greco-Persian gems. It is perhaps to be located in the Syria–Palestine area where, in the Classical period, many styles seem to have been current side by side—the Phoenician, Babylonian, Persian, and hybrids deriving from these.

There is a marked fondness for slightly convex engraved faces on these stones, or for the scaraboids to be cut on their backs. They cannot be closely dated but there are no certainly fourth-century features.

THE LATEST CLASSICAL GEMS

The last period in which scaraboids were still being engraved in some numbers in Greek lands seems to have been the second half of the fourth century. By this time ringstones large and small may have been just as popular, and the preference for engraving a curved surface meant that more of the scaraboids themselves were cut on their convex backs. Our only criteria for attributing gems to this period of transition depend on style and, to a lesser degree, shape. Alexander's conquests had finished the Persian empire and with it, it seems, most of those western studios which engraved scaraboids in the Greco-Persian manner, if they were indeed still active to the end. In Greek art new styles in representing the human figure are dominated by traits which we associate with the sculptor Lysippus—new proportions, with small heads on heavy male bodies, and a feeling for composition in the round, which for work in relief or two dimensions meant a series of new, relaxed, twisting poses with assured foreshortenings. For figures of women and children (like Eros) Praxiteles had earlier in the century introduced the new more sensuous treatment of figures and poses, which was to be most fully developed in the Hellenistic period. For most of the fourth century the style and subjects of the devices on engraved gems and rings were still largely determined by the strong and individual fifth-century tradition in the craft. A few stylistic innovations can be observed but the problems of dating are acute without any useful grave contexts, such as begin to appear in the third century. These contain ringstones only, so we may judge that the last of the scaraboids belong to the period of Alexander and just afterwards.

A domed blue scaraboid showing a woman writing on a tablet (*Pl. 632*) is of the usual Classical shape and material, but the pose of the figure is more relaxed, the drapery more restless, well on the way to the fully Hellenistic treatment. She sits on rocks and must be a Muse: a mortal would have chosen a stool. Another unexpected but explicable figure is the Omphale on *Pl. 635*, carrying Herakles' lion skin and club. The subject is seen also on two fourth-century finger rings (*Pl. 766; Fig. 228*), but not otherwise until

the full Hellenistic period. The victorious athlete on *Pl. 636* adopts a pose which is used for boxers in later years and is related to the usual way of showing a dejected Achilles.

Ringstones are more characteristic of the new styles. One in Berlin is signed by Olympios, and shows Eros, drawing his bow (*Pl. 633*). There is more of Lysippus than Praxiteles in the physique, but the strong body and detailed wings look back to the 'Onatas' Nike (*Pl. 590*). If the 'Olym' signature on fourth-century coins of Arcadia refers to an artist Olympios, this could be the same. It is not easy to put a name to the figure on *Pl. 634*: a naked winged girl, sitting on the edge of a basin and holding a band of some sort in her two hands. If an Eros, we would think that he was playing with the magic iunx wheel, but the sex and the basin are more in keeping with the scenes of women bathing.

The women, on scaraboids and ringstones, are heavy-bodied semi-nudes. A Danae, it seems, is seated on a stool (*Pl. 637*) which is for her unusual, and there are the familiar women bathers occupied with their dress. The girl on *Pl. 638* looks as though she has been surprised. There was a similar pose on the all-stone ring (*Pl. 592*), and on an Attic red figure vase such a figure is Thetis, attacked by Peleus. Larger flat scaraboids cut on the convex side approximate closely to ringstones although still pierced for a swivel or suspension. Some of about this period show accomplished chariot groups, usually driven by Nike, with successful foreshortening of horses, heads and wheels (*Pl. 639*). Already in the fifth century there had been versions of this motif in which the foreshortening had been tentatively applied (see *Pl. 561*). The development of such chariot groups in Classical art can probably be observed more fully on coins. On one gem, in New York, the team reverts to the old, eastern, rocking horse pose with forelegs raised in concert like circus animals, which will be the regular form on later coins, including Roman.

Finally there are some reminders of earlier fashions. Some cylinders are cut in a Greek style. Motifs include a woman with a heron (*Pl. 640*), another at a basin (*Pl. 641*), Nike with a thymiaterion—old motifs on a shape reluctantly used by the Greeks, and now to be abandoned with the eastern empire destroyed. Other cylinders found in South Russia and apparently fourth-century, have archaising subjects.

Glass Scaraboids

There appears to have been a brisk production of intaglio glass gems in the fifth and fourth centuries. Most of the surviving examples are from Greece, the Near East, Egypt or South Russia. One exception is from a fourth-century grave at Vulci in Etruria. It is a tabloid, not a scaraboid, but its device is almost a replica of that on a scaraboid from Odessa. The earlier popularity of glass scaraboids in the Near East may have inspired the practice in Greece, and contemporary glass conoids, generally with Achaemenid motifs and made in Syria or Palestine, could have given it added impetus. But many of these conoids are in deep blue glass, which was only very rarely used for Greek scaraboids after the Archaic period.

They are clearly cheap substitutes for the gems of semi-precious stones, although it is quite probable that some have original engraved devices, not cast from existing intaglios, and that for the rest the moulds or intaglios were touched up by hand. Where they have hitherto been discussed reference is generally made to the σφραγῖδες ὑαλίναι mentioned in the treasury accounts of the Parthenon in the fourth century. It is most unlikely that glass scaraboids of the type under discussion would have been considered worthy of such attention in this period. The Greeks were extremely imprecise in their terminology and they used the word ὕαλος for any transparent material, including (and indeed usually, until clear glass was in general use) rock crystal. They may well have used it of other transparent stones like clear chalcedony or cornelian. Our glass scaraboids were decidedly second-best and probably mass-produced. Yet there seems to be only one example of a duplicate.

All are quite large, and although some are fairly thin, their backs are shallow (I have seen one exception only), sometimes almost completely flat. This does not imply a connection with the Type B stone scara-

210

216

boids. The shape in glass gives a clue to their manufacture, for there are never traces of the join of a two-piece mould. The scaraboids must have been cast in open moulds, probably of fired clay, which could easily have been made from a stone scaraboid. The molten glass filled the impression or may have slightly overfilled it, with a shallow meniscus. This explains the absence of domed backs. The exceptional tabloid from Vulci may have been cut. Whole finger rings were also cast in green glass and given intaglios but this is a commoner practice with larger rings in the Hellenistic period.

Most of the scaraboids which by style or subject seem to belong to the fifth century or earliest fourth are of clear glass, and so a close imitation of rock crystal. Several have been preserved with considerable surface detail still clear. Most of the fourth-century scaraboids are in pale green glass and their surfaces have suffered more often, giving a lumpy appearance to impressions. From the way that several of these later devices seem gouged out of the glass it seems likely that these at least were cut after the casting, and that the intaglios, for what they are worth, are original.

The fifth-century scaraboids include some Early Classical figures. A frontal figure, like the athlete or the Apollo on Early Classical scaraboids (*Pl. 455*), is inscribed 'Kastor' (*Fig. 216*). A warrior on another glass scaraboid is labelled 'Lampadias', some sort of reference to the torch he is carrying, unless this is a canting device. A Skylla closely resembles the device of stone intaglios already noticed. New motifs of this date include a facing Artemis with lions (*Pl. 642*). There are chariot groups (*Pl. 643*), horses (*Pl. 644*), a good copy of a grazing stag like those associated with Dexamenos, and studies of seated or dancing women (*Pls. 645, 646*). Other figure devices of the later fifth century less obviously match what we have seen on stone and could be original. They include a kneeling Diomedes with the palladion. The eagles tearing a fawn on a scaraboid in London (*Pl. 647*) may not match the best examples of this motif on Greek coins but could derive from a fine stone intaglio. One good scaraboid with a woman's head recalls the Sosias gem, and is only little earlier (*Pl. 651*).

Other examples have simple head studies. All those of men, and one of a woman, frontal, are in clear glass and need be no later than the fifth century. The women's heads in green glass, including the tabloid from Vulci (*Pl. 649*), have fuller, fourth-century features.

Poorer fourth-century green scaraboids have various rather ordinary figure and animal devices (*Pls. 652–655*). We may single out one showing a woman holding back her cloak to expose her body and buttocks (*Pl. 650*). The intention and pose resemble those of the famous Farnese Aphrodite Kallipygos, where the lady is wearing a chiton which she lifts. There are, however, Roman copies of a figure drawing a cloak back from her body, and not a dress. It is just possible that this type has priority, since our scaraboid is at least as early as any representation of the figure with the chiton.

Two examples have subjects with a decidedly eastern flavour: a bearded male sphinx, and a Persian horseman, probably cast from a Greco-Persian scaraboid.

Archaic all-metal rings with intaglio devices were distinguished for their great variety of shapes. In the Classical period there is far more uniformity. Regional differences are as difficult to determine as with the gemstones, but the proveniences of some rings of cognate style have led me to isolate some probably western Greek groups and one Pontic one. There is, however, no particular reason why these should differ more from the Aegean Greek than, say, Corinthian rings might from Rhodian, and the other rings attributed to the groups here find their place on grounds of apparent style or shape. By and large the separate criteria of style, shape and date do yield a number of compact groups, some of which I have presumed to name. These are of rings in gold and silver. The bronze rings are considered separately, and the evidence of impressions on ancient objects can only be taken into consideration briefly. No bronze rings are of top quality, although many are better than the poorer rings of precious metal. Of particular importance are the rings from Olynthus which have a terminal date of 348 BC. To complete the story of the Classical all-metal signet ring we have to go later than with the stone gems, and into the third century BC.

We notice straightaway the difference in style from the engraved stone gems. This is a matter of technique, since the intaglios on the rings were cut directly in the metal without the aid of a drill. This makes for some deep cutting, with much bold linear detail, instead of the smoothly rounded masses on the stones. The devices are readily appreciated on the rings without impressions and where possible photographs of the originals are shown, but the artists had the impression in mind, as we can judge from the way they dealt with the problem of right or left hands.

SHAPES AND MATERIALS

The standard form for Early Classical rings is that which was most popular in east and west in the Late Archaic period—stirrup-shaped, with a slim hoop, round in section, and a thin leaf-shaped bezel (Archaic Type N). By the end of the fourth century the regular shape was a large circular bezel and heavy hoop shaped to the finger, semi-circular or facetted in section. Between these two extremes there was an irregular progression from leaf-shaped to circular, from light to heavy. The slim leaf-shaped bezel had a long life, although the stirrup hoop either took a more rounded form or filled out its shoulders so that the inner surface fitted the finger, and already in the mid fifth century or soon afterwards some quite broad oval bezels appear. Some of our evidence for the survival of early shapes is given by impressions from rings on clay loomweights where the outline of the bezel is clearly defined and the style or subject of the intaglio gives the date.

The following survey indicates the principal shapes and the main periods of their use, but it must be remembered that virtually our only criterion of date is style, and any simplified classification, such as this, can take no account of the many possible local variations. The distinction between the types as described here is sometimes not so clear that a ring can be readily assigned to one rather than the other. But this system helps description and we shall see that stylistic groups seem to correspond fairly well with broad distinctions of shape. I include here the main early Hellenistic types of all-metal rings. A summary of shapes is given in *Fig. 217*.

Type I, the Archaic form, remains the only usual shape to the middle of the fifth century. There are some very flimsy rings of this form which may be later.

Type II has the slim hoop shaped more to the finger and the thin bezel too is often bent out in sympathy

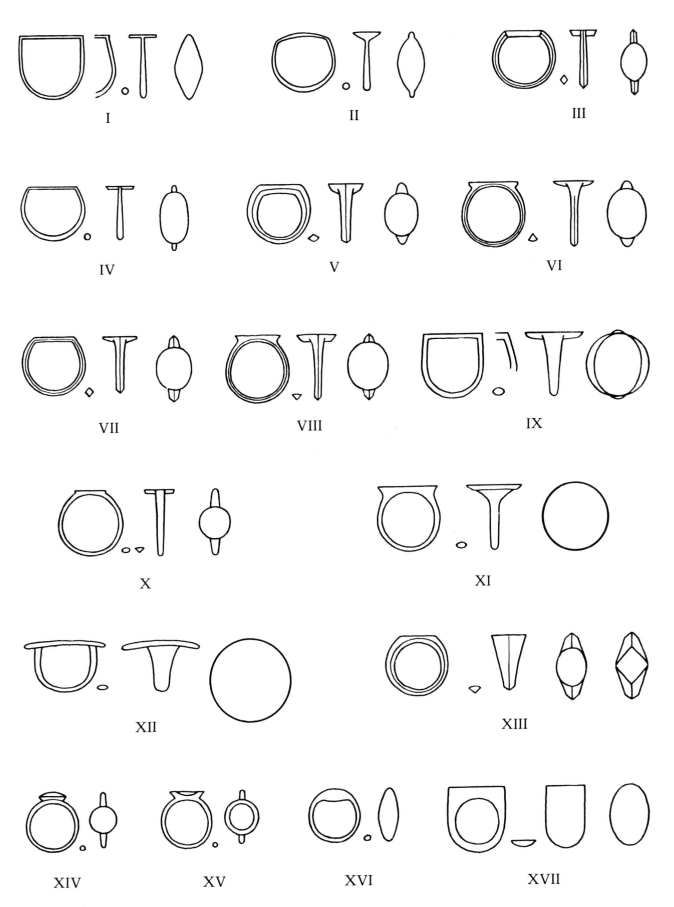

with the line of the hoop. The bezel is still leaf-shaped but some swell, and one or two are slim ovals. This is current from the middle to the end of the fifth century.

Type III, contemporary with the last, is a heavier version with thicker flat bezel, often lightly facetted behind, and an angular, sometimes diamond-shaped section to the hoop. The bezel is a broad leaf.

Type IV may belong mainly to the later part of the fifth century, with a simple hoop and light bezel, now a slim oval. This is a simple development of Types I–III.

Type V, in the later fifth century, presents a heavy version of III, with a thick bezel and hoop, the shoulder filled fairly well and the back of the bezel facetted. The hoop may be oval or facetted in section; the bezel is oval. The tendency now is to broaden the outline of the hoop as it joins the bezel.

Type VI. On Types II and V the bezel face was often slightly curved. The Greeks preferred a flat engraved surface and to achieve this, with the new type of hoop which fits the finger, the bezel has to be raised outside the outer line of the hoop. This may not be very marked, but it is sometimes accentuated by a groove running just behind the face of the bezel, making it look as though it was a separate plate fastened to the hoop, which it is not. This slight fold at the edge might otherwise have been produced by beating the bezel face flat preparatory to engraving. The bezel is oval. This type persists from about 400 BC through the fourth century, eventually with a circular bezel.

Type VII is the fourth-century version of III, but with an oval bezel, not projecting outside the outer edge of the hoop (as on VI).

Type VIII is a further development of VI in which the ends of the bezel are slightly undercut, overlapping the outer edge of the hoop, and the bezel face is a broader oval. This seems popular in the middle and later part of the fourth century, and there is a rather heavier Ptolemaic version.

Type IX, with the broad oval bezel again, reverts to the near-stirrup shape, but the hoops are broad and the rings are heavy. This may be a West Greek speciality in the middle or later fourth century. From the end of the fourth century on it is a common type, with circular bezel, and sometimes with a rather depressed, nearly semicircular hoop.

Type X is a light variety of VI, with oval bezel.

Type XI. The rings of the second half of the fourth century and later with circular bezels may have square shoulders, as IX, but more often the hoop spreads to the edge of the excessively large bezel, and because of the latter's size the outline is again a stirrup. These later rings often have ribbon hoops, flat within, lightly curved outside.

Type XII. As the last, in date and general type, but the hoop is attached well within the edge of the spreading circular bezel. Common for the West Greek Hellenistic rings of the flimsier sort.

Type XIII. The hoop spreads regularly to accommodate the small oval, or occasionally diamond-shaped, bezel. This is a direct imitation of the simplest form of hoop setting for a small ringstone. Late fourth century and later.

Type XIV. The small oval or circular bezel has a convex face and is raised clear of the line of the hoop. This again matches a setting for a stone, but also the stone's convex face. Late fourth century and later, mainly West Greek.

Type XV. As the last but a circular concave area for the device, as for a setting without its stone. Were they once filled with clear glass? The rings are flimsy and several are from Crete. Hellenistic.

Type XVI. The slim hoop swells to a long rounded lump on which there is a small device with no defined border. Probably a summary version of XIII. Fourth century or later.

Type XVII. Ptolemaic, massive rings, imitating a long established Egyptian type, to which the Archaic cartouche rings are related. They have a heavy, stirrup-shaped outline and oval bezel. Lighter varieties have hollow hoop and bezel.

218

The normal materials for fine rings in the Classical period are gold and silver. Rarely electrum is used—the natural alloy of gold and silver which had been employed for the earliest Greek coins and some Archaic rings. This is called 'white gold' in the temple inventories. There are one or two examples of heavy gold plating of bronze, and gilding of silver and bronze. The silver rings are rather commoner with the West Greeks. Many of the silver bezels are pierced by gold studs (once on the shoulder of the ring)—a practice already noticed—but there are also some examples with a gold crescent inlaid beside the device. There are bronze versions of all the main types, but they are less elaborately finished. A few are pierced with gold studs, one with a silver stud, one with both a gold and a silver stud and one inset with a gold crescent. There are isolated examples of all-stone (as *Pl. 592*) and all-glass rings with intaglios.

The metal hoops and bezels have usually been well enough finished to disguise all evidence for how they were made. It is probable that the heavy rings were cast in three-piece moulds, as in the Bronze Age. Simple lead rings with relief devices, made in South Italy towards the end of the fifth century, were certainly made in three-piece moulds, since the surplus lead between the parts was often not cut away. Some of the earlier rings, however (as Types I and II), may have been made from a separate cut bezel and drawn hoop brazed together. Some of the poorer examples of the Classical period were fashioned according to the Archaic technique of hammering out the bezel and then joining the ends of the hoop (see p.155, Type F). This seems probably true also of the rare examples which have 'expanding' hoops made with open, overlapping ends. These seem a South Russian speciality. The fine Herakleidas ring in Naples (*Pl. 1005*) is exceptional in having the intaglio cut on a gold plate set into the gold ring.

EARLY CLASSICAL: THE PENELOPE GROUP (TYPE I)

There is no easily defined distinction between these and the latest of the Archaic rings of the same shape, and several of those already considered probably belong to the second quarter of the fifth century. The name piece of this group (*Pl. 656*) certainly belongs to this transitional phase. Penelope sits pensive, in the pose which is particularly associated with her and other mourning or disconsolate mortals. The only difference is that her head is raised, and with it her right forearm, the elbow of which does not rest on her knee in the usual way. The seated pose, her hand on the stool and himation wrapped around the legs, will be met often again on Classical rings. The bow before her appears in other versions of the scene. It is probably the artist's reminder to us of the role her husband Odysseus will play when at last he returns home—the contest with the bow and the slaying of the suitors: a hint at the happy ending. The final novelty on this ring is the frankly Doric version of her name, *Panelopa*, for Penelope. Her slight figure and pose closely resemble those of the Electra seated on the tomb of Agamemnon on near contemporary Melian clay plaques, but the inscription is not Melian. Sparta is a possible source.

Of the other motifs I show a flying Eros (*Pl. 659*) who was a favourite Archaic subject on gems and rings, and flying Nike (*Pl. 658*). Animals well suit the long bezel (*Pl. 657; Fig. 218*), as they had before, and a more complicated scene is attempted with Kybele driving her lion chariot. It was probably the decision to give more room for groups like this which encouraged the gradual broadening of bezels for finger rings, as well as the feeling for a free field around the figures, which we observed on the stone gems. The Archaic hatched border is retained for some of these devices but it is soon to be abandoned.

Finally, the odd pastoral on *Pl. 660* may owe something in its style and subject to the Greco-Punic studios.

THE WATERTON GROUP (TYPE I)

These fine rings belong to the middle and third quarters of the fifth century. They show a notable advance in technique, style and choice of subjects on anything that has been attempted before on metal bezels. At their head is a ring in the Victoria and Albert Museum, once in the Waterton Collection, showing a head circumscribed by a circle on the leaf-shaped bezel (*Pl. 661*). The deliberate detail of features and hair makes it possible to draw immediate comparisons with the sculptural type of the Cassel Apollo. The way the head is shown in a disc is unique on bezels of this shape and should help us identify it. If it is male, a possibility is that it represents the sun god, Helios, for whom an Apollo type is wholly proper. Otherwise this might be the moon goddess, Selene.

There are whole figures of deities too, like the Artemis by an altar on a London ring (*Pl. 662*). She is pouring a libation—a mortal activity indulged also by the gods, but Artemis is normally shown pouring for her brother Apollo. She wears the short dress of a huntress and carries two hunting spears. The Hermes (*Pl. 663*) also holds a phiale for libation. From now on the pillar support for such figures will become common in sculpture and on gems.

Penelope reappears, but with a better three-quarter view of the body and the more usual pose with sunken head and elbow supported on knee (*Pl. 664*), not named in this inscription, however, which may be amorous. The enigmatic lady on *Pl. 665* was thought to be Selene, the moon goddess, by Marshall, but no Greek ever showed her sitting in a crescent moon in this way. The identification is abetted by the crosses in the field, which look like stars and seem original, and her upturned face. The crescent is in fact rather irregular and might possibly be meant for a swing. Ritual swinging is attested in Greece, and our girl is holding a ritual basket, but her balance is too good to be true—no-hands and head up. If this is really a celestial scene it could be a hellenised version of the eastern deity whose bust may be shown in or emerging from a crescent. The problem remains. Another strange motif is the Aphrodite weighing Erotes (*Pl. 666*). The subject has been much discussed, since it appears on fourth-century vases. This is the earliest version. The idea of the weighing of souls is Homeric, and before that Egyptian, though without quite the same significance since in Egypt the soul is weighed against a symbol or goddess (Maat): in Greece—as often—like is weighed against like. With Erotes the purpose is not likely to be a serious one and later the subject seems linked with venal love. The standing Danae we saw on an earlier gem (*Pl. 449*) appears again on a ring of this group (*Pl. 667*), but the clothes are now rendered in the full Classical manner. An odd feature is the way the origin of the golden rain is indicated by the tiny Zeus-eagle overhead. An athlete (*Pl. 668*) can probably be placed here; and finally, a superbly detailed animal study of 'a poor old donkey. . . . A study of decrepitude difficult to parallel among Greek representations of animals' (Beazley) and worthy of a Dexamenos (*Pl. 669*).

CLASSICAL: LIGHT RINGS (TYPES I AND II)

These are contemporary with the last group and a few are of equal quality. There is a tendency towards a broader bezel and one, showing Athena fighting a giant, has a full oval bezel but must be placed here for its style, which still holds something of the Archaic. Two fiery horses with riders share the spirit of the Parthenon frieze (*Pls. 671, 672; colour, p. 217.2*). One is from Thrace, owned by a 'friend to the Scythians', Skythodokos, and will be recalled in a different context. A man's head on a ring from Nymphaeum (*Pl. 670*) is not obviously a portrait, but it does resemble the strong characterisation of the head on a heavier ring (*Fig. 220*) and even Dexamenos' 'portraits'.

Studies of dancing maenads, their heads thrown back in ecstasy, become a popular motif on rings and are found here for the first time. On Classical red figure vases too these figures become increasingly common, with their drapery swirling away from their legs. A series of distinct types for the dancers is

216

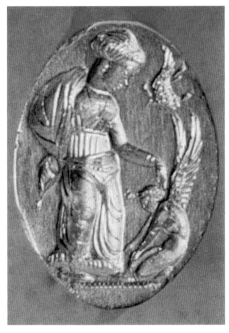

1

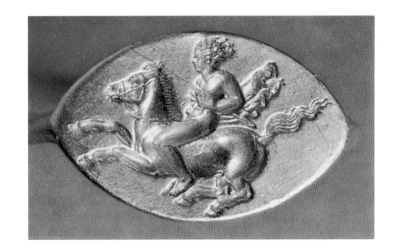

2

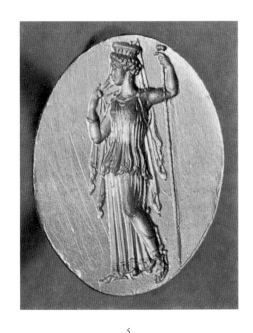

5

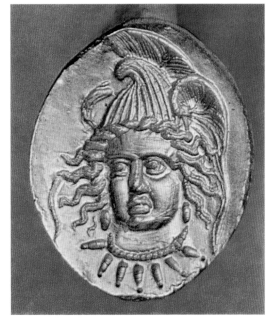

3

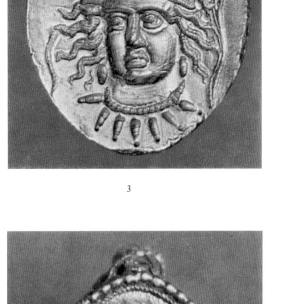

4

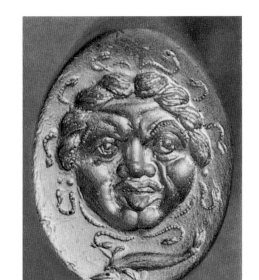

6

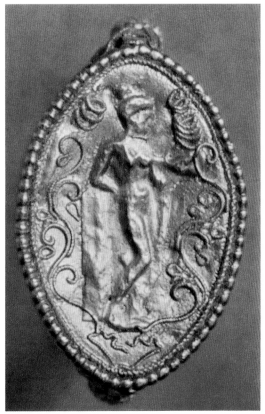

7

7

219 220

associated with the name of the artist Kallimachos. Generally they carry the thyrsos wand and sometimes dismembered animals, but one, on a Paris ring, holds a sword and a severed human head (*Pl. 673*). Orpheus or Pentheus might be the victim, but in other representations Pentheus is not attacked with a sword. It is used against Orpheus, but in Greek art of the fifth century the Thracian women who attack him are not characterised as maenads (ours wears an animal skin) although Aeschylus calls them Bassarids. The girl's full features, her hair flying back and loosely gathered, are typical of these figures.

Other motifs are a nymph seated on the stern of a ship (*Pl. 674*) anticipating fourth-century coins of Histiaea and possibly commemorating a naval victory; and Thetis riding a sea horse, bearing fresh armour for her son Achilles at Troy (*Pl. 675*). There is some evidence that it is Thetis herself who is carried by the sea monster in these scenes, while attendant sea nymphs, Nereids, ride dolphins and carry other equipment for Achilles. The group appears first in this form at about this time and soon wins popularity as a decorative device, especially on rings and jewellery. Here again we see the himation cloak around the legs and the chiton beneath shown by close incised lines which well suggest the forms of the body and fall of the material.

The seated figures with mirrors and wreathes might be mortals or Aphrodites; we cannot tell. One mortal is shown with distaff and wool basket, and the ring names its recipient, Apollonides (*Pl. 676*). Some rings with animals belong here: a pelican (*Fig. 219*) and a flying heron (*Pl. 677*), like Dexamenos' birds.

CLASSICAL: HEAVY RINGS (TYPE III)

The earliest heavy Classical rings belong to the last quarter of the fifth century. They are far more massive than any we have looked at so far, with thick facetted backs to their bezels and hoops angular in section. Many have quite broad bezels, some near oval. The quality of the engraving is first rate, and only declines slightly for some animal groups. A number of the motifs we have seen already—the maenads, seated women and Penelopes. Others are new, although they recall once popular Archaic subjects.

Foremost are the studies of heads. Three of women—profile or three-quarter face, and a satyr—frontal, are unremarkable except for their command of foreshortening and delicacy of detail. One, of a bearded man (*Fig. 220*) is of an individuality which recalls Dexamenos' gems but more hard bitten. The general type is that of the ring shown in *Pl. 670*. Below the chin the artist has put male genitals, which might be intended as a signature or mark of ownership, even a canting device for an embarrassing name. They are hardly 'apotropaic'—a convenient label for the inexplicable—since they are not shown in a threatening condition. The women's heads are purely Classical (*Pls. 678, 679*).

A big ring with an oval bezel shows a woman (?) hunting a deer from horseback, accompanied by a bird and dog (*Pl. 680*). If this is an Amazon the hunting motif is unexpected, but in itself reasonable. It looks like a consciously hellenised version of an eastern hunting scene of the type common on Greco-Persian gems, but here the easterner might be mythical and the rendering is purely Greek.

Two rather exceptional rings from South Russia may be considered with these. One is signed Athenades and shows a Persian seated, and testing his arrow (*Pl. 681*), the old Archaic motif which is revived here, on a Greco-Persian gem (*Fig. 294*), on later Greco-Scythian metalwork where Scythians are shown, on a coin of Kyzikos and a satrapal coin from Tarsus. The second is a massive hoop, like a car tyre, otherwise known only in a plain version also from South Russia (Chertomlyk). Part of the device—the youth and the tunny fish (*Pl. 682*)—is exactly repeated on a rare electrum coin of Kyzikos.

A reclining half-naked woman is our first near-naked study on a ring (*Pl. 683*). She is no bather and must be a nymph. An Athena sits holding her owl (*Pl. 688*) on a ring with the name Anaxiles on it—owner or artist—and is shown standing with her shield at her side (*Fig. 221*) in a pose which may owe something to Pheidian figures. Maenads leap from the ground waving thyrsoi and animals (*Pls. 684, 685*). Thetis rides her sea horse, but without the armour (*Pl. 686*). And Penelope mourns, her cloak drawn up over her head, one foot supported on a footstool, in one of the simplest and most affecting versions of the scene (*Pl. 687*). There are several variants on the motif of a seated woman (*Pls. 689, 690*) and not all are domestic. An Eros nonchalantly rides a dolphin (*Pl. 691*).

Among the animal motifs lion fights predominate, the lions with the short bristling manes we saw on contemporary gemstones. The style is accomplished and sometimes very detailed. The club over a sole lion on *Pl. 692* may indicate that this is the Nemean beast, but Herakles can only subdue it with his hands, not his club. The most remarkable group, with a lion savaging a dolphin (*Pl. 693*), is of the finest quality. It is tempting to look for some symbolic explanation for such an odd contest, but wolves and bears can in fact catch swimming fish and it might not have seemed out of place to a Greek to show a lion similarly occupied. Eagle and lion were often equated by Greeks as the most powerful animals of air and land. The motif of an eagle seizing a dolphin was used as a coin blazon by Greek cities on the Black Sea, from Sinope to Olbia. A fable of Aesop (no. 202) tells of the alliance of a lion and a dolphin, and the latter might well have seemed to the Greeks the fishy counterpart to the lion and eagle. In the other fights stags, a bull and a horse are the victims, and the aggressor once a griffin (*Pls. 694–697*). These are popular Classical motifs, especially in the Black Sea cities, in which several of these rings were found. There is much too in the iconography to recall Greek work for Scythians and it may be that some of these rings were made by Greek goldsmiths on the shores of the Black Sea. This is more certainly true of the next group.

A PONTIC GROUP

The 'queen' in the Chertomlyk tomb wore a gold ring on each finger. All were the same shape, our Type VII, but all had open hoops with the ends overlapping. They could thus be adapted to the finger size, which was necessary when all fingers were to be occupied. One only was engraved, with a subject in purely Greek style, but not seen on any other gem or ring, a duck alighting in a marshy setting (*Pl. 700*). That this set of ten rings was provided by Black Sea Greeks is suggested by the ring form, otherwise met only in the South Russian finds, and the plant life shown with the duck, which recurs on other rings from the same area. The wild ducks, moreover, are shown on a Greco-Scythian bowl.

There are two other rings of this shape but with wider bezels (Type VIII) from another Chertomlyk tomb (*Pl. 701*) and two plain examples from Tanais. The finest specimen is from a Kerch grave. It shows a snake drawing a bow (*Pl. 699*), a device which is seen again on a later gem. Both snake and bow may be associated with Apollo, and the creature twines around the god's bow on later works. But the actual operation of the weapon suggests that there may be some other explanation to be found. One which has been suggested draws attention to the snake called 'quick-darting', *akontias*, by the Greeks. But the *akon* is a javelin, not an arrow. This is more in the spirit of the imaginative devices on some Greco-Persian stones, like the lion soldier (*Fig. 286*) or the Greek heron drawing a bow (*Pl. 554*).

221 222 223 224

Some other rings with animal and vegetable devices from South Russia may go here, including one with a fine griffin-cock (*Pl. 702*), recalling the old confusion between the real and fictitious creatures experienced by Greek artists when they were first introduced from the east in the eighth century; and a locust on a flower (*Pl. 703*). These all seem of the late fifth or fourth century.

THE DE CLERCQ GROUP

A number of fairly simple rings from Phoenician sites from the de Clercq collection in Paris, seem to represent local production, probably by Greeks. The shapes and motifs show that they belong to the second half of the fifth century. All are gold, with pointed or slim oval bezels. The devices include standing males and maenads of the usual type, but executed in a rather stiff and summary manner (*Fig. 222*). More characteristic are the rings with animal devices which repeat common Classical motifs (*Fig. 224*). Among these we twice see a deviant subject—a lion attacking a griffin (*Fig. 223*). The general scheme is familiar enough but in Greek art these carnivores, one real, one mythical, normally observe a gentleman's agreement not to attack each other. The battle, and with serpents attending, is repeated on a relief gold plaque from Letnitsa in Bulgaria. These rings come from an area which, although within the Persian empire, was thoroughly hellenised and whose coins were struck with hellenised devices. The local production of rings with Greek shapes and motifs is a similar phenomenon and we may compare the stylistically different Plain Eastern stones already discussed (p.209). The de Clercq rings are quite unlike the usual Achaemenid metal rings, which either have round bezels or present a quite different range of devices.

CLASSICAL: SUMMARY AND COMMON STYLES

A small number of Type I rings with extremely narrow bezels are decorated in a summary manner. They seem later than the fine Type I rings already shown, and may represent cheap, later fifth-century versions. Motifs include the standing Danae, a maenad, seated women and a girl washing her hair (*Pls. 704–706*).

The Common Style rings of the later fifth century derive from Types I and II but have oval bezels. They have not the quality of the heavy rings, the drapery in particular being treated with as much detail but less care, but some are quite competently cut. Most of the subjects are already familiar—maenads, seated women and women's heads (*Pls. 707, 708*). Some are worth special comment. The girl balancing a staff on her foot (*Fig. 225*) recalls the girl balancing a slender rod on her hand (*Pl. 593*). The rod is used in the game of *morra* which will be shown on a later ring (*Fig. 231*). A seated woman is faced by a sphinx on a tripod (*Pl. 707*): a very odd juxtaposition of motifs. The sphinx on a column we could have taken for the enigmatic Theban (a tripod of a different sort figured in the famous riddle) or an offering. The tripod and woman could indicate an Apolline subject. A prophetess or sibyl consulting a sphinx has been suggested. The woman has no distinguishing attributes and looks very much at ease. The style is less crude than has been suggested, but the involved subject, quite deliberately chosen and possibly bespoken, is rather cramped on the bezel.

Two small metal prisms, presumably to be set on a swivel ring in the Archaic manner, may go here. They have devices on each long side, with figures and animals met otherwise mainly on Classical gems (heron, fly, dogs) or bronze finger rings. The devices on one are shown in *Fig. 226*.

THE KASSANDRA GROUP (TYPE V)

Four fine rings, of around 400 BC or little later, go together for their shape—heavy versions of the earlier Type III, and for the style and matter of their motifs. They could be by one artist. All show women with their heads thrown back and their hands raised, a pose of singular allure, as every woman knows. Their bodies are shown in three-quarter view with successful and finely modelled rendering of the nude. The only one who is partly clothed is Kassandra, kneeling at the statue of Athena which she clasps seeking divine protection from the Greeks (*Pl. 709*). An inscription names her, superfluously and un-expectedly. On two other rings the girl is standing, naked, stretching in a pose which recalls a favourite dance posture on vases, or the later figures of Aphrodite binding her hair. On one she is exaggeratedly twisted to show both breasts and buttocks, and beside her on a chair are her clothes (*Pl. 710*). On the other her stance is more plausible and a tiny satyr steals up from behind to admire (*Pl. 711*). These two rings are said to be from Macedonia and the second is the only one of the group in silver. The fourth ring shows the girl kneeling naked (*Pl. 712*), and is from Tarentum. The depth of the modelling of the naked body is something new on finger rings and looks forward to some fine miniature sculptural renderings on later fourth-century rings. It is odd that there seem to be no other rings of this shape and near-monu-mental style with other subjects.

THE IUNX GROUP (TYPE VI)

On these rings the bezel plate is conceived as a separate entity from the heavy circular hoop which spreads to join it. The bezel outline is still fairly pointed, rarely oval. All these rings are of high quality and none seem necessarily later than the first quarter of the fourth century. The name piece is a fine ring from one of the most prolific South Russian graves, that of the 'Demeter priestess' at Bliznitsa. A woman is seated on an elegant stool with foot rest, and Eros stands before her (*Pl. 713*). She is playing with a disc, twirled on a double strand. This, the iunx-wheel, is a well known love charm, deriving its name probably from the action of the wryneck (*iunx*) which twists its neck vigorously when courting. There are several representations on vases from the later fifth century on, and a few on rings. Eros is often involved, some-times playing with the wheel on his own (as our *Pl. 723*). The woman here need not be Aphrodite since Erotes intrude on the boudoir, but it is probably she. Her dress is shown still in the rather formal manner of the fifth-century rings, and on other studies of seated women in this group more play is made with the pattern of folds across the dress.

The woman's head on a London ring (*Pl. 714*) shows clearly the advance in treatment of detail. The eye is wide open with long upper lid, in a proper profile view. The earring is of an elaborate type well known in Greece and Italy, but not before the fourth century. This, apart from the style of the head, suggests a later date for the ring than has hitherto been proposed. The head with a mask (*Fig. 227*) is broadly similar.

There is the familiar range of boudoir studies with women, perhaps all Aphrodites, attended by Eros, who fastens a sandal (*Pl. 716; colour, p. 217.1*), bestows a crown (*Pl. 717*) or otherwise entertains (*Pls. 718, 719*). Isolated groups like this are less cloying than the contemporary gynaikeion scenes on red figure vases. The use of a column as support for standing figures is now well established (*Pl. 719*).

The tomb which yielded the name piece of our group also contained *Pl. 721* with its strange scorpion-locust-siren.

225 226 227

THE NIKE GROUP (TYPE VII)

The successors to the heavy rings are still broadly stirrup-shaped in outline, with their bezels not raised from the hoop. Some bezels have slightly convex faces and they are generally oval in outline. They offer the first examples of what we can recognise to be a fourth-century style of engraving. Most are from South Russian sites, and the popularity of Nike figures upon them suggests the name for the group. There is considerable stylistic unity here, and none need be later than the mid fourth century.

The finest shows Nike sacrificing a deer (*Pl. 723*), kneeling on its back in the pose already met on the Nike Temple balustrade in Athens, and which will long persist for such groups, being eventually adopted by Mithras. We noted an Archaic prototype (*Fig. 188*). Her long wing feathers splay and separate, the drapery moves in simply cut folds, and the animal is rendered in the best tradition of the fifth century. Nike is usually shown slaying a bull and the choice of animal here may indicate a sacrifice for Artemis.

On another ring from Kerch she is shown in different dress—or lack of it—with a himation wrapped around her legs (*Pl. 724*). This we have seen already on the fine 'Onatas' gem (*Pl. 590*) and earlier on a ring. Here she is nailing a shield to a tree, preparing a trophy, with just the gesture and dress that we see on coins of Agathokles of Syracuse at the end of the century, but the proportions of her head and body and the treatment of the wings look much earlier. The inscription is puzzling. *Basilei* suggests that it was a gift to a king, but although rings inscribed *doron* ('gift') are known, this formula with the dative alone is not met again on gems or rings. It is, of course, common on other objects. The donor's name is hard to read. Furtwängler thought he could read P)a(r)menon, and naturally recalled that Parmenion who was associated with Alexander, the King. The leafy branch growing from the trunk of the trophy appears first on coins later still (see below, on *Pl. 747*), so we must admit the possibility of a yet lower date, and reference to a Macedonian king, although the shape of the ring might then seem rather outdated.

Kneeling figures apparently suited the artists of this group. They resemble the bathing women seen on the stone gems, and there is one here (*Pl. 725*). A kneeling Eros plays with the iunx wheel (*Pl. 723*), and a girl plays with knucklebones (*Pl. 726*), her hair drawn back to a knot in a fashion which will be seen more often now on rings. The depth of modelling here, combined with the contrasting texture of undergarment and cloak, well brought out by simple incision, make this ring one of the finest of the group. It was stolen from the Boston Museum in 1952.

A most detailed frontal Nike in a chariot (*Pl. 727*) is rather a tour de force. From the shape of the ring it seems that the Leda and the swan (*Pl. 728*) may be placed here. If so, this is the earliest representation of her reclining to receive the creature's favours, instead of standing to it, in the usual earlier fashion. The total nakedness and turned back is also unexpected, but not unparalleled for other figures so early.

Studies of facing heads (as *Pl. 729*) become increasingly popular on the latest Classical rings. The horns worn by the head on *Pl. 730* are odd but they may indicate a river deity. Coins of Gela show such a head in profile, and there are Hellenistic gems with the frontal horned head. The cicada above might be some sort of personal device but it also calls to mind the name for a male hair ornament (*tettix*).

223

The Gorgon head became a rare device for gems after the Archaic period. On *Pl. 731, colour, p. 217.6*, we see one of the last to retain the exaggerated grimace, but with the snakes neatly knotted beneath her chin in the Classical manner. The dolphin beneath may be intended to recall the Gorgon sisters' pursuit of Perseus over the sea, with a convention used long before by the Nessos Painter on his name vase. It suggests that even at this date the full context of the story was in the artist's mind when he depicted such a common extract from it. Finally, a still life with Herakles' bow and club (*Pl. 732*), popular symbols on many East Greek coins, for instance on the gold coins of Philip of Macedon.

THE SALTING GROUP (MAINLY TYPE VIII)

These are characterised by slim, statuesque figures, impeccably detailed, and generally occupying a fairly small part of the whole bezel, which is raised from the hoop, and oval or even approaching a circle in outline. In sculptural terms the figures may be seen to betray the influence of Praxiteles and to approach Lysippus. Figure studies are more languid, although not yet exaggerated, but there is a more deliberate sensuality especially in the treatment of the nude. There is great virtuosity in the rendering of drapery and wings spread more, with separating feathers. The proportions of heads to bodies are more life like, and sometimes the heads may look too small, where on earlier works they were large and boldly detailed. The hair style, drawn back from the face to a point with a knot or bunched tail, is becoming more popular. These works are complements to the gemstones of the fourth-century Fine Style.

At the head stands a magnificent study of a goddess on a ring from the Salting bequest in the Victoria and Albert Museum (*Pl. 733; colour, p. 217.5*). We see the same headdress on other rings (*Pl. 734*), where the goddess is half-naked, with Eros, and presumably an Aphrodite. She has this headdress too on fourth-century coins, but on the Salting ring a veil also is worn and the identification of a Hera is possible. The statuesque figure is classicising, Praxitelean in its grace, and need be no later than the mid fourth century.

Aphrodite wears a higher crown on *Pl. 734*, half-naked, lounging by a pillar and teasing Eros with a bird. Later, perhaps, is another fine ring showing Persephone carrying two torches (*Pl. 735*). Another Aphrodite who is completely naked (and this is by no means common yet) leaves her column to support her clothes (*Pl. 736*). Queen Omphale, whose whim it was that Herakles should exchange his clothes for hers, is first represented in Greek art at about this time. We have already seen the normal type for the figure (*Pl. 635*, and cf. *766*), but there is a wholly unusual version in a very worn gold ring from the Oxus Treasure, on which Omphale has not only adopted Herakles' club and lion skin but poses with them like him, stark naked (*Fig. 228*).

Eros in these years is still adolescent. There are good studies of him with Aphrodite (*Pl. 737*) or alone, seated on an altar (*Pl. 738*). Even when he is shown summarily as a tiny figure beside his mother, his proportions are still slim and mature. Only later is he shown as a chubby putto.

A new version of the sacrifice motif, related to the divine figures with phialai on earlier rings (as *Pl. 662*), has a woman dropping incense on an altar, where the bird signifies a Zeus or Apollo (*Pl. 739*). A wholly new subject is the dramatic and vigorous runner with a torch (*Pl. 740*).

There are other devices with seated women, more often naked to the waist now, in a less accomplished style (*Pl. 741*). One is shown seated beside a tall grave lutrophoros (*Fig. 229*), a type of grave marker which was becoming more popular in fourth-century Athens. The allusion does not make this a funerary ring, and a figure of myth should perhaps be identified, even Electra.

It is here that one remarkable recent find of a silver ring should be mentioned, although its style and complexity go far beyond anything in this or any other fourth-century group. It is from Kerasa, in north-west Greece, and the intaglio shows Klytaimnestra seated on an altar being killed by her son Orestes (*Fig. 230*). Both are named. The figures fill the oval field and are rendered with exceptional detail of dress

224

228 229 231 232 230

and features. Notice especially the palmettes on the queen's dress, which recall the patterning on costumes on some late fifth-century vases. The find was made in a tomb of apparently early fourth-century date. The lettering of the inscription seems certainly no earlier. This looks very much like a deliberate copy of a composition familiar in some larger work of art, and its discovery is a sharp reminder of how much we may still have to learn of fourth-century Greek gem engraving.

FOURTH CENTURY: ROUND BEZELS

Large rings with circular bezels seem not to have been made before the second half of the fourth century and they were certainly still being made in the third. They form the most characteristic class of early Hellenistic glyptic and are the last stage in the development of the bezel to a full circle, on a heavy, solid hoop with a flat section. The tendency is towards either elaboration with some decorated hoops and floral borders to devices, or a diminution of the device, leaving the mass of gold to speak for itself. On the better rings the motif fills at least the height of the field, although head studies, which regain popularity now, are isolated in the centre. The hair drawn back to a point is very common and we begin to see examples of the 'melon' coiffure which is most popular in the third century. Figures have small heads and plumply sensual bodies. Eros is becoming a baby and his wings are often smaller too, like those of Hellenistic and Roman Erotes. A few oval bezels are still met and the form was never wholly replaced by the circular.

Aphrodite and Eros find new occupations. They play *morra*, no doubt using the stick we have seen other girls balancing on their hands. The game involves guessing the number of fingers held out by the partner, who shows only one hand, the other being partly closed over the stick, or, in the modern version, held behind the back. The stick may have been used also for the scoring. The game had already been shown on fifth-century vases and appears on a fine gold ring from Lampsakos (*Fig. 231*).

Aphrodite teaches Eros how to shoot (*Pl. 742*), since he is only now entering upon his career with love's darts. On the ring he is precariously perched on a pile of rocks and the scene is better managed on the famous mirror cover in Paris, which is slightly earlier, but repeated in this form on a Hellenistic gem. Another Eros, seated abjectly at a tomb with an upturned torch (*Pl. 743*) introduces another new motif to be further exploited in Roman funerary art.

With the full Hellenistic period of Alexander's successors we find greater correspondence in both style and subject between the devices on coins and the devices on finger rings. A Leningrad ring (*Pl. 744*)

gives a close copy of the Athena who appears on coins of Lysimachos, ruler of Macedon and much of Asia Minor. The goddess looks slighter and more elegant than she does on the coins, but in all respects of furniture, armour and the Nike on her outstretched hand, the coin device is copied.

The actor on *Pl. 745* is a fine statuesque figure. Coin types are again recalled on a ring showing Nike carrying a ship's *aphlaston* and *stylis*, emblems of victory at sea. In this, and other studies of Eros or Erotes (as *Pl. 746*) we see the wings more boldly feathered, often with tips splaying in the Hellenistic manner. The Kybele seated in the doorway of her shrine on *Pl. 748* is a version of the contemporary votive reliefs which are especially common in East Greece and Asia Minor.

A few rings admit the extra elaboration of a decorative border to the device. The finest, shown on *Pl. 747*, also has a decorated hoop, with tiny relief scenes of Nike and an Eros (?) flying towards a tripod at either side. The device is again a Nike, setting up a trophy. A clumsier version of the group is seen on coins of Seleucus I (312–280 BC) where, however, we also see the odd detail of a branch growing from the stump of the trophy. This may give an indication of the date of the ring (but see above, on *Pl. 724*). Another ring with a decorative border (*Pl. 749*) has a device which becomes a commonplace on metal rings from the later fourth century on—a woman standing before an incense burner (*thymiaterion*).

An elephant with his driver, on a ring in private hands (*Pl. 750*), is cut in a rather stiff manner, and is only placed here, rather than with the western rings of similar style, because the elephant is Indian. The creature is represented on a number of Hellenistic coins from the Greek east.

Rings with still-life motifs are comparatively rare, but there is one from Crete showing the typically Cretan type of arrowhead (*Fig. 233*). A most attractive group has Athena's owl guarding her armour (*Fig. 232*). The bird is seen on a fifth-century vase actually carrying her weapons and wearing a helmet, a motif repeated on gems much later. A rat, bound to a column for stealing corn (*Pl. 751*), comes from Alexandria and must certainly be third-century in date. Again the motif looks forward to later Hellenistic (usually Alexandrian) and Roman art. This may be the place for two rings which archaise both in the form of their Athena devices and the shapes of their bezels, which are slim and pointed (*Fig. 234*). The published ring shape of one example shows, however, that it is not Archaic or even Early Classical, and there are archaising Athenas on coins of the latest fourth and third centuries.

These have all been rings cut with some care and often with original devices, but the commonest of this shape bear motifs of seated or standing women, some with torches (as Kore on *Fig. 236*), or Nikai, in the tradition of the earlier fourth-century rings. Now, however, the object of the women's attention is not invariably Eros, but may be a child (*Fig. 235*) and is more often an incense burner which they are either fuelling (*Pl. 753*) or carrying. This is not a new piece of furniture but only now are women regularly occupied with them on rings. The execution of these rings is generally poorer. We see the new hair styles and often the third-century dress with the himation drawn in broad folds over the heavy hips and legs. These figures are often quite small, and isolated on a ground line in the centre of the bezel.

Finally, a few fairly large rings with broad oval or round bezels and simple animal blazons may go here. The device is sometimes set in a wreath (*Fig. 238*). They have humbler kin on the smaller Hellenistic metal rings. One (*Fig. 237*) repeats the fox and vine we saw on a Classical gem (*Pl. 497*), and there is an eagle and dolphin (*Pl. 755*) such as appear on Black Sea coins.

WESTERN GREEK: FIFTH CENTURY

The problem of identifying Western Greek engraved finger rings can be approached with more confidence than the search for Western Greek engraved stones of the Classical period, and it seems most probable that a tradition for the manufacture of metal signet rings had already been established in the Archaic period. Nevertheless, it is not easy to isolate or to define criteria for the identification of Western Greek

233 234 235

236 237 238

239

rings. Those assembled in this and the following sections either have a Western Greek provenience, or are closely related to such rings, and have some stylistic features not wholly similar to those of the main series of Greek rings. It is very likely that there are errors in this classification and much more material is required before anything like the style of a school or artist can be defined. We know that Greek artists visited or emigrated to the west. What we look for is evidence for a western school with a distinctive style. Ring shapes are the same, and for the materials all that can be observed is that proportionally more silver rings (and virtually none of bronze) seem to have been preserved on western sites, which probably means that they were made in the west.

The study of a girl on *Pl. 756* is not immediately matched in the Greek groups of the mid fifth century and just after, where the ring is presumably to be dated. The hoop is elaborated with mouldings, which could be another western feature. Twisted hoops, presumably made separately from the bezel, also seem popular in the west. Other rings with narrow bezels in a rough, bold style showing little real sympathy for the representation of drapery or hair, may be western too.

There is a number of finer rings from western sites of the later years of the fifth century or earliest fourth on which it is perhaps possible to detect some common stylistic features. The most important are from Tarentum (*Pls. 757–759*). One shows an old man with a dog (*Pl. 757*); the others women, usually winged. Their heads are relatively large, the bodies neat and the drapery well rendered. The heavy roll of hair seems a characteristic feature. The winged women, whom we might take to be Nikai, are especially popular, and they appear in some odd scenes—holding a caduceus with a bird on it (*Fig. 239*), or kneeling on a column (*Pl. 758*); as well as in the more usual sandal-binding pose (*Pl. 760; colour, p. 217.4*; this is of unknown provenience but in the same style). The kneeling figure is puzzling since she seems to be naked and even in the fourth century Nike is usually given a himation around her legs, but there seems no doubt that this ring is appreciably earlier than the half-clothed Nikai with trophies which are seen on other gems, rings and coins. On coins of Terina (on the S.W. coast of Italy), which are much in the style of the rings, we see a winged woman seated on a hydria or stool, and holding a caduceus, wreath or bird (compare *Fig. 240*). She is sometimes taken for Nike, but on an Early Classical coin of Terina Nike is named and shown wingless. Regling thought that she was a collation of Nike with the local nymph Terina, and a similar explanation is probably to be sought for the figures on the rings.

WESTERN GREEK: FOURTH CENTURY (TYPES VIII AND IX)

A number of rings of good quality, mainly from western sites and of Type VIII, may be treated together. The bezels are still oval and the devices seem not necessarily later than the mid century.

A problem piece is a heavy ring in New York from North Italy resembling Type V, with a three-quarter facing head of the youthful Herakles wearing the lion skin (*Pl. 761*). This is exactly the scheme for the Alexander heads which appear on coins of Cos, but the treatment of the eyes and features on the ring are quite different and distinctly earlier. It presumably records the Greek type which was copied for the Alexanders.

An Athena head in rather similar style comes from Sicily (*Pl. 762*). It is, at any rate, taken for an Athena, but the hair is very wild and the helmet, with its wing-like crests, recalls the bird- or griffin-caps worn on other gems and later coins. This could be an Amazon queen.

A good Artemis with her dog on a Geneva ring (*Pl. 763*) is repeated on a poorer silver ring in London (*Pl. 764*), where she holds a torch, not a throwing stick. The figure becomes a popular one after the end of the fifth century, and may be influenced by Strongylion's Artemis statue, showing her running with torches. She can carry a torch in the hunt, but the throwing stick is of more obvious service.

Deities and heroes are perhaps commoner on the western rings: an Athena of the familiar type (*Pl. 765*; compare the earlier *Pl. 486*); another Omphale (*Pl. 766*), this time shown as she was on a stone scaraboid (*Pl. 635*) shouldering Herakles' club, and not mimicking his strong-man pose as in *Fig. 228*; Hermes fastens a sandal (*Fig. 241*); Perseus flees (*Pl. 767*); Nike crowns Herakles (*Pl. 769*). The last is a group seen often on Italic and Late Etruscan gems and mirrors.

WESTERN GREEK: FOURTH CENTURY, THE COMMON STYLE

There are three main groups of lower quality finger rings, most of them silver, and all presumably western, to judge from alleged proveniences. The first, of Type VII, still have narrow, even pointed bezels (*Pls. 771–773*). The whole figures have long necks and tiny heads. On one, showing an Eros with a *thymiaterion* (*Pl. 772*), there is an inscription, not necessarily Etruscan as has been suggested. The speciality seems to be facing heads of women (*Pl. 773*) and some bezels have borders, either a hatched line (*Fig. 242*) or a wreath.

The second group, of Type VIII, have broader bezels, and the subjects are all women or Nikai, standing or seated. The drapery is rendered with clear, simple incision. One Nike crowns a trophy (*Pl. 776*). Here and on the other rings she is fully clothed. There are more hatched borders to the bezels, cut to give a raised, cable-like impression. Many of these silver rings have their bezels pierced with a gold stud, the one in *Pl. 779* being unusually decorated with a star pattern.

The third group, mainly of Type X, have small oval bezels cut in a simple but effective manner, occasionally with some care and detail. Most carry the usual Nikai or Erotes, but there is an Athena with her owl and, in a similar pose, Herakles beside the tree with the golden apples of the Hesperides, guarded by a serpent (*Pl. 780*). More uncommon subjects are the lounging lyre player (*Pl. 781*) and floral (*Pl. 783*). Two rings of this type, with small round bezels—in one instance made separately—are unusual in having a border of tremolo pattern (one on *Pl. 784*). This zigzag is made by the rocking movement of a scorper, cutting a zigzag of arcs in a band across the metal. The technique was first used on Greek metalwork in the eighth century. It is not usually found on later jewellery (a rare exception seems to be our *Pl. 441*) but in Italy and Europe it had a longer vogue on bronzes than it enjoyed in Greece.

Two rings which seem to archaise in shape and subject, but not in style or technique, may be added here. One in Syracuse shows the comparatively rare scene of Phrixos riding the ram, and tremolo is used on the border and for the beast's horn and tail (*Pl. 785*). The shape of the ring is old-fashioned, with a broad pointed bezel following the line of the hoop which is itself, like the bezel, of thin beaten gold.

240 241

242 243

244 245 246

WESTERN GREEK: FOURTH CENTURY, ROUND BEZELS

A few rings with round bezels, of high quality and with devices which, where datable on grounds of style, would suit the middle or third quarter of the fourth century, have been found in the west and may have been made there. Their successors, which are more numerous in the west, are far less distinguished.

A fine Nike in a wheeling chariot (*Pl. 786*) recalls the subject of several fourth-century gemstones as well as coins. Her pose, leaning well out over the team, is seen on fourth-century Sicilian coins, but the spirited rendering of the horses with their tossing heads resembles the best of the later fifth century. A ring in Oxford, with a half-naked Nike dressing a trophy (*Pl. 787*), seems very much in the spirit of Agathokles' Syracusan coins and it is probably western too. The composition is a better one and the placing of the wings more effective than on the coins, which are of the end of the century. There is much finer modelling here than we have seen on other western rings and the treatment of the drapery is economical and effective.

Hippocamps have been seen already, bearing Thetis, and on their own they are popular decorative devices. One on a London ring is rather old-fashioned in being winged (*Pl. 788*). Another, wingless, is cut in an odd stiff manner (*Fig. 243*) which is repeated on a second ring, with a griffin. These may be the products of some minor workshop, perhaps not wholly Greek in staff or patronage.

Most of the western rings with round bezels are early Hellenistic (*Pls. 791–793; Figs. 244–246*). The bezel is very large, often considerably overlapping the hoop, but the structure of the ring is generally flimsy, and the device, rather summarily cut, is placed centrally in an otherwise empty field, rarely filling most of it (as *Fig. 245*). A few show divinities, but many have a woman or Nike busy at a *thymiaterion*, and most popular of all is Eros. He is shown at that transition between adolescence and babyhood which marks the reversal of his growing up in Greek art, and can be placed around the end of the fourth century. He is variously occupied on the rings—with his new bow and arrows, often with torches and thyrsos, for he is now admitted to the Dionysiac circle, reading and on an altar. These rings were intended as a display of bullion, not for use as seals or as fields for high artistry.

229

OTHER LATE TYPES

The rings of Types XIII–XVI all imitate finger rings designed to receive engraved or plain stone bezels. They belong, therefore, to a period in which such rings with stones were becoming more popular than all-metal engraved rings. This is true already before the end of the fourth century, when the demise of the scaraboid marks the victory of the new type. But the rings with set stones were to oust not only the larger stone gems, like scaraboids, set on swivels or pendants, but also eventually the engraved all-metal rings which, but for a notable series of Hellenistic portrait rings, barely survive into the Roman period. Most of the rings of Types XIII–XVI, therefore, are likely to belong to the later fourth and third centuries. Their devices do not go beyond the fourth-century repertory (*Pls. 795, 796; Figs. 247, 248*) and the style makes no concessions to novelty, although the summary cutting of most of them does not allow a clear decision about this. The types appear to be current in both Greece and the west, but it is worth noting how many are said to be from Crete. There are also a number of very flimsy rings of Type X, for which the only specific proveniences are Crete (*Figs. 249, 250*), and which seem related both to the smaller rings already discussed and the contemporary heavier rings with circular bezels.

The devices call for no special comment. Simple head studies are common, rarely myth scenes. One ring of Type XIV shows a girl sitting on a youth's lap (*Fig. 247*). The subject appears occasionally on vases and was used on Etruscan relief rings in the fifth century. It is, however, surprisingly well represented among the impressions on clay loomweights.

RINGS IN THRACE

The manufacture and use of finger rings outside the Greek world, but under the influence of Greek practice, deserves a note. In the de Clercq group we have observed such a phenomenon but the results are Greek in style and execution, and they are from an area well accustomed to seal usage. In Thrace (modern Bulgaria, well north of the Aegean coast) a gold scaraboid was set in a gold swivel in the earlier fifth century and inscribed on its face and one edge with a long Thracian inscription in, as was usual, Greek letters. The inscription appears to be funerary and the ring may have been made for burial, but its form is Greek. Not much later a Greek ring (Type I) reached Thrace and was inscribed *Skythodoko*, an odd name which should mean 'friend', or 'host of the Scythian' (*Pl. 672*). This is appropriate enough for an area well supplied at this time with Scythian objects. The device is a fine horseman. The same subject on a ring of similar form but in a far poorer style, provincial Greek if not native, was found in another fifth-century tomb. It too was inscribed in Thracian, apparently with the owner's name (*Pl. 794*). Later still, perhaps in the fourth century, a woman and horseman appear on another gold ring in a similar awkward, probably local style. A far more competent version of the same theme is seen on a fourth-century ring which could be Greco-Persian. There are other arrivals from the western parts of the Persian empire into Thrace, probably via the Black Sea, in these years: the most notable is the Panagurishte Treasure, and the influence of the same area can be traced in another treasure, from Letnitsa. Finally, a gold ring of the latest fourth or third century (Type XI) shows a man with a drinking horn beyond (or on ?) a horse, in a thoroughly degenerate, curvilinear style which might owe something to local Scythian fashions for all that the shape of the ring is Greek; and there is a bronze ring in similar style from South Russia.

BRONZE RINGS

Most of the simpler types of rings in precious metal are also found in bronze. Although many of the devices on the bronze rings closely match those on gold or silver rings there is a marked difference in the range of motifs, and, for most of them, a very considerable difference in the quality of the engraving. Very

247 248 249 250

251 252 253 254 255

few indeed have been found in the west, which is surprising since there is a number of Late Archaic bronze rings which seem to have been made in Italy. Some must certainly have been made there still in the later fifth and fourth centuries but from the extant material it is not possible to distinguish local groups or styles. Rare examples are gilt or silvered, but where the plating in precious metal is heavy they have been included with the gold and silver rings. A few have gold or silver studs set in the bezel, or a gold crescent. A small number of iron rings with intaglios may be included. In the following survey I draw attention to the principal types and discuss selected examples. By shape and date they fall into four broad groups:

A. Type I rings are few, but some listed as Late Archaic may belong here. The motifs include the familiar Penelope figure and Nikai (*Pl. 797*). The only strange motif is a lobster on a ring from Sicily (*Fig. 251*).

B. Rings of Types II, III, IV or VI, still of the fifth century. There are some excellent examples here, like the kneeling Herakles with his bow (*Pl. 798*). Thetis riding her sea horse, a maenad, and Eros with a woman are some of the subjects familiar from gold rings and there are a few minor animal studies (*Fig. 252*).

C. The largest series is of rings of Types VII and VIII, with oval bezels, a few still rather pointed, a few already approaching the circular. They belong to the later fifth and the first half of the fourth century, and are the most repetitive, although there are some original and important devices.

There are a few head studies, including one with a mask cap (*Pl. 800*), and a grotesque incorporating three heads and a bird (*Fig. 257*) like those on the earlier Greco-Phoenician scarabs (*Pl. 417*). A nymph holding an *aphlaston* seated on a ship's stern (*Pl. 801*) recalls the device of a gold ring, already discussed (*Pl. 674*), and there are further examples of Thetis on her hippocamp. Instead of the whole maenad we have a good study of the head and shoulders alone, with the head thrown back in ecstasy and hair streaming (*Pl. 802*). This is far more in the spirit of the fourth century. Women are escorted by Eros, tend an incense burner or bathe. Nikai (*Pls. 803, 806*) and Erotes are commonplace. An Eros from Olynthus (*Fig. 254*) draws a bow and is early evidence (pre 348 BC) for his use of the weapon. There are one or two more formal studies of deities, including what may be a goddess or priestess facing us between two *thymiateria* and with an odd arch-like arrangement above which suggests some architectural elaboration (*Pl. 805*). This is a gold-plated ring.

231

Of the new subjects one, which appears on other bronze rings, a metal prism, a Late Etruscan scarab, and sealings at Selinus, is puzzling. It shows a figure seated on a stippled rock, head bent, one arm stretched out over the knee, the other apparently bent (*Pl. 804*). If this is a woman it might be the sorrowing Demeter, seated on the Mirthless Rock at Eleusis. Several rings have Hermes with his foot raised on a rock, fastening his sandal, poor versions of the figure well shown on a gold ring (*Fig. 241*). An engaging set of fat men, satyrs and young Pans hunt (*Fig. 253*), pipe, carry wine or women. One young satyr is given wings, like a bestial Eros (*Pl. 807*). A panther perched on a column (*Fig. 256*) is a motif otherwise represented so early only in impressions preserved on loomweights, where the animal may be a dog (*Fig. 275*). Herms are popular and sometimes in rather odd combinations. Oddest, perhaps, the male and female herms with the tiny figure of the Egyptian god Bes squatting between them (*Pl. 809*). On others the herm is shown with Hermes' goat (*Pl. 811*) or by an altar.

Several original grotesques or monsters anticipate some of the more popular motifs on later gems. The combination of a human head with a shell (*Fig. 258*), bird or insect is to become a common recipe, and the bearded siren (*Fig. 259*). Less readily placed are a dog-bodied Eros (*Pl. 812*) and a feline with a dragon's head and neck (*Pl. 810*) which would have delighted Lewis Carroll. There are other animal studies including a lion biting the rim of a shield, which is a rare variant of the lion breaking a spear in its jaws, seen on other gems. And some flora—silphion and a poppy (*Fig. 255*).

D. Rings of Types IX, X, XI and XVII bring us towards and into the Hellenistic period with a very different range of subjects. Several are heads, human or divine. We may single out a superb Late Classical Zeus Ammon (*Pl. 814*), with the ram's horns, and women's heads with the melon hairdressing (*Pl. 815*). Tall, heavy-hipped Nikai hold a branch, or dress a trophy, and Eros plies his bow. Nike carrying Eros (*Pl. 818*) is an unusual scene of intimacy between the two figures who are rarely associated although their physique and activities are so closely related. A particularly heavy ring has a Janiform head, *Fig. 260*.

It is not possible to be certain for how long bronze rings of these shapes were being made. The few with obviously Roman subjects have light hoops and rather high, cylindrical bezels, or else are of completely different shapes which are represented also in other materials.

DECORATIVE RINGS

The scarabs set in swivels, the engraved finger rings and the set ringstones inspired a number of other types of decorative finger rings which could not be used for sealing. The 'devices' on these rings are generally in relief, imitating the intaglio. There were rare examples of this form in Archaic Greece, but it was common enough in sixth-century Etruria, and in Italy the fashion lingered on in the fifth-century 'Fortnum Group' of finger rings, and in the humbler miniature lead rings from South Italy. These have distinctive shapes and decoration, but we are here more concerned with imitations of the usual Greek ring forms, whether they were made in Greece or the west (as a few seem to be). Their jewellery technique and relationship with the intaglio rings remind us that the gem-engravers probably sat in jewellers' studios.

The simplest type takes the slim pointed bezel and decorates it with a relief pattern of scrolls and palmettes or rosettes, either cast, added with studs, or rendered in filigree. The simplest of these—some are of bronze—have quite thin bezels, but in the later fifth and fourth centuries they take on a box-like form, with a scroll pattern on the sides. The hoop may be twisted and on many of these rings there are elaborate terminals to the hoops in the form of animal heads. Related to these are successors to the Archaic rings with bezels in the shape of a Boeotian shield (Archaic Type J). These sometimes have relief gorgoneia as devices or blazons.

Some relief rings simply imitate engraved rings of Types I, III or VII, with thin, broad pointed, or oval bezels, without any elaboration. The device is cast, or, more often, beaten in gold plate and the

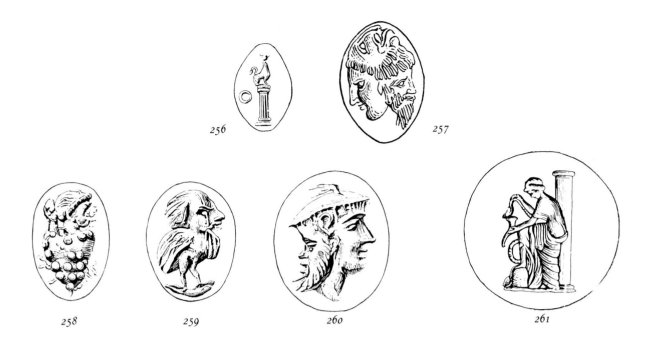

256 257

258 259 260 261

bezel is hollow. It may also sometimes be decorated on the underside with a filigree pattern. Type I rings repeat the common subjects of Penelope or a lion. We might judge from the sorrowing Penelope type that these were funerary rings, but they are not mere character studies of grief, but Penelope herself, as is shown by Odysseus' bow which is set before her (compare *Pl. 656*); and Penelope's grief had a happy ending. With Type III we see again the motifs of the seated women, and the examples from Italy suggest that they were mainly popular there. A late example in Rome bears an Etruscan inscription. Rarely a finger ring of the standard type, with a flat bezel, has an inlaid device in contrasting metal, silver in gold, or gold and silver in bronze.

The cornelian lion gems are copied in gold in a superb fourth-century example from South Russia (*Pl. 819*) with an intaglio showing Artemis. Scarabs in swivel hoops are also imitated in gold in the fourth century. A few have intaglio devices, figuring Aphrodite and Eros (*Pls. 820, 821*), while others have relief devices, which may be a western speciality. On one the small figure of Eros as device is surrounded by scrolls, which relates these gold scarabs to the next group of decorative rings to be discussed.

The most elaborate fourth-century type has a heavy box-like bezel of oval shape, which is either fixed immobile to the elaborate hoop (*colour, p. 217.7*), or is mounted in a swivel hoop and has relief decoration on both faces as well as the sides. The relief figures are within scrolls. Two with flattened scarab beetles on one face afford another link with the gold scarabs, and the general form resembles the more ornate rings with pointed bezels and relief floral patterns already mentioned. These again may be western, but there is an ordinary silver ring of Type V which has gold relief decoration soldered on to it in just this manner, and is said to be from Nisyros, an East Greek island.

On the last mentioned ring the device was distinguished by being in gold on silver. Occasionally the colour contrast is achieved in other ways. A minor example is the gilt border on the silver ring, *Pl. 784*, and we have noted examples of a whole device, but not figures, being inlaid in other metal. There are more elaborate specimens employing other materials on bezels in the shape of oval plaques set on swivels. Two have cut-out gold figures on either side of a blue plaque (lapis lazuli or glass) which is then covered with clear glass or crystal. One, from South Russia, has dancers on one side, a sea serpent and fish on the other (*Pl. 822*). The second, from Thessaly and very probably from the same workshop, shows the serpent ridden by a Nereid, and Eros on a dolphin. The context of the Thessaly ring suggests a date no later than

233

the early fourth century. In the third century there are examples of cut-out gold or painted relief figures on the fixed bezels of rings, covered with glass. These are thought to be an Alexandrian speciality.

Two discs from Pompeii, of uncertain purpose, are treated in a unique manner. They are cornelian plaques with intaglio device, but the back and surface, up to the edge of the intaglio, is covered in sheet gold, leaving the intaglio alone illumined by the reflection from the gold backing. The devices are the same, but one is reversed. It shows a goddess with a horn and a snake (*Fig. 261*), probably Hygieia, goddess of Health, although she is usually shown feeding her snake from a cup while here she has acquired something more like the cornucopia. Her pose resembles that of a fine statue of Hygieia from Epidauros.

Finally, there is a number of bronze and iron relief rings of the later fourth and third centuries, on which the commonest devices are heads, some of them recognisable portraits.

ANCIENT IMPRESSIONS

There have been several occasions to mention ancient impressions of gems and rings on objects of fired clay (see p.190 and Notes, pp.423f.), and some have seemed worthy of a place in the main groups. The others are also mainly of iconographic interest, and they can often be dated on external evidence, but it is not always easy to be certain about nuances of style or even about whether a stone or a metal ring had been used. I assemble here some token illustrations to demonstrate a little of the range of evidence available from this source, so often overlooked.

The impressions on loomweights form the largest class. The series from Corinth and Athens are best published and roughly datable either by context or the shape of the weights. Some from Corinth are shown in *Figs. 262–8*. The loomweight itself as a device is worth noting (*Fig. 265*); it appears often here and in Athens. A few of the other motifs are interesting. The posing of figures or animals on an altar (as *Fig. 264*) becomes common in the fourth century (compare *Fig. 272*). Columns too had served as statue bases in the Archaic period and are more often shown now supporting animals (as the dog on the impression from near Paestum in Italy, *Fig. 275*) or figures like statues, as on the fourth-century Panathenaic vases. Eros bound at the foot of a trophy (*Fig. 267*) is an early example of what is normally regarded as a Greco-Roman subject. The impressions on one loomweight from Corinth (*Fig. 268*) offer a satyr balancing a cup—a trick for girls or satyrs which seems to have interested Classical artists, and an armed bird, recalling Athena's owl with her weapons (our *Fig. 232*). From Athens is an impression with two mugs of familiar Classical form (*Fig. 269*) and a rather obscure cult scene involving a naked woman in a cart with a goat's head upon it (*Fig. 270*). On Athenian clay 'tokens', of uncertain purpose, but apparently impressed by finger rings or stamps very like them, there are some typical devices: the popular joined heads on a token with a vase on the reverse (*Fig. 271*); the altar base serving two Erotes (*Fig. 272*); and the familiar crouching warrior (*Fig. 273*, compare *Fig. 213*) here faced by a rampant lion, although we need not believe that a lion hunt was intended rather than a random but intelligible combination of heroic devices.

Phaistos in Crete yields an impression (*Fig. 274*) closely analogous with the device on an extant stone (*Pl. 859*). Such parallels are easily drawn for many of the more commonplace devices, and occasionally for the more sophisticated, like the boy and girl on the New York gem and the impression from Persepolis (*Pl. 551, Fig. 208*). The Ur impressions, from a late fifth-century tomb (see p.190) are among the most interesting of all since they seem to have been made deliberately for the record of their devices, and are not real sealings or merely decorative or labelling devices added to a clay object. The boy and girl (*Fig. 276*) are seen on rings, and there is an odd variant of the 'hero crowned' group, involving a Hermes

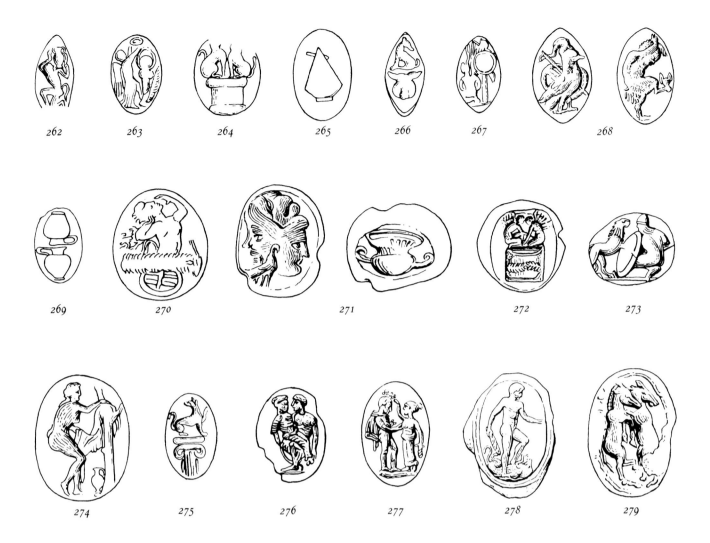

262 263 264 265 266 267 268

269 270 271 272 273

274 275 276 277 278 279

(*Fig. 277*). Herakles with his foot on the lion, on an impression apparently of a stone scaraboid set in a metal hoop (*Fig. 278*), offers a version of the famous Olympia metope and otherwise appears only on another eastern, Greco-Persian stone, yet to be discussed (*Pl. 856*). The animals at play (*Fig. 279*) are also matched in the Greco-Persian series (as *Pl. 913*) and we can see that the Ur hoard spans the full range of Classical Greek, Greco-Persian and Achaemenid glyptic (also *Figs. 313–315*, for impressions of finger rings).

SEAL AND GEM USAGE IN THE CLASSICAL WORLD

Ancient authors tell us a little about the use of seals in the Classical period. Their remarks have often been discussed by others and I have here relegated to the Notes references to the more useful passages. Clearly seals were in common use for securing property and doors, presumably by a sealed clay dump which would have to be broken to untie a cord and open a door or lid. They were used by the womenfolk on their larders, by lawyers on documents, by public officials on property or voting urns. The possession of a master's seal by a steward or agent was a badge of office, and a seal or sealing could be used as a form of identification. Letters in tablets or scrolls were sealed by binding them with cord and sealing the knot. Temple inventories of the Parthenon in the fourth century mention among the offerings signet rings

and seals, mounted or plain, and we know from actual finds that they were acceptable dedications, like any other jewellery, but none would have been made specifically for this purpose, nor are any inscribed as dedications.

Actual sealings from documents or property do not usually survive, since neither wax nor unfired clay are particularly durable. A fire will bake the clay, but there are no major finds of real sealings from the Classical period as there are from the Bronze Age or the Hellenistic. Vases would have been closed, as in the Bronze Age, by a wad of clay over the mouth, and the clay could be sealed. One such seal has been preserved on a sixth-century Chian wine jar from a site in Egypt, but the jar had been reused and the impression on the clay is from an Egyptian seal, naming King Amasis.

We might hope to win some information about the use of seals from a review of the devices chosen for them, and this is a subject which could reward further study, especially if the evidence of surviving impressions is fully used, although at first sight the evidence is not promising. There are many 'feminine' devices—women, Aphrodite or Eros—especially on rings, and some inscriptions name women as owners, like Mika on *Pl. 467* or Panawis on *Pl. 562*. We might wonder what a girl would make of the gift of a gem or gold ring showing Danae, seduced by Zeus' golden rain. A 'Penelope' on the other hand, promises a happy homecoming after separation. If gems and rings were much worn by women it would probably be for their value as jewellery rather than for their use as signets. There are not enough with funerary subjects for us to presume any deliberate production of rings for burial in the Classical period, and we can do no more than speculate about the possible personal significance of a device like an amphora, tripod, loomweight, or, for sailors, Thetis riding her sea horse. Where Nike is shown or symbols of success at sea or in battle we cannot know whether a particular event is commemorated or if general good fortune is being invoked. The devices are usually chosen from the decorative repertory exploited on other works of art. This is somewhat less true of the fifth century, when there is far greater originality in choice and one may suspect a strong and distinctive iconographic tradition in the craft. It is increasingly true of the fourth century. There are very few devices which suggest the influence of any personal or even civic heraldry. Towards the end of our period there is a little more, perhaps, with a number of coin devices being fairly closely copied, but it looks very much as though, by then, gem and ring engraving had lost any independence of tradition in their iconography and had become just another of the decorative arts, although still attracting some outstanding artists.

The inscriptions on Classical gems and rings are hardly more informative than they were in the Archaic period (p.141). Most are names and they appear in the fifth century with a few in the fourth, when we begin to find simpler greetings or labels like 'hello' (*chaire*) or 'a gift' (*doron*). Personal advertisement becomes commoner again with the Hellenistic period. Names in the genitive might be of owners or artists, certainly of an owner in the case of Mika's gem (*Pl. 467*) where the artist signs also. Other names in the genitive on fifth-century gems are Timodemos, Potaneas (?), Polos and Panawis (*Pls. 459, 473, 492, 562*); on rings, Skythodokos (*Pl. 672*); and a gem with only an inscription as device, Isagor(as), must name the owner. Of the artists only Dexamenos explicitly and twice adds the verb 'made', once adding his home (Chios), but twice leaving his name in the nominative (*Pls. 446–469*). Other nominative names, perhaps of artists, are Sosias, Olympios and Phrygillos (*Pls. 480, 633, 529*), and on rings Athenades and Anaxiles (*Pls. 681, 688*). Abbreviations or initials hid discreetly in the device probably also indicate artists: Perga(mos), ND (pseudo-Onatas) and AD (*Pls. 531, 590, 599*), but when they are in the field they were more probably added for the owner. Minor devices in the field resemble the 'magistrates'' or 'moneyers'' countermarks on coins, and may be personal blazons—a knucklebone, crab, olive twigs, genitals, fish, insects. Names in the dative on rings (*Pls. 676, 724*) are presumably of recipients and on the latter the donor is named also. A complete departure from Archaic practice on gems, apart from the

236

Island gem Ajax (*Pl. 264*) and Boreas, and the *soter* on a Late Archaic ring which appears to be an epithet for the Herakles shown upon it (*Pl. 441*), is the labelling of devices and figures. This had been common on sixth-century vases. Now we find Eos, the Dioskouroi, Kastor, Penelope, Danae and Kassandra all labelled, Orestes and Klytaimnestra, and a Lampadias, unless this is the owner's name beside a canting device of a torchbearer. The Western Greeks avoided names on their gems and rings, but not the Thracians, or Etruscans.

There is not much opportunity for us to judge how many people possessed a seal. Herodotus remarks that every Persian carried one, so perhaps every Greek did not, and from Aristophanes it appears that many seals and rings distinguished the fops and the pompous. In the Olynthus cemetery it was common to find one bronze ring worn on the third finger of the left hand. Representations on vases might be expected to help since details of diadems and jewellery are commonly shown, but on red figure vases no finger rings at all are worn by men or women. Since the stone seals, which were more common in Greece than the metal signets, may usually have been worn as pendants and not on finger ring hoops, it is possible that some of the other ornaments worn by figures on vases held engraved seals. This might easily be true of necklets with a single pendant, or wristlets, but most of the similar ornaments which appear worn on ankles, thighs or upper arms are generally described as amulets or lucky knots.

We have to turn to the seals themselves for evidence about how they were worn. The scarabs and smaller scaraboids might still be mounted on swivel hoops and worn on the fingers, but it is not likely that the larger scaraboids were worn in this manner. These could be set in metal hoops to which a chain was attached so that they could be worn around the neck or wrist (*Pl. 378*), or on a rigid gold bracelet. Alternatively a semicircular swivel could be provided, as for a finger ring, but worn as a pendant. This had been a common method of mounting seals in the Near East. In Cyprus it seems to have been common practice to provide a heavy circular swivel of silver, with a bulging hoop. The gold swivels from the Greek world do not rival the Etruscan for their elaboration and quality as jewellery.

The earliest ringstones, oval with convex faces, are set in gold boxes on a stirrup-shaped hoop, like a swivel, but immobile. The edges of the box may be elaborated with filigree (*Pls. 386, 625*). Cyprus provides several examples. The later ringstones are set on hoops of the sort used for all-metal rings rather than the swivel hoops. They fit the finger closely and the stone is either embedded in the thickened hoop (as the metal ring types XIII, XVI) or provided with a separate socket upon the hoop (as Types XIV, XV). These particular metal ring shapes of course derive from those with set stones and not vice versa.

We have so far considered only the private use of gems and rings as jewellery or seals. What of public or official seals which would be fastened to state documents? It seems unlikely that these seals were much like the gems or rings we have been studying. In Athens there is evidence from inscriptions for the existence of a Public Seal in the fourth century, and on his one day of office the President of the Council held the seal and the keys to the state treasuries. Whether such a seal existed in the fifth century is a matter for dispute. The references are to a single seal, preserved, one imagines, for certifying the highest state business. But there is evidence from the fifth century for other official seals, and the Public Seal may not have been all that unlike them. On official measures found in the Athenian Agora—vessels of clay—impressions of circular seals are found. They are not from finger rings or gems but seem to be made by cylindrical rods, probably of metal, and their devices are so close to the contemporary coin devices that we may suppose that they were cut by the artists who made the coin dies being used in the state mint, a mere two hundred metres from the Council House.

Outside Athens the evidence is weaker. We have already observed that from its shape and device a gem in New York (*Pl. 528*) could have served as an official seal for Syracuse in the early fourth century, but it is of cornelian, not metal. Other attempts to identify public seals have not been convincing. Com-

parable use of intaglio stamps in official business may be noticed. In Athens there are the clay and lead 'tokens', the former starting in the fifth century, the latter in the fourth. Most of the clay and all the lead are impressed by circular stamps, not our gems or rings, but perhaps made of clay, wood or metal. The stamps used on wine amphorae or tiles, first in the fifth century and increasingly later, were apparently of clay. They sometimes carried city blazons like those which appear on the coins.

It is appropriate that this chapter should end with some remarks about the relationship between Classical gems and coins. We might expect this relationship to be a close one. The scale is approximately the same, and the technique of cutting an intaglio coin die in metal must be related to that of cutting a stone gem or metal ring, even if it is not the same precisely. Moreover, the devices of both gems and coins are intended to label or identify on the one hand a person, on the other a state. Where there has been cause to discuss the possibility of official seals the comparisons have inevitably been with coin devices. Otherwise, however, there is remarkably little correspondence in devices, and there are not many examples—mainly of the fourth century—where a coin device seems to have been deliberately copied for a gem or ring. Even then we may wonder whether both may own some other common source for the design.

Stylistically—and here the exigences of technique play a role—there are better grounds for comparison in the Archaic series (see p.158) than the Classical. The best Classical gems are far more finely detailed and delicately modelled than the best coins and comparisons are more readily drawn with finger rings. Yet it is impossible to believe that the cutting of coin dies could have been a full-time job for even an itinerant artist, and it is highly probable that the same artists worked on gem stones, metal rings, metal dies and probably gold jewellery. It is a pity, then, that arguments based on the only apparent signatures common to coins and gems (Phrygillos and Olympios, see pp. 200, 210) have to be so inconclusive. Comparisons with the subjects and styles of coins have been drawn in this and the last chapter, and there is undoubtedly room for more study, but it seems likely to prove of at least as much benefit to the numismatist as to the student of gem engraving and cannot be pursued further here.

444 4:1

445 4:1

446 4:1

447 4:1

448 4:1

449 4:1

450 4:1

451 3:1

452 3:1

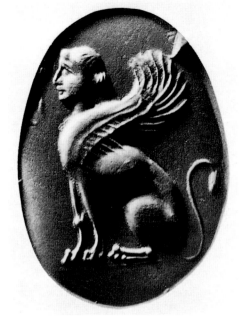

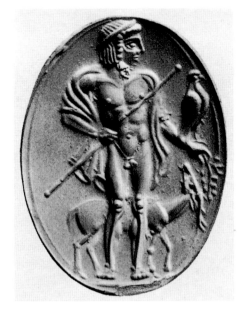

453

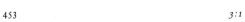

3:1

454

3:1

455

4:1

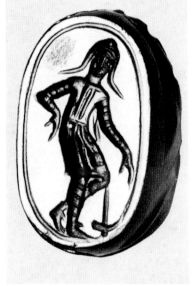

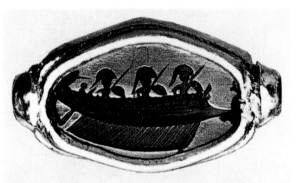

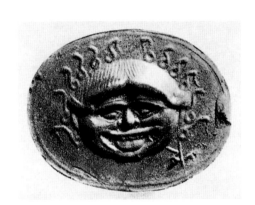

456

4:1

457

4:1

458

3:1

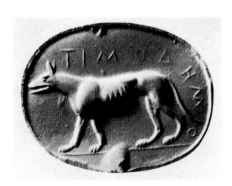

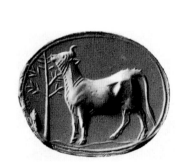

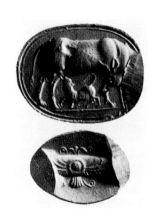

459

3:1

460

5:2

461

2:1

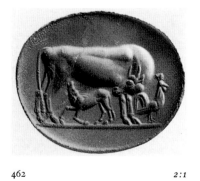

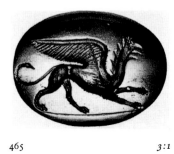

462

2:1

463

2:1

464

2:1

465

3:1

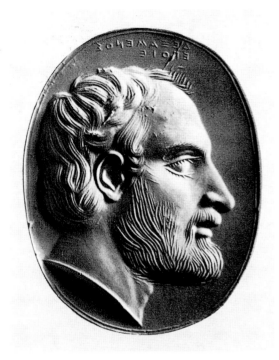

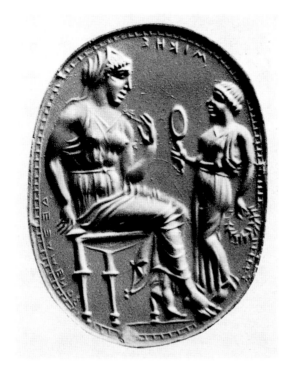

466 4:1 467 4:1

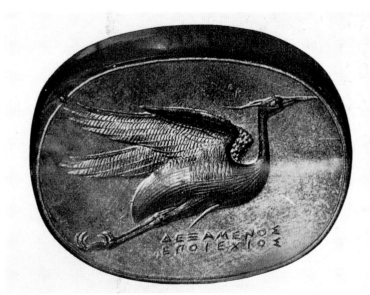

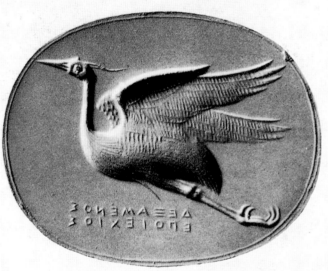

468 4:1

469 4:1

470 3:1

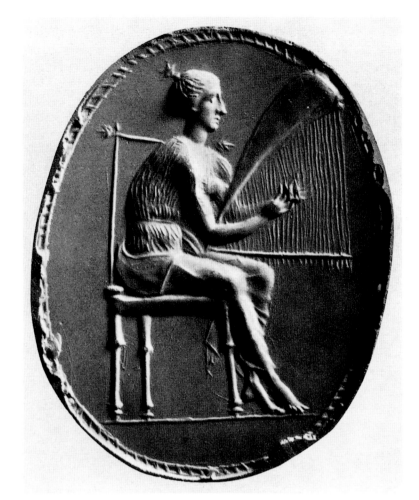

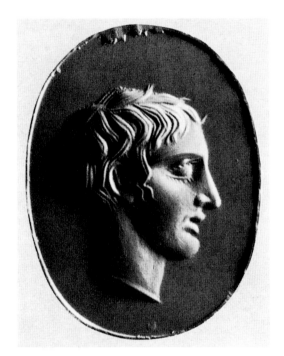

472 4:1

471 4:1

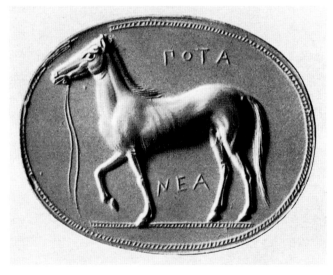

473 4:1

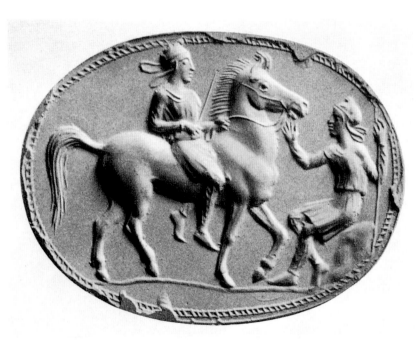

474 4:1

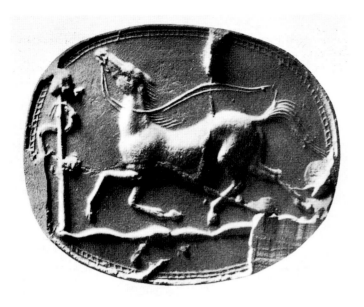

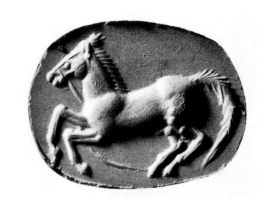

475 *4:1* 476 *3:1*

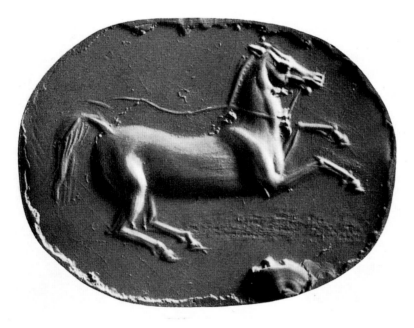

477 *4:1*

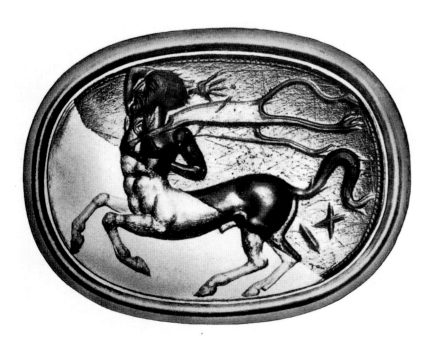

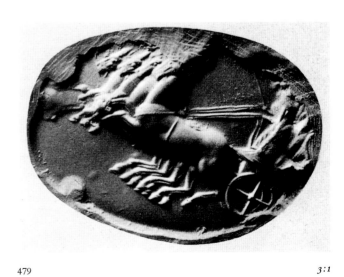

478 *4:1* 479 *3:1*

480 *4:1* 481 *4:1*

482 *4:1*

483 *4:1* 484 *4:1*

485
4:1

 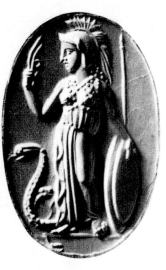 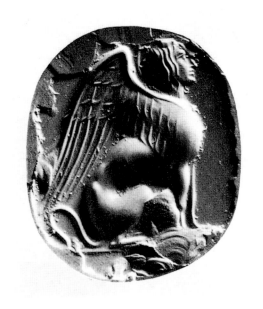

486 *4:1* 487 *4:1*

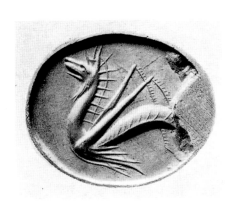 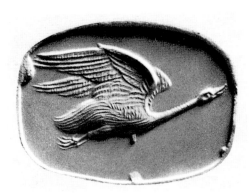

488 *2:1* 489 *4:1*

490 *4:1*

491 *3:1* 492 *3:1*

493

3:1

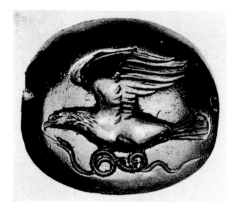

494 *3:1*

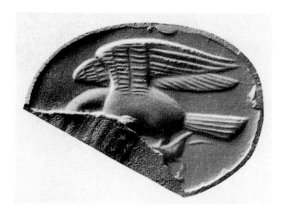

495 *3:1*

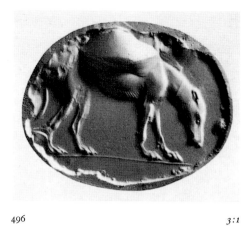

496 *3:1*

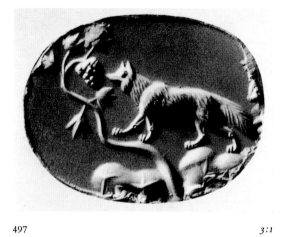

497 *3:1*

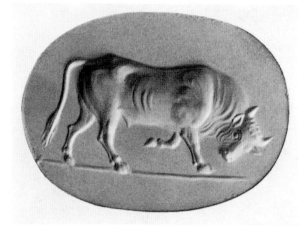

498
3:1

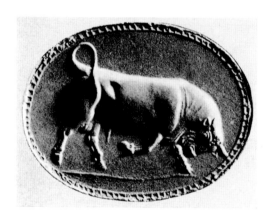

499 *3:1*

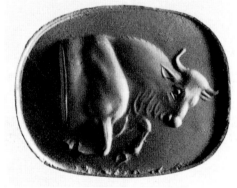

500 *3:1*

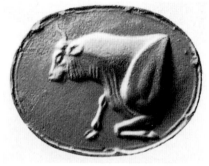

501 *3:1*

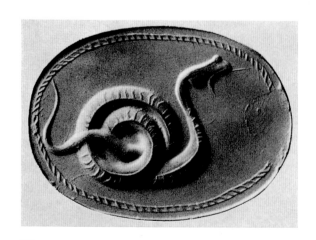

503 *3:1*

502 *3:1*

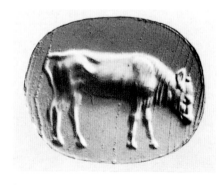

504 *3:1*

505
3:1

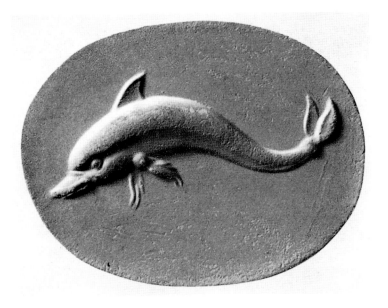

506 4:1

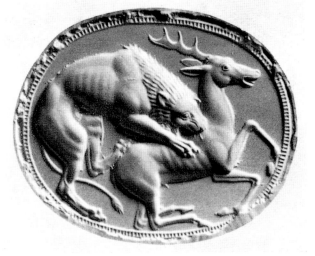

507
4:1

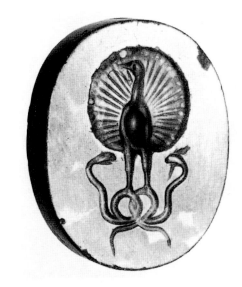

509 4:1

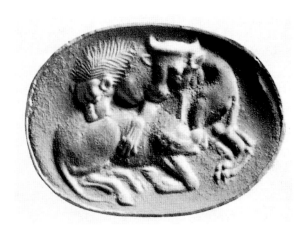

508 4:1

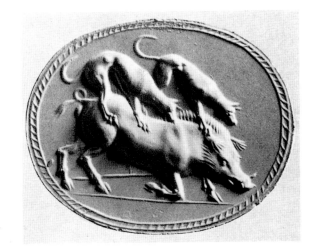

510 3:1

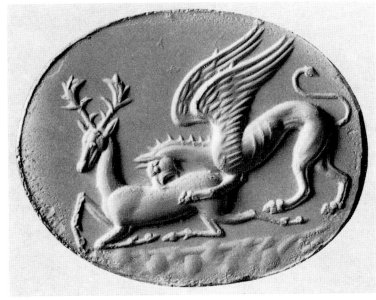

511 4:1

512
3:1

513 4:1

514 4:1

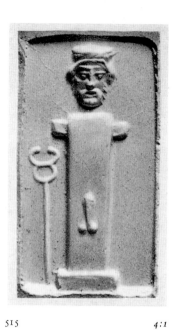

515 4:1

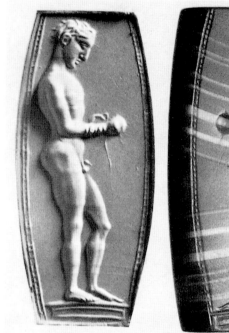
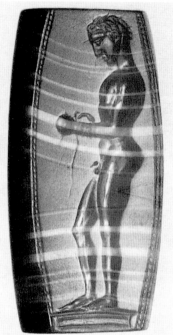

516 4:1

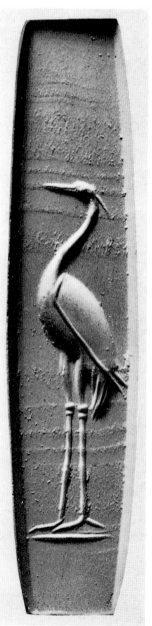

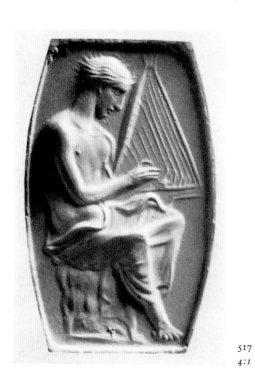

517
4:1

518 4:1

519
4:1

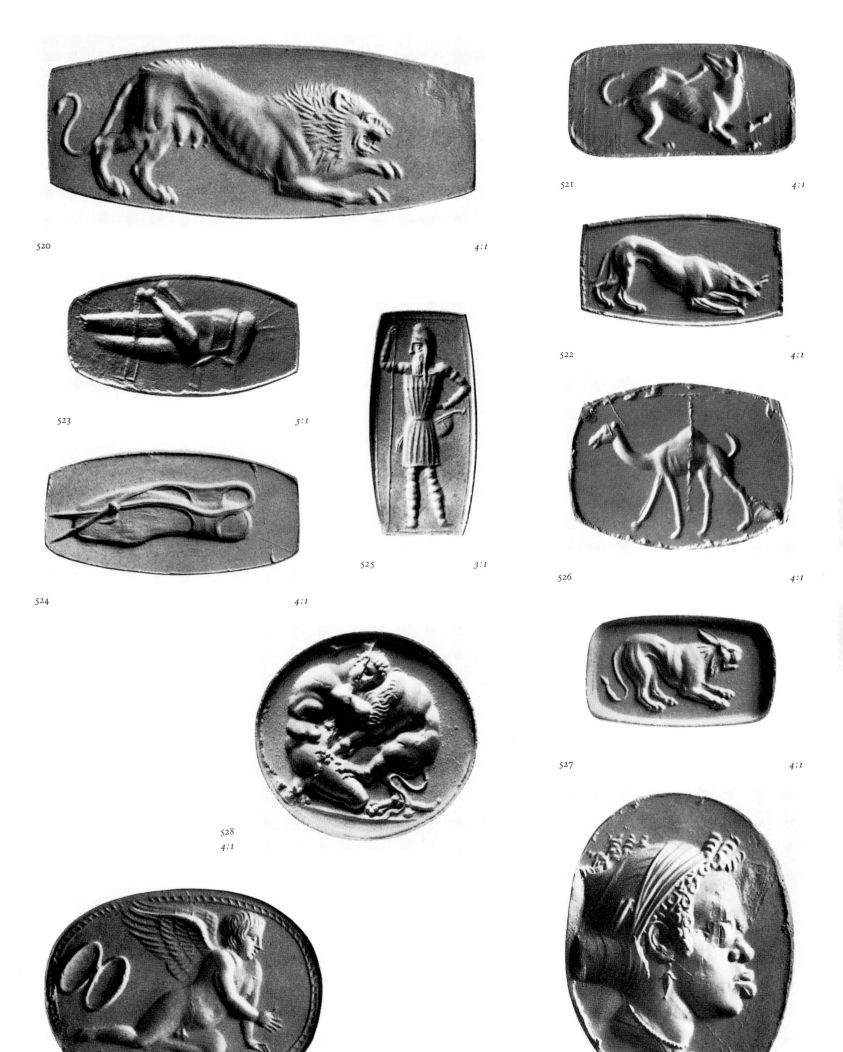

520 4:1

 521 4:1

 522 4:1

523 3:1

 525 526 4:1
 3:1

524 4:1

 527 4:1

 528
 4:1

 529 530
 4:1 4:1

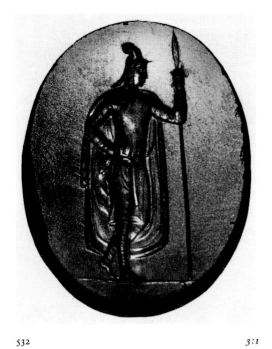

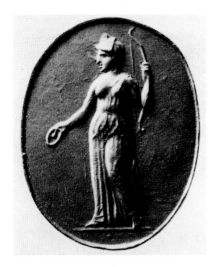

531 4:1 532 3:1

533
3:1

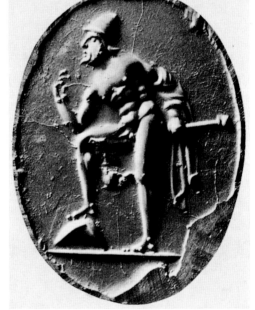

534
3:1

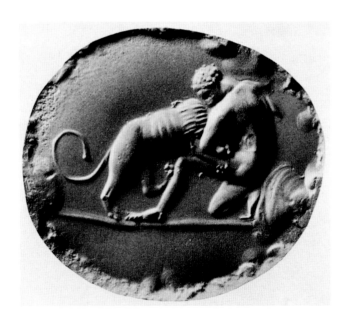

535 3:1

536
3:1

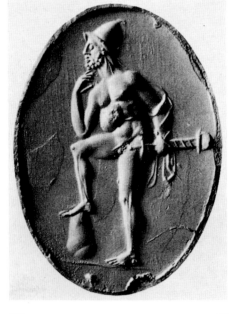

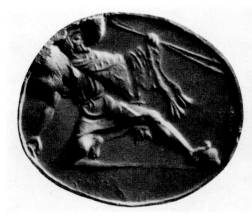

537 3:1 538 4:1

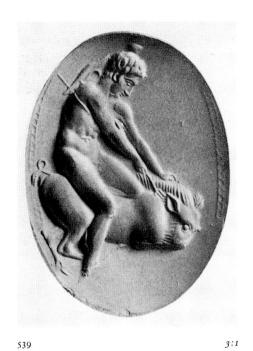

539 *3:1*

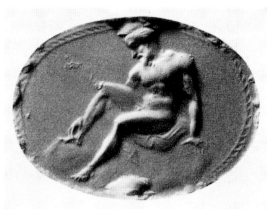

540 *3:1*

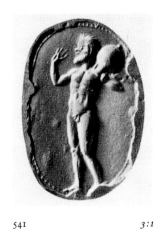

541 *3:1*

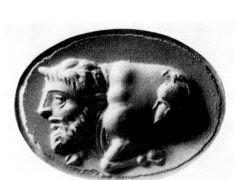

542 *4:1*

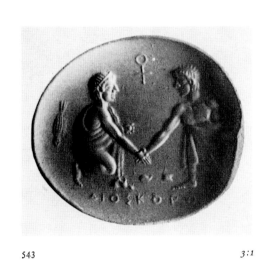

543 *3:1*

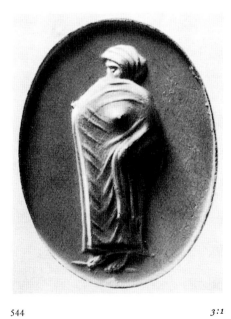

544 *3:1*

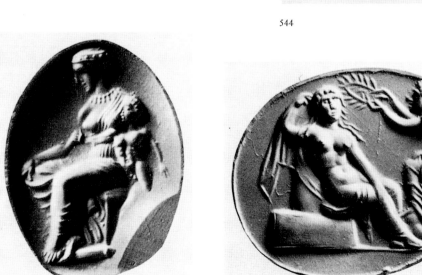

545 *3:1* 546 *3:1*

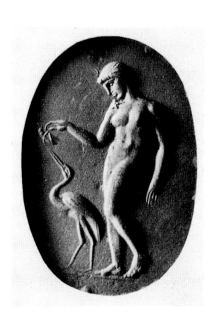

547 *3:1*

548

4:1

549

3:1

550

3:1

551

2:1

552

4:1

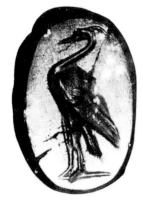

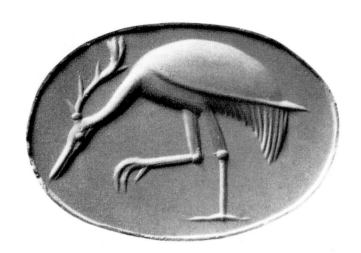

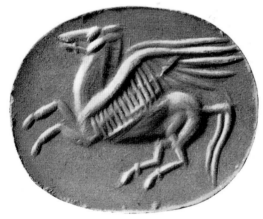

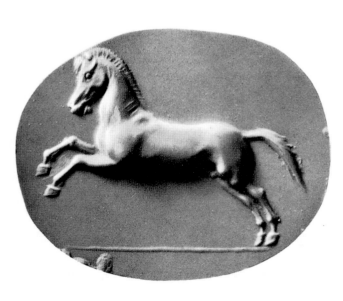

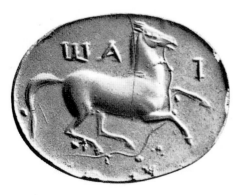

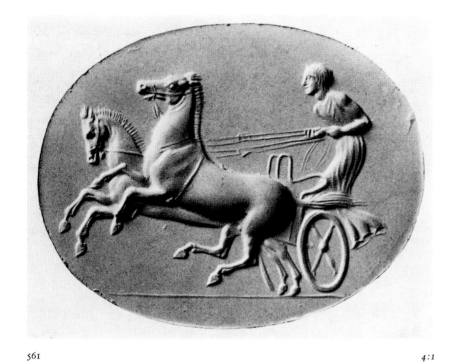

561　　　　　　　　　　　　　　　　　　　　4:1

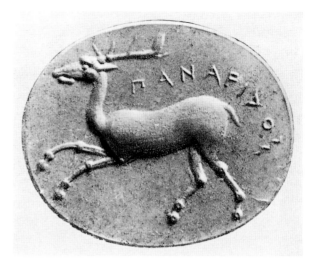

562　　　　　　　　　　　　　　　　　　　　4:1

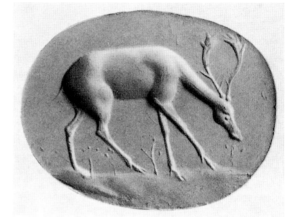

564　　　　　　　　　　　　　　　　　　　　3:1

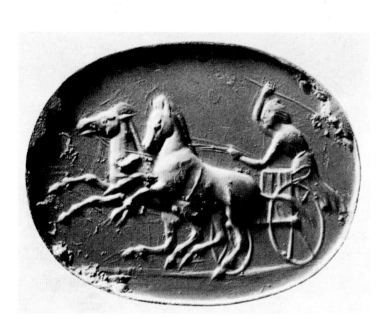

563　　　　　　　　　　　　3:1

565　　　　　　　　　　3:1

566　　　　　　　　　　　　4:1

567　　　　　　　　　　　　　　　　　　　　4:1

568 3:1

569 4:1

570 3:1

571 3:1

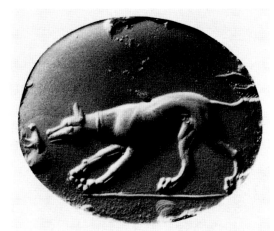

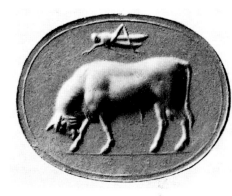

573 3:1

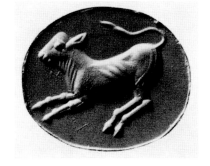

574 3:1

572 3:1

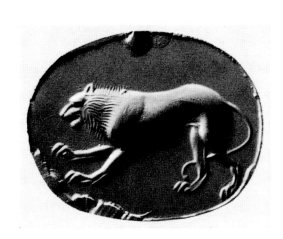

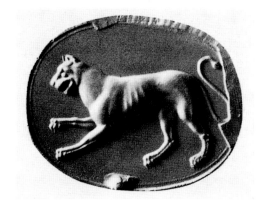

576 4:1

575 3:1

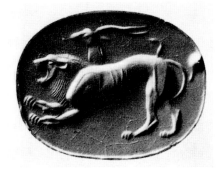

577 3:1

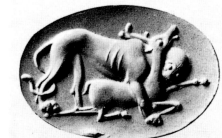
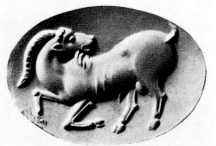

578 3:1

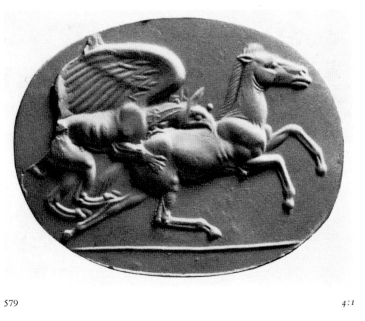

579

4:1

580
3:1

581

3:1

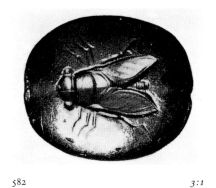

582

3:1

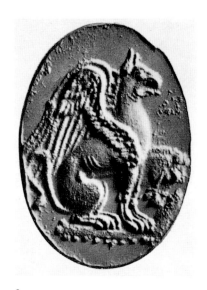

583
3:1

584
3:1

585

3:1

586

3:1

587
2:1

588
3:1

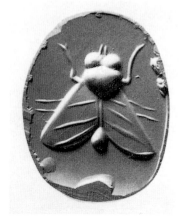

589
4:1

590
3:1

590
4:1

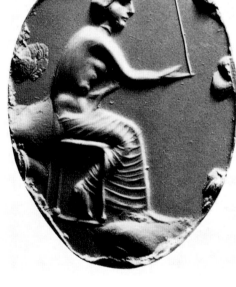

593 3:1

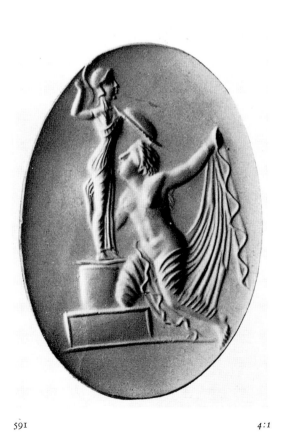

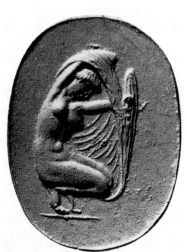

592 3:1

591 4:1

594
2:1

595
3:1

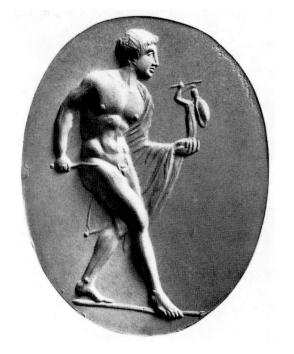

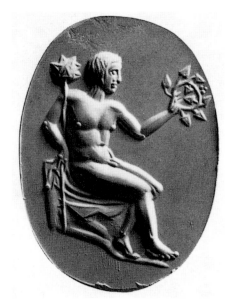

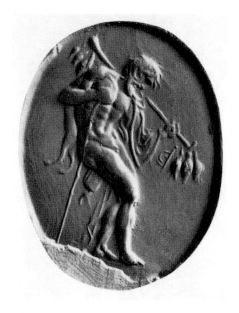

596 3:1 597 3:1 598 3:1

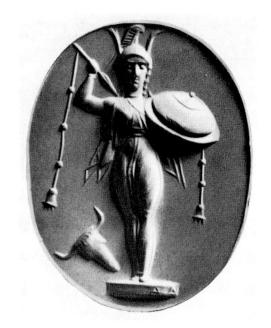

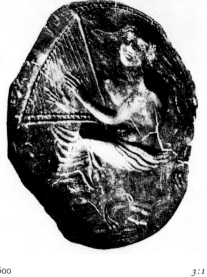

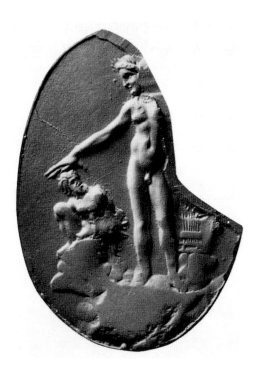

599 4:1 600 3:1

601 3:1

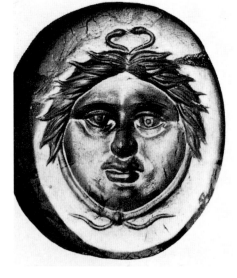

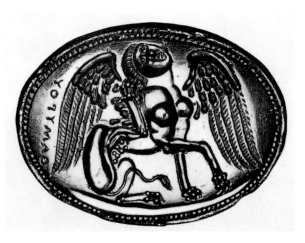

602
4:1

603
4:1

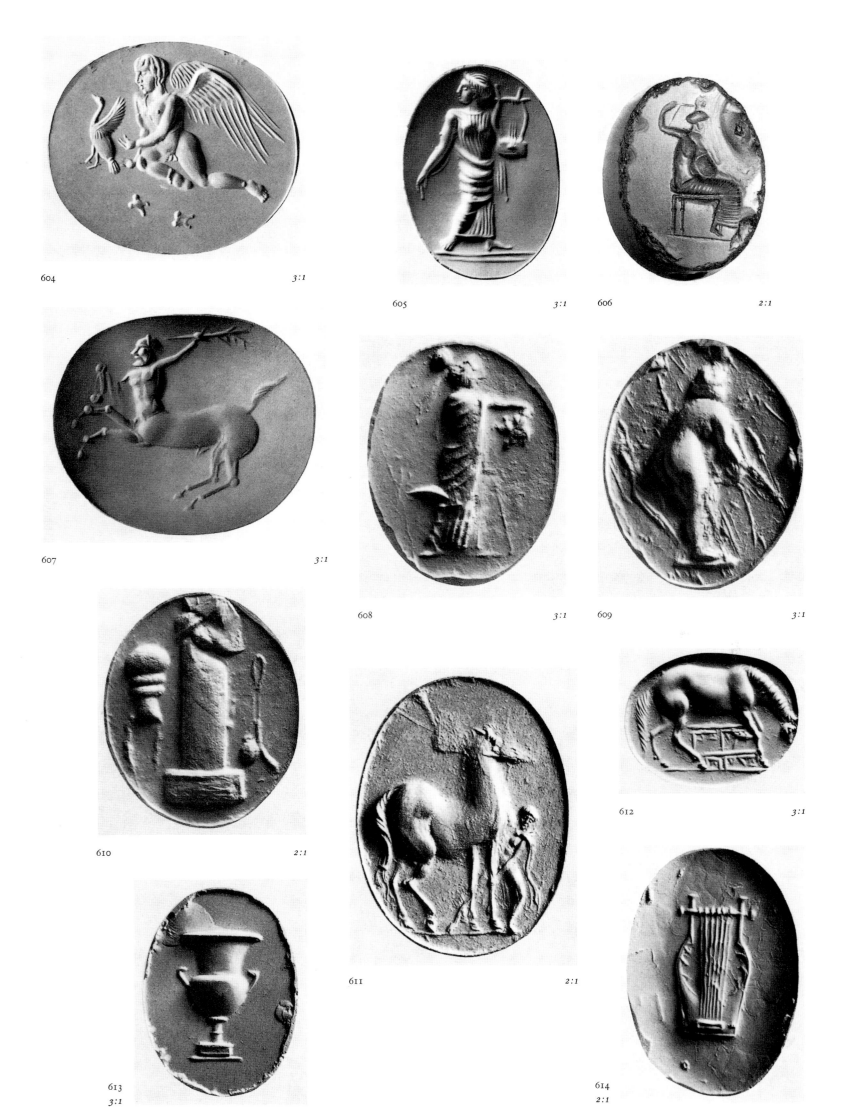

604 3:1

605 3:1 606 2:1

607 3:1

608 3:1 609 3:1

610 2:1

612 3:1

611 2:1

613

3:1

614

2:1

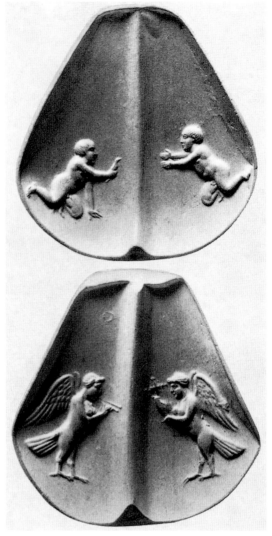

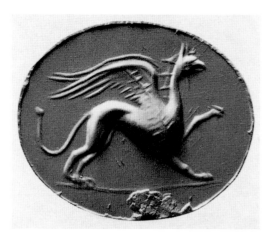

616 3:1

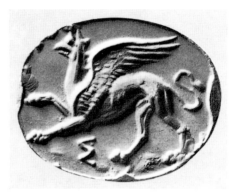

617 3:1

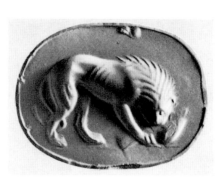

619 3:1

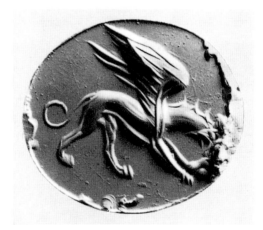

618 3:1

615 3:1

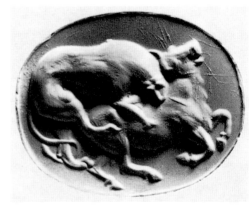

620 3:1

621 3:1

623 3:1

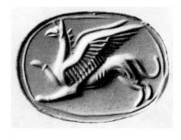

622 3:1

624 3:1

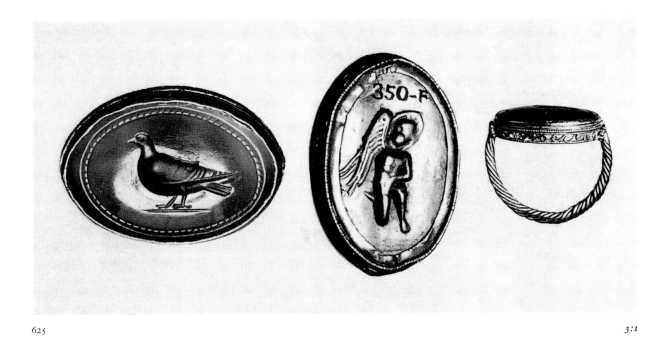

625

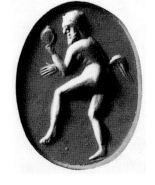

626
2:1

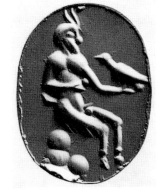

627 2:1

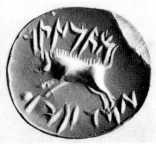

628 2:1

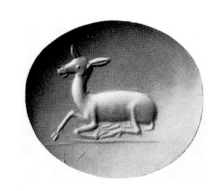

629 2:1

631 2:1

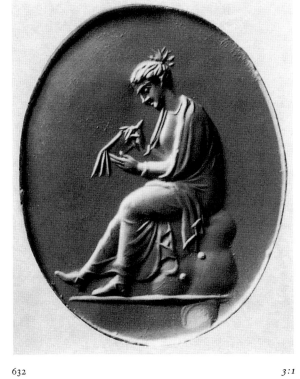

630 2:1

632 3:1 633 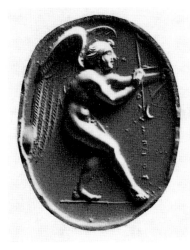 4:1

3:1

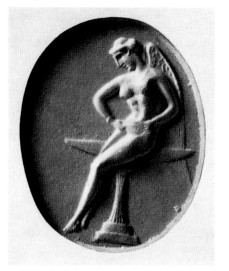

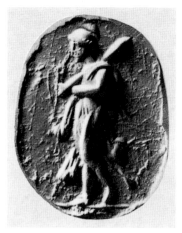

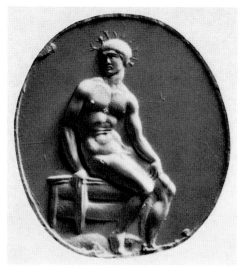

634 *3:1* 635 *3:1* 636 *3:1*

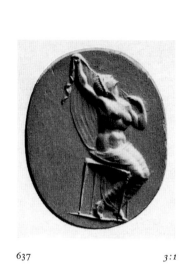

637 *3:1* 638 *3:1*

640 *2:1*

639 *3:1* 641 *3:1*

642 3:1

643 3:1 644 2:1

645 2:1 646 2:1 647 2:1

648 2:1 649 2:1 650 3:2

651 3:1

652 2:1 653 2:1 654 2:1

655 2:1

656 4:1

657 4:1

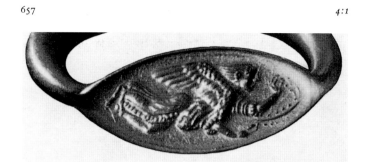

658 4:1

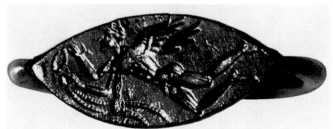

659 4:1

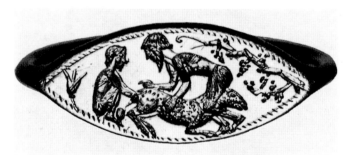

660 4:1

661 4:1

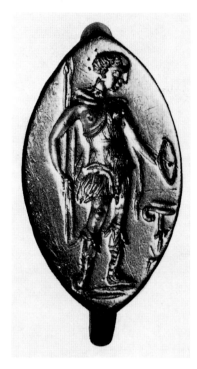

662 4:1

663 4:1

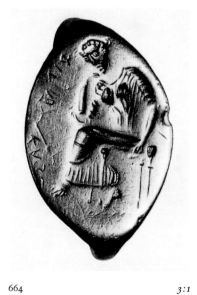

664 3:1

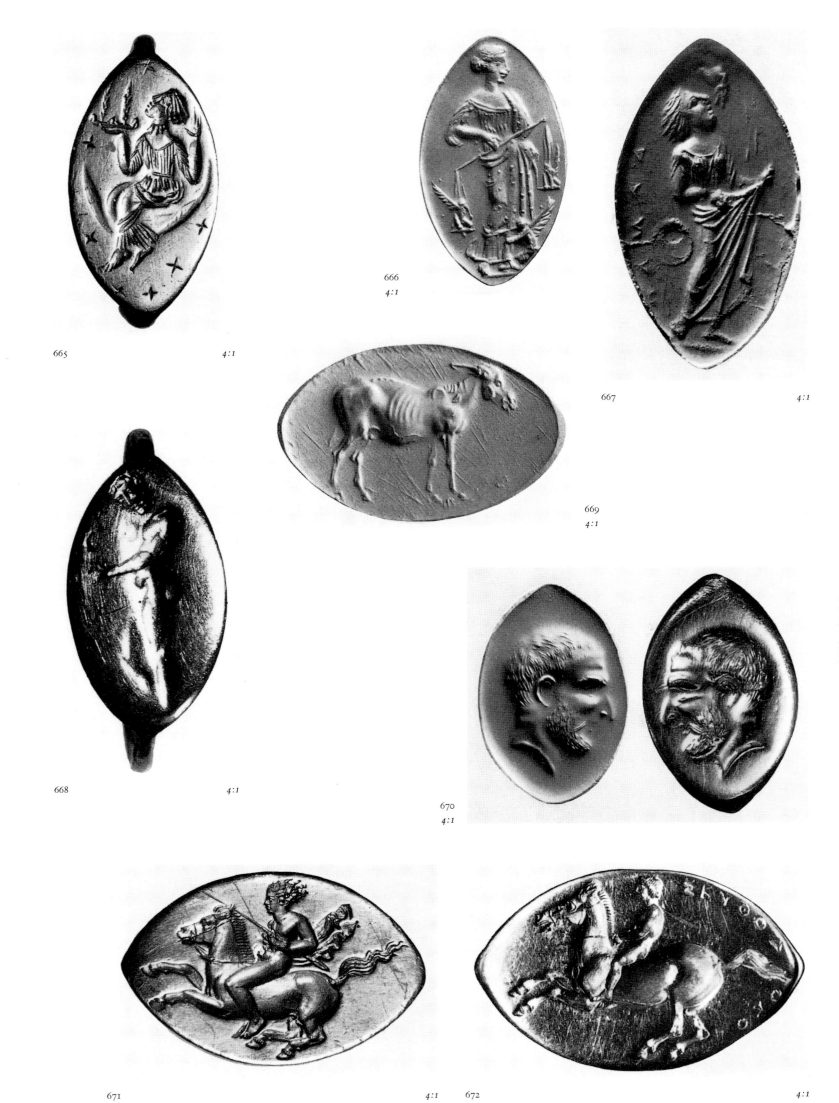

665 4:1

666
4:1

667 4:1

669
4:1

668 4:1

670
4:1

671 4:1 672 4:1

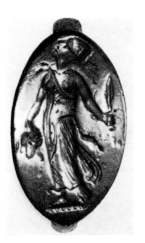

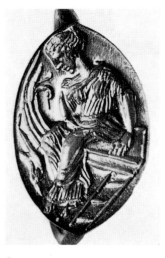

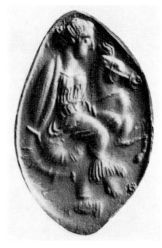

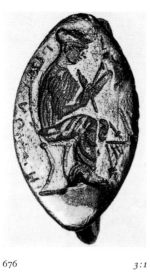

673 *3:1* 674 *3:1* 675 *3:1* 676 *3:1*

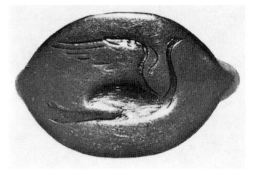

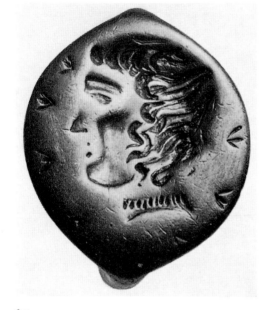

677 *3:1*

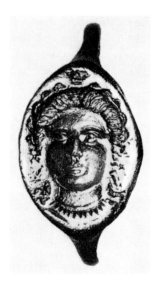

679 *3:1*

678 *3:1*

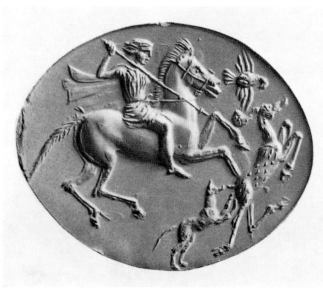

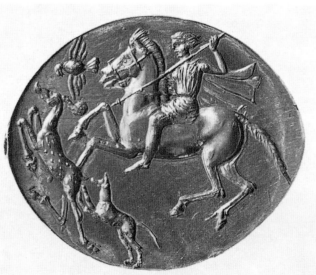

680 *3:1*

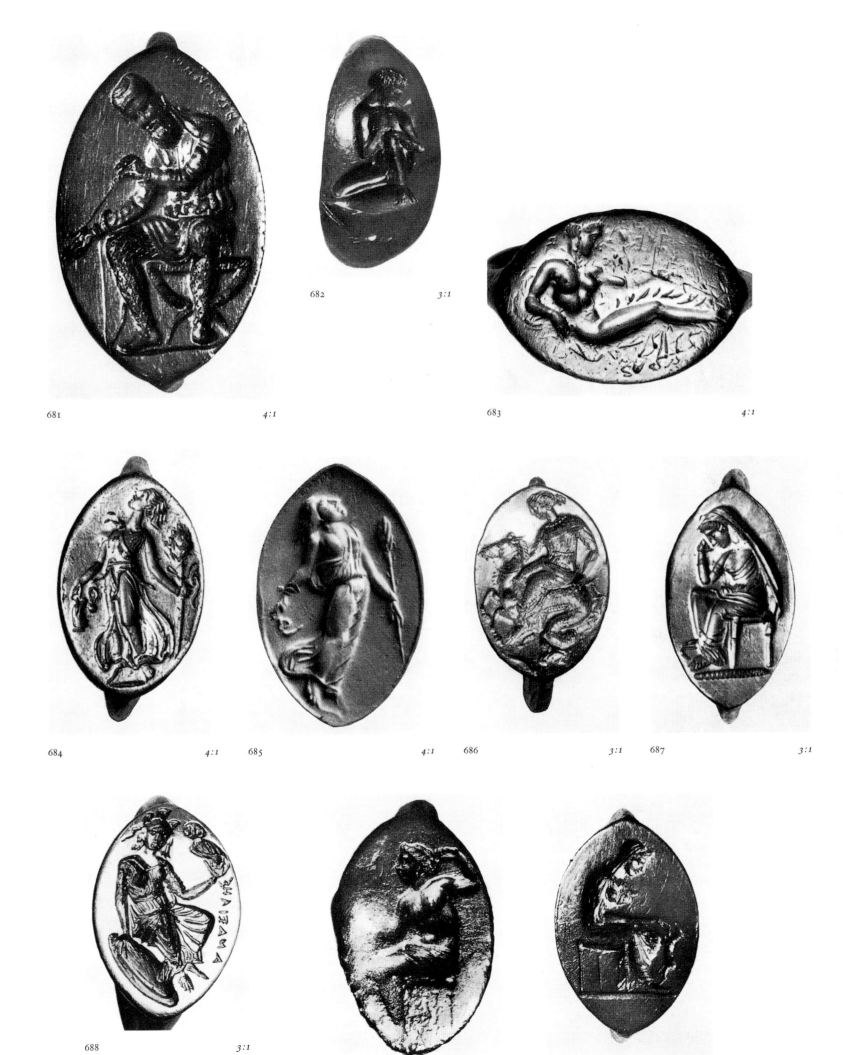

681 4:1 682 3:1 683 4:1

684 4:1 685 4:1 686 3:1 687 3:1

688 3:1 689 3:1 690 3:1

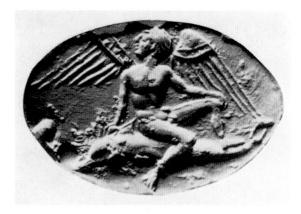

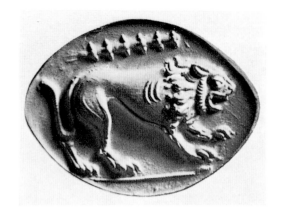

691 *4:1* 692 *4:1*

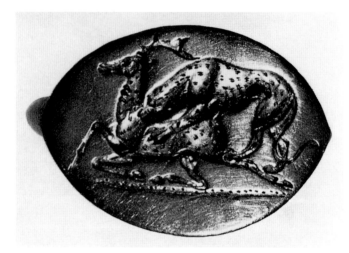

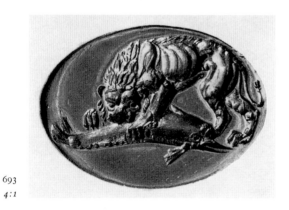

693
4:1

694 *4:1*

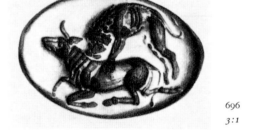

696
3:1

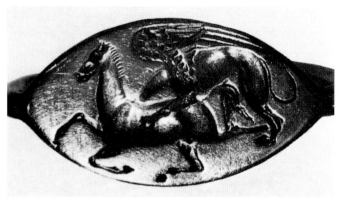

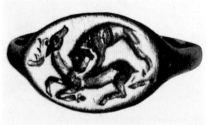

697
3:1

695 *4:1*

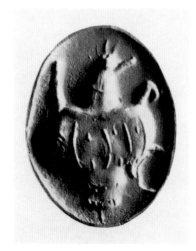

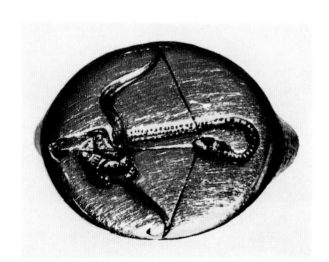

698 *4:1* 699 *4:1*

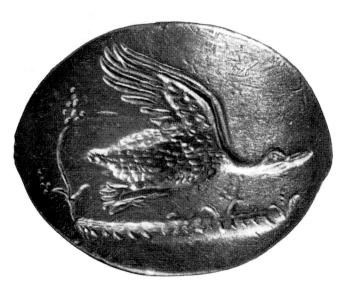

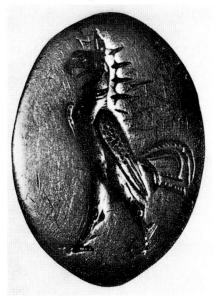

700

702

703

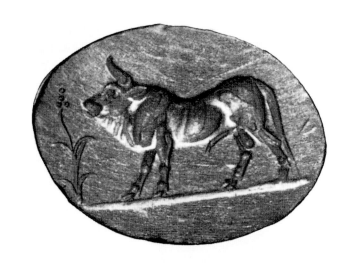

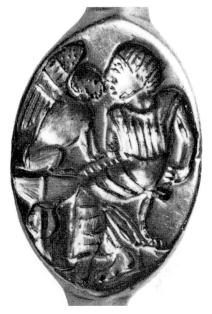

701

707

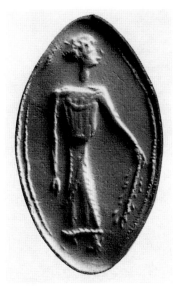

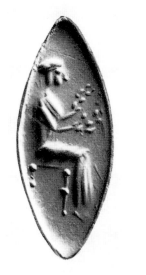

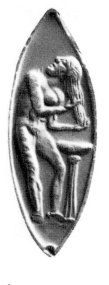

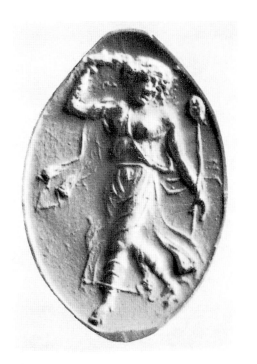

704

705

706

708

709 4:1

710 4:1

711 4:1

714 4:1

712 5:1 713 4:1

715
4:1

716
4:1

717
4:1

718
4:1

719

3:1

720

4:1

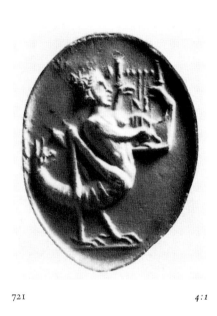

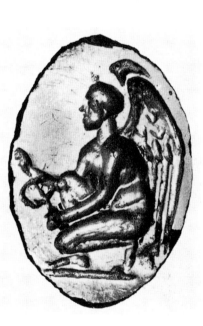

722

4:1

721

4:1

723

4:1

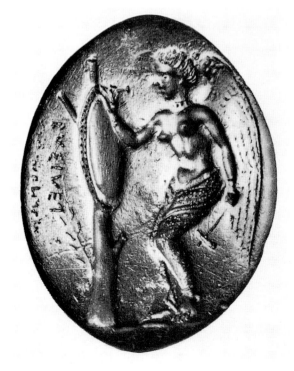

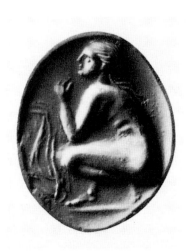

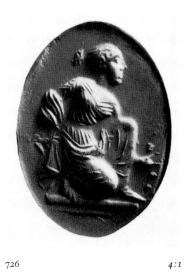

724
4:1

725

4:1

726

4:1

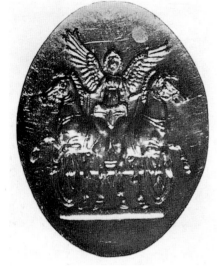

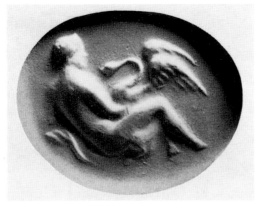

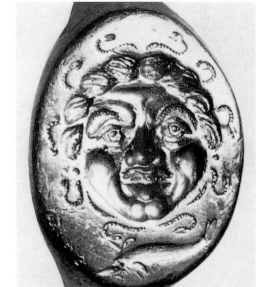

727 *3:1* 728 *4:1*

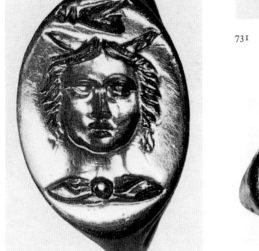

731 *4:1*

729 *4:1* 730 *4:1* 732 *3:1*

733

4:1

734 *3:1*

735

736 4:1

737 3:1

738 4:1

739 4:1

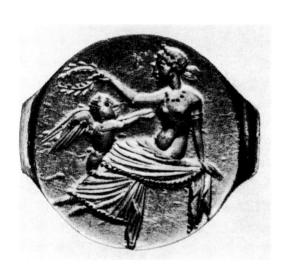

740
4:1

741 4:1

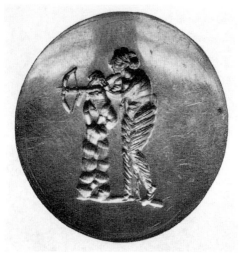

742

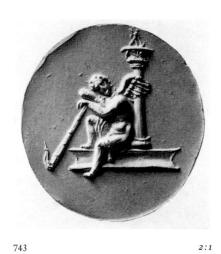

743 *2:1*

3:1

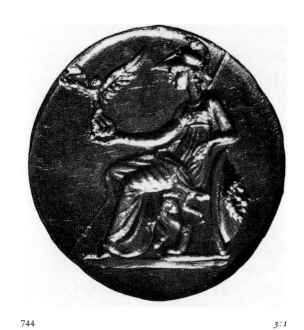

744 *3:1*

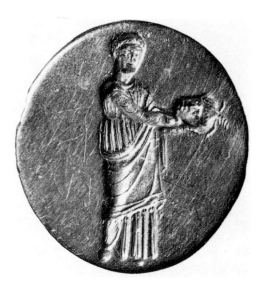

745 *3:1*

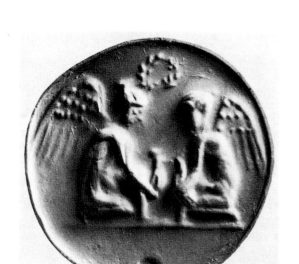

746 *3:1*

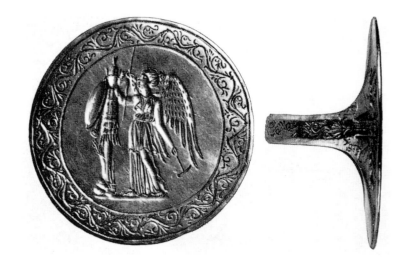

747

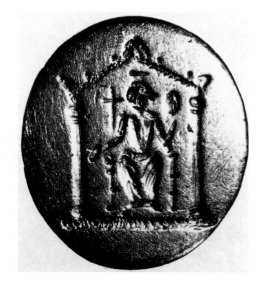

748 *3:1*

747

749

3:1 750

751

3:1

752 3:1

753 3:1

754

3:1

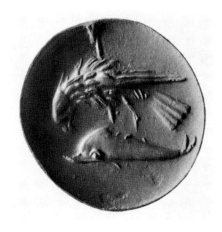

755 3:1

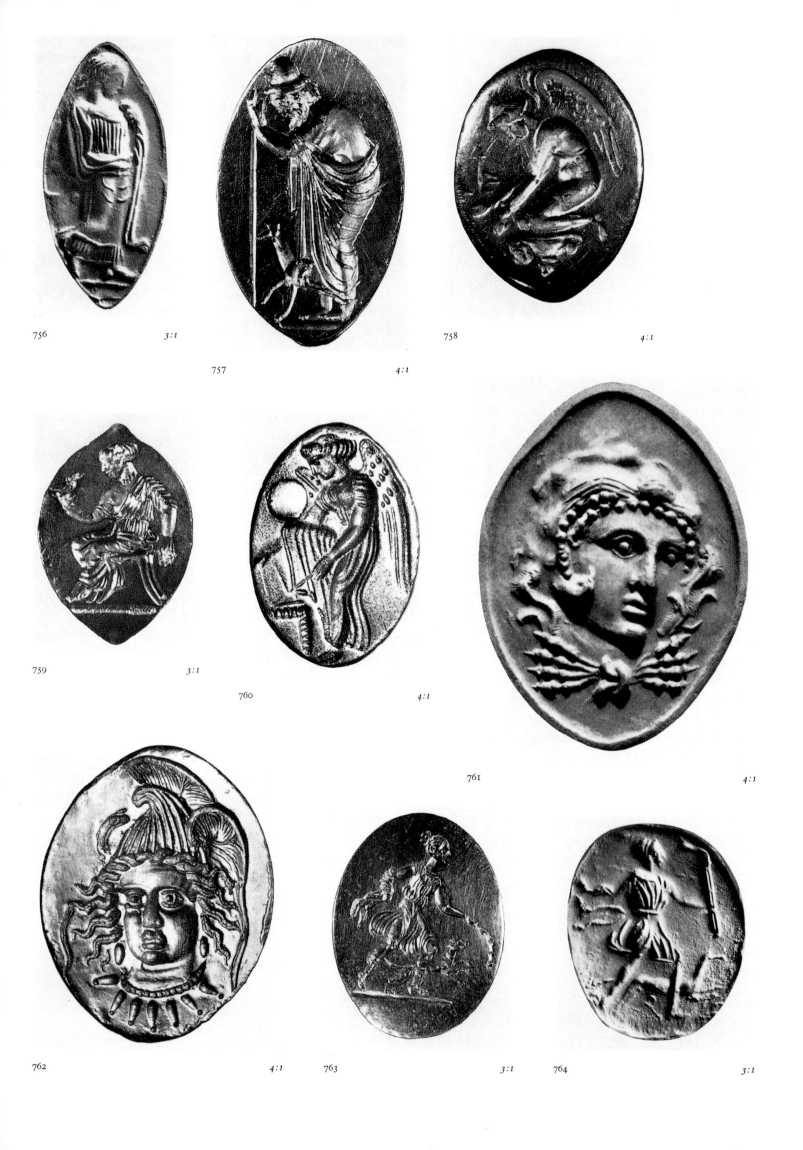

756 *3:1*

757 *4:1*

758 *4:1*

759 *3:1*

760 *4:1*

761 *4:1*

762 *4:1* 763 *3:1* 764 *3:1*

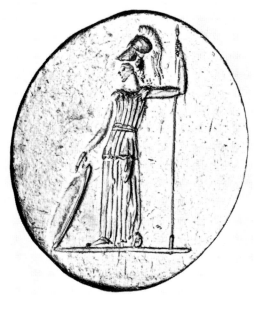

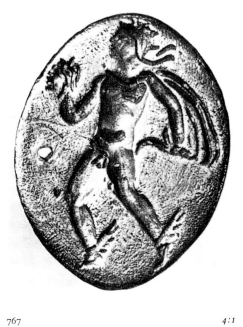

765 3:1 766 2:1 767 4:1

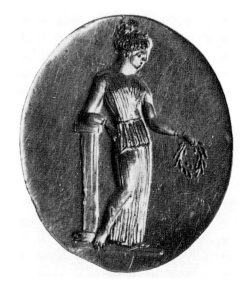

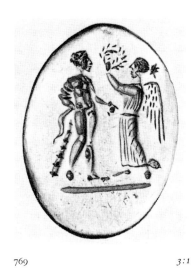

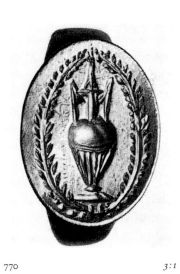

769 3:1 770 3:1

768 4:1

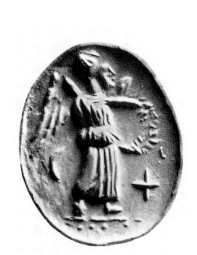

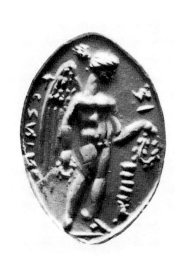

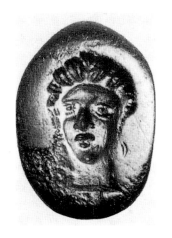

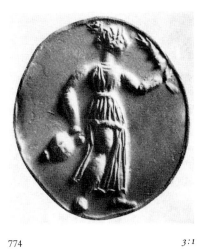

773 3:1 774 3:1

771 4:1 772 4:1

775 3:1 776 3:1 777 3:1

780 3:1

778 3:1 779 3:1

781 3:1

783 3:1

784 4:1

782 3:1

785

5:1

786 2:1

787 2:1

788 2:1

789 3:1

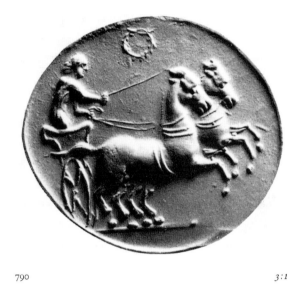

790 3:1

791 2:1

792 2:1

793 2:1

794

4:1

795 4:1 796 3:1 797 3:1

798 3:1

800 3:1 801 3:1

802 3:1

799 3:1

804 3:1 805 3:1 806 3:1

803 3:1

807 808
3:1 3:1

809 3:1

810 3:1

811 3:1

812 3:1

813 3:1

814 3:1

815 3:1

816 3:1

817
3:1

818 3:1

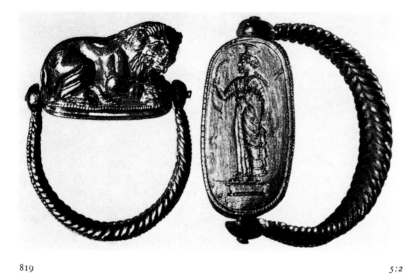

819 5:2

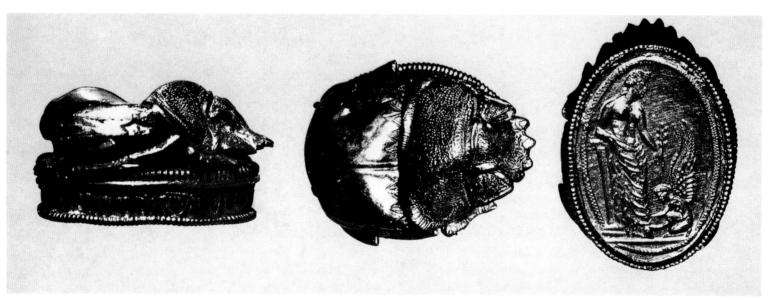

820 3:1

821

5:1

822 2:1

LIST OF ILLUSTRATIONS TO CHAPTER V

Measurements are given of the maximum dimension of the intaglio face, in millimetres

COLOUR PLATES

TEXT FIGURES

Fig. 214 Athens, from Thebes. Mottled jasper scaraboid. L.24. A horned, winged Priapus figure holding a thyrsos, with a throwing stick on the ground. *AG* fig. 100.

Fig. 215 Boston, *LHG* 84, pl. 5. Mottled jasper scaraboid. L.22. A tripod cauldron with a lid bearing spikes.

Fig. 216 Once Evans, from Spata, Attica. Clear glass scaraboid. L.22. A naked man, frontal, with two spears and a branch. Inscribed *Kastor* (H). *AG* pl. 12.23; *LHG* pl. A.23.

CLASSICAL FINGER RINGS
Fig. 217 Classical ring shapes.

Fig. 218 Once Arndt A2468, from Lesbos. Gold. L.18. A lion.

Fig. 219 Bern, Merz Coll. Gold (II). L.11. A pelican. Schefold, *Meisterwerke* (Basel, 1960) no. 565. For the bird in Greek art see Jacobsthal, *Greek Pins* (Oxford, 1956) 62.

Fig. 220 *Berlin* F 287, pl. 6. Gold (III). L.16. A man's head and genitals. *AG* pl. 10.35; Lippold, pl. 67.4; Becatti, pl. 80.322; Jacobsthal, *Die Mel. Rel.* (Berlin, 1931) 157; *Rend. Pont. Acc.* xxxiv, 56, fig. 24.

Fig. 221 Once *Guilhou* 83, pl. 4. Gold (III). L.16. Athena standing between branches (olive?), her shield on the ground before her, a bird flying to her.

Fig. 222 Paris, *de Clercq* vii, 2810, pl. 19, from Amrit. Gold (II). L.18. A beardless Herakles standing with a club. A chlamys over his left arm (?).

Fig. 223 Paris, *de Clercq* vii, 2867, pl. 20, from Amrit. Gold (II). L.15. A lion attacks a griffin. For the same adversaries on the Letnitsa plaque see Venedikov, *Bulgaria's Treasures from the Past* (Sofia, 1965).

Fig. 224 Paris, *de Clercq* 2870, pl. 20, from Amrit. Gold (II). L.13. A lion with an animal limb.

Fig. 225 *New York* 86, pl. 15. Gold (IV). L.16. A girl balancing a stick on her foot. Compare the stick balanced on the hand on our *Pl. 593*.

Fig. 226 Unknown (impressions in Oxford). Metal prism. L.12. 1. A seated woman with Eros (?). 2. A Maltese dog. 3. A seated woman with a branch. 4. A herm.

Fig. 227 Bern, Merz Coll. Gold (VI). L.16. A woman's head, wearing a satyr mask cap.

Fig. 228 London WA, obtained in Rawalpindi. Gold (IX). L.24. Omphale, naked, in the pose of Herakles. Dalton, *Oxus Treasure* (London, 1926) pl. 16.102.

Fig. 229 Once *Guilhou* pl. 6.124. Gold. L.18. A half naked woman seated on an altar before a funeral loutrophoros.

Fig. 230 Jannina, from Kerasa. Silver. Orestes slays Klytaimnestra, seated on an altar. Inscribed with their names. *BCH* lxxxiv, 744f., fig. 2; Dakaris, *Genealogikoi mythoi ton Molosson* (Athens, 1964) pl. 3. I am indebted to Professor Dakaris for notes on this important piece. For the slaying on an altar see *BCH* lxxv, 316ff.

Fig. 231 Istanbul, from Lampsakos. Gold (the sides of the hoop are decorated with scrolls). L.25. Aphrodite, seated on a stool, plays morra with Eros. *AG* fig. 90; *JHS* 1898, 129. On the game see Metzger, *Mon. Piot* xl, 69ff. (*Coll. Stathatos* iii, 169ff.); also Trendall, *Red figured vases of Lucania* . . . (Oxford, 1967) 90; *Arch. Reports* 1963/4 12, fig. 13; on a bronze mirror support, Jantzen, *Bronzewerkstätten* (Berlin, 1937) pl. 6.28.

Fig. 232 Oppenländer Coll. Gold (XI). An owl, shouldering a branch, perched on a shield with a helmet beside it. *Ars Antiqua* (Luzern) iv, pl. 54.165. On armed owls, le Lasseur, *Les Déesses armées* (Paris, 1919) 354ff.; *BCH* lxx, 177, fig. 8 and pl. 9; and compare our *Fig. 268*.

Fig. 233 *LondonR* 83, pl. 3, from Selino, Crete. Gold (IX). L.27. An arrowhead, with the letters *GA*. On Cretan arrowheads, *Proc. Soc. Ant.* xxxii, 154–7; Boardman, *Cretan Coll.* (Oxford, 1961) 121, no. 530; Snodgrass, *Greek Arms and Armour* (London, 1967) 40, 81. Compare *LondonR* 90 (Notes, no. 669). A ring with a spear device mentioned in the third-century Delian inventory, cf. *EADelos* xviii, 316, no. 5.

Fig. 234 *New York* 143, pl. 25. Silver with three bronze studs. Slim pointed bezel, but the hoop has broad filled shoulders. L.24. An archaising armed Athena. Compare coins of Ptolemy I, Kraay-Hirmer, figs. 797, 798.

Fig. 235 Salonika 5420, from Sedes, tomb (later fourth-century, with a coin of Philip II and jewellery). Gold (IX). L.19. A seated woman suckling a child. *Arch. Eph.* 1937, 882, fig. 15.

Fig. 236 Oxford, Gordon Coll., from Piraeus. Silver with a gold crescent inset (IX). L.18. A woman with two torches.

Fig. 237 *LondonR* 1131. Silver (IX). L.18. A fox with a vine. Compare *Pl. 497*.

Fig. 238 *LondonR* 1043, from Greece. Silver (VIII). L.20. A knucklebone in a wreath.

Fig. 239 Tarentum. Gold (III?). A winged nymph with a caduceus and bird. Becatti, pl. 84.335. For an explanation of the winged figures on this group of rings (also our *Pls. 758, 760*) see Regling, *Terina* (Berlin, 1906) 66–68; and the Terina coins are shown in Kraay-Hirmer, figs. 272–280, where she is called simply Nike. The association of these rings with Terina is discussed now by Pozzi in *Klearchos* 29–32, 153ff.

Fig. 240 Unknown. L.19. A seated woman with a bird on her wrist (H).

Fig. 241 Once *Guilhou* 128, pl. 6, from Tarentum. Gold. L.22. Hermes fastens a winged sandal. *AG* pl. 61.35; Lippold, pl. 10.6. The motif is common later and compare late fourth-century coins of Sybrita in Crete, Kraay-Hirmer, fig. 553.

Fig. 242 Paris, Louvre Bj. 1349. Silver (VII?). A woman with a wreath (H).

Fig. 243 Once *Guilhou* 86, pl. 4. Gold. L.25. A hippocamp. Compare the style of Naples 126464 (Notes, no. 808).

Fig. 244 Naples 25088, from Capua Vetere. Gold (XII). L.24. Athena. Siviero, *Gli ori e le ambre* (Florence, 1954) no. 103, pl. 114c,d; Breglia, *Cat.* (Rome, 1941) no. 115, pl. 17.3; Becatti, pl. 85.342.

Fig. 245 Once *Guilhou* pl. 6.126. Gold. L.20. Nike with stylis(?) and thymiaterion. The figure fills the field.

Fig. 246 Naples 126451. Gold (XII). L.24. Eros with a thyrsos, bowl and club (?). Silviero, op. cit., no. 100, pls. 112a,b,113; Breglia, *Cat.* no. 154, pl. 24.4.

Fig. 247 *LondonR* 1092, pl. 27, fig. 132. Silver with an inset gold crescent (XIV). L.14. A girl is sitting in the lap of a youth. Compare *BSR* xxxiv, pl. 4, ix–xi; Selinus sealing, *Not Scav.* 1883, pl. 5.1, 2.

Fig. 248 *LondonR* 1103, fig. 135. Silver (XVI). L.17. A bird on a rose.

Fig. 249 *LondonR* 111, from Crete. Gold (X). L.11. A flying bird in a wreath.

Fig. 250 *LondonR* 1059, from Crete. Silver (X). L.20. Eros with raised arms.

Fig. 251 *LondonR* 1230, pl. 30, from Sidon. Bronze (I). L.23. A lobster.

Fig. 252 *New York* 127, pl. 21. Bronze (IV?). L.21. An eagle tears a fawn.

Fig. 253 *New York* 44, pl. 8. Gilt bronze (VIII). L.21. A fat man carrying a fawn, game and a crooked stick.

Fig. 254 Salonika, *Olynthus* x, 459, pl. 26. Bronze (VII). L.18. Eros kneels to shoot a bow.

Fig. 255 Salonika, Robinson, *Olynthus* x (Baltimore, 1941), 448, pl. 26. Bronze (VII). L.15. A poppy.

Fig. 256 *LondonR* 1455, pl. 33. Silvered iron, a bronze bezel plate with gold stud (VII). L.14. A panther (not 'a seal') sitting on a column. Compare the pairs on coins of Lycia, Babelon, pl. 102.12–16.

Fig. 257 Salonika, *Olynthus* x, 446, pl. 26. Bronze (VII). L.21. A grotesque of beardless, bearded and a satyr's head, with a bird.

Fig. 258 *LondonR* 1256, pl. 30. Bronze (X, with a ridged hoop near the bezel). L.14. A boy's head emerging from a murex shell. For figures emerging from shells compare *AG* pls. 25.32, 28.24,30,69; *London* 2414, pl. 28.

Fig. 259 *LondonR* 1253. Bronze (VII). L.20. A bird with a large, bearded man's head. Compare *OJh* xxxii, 31, fig. 15; Hackin, *Nouv. Rech. à Begram* (Paris, 1954) 147, figs. 455–6; and an amphora handle stamp from Samos (late fourth century).

Fig. 260 *LondonR* 1332. Bronze (XVII, very heavy). L.37. A janiform man's and youth's head wearing a flat conical hat. On the type see Marcadé in *BCH* lxxvi, 596ff. The same device on the Hellenistic gem, *AG* pl. 26.32.

Fig. 261 Naples 25222, from Pompeii. One of a pair of gold discs, cut out to show the device of a cornelian intaglio. W.17. A half-naked goddess, by a column and with her foot on a helmet (?), feeds a snake from a horn. Hygieia. Siviero, op. cit., no. 96, pls. 110b, 111a; Breglia, *Cat.* nos. 186–7. The second disc has the same device, reversed.

Figs. 262–8 are impressions on loomweights of a type assigned to the first half of the fourth century at Corinth: *Corinth* xii (Princeton, 1952), 153, IX.

Fig. 262 *Corinth* xii, no. 1109, pl. 75, fig. 25. Impression of a finger ring on a clay loomweight. L.13. A satyr shoulders a wine jar.

Fig. 263. Ibid., no. 1125. L.14. Nike crowns a trophy.

Fig. 264 Ibid., no. 1144. L. 14. Two felines seated on an altar. For the two animals see the glass scaraboid, *Munich* i, 287, pl. 33.

Fig. 265 *Corinth* xii, no. 1145, pl. 75, fig. 25. L.16. A loom-weight; as the object on which it is impressed.

Fig. 266 Corinth KN86. Impression on a clay loomweight. L.28. A seated dog, and male genitals. *Corinth* xv, 2, 277, fig. 7, pl. 57, no. 20. For the genitals compare our *Fig. 220*.

Fig. 267 Corinth KN126. Impression on a clay loom-weight. L.26. Eros bound at the foot of a trophy with helmet, spear and shield. Ibid., no. 40; *Corinth* xii, no. 1149; *AJA* xl, 481, fig. 21. An early representation of a subject common on later Hellenistic and Roman gems; see Rumpf in *Reallex. Antike und Christentum* vi, 327.

Fig. 268 Corinth. Two impressions on a clay loomweight. 1. A bird wearing a plumed helmet and carrying a shield and spear. Compare the armed owl of Athena on the finger ring, *Fig. 232*, and references there cited. 2. A satyr with goat legs dances, balancing a kantharos on his foot. Compare the balancing tricks of satyrs on the Douris psykter, Buschor, *Gr. Vasen* (Munich, 1940) fig. 184, and the girl on our *Fig. 225*. *BCH* xc, 753, fig. 4; *ADelt* xxi, Chr., pl. 127a,b.

Fig. 269 Athens, Agora, Pnyx W53. Impression on a clay loomweight. L.18. Two mugs. *Hesp.* Suppl. vii, 83, fig. 34, no. 67. The shape is common in Athenian black ware of the later fifth century.

Fig. 270 Berlin 6787, from Athens. Impression on a clay loomweight. A woman, apparently naked, in a cart decorated with a goat's head. Her gesture is that of the dancing girls on our *Pls. 710, 711*. Furtwängler, *Meisterwerke* (Leipzig, 1893) 257, fig. 33.

Fig. 271 Athens, Agora T3334 (context of second half of the fourth century). Impression on a clay token. W.18. 1. Grotesque composed of heads of a man, a woman and a lion, with a bird as the man's beard. 2. A broad kantharos.

Lang, *Agora* x (Princeton, 1964), pl. 32, C7. For 1 compare our *Fig. 227* and *Pl. 417*.

Fig. 272 Athens, Agora MC799 (fourth-century context). Impression on a clay token. W.15. Two erotes crouch, perhaps playing knucklebones, on an altar. *Agora* x, pl. 32. C10.

Fig. 273 Athens, Agora MC271 (fourth-century context). Impression on a clay token. W.18. A warrior with pilos helmet and spear crouching behind his shield before which is a rearing lion. *Agora* x, pl. 32, C14. For the warrior alone see our *Fig. 213*.

Fig. 274 Heraklion, from Phaistos. Impression on a clay disc weight. A woman lifting her clothes from a tree, at the foot of which stands a jug. *Ann.* xliii–xliv, 581ff., figs. 18.1, 23. Compare our *Pl. 859*.

Fig. 275 Paestum, from S. Cecilia. Impression on a clay cylinder, like part of a handle. L.16. A dog seated on an Ionic column. *Röm. Mitt.* lxx, 29, pl. 15.1,2

Fig. 276 From Ur. Clay sealing from a finger ring (?). L.16. A girl seated on the lap of a youth. *Ur* x, pl. 40.736. On the motif see *BSR* xxxiv, 14, our *Fig. 247*. This, and the following three, with *Figs. 313–315*, are from a late fifth-century grave.

Fig. 277 From Ur. Clay sealing from a finger ring (?). L.18. A woman crowns Hermes who is wearing a chlamys and holding his caduceus. *Ur* x, pl. 40.737. The scheme is as that of Nike and Herakles, and the situation here, with Hermes, is not readily explained.

Fig. 278 From Ur. Clay sealing from a scaraboid set in a metal hoop. L.18. Herakles, with his club, stands with his foot on the defeated lion. *Ur* x, pl. 40.746. For Herakles with his foot on the lion compare the Olympia metope and our *Pl. 856*.

Fig. 279 From Ur. Clay sealing from a scaraboid (?). L.22. Two rearing horses, rubbing necks. *Ur.* x, pl. 41.766. Compare the animal games on *Pl. 913* and Notes, Chapter VI, no. 114.

BLACK AND WHITE PLATES

**Asterisked numbers indicate that the piece is illustrated in original. All other photographs show impressions*

CLASSICAL GEMS

EARLY CLASSICAL
Pl. 444 *London 507*, pl. 9. Green jasper scarab (very simply incised, perhaps recut). L.17. The head of a bearded man (H). The two letters are modern additions. See *colour*, p. 203.1.

Pl. 445 *London 508*, pl. 9. Cornelian scarab (well cut). L.16. The head of a youth wearing a pilos, which is fastened beneath the chin by a cord. A loop for hanging the cap at its crown (H). *AG* pl. 14.31; Lippold, pl. 57.2. Compare coins of Melos, *Num. Chron.* 1964, pl. 1.18, 2.28.

Pl. 446 *London* 504, pl. 9. Plasma scaraboid (Archaic shape). L.17. Unfinished. A bearded head with a ram's head and lion's head attached behind. The beard looks as though it was to be treated as a bird's body, like the Greco-Phoenician mixed heads (see *Pl. 417*), in which case the flap below might have been first cut for an animal forepart (a boar?).

Pl. 447 *London* 510, pl. 9. Cornelian scarab (well cut). L.18. The head of a woman, wearing earring and necklace. A crescent above (H). For the hairstyle compare the Syracuse coin, Kraay-Hirmer, fig. 90. For heads of Selene see *AA* 1963, 680ff.

Pl. 448 *London* 509, pl. 9, from near Syracuse. Agate scarab (well cut). L.21. A woman's head, as the last, but frontal, or lightly turned right (only one ear shown) (H). *AG* pl. 14.37.

Pl. 449 Boston 98.716, from Greece. Red and white jasper scaraboid (A). L.17. Danae holds out her himation to receive the golden rain of Zeus. Beyond her is the end of her bed, with pillows. *AG* pl. 61.36; Lippold, pl. 47.3. On the subject see *BCH* lxx, 438; Cook, *Zeus* iii, 460ff.

Pl. 450 Paris, BN, de Luynes 254. Chalcedony scaraboid (A). L.16. Demeter, holding a corn stalk. *AG* pl. 12.29; Lippold, pl. 22.1.

Pl. 451 *New York* 68, pl. 11, from Cyprus. Chalcedony scaraboid (A). L.19. Hades abducts Persephone, who drops her torch. *AG* pl. 9.32. On the subject, Schauenburg in *JdI* lxxiii, 49, and *ARV* 647.

Pl. 452 Boston, *LHG* 49, pl. 3, from Delphi. Mottled yellow jasper scaraboid. L.20. Apollo with bow and tripod. Beazley suggests that this may be an excerpt from the scene of the struggle with Herakles for the tripod.

Pl. 453 Paris, BN, de Luynes 264. Rock crystal scaraboid (A). L.21. Skylla. Perrot-Chipiez, *Histoire de l'Art* iii (1885) 442, fig. 315. For the motif on gems see *BSR* xxxiv, 7. Another (?) gem with the motif in *Mon. Ined.* iii, pl. 52.9 (Lenormant), and on a glass scaraboid, Notes to chapter V, no. 388.

Pl. 454 Paris, BN, de Luynes 289. Rock crystal scaraboid (A). L.26. A seated sphinx. *AG* pl. 12.48; Lippold, pl. 78.6.

Pl. 455 Boston, *LHG* 47, pl. 3. Cornelian scaraboid, cut on the back. L.18. Apollo frontal, with sceptre, laurel, hawk and fawn (H). *AG* pl. 10.3; Lippold, pl. 8.4.

Pl. 456* Bonn, Müller Coll. Cornelian scarab (well cut). L.15. An Amazon in eastern dress and with facing head, is leaning on her battle axe. For comparably equipped Amazons on fifth-century vases see von Bothmer, *Amazons in Greek Art* (Oxford, 1957) pls. 72ff.

Pl. 457* *London* 449, pl. 8, from Amathus, tomb 287. Cornelian scaraboid, with a ridged back. L.14. A warship, showing rowers and three marines. Found with *London* 267 and a fifth-century coin of Idalion.

Pl. 458 Bowdoin College 486. Chalcedony scaraboid. L.18. Gorgoneion. Inscribed *is*. *AJA* lxvi, pl. 104.2.

Pl. 459 Péronne, Danicourt Coll. (once Castellani 990), from Sparta. Blue chalcedony scaraboid (A). L.17. A dog. Inscribed *Timodemo*. *AG* iii, 136.

Pl. 460 Boston 98.718, from Greece. Chalcedony scaraboid (A). L.18. A cow and a tree. *AG* pl. 61.38; Lippold, pl. 90.12; Richter, *Animals* fig. 100. We think of Io tethered to the tree at Argos (cf. Cook, *Zeus* i, 440).

Pl. 461 Leningrad, from Nymphaeum, tumulus 24. Obsidian (?) scaraboid (Archaic shape). L.17. A cow and calf. An Achaemenid winged disc cut on the convex back. *AG* iii, 128; *Mat Res.* lxix, pl. 24.2; Artamonov, fig. 36. The motifs of front and back combined on a later coin of Tarsus, Kraay-Hirmer, fig. 673.

Pl. 462 Boston 27.664. Cornelian scaraboid, cut on the back. L.22. A cow with a calf, and a cock. Richter, *Animals* (Oxford, 1930) fig. 92.

Pl. 463 Boston, *LHG* 69, pl. 4. Cornelian scaraboid. L.18. A mule.

Pl. 464 Leningrad, from Kerch, found with *Pl. 681*. Rock crystal scaraboid (Archaic shape). L.18. A griffin with an astragalos below. *AG* pl. 11.27; Lippold, pl. 80.14.

Pl. 465* London 1925. 10–17.2. Cornelian scaraboid with a lightly convex face. L.14. A griffin.

DEXAMENOS AND HIS CONTEMPORARIES
Pl. 466 Boston, *LHG* 50, pl. 3, from Kara, Attica. Red and yellow mottled jasper scaraboid (A). L.20. The head of a man (H). Signed *Dexamenos epoie*. *AG* pls. 14.3, 51.8; Jacobsthal, *Die Mel. Rel.* (Berlin, 1931) 156f., fig. 37; *Rend. Pont. Acc.* xxxiv, 56, fig. 23; *Berlin. Mus. Ber.* xvii, 44, fig. 1; *Burl. Mag.* 1969, 591, fig. 21.

Pl. 467 Cambridge, from Greece. Blue chalcedony scaraboid (C). L.21. A woman seated on a stool, faced by a maid with mirror and wreath (H). Signed *Dexamenos*, with the name *Mikes* above the woman. *AG* pl. 14.1; Lippold, pl. 64.1; Richter, *Furniture* (London, 1966) 132,

fig. 631; Jacobsthal, op. cit., 152, fig. 31 (dated c.440); *Burl. Mag.* 1969, 592, fig. 32.

Pl. 468 Leningrad, from Kerch. Blue chalcedony scaraboid (C). L.20. A flying heron. Signed *Dexamenos epoie Chios. Rev. Arch.* 1898.i, pl. 8.1; *AG* pl. 14.4; Lippold, pl. 95.5; *LHG* pl. B.3; Maximova, *Kat.* pl. 2.3; *Burl. Mag.* 1969, 592, figs. 29, 30. On the identification of these birds see *LHG* pp. 59–61.

Pl.469 Leningrad, from Taman. Red and black mottled jasper scaraboid (A). L.19. A heron and a locust (H). Signed *Dexamenos. Rev. Arch.* 1898.i, pl. 8.3; *AG* fig. 94; *Burl. Mag.* 1969, 592, figs. 25, 26.

Pl. 470 Leningrad, from Kerch. Red, black and white mottled jasper scaraboid. (A). L.20. A Chian wine amphora. *AG* iii, 139; *ABC* pl. 24.15. For Chian vases of this shape see *BSA* liii/liv, 308 and Grace, *Amphoras and the ancient wine trade* (Princeton, 1961) figs. 44, 48, 49; *Burl. Mag.* 1969, 591, fig. 27.

Pl. 471 *Berlin* D 158. Rock crystal scaraboid (A). L.22. The head of a youth. Diehl, *Berlin Mus. Ber.* xvii, 44, fig. 1; *Burl. Mag.* 1969, 591, fig. 22

Pl. 472 *London* 529, pl. 9, from Greece. Rock crystal scaraboid (A). L.30. A woman seated on a chair, playing a triangular harp (H). *AG* pl. 14.20; Lippold, pl. 59.10; *Bur. Mag.* 1969, 592, figs. 32, 33. For the type of harp see Herbig, *Ath. Mitt.* liv, 169ff., and fig. 2; *JHS* lxxxvi, 69ff.

Pl. 473 Boston, *LHG* 67, pls. 4, 10, from Messenia. Chalcedony cut scaraboid. L.20. A horse with loose reins (H). Inscribed *Potanea. AG* pls. 9.31, 14.5, 51.9; Lippold, pl. 89.3.

Pl. 474 Boston, *LHG* 49bis, pl. 3, from Melos. Rock crystal scaraboid (A). L.26. Amazons, one mounted, one seated, in eastern dress.

Pl. 475 Leningrad, from Kerch, Iuz-Oba. Red and yellow mottled jasper scaraboid (A). L.22. A horse with loose reins runs towards a pole with a fillet attached to it (H). *AG* pl. 14.15; Lippold, pl. 89.6. The loose horse by a post is seen on coins of Kleitor, Babelon, pl. 225.24, 25.

Pl. 476 Zürich, Remund Coll. Scaraboid (A). A horse with loose reins. Earlier than the last.

Pl. 477 *London* 588, pl. 10, from Lecce. Rock crystal scaraboid (A). L.28. A horse with loose reins.

Pl. 478* *London* 557, pl. 10. Chalcedony cut scaraboid. L.22. A centaur, struck in the back, an animal skin around

his neck (H). Inscribed *chi*. Half the stone is missing (below the human chest and the horse's legs and belly: restored). *AG* pl. 13.30; Lippold, pl. 76.4.

Pl. 479 Paris, BN 1866. Blue chalcedony scaraboid (A). L.24. A four-horse chariot. *AG* pl. 9.54.

Pl. 480 Naples 1297. Agate scaraboid (B). L.19. The head of a woman (H). Signed *Sosias. AJA* lxi, pl. 80.1. For the flattened *omega* in the inscription see Jeffery, *Local Scripts* (Oxford, 1961) 325.

Pl. 481 *London* 518, pl. 9, from Ithome. Agate scaraboid (A). L.18. The head of a woman. Inscribed *Eos. AG* pl. 14.33; Lippold, pl. 32.7; *Berlin. Mus. Ber.* xvii, 47, fig. 4.

Pl. 482 *London* 531, pl. 9. Chalcedony scaraboid (A/C). L.21. A reclining half-naked woman pets a heron. Above is a flying ant. *AG* pl. 13.20; Lippold, pl. 63.5.

Pl. 483 Leningrad, from Kerch, Pavlovsky kurgan. Cornelian scarab (simple). L.15. A naked woman crouching, holding some material (H). *AG* pl. 13.27; Lippold, pl. 63.6. On the subject, Lullies, *Die kauernde Aphrodite* (Munich, 1954) 58.

Pl. 484 *Munich* i, 331, pl. 39. Cornelian scaraboid (Archaic shape). L.15. An athlete, frontal, but one foot in profile, with mattock (not a 'Schlagstock zum Ballspiel'!) and strigil (H). The mattock is more common in Etruscan scenes (Beazley, *Etr. Vase Painting* (Oxford, 1947) 60, 80); the Greek usually show pick axes.

Pl. 485* Taranto 100024, from Piazzale Sardegna, 1954. Cornelian scaraboid. A lion-headed Herakles with club, bow and lion skin. *AA* 1956, 248. For Myron's Herakles see Lippold, *Gr. Plastik* (Munich, 1950) 139 with pl. 49.2.

Pl. 486 *London* 515, pl. 9, from Kourion. Cornelian scaraboid (A). L.18. Athena stands holding an *aphlaston* in her right hand, her shield and spear at her other side. Beside her a coiled snake. *AG* pl. 9.33; Lippold, pl. 20.3. On the subject see Brett in *Trans. Int. Num. Congress* (London, 1938) 23ff., and for our gem 31f. and fig. 5. For the Athena and snake see the relief dated 427/6 BC, *Essays ... Lehmann* 155, ill.2.

Pl. 487 *London* 520, pl. 9. Blue chalcedony scaraboid (A). A sphinx. *AG* pl. 14.12; Lippold, pl. 78.2.

Pl. 488 *New York* 129, pl. 21. Chalcedony scaraboid (B). L.24. A sea serpent. The limbs and streamers may have been suggested by wings. Apart from the dog-like head this is a wholly uncanonical treatment of the monster.

Pl. 489 *London* 511, pl. 9. Onyx scarab (simple, with *omega* back and double ridge; on the banding of the stone see p. 376). L.16. A flying goose. *AG* pl. 14.2; Lippold, pl. 95.7. See *colour, p. 203.6*.

Pl. 490 Boston, *LHG* 66, pls. 5, 10. Chalcedony scaraboid (A). L.20. A heron. *AG* fig. 228; Lippold, pl. 95.6.

Pl. 491 *Munich* i, 297, pl. 34. Red and clear jasper scaraboid (A). L.22. A seated griffin. Lippold, pl. 80.2.

Pl. 492 Boston 13.242, from Ithome. Chalcedony cut scaraboid. L.19. Herons beside a silphion plant (H). Inscribed *Polo*. *AG* pl. 61.39; Lippold, pl. 95.8.

Pl. 493 Boston 01.7562. Chalcedony scaraboid (A). L.25. An eagle flying with a snake, seen from below. Lippold, pl. 94.8. On views of the eagle from beneath see Karouzos in *Theoria* (Festschrift Schuchhardt: Baden-Baden, 1960) 120f.

Pl. 494* *London* 552, pl. 10. Cornelian scaraboid, cut on the back (A). L. 20. An eagle flying with a snake.

Pl. 495 Heraklion, Metaxas Coll. 1249. Scaraboid. L.22. An eagle carrying a dead animal (fawn or hare?).

Pl. 496 Heraklion 725. Cornelian scaraboid (A). L.19. A dog. Cf. mid-century coins of Segesta, Rizzo, *Monete gr. di Sicilia* (Rome, 1945) pl. 61. 1–3.

Pl. 497 Oxford 1892. 1494, from Trikka. Blue chalcedony cut scaraboid. L.21. A fox and a vine. *AG* pl. 9.62; Lippold, pl. 87.5. The scene as a shield device on *ARV* 85, 23 (Skythes), and a fourth-century finger ring (our *Fig. 237*). On foxes and grapes see Gow on Theocritus, *Idylls* i 49 (the gem in ii, pl. 1.3).

Pl. 498 Boston, *LHG* 79, pl. 4, bought in Ruvo. Blue chalcedony scaraboid (B). L.24. A plunging bull. The legs differently posed to the next.

Pl. 499 Unknown. L.21. A plunging bull (H). For this and the walking bull types on coins of Thurium see Kraay-Hirmer, figs. 251, 252. 254; *Num. Chr.* 1958, 25; there is the same succession of types on coins of Phlious, Babelon, pls. 218–9.

Pl. 500 Paris, BN, *Pauvert* 63, pl. 5, from South Italy. Agate scaraboid (A). L.19. The forepart of a bull, the head in three-quarter view.

Pl. 501 *Munich* i, 310, pl. 36, from Caesarea. Blue chalcedony scaraboid (A). L.17. As the last but the head in profile. Lippold, pl. 91.3. Cf. coins of Samos, Kraay-Hirmer, fig. 615.

Pl. 502* *London* 512. Cornelian scarab (probably cut down from a scaraboid since the wingcases are oddly striated for this period). L.19. A locust on a corn stalk, with a moth above. Contrast coins of Metapontum, Kraay-Hirmer, figs. 228, 235, where the scale is reversed. It is a common device on later gems, as *London* 2546, pl. 29.

Pl. 503 Boston, *LHG* 78, pl. 4. Cornelian scaraboid (A). L.24. A coiled snake (H).

Pl. 504 Boston, *LHG* 76, pl. 4. Agate scaraboid (B). L.16. A bull calf.

Pl. 505* Leningrad 583. Rock crystal scaraboid (A). L.14. A wasp. Compare the bee on earlier coins of Ephesus, Kraay-Hirmer, fig. 598.

Pl. 506 Boston 27.690. Mottled jasper scaraboid (A). L.24. A dolphin. Richter, *Animals* fig. 227.

Pl. 507 *London* 538, pl. 9. Rock crystal scaraboid (A). L.20. A lion attacking a stag (H). *AG* pl. 13.36; Lippold, pl. 85.9.

Pl. 508 Bowdoin College 488. Green ringstone. L.18. A lion attacking a bull.

Pl. 509* *London* 554, pl. 10. Mottled clear red and yellow scaraboid (A). L.17. A peacock displayed frontal, holding two snakes, one of them with a beard and perhaps a crest. Lippold, pl. 163.3 (as modern).

Pl. 510 Unknown. L.24. Two dogs attack a boar (H). *AG* pl. 11.35. The subject is repeated on Roman gems as *London* 2384–5, pl. 28.

Pl. 511 Boston 95.81, from the Peloponnese, Chalcedony scaraboid (C). A griffin attacking a stag on rocky ground. *AG* pl. 31.4; Lippold, pl. 81.4.

Pl. 512 *Geneva Cat.* i 216, pl. 83. Rock crystal scaraboid (A). L.25. A leaping griffin. In the field three letters.

Pl. 513* Nicosia R.96, from Marion. Cornelian scaraboid (A). L.12. A sandal (H). Myres-Richter, *Cat.* pl. 8.4588, as a footprint. Cf. our *Pl. 524*.

Pl. 514 Boston, *LHG* 68, pl. 5. Chalcedony scaraboid (Archaic shape). L.14. A hazel nut (H).

Pl. 515 Boston 95.85. Cornelian prism. L.17. A herm and caduceus. *AG* pl. 9.25; Lippold, pl. 10.10. Cf. Lullies, *Typen der gr. Herme* (Königsberg, 1931) 45, 49, 51; Metzger, *Recherches* (Paris, 1965) 84f.

SLICED CYLINDERS AND BARRELS

Pl. 516 *London* 562, pl. 10, from Epirus. Agate sliced barrel. L.22. A naked youth standing, binding thongs on to his wrist. *AG* pl. 9.30; Lippold, pl. 56.6; *Burl. Mag.* 1969, 591, fig. 23-4. See *colour, p. 203.2,5*.

Pl. 517 *London* 563, pl. 10, from Corfu. Burnt sliced barrel. L.21. A seated youth, himation round his hips and legs, playing a harp. *AG* pl. 14.14; Lippold, pl. 59.7. The harp has a spindle shaped arm; cf. Herbig, *Ath. Mitt.* liv, 173ff., our gem on fig. 4. See *colour, p. 203.4*.

Pl. 518 Boston, from Greece. Agate sliced barrel. L.18. A heron. *AG* pl. 9.29; Lippold, pl. 95.1.

Pl. 519 Once Warren. Agate sliced barrel. L.38. A heron. *LHG* pl. B.2.

Pl. 520 Boston, *LHG* 65, pl. 5, from Tarentum. Agate sliced barrel. L.28. A lioness. *AG* pl. 9.59; Lippold, pl. 84.13.

Pl. 521 Moscow 10561. Cornelian sliced cylinder. L.17. A dog scratching itself. Zaharov, pl. 3.113.

Pl. 522 Oxford 1925. 136. Agate sliced barrel. L.13. A dog with a bone. Cf. mid-century coins of Segesta, Rizzo, *Monete gr. di Sicilia* pl. 61.16.

Pl. 523 Boston 01.7550. Agate sliced barrel. L.21. A locust. Richter, *Animals* (Oxford, 1930) fig. 220.

Pl. 524 Boston, *LHG* 77, pl. 5. Agate sliced barrel. L.17. A sandal. Cf. our *Pl. 513*.

Pl. 525 *New York* 132, pl. 22. Agate sliced barrel. L.20. A Persian with spear and bowcase. *Hesp.* Suppl. viii, pl. 34.5.

Pl. 526 Oxford 1892. 1537. Onyx sliced barrel. L.15. A camel.

Pl. 527 Once Kestner. Agate sliced barrel (?). L.12. A lion. *AG* pl. 13.35; Lippold, pl. 86.11.

AFTER DEXAMENOS

Pl. 528 *New York* 76, pl. 12, from near Catania. Cornelian ringstone. L.15. Herakles fights the lion. *AG* pl. 9.49. For the comparisons with coins see Evans, *Syracusan Medallions* (London, 1892) 117 and pl. 5.5; for the coin type of Euainetos, Kraay-Hirmer, figs. 127, 129.

Pl. 529 Once Blacas. Cornelian scaraboid (?). L.19. Eros, with behind him an open shell. Signed *Phrygillos*. *AG* pl. 14.6; Lippold, pl. 26.16. In *AG* ii, 290, Furtwängler took the shell for an open egg (*contra*, p. 67) which is the more usual source for Eros, but in the impression of the

gem there does seem to be a ligature between the two halves. On coins signed by Phrygillos see Breglia in *Enc. dell'Arte antica* s.v.; Seltman, *Masterpieces* (Oxford, 1949) 16f., 66ff.; Benton, *JHS* lxxxi, 46–8. A child in this pose on coins of Kyzikos, *Nomisma* vii, pl. 5.17.

Pl. 530 Boston, *LHG* 52, pl. 3. Cornelian scarab (highly polished, ridged). L.20. The head of a negress, with necklet and drop earrings. *AG* pl. 12.43; Lippold, pl. 65.2. Compare the earrings worn on the Syracusan coin of c.405 BC, Kraay-Hirmer, fig. 117.

Pl. 531* Leningrad, from Kerch. Burnt scarab (simple). L.24. The head of a youth in a Phrygian cap (H). Inscribed *Perga*, on the flap of the cap. *AG* pl. 13.2; Lippold, pl. 66.3.

Pl. 532* Leningrad, from Kerch. Blue chalcedony scaraboid (C). L.25. A Persian with a spear, shown in a purely Greek style, wearing a long cloak over Persian dress. *AG* pl. 13.5; Lippold, pl. 65.9; *AA* 1928, 669, fig. 23.

Pl. 533 Leningrad, from South Russia. Blue chalcedony scaraboid (C). L.21. Artemis, wearing a tiara, stands holding a bow and phiale. *AG* pl. 13.6; Lippold, pl. 22.3.

Pl. 534 Once Arndt A1486, from Tripolis, North Africa. Mottled jasper scaraboid. L.21. A warrior in Thracian helmet crouches behind his shield.

Pl. 535 *Berlin* F 316, pl. 6, D 155, from Crete. Chalcedony scaraboid (A). L.27. A bearded man with pilos and chlamys, standing pensively with one foot on a rock, his right elbow resting on his knee. He holds a scabbard (not empty, as Furtwängler says). *AG* pl. 13.12; Lippold, pl. 43.9. Possibly a version of Odysseus at the entrance to Hades (see Beazley, *Boston Vases* ii (Oxford, 1954), 87–89) and compare the mood of near contemporary studies in metalwork, Greifenhagen, *Antike Kunstwerke* (Berlin, 1966) fig. 19; *Hesp.* xxiv, pl. 31c. If the right forearm and hand were lowered to beside the raised leg, the whole figure, including the chlamys around the left arm and the sword, would closely resemble the Odysseus shown receiving Diomedes after the rape of the palladion (see our *Pl. 1015*) and it is just possible that the gem presents an extract from an earlier version of the scene. On the motif with the raised foot see Jacobsthal, *Die Mel. Rel.* (Berlin, 1931) 190–2.

Pl. 536 Paris, BN, ex Louvre. Chalcedony scaraboid (A). L.29. Herakles wrestles with the lion. *AG* pl. 12.26; Lippold, pl. 36.2.

Pl. 537 Boston 01.7539. Mottled jasper scaraboid (C). L.23. As *Pl. 535*, but the right hand raised to the chin. Osborne, *Engraved Gems* (New York, 1912) pl. 7.9.

Pl. 538 *London* 558, pl. 10. Chalcedony cut, the edges trimmed. L.16. A giant, in short chiton and animal skin, falls on to one knee to seize a stone, brandishing two spears. Most careful work. *AG* pl. 10.48. A more summary version appears on a scarab (impression in Oxford).

Pl. 539 Boston, *LHG* 61, pl. 4, from Greece. Cornelian scaraboid, cut on the back. L.25. Theseus subdues the Crommyonian sow (H). *AG* pl. 21.11. He is holding a trident boar-spear, and not a cord, as Beazley suggests. Compare on *Fig. 292*; and for trident spears used against the Calydonian boar, the Glaukytes cup, Buschor, *Gr. Vasen* (Munich, 1940) fig. 143.

Pl. 540 Athens, Num. Mus., *Karapanos* 330, pl. 5. Chalcedony scaraboid (Archaic shape). L.20. Philoktetes seated on a rock nursing his leg (H).

Pl. 541 Paris, BN, de Luynes 263. Chalcedony scarab (very simple). L.17. A satyr shoulders an empty amphora (H). *AG* pl. 12.37; Lippold, pl. 14.6.

Pl. 542 *New York* 97, pl. 17, from Sicily (?). Cornelian ringstone. L.13. The forepart of Acheloos, with a helmet on his flank. The helmet is decorated with a horse in relief.

Pl. 543 *Berlin* F 328, pl. 7, D 153, from Asia Minor. Cornelian ringstone. L.19. Two youths crouch to play with astragaloi. Above, an ankh sign; to the left, a fish (compare that with the Beazley Europa, *Pl. 345*). In the exergue the inscription *Dioskoroi*. *AG* pl. 10.17. Furtwängler thought that our *Pl. 455* was by the same hand, and both the possession of a Spartan. Girls are more often shown thus occupied. See Dörig, *Mus. Helv.* xvi, 29ff.; ibid., fig. 3 for boys, on a vase.

Pl. 544 New York, Velay Coll. Chalcedony scaraboid. L.22. A woman muffled in her himation. Evans, *Selection* pl. 2.49. The feet show that the figure is dancing, so an early example of a 'mantle-dancer' with part of the face covered (see *BMC Terracottas* i, no. 881; *AJA* xxxv, 374, fig. 1, on a red figure vase of the third quarter of the fifth century; Lullies in *Studies Robinson* i, 668ff.).

Pl. 545 *London* 599, pl. 10. Cornelian ringstone. L.18. A seated woman, one breast bared, with a child standing close by her side. Probably Aphrodite and a wingless Eros. *AG* pl. 10.31. The edges of the face of the stone have been rounded off. Cf. coins of Nagidos, Babelon, pl. 141.12,13.

Pl. 546 *Berlin* F 319, pl. 6, D 150. Brown chalcedony scaraboid (A). L.24. A partly dressed woman seated disconsolately at the foot of a stele, being crowned by a standing Nike, who is as little clothed. *AG* pl. 13.18. Furtwängler thought she might be the nymph of a place

where games were held, the stele being a *terma*, but it looks more like a gravestone. It might still be Nemea, at the grave of her son (according to some), Archemoros, in whose honour the Nemean Games were inaugurated. She also recalls the more fully dressed figures of Electra at the tomb of Agamemnon (references in Trendall, op. cit., 118, with pl. 60.3) but the scene cannot easily be interpreted in terms of that story. This is a very early undressed Nike.

Pl. 547 Syracuse. Mottled jasper scaraboid. L.23. A naked woman standing beside a heron. Vollenweider, *Connoisseur des Arts* Feb., 1959, 59 K.; *LHG* 61.

Pl. 548 Péronne, Danicourt Coll. Blue chalcedony scaraboid (A). L.25. A girl Pan with a bird or cup. On girl Pans see Herbig, *Pan* 37. We would expect the figure to hold a bird (compare *Pl. 627*, the pose on *Fig. 240*, or on vases, as Hahland, *Vasen um Meidias* (Berlin, 1930) pl. 14b) but the object is formed more like a cup, and the gesture would then be as for playing kottabos. In the Classical period Pan can be shown as largely human in anatomy; see Kraay-Hirmer, fig. 512.

Pl. 549 *New York* 73, pl. 12, from Kastoria. Cornelian scaraboid (B). L.25. On the face a heron (H). On the convex back a naked woman beside a standed basin, holding a cloak out over her head (H). *AG* pl. 12.38, 39; Lippold, pl. 95.4.

Pl. 550 Oxford 1892. 1486, from Spezia. Blue chalcedony scaraboid (A). L.23. A naked girl crouches to pull a chiton over her head. *AG* pl. 12.34. By the same hand as *Berlin* F 315 (our Notes no. 177) and *Pl. 551*, and related to Greco-Persian gems, as those in our *Pls. 857–859*.

Pl. 551 *New York* 74, pl. 13, from Sparta. Chalcedony scaraboid (C). L.34. A naked girl, kneeling, pulls at the cloak of a youth, who holds her clothes up and out of her reach. Richter suggests that the youth is the victim of the assault, but this does not explain all the gestures. Compare our *Fig. 208*, for the subject, and see *Pl 550*.

Pl. 552 Boston, *LHG* 60, bought at Demanhur. Blue chalcedony scaraboid. L.26. A bearded man makes love to a woman who lies across a couch. *AG* pl. 61.34. Beazley cites Ovid, *Ars Amatoria* iii, 775, for the pose, with her legs over his arms; and ibid., 782 is apposite: *'stet vir, in obliquo fusa sit ipsa toro'*. This use of the furniture is not seen otherwise in Greek representations, but compare our *Pl. 862*. The couch has turned legs.

Pl. 553 *New York* 43, pl. 7, from Phaleron. Chalcedony scaraboid. L.30. A warship. The treatment of the boar's head prow, resembling Greco-Persian animal studies, suggests this date for the stone. Its size and shape too are against the early date (*c.*500) proposed by Miss Richter.

LION GEMS

A woman taking off her dress, top down, by a standed basin. Possibly recut.

Pl. 585 New York, Velay Coll., bought in Athens. Cornelian lion gem. L.20. A naked woman crouching. Evans, *Selection* pl. 2.43.

SOME PLAIN WESTERN GEMS
Pl. 586 Boston, *LHG* 80, pl. 5, from Sicily. Chalcedony scaraboid with yellow flecks (A). L.23. A lioness. *AG* pl. 9.60; Lippold, pl. 87.1.

Pl. 587* London 591, pl. 10, from Lecce. Rock crystal scaraboid (A). L.29. A goat. *LHG* pl. B.6.

Pl. 588 *Munich* i, 309, pl. 36, from Patras. Blue chalcedony scaraboid (B). L.20. A bucranium with fillets. *AG* pl. 31.1.

Pl. 589 Oxford 1892. 1475, from Tarentum. Blue chalcedony scaraboid (A). L.12. A fly. *AG* pl. 9.50; Lippold, pl. 97.14.

FOURTH CENTURY: THE FINE STYLE
Pl. 590 *London* 601, pl. 10. Blue chalcedony scaraboid (C). L.33. Nike, her himation around her legs, erects a trophy. This is composed of a crested Thracian helmet with animal ears in the crown, a corselet with undercloth, a sheathed sword (*kopis*) and a light shield with centre boss. A cloth hangs on a branch of the stump, where a greave is hung and a hoplite shield rests. Beside it a spear with spear butt is set in the ground and on its pennant are the letters *ND*. *AG* pl. 13.37; Lippold, pl. 33.8. The inscription is fairly well drawn in *JdI* iii, 205, but the only two deliberately cut letters are a *nu* and *delta* (rather than *alpha*). The other marks are light scratches perhaps meant to show the pattern of the pennant. Furtwängler was cautious about reading 'Onatas' but let the name stand. Later writers have not questioned it. Cf. Bellinger, *Victory as a Coin Type* (New York, 1963) 20, pls. 5.12 (Lampsakos), 6.6 (Agathokles; also Kraay-Hirmer, fig. 137) and our *Pls. 724, 747, 776, 787.*

Pl. 591 Boston, *LHG* 62, pls. 3, 10, from Granitsa. Cornelian ringstone. L.22. Kassandra takes refuge at the statue of Athena. *AG* pl. 14.26; Lippold, pl. 43.7; Davreux, *Cassandre* (Liège, 1942) 180, no. 132, fig. 83. Ajax's intention is made specific on a Cabirion vase, Lullies, *Gr. Kunstwerke* (Sammlung Ludwig: Düsseldorf, 1968) 132f.

Pl. 592* Leningrad 575, from South Russia. All-cornelian ring with a convex face to the bezel. L.23. A crouching naked girl with a cloth and mirror, her body turned to the viewer. *AG* pl. 33.43; Lippold, pl. 63.12. Compare *Pl. 594*.

Pl. 593 Berlin F 313, pl. 6, D 162, from Kyparissos. Chalcedony scaraboid (C). L.29. A seated girl, himation around her legs, balances a stick on her hand. *AG* pl. 13.10. For the

motif cf. our *Fig. 202* (with a ball) and Notes, no. 647; the 'oekist' with a distaff on coins of Tarentum, Kraay-Hirmer, fig. 305; and the girl on a gem by Aulos of the first century BC, Vollenweider, 40f., pls. 31.1, 32.1,2, with comparanda.

Pl. 594 *London* 530, pl. 9, from Athens. Lapis lazuli scaraboid (A). L.29. A kneeling girl climbs into her chiton. Compare *Pl. 592*. *AG* pl. 12.33.

Pl. 595 London, Victoria and Albert 122–1864. Cornelian cylinder in a gold setting with chain. Visible L.23. A half naked woman with a heron. Mentioned in *AG* iii, 133; *CS* fig. 10; *Antike Kunst*, forthcoming. See *colour, p. 203.3.*

Pl. 596 Boston, *LHG* 58, pl. 4, from Kythera. Chalcedony scaraboid (A). L.28. Diomedes tiptoes away with the palladion, his sword drawn. Compare the figure on the name vase of the Diomed Painter, *ARV* 1516, 1.

Pl. 597 Once *Evans* pl. 2.27, from Chios. Chalcedony scaraboid. L.25. A naked man, perhaps Dionysos, seated, with thyrsos and wreath.

Pl. 598 Paris, BN, ex Louvre 1630. Agate scaraboid (A). L.22. An old man walks, resting on a stick, carrying dead birds and a hare hanging from a pole across his shoulder, a bow case at his side. *AG* pl. 31.10 (Furtwängler takes the figure for Philoktetes, but this does not seem necessary).

Pl. 599 Boston, *LHG* 57, pl. 3. Cornelian scaraboid. L.20. A statue of Athena, frontal, adorned with fillets. A bucranium in the field. *AD* inscribed on the base, perhaps the initials of the artist's name. Compare the Athena on late fourth-century coins of Pergamon, Lacroix, *Repr. de statues* (Liège, 1949) 124f., pl. 9.6.

Pl. 600* Leningrad, from Kerch, Temir-Gora. Burnt scaraboid (B). L.23. A youth seated on an animal skin playing a *trigonon* harp (H). *AG* fig. 102; Maximova, *Kat.* pl. 2.4. For the type of harp ('Phrygian') see Herbig, *Ath. Mitt.* liv, 179ff.

Pl. 601. Leningrad. Burnt scaraboid (A). L.27. Apollo and Marsyas. A kithara beside Apollo, while Marsyas is crouching, bound. *AG* fig. 95; *ABC* pl. 16.7. On the subject see Schauenburg, *Röm. Mitt.* lxv, 42ff. and pl. 35 for a standing Apollo, kithara on ground, and bound Marsyas, but the group on the gem is not exactly repeated.

Pl. 602* *London* 570. Mottled red jasper and chalcedony scaraboid (B). L.17. The head of Medusa.

Pl. 603* *London* 602, pl. 10. Cornelian ringstone. L.19. A sphinx scratching herself (H). Inscribed *Thamypou*. *AG* pl. 10.58; Lippold, pl. 78.10; Vollenweider, 38, n. A later copy of the motif is *AG* pl. 10.54.

tablet. *AG* pl. 31.12; Lippold, pl. 64.7; *Geneva* xii, pl. 2.5, where it is attributed to Kallippos.

Pl. 633 *Berlin* F 351, pl. 7, D 151. Cornelian ringstone. L.15. Eros draws a bow. Signed *Olympios. AG* pl. 14.8; *Geneva* xii, pl. 3.2. For the coins of Arcadia signed *Olym* see Kraay-Hirmer, fig. 512. The flat ringstone (?), *AG* pl. 14.7, Lippold, pl. 26.11, with the same subject might be of about the same date, and compare the convex ringstone, *AG* pl. 14.9.

Pl. 634 Unknown. L.20. A winged girl seated on the edge of a standed basin. In her hands is a fillet (?). *AG* pl. 14.30.

Pl. 635 *London* 572, pl. 10. Sparkling green, mottled black serpentine scaraboid (B). L.20. Omphale, wearing Herakles' lion skin and shouldering his club. Omphale dressed as Herakles is not otherwise seen before the Hellenistic period (see Schauenburg in *Rhein. Mus.* ciii, 57ff. on the subject) but it is difficult to date this stone later than the fourth century, unless the odd material is an indication of provincial or non-metropolitan work. The style is excellent. Compare the finger rings with Omphale, our *Pl. 766, Fig. 228*, which also seem no later than the fourth century, and *Wiss. Zeitschr. Griefswald* iv, 92–4.

Pl. 636 Oxford 1892. 1485, from Sparta. White and brown mottled jasper scaraboid. (C). L.21. A wreathed athlete seated on a stool. *AG* pl. 12.24; Lippold, pl. 56.10; *AJA* lxi, pl. 80. 16 (caption as 17), as fifth-century; the motif discussed by Richter, ibid., 267f.

Pl. 637 Leningrad 599. Chalcedony cut. L.15. Danae (?) seated on a stool. *AG* pl. 14.25; Lippold, pl. 47.1. For a seated Danae see Metzger, *Repr.* pl. 43.1.

Pl. 638 Leningrad. Blue chalcedony scaraboid (A). L.24. A crouching naked girl, pulling on her clothes. *AG* pl. 13.25; Lippold, pl. 63.1; *ABC* pl. 17.10. Similar to the last. Compare the Peleus and Thetis vase, Arias-Hirmer pl. XLVII. The same device on a gem impression on a clay weight from Erythrae, Oxford 1892. 1247.

Pl. 639 *London* 569, pl. 10, from Garma, North Persia. Chalcedony scaraboid, cut on the back (B). L.36. Nike in a wheeling biga.

Pl. 640 Oxford 1892. 1598, from Rhodes. Cornelian cylinder. H.29. A woman with a heron. Buchanan, *Cat.* i, pl. 63.1045. On this, unlike the next, the device could be impressed without rolling the whole cylinder, as it could also on the barrels.

Pl. 641 Moscow. Cornelian cylinder. H.15. A woman before a standed basin with a bird on it. Zaharov, pl. 3.111. For the bird see Trendall, op. cit., pl. 47.3 (and cf. pls. 77.9, 204.2,3).

GLASS SCARABOIDS

Pl. 642 *London* 567, pl. 10. Green glass. L.18. Artemis with raised arms. Before her two lions, back to back, rampant (not two foreparts, as Walters). (H).

Pl. 643 *Munich* i, 315, pl. 36, from Athens. Clear glass. L.22. A biga (H). *Evans* pl. 3.38; *MJBK* 1951, pl. 4.29.

Pl. 644 Athens, Num. Mus., *Karapanos* 494, pl. 7. Clear glass. L.25. A grazing horse (H).

Pl. 645 *London* 577. Clear glass. L.26. A woman seated cross-legged, holding a flower (H). *AG* pl. 65.7.

Pl. 646 *Berlin* (East) F 322, pl. 6, from Arcadia. Green glass. L.26. A woman dancing with a tambourine (H). *AG* pl. 13.7.

Pl. 647 *London* 592, from Greece. Green glass. L.30. Two eagles tearing at a fawn. IBK pl. 20.43.

Pl. 648 Boston. L.25. A wreathed head of a youth (H).

Pl. 649 *Berlin* (East) F 335, pl. 7, from Vulci, a 'fourth-century grave'. Green glass tabloid, the long edges at the back bevelled. L.27. A woman's head, very like *London* 578.

Pl. 650 London, Mrs Russell Coll. Green glass. L.33. A naked woman looking round and drawing back her cloak to show her body and buttocks. See Säflund, *Aphrodite Kallipygos*, with figs. 29, 30, for the type with cloak, not chiton. Our gem also supports the restoration of the Farnese figure with head raised rather than twisted back and down.

Pl. 651 Salonika 5435. Clear yellowish glass. L.20. A woman's head (H).

Pl. 652 Leningrad 500. Green glass. L.23. A bearded man rides a hippocamp.

Pl. 653 Salonika, from Olynthus. Green glass. L.21. Goats rampant at a kantharos. *Olynthus* x, pl. 171.2648 and fig. 32.

Pl. 654 Oxford 1922. 14. Green glass. L.25. A hippocamp.

Pl. 655 *London* 594, from Beirut. Green glass. L.19. A crab.

CLASSICAL FINGER RINGS

THE PENELOPE GROUP

Pl. 656 New York, Velay Coll. Gold (I). L.16. Penelope seated. A bow before her. Inscribed *Panelopa*, the Doric form. *Guilhou* pl. 4.82; Evans, *Selection* pl. 2.50. Cf. Jacobsthal, *Die Mel. Rel.* (Berlin, 1931) pl. 1.1 for the figure, and pp. 192ff. for the Penelope pose. Also Ohly in *Freundesgabe Boehringer* (Tübingen, 1957) 443ff. (our ring, fig. 17; Penelope on a vase with the bow, fig. 15 and see p. 457); *AA* 1962, 852–6. The bow is also seen on a relief ring, see below, p. 446; and with a winged 'Penelope', London 657, pl. 11 (Etruscan).

Pl. 657* Oxford 1885.492, from Nymphaeum, tumulus II. Gold (I). L.17. A sphinx. Flowers in the bezel corners. *JHS* v, pl. 47.11.

Pl. 658* Leningrad, from Nymphaeum, tomb 17. Gold (I). Nike flying with a wreath. *CR* 1877, pl. 3.35; *Mat. Res.* lxix, pl. 38.3; Artamonov, fig. 37.

Pl. 659* Leningrad T.1855.1, from Phanagoria. Silver (I; with an open hoop). L.17. Eros flying with a wreath and fillet. *CR* 1877, pl. 3.36; *ABC* pl. 18.14; *AG* pl. 10.10.

Pl. 660* LondonR 44, pl. 2, from Tharros, tomb 12. Gold (IV). L.19. A boy milks a ewe which is being held by a man. A flower and tree in the field. Monkeys milked goats on some Archaic gems (*AGGems* 152) but rustic activities are seen on Greco-Punic gems, to which this ring is related. For other Punic or Greco-Punic rings of this shape see *Arch. Viva* i, 2, pls. xi–xiv, xliv–xlv.

THE WATERTON GROUP

Pl. 661* London, Victoria and Albert 431–1871. Gold (I). L.17. A head in a circle. Oman, pl. 2.24. This resembles the Kassel Apollo head, for which, and similar types, see *Antike Plastik* v. For heads in tondi see *JHS* lxxi, 100f. On the possibility of identifying a Selene head in a disc see *JHS* lix, 150. The general style is close to contemporary coins of Leontini, as Kraay-Hirmer, fig. 22.

Pl. 662* London 1914. 10 17.2. Gold (I). L.18. Artemis, in a long, close-fitting tunic, holds two spears and a phiale, beside an altar. Higgins, *Greek and Roman Jewellery* (London, 1961) pl. 24c. Cf. Simon, *Opfernde Götter* (Berlin, 1953) 15f. and Bruns, *Die Jägerin Artemis* (Borna, 1929) 45ff., 52f. on the dress.

Pl. 663 Boston, *LHG* 48, pl. 3. Gold (I/III, with a heavy cushion bezel). L.15. Hermes, with chlamys, phiale and caduceus, leans on a small Ionic pillar. *AG* pl. 61.32; *LHG* p. 43 on the type with the pillar.

Pl. 664* LondonR 48, pl. 2. Gold (I). L.19. A seated Penelope. Inscribed *philo kao*. *AG* pl. 9.35; Jacobsthal, op. cit., 191, fig. 67.

Pl. 665* LondonR 45, pl. 2, from Beirut. Gold (I). L.17. A girl seated on a swing or crescent holding a basket with cakes and two upright sprigs. For the type of ritual basket (*kanoun*) see Beazley, *Boston Vases* iii (Boston, 1963), 77. On Selene, *Antike Kunst* v, 60f. For ritual swinging, Deubner, *Attische Feste* (Berlin, 1932) 118ff.

Pl. 666 Boston, *LHG* 53, pl. 3. Gold (I). L.17. Aphrodite weighs two Erotes with a third at her feet. The earliest other representations are on a later fifth-century medallion, fourth-century vases and a ring: Frel, *Klearchos* v, 125ff. On Psychostasia, Beazley, *Boston Vases* iii, 44–6.

Pl. 667 Boston 99.437. Silver with a gold stud (I). L.21. A standing Danae. Inscribed *Dana*. Lippold, pl. 47.2.

Pl. 668* Leningrad 480. Gold (I). L.18. A naked man standing and holding a strigil (?).

Pl. 669 Boston, *LHG* 83, pl. 4, bought in Sicily. Gold (I). L.17. A donkey. Hoffmann-Davidson, *Greek Gold* (Brooklyn, 1965) 450f., no. 110.

CLASSICAL: LIGHT RINGS

Pl. 670* Oxford 1885. 484, from Nymphaeum, tumulus IV. Gold (II). L.14. The head of a bearded man. *JHS* v, pl. 47.6; *LHG* pl. A.29; *Rend. Pont. Acc.* xxxiv, 56, fig. 25.

Pl. 671* LondonR 49, pl. 2, fig. 14. Gold (II). L.21. A horseman with a spear. *AG* pl. 9.39, 51.20; Lippold, pl. 55.1. See *colour, p. 217.2*.

Pl. 672* Plovdiv, from Golemata Mogila. Gold (II?). L.26. A horseman. Inscribed *Skythodoko*. Filow, *Duvanlij* (Berlin, 1930) pl. 8.4, 9; Becatti, pl. 76.306.

Pl. 673* Paris, BN, de Luynes 521, from Syria. Gold (II). L.15. A maenad wearing an animal skin and chiton, holding a human head and sword. On the death of Orpheus, Beazley, *Boston Vases* ii, 73; on Pentheus, ibid., 2. For representations of dancing maenads see the illustrations to Lawler's article in *Mem. Amer. Acad. Rome* vi.

Pl. 674* LondonR 66, pl. 3. Gold (II). L.19. A woman seated on the stern of a ship, a ladder at its side and a dolphin. Cf. coins of Histiaia, *Num. Notes and Mon.* ii and *Trans. Int. Num. Congr.* (1938) 23, fig. 1, dated 340/38 BC.

Pl. 675 Boston 98.789, from near Thebes. Silver (II). L.17. Thetis riding a hippocamp, holding a shield. *AG* pl. 61.33. On the identity of Thetis see Eichler in *Essays presented to K. Lehmann* 100–2.

Pl. 676* LondonR 1036, pl. 27, from Asia Minor. Silver (I, but the hoop ends are set in from the bezel ends). L.19. A seated woman holding a distaff, a basket before her. Inscribed *A]polloni[d]ei*.

Pl. 677* Leningrad. Gold (II). L.18. A heron flying. Compare the Dexamenos gem, our *Pl. 468*.

CLASSICAL: HEAVY RINGS

Pl. 678* Leningrad 577. Gold (III). L.13. The facing head of a woman.

Pl. 679* Oxford F.115, from Constantinople. Gold (III). L.23. The profile head of a woman with trefoils in the field.

Pl. 680 Boston, *LHG* 54, pl. 4. Gold (III, oval, heavy). L.26. A mounted woman (?) with a spear chases a stag. A bird flies above and a dog worries the stag. Hoffmann-Davidson, *Greek Gold* no. 109.

Pl. 681* Leningrad, from Kerch. Gold (III). L.23. A seated Persian tests an arrow, his bow over his wrist, Signed A]*thenades. AG* pl. 10.27; Lippold, p. 66.2; Maximova, *Kat.* pl. 2.7; *AA* 1928, 670, fig. 25. For the coins of Kyzikos, *Nomisma* vii, pl. 5.14; of Datames, satrap of Tarsus, 378–2 BC, *BMCLycaonia* pl. 29.11–13 and *Mat. Res.* l, 194, fig. 4, where, in figs. 1, 2, is shown an impression from a tabloid with a similar motif. For the Greco-Persian gem with the figure see our *Fig. 294*. For the action see our *Pl. 357*. On the dress, see Minns, *Scythians and Greeks* (Cambridge, 1913) 56.

Pl. 682* Leningrad, from Kerch. Gold. A massive hoop, not flattened and barely widened for the bezel. A youth kneeling over a tunny fish and prawn. *AG* pl. 10.19; *ABC* pl. 18.2. There is a plain version of this shape from Chersonese in the Crimea. For the Kyzikos stater see *Mél.Michalowski* (Warsaw, 1966) 430, fig. 1.

Pl. 683* *LondonR* 61, pl. 2, from Kourion, tomb 73. Gold (III). L.17. A reclining woman, her himation round her legs.

Pl. 684* *LondonR* 64, pl. 3. Gold (III). L.16. A maenad dancing, holding a thyrsos and half an animal.

Pl. 685 Paris, Louvre Bj.1051. Gold (III). L.18. As the last, holding a thyrsos and snake.

Pl. 686* Boston 95.92. Gold (III). L.19. Thetis rides a hippocamp, a fish below. *AG* pl. 9.42; Hoffmann-Davidson, *Greek Gold* no. 111.

Pl. 687* Paris, BN, de Luynes 515. Gold (III). L.18. Penelope. *AG* pl. 10.34; Jacobsthal, *Die Mel.Rel.* 191, fig. 66.

Pl. 688* *LondonR* 52, pl. 2, from Marion, tomb 66. Gold (III). L.20. Athena seated by her shield holding her owl. Inscribed *Anaxiles. AG* pl. 9.41; Lippold, pl. 20.7; *JHS* xii, 320f., for the tomb group, late fifth century. On Athena holding her owl see now *Bull.Vereen.* xliii, 35ff.

Pl. 689* Leningrad. Gold (III). L.20. A seated woman.

Pl. 690* Leningrad, from Kerch. Gold. L.19. A woman seated with a dog jumping up to her. *CR* 1870/1, pl. 6.19; Artamonov, pl. 281.

Pl. 691 London 1907. 12–17.2, from Rhodes. Silver (III) with a gold stud. L.18. Eros riding on a dolphin. On the motif see Greifenhagen, *Gr.Eroten* (Berlin, 1957) 70 and cf. the posture of the Eros on a dolphin on coins of Ambracia, Babelon, pl. 281.16.

Pl. 692 Boston, *LHG* 82, pl. 5. Silver. L.16. A lion below a club. Perhaps the Nemean lion, the club referring to Herakles. Beazley (in *LHG*) refers to comparable coin types.

Pl. 693* Boston 98.795. Gold (III). L.14. A lion attacks a dolphin. *AG* pl. 61.27; Lippold, pl. 85.4; Hoffman-Davidson, *Greek Gold* no. 114.

Pl. 694* Leningrad, from the Seven Brothers' Tumulus. Gold (III). L.20. A lion attacks a stag. *CR* 1876, pl. 3.34; Artamonov, pl. 132.

Pl. 695* Leningrad, from Nymphaeum. Gold (I). L.20. A griffin attacks a horse. *CR* 1877, pl. 5.12; *Mat.Res.* lxix, pl. 19.3.

Pl. 696* Paris, BN, de Luynes 526. Gold (III). L.18. A lion attacks a bull.

Pl. 697* Paris, BN 495. Gold (III, a tiny ring). L.12. A lion attacks a stag.

Pl. 698 *LondonR* 1080, pl. 27. Silver with a gold stud (III). L.15. A dog's head emerging from a murex shell. *JHS* xxiv, 332, fig.

A PONTIC GROUP

Pl. 699* Leningrad, from near Kerch. Gold (VII, with open overlapping hoop). L.16. A snake draws a bow. *CR* 1861, pl. 6.8; Lippold, pl. 97.3 and cf. pl. 97.1 ('Roman'). For the snake with Apollo's bow on the Lansdowne throne, Michaelis, *Ancient Marbles* (Cambridge, 1882) 441f., no. 20; *Mon.Ined.* v, pl. 28 r.

Pl. 700* Leningrad, from Chertomlyk. Gold (VII, with open overlapping hoop). L.17. A duck flying over bushes. *CR* 1864, pl. 5.10, 10a; *AG* pl. 10.14; Lippold, pl. 95.9; Artamonov, pl. 98. Cf. the silver vase, *ABC* pl. 35.5, 6; Artamonov, pls. 239, 240.

Pl. 701* Leningrad, from Chertomlyk. Gold (VI, with open overlapping hoop). A bull and a tree. *CR* 1864, pl. 5.12; Artamonov, fig. 110.

Pl. 702* Leningrad, from Taman. Gold (VI). L.18. A cock with a griffin's head and mane. *CR* 1870/1, pl. 6.18. A throw-back to the confusion between griffins and cocks experienced by Greek artists when both creatures, fact and fiction, were first introduced to Greece, towards the end of the eighth century.

Pl. 703* Leningrad, from Kerch, Iuz-Oba. Gold (VII). L.15. A locust on a rose. *CR* 1860, pl. 4.12.

CLASSICAL: SUMMARY AND COMMON STYLES
Pl. 704 London, Victoria and Albert 8767–1863. Gold (I). L.17. A woman standing, with a branch. Oman, no. 59.

Pl. 705 Cambridge. Gold (I). L.16. A seated woman holding a wreath.

Pl. 706 Moscow. Electrum. L.16. A naked girl stands to wash her hair at a basin. Zaharov, pl. 3.114.

Pl. 707* Paris, Louvre Bj. 1084. Gold (IV?). L.18. A sphinx on a tripod before a seated woman. *AG* pl. 20.46 (as late Etruscan); Coche de la Ferté, *Les bijoux antiques* (Paris, 1956) pl. 39.1; Hoffmann-Davidson, *Greek Gold* no. 108; *Enc.dell'Arte antica* v, 767, fig. 929.

Pl. 708 *New York* 82, pl. 15, from Jannina. Silver. L.22. A maenad dances holding a thyrsos.

THE KASSANDRA GROUP
Pl. 709* *New York* 80, pl. 14. Gold (V). L.20. Kassandra kneels at the statue of Athena. Inscribed *Kassandra*.

Pl. 710* *New York* 77, pl. 13, from Macedonia. Gold (V). L.20. A naked girl beside a chair with a cloak on it. Becatti, pl. 84.338. For Aphrodites binding their hair, and parodies of them, *Wiss.Zeitschrift Greifswald* iii, 107–9.

Pl. 711* Oxford F.119, from Macedonia. Silver (V). L.17. A naked girl with arms raised, as though dancing, with a small satyr behind her crouching with intent. Cf. the figure on the Greco-Persian prism, our *Pl. 861*. For the relative scale of the satyr and girl cf. coins of Himera, Kraay-Hirmer, figs. 68, 69, 71.

Pl. 712* Tarentum. Gold. L.15. A kneeling naked girl with arms raised to her head. An uncertain object beyond her (a ship's *stylis*?). *Iapygia* x, 27, no. 30; Becatti, pl. 84.337.

THE IUNX GROUP
Pl. 713* Leningrad, from Bliznitsa, main tomb. Gold (VI). L.21. A woman seated on a stool, with footstool, playing with a iunx wheel. Before her Eros. Maximova, *Kat.* pl. 2.9; Segall, *Zur gr. Goldschmiedekunst* (Wiesbaden, 1966) pl. 37.3; *Geneva* xii, pl. 2.6, 8; Artamonov, pl. 283. On the iunx wheel see Gow, *Theocritus* ii, 41; Greifenhagen, *Gr.Eroten* 78; *AJA* xliv, 453f. for representations (omitting finger rings).

Pl. 714* *LondonR* 53, pl. 2. Gold (VI). L.19. A woman's head. *AG* pl. 9.38; Lippold, pl. 64.4. For the earring type see Segall, op. cit., 19ff.

Pl. 715* *LondonR* 67, pl. 3, from Kourion, tomb 83. Gold (VI). L.15. A woman's head.

Pl. 716* *LondonR* 56, pl. 2, from Syracuse. Gold (VI). L.16. Eros fastens a woman's sandal. A dove overhead. See *colour*, *p. 217.1*.

Pl. 717* London, Victoria and Albert 430–1871. Gold (VI). L.16. A seated woman holds Eros on her outstretched hand while he crowns her. Oman, no. 26.

Pl. 718* *LondonR* 62, fig. 19. Gold (VI). L.17. A seated woman holds a kneeling Eros on her knees. Finely incised chiton, barely visible.

Pl. 719* *LondonR* 55, fig. 17, from Ithaca. Gold (VI). L.21. A woman holding a flower, leaning on an Ionic column, with Eros before her.

Pl. 720 *LondonR* 1046, from Cyrene. Silver (VI). L.16. A silphion plant. Cf. the Cyrene coins as Kraay-Hirmer, fig. 788.

Pl. 721 Leningrad, from Bliznitsa. Gold (VI). L.16. A siren with a kithara; her body is a locust's and her tail a scorpion's with a griffin head at the tip. Maximova, *Kat.* pl. 2.2; Segall, op. cit., pl. 37.2; Artamonov, pl. 282.

THE NIKE GROUP
Pl. 722* Leningrad, from Kerch. Gold (VII). L.23. Nike sacrifices a deer. *AG* pl. 10.46; Lippold, pl. 32.6; Maximova, *Kat.* pl. 2.6; *Geneva* xii, pl. 64.1, 2. For the motif see Kunisch, *Die stiertötende Nike* (Munich, 1964) 21, no. 6, 26; Borbein, *Campanareliefs* (Heidelberg, 1968) 48ff. Nike sacrificing a ram on coins of Abydos and Lampsakos, *Num.Notes and Mon.* cxlix, 16f., pl. 5.10, 11.

Pl. 723* *LondonR* 1258, pl. 30, from Naukratis. Gold plated bronze (VII). L.18. Eros kneeling with a iunx wheel (not recognised in the publications).

Pl. 724* *LondonR* 51, pl. 2, from Kerch. Gold (VII). L.23. Nike, her himation round her legs, nails a shield to a tree. Inscribed *Parmenon basilei*. *AG* pl. 9.44; Lippold, pl. 33.5. Cf. coins of Agathokles, as Kraay-Hirmer, fig. 137, where

the figure is heavier. For an early half-naked Nike on coins of Herakleia in Pontus see Kraay-Hirmer, fig. 726, there dated 380–60 BC. The leafy branch springing from the trophy stump is not shown on coins until after Alexander (*Num.Notes and Mon.* cxlix, 27f., pl. 7.1, Seleucus I, and cf. our *Pl. 747*) but the ring is unlikely to be so late.

Pl. 725 Paris, Louvre Bj. 1050. Gold (VII). L.13. A crouching naked girl. Exactly the type of the rather later figure of Thetis on the red figure pelike in London with Peleus, Arias-Hirmer, pl. XLVII.

Pl. 726 Boston (now missing), from Kythnos. Gold (VII). A kneeling girl plays with knucklebones. *AG* pl. 61.28; Lippold, pl. 64.9.

Pl. 727* Leningrad I.O.30, from Kerch, Iuz-Oba. Gold (VI). L.22. Nike in a frontal biga. *AG* pl. 10.47.

Pl. 728 Private. Gold (VII). L.15. Leda and the swan.

Pl. 729* Nicosia J.627. Gold (VII). L.17. The facing head of a woman.

Pl. 730* Oxford 1885. 490, from Nymphaeum, tumulus V. Gold (VII). L.16. A frontal head with horns, wearing a chlamys fastened at the neck. Above, a cicada. *JHS* v, pl. 47.7. For coins of Gela, Kraay-Hirmer, figs. 164–6. Hellenistic gems with river gods, *AG* pl. 26.2, 10, 18.

Pl. 731* *LondonR* 94, pl. 4, from Smyrna. Gold (VII). L.20. Gorgoneion with a dolphin below. See *colour, p. 217.6.*

Pl. 732* Leningrad, from Chersonesos. Gold (VII). L.18. Bow and club. Gaidukevich and Maximova, *Antichnie Gorod* 440, pl. 1.2.

The Salting Group

Pl. 733* London, Victoria and Albert 552–1910. Gold (VIII). L.20. A goddess with peplos, veil, crown and sceptre. Oman, pl. 2. 28. The crown for Aphrodite, our *Pl. 734*, and coins of Cilicia (Kraay-Hirmer, figs. 669, 670), Paphos (Babelon, pl. 129.17) and Nagidos (ibid., pl. 141.17, 20–25). The dress would equally serve Hera. Comparable early fourth-century figures, Süsserott, *Gr. Plastik des IV. Jhdt.* (Frankfurt, 1938) pl. 28. See *colour, p. 217.5.*

Pl. 734* Vienna 217, from Campania (a woman's grave containing jewellery and a scarab in a swivel ring). Gold (stirrup-shaped, with a hollow hoop, the bezel a gold plaque with thinner gold plaques above and below). L.23. Aphrodite wearing a crown and half naked, leans on an Ionic column and holds a bird out to Eros. *AG* pl. 9.48 and ii, 47, fig.; Lippold, pl. 25.5.

Pl. 735* London Market, 1934. Gold. Kore, with two

torches. Sotheby, 18. vii. 1934, no. 116, pl. 3. On a coin of Kyzikos, *Nomisma* vii, pl. 6.12 and cf. Metzger, *Recherches* (Paris, 1965) pls. 12–25 *passim*.

Pl. 736* *LondonR* 58, pl. 2. Gold (VIII). L.21. Aphrodite, naked, with a dove. Eros before her with a crown. A pillar with her clothes behind her. *AG* pl. 9.47; Lippold, pl. 25.1.

Pl. 737* Paris, Louvre Bj. 1089, from Pyrgos near Olympia. Gold, circular bezel. Aphrodite seated, with Eros. A wreath in the field. Coche de la Ferté, *Les bijoux antiques* pl. 21.4.

Pl. 738* *LondonR* 54, pl. 2, fig. 16. Gold (VIII). L.21. Eros holding a dove, seated on an altar. *AG* pl. 9.45; Lippold, pl. 28.1.

Pl. 739* *LondonR* 59, pl. 2, from Phocacea. Gold (VIII). L.20. A woman drops an offering or incense from a basket on to an altar, on which is perched an eagle. Note the perspective view of the altar side. Cook, *Zeus* iii (Cambridge, 1940), 782f., fig. 579.

Pl. 740 *LondonR* 1066, pl. 27. Silver (VIII). L.20. A running man with a torch. A strange and vigorous pose.

Pl. 741* Boston. Gold (IX). Aphrodite, half naked, seated, crowns Eros. Chase, *Handbook* (Boston, 1950) 106, fig. 126. For the way the himation is drawn back by her hand compare the earlier ring, our Notes, no. 608.

Fourth Century: Round Bezels

Pl. 742* Berlin 10823c, from Kalymnos. Gold (IX). L.22. Aphrodite, with her himation round her hips, teaches Eros, perched on a rock, how to shoot. Segall, op. cit., pl. 42.1; Greifenhagen, *Antike Kunstwerke* (Berlin 1966) pl. 103.3. Cf. the Louvre mirror, Boardman, *Greek Art* (London, 1964) 68, fig. 153 and for a scheme most like that on this ring the Hellenistic gem, *London* 1156, pl. 17, and Selinus sealing, Richter, *Engr.Gems* p. 143. On the rare representations of Eros with a bow as early as the fourth century see Rumpf in *Reallexikon für Antike und Christentum* s.v. 'Eros' 314f., 318; Metzger, *Representations* (Paris, 1951) 50, 343; our Notes no. 615 (in a shell); and our *Fig. 254* (pre-348 BC).

Pl. 743 Once *Evans*, pl. 4.57, from the Peloponnese. Gold. L.25. Eros sits, resting his arms and head on an upturned torch, on a base which supports a Corinthian column (?). On the column is, apparently, another Eros with a torch. On Eros with a torch see Rumpf, loc. cit., 335f.

Pl. 744* Leningrad X.1899. Gold (IX). L.25. Athena seated, holding a Nike. She is armed and her shield has a relief lion head blazon. The type on coins of Lysimachos,

Kraay-Hirmer, figs. 580, 582; *Essays in Greek Coinage* (presented to E. S. G. Robinson: Oxford, 1968) pls. 16–22.

Pl. 745* Moretti Coll. Gold (IX). L.22. A woman holding a mask. Hoffmann-Davidson, *Greek Gold* no. 116.

Pl. 746 Once Arndt, A2487/8. Silver with a gold stud. L.20. Two kneeling Erotes with cocks and a wreath above. Bulle, no. 21.

Pl. 747* Riehen, Hoek Coll., from Epirus. Gold (XI). Nike erects a trophy. A floral scroll border, also on the hoop. At the junction of hoop and bezel, on either side, are relief scenes of an Eros (?) and a Nike flying with fillets to a lidded tripod. Cf. coins of Seleucus I, *Num.Notes and Mon.* cxlix, 27f., pl. 7.1 for the Nike type with trophy.

Pl. 748* Leningrad 578. Gold (IX). L.22. Kybele, holding phiale and tympanon, enthroned in a shrine. The face is damaged. Pollak, *Nelidow Coll.* (Leipzig, 1903) pl. 19.483 and p. 165.

Pl. 749* London 1920. 5–29.6, from Ithaca. Gold (XI). L.25. A woman with a thymiaterion. There is a patterned floral border.

Pl. 750* Oppenländer Coll. Gold (XI). An elephant and driver. *Geneva* xii, pl. 64.4, 5.

Pl. 751* LondonR 89, pl. 3, from Alexandria. Gold (XI). L.24. A mouse with two ears of corn in its mouth, is tied to a column.

Pl. 752 Rustington, Palmer Coll. Silver (convex bezel face). L.16. The facing head of a woman. Inscribed *doron*, 'gift'.

Pl. 753* Oxford F.116, bought in Constantinople. Gold (IX). L.21. A seated woman with a thymiaterion.

Pl. 754* LondonR 86, pl. 3, from Crete. Gold (XII). L.28. Nike with a wreath at a thymiaterion.

Pl. 755 Munich A2489. Silver (IX, with lightly convex bezel). L.16. An eagle attacking a dolphin. Compare the devices of Black Sea coins.

WESTERN GREEK: FIFTH CENTURY
Pl. 756 Munich A2481, from South Italy. Silver with a gold stud (I, with three mouldings on the hoop). L.23. A woman in chiton and himation. Sambon-Canessa, iii. 1902, no. 247, with fig.

Pl. 757* Tarentum. Gold. An old man with a dog. He is wearing a pilos cap. Perhaps Odysseus. *Iapygia* x, 27–9, fig. 16; Becatti, pl. 81.329.

Pl. 758* Tarentum. Gold (III?). A winged woman (apparently) kneels on an Ionic capital, holding an uncertain object which has been taken for a ship's *aphlaston*. *Iapygia* x, 30, fig. 18; Becatti, pl. 84.336. She appears to be naked. Found with the gold scarab, Becatti, pl. 81.332.

Pl. 759* Tarentum. Gold (III). A seated woman holding a dove. Becatti, pl. 80.325. On the significance of the motif see Segall, *Zur gr. Goldschmiedekunst* (Wiesbaden, 1966) 34f.

Pl. 760* London, Victoria and Albert 437–1871. Silver with a gold stud (VI). L.16. A winged woman binds her sandal, her foot on a step. Oman, pl. 23. See *colour*, p. 217.4.

WESTERN GREEK: FOURTH CENTURY
Pl. 761 *New York* 81, pl. 14, from Sovana. Gold (V?). L.25. A three-quarter facing head of Herakles wearing the lion skin. Bieber, *Alexander the Great* (Chicago, 1964) fig. 62 (the ring), fig. 61 (coin of Cos).

Pl. 762* LondonR 68, pl. 3, from Sicily. Gold (VIII). L.20. A three-quarter facing head of a woman, possibly Athena. *AG* pl. 9.40; Lippold, pl. 20.8. For heads in this style see fourth-century coins of Tarsus, *BMCLyc.* pl. 29.4, 6. For the helmet or cap compare Thracian helmets, *JdI* xxvii, 326, fig. 9 and Beil. 10, 11; *AGGems* 84. See *colour*, p. 217.3.

Pl. 763* *Geneva Cat.* i, 220, pl. 84 (now missing). Gold (IX). L.23. Artemis runs, holding a *lagobolon*, hunting stick, her dog at her side. *Geneva* xii, pls. 1, 2.1. Miss Vollenweider associates it with the work of Kallippos. For the type cf. Bruns, *Die Jägerin Artemis* (Borna, 1929) 59ff.; for Strongylion see Lippold, *Gr.Plastik* (Munich, 1950) 189f.; *Antike Plastik* vi, 50ff.; with a torch on fourth-century coins of Corinth, Babelon, pl. 214.6, 7; and see the next.

Pl. 764* LondonR 1079, pl. 27. Silver with a gold stud in the shoulder (VIII). L.20. Artemis runs holding a torch, her dog at her side. A summary version of the figure on the last.

Pl. 765* LondonR 69, pl. 3. Gold (VIII). L.24. Athena stands, her shield on the ground, wearing helmet and peplos and leaning on her spear.

Pl. 766* Switzerland, Private, bought in Naples. Gold (IX). L.22. Omphale, with Herakles' club and lion skin. *Wiss.Zeitschr.Greifswald* iv, 92, fig. 2, and Bielefeld, ibid., 92–94 on Omphale. Compare our *Pl. 635, Fig. 228*, and on later representations on gems see Vollenweider, 42 (with pl. 32.3–5); Zazoff, *AA* 1965, 68.

Pl. 767* Tarentum, from near Montemesola. Silver with a gold stud. Perseus runs carrying the head of Medusa and the *harpe*-sickle with which he decapitated her. Becatti, pl. 81.328.

Pl. 768* Tarentum 10006. Gold. A woman holding a wreath leans on a pillar. Becatti, pl. 82.333; *Geneva* xii, pls. 3.4, 4.3; *Klearchos* 29–32, 154, fig. 1.

Pl. 769* *LondonR* 57, fig. 18. Gold (VIII). L.19. Nike crowns Herakles, who holds a cup. For the group cf. Roscher, s.v. Herakles, 2250f.; on South Italian vases, Trendall, op. cit., pls. 36.5, 41.1.

Pl. 770* *LondonR* 98, pl. 4. Gold (VIII). L.17. A lidded amphora, in a wreath.

WESTERN GREEK: FOURTH CENTURY: THE COMMON STYLE
Pl. 771 *LondonR* 1088. Silver (VII). L.15. Nike holds a wreath. There is a crescent and cross in the field.

Pl. 772 Paris, Louvre Bj.1055. Gold (VII). L.14. Eros stands holding a wreath beside a thymiaterion. Inscribed *is .eṣnin*.

Pl. 773* Oxford F.153, from Vicarello. Silver (VII). L.19. The facing head of a woman.

Pl. 774 London market, 1965. Gold (VIII). L.20. A woman holding a torch and a jug. Sotheby, 28.vi.1965, no. 78.

Pl. 775* *LondonR* 101. Gold (VIII). L.15. Nike holding two wreathes.

Pl. 776 Munich A2496. Silver with a gold stud (VIII?). L.19. Nike is crowning a trophy, shown as the complete upper part of a warrior, including the head.

Pl. 777 Paris, Louvre Bj.1042. Gold (X). L.18. Nike seated on a stool, with a bird and a wreath.

Pl. 778* Oxford F.782. Silver with a gold stud (IX). L.20. A woman seated on a stool with a bird and a wreath. A stick or torch is leaning against the stool. Hatched border.

Pl. 779 *LondonR* 1050, pl. 27. Silver with a gold stud, decorated with a star (VIII). L.20. A woman seated on a stool holds out a wreath. Hatched border.

Pl. 780 *LondonR* 1087, pl. 27. Silver (X). L.16. Herakles with his club and lion skin at the tree of the Hesperides with its guardian serpent wound around it.

Pl. 781 *LondonR* 1068, fig. 133, from Catania. Silver with incised shoulders to the hoop (X). L.15. A seated youth holds a lyre. Chevron border.

Pl. 782 Munich A2494. Silver (X). L.15. Eros holds a thymiaterion, on a stand.

Pl. 783 *LondonR* 1089. Silver (X). L.13. A rose.

Pl. 784* Oxford F.154, from Vicarello. Silver (X). L.13. The facing head of a woman. The tremolo border is gilt.

Pl. 785* Syracuse 42251, from Gela (with a hoard of mainly Punic gold coins). Gold (II, but a broad bezel). L.15. Phrixos rides the ram. Tremolo border and on the creature's tail and horn. On Phrixos see Schauenburg, *Rhein.Mus.* ci, 41ff.

WESTERN GREEK: FOURTH CENTURY: ROUND BEZELS
Pl. 786* *LondonR* 42, pl. 2, from South Italy. Gold (XI). L.28. Nike in a wheeling quadriga. *AG* pl. 9.46; Lippold, pl. 33.4; Higgins, *Jewellery* pl. 24d.

Pl. 787* Oxford 1918. 62. Gold (XI). L.25. A half naked Nike dresses a trophy of helmet, shield, corselet and sword. For the subject on coins of Agathokles, Kraay-Hirmer, fig. 137.

Pl. 788* *LondonR* 84, pl. 3, from Reggio. Gold (XII). L.29. A winged hippocamp. *AG* pl. 64.14; Lippold, pl. 82.14.

Pl. 789 Dresden Z.V. 1461. Silver (VIII). L.19. A winged hippocamp, as the last but poorer style. *AA* 1896, 211, no. 43.

Pl. 790 Vienna VII.949. Silver (XI), with a ribbed hoop. L.25. A wheeling biga with a wreath above.

Pl. 791* London, Victoria and Albert 429–1871. Silver (XI). L.19. A woman stands by a thymiaterion. Oman, pl. 2.32.

Pl. 792* *LondonR* 85, pl. 3, from Gela. Gold (XI). L.22. A woman crowns a column on which there stands the figure of a goddess holding two torches. *AG* pl. 64.17; Lippold, pl. 58.1.

Pl. 793* Oxford F.117, 'from Athens'. Gold (IX). L.21. Eros with a falling torch. Possibly eastern. Compare the Roman gem, *Thorwaldsen* 754, pl. 9, where the torch leans away from him but his hands are bound.

RINGS IN THRACE
Pl. 794* Plovdiv, from Arabad žijskata Mogila. Gold (I). A horseman. Inscribed in Thracian. Dentschew, *Die Thrakische Sprachreste* 291, reads *Mezenli*, as genitive of a proper name; in which case the other word, *ete* perhaps is the equivalent of a Greek *eimi*. Filow, *Duvanlij* (Berlin, 1930) pl. 8.3.

OTHER LATE TYPES
Pl. 795* *LondonR* 93, pl. 4. Gold (XIII). L.9. The head of a woman.

Pl. 796* London, Victoria and Albert 435–1871. Silver (XIII). L.12. A naked woman leaning on a stand or candelabrum, adjusts a sandal. Oman, no. 30.

BRONZE RINGS

Pl. 797 *LondonR* 1229, pl. 30. (I, twisted hoop with snake head terminals). L.23. Nike running with her head turned back.

Pl. 798 Munich A2537/8. (IV) with a silver stud. L.23. Herakles kneels to shoot, his club behind him. Cf. coins of Thasos, Kraay-Hirmer, fig. 439.

Pl. 799 *LondonR* 1241, pl. 30. (IV). L.23. Herakles (?) with a shield and club.

Pl. 800 Munich A2531. (VII) with a gold crescent inset. L.15. A man's head with a mask pushed to the back of his head. Cf. the Hellenistic gem, *AG* pl. 26.40.

Pl. 801 Munich A2580. (VII). L.15. A woman is sitting on the stern of a ship, holding an *aphlaston*, beside a ladder. See on *Pl. 674*.

Pl. 802 *LondonR* 1252, pl. 30, from Catania. (VII). L.18. The bust of a maenad.

Pl. 803 Oxford F.127. (VIII). L.20. Nike is holding a small thymiaterion.

Pl. 804 London, Victoria and Albert 432–1871. (VII). L.18. A youth is seated on a speckled rock, his head bowed. One arm rests along his knee, the other is bent or lowered between his legs as if to nurse a foot. Oman, no. 27. The motif is shown most clearly on a late Etruscan scarab (Velay Coll.; Evans, *Selection* pl. 6.100; not 'bearded'). See also our Notes nos. 292, 596, 874, 952–3; and compare the 'priestess' on *AG* pl. 64.54; Selinus sealings, *Not.Scav.* 1883, pl. 6.98–100. The near arm may be bent or stretched down between the legs towards the feet. For Demeter on the 'petra agelastos' and possible representations, see Rubensohn, *Ath.Mitt.* xxiv, 50ff.; Mylonas, *Eleusis* (Princeton, 1961) fig. 72; Metzger, *Recherches* (Paris, 1965) 46f.

Pl. 805* *LondonR* 1335, from Smyrna. (VIII). Gold plated. L.18. A facing woman between thymiateria. An arch above with gorgon head terminals.

Pl. 806* London 1908. 4–10.5. (VII) with gold and silver studs. L.22. Nike holding a torch (?), or hammer.

Pl. 807 Munich A2553/4, from Athens. (VIII). L.24. A winged satyr with goats' legs holds a ribbon.

Pl. 808 Munich A2570, from Athens. (VIII). L.23. Two goats posed heraldically beside a tree.

Pl. 809 Munich A2540/1. (VII). L.22. Male and female herms, frontal, with a tiny figure of Bes squatting between them. On pairs of herms see Marcadé, *BCH* lxxvi, 608ff.; Metzger, *Recherches* 84.

Pl. 810 *LondonR* 1240, pl. 30. (VII). L.18. A sphinx with a sea serpent's head (or is it human, bearded?) and neck.

Pl. 811 Munich A2542, from Athens. (VII). L.21. A goat leaping before a herm. A caduceus behind.

Pl. 812 Boston, *LHG* 59, pl. 3, bought in Sicily. L.18. Eros with a dog's body.

Pl. 813 Paris, BN 608. (VII). L.18. A wingless griffin attacks a stag.

Pl. 814 Munich A2532, from Thebes. (X). L.23. A head of Zeus Ammon.

Pl. 815 Oxford 1941. 318. (IX). L.30. The head of a woman.

Pl. 816* *LondonR* 1279, pl. 31. (X). L.22. The head of a youth.

Pl. 817 London, U.C.L. 162, from Egypt. (XI). L.23. Two women at their toilet (?). Petrie, *Objects of Daily Use* pl. 13.162.

Pl. 818 Munich A2550, from Samos. (XI). L.24. A Nike holding Eros. A club before them. On the association of Nike and Eros see Greifenhagen, *Gr.Eroten* (Berlin, 1957) 75f.

DECORATIVE

Pl. 819* Leningrad, from Bliznitsa. Gold lion seal. L.18. Artemis, crowned and holding a bow, is shown standing on a base, as if a statue were intended. *AG* figs. 88, 89; Segall, *Zu gr. Goldschmiedekunst* (Wiesbaden, 1966), pl. 37.4; Artamonov, figs. 142–3.

Pl. 820* Leningrad, from Bliznitsa. Gold scarab. L.20. A half naked Aphrodite is leaning on a pillar, holding a branch. Eros kneels to fasten her sandal. *AG* fig. 96; Segall, op. cit. pl. 37.1; Artamonov, pl. 280, fig. 144.

Pl. 821* Pforzheim. Gold scarab. L.18. A seated woman holding a bird. Tremolo decoration on the border, stool and ground line. Segall, op. cit., pls. 9, 26, 27, 29, 30.

Pl. 822* Leningrad, from Kerch, Pavlovsky kurgan. Oval plaque mounted in a gold swivel. Cut out gold figures on a blue glass ground, covered by clear glass. 1. Dancers. 2. Ketos and fish. *CR* 1859, pl. 3.4, 5; Artamonov, pls. 274–5. For the type of dancers in eastern dress see Lawler, *The Dance in Ancient Greece* (London, 1964) 114f.

Chapter VI

GREEKS AND PERSIANS

There has already been occasion to remark that in the Classical period much of the East Greek world and Cyprus, areas involved in the production of engraved gems and finger rings, was on the borders of the Persian Empire if not within it. There is, moreover, both archaeological and epigraphical evidence that Greek artists worked in the courts of the Achaemenid Persian kings. In glyptic this association of Greeks and Persians is represented by a very large class of so-called Greco-Persian gems which are identified on grounds of style, shape or motif. Minor scholarly arguments have developed over the question whether they were cut by Greeks who had in part lost touch with homeland styles and were serving a non-Greek market, or by easterners who were imitating Greek manners and models with varying success. Since the maximum period of time involved is some two hundred years, and since the Persian Empire stretched from the Aegean to India, from the Black Sea to the Nile, it is improbable that there is a single or simple answer. Only Miss Maximova and Professor Seyrig have, by isolating small groups of gems which can be linked by shape and style, shown the way to a proper treatment of the problem. It is necessary to consider geography, date, shape, motif and sometimes inscriptions on the way to an adequate assessment of style. It is not possible to divorce from the discussion those purely Achaemenid seals, both stamps and cylinders, for which no one would suggest a Greek hand, and, as in all such matters, a study of origins may lead to better understanding. The account which follows can only incidentally dwell on all the vital topics, since the main intention is to study what is basically Greek, and secondarily what is immediately influenced by Greek work, but it may clarify the problem by mapping out the evidence. If it does not produce a simple answer to the question—Greek or Persian?—at least it may show how comparatively unimportant the question is (like that of 'Greek or Etruscan?') beside the attempt to locate and date the main series. As in other fields of Greek art it becomes far easier to understand problems of style and development when the material can be examined in terms of individual artists or workshops, and not dealt with piece-meal. I discuss elsewhere in more detail the significance and style of some of the more purely Achaemenid stamp seals which will be mentioned in passing below; and the illustrations here (with the lists in the Notes) are mainly confined to examples of Greek style or shape, although other styles will receive attention and some token examples are shown.

First, the historical background to this unusual chapter in the history of Greek gem engraving must be surveyed. The newly-founded Achaemenid Empire first clashed with Greeks when Cyrus deposed the Lydian King Croesus at Sardis in 546 BC, and succeeded to the Lydians' control of many of the Greek cities and offshore islands of Asia Minor. The Great King's rule soon embraced all Anatolia, penetrated Thrace and compassed the west shores of the Black Sea on the north, Cyprus, Phoenicia and Egypt to the south. The Greeks were uneasy subjects and many enjoyed some degree of independence even if under Persian-appointed tyrants. There were revolts against Persian authority leading, at the turn of the century, to a general uprising and a daring raid, supported by Athens, which burnt Sardis, the old Lydian capital and new seat of the local Persian governor or satrap. These revolts were crushed and the King turned his attention to the Greek homeland with armies and fleets which included many East Greeks, not all of whom

were unwilling subjects. At Marathon, Salamis and Plataea the Persians were repulsed and their possessions in Europe soon lost. The Athenian League continued the struggle until the coastal cities of western Anatolia and the islands were free. The Persian satrapies still controlled the hinterland of Anatolia, but their hold on its west coast was light, and there were cities who found it necessary to acknowledge by tribute the interests of both Athens and the Persian King. Local dynasties enjoying some measure of independence were established in Lycia, Caria, Cilicia and Cyprus, all hellenised in different degrees. This fluctuating and imprecise situation persisted through the rest of the fifth century and first half of the fourth, punctuated by intrigues with the major Greek powers and considerable successes against the East Greek cities, most of whom were again absorbed into the Persian Empire. But in 334 BC Alexander of Macedon marched against Persia and in the next year, at Issus, the Persian King finally lost his western empire. Three years later Alexander sacked Persepolis.

From an inscription found at Susa in Persia we know that Darius employed Greek craftsmen in the construction and decoration of his palace there. Material evidence for their presence is not lacking, and although there is bound to be some disagreement about the degree of Greek influence on Persian sculpture, architecture and metalwork in Persia itself, there is no doubt about the fact of their contribution. In the western satrapies of the empire, where the division between Persian and Greek was so poorly defined, we can envisage and find evidence for varying degrees of influence or collaboration. In cities like Miletus or Ephesus or on the islands of Ionia Greek artists were unlikely to take much notice of Persian interest, whatever the political climate of the day. In the Persian-controlled kingdoms of Lycia, Caria and Cilicia and in Cyprus East Greek artists worked freely in their usual manner, with only occasional concession to native or Persian motifs, as on some of the Lycian tomb monuments and, as we shall see, on coin dies. In the more thoroughly Persian-dominated centres, like the satrapy-capitals at Sardis and Daskylion, Persian interests were more important. Although Lydia and Phrygia were still very much under the influence of Greek artists, who must still have been working there, we find much more in the way of Persian motifs and styles. It is in these western satrapies and kingdoms that Greeks and Persians were most closely involved in each other's affairs, and it is mainly in these areas that the Greco-Persian gem engravers were working.

The use and production of coinage in this region presents a close parallel. Lydians, or Greeks in Lydia, invented coinage as we know it in the later seventh century. By the mid sixth century there were mints in several East Greek and some mainland Greek cities. When Sardis fell the Persians saw the merit of operating a mint in an area already conditioned to the use of coined money. Their mints continued in the Lydian tradition, using the same devices, but with Darius the device for the gold 'Darics' and silver 'sigloi' is the King himself, kneeling with spear and bow. To the time of the collapse of the Persian Empire this device changes significantly only in style, but relative, let alone absolute, dating is difficult, and it is not even certain that the minting went on without interruption. What is clear, however, is that distribution and use were largely confined to the partly-hellenised areas of the western empire.

The beginnings of Achaemenid glyptic are rather complicated. We have to remember the vast extent of the empire. There had been a long tradition of seal engraving in Persia itself, but this seems to have had no dominant effect on Achaemenid work. The immediately precedent Assyrian and Babylonian styles of engraving had been practised principally on cylinders and stamp seals, either pyramidal or conical in shape. The Mesopotamian style, at first sight more Assyrian than Babylonian, plays an important part in the decoration of the earlier Achaemenid cylinder seals and conoid stamps used at home and, to a lesser degree, all over the empire. In Syria and Phoenicia the local taste had been for scarabs, but there are not many with Achaemenid subjects (some of which do appear on glass conoids from this area). The seals of the Achaemenid period in this part of the world are still strongly Phoenician in form

with some Greek touches. Western Asia Minor and Cyprus saw the development of the Greek series, from Archaic to Classical. This is the area of maximum Greco-Persian interest, which is expressed in a mixed style, partly on pyramidal stamps and, later, on scaraboids.

In the following account of the principal styles of Persian or Greco-Persian seals emphasis is placed on those with the strongest Greek elements, but, even in a summary way, an attempt is made to cover the main range of Achaemenid glyptic. The differences between the groups are mainly stylistic, but chronological and geographical factors are also here and there involved. Nevertheless, the dividing lines are sometimes weak.

The normal material for the gems is chalcedony, especially the blue or 'sapphirine', which had been favoured for Babylonian stamps, but there is occasional use too for cornelian, rock crystal, agate, jasper. The purely Greek schools made more use of the clearer or white chalcedonies and jaspers. We will notice that the Greek hatched border to devices is wholly rejected.

THE COURT STYLE (*Pls. 823–844*)

This is the glyptic style which owes nothing to Greece except in its Archaic western form, where there is contamination by Greek motifs and, possibly, some concessions to Greek Archaic styles.

The Archaic eastern Court Style is, par excellence, the style of the Persian palaces and in glyptic is expressed on cylinders and on conoid stamps. The latter derive from Assyrian and Babylonian stamps: fairly massive with high, sometimes swelling backs, and convex faces which may be circular or a broad oval. The details of the style owe much to Assyrian, rather than Babylonian, precedents, with severely mannered treatment of faces and dress, but some fine lion studies, with cross-hatched manes. The best example is the famous Darius cylinder in London. This is, broadly, also the style of the earlier Achaemenid sculpture in Persia, although here there are more traits, part technical, part stylistic, to be attributed to the influence of immigrant Greek artists. As one might expect, these newcomers had far less influence on the stronger native traditions in glyptic and metalwork. The subjects on most of the cylinder seals are very formal studies, usually of the Persian hero with animals and monsters. There are good dated examples known from impressions on tablets found in the Persepolis Treasury, belonging to the 460's and earlier.

The Archaic western Court Style is an attenuated and rather summary version of the eastern. It appears on a very few scaraboids and is otherwise seen almost exclusively on pyramidal stamp seals. These are basically rectangular in section with bevelled edges and a lightly convex face. Occasionally the edges are rounded, not bevelled, but these are still to be distinguished from the conoids (although some conoids were cut in the west also). Seals of this shape were worn as pendants, and various types of metal suspension hoops are found on these and later examples, some of them fine specimens of the goldsmith's craft. Sometimes part of the shaft is encased in gold. The shape was Assyrian and Babylonian, the latter being generally taller and slimmer in proportions.

The style resembles the eastern but is often simplified. In the dress of the Persian hero, a common subject, we occasionally see the same sort of confusion with Greek representations of the chiton, which influenced the carving of Persian dress in the homeland palaces. The headdress is usually the spiky crown or 'tiara' but there are some Medes with busbies. The treatment of the lions is very close to that on Archaic Greek gems of the Common Style. There are many purely Persian subjects, involving the hero with lions (as *Pl. 824*) or other monsters, but there are some which are peculiar to this style and betray more Greek influence. They include a winged goddess with lions (*Pl. 823*), birds tearing the body of an animal and some griffin and sphinx types, more Greek than eastern.

The find places of these seals are overwhelmingly western—Asia Minor, especially Sardis, the satrapy capital, with a number found in Greece and some carried to south Russia. Virtually none of this shape is seen in the east, even in impression. A further indication of their western origin is the number bearing Lydian inscriptions, with which can be associated an even greater number with personal linear devices in the field, a usage not observed on the eastern cylinders. But the details of this interesting, basically non-Greek group are studied elsewhere. I give here only token illustrations. The style is that of the earlier Achaemenid coins which, it is generally agreed, were minted in the west, at Sardis and perhaps in other places.

The Archaic Court Style scaraboids carry the same range of Persian subjects as the pyramidal stamps (*Figs. 280–1; Pl. 825*), but there are also some with archers (as *Pls. 826, 827*), looking forward to the Mixed Style.

The Classical Court Style is a more mannered and meticulous version of the Archaic. Human heads are shown with more detail, where before there were little more than blobs for the cheeks and hair, lines for brow and beard. Dress shows more detail of patterning and folds, and there are points of contact between this style and some of the latest Archaic Greek, as in the Leningrad Gorgon scaraboid (*Pl. 378*) where, however, the dress is detailed more in the Greek manner. There are also some Egypto-Phoenician borrowings, like the god Bes. The bodies of animals are smoothly rounded without real modelling of anatomy. Instead, surface detail of drilling or incision gives a highly decorative scheme of shoulder patterns, ribs, haunch muscles and knobbly paws. This is a crystallisation of the more formal elements of earlier Persian styles, with something from Assyrian, but has lost completely the lifelike qualities still to some degree apparent in the Archaic. It has been aptly named the Frozen Style. In the west it is seen first on the pyramidal stamps, where the changes are most apparent, but exclusively for scenes with Persian subjects. It is also seen on a number of big scaraboids, and although the style is unaltered we are here dealing with the Greek shape which had become increasingly popular in the fifth century. There had been Assyrian and Babylonian scaraboids, some with low conical backs and some with shallow convex faces, but there seems to be no connection between these and the western Achaemenid scaraboids which appear only once the Greek form has become well established. The shapes of the Court Style scaraboids are the standard Type A and a number of the domed Type C, which begin to appear with purely Greek subjects in the later fifth century. One Type A scaraboid is in the mottled red and yellow jasper favoured by Dexamenos (*colour, p. 307.5*). There are also two cylinders which can be placed in the west for their single-figure subjects—a horse (*Pl. 831*; found in Attica) and a bull; and two scarabs (one in *Pl. 828*). One of the scarabs is of a distinctive shape, to be met again in the Greco-Persian stones. Its head is a semicircle in high relief on the plain thorax, and the wing cases have oblique lines at their corners.

The other subjects on the scaraboids are of the usual Achaemenid repertory—an archer (*Pl. 829*), some animals (*Pls. 830–833*), winged bulls (*Pl. 835*) including the common Persian type with human head (*Pl. 837*), and the lion-griffins with horns, wings, and the hind legs and tail of a bird (*Pls. 838–841*). There is even a bicorporate sphinx wearing a Persian tiara (*Pl. 836*). Above it is the usual Achaemenid version of the winged sun disc, which was seen over the horse on the cylinder, and which will appear again several times on the Greco-Persian gems, but never carrying the god Ahuramazda as it does so often on eastern cylinders and stamps. A scaraboid with royal sphinxes and a Lydian inscription (*Pl. 834*) provides a direct link with the pyramidal stamps already mentioned.

Two other cylinders have also to be considered here since they provide a further link with the main series of Greco-Persian gems. The first (*Pl. 843*) shows a Persian on a galloping horse, dressed and detailed in exactly the style of the Greco-Persian scaraboids yet to be described, but while on these gems such figures are hunting animals, here the Persian is attacking a rearing lion-monster rendered in the full

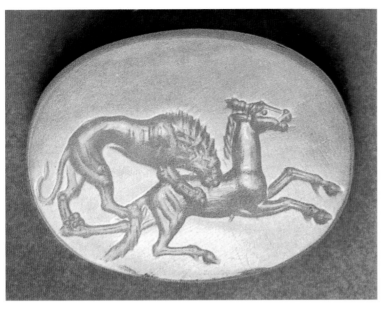

1

2

4

3

5

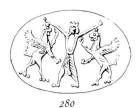
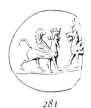

280 *281*

Classical Court Style. This makes the Persian a hero at least since his adversary is the monster faced by a King or hero on other Achaemenid stamps and cylinders. Below the rider is an inscription in Aramaic. This was the official script for the Persian empire, and of course the cylinder and not the stamp was the official seal form. The name can be read as a version of the Greek Artimas. An Artimas, Xenophon tells us, was a Lydian official at the end of the fifth century, and in Lydian inscriptions Artimas is not an uncommon name. This might well be a governor's seal. On the second, fragmentary cylinder, which is from Lydia but not, on its preserved part, inscribed, a very similar Persian on foot fights a lion at close quarters (*Pl. 844*). He might be a mortal, assisted by his dog, like an ordinary hunter, and the winged bird behind him seems a filling device in the Greek manner, answering the more formal winged sun disc above.

The Classical Court Style appears also on conoids and other cylinders, and it is the nearest to being an Achaemenid '*koine*' style that can be identified. This is basically the style of most of the finer Achaemenid metalwork, where again a distinction between the more mannered eastern and graceful western, possibly Lydian (as for many metal vases), may be made. But in glyptic too the dividing line is not easily drawn, and although the well-known cylinder in London showing heroes with a lion and a bull seems Classical Court, it has an exceptional freedom and verve, and the lion with its bristling mane looks a Greek. This is quite different from the Achaemenid cylinders with figure scenes, represented in the Persepolis sealings or by the cylinders showing Persians fighting foreigners and taking prisoners. But these are not our concern.

THE GREEK STYLE (*Pls. 845–875*)

Here we have to deal with gems which are purely Greek in style but Achaemenid in shape or subject, or, if Greek in subject, have other associations with the east. Two Archaic seals find a place solely for their shape, since their devices and style are Greek. They are pyramidal stamps of the type we have seen to be characteristic of the western empire. One shows a Hermes dressed in a long chiton and wearing a one-wing cap (*Pl. 845*), both of these features being East Greek. The second has some eastern elements, but no more than are apparent on other Archaic Greek gems, and they are not Persian. Herakles holds his lion by its forelock, watching a Gorgon mistress of animals with two lions (*Pl. 846*). The beasts have a little in common with those on seals of the contemporary Archaic Court Style. These seals must have been cut by Greeks, around or just after 500 BC, in an area where the Achaemenid pyramidal stamp was already current. For the second we might suggest Cyprus.

There are more Classical successors. First, a very few pyramidal stamps. One with a superb griffin attacking a stag (*Pl. 847*), very like the animals on gems already listed 'after Dexamenos', and accompanied by an inscription in Cypriot. Hardly much later is a seal which shows a lion attacking a camel, clearly indicating an eastern origin but purely Greek in style. We might recall here Herodotus' account (vii, 125) of how the camels in Xerxes' host were attacked by lions in north Greece. Birds tearing the body of a calf translate into Greek idiom a device popular on the Archaic Court Style stamps and the inscription on this stone may be Cypriot or Aramaic. Finally there is a child with a vine (*Pl. 848*), like the device

on coins of Dardanos in the Troad. It seems that few Greek engravers were moved to work on pyramidal stamps.

A wholly Greek style but more often with Persian subjects is seen on scaraboids, some cylinders and a number of multifaced seals. We may feel reasonably sure that these are by Greek artists despite the subjects and shapes. The most aggressively Persian subjects in a Greek style are those showing a Persian, perhaps meant for the King, striking down a Greek (*Pl. 849*). The latter may be the usual near-naked warrior we see on other Greek works or fully armed. The King is on foot but we see mounted Persians too (*Fig. 282*), riding down their adversaries like the figures on Classical Greek reliefs. There are also some figures of Greeks alone in this style: mercenaries, perhaps. A warrior binding a sandal or boot in a familiar Classical pose is seen on two scaraboids, on the convex back of one of which there is a mounted Persian chasing a stag, added in the Mixed Style (below). On a clay impression from Daskylion, the Phrygian satrapy capital, and on a scaraboid from the Oxus Treasure we find that Greek fights Greek (*Pl. 851*). The horses include a fine study of the creature alone beneath the winged sun disc, on a cylinder. It is of the Greek type with flowing tail and straight muzzle, a remarkable contrast with the Court Style horse we have observed similarly placed on a cylinder (*Pl. 831*), which is of the eastern breed with rounded muzzle, and patterned saddle cloth. Of similar quality is the bull on a cylinder from Taranto (*Pl. 852*).

As on the Court Style seals the Persian on foot wears the formal long chiton-like dress and tiara. The Persians on foot or horseback who appear on most of the other seals which are our concern wear a soft hat, tied under the chin, with a floppy crown which may fold flat or hang behind, a garment with long sleeves and loose leggings, and a knee-length tunic with or without sleeves. This is the way Persians are usually shown in the Greek world (compare *Pl. 525*). There is an excellent Greek study of such a Persian on a scaraboid. He is a hunter, returning home carrying the bird he has shot (*Pl. 853*), a subject no easterner would have dreamed of or treated in this manner. His lady is seen on another scaraboid (*Fig. 283*). She wears a fuller, chiton-like dress with the folds rendered more elaborately than the Persian garment seen in the Court Style. Her hair is dressed in a pigtail and even the Greek artist has caught the Persian's preference for full breasts and buttocks. She carries an ointment jar and wears sandals. This graceful study will be often repeated on Greco-Persian gems, as well as other versions of the menfolk at ease.

There are combinations of Greek and Persian subjects too. A prism (*Pl. 861*) has on one side a Persian, on others cocks fighting (a theme to be often repeated and in just this style, as in the Arndt Group), a Greek scene of a man with his dog, and a naked woman resembling those seen on Greek finger rings around 400 BC (as *Pls. 710, 711*). This is a nice combination of subjects by one artist but on separate fields. Another angular seal shape we shall meet again is the tabloid (see p. 313). One one we see a classical Greek Hermes while other faces of the same seal have animals whose close kin will be found in the Mixed Style. The Hermes was cited by Miss Richter to demonstrate that Greek artists cut the Greco-Persian gems. The plot thickens when we observe that the only other known representation of this Hermes on a gem is seen on a scaraboid of the same group, beside an Athena, and found at Sardis (*Pl. 855*). This is, then, a Classical motif, like the man and girl on the prism, copied in the eastern studios. The Hermes is a broadly Polyclitan type about which little is known although it has been associated with the record of a Hermes by Polyclitus himself. He is Hermes Logios, expostulating or merely conversing. On the Sardis stone he is grouped satisfactorily with an Athena, who is in a broadly Pheidian pose. The two deities are often associated at this period and it could be that the gem gives a clue to an original sculptural group. But, being from a 'provincial' studio, it might as easily be an arbitrary association of appropriate types.

There is, however, another scaraboid by the same artist. This is from beyond the opposite end of the Persian empire, the Punjab, and it too has an odd version of a Greek myth (*Pl. 856*). It shows Herakles, his foot on the beaten Nemean lion, safari-style, being offered a water jar by a woman who is being

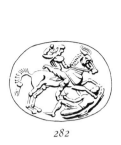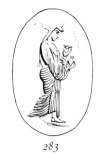

282 283 284

crowned by a tiny Eros. An early date (*c.* 460 BC) has been proposed for this on grounds of drapery and anatomy, but the figures' small heads, the open composition and the way the ground is shown by dashes tell against this, and at any rate one would prefer to reserve for the master of the Olympia sculptures the reputation of having invented the motif of Herakles, after the labour, resting his foot on the lion. The motif occurs otherwise only on our gem, and another known from an impression found at Ur (*Fig. 278*). This currency of an unusual scene in the Persian Empire recalls the record of the Hermes figure on our artist's other gem, already discussed. But we must return to the Herakles. Who is offering him a drink, and from a jug, not a cup? And why should *she* be crowned, and not Herakles, the victor? And why by Eros? The nymph should be Nemea, whose presence may be suspected in an earlier version of the fight, but is only made specific later. It has been suggested that the scene implies that Herakles' reward was to be love as well as liquor, which is possible. We remember too his association with springs and fountains. This is another example of a gem offering an unfamiliar variant on a common story, and the more interesting for its being Greek work in the Persian Empire.

Other gems may be added here, by different artists, it seems, but cut in a similar, rather awkward and lumpy style, with beady eyes and knobbly toes. One shows an Aphrodite with a bird, leaning on a pillar (*Pl. 857*). This is another domed (Type C) scaraboid, and from Syria. On the same shape, but from the Greek island Spezia, is *Pl. 859*, with a bather collecting her clothes, and perhaps by the same hand the girl washing her hair on *Pl. 858*. It is possible that other gems with Greek subjects, but in what seems a rough though competent provincial style, could be attributed to this studio whose works have a considerable affinity to several of those listed here 'after Dexamenos' (compare *Pls. 547–551*).

A more intimate combination, with a thoroughly Greek theme acted by Persians, shows love-making, the Persian girl being identified by her pigtail (*Pl. 862*). In the east such scenes, with the love-making usually from behind, seem to have a religious significance, but this is decidedly secular. The kneeling position for the youth is not normal in Greek representations, but the girl's legs in the air recall Lysistrata's injunction to her followers not to 'lift their Persian slippers to the ceiling' (Ar. *Lys.* 229). The back of this scaraboid was later graced by the device of a Hellenistic eagle and thunderbolt (*Pl. 996*).

Many of these stones probably belong still to the fifth century, and the bathers, perhaps, to the early fourth, but there are a few later scaraboids in a purely Greek style. On them Persian horsemen, on Greek horses, ride down a stag (*Pl. 863*) or a Greek warrior. The finest scene is certainly late in the series, and is cut on the convex back of a scaraboid whose face bears an earlier Classical Greek representation of a seated dog. It shows a Persian horseman pursuing two easterners in a two-horse chariot (*Pl. 864; colour, p. 307.3*), and its treatment of such an ambitious theme comes closer to the spirit of monumental narrative than any we have seen on seals. One thinks even of the Alexander mosaic.

The range of animal studies in the Greek Style is not great and rarely admits a purely eastern subject. There are lions (*Fig. 284, Pls. 865, 866*), lightly stylised in an approximation to the Court Style, but hardly more so than many of the finer animal studies of the period of Dexamenos and afterwards. A lion attacks

311

a horse (*Pl. 867*), while others tear at an animal limb (*Fig. 285*). One wields sword and shield (*Fig. 286*). It recalls the animal-headed humans of Late Archaic gems for which some eastern inspiration may be suspected, but this is a far more thorough representation of human activity by a wholly normal animal, like the heron and snake archers (*Pls. 554, 699*), and was surely suggested by an easterner even if the art of the east provides no exact parallel for it. Two fine Greek griffins on scaraboids hunt stags (one in *Pl. 868*). The bulls on these stones (*Pls. 870, 871; Fig. 287*) include the humped eastern zebu, one approximating to the Court Style, another plunging with his head turned in three-quarter view like the common Classical Greek type. The motif is recalled after Alexander in the East, on Seleucid coins. The wild boar (*Pl. 872*), which will be seen again often in hunting scenes, has a massive head and shoulders, bristling tail and short back hair. Beside it Greek porkers look like household pets. Another newcomer is the bear (*Fig. 288*), which Greek artists in south Russia had already learned to depict in the sixth century, and the camel. And finally, the 'Maltese' dog (*Pl. 874*), with long coat and curly tail, which seems to have found a home at Persian hearths—at least, it is the only quadruped on these seals which never runs.

The style of all these animals is Greek in that their bodies are well modelled and there is attention to accurate anatomical detail. Some of this is, however, stylised in a manner which lies between that of the Court Style, with its formal patterning, and the treatment of some of the later Archaic Greek gems. And the creatures can be readily distinguished from those on the main series of Classical Greek gems. We may take as an example the treatment of the muscles on the haunches of lions and some other beasts. The Court Style shows these as three parallel arcs ending in a knob (as *Pl. 842*), and the same feature has been observed, but not stressed, by the Greek Aristoteiches on his lioness (*Pl. 388*). On our scaraboids the Court Style pattern is approached, but treated more realistically, and this is the manner seen on Greek gems of the Dexamenos period and after. The strange Court Style stylisation of the lion's shoulder was not acceptable.

THE MIXED STYLE

On these gems the assurance and competence of the Greek Style scaraboids is missing, but there are still a great many subjects which could only have been inspired by Greek art. The detailed treatment of animals and human features is somewhat poorer, however. Many of the animals are stiff and overfond of the 'flying gallop', which Greek artists generally ignored. There is some loss of body modelling and a tendency towards a more summary treatment of joints and feet or paws. More Court Style anatomy patterns are seen—as on the lions' shoulders, but there are still a number of pieces of very high quality.

It is with these gems that the question is posed whether they were cut by Greek or Persian artists. From their find places and the dominant use of the scaraboid it is clear that they belong to the same general area as the other stones we have considered in this chapter. The possibility that they are of Greek workmanship must therefore be admitted. They are clearly of much the same date as the Greek Style scaraboids. The differences, as they will appear in the groups named in this section, are graduated, and the range is from the very Greek to the completely provincial in subject and style. If these differences are to be explained in terms of place, we cannot define them closely, and it is at any rate unlikely that the demand for such gems was being satisfied in a radically different manner in different parts of the western Persian empire. The difference is likely then to be a more personal one, of artist or studio, working at various removes from the influence of Greek studios. To some degree these are the successors to the Court Style scaraboids, which were less affected by Greek fashion. They are not, of course, closely datable, but we should perhaps regard the Mixed Style as a generally later phenomenon than the Court Style scaraboids. The artists

<p style="text-align:center">285 286 287 288</p>

might then as well be native as Greek, and, if native, not necessarily Persian. Some are skilled copyists, and there can be no reason to assume, as some have, that no non-Greek could copy a Greek subject or, for instance, Greek treatment of a head in three-quarter view. This is exactly the sort of thing that local workshops in the western Persian empire might be expected to try to do, and with varying success.

I have tried to isolate groups of this, the basic Greco-Persian material, but it is rather like attempting to define on a spectrum where one primary colour ends and another begins. It is, nevertheless, possible to pick out the nuclei of different styles. These are probably to be understood as the personal styles of individual artists and the material is rich enough for attributions of several stones to one hand to be possible, but these are nuclei only, and the groups are filled out with the work of pupils or copyists. We may begin by considering shapes.

The normal shape is the scaraboid of standard Type A, occasionally cut on the convex back rather than on the face—a concession to eastern stamp usage which is noted also in Greek studios, or with a shallow convex face. There are several of the domed Type C, and a few of the shallow Type B. The very few scarabs have simply cut backs. The four-sided prism we have met already. It seems to represent the common Greek preference for a flat engraved surface or a series of flat fields presenting separate surfaces, rather than the curved surface of eastern cylinders and stamps, or the cylinder's frieze-like composition. Since the convex surface gives a better impression and the Greeks were well used to friezes and had used cylinders to decorate pithoi, this is rather strange. A new shape is the tabloid, with a rectangular face and broadly-bevelled back, with devices on the four sloping shoulders, back and front, only the vertical walls left plain. This looks like an angular version of a scaraboid, with that tendency to flatten the curve which has already been noticed. In much this spirit are two multifaced seals with twelve decorated facets. New are pear-shaped pendants, a Greek version of which has been noticed (*Pl. 615*) and some lentoids and shallow circular scaraboids resembling ringstones but two of them with devices on both sides.

THE ARNDT GROUP (*Pls. 876–880*)

Multifaced seals or the tabloids with their six engraved faces can each offer a valuable range of subjects, usually by a single artist. There are examples in Munich and London of cubical seals with their corners bevelled back to the middle of each side, so that there are four diamond-shaped faces and eight triangular faces for engraving, while the two square ends accommodate the stringhole. The larger fields have human figures, the smaller have animals. On the Munich stone (*Fig. 289*) there are two Persians in formal dress, with tiara, spear, bow and quiver. Another stands in a relaxed pose, like a Greek, hand on hip and leaning on his spear. He wears the dress most common later, of soft hat, tunic, sleeves and leggings, but here he has a cloak as well. On the fourth main face his buxom lady—the type created on the Greek Style scaraboids—holds a flower and a wreath. The human figures are treated with some attention to their dress and features. The more formal dress we see again for Three Musketeers on a scaraboid (*Pl. 877*), and on another stone (*Pl. 880*) the Persian lady brings her ointment jar to her master who is seated on a cloth-covered

313

stool with turned legs of a type seen on other Persian gems and monuments. The other faces of the Munich stone show animals, some behaving in what we might believe a Greek manner, like the fox stealing a hen or the dog scratching himself; others of common interest to east and west, like a calf, goats, a fighting cock, a Maltese dog; and one newcomer—a hyena. The last appears again on a tabloid (*Fig. 290*) where a fox is again in the sort of natural situation observed by Greek artists, sniffing at a locust. The devices on this stone follow the scheme common for tabloids, with a hunting scene on the base (here with the horseman frontal, which is odd) and animals on the four shoulders and back. The multifaced stone in London (*Pl. 876*) is rather less detailed. On the main faces there are again the Persian and his lady, but the third face shows an attacking bowman in Persian dress, and the fourth a wholly Greek figure of a youth in a himation in a realistically relaxed pose. The eight minor faces have animals—less interesting than those on the Munich seal.

In much the style of these is the impression of a scaraboid found in the Persian capital in Phrygia, Daskylion. It shows an elderly Persian holding the sacred barsom bundle, which is not represented otherwise on our gems but is shown on stone reliefs from Anatolia. There is another religious scene on a fine cylinder found in South Russia, in the tomb with the prism, already described. It shows a Persian king worshipping a radiate goddess, Anahita, who stands on a lion's back (*Pl. 878*). The human and animal figures are very like those on the scaraboids of this group. Anahita was equated with Artemis by the Greeks, and her worship was fostered in the Persiam Empire by Artaxerxes II. He set up statues of her in various places, including Sardis, where an eastern Artemis was worshipped. But this seal need not be so late, since the goddess-on-lion type has a long history, and even East Greeks had made lead roundels showing her thus in the sixth century. The proud bearing and dress of the goddess in her nimbus of rays vividly recall descriptions of her in Persian religious texts.

These gems are of high quality, somewhat less stereotyped than others yet to be described. The anatomy of the animals is detailed with the care normally devoted to such subjects by a Greek and it is quite possible that Greek artists are at work here. But if so it is they who established the idiom for the whole series. That their work stands early in the sequence—still certainly fifth century—is suggested by the presence still of some of the formal Persians with tiaras who are not later represented in western Achaemenid art.

THE BOLSENA GROUP (*Pls. 881–883*)

Thls may be named after a fine scaraboid found recently in an Etruscan tomb (*Pl. 881*). The style is somewhat stiffer than that of the Arndt Group, but accomplished, and some of the figures, especially of Greeks, match the best we have seen in this series. There are more tabloids in this group and a unique—for this style—conoid. Mounted Persians on horses of Persian breed fight Greeks, including a naked warrior with pilos-helmet and hoplites. On the conoid (*Pl. 883*) a dead Greek is also shown. The Persian horsemen on two tabloids wear odd armour with shoulder pieces, crested helmets and leggings (*Fig. 291*). It is a rather similar horseman who pursues what might be two Scythian riders (*Pl. 882*). Their Greek opponents are also awkwardly dressed although, it seems, with conventional equipment. With their knee-length chiton beneath the corselet they closely resemble the warriors shown on Greek reliefs executed in Lycia in the later fifth century, as at Trysa and on the Xanthos tombs. There is a separate study of a hunter with a trident spear (see below) but also, it seems, a shield.

The animals present some new and lively motifs: a fox mounts a vixen, cocks fight, a dog is curled up asleep, a fox worries a stork, and we see a bear, hyenas and a leaping lion who will be met often again. These gems have not lost touch with Greek styles by any means. On the Bolsena stone the broken ground line can be matched on purely Greek work, but we are moving into a world where Greek principles of composition and delicacy of treatment have no meaning, although Greek observation of pose and original

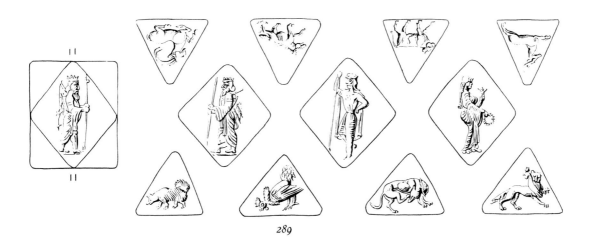

289

290

291

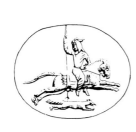

292

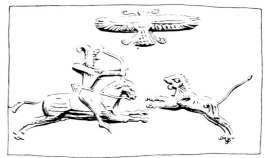

293

subjects are kept in view. It is interesting to notice how the schemes involving a horseman in battle or in the hunt are exactly the same.

THE PENDANTS GROUP (*Pls. 884–902*)

Three examples of the rare pear-shaped pendant (as *colour, p.307 .4*) distinguish this group. It is large and homogeneous with many pieces, perhaps the work of one artist. The style resembles that of the Arndt Group but is more summary and heads in particular are less finely proportioned. The Greek characteristics here are mainly the poses and behaviour of the Persians and their women. In the man's dress there is a fondness for showing the crown of the soft hat hanging behind the head, or folded flat to make an angular top. The men stand at ease (*Pl. 884*), one with his arm round his girl in a pose of un-oriental familiarity (*Pl. 891*). The women carry jars, drinking horns or wreaths (*Pl. 892; Fig. 294*). One is seated, playing with a child like any fashionable Greek (*Pl. 891*) and another has a tame water bird (*Pl. 892*). A seated Persian tests an arrow (*Fig. 294*)—a motif we met on Athenades' ring (*Pl. 681*). We may probably also place here an animal-cum-still-life study of a rhyton with antelope forepart (*Pl. 894*), a favourite Persian vessel in metal.

Just as characteristic of the group as the figure studies are the hunting scenes (*Pls. 885–886, 888–890; Figs. 292–296*), and this is an appropriate place for some general observations about these subjects on the Greco-Persian gems. The hunter is rarely on foot, as here, with his dog, spearing a boar (*Pl. 885*); and on cylinders we may see his horse waiting for him. On a cylinder uneasily given to this group the boar leaps out from a thicket and the hunter meets it with a cloth wrapped round his left arm. The gesture and setting are repeated on a number of other cylinders probably of eastern Achaemenid origin. More often the hunter is on horseback, his mount in the flying gallop, although in the Pendants Group it is sometimes shown rather awkwardly plunging or as if off balance. The quarry races away, also in flying gallop with legs extended, except for the lions and a bear who may turn to fight. Against boar, bear and fox a spear is used; against lion and goat a bow; against stags either weapon. Dogs join in the hunt, especially against the boar, stags or deer, and there are occasional separate studies of dogs bringing down a deer or tearing a carcase (*Fig. 296*). Foxes are particularly favoured in the Pendants Group. One intervenes in a stag hunt (*Pl. 888*), another races beside a lion (Group of the Leaping Lions, *Pl. 908*), while on a third stone two are transfixed by a spear while another runs. The creature may have been hunted for its pelt. On two stones the spear used against the fox has a small trident tip (*Pl. 890; Fig. 292*). For slippery quarry, like foxes, hare or fish, such a device is valuable, and these gems offer the earliest evidence for its use against land animals. Forked boar spears (not shown on these gems, but see *Pl. 539*) have a different purpose, to check the rush of the transfixed beast along the shaft.

Other animals appear on the tabloids, some scaraboids, and two scarabs of distinctive shape. New creatures on a tabloid are a rat (seen only here), two quail and a locust (*Pl. 893*). We have another camel (*Pl. 901*) and bear, and fine dogs (*Pl. 900*) or lynxes. The leaping lion with bristling mane and flying tail is seen as a separate study and also attacking horsemen (*Pls. 893, 889*). Its body is well muscled but without the exaggerated patterning of the Court Style, and in this respect it is closer to the Greek rendering of the animal. But its rocking-horse pose, legs together, follows an eastern convention. A good version of the plunging bull with three-quarter head of Greek type (*Pls. 898, 899*) is seen on two scaraboids and a tabloid.

THE PHI GROUP (*Pls. 903–906*)

The human figures are here executed with less attention to drapery and features, but still with dignity and good command of the standard poses. Facial outlines are reduced to straight cuts and there is freer

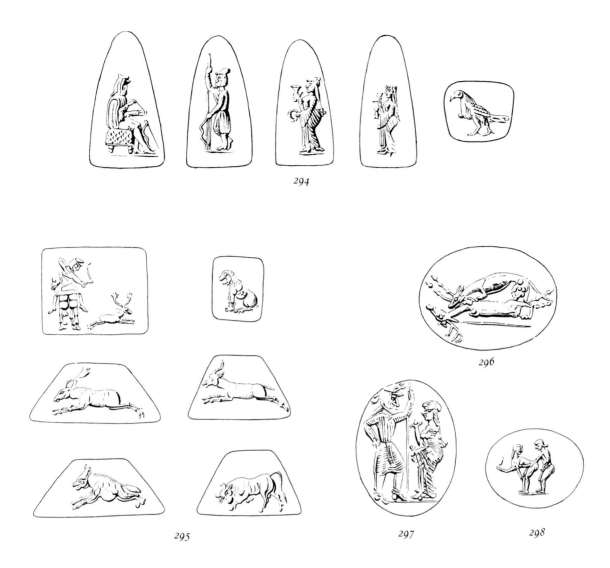

294

296

295

297

298

and undisguised use of the drill on human and animal anatomy. Where there is more than one figure to the field the artists (and there cannot have been many) often fail seriously to fit their composition to the space as satisfactorily as would a Greek. The animals are country cousins to the fine Greek animal studies of the later fifth century, but instead of the near-idyllic setting of grazing deer all here is bustle and chase, or mannered posing (*Pls. 904–906*).

The subjects are few. There are several of the by now familiar single studies of Persians and women (*Pl. 903; Fig. 297*), some hunting scenes and the usual animals. Two scenes of love-making, on a scaraboid and a tabloid (*Fig. 298; Pl. 906*), are conducted from behind, but still thoroughly secular to judge from the way the girl holds a mirror and from her interested backward glance.

THE GROUP OF THE LEAPING LIONS (*Pls. 907–923*)
A number of gems with animal devices are closely related to the last three groups considered but show greater variety in treatment. Lions now have the outlined shoulder box of the Court Style creatures and some of its other patterns, but still with a basically realistic physique and even a three-quarter head is attempted for a fine stag being attacked by a lion (*Pl. 909*). Pairs of bulls either rear heraldically or play

(*Pl. 913*), There are goats and camels, running and kneeling, and a horse (*Fig. 299*). A boar on a cylinder (*Pl. 914*) has cursory Court Style markings on the haunches but is a Greek beast with broken back bristles, and there is a similar bear (*Pl. 910*). Some Achaemenid monsters belong here too—winged bulls and goats, running or rearing (*Pls. 918–923*), and even a Greek griffin in exactly the same style. Some Persepolis sealings come quite close to this treatment of single animal studies. There is far more use of the drill and rather coarse incision for details in this group while the body modelling is often lumpy.

THE CAMBRIDGE GROUP (*Pls. 924–930*)

This, with the following Wyndham Cook Group animals, is the last of the main groups with devices executed with some finesse. Hunting scenes are dominant, usually on scaraboids, but there is one tabloid. The big Cambridge scaraboid (*Pl. 924*) showing a lion hunt and a boar hunt in two undivided registers recalls the compositions of the Assyrian reliefs. The Persians and their horses are treated almost mechanically on these stones and the lions are closer to the Court Style in their modelling. One more formal scene of a Persian bowman shooting from a four-horse chariot (*Pl. 928*) is close to the style we see on some cylinders, and the treatment resembles the lion hunt shown on an impression from Nippur. Another native theme is the Persian hero fighting a rearing goat, once winged (*Pl. 930*), once not. The drill is used freely now on the heads of animals as well as their limbs. An odd device of two bears and a snake (*Fig. 300*) apparently shows the star groups of Ursa Major and Minor with Draco, and has been taken as evidence for the existence of globe maps of the heavens at this date. We may recall the Sagittarius on a Greek gem of the fifth century and its Persian associations (*Fig. 201*).

THE WYNDHAM COOK GROUP (*Pls. 931–946*)

The name-piece here is a prism (*Pl. 934*). There is one other of this shape in the group, a scarab and a cylinder, but all the others are scaraboids. One or two are carved on the convex backs of scaraboids, a Greek practice beginning in the fifth century which may owe something to the eastern preference for engraving a curved surface. The best studies are of lions, some with puffy features and with drilled detail on their sinewy bodies and knobbly paws. The animals they attack are as those in the rest of the group. They are generally less detailed versions of creatures seen already, but many of them are executed with considerable care despite the simplified technique. There is much use of the drill for joints, paws and heads. Bodies may be marked with hatching or ribs but they are not properly modelled and many are plain and sausage-like. The flying gallop is excessively popular. The prisms show the best animals, one including scenes of both foxes and poultry coupling. Some dogs are seen chasing deer or worrying a boar, and there is a bitch with a hare. These are excerpts from hunting scenes. This is the most basic style for Greco-Persian glyptic and many of these gems, as those of the Group of the Leaping Lions, might be assigned to the other groups which have been isolated here mainly for their treatment of human figure motifs.

THE TAXILA GROUP (*Pls. 947–950*)

One find of Greco-Persian gems must be kept for separate discussion. It was made in one of the mounds of the great city of Taxila in the Punjab, an area which witnessed the interaction and fusion of the cultures of India, Persia and Greece. There are three gems (*Figs. 303–305*) representing, as it were from a travelling salesman's suitcase, three basic Greco-Persian shapes—the scaraboid, the tabloid and the pear-shaped pendant. The last two have devices of a lion attacking a stag, by the same hand, and the scaraboid a stag in a closely related style. The creatures are well cut but there is an odd stylisation of dots along the front of the lions' haunches imitating the usual Court Style pattern. A gem in private hands with the same scene (*Pl. 947*) could also be by the Taxila Master. The tabloid seems unfinished and there was another

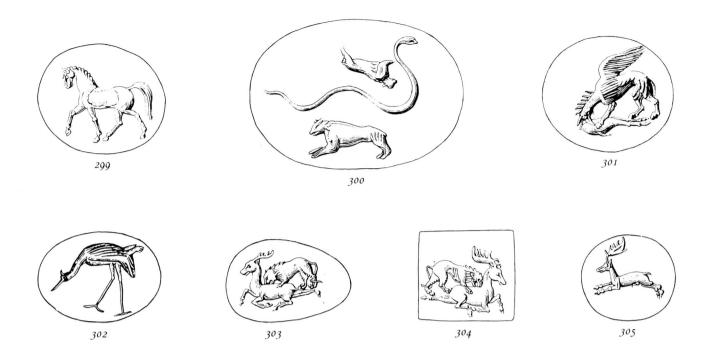

299　　　　　　　　　　　300　　　　　　　　　　　301

302　　　　　　　303　　　　　　　304　　　　　　　305

without intaglio, of rock crystal. This does not necessarily mean that the artist was working in Taxila but it is not impossible, and Taxila was an important Persian city, visited by Alexander. It is odd that agate was used for the tabloid, and there are no engraved tabloids of rock crystal known, while this is the only Greco-Persian scaraboid in green jasper. A tabloid from India, with a stag in just the style of this group (*Pl. 948*), is in obsidian (?), another unfamiliar material for the shape; and there are other comparable stones from India (*Pls. 949, 950*). Finds of the Persian period this far east are slight but they include seals in a distinctive style (the Bern Group, below). The Taxila Group is more fully in the western tradition, and an extraordinary reflection of styles current at the opposite end of the Persian empire, nearly 3,000 miles away from the place where most of the Greco-Persian gems were made and used. It is a vivid example of the sort of problems which beset all studies of Achaemenid art and archaeology.

OTHER HELLENISING GEMS (*Pls. 951–964*)

There are a number of other gems which avoid the more obvious Persian subjects, but which belong to this general class for their shapes or style, and yet are probably not to be treated as the work of Greek artists at home. Thus, there are some purely Greek themes rendered in the style of the main Greco-Persian groups already considered. They show Erotes playing pipes and a triangular harp (*Pl. 951*), and children suckled by deer or a bitch (*Pl. 952*), recalling Greek stories of Telephos and some unexplained coin types in Crete. There is always the possibility that the child figures were added later for extra interest, as is certainly true of a goat ridden by a Hellenistic or Roman Eros, but the children on these stones seem contemporary. On two good studies of a Greek warrior wearing a pilos helmet (*Pl. 954*) we look round for the attacking Persian. There are a number of Greek sphinxes, one with a pilos-helmet (*Pl. 956*), and griffins in the Greco-Persian manner (*Pls. 957, 958*). A warship in the form of a dolphin, carrying marines and done in a summary drilled style (*Pl. 953*) is another thoroughly un-Persian subject, and there is a device with two dolphins alone, apparently an apprentice work. The five deer sharing a head on *Pl. 962* are an example of a rare concept in Greek art. The translation of antlers into a bird (*Fig. 306*) is a Greek version of the eastern and 'animal style' motif. On the two sides of a scaraboid in Boston Persian women behave like Greeks, with triangular harp, dog, bird and child (*Pl. 964*). A Greek griffin learns the flying gallop

and two circular scaraboids carved on both faces include Greek devices like the heron and an ant attacking a locust (*Fig. 308*). Related may be two small round ringstones with animal subjects (*Pl. 963*).

In strict opposition to the Hellenising gems we may perhaps isolate a LINEAR STYLE in which there is hardly any modelling but plenty of incised detail. It is represented only by a biconvex seal with a Persian horseman on one side pursuing a boar on the other, and a scaraboid with a hawk. Both are in black serpentine and might be Syrian or Cypriot. Several Achaemenid cylinders resemble these in style.

THE BERN GROUP AND A GLOBOLO GEMS

The Bern Group (*Pls. 965–980 ; Figs. 309–311*) presents the most distinctive of the late styles. At its head is a fine stone with a hunting scene (*Pl. 965*) reminiscent of the hunts we have seen already but with a new softness of contour to the figures, bulging drilled bodies and some odd stylisations, as of the horses' heads and tails. A few other stones have devices in this manner and are as well composed although less detailed, but the most enigmatic, and most important, seal of this class is a cylinder, known now only from an impression (drawn in *Fig. 309*). It is odd in having its figures arranged down the cylinder, and occupying barely one half of its surface, instead of around it to produce a continuous frieze. This looks like a different symptom of Greek contempt for the cylinder form to what we have met on Classical stones. It is odd in its composition of two registers which display, not a battle, but the marshalling of foot soldiers and cavalry. It is unique in showing the foot soldiers as Celts, with their unmistakable long mid-ribbed shields, long spears and pointed helmets. And its two Aramaic inscriptions seem almost to label figures rather than record ownership. This is one of the very rare eastern representations of Celtic troops, hitherto unidentified and overlooked. Celts had been fighting in Italy and Sicily in the first half of the fourth century and mercenaries were sent from Syracuse to help the Spartans, but there is no record of their activity so early farther east. Alexander encountered them on the Danube in an expedition before his drive to the east, and just before his death some western delegations which met him on the road to Babylon were said to include Celts, but there is no evidence for use of Celtic mercenaries either for him or against him. After his death the Celts invaded Greece and Asia Minor (becoming the Galatians) and served Hellenistic rulers as mercenaries. On the face of it our seal should then be latest fourth- or third-century, and since this is a marshalling, not a battle, these should be mercenaries. The horsemen could be Macedonians, with their long spears, while their leader, at the centre of the operation, looks more a Greek than a Persian, with his helmet and cloak, although he may be wearing Persian tunic and leggings. The inscriptions are Aramaic and Aramaic was the official script of the Persian Empire, crushed by Alexander. By the third century we might expect Greek on a seal apparently commemorating a muster somewhere within the old Empire, but there is evidence that Aramaic survived in use, possibly even as an official script, in some areas or offices of the Seleucid kingdom.

When we turn to the other seals of this group, which is closely knit stylistically, we find scenes deriving from the Greco-Persian series which, together with the shapes, demonstrate that the Bern Group is of the same tradition. The best of them have figure studies, like a Persian woman (one on an all-stone ring, *Pl. 966*), and on another the old Persian motif of a hero fighting a rearing lion shows the hero as a Greek with cloak, spear and shield. There are a few other Persian rather than Greek traits, no more than we would expect in the Empire once it was occupied by Greeks. On the cylinder the single horseman, bottom left, has his mount's tail dressed like a Persian, but the other horses' tails fly free, and on the other stones only one or two tails are dressed. The headgear is puzzling, but generally too summarily shown for close identification. The flat caps of the horsemen on the name piece, *Pl. 965*, resemble nothing more than the Macedonian *kausia*, and these may well be Macedonians, behaving as Persians, even in Persia.

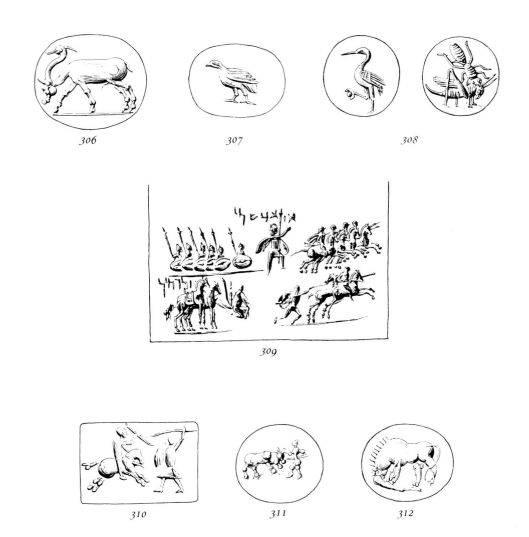

306
307
308

309

310
311
312

If the horses on *Pls. 965, 973, 974*, are indeed horned, and this is not an odd stylisation of the forelock and ear, then we have another late feature matched on coins of Alexander's successor, Seleucus I, in his eastern mints, where too the mounted Dioskouroi ride out like our hunters and the Greek King may be seen riding down a foe. The evidence is circumstantial and each element may be disputed, but there seems a strong presumption that the Bern Group is mainly or wholly post-Achaemenid in date, mixed Macedonian and Persian in subject matter, but in the style and shape of its stones the immediate successor to the main Greco-Persian series. We might even dub it Macedonian or Seleucid, but if so it must belong to the early years of the Succession, for there are but few points of contact between these seals and the many clay sealings of the Seleucid period which have survived. Or it may be rather a style of the eastern regions, less affected by Hellenistic Greek fashions in gem engraving. The last suggestion receives some support from the character of the poorer stones assigned to this group. These include tabloids with a device on the base only. There is a fondness for rather plump stones with nearly circular faces, for reddish stones and for exceptionally narrow perforations, presumably for a wire fitting. These are characteristics of the following 'a globolo' style also, where too we find hemi-spheroids and hemi-ovoids, no doubt derived from humped scaraboids (Type C) but approaching far later Sassanian forms. The other devices include the usual battle and hunting scenes (*Pls. 972–977*) and the only real oddity is the man fighting a winged centaur (*Pl. 976*). There is little detail in these figures, and drill work is not always emphasised.

321

Finally, an A GLOBOLO style (the term generally reserved for Etruscan gems) presents mainly animal motifs with undisguised play of the drill (*Pls. 981–988; Fig. 312*). The technique is closely related to the Bern Group gems already described. Round devices seem favoured—one on a cone. A lion tearing a limb (*Pl. 984*) we have seen on better gems and there is a sphinx (?) in flying gallop (*Pl. 988*). This style may have had one home in the Syria–Phoenicia area during or after the Achaemenid period (one is from Alishar in Asia Minor, and some are said to be from Egypt) but the gems carry no specifically Persian motifs except perhaps the zebu bull. There are several examples from India and the style is deceptively like that of many Persian gems of the Sassanian period, a millennium later. It may be that the style persisted longer in the east, and the term 'Indo-Ionian' has been proposed for it by Mr Bivar.

Another provincial Achaemenid style is attested now in South Russia, in Georgia (Tiflis), where there are glass tabloids with Achaemenid motifs. These are recent finds and yet to be fully studied and published. Their style resembles that of our *Pls. 972–977*.

FINGER RINGS (*Pls. 989–995*)

The commonest type of Achaemenid finger ring has a small bezel with a thin hoop. The bezel shape is generally pointed, like Greek Type III, but some are oval or round. The hoop is often ribbed. But for one from Cyprus, with a Persian woman like the figures on the scaraboids, all have animal devices—a stag, lion, griffins, winged bull, and one with the Achaemenid architectural capital with two bull foreparts back to back (*Pl. 989*). This, and other rings of this type, are best represented in the Oxus Treasure, but Cyprus and Memphis in Egypt are other proveniences.

Some heavier rings of Type VII, and more often with oval bezels, have a wider range of subjects. The Persian woman again, but she may be seated holding flowers (*Pls. 990, 991*). A horseman chases a deer (*Pl. 992*) and minor Court Style subjects are the hero with a lion and a royal sphinx, again from Oxus and with an Aramaic inscription. The animal devices include some eastern creations like the lion-monster and winged bulls (*Pls. 993, 994*). The style of the best of these rings is like the duller Court Style gems, or, for other subjects, like the Mixed Style.

A more prolific source of information about Achaemenid finger rings is the series of impressions found in excavations in Persia and Mesopotamia. There are clay impressions from a Persian tomb at Ur, which has already been mentioned (p. 190), a number on cuneiform tablets from Nippur, and a few on clay tablets from the Treasury at Persepolis. The terminal date at Nippur is 404 BC and close correspondence with the Ur impressions suggests that both finds are mainly fifth century. Most are from rings with pointed oval bezels, few from the generally later oval bezels. Several have purely Achaemenid motifs involving the Persian hero or monsters. There are animal scenes with lions, bulls, horses, birds and 'otters'. Of more interest to us are those with grotesques composed of human and animal heads (*Fig. 313*) of the type already observed on Archaic Greek and Phoenician gems. These show considerable originality. Motifs betraying contamination by Greek subjects include some odd scenes with hominids and composite devices with amphorae, cups and animals. Some purely Greek subjects are treated in an odd provincial manner, like a flying Nike, warriors, Herakles and the lion (*Fig. 314*), a scratching dog. A fine impression from what might be a ring stone rather than a ring at Ur shows an arm holding an eastern ritual vase—a rhyton with sphinx forepart and a fluted jug (*Fig. 315*): both types encountered in the finer Achaemenid metalwork. The impressions from Persepolis have a later possible terminal date but several appear together with impressions datable to the fifth century by style or inscription. Except for the few Greek subjects just mentioned Persian finger rings tell us little of value about Greek work in the east. None with Persian motifs seems to be of Greek workmanship.

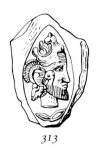

313

314 315

SUMMARY

When the Persians overran Lydia in the mid sixth century they became heirs to Croesus' empire which had embraced many of the Greek cities of the east Aegean. In the new Persian court at Sardis eastern practice in the use of seals was followed, but for the Persians in the west stamp seals rather than cylinders were cut, perhaps to serve rather different purposes from those of the tablet-bureaucracy of the east. The representational arts in Lydia and other kingdoms, now Persian, had been in the hands of Greeks or thoroughly hellenised. This process was not interrupted by the arrival of the Persians, but they introduced new ideas and new art forms. Through the rest of the Greek Archaic period the Greeks of Ionia and Cyprus, on the fringes of the Persian empire, were developing their skills in gem engraving which had recently been freshly inspired by Phoenicians, not Persians. But they occasionally cut gems of Persian form (the pyramidal stamp), and Persian seals of the same shape which were cut locally and provided with the stereotyped hieratic devices were to some degree affected by Greek style. In the fifth century the East Greek studios developed their preference for the scaraboid form and cut scenes and figures which were truly representative of the new Classical arts of Greece. It might be argued that the new preference for scaraboids derived from Persia, but there are no Persian scaraboids demonstrably old enough to have had effect on a tradition whose own development can be traced clearly without reference to further inspiration from outside. But in about the second quarter of the fifth century—at least, after the Persian wars—the Greek scaraboid form was adopted by various workshops in the western Persian empire. It might be that its continued popularity in this area helped determine the persistence of Greek use of the shape at home, but by now gem engraving had spread through Greece farther than Persian interests could reach. At any rate, while some of the new scaraboids are cut in the Persian Court Style, many are clearly the work of Greek artists, interpreting Persian themes and even showing their fellow-countrymen defeated by the Persians. Like the easterners they came to prefer the blue chalcedony to the clear or white, and they evolved a bulky humped scaraboid form, Type c. Neither of these features was so dominant in the independent Greek studios.

323

The Greek artists introduced a number of motifs which must have appeared startling to Persians in the provincial western courts, who had been used to the more formal treatment of divine or royal motifs on their seals. The innovations reflect not only the utterly different atmosphere of Greek art, with its realism and observation of natural forms and action, but also to some degree the real influence of Greeks and their 'civilising' of the newcomers from the east. Dogs scratching themselves or animals coupling must have been as common sights in Persia as in Greece but it took Greeks to find subjects like this suitable for portrayal. No doubt in Persepolis too Persians leaned on their spears to gossip while their women played with their children and dogs, but these were not motifs for an easterner's art; while to show them making love—and naked—and enjoying it! We must hope that the stricter Persians took such scenes for a ritual marriage of gods. Herodotus, however, observed that the Persians were uxorious ('every man has a number of wives and a much greater number of mistresses'), although they at least learned paederasty from the Greeks. Public nakedness they found intolerable, or any public display of private acts, which makes the scenes on the gems the more remarkable. It is not surprising that they were never current in Persia itself.

There were some Greeks to cut scaraboids for Persians, and even the occasional cylinder, although they disliked the form, for as long as the Persian empire lasted, but the greater part of the production of Greco-Persian gems is probably due to other hands. It seems that they did not work only in Anatolia. Reported proveniences for the gems are few, and many may be unreliable (we shall review them in a moment) but none of the tabloids—one of the new shapes in the group—is reported from Anatolia rather than Syria, Egypt or farther east. The new studios show a preference for flat engraved faces—on scaraboids, tabloids, prisms—although in time there are scaraboids with lightly convex faces, like the pyramidal and conoid stamp seals, and some scaraboids are cut on their convex backs. The reasons for this we have already discussed à propos of the Greek gems.

The style of the gems clearly owes a great deal to Greek models, and it is not impossible that Greek artists still took a hand in their production, as in the Arndt Group. But it is not necessary. Even on most of the Greek Style gems discussed here there is a perceptible difference in style from that of the Greek studios whose work was described in the last chapter. Although many of the stones are as carefully cut as the Greek, there is one characteristic which becomes more and more apparent on the main Greco-Persian series. This is the betrayal or exploitation of technique. Greek artists at home took pains to disguise all traces of the cutting or drilling through which the intaglio was achieved, so that impressions can be criticised in much the same terms that we might use of major works of stone relief sculpture. The east was more accustomed to exploit the straight cut or drilled cavity in their figure intaglios. In the features and details of even the most Greek of the gems described in this chapter (as *Pls. 855–860*) we can detect something of this feeling for technique, which is not mere laziness, and which was something the Greeks generally took the greatest pains to disguise in all their arts. It is this that makes a second-rate Greek intaglio, poorly proportioned and carelessly detailed, so different from a second-rate Greco-Persian intaglio, which is all drilled blobs; and it may be this sort of criterion that should be applied if we wish to distinguish Greek from non-Greek in this period.

In the repertory of motifs we see that occasional Greek subjects were copied and a range of more intimate and lively animal studies was borrowed. The Greeks' portrayal of the Persians themselves as human beings and not just court ciphers, was also copied, albeit self-consciously, as we have observed. Eastern hunting scenes were popular, but generally reduced to a very strict convention of one horseman, one quarry, with the occasional dog. Although the motif of one animal attacking another was learned by the Greeks from the east, it is the Greek versions which are copied on the gems, with Greek types generally for the lions, or Greek griffins. Some new animals are introduced—hyena, bear, fox, varieties

of antelope—which were either ignored or very seldom shown by Greek artists. The engravers had learned some tricks of Greek figure composition and there are good attempts at three-quarter heads for animals, while the strictly profile view is relaxed to show the farther leg of a horseman or both the ears of an animal. The tendency was to stereotype the figures and compositions, and an important element in this is the flying gallop for animals, which the Greeks had generally avoided, except, of course, in the Bronze Age. The better artists succeeded in good anatomical studies of limbs, muscles and sinews in the Greek manner, but the trend was either to reduce modelling so that bodies were smooth and featureless and the joints or paws mere drilled blobs, or to copy the bold formal patterns of the Persian Court Style, some few features of which had not been entirely unfamiliar to Greek artists at home. The best of these works show a happy blend of the purely formal elements of pose and anatomy pattern, with a freedom and verve of composition which was inspired by Greek participation in gem engraving in the Persian empire. The restriction of the device to one or two figures set in free field, although not always fitting it as neatly as a Greek artist could; the excerpting of scenes from larger compositions of a hunt, battle or domestic scene; the elimination of superfluous symbols, except for an occasional winged disc; the avoidance of the formal religious iconography: these are all new features in eastern glyptic and all introduced by Greeks. But the execution never approaches the quality of even the Greek Style gems included in this chapter, and it is at its most impressive when it uses Persian Court Style mannerisms. The attribution of other Achaemenid arts to Greek artists, where the local craft tradition was strong—as in metalwork, is also more often questioned now, although we can sometimes identify a Greek motif or suspect that Greek example has been well observed. In the monumental arts of stone sculpture and architecture the story is rather different, and some minor Greek motifs, as the representation of dress, which we see in other arts, may well have been inspired by the work of Greek masons at Persian courts.

There are a few other matters to consider before we leave the Greco-Persian gems. Not many have an assured provenience. The pyramidal stamps of the Court Style come mainly from Sardis, with a number from other Anatolian sites and the Greek islands, and a few in other styles from Syria, Phoenicia and Egypt. The scaraboids and other gems in related style own much the same sources, but there are many more reported from the Greek homeland and even farther west. The Peloponnese seems an important source, notably Sparta. Unfortunately none is from controlled excavation, but it is hard to see why Sparta should have been chosen as provenience so often and at different times by dealers, and there were several purely Greek Classical gems with the same reported origin. These are, after all, years of Spartan dominance in Greek affairs, a dominance at times assured or backed by Persian interest. This connection might have been enough to bring the seals west. Two, including a cylinder, went on to the Spartan colony of Tarentum, and singletons to Etruria (Bolsena), Bologna, Rome and Sicily. The number in South Russia can be accounted for in part by the fact that its markets were well served by East Greeks, and in part, for those in the later tombs, by the dispersal of loot from the Persian empire. Mesopotamian sites offer very few and there are none in Persia itself, where even impressions from scaraboids rarely show other than a purely Greek style. The finger rings are an eastern phenomenon, however, best represented by impressions from Persia and Mesopotamia, and *in corpore* in the gold from the Oxus Treasure in Bactria, on the road to Samarkand. The exceptional find of Greco-Persian stones at Taxila in the Punjab and the possible location of some late groups (the Bern Group and *a globolo*) are slight indications of the extension of the Greco-Persian style to the most easterly borders of the Persian empire, but it could have been Greek arms that carried it there. Egypt received summary versions of the Greco-Persian gems, possibly made in the country.

The dating of the gems is difficult. That of the main Achaemenid series and its cylinders is difficult enough, but the Persepolis sealings indicate the later sixth and first half of the fifth centuries for what

we have called the Archaic Court Style, and this must be the range for the majority, although not all, of the pyramidal stamps from Anatolia. The scaraboids are related to Greek work and from the Greek series we may postulate the second quarter of the fifth century for the earliest of them. Some of the earliest must be of the Classical Court Style and of the Greek Style, as defined above. Most of the Mixed Style gems, the most typically Greco-Persian, may then belong to the second half of the fifth century and the early fourth. Their animal studies can be related to the works of Dexamenos' immediate successors. How late these styles may have continued in the fourth century cannot be determined. There is nothing in them which betrays knowledge of Greek work of the mid fourth century. Comparatively few artists may have been involved and the gems may have enjoyed quite a short vogue. There is no compelling reason to make their work span the whole later history of the Persian empire. After all, none but the cylinders is likely to have been an official seal. It might be that the purely Achaemenid cylinders took their place in the few centres where they had been used, or perhaps for this, as in other Persian arts, we should admit our inability clearly to distinguish the work of the later empire. At any rate, Achaemenid seals or impressions from cylinders securely datable to the fourth century are remarkably scarce. Even the finger ring impressions seem mainly fifth-century and there are no impressions from fourth-century Greek rings or gems until after Alexander. Can it be that the major arts of Achaemenid Persia were played out already one or even two generations before Alexander burnt Persepolis? Only the Bern Group, if rightly interpreted here, suggests continuity into the Macedonian period.

Engraved gems were not the only products of the western Persian empire, and we should expect to find other art forms which reflect much the same background and conflation of styles as the Greco-Persian gems. Metalwork is an obvious parallel, since the goldsmiths, jewellers and gem engravers were likely to be closely associated, possibly even the same people. Closer perhaps is some of the relief sculpture for gravestones. From the Daskylion area come stelai with Persian subjects treated in a broadly Greek manner, and there are reliefs from other parts of Anatolia and from Egypt presenting much the same blend of styles and subject matter. Coins tell the same story. The details of the relative chronology of Persian coins—the Darics and sigloi—are still not clear, but the early ones are obviously related to the Archaic Court Style, while on later ones the King's head is treated in a more realistic, Classical Greek manner. Some satraps were allowed to strike coins, and there were mints in a number of the subject kingdoms. Coinage was very much a Greek affair and the types used in the Persian empire copy Greek types, some of them being clearly the work of Greek artists. Many, however, and especially those with Persian subjects, seem to be by competent local artists following a Greek lead, and the situation is therefore similar to that we have postulated for the gems. Recurrent themes from the Court Style repertory show the hero fighting a lion or versions of the lion-monster. The royal chariot (but perhaps for the god Baal) appears on coins from Phoenicia and there are studies of the royal guards on Cilician coins. From the Greco-Persian repertory come Persian horsemen on coins of Salamis in Cyprus, closely comparable lion-fights, especially in Phoenicia, and crouching warriors with the pilos helmet. Subjects on finger rings which reappear are the bulls' capital (Lycia) and the combined heads, on coins of Phoenicia, where the motif probably originated. A reciprocal effect can be observed in some of the winged animal devices executed in a Greek style in Cilicia, Lycia and parts of East Greece itself. We have observed already the same current of influence in the subjects of some Late Archaic Greek gems.

At the end of this survey it is still not easy to suggest a precise location for the Greco-Persian gem studios. Distribution and style lead us in a general way to Anatolia. We should probably consider the more independent and actively hellenising kingdoms of the south—from Caria and Lycia to Cilicia—as their homes, rather than the Persian satrapy capitals in Lydia or Phrygia, where the eastern stamps and cylinders were preferred. Broadly speaking, Lydian inscriptions are found only on stamps, and Aramaic only on

cylinders or stamps in the Persian empire. Our scaraboids carry a few Greek letters but usually nothing in any other script. The strange linear devices on Lydian Achaemenid stamps appear otherwise only on some wholly Greek gems, not on the Greco-Persian, and there is only one Greco-Persian scaraboid (in Greek Style) from Sardis. For the few scaraboids with Court Style subjects, however, a Lydian origin or distribution is always possible. This is obviously true of the Court Style scaraboid with a Lydian inscription (*Pl. 834*).

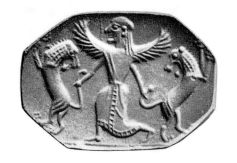

823 *3:1*

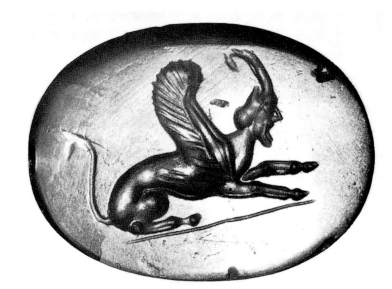

825 *3:1*

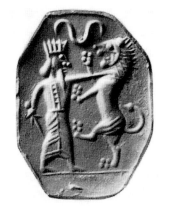

824 *3:1*

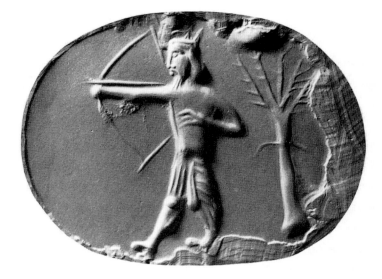

826 *3:1*

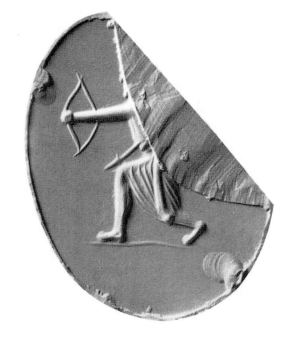

827 *3:1*

828 *3:1*

830 *3:1*

831 *5:2*

829 *3:1*

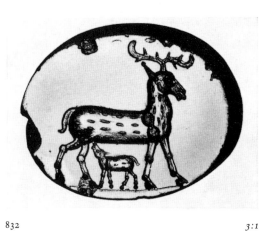

832 *3:1*

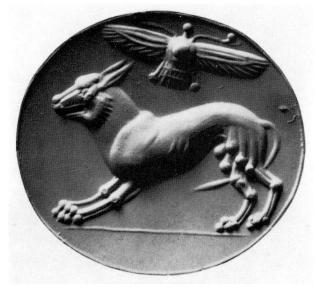

833 *3:1*

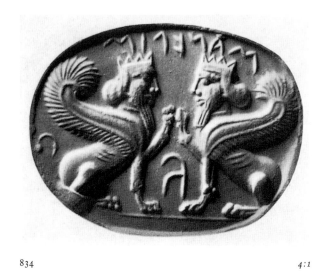

834 *4:1*

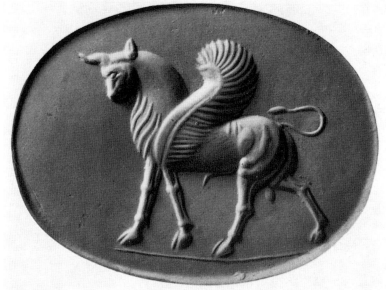

835 *3:1*

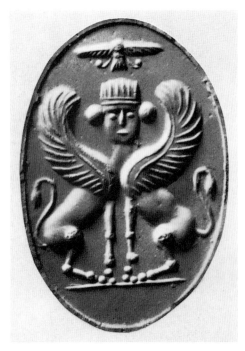

836 *4:1*

837 *4:1*

838 4:1

839 3:1

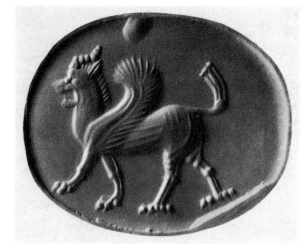

840 3:1

841 3:1

843 2:1

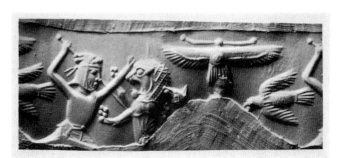

844 2:1

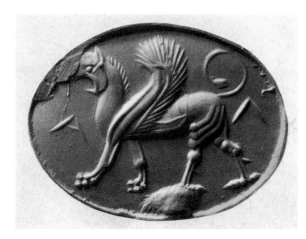

842 3:1

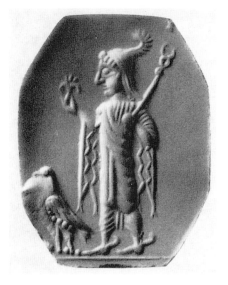

845 4:1

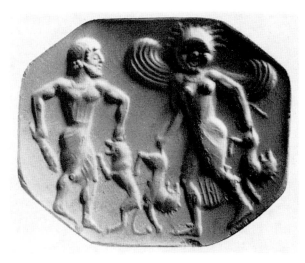

846 4:1

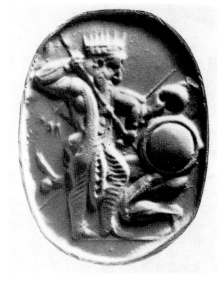

849 4:1

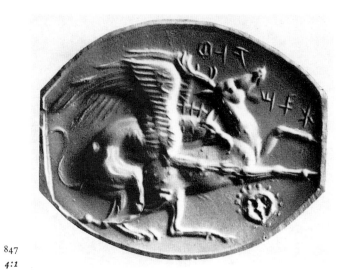

847
4:1

848
4:1

851
2:1

850
2:1

852

853
3:1

854
3:1

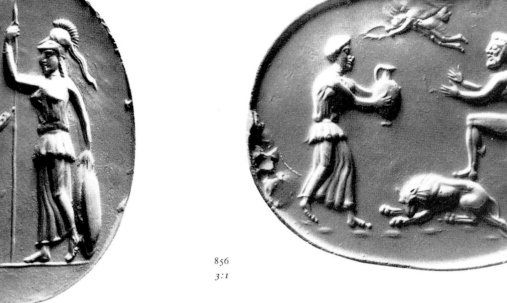

855 3:1

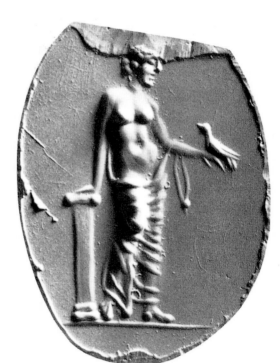

856
3:1

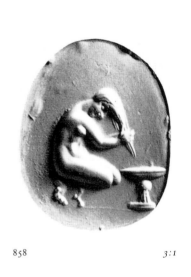

858 3:1

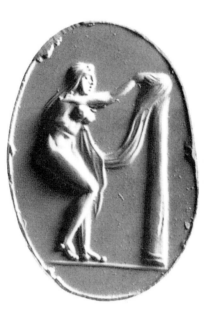

859
3:1

857 3:1

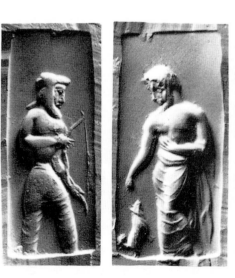

861
3:1

860 3:1

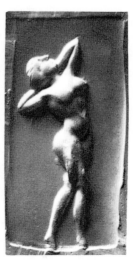

861
3:1

862

4:1

863

4:1

864

4:1

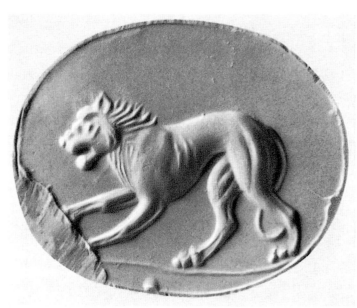

865

4:1

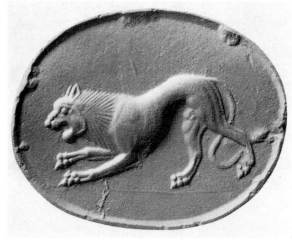

866

3:1

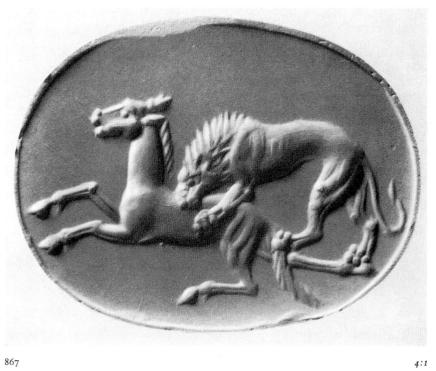

867

4:1

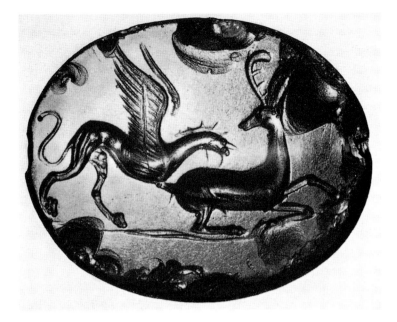

868 3:1

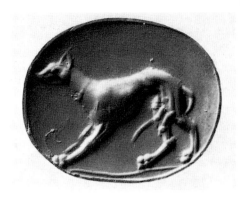

869 3:1

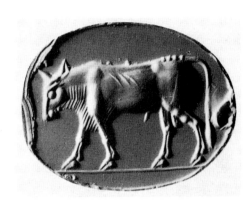

870 3:1

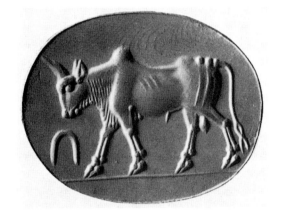

871 3:1

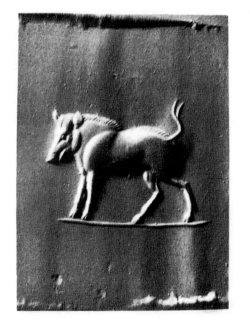

872 3:1

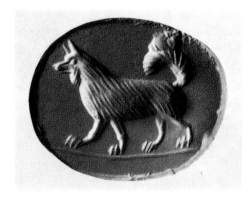

874 3:1

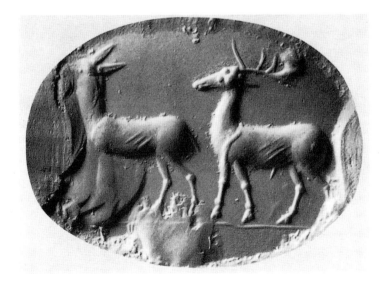

873 3:1

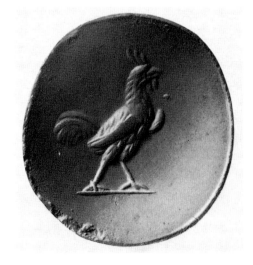

875 3:1

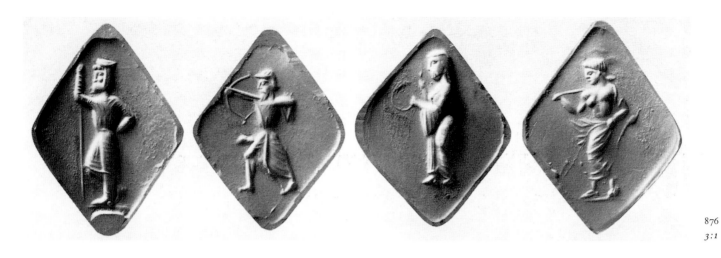

876
3:1

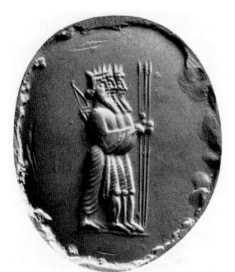

877
3:1

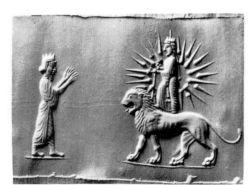

878 2:1

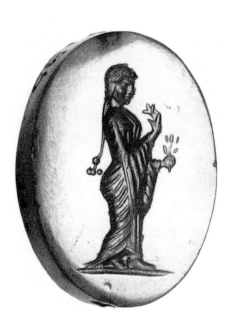

879 4:1

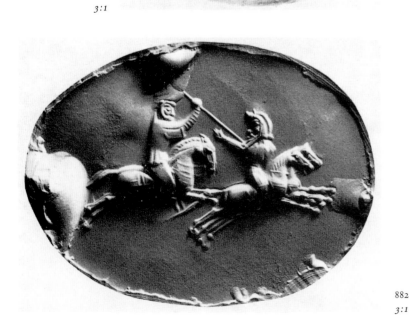

880
3:1

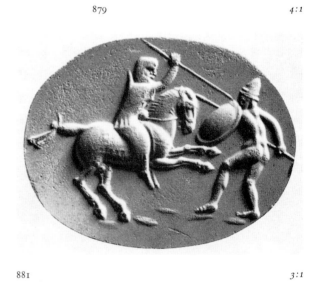

881 3:1

882
3:1

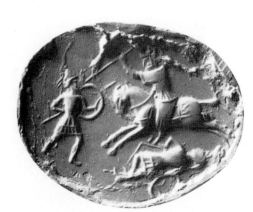

883
3:1

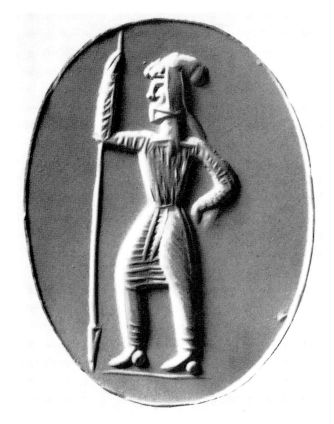

884
4:1

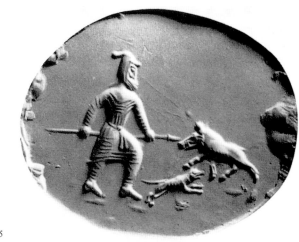

885
3:1

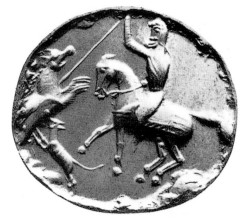

886
3:1

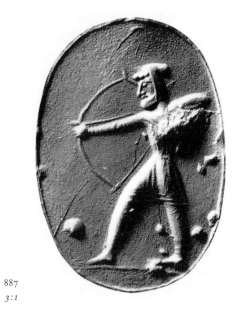

887
3:1

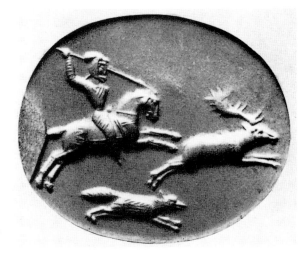

888
3:1

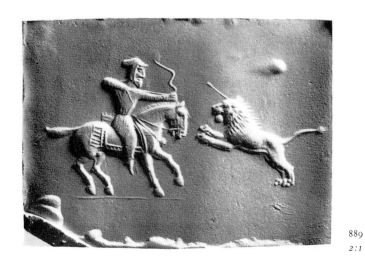

889
2:1

890
3:1

891 3:1

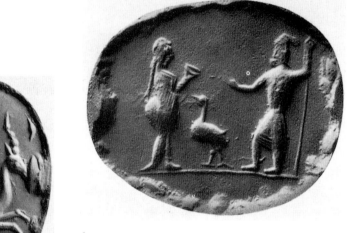

894 2:1

892 3:1

893 3:1

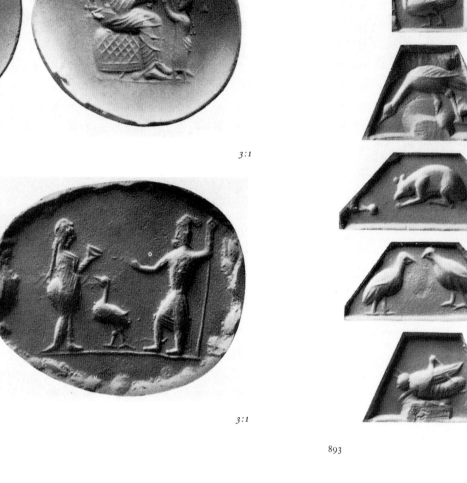

895 4:1

896

2:1

897 2:1

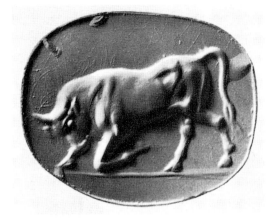

898 3:1

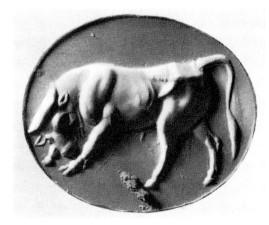

899 3:1

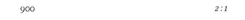

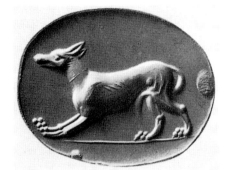

900 2:1

902 4:1

901 3:1

905 2:1

903 3:1

904 3:1

907
3:1

908
3:1

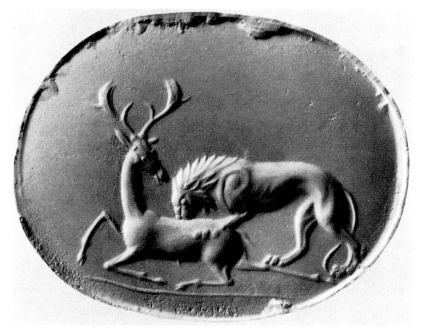

909
3:1

906 *3:1*

910
3:1

911
3:1

912

913 *2:1*

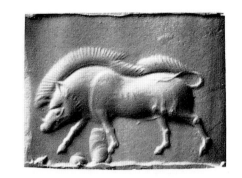

914 *2:1*

912 *2:1*

915 *2:1*

916 *2:1*

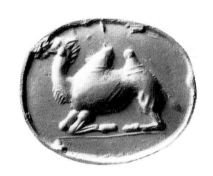

917 *2:1*

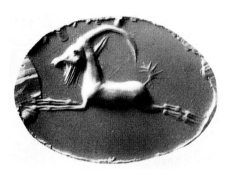

918 *2:1*

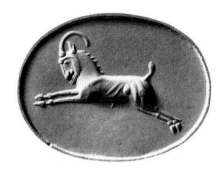

919 *2:1*

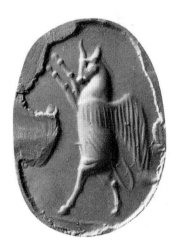

920 *2:1*

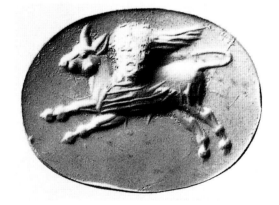

921 *3:1*

922 *3:1*

923

2:1

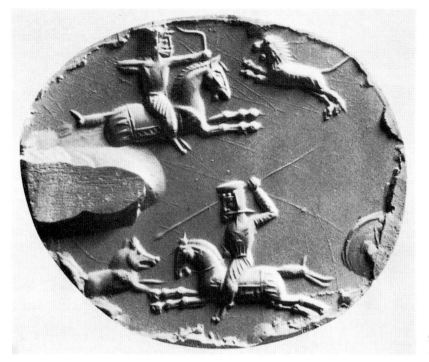

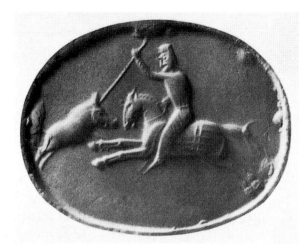

924
4:1

925
3:1

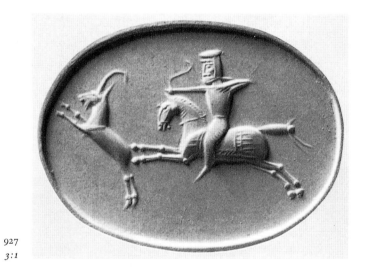

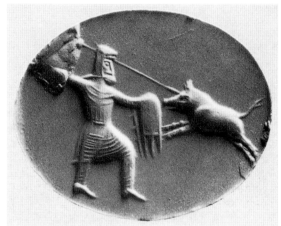

926
3:1

927
3:1

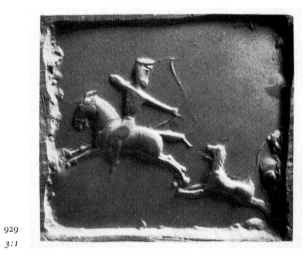

929
3:1

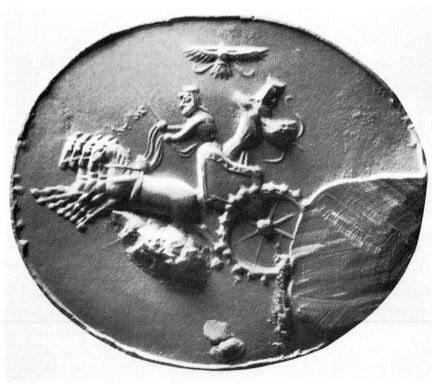

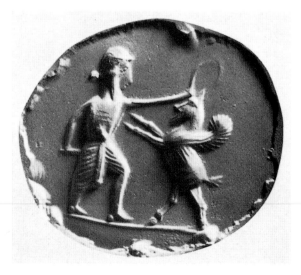

928

930

4:1

4:1

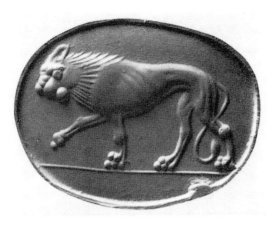

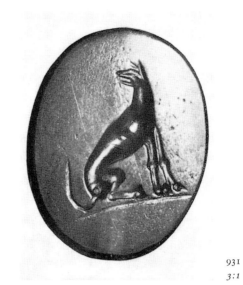

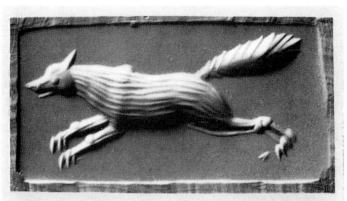

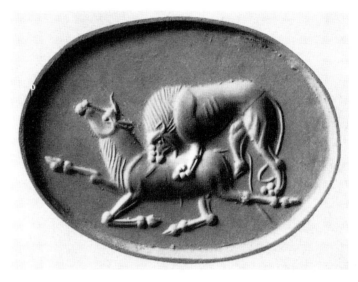

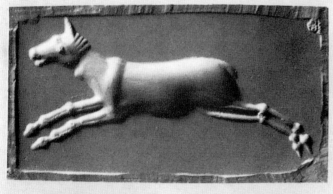

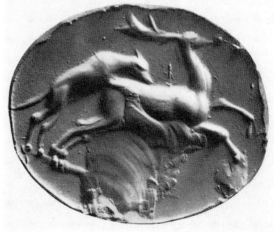

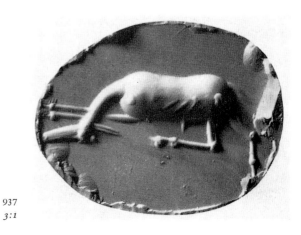

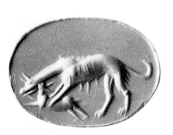 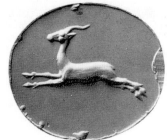 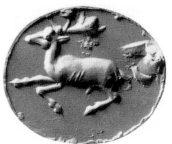

938 2:1 939 2:1 940 2:1

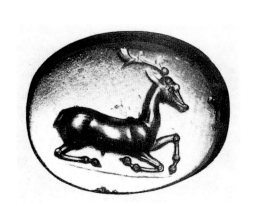 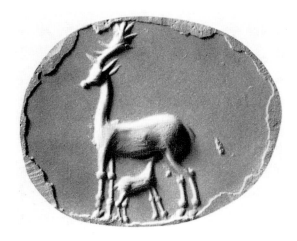 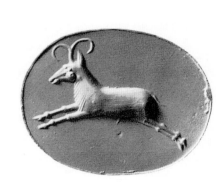

941 3:1 942 3:1 943 2:1

 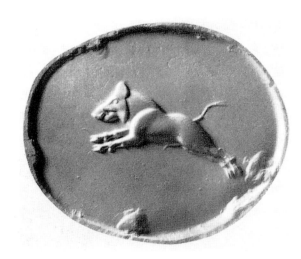 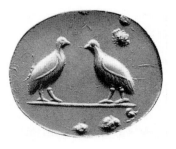

946 2:1

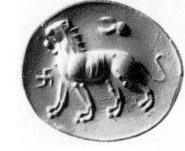

944 3:1 945 3:1

949 3:1

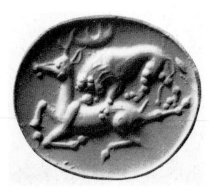 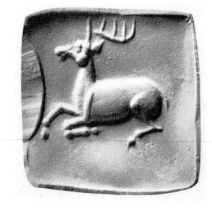

950 3:1

947 4:1 948 3:1

951
3:1

953 3:1

952
3:1

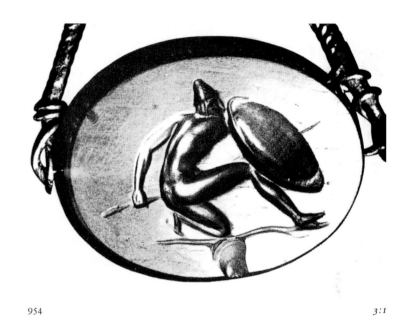

954 3:1

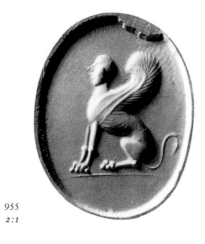

955
2:1

957
2:1

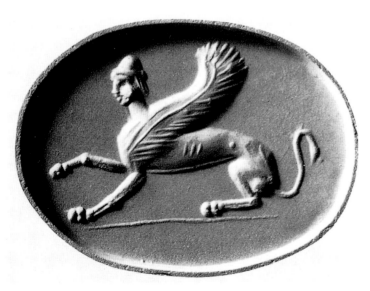

956 3:1

958 4:1

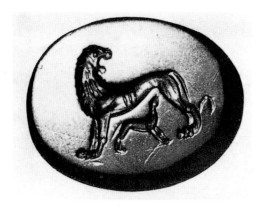

959

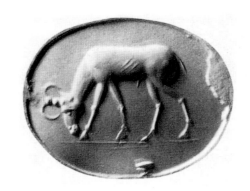

960

3:1

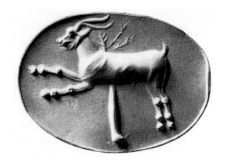

961

2:1

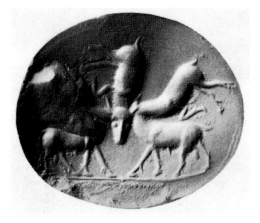

962

3:1

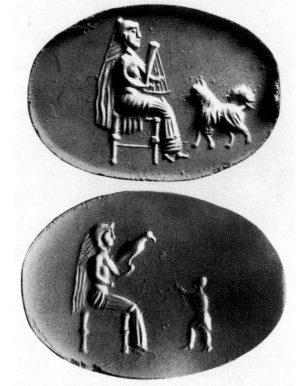

964

3:1

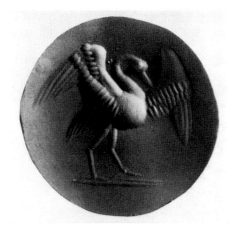

963

4:1

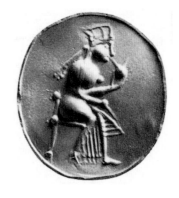

966

2:1

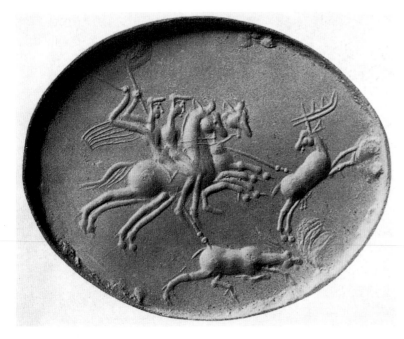

965

3:1

967

2:1

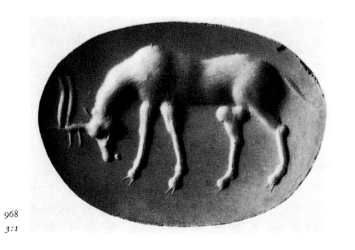

968
3:1

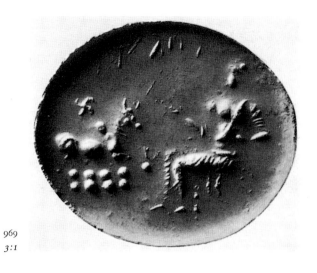

969
3:1

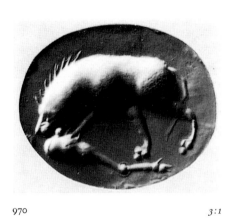

970

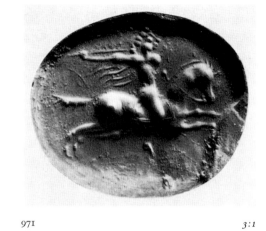

971
3:1

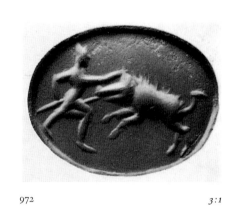

972
3:1

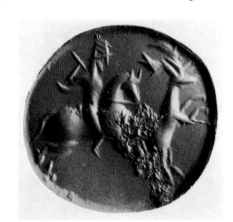

973
3:1

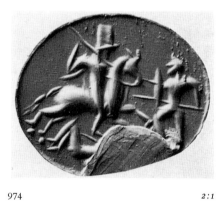

974
2:1

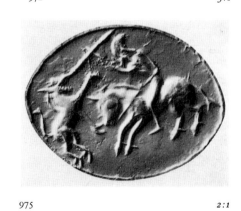

975
2:1

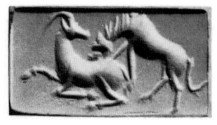

976
3:1

977
3:1

978
3:1

979
3:1

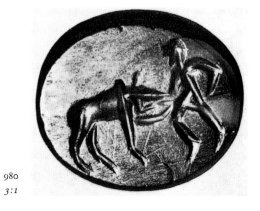

980
3:1

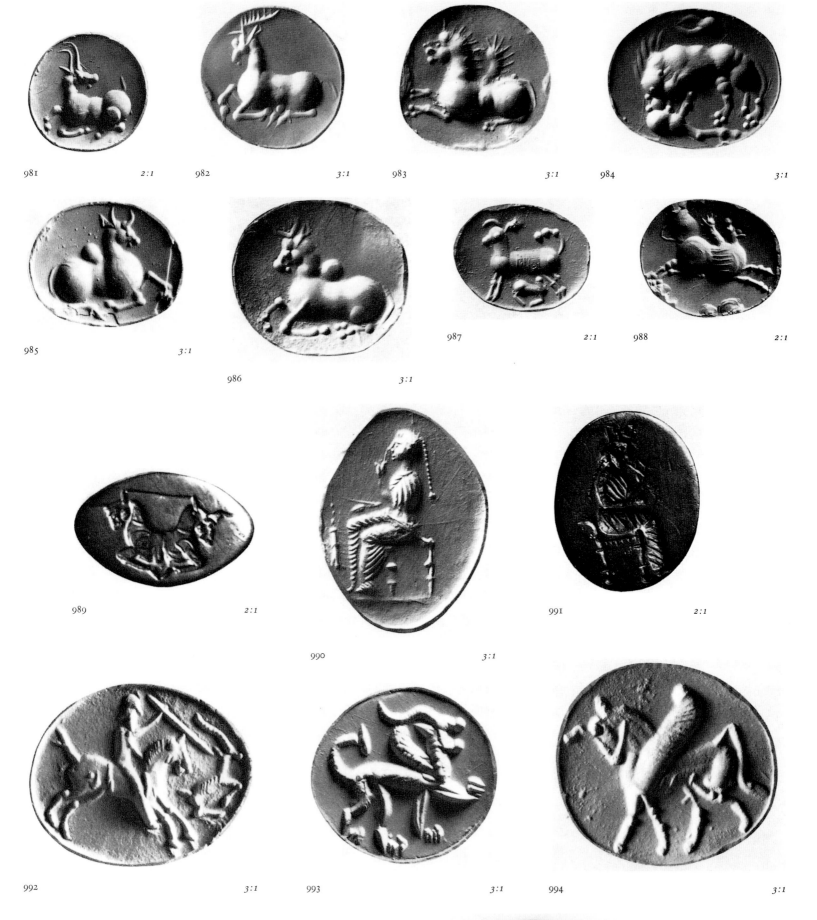

981 2:1 982 3:1 983 3:1 984 3:1

985 3:1 987 2:1 988 2:1

986 3:1

989 2:1 991 2:1

990 3:1

992 3:1 993 3:1 994 3:1

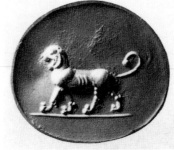

995

3:1

COLOUR PLATES

PAGE 307

1 *London* 536, pl. 9. Blue chalcedony scaraboid. See *Pl. 867*.

2 *London* 434, pl. 7. Cornelian scaraboid. See *Pl. 879*.

3 *London* 435, pl. 7. Cornelian scaraboid, cut on the back. See *Pl. 864*.

4 *London* 436, pl. 7. Pink chalcedony pear-shaped pendant. See *Pl. 891*.

5 Oxford 1965. 362. Red and yellow jasper scaraboid. See *Pl. 837*.

TEXT FIGURES

Fig. 280 Once Arndt A 1419, from Tarentum. Chalcedony scaraboid. L.32. A Persian hero with two lion griffins. von Duhn, fig. 3.

Fig. 281 Once Arndt A 1411. Chalcedony scaraboid. L.20. A royal sphinx and a lion griffin.

Fig. 282 *New York* 135, pl. 22. Plasma scaraboid. L.16. A mounted Persian spears a fallen Greek. *Hesp.* Suppl. viii, pl. 34.2. The horse has a 'Greek' head, Persian dressed tail.

Fig. 283 *New York* 133, pl. 22. Chalcedony scaraboid. L.29. A Persian woman with an ointment jar. *JHS* xlviii, pl. 10.1.

Fig. 284 Baltimore 42.155. Chalcedony cut scaraboid (C ?). L.35. A lion and a tree. *BFAC* pl. 110.M156; *Archaeology* 1962, 121.

Fig. 285 Paris, BN, *de Clercq* ii, pl. 5.99. Blue chalcedony scaraboid (A). L.23. A lion tears a limb.

Fig. 286 'London'. A lion with a shield and sword. *AG* iii, 124; IBK pl. 14.46.

Fig. 287 *New York* 102, pl. 18. Chalcedony scaraboid, cut on the back. L.32. A plunging zebu bull. *Hesp.* Suppl. viii, pl. 36.1.

Fig. 288 *Munich* i, 294, pl. 34. Chalcedony scarab, not modelled, with incised detail including triple line corner winglets. L.27. A running bear. Lippold, pl. 88.2; Maximova, fig. 27d; *MJBK* 1951, pl. 4.20.

Fig. 289 *Munich* i, 249, pls. 28, 29. Chalcedony multi-faced seal. 18 × 15. 1–2. Persian bowmen with spears, wearing tiaras. 3. A Persian leaning on a spear. 4. A Persian woman with flower and wreath. 5. A dog. 6. A cock. 7. A dog scratching itself. 8. A fox with a cock in its mouth. 9. A deer. 10. A calf. 11. A hyena. 12. A goat.

Fig. 290 *New York* 139, pl. 24, from near Baghdad. Agate taloid. L.16. 1. A Persian horseman, frontal, spears a boar. 2. A hawk. 3. A bear. 4. A lizard. 5. A hyena. 6. A fox sniffing at a locust. *Hesp.* Suppl. viii, pl. 32.3–8; Richter, *Animals* (Oxford, 1930) figs. 210, 236.

Fig. 291 Private, from near Massyaf. Blue chalcedony tabloid. L.24. 1. A Persian horseman fights a Greek. 2. A dog curled up. 3. A running lion. 4. A fox. 5. A running stag. 6. Cocks fight. *Arch.Or.* pl. 31.1.

Fig. 292 Rome, Sangiorgi Coll. Chalcedony scaraboid. L.27. A Persian horseman chases a fox with a trident spear. Pope, *Survey* (London, 1939) 390, fig. 89; *AJA* lxi, pl. 81.6. For the spear see also Notes no. 124, *Pl. 890*, and Hull, *Hounds and Hunting* (Chicago, 1964) 5. For its use against hares, Oppian, *Kyneg.* i, 154. Boar spears, Pollux, v, 22.

Fig. 293 Yale, *Newell Coll.* pl. 31.459. Chalcedony cylinder. H.27. A Persian horseman with a bow faces a charging lion. Winged sun disc overhead. *Hesp.* Suppl. viii, pl. 33.1.

Fig. 294 Once Arndt. Cornelian pear-shaped pendant. 1. A seated Persian tests an arrow. 2. A Persian with spear and bow. 3. A Persian woman with horn and wreath. 4. A Persian woman with horn and jar. 5 (base). A bird. von Duhn, pl. 1.2–6; Maximova, fig. 24; Lippold, pls. 65.1, 3, 4, 6, 94.2.

Fig. 295 *New York* 138, pl. 23. Agate tabloid. L.20. 1. A frontal Persian horseman shoots at a stag. 2. A seated lion. 3. A running stag. 4. A running antelope. 5. A running hyena. 6. A plunging bull. *Hesp.* Suppl. viii, pls. 31.4–7, 32.1, 2.

Fig. 296 *New York* 115, pl. 20. Chalcedony scaraboid. L.37. A dog tears a fallen stag. *Hesp.* Suppl. viii, pl. 35.4.

Fig. 297 Once *Southesk* i, pl. 16.O.10, from Spezia. Scaraboid. L.25. A Persian with a spear, facing a woman with a flower. *AG* pl. 12.11; Maximova, fig. 5.

Fig. 298 Munich A 1432 (missing). Chalcedony scaraboid. L.18. Love making. Lippold, pl. 62.8. The girl holds a mirror and looks round. Bodies are shown in a rudimentary three-quarter view, both breasts being marked. Compare *Pl. 906*.

Fig. 299 Unknown. L.23. A horse.

Fig. 300 Paris, BN 1093. Blue chalcedony scaraboid (C). L.30. Two bears and a snake. *AG* pl. 12.47; Lippold, pl. 88.13. Thiele, *Ant.Himmelsbilder* (Berlin, 1898) 28, 39.

Fig. 301 New York L.45.55.16. Blue chalcedony scaraboid. L.24. A griffin tears the hind legs of a deer. *Hesp.* Suppl. viii, pl. 35.3.

Fig. 302 Indiana 14, bought in Istanbul. Chalcedony scaraboid. L.28. A heron with its head stretched forward. Berry, *Selection of Ancient Gems* no. 14.

Fig. 303 From Taxila. Agate pear-shaped pendant. L.23. A lion attacks a stag. *Ancient India* i, pl. 10.B1.

Fig. 304 From Taxila. Agate tabloid. L.17. As the last; same hand. Ibid., pl. 10.B3; compare the plain rock crystal tabloid, pl. 10.5.

Fig. 305 From Taxila. Green jasper scaraboid. L.18. A running stag. Ibid., pl. 10.B2.

Fig. 306 Once *Evans* pl. 2.29, from Athens. L.15. A deer with heron's head antlers.

Fig. 307 *New York* 126, pl. 21. Rock crystal scaraboid. L.22. A quail.

Fig. 308 Once Arndt. Cornelian disc. W.16. 1. A heron holding a stone. 2. An ant attacking a locust. Lippold, pls. 95.11, 97.11; Bulle, nos. 17, 18.

Fig. 309 Once Draper Coll. Cornelian cylinder (the figures are set along the seal, not around it, and occupy no more than half the circumference). H.45. There are two registers. Above, a file of six Celtic soldiers, with long spears, pointed helmets, and oval ribbed shields. Before them an officer, with Greek spear, helmet and cloak, possibly Persian tunic and leggings, apparently ordering them on. Before him four horsemen with helmets, cloaks and long spears, gallop away. Below left are two horses standing, saddled and with dressed tail, with a kneeling figure before them, and a man running after a horseman who is leading a loose horse. Aramaic inscriptions in the field. Ward, *Seal Cylinders* (Washington, 1910) 1054; Galling, *Zeitschr.d. Pal.Vereins* lxiv, pl. 11.171. I am indebted to Mr Briggs Buchanan for a photograph of an impression in Yale. Celts and Alexander, Arrian, *Anabasis* i, 46; vii, 15. Their invasion and mercenary service in the Hellenistic world, Launey, *Recherches sur les armées hellénistiques* i (Paris, 1949), 490ff.; Griffith, *Mercenaries of the Hellenistic World* (Cambridge, 1935) 143ff., 166ff.; Megaw in *Fest.Kostrzewski* 185ff. Greek representations of their pointed helmets and shields, *Rev.Arch.* xxv.2, 47; l, 307; *Rev.Et.Anc.* xlvi, 217ff.

Fig. 310 Baltimore 130. Blue chalcedony tabloid. L.16. A horseman fights a warrior.

Fig. 311 Basel, Dreyfus Coll. Agate scaraboid (A). L.14. A man spears a boar; almost a globolo.

Fig. 312 Cambridge, from N.W. India. Pale greenish chalcedony scaraboid (C). L.18. A lion tears a limb.

Fig. 313 Clay impression from Ur. Joined heads of a bearded man, goat and lion; the man's beard as a bird. Leaves below. *Ur* x, pl. 39.720; *JHS* lv, 232–5. Compare also Greek and Greco-Phoenician versions, *Pls. 417, 446*. There are other examples from Ur, ibid., nos. 712–6, 718–25, and Nippur, Legrain, *Culture* nos. 971–2.

Fig. 314 Clay impression from Ur. Herakles and the lion. *Ur* x, pl. 40.748; *Iraq* xxii, pl. 31.7. For the Greek version see *Pl. 536*. Another impression of this type, Schmidt, *Persepolis* ii (Chicago, 1957), pl. 12. no. 52.

Fig. 315 Clay impression from Ur. A human arm holds a rhyton with a sphinx forepart. In the field a fluted jug. *Ur* x, pl. 42.832. This, with *Figs. 313, 314*, is from a late fifth-century burial.

BLACK AND WHITE PLATES

Asterisked numbers indicate that the piece is illustrated in original. All other photographs show impressions

COURT STYLE

Pl. 823 Bowdoin College 484, from the Black Sea area. Chalcedony pyramidal stamp. L.20. A winged goddess holds two lions. Radet, *Cybébé* 21, fig. 28; *Arch.Zeitung* 1854, pl. 53.2; *Mon.Ined.* pl. 1.23; *Iran* viii, pl. 2.24.

Pl. 824 Leningrad, from Bliznitsa. Chalcedony pyramidal stamp. L.16. A Persian hero fights a lion. *CR* 1869, pl. 1.18; Minns, 427, fig. 318; *Iran* viii, pl. 4.86.

Pl. 825* Leningrad 594. Blue chalcedony scaraboid (A). L.29. A goat-sphinx: winged lion's body, human head, goat's horns and legs. Lajard, *Mithra* pl. 44.9; *AG* pl. 11.18.

Pl. 826 Leningrad. Blue chalcedony scaraboid (A). L.30. A Persian draws a bow before a tree. Compare the next.

Pl. 827 Oxford 1910. 613, from Anoyia, near Sparta. Blue chalcedony scaraboid (A). L.27. A crouching Persian with spear and bow as on Darics. *BSA* xvi, 70f.

Pl. 828 Istanbul, from Sardis. Cornelian scarab. L.14. A bull walking. *Sardis* xiii.1, pls. 9, 11, no. 96.

Pl. 829 Paris, BN 1049 (E.1). Blue chalcedony scaraboid (A). L.23. A Persian archer, wearing a tiara. Maximova, fig. 17b; Menant, *Glyptique or.* (Paris, 1883) pl. 9.8.

Pl. 830* *London* 544, pl. 9. Blue chalcedony scaraboid (A). L.23. A butting bull.

Pl. 831 *Berlin* F 180, pl. 4, D 195, from Attica. Chalcedony cylinder. H.20. A harnessed horse standing beneath the winged sun disc. The tail is not dressed in the usual Persian manner.

Pl. 832* Leningrad 566, from South Russia. Chalcedony scaraboid (A). L.19. A horned deer suckles a fawn. *AG* pl. 11.26.

Pl. 833 *London* 534, pl. 9. Agate scaraboid (C). L.29. A dog or lynx beneath a winged sun disc. *AG* fig. 103.

Pl. 834 Leningrad, from Kerch. Cornelian scaraboid (A). L.20. Two royal sphinxes, with the Lydian inscription *Manelim*, 'of Manes'. *ABC* pl. 16.10; Lippold, pl. 79.2; *Iran* viii, pl. 1.5.

Pl. 835 Paris, BN 1088. Chalcedony scaraboid (C). L.34. A winged bull. *AG* pl. 12.3; Lippold, pl. 82.7.

Pl. 836 Once *Evans* pl. 2.21. Chalcedony scaraboid. L.20. A bicorporate sphinx seated beneath a winged sun disc. The motif appeared on an Archaic Court Style pyramidal stamp, Delaporte, *Bibl.Nat.* pl. 38.631.

Pl. 837* Oxford 1965. 362. Mottled red and yellow jasper scaraboid (A). L.20. A royal winged bull. Pope, *Survey* pl. 124G; *Catalogue Spencer-Churchill* (Oxford, 1965) pl. 17.35. See *colour, p. 307.5.*

Pl. 838* Oxford 1885. 491, from Nymphaeum, tumulus IV. Blue chalcedony scaraboid. L.26. A rearing lion griffin. *AG* pl. 12.4; Lippold, pl. 81.2; *JHS* v, pl. 47.8.

Pl. 839 Paris, BN D1590. Cornelian cut. L.15. As the last.

Pl. 840 Paris, Louvre A777. Agate scaraboid. L.24. A walking lion griffin. Delaporte, *Louvre* ii, pl. 92; *AJA* lvii, pl. 25.56.

Pl. 841 Baltimore 42.839. Chalcedony scaraboid. L.20. As the last but with a lion's tail. Evans, *Selection* no. 55.

Pl. 842 Paris, BN 1090. Agate cut scaraboid. L.23. A griffin. Inscribed *AL*. *AG* pl. 12.50; Lippold, pl. 81.10.

Pl. 843 London WA 132504 (electrotype). Cylinder. H.24. A Persian horseman spears a lion griffin. Aramaic inscription, 'of Artimas'. Ward 1148; Galling, pl. 11.165; Bivar, *Num.Chron.* 1961, 119ff., fig. 1. For Artimaś in Lydia see Gusmani, *Lydisches Wörterbuch* (Heidelberg, 1964) 63f. Artimas of Lydia, Xenophon, *Anabasis* vii, 8.25.

Pl. 844 Leningrad ГΛ . 886, from Lydia. Blue chalcedony cylinder fragment. H.14. A Persian spears a lion who is also attacked from behind by a dog. A winged sun disc and flying bird.

GREEK STYLE

Pl. 845 *New York* 33, pl. 6. Blue chalcedony pyramidal stamp. W.17. Hermes with caduceus and flower, a bird before him. *AG* pl. 6.49; Boardman, *Iran* viii, pl. 2.11. For the dress and cap see *AGGems* 32. For Hermes as master of animals, *Hesp.* xvi, 89ff.

Pl. 846 Boston 95.80. Blue chalcedony pyramidal stamp. W. 18. Herakles with club and lion facing Medusa with two lions. *AG* pl. 6.48; *Iran* viii, pl. 2.12. For the motif see *AGGems* 28. Herakles confronted Medusa in Hades, Apollodorus, ii, 5, 12. The Medusa is a slighter version of the Leningrad Gorgon, our *Pl. 378*.

Pl. 847 Péronne, Danicourt Coll. Blue chalcedony pyramidal stamp. W.19. A griffin attacks a stag. Cypriot inscription *a-ke-se-to-ta-mo*, 'of Akestodamos' and a sun disc in the field, perhaps both added at one time. Masson,

Inscr.Chypr. (Paris, 1961) no. 363, fig. 118, p. 349; *Iran* viii, pl. 2.13.

Pl. 848 *London* 609, pl. 10. Cornelian pyramidal stamp. W.13. A child with a vine. *AG* pl. 10.30; *Iran* viii, pl. 2.16. Compare coins of Dardanos, Babelon, pl. 167.13–15.

Pl. 849 Once Arndt, A1410, from Caria. Onyx scaraboid. L.16. A Persian, wearing a tiara, spears a falling Greek. von Duhn, figs. 1, 5, pl. 1.1.

Pl. 850 Boston 03.1011. Chalcedony cylinder. H.23. A Persian spears a boar. His horse, of Greek type, with flowing tail, waits behind him.

Pl. 851* London WA, from the Oxus. Chalcedony scaraboid (C). L.24. A Greek spears a naked fallen warrior. Dalton, *Oxus* (London, 1926) no. 113, fig. 62. See *Cambridge History of India* i, pl. 33a (apparently a replica, from the Punjab).

Pl. 852* Taranto 12015, from Tarentum. Chalcedony cylinder. A bull.

Pl. 853 Oxford 1892. 1482, from the Peloponnese. Chalcedony scaraboid (A/C). L.26. A Persian with a bow and a dead bird. *AG* pl. 12.13.

Pl. 854 *Berlin* F 181, pl. 4, D 191, from Megalopolis. Chalcedony scaraboid (A). L.27. A Persian woman with an ointment jar, its lid and dipper. *AG* pl. 11.6; Lippold, pl. 65.7; *Arch.Eph.* 1960, 120, Fig. 2.

Pl. 855 Istanbul, from Sardis. Blue chalcedony scaraboid (C). L.29. Athena and Hermes. *Sardis* xiii.1, pls. 9, 11, no. 101; *Burl.Mag.* 1969, 595, fig. 34, for the artist (see the next) and motif.

Pl. 856 *London* 524, pl. 9, from the Punjab. Blue chalcedony scaraboid (C). L.35. Herakles, having abandoned his club, steps over the dead lion towards a woman who offers him a jar. Eros flies overhead to crown the woman. *AG* pl. 12.25; Lippold, pl. 36.1; *Burl.Mag.* 1969, 595, fig. 35, for the artist (see the last) and the motif.

Pl. 857 Oxford 1892. 1488, from Syria. Blue chalcedony scaraboid (C). L.31. A half naked woman leans on a column and holds a bird. On the back of the stone busts of Isis and Sarapis were carved at a later date. *AG* pl. 12.22.

Pl. 858 Paris, BN 1103. Blue chalcedony scaraboid (A). L.17. A naked woman kneels to wash her hair before a low standed basin. *AG* pl. 12.31; Lippold, pl. 63.3.

Pl. 859 Oxford 1892. 1487, from Spezia. Chalcedony scaraboid (C). L.27. A naked woman lifts her clothes down from a column. *AG* pl. 12.32. See also *Fig. 274.*

Pl. 860 *London* 559, pl. 10, from Tarsus. Red-pink-white cornelian scaraboid (B). L.22. A youth, with helmet and chlamys, crouches to fasten a boot. *AG* pl. 31.13; Lippold, pl. 53.14.

Pl. 861 Leningrad, from north of Anapa (found with a coin of Lysimachos). Cornelian prism, one end cut short. L.20. 1. A Persian holding a bow. 2. A bearded Greek in a himation, with a dog. 3. A naked woman stretching. 4. Two cocks fight. *CR* 1882/3, pl. 5.1, a; *AG* fig. 93; *Arch. Or.* pl. 30.9, 10. For the woman compare the finger rings, our *Pls. 710, 711.*

Pl. 862 Boston, *LHG* 63, from Tripolitsa. Chalcedony scaraboid (A). L.24. Love making. For the device cut later on the back see *Pl. 996.*

Pl. 863 Cambridge. Onyx scaraboid, cut to present a layered back (broad C). L.23. A Persian horseman spears a stag. Middleton, pl. 1.16; *AG* pl. 11.4.

Pl. 864 *London* 435, pl. 7, from Mesopotamia. Cornelian scaraboid (A). L.24. On the back is cut a Persian horseman pursuing two Persians in a biga. Maximova, fig. 26. For the device on the front of the stone see Notes to Chapter V, no. 94. See *colour, p. 307.3.*

Pl. 865 Dresden. Chalcedony scaraboid. L.23. A lion. *Arch.Anz.* 1898, 65, no. 41, with fig.; *AG* pl. 9.56.

Pl. 866 Boston. Chalcedony scaraboid. L.24. A lion.

Pl. 867 *London* 536, pl. 9. Chalcedony scaraboid (A). L.28. A lion attacks a horse. IBK pl. 16.68. See *colour, p. 307.1.*

P. 868* Leningrad 593. Blue chalcedony scaraboid (A). L.27. A griffin attacks a stag. *AG* pl. 11.29; *CR* 1864, 71, n. 9; Lajard, *Mithra* pl. 43.21.

Pl. 869 Oxford 1892. 1474. Cornelian scaraboid with lightly convex face (A). L.17. A dog.

Pl. 870 *Berlin* F 174, pl. 4, D 193, from Greece. Cornelian scaraboid (A). L.20. A bull. Lippold, pl. 90.9.

Pl. 871 Boston, *LHG* 64, pl. 4, from Greece. Agate scaraboid. L.22. A zebu bull. *AG* pl. 12.6.

Pl. 872 Oxford 1938. 961, from Crete. Cornelian cylinder. H.31. A boar at bay. Boardman, *Cretan Collection* (Oxford, 1961), pl. 46.540; Buchanan, *Cat.* i, pl. 45.692.

Pl. 873 Paris, BN, *Pauvert* 57, pl. 5, from Sicily. Rock crystal scaraboid (C). L.28. Two stags.

Pl. 874 Paris, BN M5448. Chalcedony scaraboid (C). L.17. A Maltese dog. Perrot-Chipiez, ix, pl. 1.11; *Rev. Num.* ix, pl. 8.5; Lippold, pl. 87.9.

Pl. 875 Paris, Louvre AO.10.880. Blue chalcedony biconvex with sharp edges, not pierced. W.20. A cock. This, and another of this shape (see Notes, no. 105) are probably for setting on a pendant, and in an advanced style, possibly of the later fourth century.

THE ARNDT GROUP
Pl. 876 London WA 128847. Red jasper multifaced seal. 18 × 13 × 12. 1. A Persian leaning on a spear. 2. A Persian with a bow (compare *Pl. 827*). 3. A Persian woman with a wreath. 4. A young Greek in a himation, shouldering a stick. (5. A seated goat. 6. A lion. 7. A fox. 8. A dog. 9. A Maltese dog. 10. A running goat. 11. A bear. 12. A stag.)

Pl. 877 Paris, BN N3621. Blue chalcedony scaraboid (C). L.21. Three Persians with spears. Maximova, fig. 21.

Pl. 878 Leningrad, from north of Anapa, the same tomb as *Pl.861*. Blue chalcedony cylinder. H.29. A Persian wearing a tiara stands with raised hands facing a radiate goddess standing on a lion's back. *AG* fig. 81; *Archiv für Orientforschung* xx, 131, fig. 12. For Anahita see Olmstead, *History* 471f.; Ringbom, *Acta Acad.Aboensis* xxiii.2. East Greek roundels, Möbius in *Fest.Eilers* (Wiesbaden, 1967); Boardman *Greeks Overseas* (Harmondsworth, 1963) 92f.

Pl. 879* *London* 434, pl. 7, from Eretria. Cornelian scaraboid (B). L.18. A Persian woman with flowers. See *colour, p. 307.2*.

Pl. 880 Oxford 1921. 2. Blue chalcedony scaraboid (C). L.24. A Persian woman with a jar, cup and dipper approaches a Persian seated on a padded stool. Kufic inscriptions of the Ummayad period added on front and back (Koran texts). For the seat see also *Pl. 891, Fig. 294*, and the relief cut by a Greek for a Persian, from near Lake Manyas in Phrygia, Akurgal, *Die Kunst Anatoliens* (Berlin, 1961) fig. 119.

THE BOLSENA GROUP
Pl. 881 Rome, Villa Giulia, from Bolsena, the dromos of a tomb. Chalcedony scaraboid. L.28. A Persian horseman attacks a Greek, naked except for pilos, spear and shield. *Mél.d'Arch.* lxvii, pl. 3.4.

Pl. 882 Leningrad 375, from Asia Minor. Blue chalcedony scaraboid (A/C). L.30. A Persian horseman pursues two horses, ridden by bearded figures who look back. von Duhn, pl. 1.8; Maximova, fig. 3 and *Kat.* pl. 1.12; *Die Antike* i, 113, fig. 5,

Pl. 883 Basel, Private. White veined marble conoid. L.20. A Persian horseman spears a Greek over the fallen body of another Greek. This is the only conoid cut in a pure Greco-Persian style.

THE PENDANTS GROUP
Pl. 884 Cambridge. Chalcedony scaraboid (C). L.24. A Persian leaning on his spear.

Pl. 885 Paris, BN 1095. Blue chalcedony scaraboid (C). L.27. A Persian with a dog spears a boar. *AG* pl. 12.14; Babelon, *Cat.* pl. 6.

Pl. 886 London WA 119919. Chalcedony scaraboid (C). L.22. A Persian horseman spears a bear, attacked also by a dog.

Pl. 887 Leningrad ГΛ 895. Chalcedony scaraboid (A/C). L.24. A Persian draws a bow.

Pl. 888 London WA 120332. Banded pink chalcedony scaraboid (A). L.20. A Persian horseman chases a stag; a fox runs below.

Pl. 889 Boston 98.708. Cylinder. H.30. A Persian horseman with a bow attacks a charging lion.

Pl. 890 *Berlin* F 183, pl. 4, D 186, from Ithome ('Mykonos' on an impression in Oxford). Chalcedony scaraboid (A). L.25. A Persian with a trident spear stands over a dead fox. Before him a horseman. *AG* pl. 11.13.

Pl. 891 *London* 436, pl. 7, from Cyprus. Pink chalcedony pear-shaped pendant. H.26. 1. A Persian man and woman. 2. A seated Persian woman, holding a flower and offering a rattle (?) to a child. Maximova, figs. 12, 18b. See *colour, p. 307.4*.

Pl. 892 Baltimore 42.517. Chalcedony scaraboid (C). L.27. A Persian with a spear facing a woman with a cup. A waterbird between them.

Pl. 893 Paris, Louvre A 1228. Blue chalcedony tabloid. L.16. 1. A running lion. 2. A bird. 3. A heron. 4. A rat. 5. Two quail. 6. A locust. *AG* pl. 12.20, 21; Delaporte, *Louvre* ii, pl. 107.

Pl. 894 Paris, Louvre AO 6916. Blue chalcedony scaraboid (C). L.26. A rhyton with an antelope forepart.

Pl. 895 *Berlin* F 307, pl. 6, D 198, from Athens. Blue chalcedony scaraboid (A). L.25. A dog attacks a deer. *AG* pl. 11.23; Lippold, pl. 92.10.

Pl. 896 Boston 01.7560. Chalcedony scaraboid (A). L.30. A running deer.

Pl. 897 London WA 120346. Chalcedony scaraboid (A). L.25. A running boar attacked by two dogs. *AG* pl. 11.11.

Pl. 898 Cambridge. Chalcedony scaraboid (A). L.22. A plunging bull. *AG* pl. 9.19; Lippold, pl. 90.7.

Pl. 899 *Berlin* F 310, pl. 6, D 171, bought in Athens. Chalcedony scaraboid (A). L.22. A plunging bull. *AG* pl. 11.31.

Pl. 900 *New York* 116, pl. 20. Cornelian scaraboid. L.25. A dog. *AG* pl. 12.44; Lippold, pl. 87.11; *Hesp.* Suppl. viii, pl. 35.6.

Pl. 901 *London* 547, pl. 10. Chalcedony scaraboid (A). L.33. A camel. *AG* pl. 12.49; Lippold, pl. 89.8.

Pl. 902* Leningrad 586. Blue chalcedony scarab with raised semicircular head. L.14. A quail.

THE PHI GROUP
Pl. 903* *London* 433, pl. 7. Chalcedony hemi-spheroid. L.26. A Persian woman with a flower. *AG* pl. 11.10; Maximova, fig. 11. *AG* iii, 123 mentions a scaraboid from Aegina with the same motif, but to the right.

Pl. 904 London WA 89816. Blue chalcedony cylinder fragment. H.25. A Persian horseman shoots with his bow backwards at a charging lion (paws only preserved). Wiseman, *Cyl.Seals* (London, 1959) 115.

Pl. 905 London WA 120325. Blue chalcedony scaraboid (C). L.27. A Persian horseman spears a charging boar. *AG* pl. 11.2; Lippold, pl. 65.5; Maximova, fig. 9.

Pl. 906 Paris, BN 1104. Blue chalcedony tabloid. L.18. 1. Love making, as on Munich A1432 (see *Fig. 298*). 2. A Maltese dog. 3. A deer. 4. A running dog. 5. A calf. 6. A running goat. *AG* pl. 12.15, 16; Maximova, fig. 28a.

THE GROUP OF THE LEAPING LIONS
Pl. 907 Paris, BN 6000. Blue chalcedony scaraboid (C). L.21. A leaping lion. Babelon, *Cat.* pl. 6; *Rev.Num.* ix, pl. 8.3.

Pl. 908 Paris, Louvre A 1229. Blue chalcedony scaraboid (A). L.24. A leaping lion and running fox beneath a winged sun disc. Delaporte, *Louvre* ii, pl. 107; *AG* pl. 12.2.

Pl. 909 Paris, BN, *Pauvert* 59, pl. 5. Mottled chalcedony scaraboid (A). L.33. A lion attacks a stag.

Pl. 910* Leningrad, from the Kuban, Seven Brothers' Tumulus. Chalcedony scaraboid (A). L.21. A bear. Artamonov, pl. 131.

Pl. 911 Oxford 1892. 1544. Blue chalcedony scaraboid (A). L.22. A bull, head frontal.

Pl. 912 Oxford 1892. 1477. Chalcedony scaraboid (C). L.21. A running bull.

Pl. 913 *Berlin* F 193, pl. 4, D 201. Chalcedony cut scaraboid. L.30. Two bulls playing. *AG* pl. 11.16. Compare the boars on no. 114 in the Notes, and the horses on our *Fig. 279*.

Pl. 914 Boston, *LHG* 71, pl. 5. Chalcedony cylinder. H.19. A boar.

Pl. 915 Oxford 1892. 1470. Blue chalcedony scaraboid (C). L.27. A running goat.

Pl. 916 Unknown. Scaraboid. L.24. A running goat. *AG* pl. 11.21; Lippold, pl. 92.2; Maximova, fig. 27b.

Pl. 917 Liverpool M 10542. Rock crystal scaraboid (C). L.22. A kneeling camel.

Pl. 918 London WA 119878. Chalcedony scaraboid (C). L.23. A winged bull.

Pl. 919 Cambridge. Chalcedony scaradony (B). L.25. A winged bull.

Pl. 920 Paris, BN 1089. Blue chalcedony scaraboid (C). L.27. An upright winged bull. Kloproth, *Ant.eg.Coll. Palin* pl. 30.1615.

Pl. 921 Once Morrison (32) and Warren. Blue chalcedony scaraboid. L.22. Flying bull.

Pl. 922 Paris, BN 1089.2, D 6430. Blue chalcedony scaraboid (A). L.19. A winged bull.

Pl. 923 Paris, BN, *Pauvert* 38, pl. 4, from Rome. Chalcedony scaraboid (C). L.25. A winged bull with a goat's head.

THE CAMBRIDGE GROUP
Pl. 924 Cambridge. Chalcedony scaraboid (A). L.29. Persian horsemen hunt a lion and a boar. *AG* pl. 11.1; Middleton, no. 24.

Pl. 925 Athens, Num.Mus., *Karapanos* 626, pl. 8. Chalcedony scaraboid (C). L. 23. A Persian spears a charging boar.

Pl. 926 Paris, Louvre A 1241. Blue chalcedony scaraboid (C). L.20. A Persian horseman spears a boar. *AG* pl. 12.10; Delaporte, *Louvre* ii, pl. 107.

Pl. 927 London WA 120326. Blue chalcedony scaraboid

(C). L.26. A Persian horseman shoots at a goat. *AG* pl. 11.8; Maximova, fig. 4.

Pl. 928 Leningrad 428, from Kerch. Chalcedony scaraboid (A). L.28. A Persian shoots from a quadriga with charifrom. Winged sun disc overhead. Maximova, fig. 1. Compare the lion hunt impression, Legrain, *Culture of the Babylonians* (Philadelphia, 1925) pl. 60.989.

Pl. 929 Paris, Louvre A 1242. Blue chalcedony tabloid. L.18. 1. A Persian horseman shoots at a lion. (2. A fox. 3. A bear. 4. An antelope. 5. A goat. 6. A hyena. All running.) Delaporte, *Louvre* ii, pl. 107; Maximova, fig. 27a; *AG* pl. 12.12,19.

Pl. 930 Paris, Louvre A 1243. Blue chalcedony scaraboid (C). L.17. A Persian hero fights a winged goat. Delaporte, *Louvre* ii, pl. 107.

THE WYNDHAM COOK GROUP
Pl. 931* Leningrad 587. Chalcedony scaraboid (A). L.19. A seated dog.

Pl. 932 Paris, BN M 5908. Chalcedony scaraboid (A). L.21. A lion walking. *Rev.Num.* ix, pl. 8.2.

Pl. 933* Taranto 5370 (inv. 12023), from Monteiasi. Chalcedony cylinder on a gold chain. H.27. A lion attacks a stag. Becatti, pl. 117.432.

Pl. 934 Oxford 1925. 134 (formerly Wyndham Cook Coll.). Blue chalcedony prism. L.21. 1. A running fox. 2. A running deer. 3. A heron. 4. A lizard. Maximova, fig. 28c; Lippold, pl. 88.10.

Pl. 935 *London* 537, pl. 9. Chalcedony scaraboid (B). L.27. A lion attacks a bull. Lajard, *Venus* pl. 7.3; *AG* pl. 11.24.

Pl. 936 Oxford 1925. 135. Rock crystal scaraboid (A). L.24. A dog attacks a stag. A replica is *Munich* i, 36, pl. 5.

Pl. 937 Oxford 1892. 1538. Quartz scaraboid (A). L.24. A fallen deer.

Pl. 938 Oxford 1892. 1543, from Piraeus. Blue chalcedony scaraboid (A). L.20. A bitch seizes a hare.

Pl. 939 Oxford 1892. 1242, from Persia. Blue chalcedony scaraboid (C). L.26. A running antelope.

Pl. 940 Oxford 1892. 1469, bought in Smyrna. Blue chalcedony scaraboid (A). L.21. A stag.

Pl. 941* Leningrad 589. Blue chalcedony scaraboid (A). L.17. A reclining stag.

Pl. 942 Oxford 1892. 1472. Chalcedony scaraboid (A/C). L.24. A horned deer suckles a fawn.

Pl. 943 *Munich* i, 281, pl. 33. Chalcedony scaraboid. L.25. A running goat. Lippold, pl. 92.1; Maximova, fig. 27c.

Pl. 944 Oxford 1921. 1224. Chalcedony scaraboid (A). L.22. A boar's head.

Pl. 945 Paris, Louvre A 1234. Blue chalcedony scaraboid (C). L.23. A running boar. *AG* pl. 12.7; Delaporte, *Louvre* ii, pl. 107; Lippold, pl. 93.8.

Pl. 946 Boston 01.7564. Chalcedony scaraboid. L.20. Two quail.

THE TAXILA GROUP
Pl. 947 Bonn, Müller Coll. Chalcedony scaraboid cut on the back. L.12. A lion attacks a stag.

Pl. 948 London, Bivar Coll. Obsidian (?) tabloid. L.16. A stag.

Pl. 949 Cambridge, from N.W. India. Chalcedony scaraboid with convex face (A). L.15. A lion, with swastika and 'taurine' device. The creature has the multiple dots on the haunches as on *Figs. 303–4*.

Pl. 950 Cambridge, from N.W. India. Brown chalcedony round scaraboid (B). L.12. A man (Greek ?) and a Persian woman holding a wreath. This seems provincial Achaemenid.

OTHER HELLENISING GEMS
Pl. 951 London, Bard Coll. Chalcedony scaraboid (C). L.28. Erotes seated on rocks playing pipes and a triangular harp. *Southesk* i, pl. 17.O.39; Sotheby, 28.vi.1965, lot 75.

Pl. 952 Athens, Num.Mus., *Karapanos* 233, pl. 4. Blue chalcedony scaraboid (C). L.18. A bitch suckles a child. Compare coins of Kydonia, Babelon, pl. 261.5–8.

Pl. 953* *London* 491, pl. 8, from Asia Minor. Chalcedony scaraboid (A/C). L.30. A warship in the form of a dolphin and heron (?), with warriors. For ships like fish see *Symb. Litt. . . Julii de Petra* (Naples, 1911) 70f.

Pl. 954* Leningrad 574. Blue chalcedony scaraboid (C). L.25. A kneeling warrior with pilos helmet.

Pl. 955 Athens, Num.Mus., *Karapanos* 464, pl. 6. Chalcedony scaraboid (A). L.24. A seated sphinx.

Pl. 956 *Geneva Cat.* i, 208, pl. 80. Chalcedony scaraboid (A). L.30. A sphinx with a pilos helmet (?).

Pl. 990 Munich A 1421, from Mersin. Silver (VII). L.20. A Persian woman seated. *MJBK* 1951, 8, fig. 3.

Pl. 991* London WA, from the Oxus. Gold (VI). L.22. A Persian woman seated. *Oxus*, no. 103, pl. 16.

Pl. 992 Baltimore 57.1007. Bronze (VI). L.19. A Persian horseman pursues a stag. *Robinson* no. 44, with pl.

Pl. 993 *London R* 1244, pl. 30. Bronze (VI). L.22. A winged horned lion.

Pl. 994 *London R* 1245. Bronze (VI). L.24. A winged bull.

Pl. 995 Istanbul, from Sardis, tomb 381. Gold (VII). L.14. A lion. *Sardis* xiii. 1, pls. 9, 11. no. 92.

Chapter VII

HELLENISTIC GREECE AND ROME

Alexander's conquests in the east and Egypt, and the subsequent division of his empire at the end of the fourth century BC, not only reopened to Greece the resources of distant lands, but meant that the Greek homeland, and even Macedonia, Alexander's home, were no longer the sole arbiters of Greek taste and centres for the arts. New Greek kingdoms and courts in Asia Minor, Syria and Egypt afforded a new patronage, from which the cities of old Greece, Athens and Corinth, could at times benefit, but with which they could rarely compete. In Italy and Sicily the Greek cities were strong and wealthy, but increasingly they had to contend with pressure from Etruscans, Carthaginians, and Romans. By the beginning of the first century BC Roman arms and Roman government had encompassed virtually all Greek lands and were soon to rival the extent of Alexander's empire in the east.

Throughout this 'Hellenistic' period Greek artists refined those skills which had been developed fully in the fourth century, in a movement which was not so much a logical progression from the past as a series of experiments in expression, narrative or portraiture, based on what had already been achieved. It is a period before which most art historians flinch, so involved are the problems of style, date and provenience. The idiom was that which was carried by Greek artists into the most fully 'classicising' period of early Roman art, with only the slightest changes or innovations in techniques, forms and subject matter. The difficulty of disentangling the true Hellenistic from the classicising early Roman is felt acutely in the study of gem engraving. In most respects—style, subject and shape—Hellenistic gems have more in common with what follows than what went before, but there are some classes which can be confidently dated. Any account of Roman gems has perforce to begin with the Hellenistic. But equally, no account of Greek gems can be complete without at least a glance at what was done in the Hellenistic period and how the continuity of the Greek tradition was achieved. This chapter is accordingly devoted to a summary account of Hellenistic gems and rings and of the period of transition to early Roman art.

Purely stylistic considerations avail little in the problems of chronology. We have reason to be grateful, therefore, that in South Russia, North Greece, Asia Minor and Italy there have been a number of graves excavated, containing gems and other materials datable to the third and second centuries BC—not as many as we could wish, but enough to enable identification of some purely Hellenistic groups and shapes.

Among the stone gems the most distinctive shape was the large oval ringstone with a convex face. The basic form was that of the ringstones which had already appeared by the end of the Archaic period, but the Hellenistic form owes as much to the fourth-century scaraboids whose convex backs were being more and more often occupied with intaglio devices in preference to their flat faces. Eliminate the scaraboid walls and perforation and you have a Hellenistic ringstone. There are, of course, some borderline cases in this transition, and a few earlier scaraboids which attract Hellenistic subjects added on their backs. An example is the eagle and thunderbolt (*Pl. 996*), a Ptolemaic dynastic blazon, which was cut on the back of the Greco-Persian stone shown on *Pl. 862*. The Hellenistic gems were mounted immobile on a hoop similar to those used before for the ringstones, or, as is more often the case, on a hoop with a spreading flat bezel, resembling the large metal finger rings of Type XI, but providing for the stone a broad frame,

which may be flat or stepped. The engraved surface was often extremely rounded, giving the artist a good opportunity to exploit the depth of the stone for intaglios which yield high relief impressions. Advantage was not always taken of this, however, and many devices are quite shallow and summarily cut on the broad curved field. These stones are not easy to view in original, nor do they easily give good impressions, especially when the intaglio is deep and, at the edges, partly undercut. Mounted, they rely very much on a gold foil backing to reflect light through them. Unmounted, they may sometimes be satisfactorily viewed and photographed with the light shining through them. The oval is the commonest shape, but round stones also are found, and the convexity of the surface may sometimes be quite slight. Thus, on *Pl. 997*, an excellent head of Poseidon is shown on a circular sapphire with an almost flat face. The features closely resemble those of the god on coins of the Macedonian king Antigonos Doson (reigned 229–220 BC). While on *Pl. 998* a portrait of Alexander the Great, wearing the rams' horns which assimilate him to Zeus Ammon, is deep cut on a circular quartz, giving exceptionally high relief in impression. The interest in portraiture shown by contemporary sculptors is shared by the gem engravers, and this is the first time that portrait gems of notables and private persons must have been regularly bespoken.

Since Alexander is equated with a deity on *Pl. 998* the gem was probably, although not necessarily, cut after his death. The type is close to that which appears on the coins of his immediate successors, especially Lysimachos. The eye in particular is treated as on the earliest portrait coins. We could well believe that it derives from the work of Pyrgoteles, who was the only artist allowed by Alexander to carve his portrait on gems (or so Pliny and others tell us). Could our gem be by Pyrgoteles himself? It is by no means impossible, and the gem would be hard to fault in execution or quality. When we look for a signature there is a tiny inscription below the cut-off of the neck, observed only after the stone had been in Oxford for over seventy-five years. In a story-book ending it should read Pyrgoteles, or some abbreviation of the name, in Greek, since its unobtrusive size and position make it look most like a signature and not at all like an owner's name which would have been more conspicuous. But in fact the inscription is even more intriguing since it appears to be in the Kharosthi script of North West India. It could still be contemporary with the gem. In 326/5 BC Alexander met the young Chandragupta who was to inaugurate the Maurya dynasty, take over the territory won in India by Alexander and deal with the courts of Alexander's successors. His grandson Aśoka encouraged Greeks to settle in India and in a bilingual inscription at Kandahar, in Greek and Aramaic, exhorted his subjects to the good life. Unfortunately the inscription on our gem so far resists plausible reading, but it is easy to understand the circumstances in which it might have been made.

Circular or broad oval stones were normally chosen for busts or heads, and the more convex stones give opportunities to cut frontal heads without serious foreshortening of features. Some more conventional heads are the portrait of a Ptolemy on a convex amethyst (*Pl. 999*) and the elderly man wearing a fez-like cap on a flat garnet (*Pl. 1000*). On the longer oval stones full figures are generally preferred. They are commonly deities or unidentified women, often leaning on pillars (as *Pl. 1002*). We soon recognise the familiar Hellenistic type in the women—with tiny heads, small breasts, heavy hips, and the long overfall of the peplos spreading below the belt, or the legs swathed in a himation. The male figures are softly modelled and effeminate, Apollo (*Pl. 1001*) and Dionysos being firm favourites. There is considerable variation in quality and depth of cutting on these stones and it is tempting to assume that the more exaggerated proportions are the later. The more elaborately cut stones are well polished, unlike the usual Classical intaglios.

Other mythological subjects were usually treated as single figures, or heads and busts, rather than in set groups, and we miss the many heroic devices of earlier years. The more involved compositions are favoured only in Italy, and generally on smaller ringstones with flat faces, which are not here our concern.

Two examples of popular devices are illustrated. The back view of the head and bare shoulder of a girl on *Pl. 1003* is one often repeated in the Hellenistic and early Roman periods. She has been called Galene, a swimming nymph, because an epigram described a gem showing her. But the description does not fit, and an example of the motif in the Ionides Collection has a sickle moon by the head, which suggests that this may be the moon goddess, Selene, emerging from or descending beyond the horizon. The figure identified as Selene on the Great Altar at Pergamum is shown from the back, head in profile and one shoulder bared. On *Pl. 1004* a naked Kassandra seeks refuge at Athena's statue in a pose appealing both for the pathos of the situation and the sensitive modelling of the nude. Contrast the more violent Classical treatment on the ring, *Pl. 709*, or the fourth-century gem, *Pl. 591*. On our stone all is calm and the emotion is expressed in the rendering of the pose and the figure.

It is necessary, however, to be wary of being over-dogmatic about what can or did appear in Hellenistic art and on gems. Many a 'Roman' motif has proved to own a Hellenistic model, and many a 'Hellenistic'—as we have seen—a fourth-century one. Impressions on clay loomweights do not afford the variety of evidence now that they did for the Classical period, but there are several hoards of sealings of Hellenistic date which indicate the possible range. Most are from the Seleucid east, but a hoard from Selinus in Sicily has a terminal date of 249 BC, and one from Cyrene in North Africa, although Roman, is thought to include impressions from late Hellenistic stones. Some late fourth-century amphora handles from Samos, impressed by finger rings, show how early some 'Hellenistic' motifs may appear.

Alexander allowed only Pyrgoteles to cut portraits of him on gems, but no signatures of the master seem to have survived. Miss Vollenweider suggests, however, that we might so restore the *Py* on *Pl. 997*, whose quality would not disgrace him. Inscribed gems do give us the names of a number of Hellenistic engravers, in neat small letters whose forms sometimes given an independent indication of date. Towards the end of the Hellenistic period the letters are regularly cut with a small blob at the end of each stroke.

The materials employed for Hellenistic gems include all those which were in use in the Classical period, but to them is added a number of translucent coloured stones, especially suitable for ringstones, and acquired from the east. Of these the most important are amethyst and the commoner garnet, but there was a whole range of coloured stones which remained current in the Roman period: beryl, topaz and zircons. Many of these new materials were already known to Theophrastus as gem stones before the end of the fourth century (see below, p. 373) and no doubt some surviving examples of intaglios in these stones are as early, although the tendency is to regard them all as 'Greco-Roman'.

Large all-metal finger rings continued in fashion at least in the third century BC and the most important class of these, with round bezels, has been considered already, in Chapter V, as the logical successor to the Greek series. There are a few other large Hellenistic rings worth showing here, as tokens of the finer work. The main preoccupation was, as we might expect, with portraiture. A famous ring from Capua, now in Naples (*Pl. 1005*), is remarkable both for its technique, with the gold intaglio plaque set into the massive gold hoop, and for the fact that it is signed by the artist Herakleidas. The vigorous portrait is taken to be that of a Roman, and Miss Vollenweider has suggested the identification of Scipio Africanus.

By way of contrast another signed portrait, by one Ph]ilon (*Pl. 1006*) and on a silver ring, is less dramatic, more idealising. The difference between this and the head by Herakleidas might be a matter of date or the temperament of the sitters, but it also reflects, even if accidentally, a difference observed in other works between the styles of a Roman Italy and a Hellenistic Greece, and the silver ring is said to be from Athens. A gold plaque in London (*Pl. 1007*) may have been for insertion in a bezel, as on the Herakleidas ring. It carries a good portrait head of the philosopher Epicurus (died 271/0 BC).

Alexandria, and Egypt under the Ptolemies, seem to have stimulated local studios of gem and ring engraving. This we have to judge less from the finds made in Egypt, than from the many surviving

portraits of the Ptolemies and their ladies. The rings (our Type XVII) hark back to the older Egyptian cartouche rings in the shapes of their heavy hoops, but they acknowledge the new Greek fashion with broad oval or sometimes circular bezels.

A fine gold ring from Tarentum (*Pl. 1008*) carried a portrait of the Ptolemaic queen Berenike II (died, 221 BC) while an iron ring in Oxford with an inset gold intaglio (*Pl. 1009*), shows an older woman, probably Berenike I (died in the 270's BC). Among the male portraits I show a ring in Paris (*Pl. 1010*) with one of the later Ptolemies, not certainly identified. There is another gold intaglio in Paris showing the same king, but wearing the double crown of Egypt. This more specific reference to Egypt leads us to rings showing deities, and especially to a London ring (*Pl. 1011*) where Sarapis and Isis are represented in exactly the manner of a Ptolemaic king and queen. Indeed the Isis head may be a portrait. A number of other, generally smaller rings, which are probably also Ptolemaic in date, have heads or busts of Isis in a more frankly Egyptian manner, but not without influence from the Greek portrait rings (as *Pl. 1012*).

The principal innovation of the Hellenistic period in the field of gem cutting was the invention of the cameo or relief gem. The cameo became most important in the early Roman period, and since the devices were not cut in intaglio, and so could not be used for seals, we are excused from a detailed consideration of them here. But the form and technique are inspired by intaglio cutting, and many cameos were set on finger rings or pendants, like the intaglio gems. Finds in South Russia and a number of Ptolemaic motifs indicate that the first were probably being made in the third century BC. They are not a logical development from any of the types of decorative gems or rings which have been considered already, but all the elements of their form had appeared before. Relief gems were known in the Archaic period, pseudo-scarabs have relief figures or heads on their backs, and several of the types of metal signet ring have their more decorative equivalents with relief devices. What distinguished the cameo was the use of a banded stone so that, at its simplest, the subject stood in relief in pale stone on a dark background. The banding of the stone had rarely been observed or exploited hitherto. For an onyx scarab the banding may be deliberately set horizontally or, once, at an angle to display different parts of the beetle in different colours (*colour, p. 203.6*); there are rare examples from Etruria of a paler band on the back being carved with a figure in relief (if all such are indeed ancient). The straight banded onyx was the usual material for cameos and this, before the Hellenistic period, had been rarely used. For simpler pieces the softer surface patination of any dark stone of the chalcedony or quartz family could be used for the figure relief. This can sometimes be quite deep (observe broken flint pebbles) and may account for more ancient cameos than is generally credited. And it is easy to imitate the banded stone in glass.

Once Rome had won control of Greek lands the artists of the Hellenistic kingdoms had to look to new patrons. Gem engraving had been prized in the eastern courts. King Mithradates had made a collection which Pompey the Great brought to Rome and dedicated on the Capitol. Not only the stones but the artists went west, persuaded or pressed into the service of generals, governors, eventually emperors. There was a flood of Greek slaves into Italy from the east, especially after the establishment of the Roman port on Delos, and with the slaves were counted artisans and craftsmen.

Most of the signatures on gems of the early Roman period are in Greek and with Greek names. If many Roman artists learned the craft, most of them must have been as ready to adopt a professional Greek name as an English hairdresser does a French one. Their techniques, materials and subjects, as well as the shapes of their gems and cameos, remained basically Hellenistic Greek, presenting those difficulties of dating which have been remarked. There had, moreover, been flourishing workshops throughout the Hellenistic period in Italy producing the 'Italic' and Republican gems, generally flat ringstones with portraits or commonplace Hellenistic subjects, as well as some derived from the older Etruscan tradition. But there are some easily defined new features which can be detected—portraits of identifiable Romans

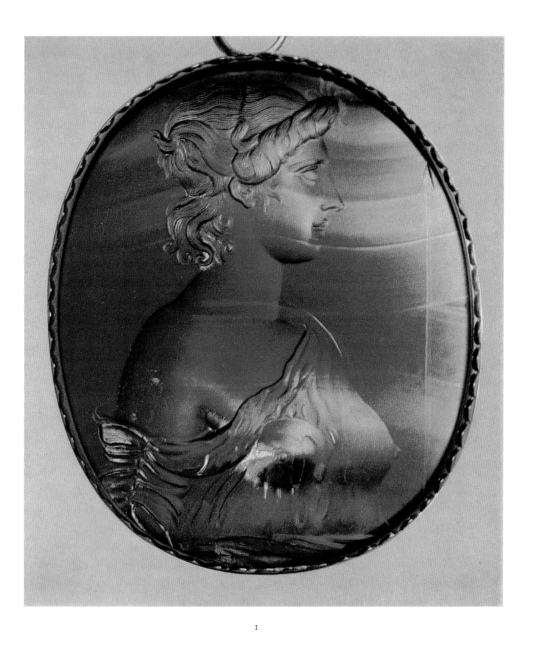

1

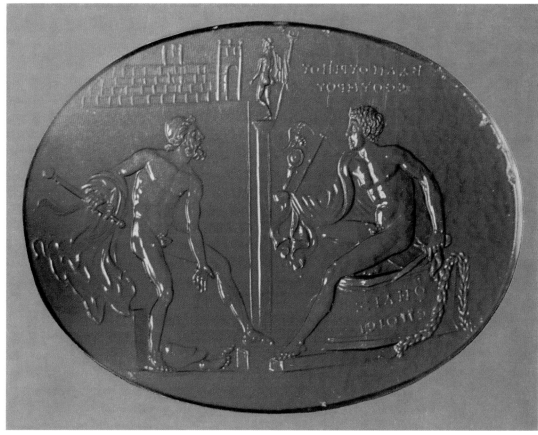

2

of the late Republic and early Empire, subjects determined by a symbolism which we can only interpret in the light of Roman coin devices, and a readiness to attempt multi-figure groups, which may be a legacy of the Republican and Italic workshops. From the point of view of style the better intaglios display a dry miniaturist precision which matches the most classicising works of early Roman art in clay or stone, but stands in contrast to the broader, more supple and impressionistic treatment of the Hellenistic gems from Greece and the east.

Four pieces only are shown here to illustrate the characteristics of this period. The first is a portrait of Mark Antony (*Pl. 1013*) signed by the artist Gnaios, who seems to have worked at first in Alexandria, and may later have travelled west, with Antony's daughter, to the kingdom of her husband, Juba II of Numidia (Algeria), who was himself a gem connoisseur. The style here is still broadly Greek, somewhat idealising the features which are rendered more brutally on coins.

The second (*colour, p. 363.1*) is one of a pair of agate pendant plaques. Its mate, which is incomplete, is in the Ionides Collection, and carries a bust of Augustus, characterised as Hermes/Mercury by the caduceus before him. The complete plaque shown here has a bust of his sister Octavia, identified as Artemis/Diana by the hunting spear set in front of her. Miss Vollenweider has attributed the pair to the artist Solon. This is the dry, precise and shallow cut style of the best first-century BC engraving. The identification of emperors and the members of their family with deities came easily after the aspirations of Alexander and the Hellenistic kings.

Hyllos, son of the famous engraver Dioskourides, was a prolific artist to judge from the surviving signed stones and those plausibly attributed to him. He signed the fine gem with a lion shown in *Pl. 1014*. The subject was common enough in Classical Greece but then the unfamiliar creature was subjected to a variety of stylisations. Hellenistic artists were better aware of the beast's appearance and the new types in Greek and early Roman art are realistic.

Finally, the Felix gem (*Pl. 1015; colour, p. 363.2*), now in Oxford: another large plaque, of cornelian, cut in the same dry detailed manner as the Octavia. The scene is a sanctuary outside the walls of Troy— a sanctuary of Poseidon to judge from the figure on the column. Diomedes has escaped from the city with the sacred image of Athena, the Palladion, and with drawn sword he leaps over an altar. Odysseus is waiting for him, and he indicates with his right hand the legs, which are all we see, of a body which is presumably that of a priest (not a soldier, to judge from the dress), whom he has dispatched. This is one of the most explicit representations of an episode commonly treated in excerpts with single figures. We have seen a Classical Diomedes (*Pl. 596*) tiptoeing from Troy with the Palladion. His pose on the Felix gem is the usual one in Hellenistic and later art, and may be borrowed from the pose of a Neoptolemos or Orestes, taking refuge at an altar. With Diomedes the action and the intention are different. It is almost a dancing step and it may not be wholly wrong to recall here the 'Trojan leap' or Pyrrhic dance, which is referred by ancient writers to Neoptolemos at the altar, or leaping from a horse. The kicking step is well attested for the Pyrrhic, but in art only Diomedes is shown in a pose like this and in a Trojan setting. There are Classical precedents too for the Odysseus with a foot raised (as our *Pls. 535, 537*) although here the gesture with the hand is a little obscure and the slaying of a priest is given unexpected prominence. The implication of a double sacrilege, in the sactuaries of both Athena and Poseidon, may be intentional. The whole detailed architectural setting with the two heroes and two statues, is for a gem engraver something new, although he is still bound to earlier models for his human figures.

The owner's name, Calpurnius Severus, appears above Diomedes. The artist's signature appears on the altar. His name is Felix, probably the Felix named in an inscription from Rome as a freedman gem engraver. But both the name and the signature are written in Greek—sufficient indication that whatever the changes in patronage or iconography, the Greek tradition in gem engraving is still dominant.

996

4:1

997

4:1

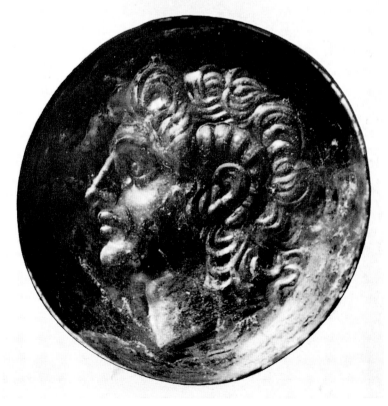

998

4:1

999

1000 4:1

1001 4:1

1002 4:1

1003 4:1

1004 4:1

1006 3:1

1005
2:1

1007
4:1

1008 4:1

1009 3:1

1010 4:1

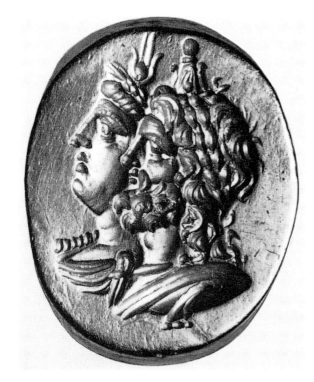

1011 4:1

1012
5:2

1013 4:1

1014 4:1

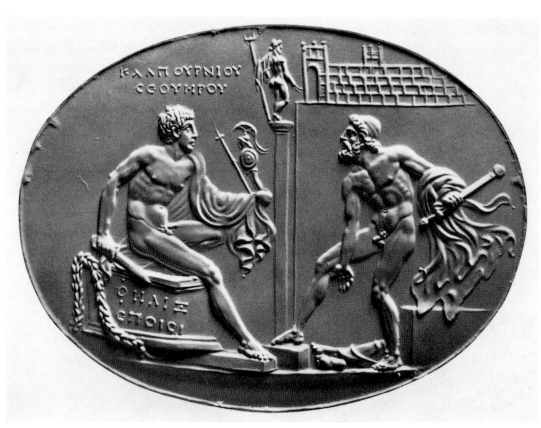

1015 4:1

LIST OF ILLUSTRATIONS TO CHAPTER VII

Measurements are given of the maximum dimension of the intaglio face, in millimetres

COLOUR PLATES

BLACK AND WHITE PLATES

**Asterisked numbers indicate that the piece is illustrated in original. All other photographs show impressions*

Mus.Helv. xv, pl. 2.2; Coche de la Ferté, *Les bijoux antiques* (Paris 1956) pl. 26.3; Richter, *Portraits* fig. 1837b.

Pl. 1011* *LondonR* 95, pl. 4. Gold ring (XVII). L.21. Busts of Sarapis and Isis. On the type see Möbius, *Alexandria und Rom* (Munich, 1964) 16ff. and *Munich* i, on no. 374.

Pl. 1012* London, Victoria and Albert M38–1963 (once Wallis Coll.). Gold ring (VIII). L.19. Bust of Isis with the vulture headdress supporting horns and disc. Compare portraits of Arsinoe II, Richter, *Portraits of the Greeks* fig. 1828.

Pl. 1013* London, *Ionides* no. 18, pl. 6 and p. 19. Amethyst ringstone with a convex face. L.16.5. The head of Mark Antony. Inscribed *Gnaios*. On Gnaios see Vollenweider, 45f. and *Ionides* 27f., 93f.

Pl. 1014* Nicosia. Cornelian ringstone. L.22. A lion. Signed *Hyllou*. *JHS* lxxiv, pl. 11a; Vollenweider, pl. 77.6; on the artist, ibid., 19ff.; *Ionides* 30f.

Pl. 1015 Oxford 1966. 1808. Cornelian, with a flat face. L.29. Diomedes with the Palladion and Odysseus in a sanctuary of Poseidon outside the walls of Troy. For a fuller description see the text. Inscribed in Greek over Diomedes, *Kalpourniou Seouerou*, and on the altar *Phelix epoiei*. *AG* pl. 49.4; Lippold, pl. 42.5; Vollenweider, 44 (on the artist) and pl. 39.1, 2; *Rev.Arch.* 1968, 282, fig. 1 (and for cameo copies in Paris). On the representation see Hackin, *Nouv. Rech. à Begram* (Paris, 1954) 130–133; *Ionides* 33f., 98 on no. 46. On the Trojan leap, Borthwick, *JHS* lxxxvii, 18ff. See *colour, p. 363.2*.

Chapter VIII

MATERIALS AND TECHNIQUES

It is not easy for us to judge the relative value in antiquity of the materials employed for gems and finger rings. The precious metals, gold and silver, are the most readily assessed, since for gold and silver coinage the coin weight was closely related to (although not necessarily exactly the same as) the face value. Most of the stones used in Greece are, by our standards, semi-precious, but it is likely that they came from overseas and that this, as well as the extreme difficulty of working them, enhanced their value. What we regard as the most precious stones are also generally the hardest and would have been avoided in Greek antiquity for this reason. This applies to stones like emerald, sapphire and ruby, but after Alexander and under the Roman empire a greater variety of harder precious stones was exploited, and we may believe that the techniques for cutting them were perfected in the west rather than in their eastern homelands. A few stones which were not difficult to work were always prized for their extreme rarity, like lapis lazuli, only obtainable from the mines of Afghanistan. All the soft stones were come by in Greece. A few of the commoner quartzes and chalcedonies could also be found there, but most must have been imported from richer sources far to the east and south, by such tortuous and undocumented ancient routes as, from another quarter, could bring Baltic amber or Cornish tin to the Mediterranean, yet never allow producer and ultimate customer to meet.

When we seek ancient authority for the sources, use and description of these stones our best guide is Pliny the Elder. He wrote his *Natural History* in the first century AD, finishing it barely two years before he died in the great eruption of Vesuvius which overwhelmed Pompeii. The 37th book of his work is devoted to a study of gem stones, based on various authorities, most of them Greek, philosophers or writers of the Roman period, but including the kings of Cappadocia (Archelaos) and Numidia (Juba), a Mithradates who may be the eastern king whose cabinet of gems Pompey the Great brought to Rome, and the courtier and collector, Maecenas. He gives an account of the history of gem engraving and collecting, and describes the stones, with comment on their names, sources and properties, real and imagined.

A major authority for Pliny was Theophrastus, the philosopher and pupil of Aristotle. He wrote his *Book on Stones*, which contained a basic classification of all minerals, at the end of the fourth century BC, and was already able to profit from knowledge of eastern sources which had been made accessible by Alexander's conquests. His study was based mainly on observation and experiment. Pliny draws heavily upon it and from it he derives, for instance, the highly philosophic notion that in gemstones too there are male and female. He describes many stones as being used for seals. Most of the varieties are those familiar to us in the Classical period, although identification is not always easy. Some, however, are more commonly referred to the Hellenistic or Roman periods when used for engraved gems, and his knowledge of them is a precious indication that surviving gems of these materials need not all be considered late. The stones in question are garnet and possibly tourmaline.

Books about gemstones probably only became popular with the new Roman patronage in the first century BC. One of Pliny's sources, for instance, was King Juba II of Numidia, a connoisseur who may have been the patron of the engraver Gnaios (see p.365) in his later career.

MATERIALS

The following pages are devoted to a survey of the principal stones employed for intaglios from the Greek Bronze Age down to the period of Alexander, before his eastern conquests brought west a considerable new range of translucent stones for ring bezels. In particular an attempt is made to define the main periods of use of each stone, since this may be of some service in identification and it is relevant to any historical account of the subject. Their hardness according to Moh's scale is given: stones of hardness 2.5 can be marked by a fingernail; of 4 by the edge of a 'copper' coin; of 5.5 by broken glass; of 6.5 by a steel file; diamond is 10.

First, the softer stones which do not require mechanical cutting aids (although they may often be used), but which can be worked by hand with blades or points of any harder stones or iron.

STEATITE is a term often met in catalogue descriptions. Real steatite is a massive talc which is extremely soft (hardness 1) like meerschaum. It is doubtful whether real steatite was ever used in Greece for seals, and the use of the word may be due to Pliny's knowledge of it. Provided this is understood 'steatite' can still be used for the softer white, black and green stones, to which earlier writers have generally applied the term. Most of these are in fact SERPENTINES (hardness 2.5 to 4) or altered rocks. Mottled, streaked or plain in markings; white, green and grey or black in colour; usually smooth, but sometimes granular in texture; these are the commonest of the softer stones used for ancient gems. They were readily accessible in the Greek world but the distinctions of colour, not composition, are significant of date and origin, and they are discussed here by colour: *White*. In the Bronze Age this seems to have been used as an alternative to ivory for stamp seals of the Pre-palatial Mesara Group and some figure seals of the Early Palace period. It recurs later for some Geometric seals, in the Island Gems and the Sunium Group. The source was probably an island one. *Red-grey mottled*. This seems most characteristic of Geometric and Early Archaic seals from the Peloponnese and is perhaps to be taken for an Argive speciality. A plain deep *red* and *yellow* are occasionally found in the Bronze Age and Early Archaic period. *Green*. With the green serpentines minor colour distinctions are important. In Bronze Age Crete a green, often mottled serpentine is used almost exclusively for the Archaic Prisms (*colour, p. 29.1, 2*) of both the Prepalatial and Early Palace periods. It is little used later, but the Early Archaic 'Amulet Seals' of Rhodes are of a very similar material. Various greens are used in the Geometric and Archaic periods, but the most important class is the pale green, usually translucent, which is the characteristic material for Island Gems (*colour, p. 115.5, 6*) and was probably to be found in the islands, possibly on Melos. The same material had been used in the islands in the Bronze Age for some very early stamps, and for a few late lentoids and amygdaloids of Mycenaean type. The stone can be hardened by fire, taking on a white surface. A very pale green stone which takes a high polish with wear was available in Cyprus. It can be yellowish or blue-green in tone. It was used for a number of conoids and stamps of various shapes in the island at the end of the Bronze Age and early Iron Age, and for a small group of Archaic pseudo-scarabs. *Black* or *grey*. This is by far the commonest material for Near Eastern stamp seals from the North Syria area which, for their style, might easily be taken for Geometric or Early Archaic Greek work. Where style, however, is ambiguous, shape generally is not. Black or grey serpentine ('steatite') was used occasionally throughout the Bronze Age in the Aegean world, but it is the dominant material in LM/LHIIIB. It recurs seldom in the Geometric and Archaic periods, when it can usually be taken to indicate a Cypriot origin, since this is the material for most of the island's Archaic stamps and scarabs, and it is rarely used for seals cut in more thoroughly Greek style.

374

The engraver's adoption of harder stones for gems marked important stages in the history of his craft both in the Bronze Age and in Archaic Greece. None of those to be described now were in use before the period of the Early Palaces in Crete (MMII) or before the Late Bronze Age in Greece; very few were still being cut in LM/LHIIIB; while in the Iron Age they are not again worked until the second quarter of the sixth century. The vast majority of the harder stones are quartzes (hardness 7).

Of the crystalline quartzes by far the commonest is the completely clear ROCK CRYSTAL, which the Greeks took for a form of petrified ice. This was obtainable in Greece and deposits are known in Crete. It was quite often used by Minoan engravers and recurs in the Archaic and Classical periods for scaraboids; not usually for scarabs since the clear stone did not reveal details of carving. Rarely, in the Archaic period, the natural hexagonal crystal was employed.

Of the coloured crystalline quartzes only AMETHYST is important. The bluish-violet colouring may be due to traces of manganese and may permeate the whole stone or appear only as blotches within the clear quartz. It acquired its Greek name from its reputation as a specific against drunkenness. The stone seems to have been regarded as particularly precious and in the Bronze Age is more often used for beads than seals. The Vaphio warrior had a necklet or pectoral of eighty amethyst beads. When used for a seal it is often reserved for an uncommon shape, like the pendant on our *Pl. 74*, and is most uncommon in Archaic and Classical Greece. It is more often found in the Hellenistic and Early Roman periods, when it is preferred for some of the finer portrait gems.

The crypto-crystalline quartzes are far commoner than rock crystal or amethyst. They can be broadly divided into the chalcedonies, which are in varying degrees translucent, and the jaspers which are opaque. Chalcedony, like flint, which is of the same family, will emit sparks when rubbed and this property may have enhanced its use as a gemstone.

CHALCEDONY is milky or grey in colour, sometimes blotchy but usually evenly coloured and rather waxy in appearance. It was used occasionally in the Bronze Age but in the Late Archaic and Classical periods it becomes the favourite material for scaraboids. BLUE CHALCEDONY (*colour, p. 203.7*), with varying intensity of colour, was favoured for Assyrian and Babylonian stamp seals. It remains most popular in the east and was preferred to the plain chalcedony for Greco-Persian scaraboids, but was also often used in the Classical Greek studios. It is sometimes described as 'sapphirine'. A chalcedony which was *pink* or rosy in colour was favoured for some Greco-Persian stones (*colour, p. 307.4*), especially for the later gems from the eastern empire.

CORNELIAN is red, reddish brown, or brown (when the term SARD is often employed), and a reddish yellow cornelian is used for many later ring stones. There are varying intensities of colour in the stone. The name is derived from Latin *cornum*, a red berry, but the false etymology from *carnis*, 'flesh', has popularised the spelling 'carnelian'. Sard is named from Sardis, the Lydian capital, though the stone was very rarely used for the one group of stones (of Persian period) which we may be sure were made there. Cornelian was a popular stone in the Bronze Age and especially favoured for the Talismanic gems of the Late Palace period (*colour, p. 39.8–10*). It is the dominant material for Archaic gems (*colour, p. 149.1–4, 6*), and remains about equally popular with chalcedony through the Classical period, although not generally for the Greco-Persian stones. All the Classical lion gems and nearly all the ringstones are in cornelian and almost all Etruscan scarabs. 'There was no gem stone more commonly used by the ancients'—Pliny.

The banded translucent chalcedonies are agate, onyx and sardonyx. AGATE has parallel wavy or concentric bands of varying width and colours, including grey, white, brown, red or yellow. The name derives from the River Achates in Sicily, one of its ancient sources, although certainly not the earliest. The type with a predominantly grey banding was especially favoured for lentoids in Late Bronze Age Greece and to a lesser extent in Crete (*colour, p. 49.4, 5*), where a greater variety of agates is seen—with

paler bands, like the flesh of raw fish, or with livid red bands (see *colour, pp. 49.12; 49.2, 3, 9*). Agates are used throughout the Archaic and Classical periods, especially the former, and are preferred for Classical sliced barrels (*colour, p. 203.2, 5*) and cylinders. The bands of ONYX are straighter and thicker, usually of dark brown and white, or red and white (when it may be called SARDONYX). The word means 'finger nail'—a reference to the colour of the pale bands. The emphatic colouring rather discouraged its use for tiny objects and it was little used in the Bronze Age although the Mycenaean workshop in Thebes seemed to be well supplied with onyx and agate. It has been suggested that the banding of agates or onyxes was observed and deliberately exploited in placing the intaglios on some Bronze Age gems. But these were not cut to be viewed in original, and the many occasions on which the banding is not exploited shows that it was never a regular practice. The few apparent exceptions may be fortuitous, although they may have been as readily admired in antiquity as they are now for this accidental enhancement. Onyx was even less often used in the Archaic and Classical periods although the Etruscans cut it for several scarabs and the banding was exploited for one Greek scarab back (*colour, p. 203.6*). The stone comes into its own for cameos.

The opaque JASPERS are readily distinguished from the serpentines, which may be of similar colours, by being harder, more homogeneous and cleaner in fracture. *White* jasper is often described as chalcedony, but the wholly opaque variety should be distinguished. Its use was as that of chalcedony. *Green* jasper was little used in the Bronze Age, mainly in Palatial Crete. It is the commonest material for Phoenician, Greco-Phoenician and Greco-Punic scarabs from the second quarter of the sixth century on, and there was occasional earlier use for it in the east. There are a few Archaic Greek scarabs in the material. *Yellow* jasper is sometimes used for Minoan gems (*colour, p. 29.7*). *Red* jasper (*colour, pp. 39.6; 49.8*) is somewhat commoner than the green in the Bronze Age and considerably less common in the Archaic period, when it is unknown for purely Greek work. *Black* was used sporadically in the Bronze Age, Archaic and Classical periods. There is a small group of fourth-century scaraboids in the material. *Mottled* jasper (*colour, p. 307.5*), with small patches of red, white, black and yellow, is seen occasionally, and seems to have been sought out for some scaraboids of the period of Dexamenos and just afterwards.

It will be observed that certain varieties of the quartzes discussed were especially favoured in particular periods or workshops. This may indicate significantly different origins for the materials but not necessarily so, since a specific demand would be readily satisfied from whatever source. There is no particular reason why any of the varieties should not have been used in any of the periods when these hard stones were being cut. This is equally true of the more exotic varieties, usually green in colour, of which only very few specimens are met in any period. Translucent examples are MOSS AGATE—a green with dendritic inclusions; CHRYSOPRASE—cloudy apple green; PLASMA—mottled green. An opaque example is BLOODSTONE (or heliotrope)—green with red flecks: 'dropped into a pail of water it, by reflection, transforms the sunlight to the colour of blood'—Pliny.

Some general considerations about the quartzes have to be kept in mind. Sometimes it is not possible to make a simple identification because the stone can appear to be, for instance, mainly cornelian or jasper but with distinct clear patches. The impurities which produce the variations in colour and translucency may not be evenly distributed through the stone but may appear in either vague or clearly defined masses. 'Burnt chalcedony' or 'burnt cornelian' is commonly read in descriptions. It can properly be applied to any chalcedony which has suffered damage by fire. Too intense heat will blacken and destroy the stone, but many gems from the pyres of South Russia are simply discoloured to a dull opaque grey and several cracked all through (see *Pls. 531, 600*). Many must have been destroyed completely. A white or grey stone which is not cracked has probably not been burnt, but is a poor chalcedony or jasper. A different discoloration, sometimes attributed to burning, is the patination or 'drying out' which a dark quartz may suffer from exposure, acquiring a softer white or grey surface. This is probably most familiar to us on

376

flint pebbles. The soft pale surface can be exploited for the cheaper cameos. White patches, usually on cornelian, are evidence of such patination, probably since antiquity.

The arts of changing or improving the colours of semi-precious stones have been well recorded by students of gems in the last century. The effects are usually achieved by heating, sometimes in oil or other liquids. Pliny (*Nat. Hist.* xxxvii, 74) knew that Corsican honey could improve the appearance of precious stones, but seems to have been unaware of the effect of heat treatment rather than staining. It is possible that in the Roman period the eastern suppliers of stones practised these changes but we have no evidence for it in the Greek period.

There is a number of other stones, not quartzes, still to be described. LAPIS LACEDAEMONIUS (*colour, p. 49.10*) is a green porphyry, flecked with pale green crystals (hardness 6–6.5), quarried in antiquity only in the neighbourhood of Sparta. It was used for lentoid gems in Greece and Crete only in LM/LHII/IIIA. LAPIS LAZULI (hardness 5.5–6), mined in antiquity only in Badakshan (Afghanistan), is an opaque blue stone, often flecked with golden pyrites. It was very rarely used for seals in the Bronze Age, and in the Classical period. A hoard of eastern lapis lazuli cylinders in Mycenaean Thebes may have been a bulk gift from an eastern king and intended for re-working into ornaments. HAEMATITE (hardness 6–6.5), a ferric oxide, is a dull opaque black, but red when powdered. It was often used for cylinder seals in Cyprus and Syria and for eastern weights. There are some Greek Bronze Age seals in haematite, especially from Crete (*colour, pp. 39.5, 7; 49.6*), some of them cylinders, which may then be eastern cylinders recut; and it is very rarely employed also in the Archaic period. OBSIDIAN, partly transparent black 'volcanic glass' (hardness 5), was found in the Aegean world mainly, although not exclusively, on the island of Melos, and was commonly struck to provide cutting edges to tools in the early period, as flint was used in other regions. It has a distinctive conchoidal fracture, like glass. Bronze Age artists cut it for vases and even an occasional seal, but the qualities of its cutting edge were more prized than its drab colour. There are rare examples of its use for Archaic gems. Of the calcites (hardness 3) white MARBLE and LIMESTONE were rarely used in the Bronze Age. Island marble was used for at least one Geometric tabloid and limestones of various colours for other Geometric and Early Archaic seals.

It is not only gems of stone which have been considered in the preceding chapters and other materials have to be mentioned here. AMBER (hardness 1.5–2), a fossil resin from extinct pine forests, is yellow to brown in colour, translucent or cloudy in texture. With age the surface dulls and cracks and the colour reddens. It was acquired for Mediterranean folk from the shores of the Baltic and passed overland from a very early date. There was a source nearer at hand, in Sicily, but it seems not to have been exploited. Amber reached Greece in the Late Bronze Age but was very rarely used for seals rather than beads. It reappears in eighth-century Greece but its only subsequent use for seals is for some imitations of Early Archaic ivories, found at Perachora, and in Etruria. The thicker SHELLS were used for ornaments or figurines from the Early Bronze Age on. One Bronze Age seal in shell is known, and one Late Geometric (*Pl. 212*). CORAL (hardness 3.75) was used for two Archaic gems found at Perachora.

IVORY (hardness 2.5–2.75) was available via Egypt, and from the Near East where the Syrian elephant herds may not have died out until the eighth or even seventh century. It was much employed for the Prepalatial Mesara Group seals in Crete and occasionally for the Early Palace period figure seals. In the later eighth and seventh centuries ivory was used for the notable series of Peloponnesian seals and for some from East Greece. Towards the end of the seventh century the Peloponnesian seals were executed in BONE (hardness 2.75) rather than ivory. Bone seems not to have been used for the Bronze Age seals unless it should be identified for some examples in the Mesara Group.

GLASS (hardness up to 6) was used for seals in Mycenaean Greece and, towards the end of the Bronze Age, for simple blue or clear lentoids found in Crete. It was more commonly employed in the Near East.

Some blue and green glass scaraboids of Phoenician type reached Greece in the early seventh century, and in the Archaic period conoids and scaraboids were being made in Syria-Phoenicia, to name only the commonest classes. A very few Late Archaic gems are cut or cast in blue, green, black or clear glass. Larger scaraboids are popular in the Classical period, usually pale green but several fifth-century examples are clear. Most were cast with their intaglios, but on some the device was cut separately. Only rarely were the finer stones copied in this way. With the Hellenistic period all-glass finger rings are found and a greater variety of glass ringstones. The surface of ancient glass has seldom survived well and devices are often seriously disfigured by pitting as well as by discoloration. FAIENCE, a common material for Near Eastern and Egyptian scarabs, was not so used in Greece although there were Bronze Age and Archaic Greek workshops for faience vases and ornaments. A factory at Naukratis in Egypt produced some Archaic faience and 'blue frit' head-seals which betray strong Greek influence.

GOLD, SILVER and ELECTRUM (an alloy of the two) were available in Greece from a very early date and obtainable in the lands and islands of the Aegean. The history of the use of these precious metals for gems and finger rings throws no light on the sources exploited at different periods. The wealth of gold in early Mycenaean Greece is not matched by any exceptional use of the material for seals, and it had been used for seals in Crete from the Early Palace period. Electrum panned from the rivers of Lydia was used for the first coins in the later seventh century BC and this 'white gold' is occasionally the material for finger rings. Silver was rarely used for signets and seals in the Early Palace period in Crete. With the Late Palaces gold is more commonly employed and it is the usual material for finger rings in Greece and Crete throughout the Late Bronze Age. There is an interesting group of rings with bezels of half gold, half silver. An isolated Late Geometric gold ring (*Pl. 421*) may be a throw-back to Bronze Age practice. From the end of the seventh century on both gold and silver is in common use for finger rings and there was a notable demand for Classical silver finger rings among the western Greeks. In all periods the rings were normally cast, with their hoops, and the intaglios cut afterwards, but some Archaic and Classical rings are beaten, and the ends of their hoops brazed together. The drill was not usually employed for the intaglio, but a cutting point or chisel, and possibly on occasion a punch. The scorper which produces a tremolo zigzag of arcs is used on one Late Archaic ring (*Pl. 441*) and a number of fourth-century rings and scarabs (*Pls. 784, 821*). Elaboration in the form of cloisons for inlay of glass or enamel appears on a small number of gold rings and seals in Greece and Crete in the fifteenth century BC, and in Cyprus at the end of the Bronze Age. It was more widely employed on other objects.

BRONZE was used extremely rarely for seals in the Bronze Age: for an Early Palace stamp and some later signet rings. There are a few Archaic bronze bezels for swivel rings, but bronze finger rings only begin to become popular at the end of the Archaic period, and are particularly common in the fourth century. LEAD rings imitate the more precious metals, and are cast together with their devices, which are generally in relief. The main classes are Peloponnesian of the second half of the seventh century and West Greek Classical.

The last material to be discussed may in some periods have been the only one used for seals, and may at all periods have enjoyed some use, but in the form of a seal has never survived in Greek lands—WOOD. The Early Bronze Age sealings from Lerna were almost certainly impressed by wooden seals, and it is likely that many Middle Minoan sealings own the same origin. Only in the Late Bronze Age can all sealings be accounted for in terms of surviving examples of stone or metal intaglios. The same seems to be true of the Archaic and Classical periods, but it was very probably wooden cylinders and stamps which were used to decorate the seventh-century relief vases (*pithoi*). For all this we turn to the evidence of surviving impressions, but ancient authors too can help us, and they offer evidence about the resumption of seal engraving in the Geometric period which is totally lacking in the archaeological record.

There is a number of ancient references to the use of a worm-eaten piece of wood as a seal. The use of such an irregular but natural device is in keeping with what we have understood to be a basic, if primitive, choice for a distinctive and individual pattern (see p. 14). Aristophanes referred to the complexity of such seals of worm-eaten wood, and later writers held that they were used for economy, or that they preceded the invention of secret devices for sealing. The Spartans were said to have used them, and Herakles to have used them first. Spartans had a reputation for thrift: Herakles for cunning. We may take these references seriously since the earliest surviving Iron Age seals of stone in the Greek world are large tabloids with irregular intaglio patterns (as *Fig. 154*) which resemble nothing more than worm holes, and are in marked contrast with the careful geometric cutting of the stones themselves.

It will be noticed that apart from the basic distinction between the soft stones and the hard, differences of colour count for more than differences of composition. We are bound to ask whether the popularity of one colour at one time or for a particular shape was decided by availability of material, by aesthetic considerations, or for some supposed magical potency. Availability would probably have determined use of the coloured serpentines and softer stones. The sheer beauty of some banded or translucent stones would have recommended them at any time, or the rarity of some materials, like ivory and precious metals. To the Greek peasants of the last century who wore Bronze Age gems as amulets their colours and banding held magical significance, and we cannot ignore the possible ancient amuletic significance of different colours which were chosen for some classes of gems. There is not much to learn of this from Greek sources, beyond an understandable reverence for red and gold and some more philosophical theory, but Pliny had some remarks, usually disparaging, about the supposed properties of certain stones, and these probably derived from their colours rather than their relative rarity. Other properties too may have been admired—the magnetism of amber (known to Plato), the degree to which some stones reflect or refract light, or, when cut like lenses, concentrate it. In Egypt the colour of stones, although not necessarily engraved stones, was certainly of significance in the ritual of death—purple to avert evil, red for the blood of Isis—but if the Greeks had any specific views about the supernatural efficacy of colours we have yet to learn of it. Of the groups of Bronze Age gems for which amuletic properties have been suggested the green serpentine Archaic Prisms exploit a common local material and the colour is probably insignificant. For the so-called Talismanic gems of the Late Palace period red cornelian is preferred, but other materials are employed also and it was by no means reserved for gems of this class. Indeed it may simply have been the commonest of the available hard stones. In Archaic and Classical Greece there are no groups of seals dominated by colour choice apart from the few agate sliced barrels and cornelian lion gems and ringstones. If most Etruscan scarabs are cornelian this may have been determined partly by the way in which the device could be readily viewed without an impression. This aspect of the seal as a jewel also promoted the attention paid to carving the scarab backs in Etruria, and the red stone well set off the rich gold mounts and settings. To the Greeks this aspect of their engraved gems was of less importance, and the scarab backs and the gold settings are usually simple. In the Hellenistic and Early Roman periods amethysts are often reserved for portrait gems, but in the Roman period Pliny leads us to suspect more deliberate interest in choice of stone and colour.

TECHNIQUES

For an understanding of the techniques of engraving gemstones in antiquity we rely on observation and on knowledge of modern methods. Greek authors are almost completely silent. Herodotus (vii, 69) remarked that Ethiopians used for arrowheads a stone otherwise employed for cutting seals, and so possibly a flint or obsidian; and Theophrastus (*On Stones* 44) knew that the stone used on seals was the

one from which whetstones were made—emery. Obsidian (hardness 5) and emery (hardness 9) were readily obtainable in the Greek islands. Obsidian had been used for cutting edges since the Neolothic period, and emery must have been in use as early to work the Cycladic marble idols, and it was certainly used for later monumental sculpture. These stones could be employed for cutting any other stone which was no harder, and in practice emery would cut any stone a Greek wished to engrave. For the softer stones and other materials blades and points of these stones or of iron could easily effect all that was required and even perforations could be rather crudely managed by gouging with splinters.

For the harder stones mechanical aids were required and modern commentators have generally assumed that these were basically like those used and described by eighteenth-century engravers, like Natter, who consciously modelled their style and techniques on what they understood of ancient gem engraving. The technique involved a fixed lathe set horizontally and usually operated by a foot wheel. To it were fixed metal drills with tips of various shapes, usually like small wheels with edges of varying thickness, or spherical and blunt. The cutting agent was emery or diamond dust mixed in oil, the stone particles becoming embedded in the cutting wheels. The stone was held in the hand against the tip of the drill and the shape and depth of the cut depended on the shape of the edge of the cutting wheel at the tip and the angle at which the stone was held to it. The edge of the wheel would be used, or the blunter face of a different point for straight drilling. Very thin wheels could be used for thin straight cuts. The end of a trough made in this way would taper up to the surface of the stone (note the strokes of the lettering on Archaic Greek gems), or, if the wheel were comparatively thick, have a rounded end, and further tooling was required to make a sharp end to any cut (later lettering has little drilled blobs at the end of the strokes).

In antiquity drills were normally operated by a bow, its string wound around the shaft of the drill and the rigid bow drawn back and forth. There are representations on Greek vases and in Egyptian paintings of the bow drill in use for carpentry and for work on stone vessels and beads. The drill is held vertically and the upper end pivots in a socket pressed down by one hand while the other operates the bow. This primitive but extremely effective device has remained in use in recent times for drilling pearls, to mention only the most relevant operation. It could have been so employed in antiquity, but because one is shown in use in the device on Etruscan scarabs (probably for carpenters) we have no good reason for believing that it was always hand-held to cut intaglios. It would certainly be possible, especially for making the perforation or for intaglios where simple vertical drilling could effect the greater part of the device. We think especially of the Minoan Hoop and Line style and the *a globolo* styles of some Bronze Age and Greco-Persian gems as well as many Etruscan scarabs. For anything more intricate it would be too difficult to place and control the point, and if anything like the cutting wheels just described were employed they could only be used on a fixed drill.

Our only evidence for the use of a fixed drill, or 'bow-lathe' in antiquity is a tombstone of a young gem engraver of the Roman period who died in Lydia aged eighteen. A fragmentary relief at the top of the slab shows what can only be a fixed, horizontal lathe worked by a bow drill (*Fig. 316*, part restored). Egyptian paintings show bow drills in use to perforate beads. The drills are hand-held but as many as three are shown operated at once with a single bow. The stone drills used with bows for perforating beads in a modern Indian workshop show hollows in their tips, either the result of use or intended to hold the abrasive material. Sometimes the hollows produced by straight drilling on Greek intaglios have raised centre pieces (e.g., *Pl. 22*) which imply a hollow tip to the drill, but this was clearly not normal.

Where the intaglio is a figure subject a great deal of the body mass can be hollowed by use of the cutting wheel. The vertical drilling of *a globolo* gems can also be employed more discretely, as for the beard of the Archaic London Satyr (*Pl. 301*) or for the joints and eyes of many Greco-Persian animals

316

(*Pls. 931–943*). But drill and cutting wheel can hardly account for all the carving. Laborious though it may have been free-hand cutting of some linear details must also have been practised. Another instrument which might have been used is a straight file: not necessarily of metal, and still requiring powdered emery as the cutting agent. Clearly, such an instrument could only be used on a convex surface and it looks very much as though something of the sort was used on the Minoan Hoop and Line style and Talismanic gems (see pp. 32, 43). Pliny mentions the use of a file (*lima*) on precious stones, and describes a bronze statue said to have been made by the famous sculptor, architect and engraver Theodorus of Samos, which showed himself holding a file and an engraved scarab. He also refers to iron tools set with diamond splinters and fragments of *ostracias*, probably flint, used for engraving (*Nat. Hist.* xxxvii, 15 and 65). In the Archaic and Classical periods something like a file, or a flat emery pebble, would have been of most use for preparing the flat surface to be engraved or fashioning the walls and backs of scaraboids. For scarab backs the drill and cutting wheel could be used and there are often vertical cuts at either side dividing thorax from wing cases and front from back legs.

A few more specific points can be made about the techniques employed for particular classes of gems, and about the evidence of unfinished stones. In the Bronze Age the Minoans had learned from Egypt the use of a tubular drill for working stone vases, and the tubular drill patterns are the distinctive element in the Hoop and Line style. The instrument was not used in later periods. Blunt drills may have been used on some of the Minoan Archaic Prisms, and their use is clear on Talismanic and later stones where the blob-like cuttings are major features in the device. The evidence from excavated workshops of Bronze Age date has already been mentioned (pp. 28, 63).

In the Archaic and Classical periods we may suspect that some variety of cutting wheels was employed, although it is generally wrong to assume too great elaboration of technique in Greek art. It has usually proved that the most remarkable effects were achieved by hard work or exceptional care in preparation, rather than advanced technology: for example, in the preparation of the black gloss paint for vases, in their firing, in gold granulation and brazing.

On many Classical scaraboids a preliminary sketch can be detected around the outline of the intaglio, usually no more than a very rough series of light scratches very like the preliminary sketches on red figure vases. These marks are rarely seen on Archaic gems on which the layout of a single figure closely fitted to its border was probably easily decided by eye.

In the Archaic and Classical periods it seems that the shape of the stone was cut first. There are many unfinished intaglios, but hardly any unfinished scarab beetles. I know two scaraboids on which the intaglio had been started, but the stone not yet perforated, although on one the positions for starting the drilling had been marked with a cross. The way that the main masses are, as it were, scooped out by the cutting implements is clear from the rougher and unfinished intaglios (as *Pls. 446, 980*). We can see too that some parts may be almost completely finished before others, like the feet, are even sketched.

We may probably assume that the drill was always used at right angles to the surface of the stone, and that when a cutting wheel was employed its edge too bit straight into the stone and not at an angle. It would have been hazardous to try to have the tip of the drill moving obliquely over the stone, and even in major sculpture this use of a 'running drill' is not attested before the fourth century.

The final stage in producing an engraved gem would usually be the polishing. This can be done with the bow-lathe using abrasive dust on a soft pad. Some Bronze Age gems are quite highly polished. On Archaic Greek gems the surface is usually left dull, but there is more polishing on Classical gems, especially on the rock crystals, to ensure the fullest value from the completely transparent stone. Etruscan gems carry the highest polish and it is common on Hellenistic and Roman ringstones.

Normal wear and tear produces a mass of tiny irregular scratches on the surface of the stone, readily visible under a glass. But ancient stones may have been repolished by modern collectors or have been buried in nearly perfect condition. Only the poorest forgers and copyists betray themselves by mistakes in technique rather than style. The problems of detecting forgeries and copies become most acute in the study of gems of the Roman period. In the study of Greek gems familiarity with the stones soon brings confidence in detection of the spurious. There are in fact extremely few which might provoke doubts.

For viewing engraved gems, in antiquity as now, the normal practice is to take an impression. Clay or wax, the usual materials for sealing, are obvious media, but the excellence of plaster for impressions was observed by Theophrastus, and this remains the best material for viewing in the hand or for photography. Some of the problems of making good impressions and photographs are discussed in the Notes to this chapter and the importance of studying stones in impressions was stressed in the Preface.

All the stones and impressions illustrated in the plates of this book are shown at several times life size, and it is usual nowadays to turn to magnifying aids in study or publication. Remarkably fine detail was achieved on some gems: detail which is not easily appreciated by the naked eye, even when a good impression is available, and yet we must suppose that for ordinary purposes no magnifying aids were used for studying or admiring the devices. Indeed it seems very probable that the artists themselves had no such aids. The magnifying effect of bottles of clear glass filled with water had been observed, and already in the fifth century BC crystal lenses were used as burning glasses. Plano-convex inlays of rock crystal from Knossos have some value as lenses and some scholars have thought that they were in fact so used by Bronze Age gem engravers. But to be of any use to an engraver the lens must not seriously distort, and although the magnifying effect of crystal or glass in lens form may well have been observed at an early date, it is highly improbable that it was exploited by artists. No deliberately fashioned lenses have been found and it is unlikely that Pliny would have failed to mention their use. Nero's famous emerald which he used to view the games is often cited in this context, but it was probably cut as a mirror, almost certainly not as a lens.

TEXT FIGURE

Fig. 316 Restored drawing of the relief decoration from the top of the gravestone of Doros of Sardis, who died at Philadelphia in Lydia, aged 18. The inscription dates the stone to the second century A.D. A fixed bow-lathe is shown. Dorus is described as a *daktylokoiloglyphos*. *AG* iii, 390, fig. 206; *Ath.Mitt.* xv, 333f.; *Journal of Glass Studies* vi, 85f., fig. 2.

EPILOGUE 1970–2000

By about 1970 a new era of study of the oldest subject in classical art history was beginning. Since Furtwängler's magisterial volumes of 1900 there had been publication of various catalogues of gems, notably those for the British Museum, New York and Copenhagen (the Thorwaldsen Collection), Miss Richter had published her compendium of illustrations of Greek and Etruscan Gems, and new series of publications of collections had also been inaugurated—for the Greek Bronze Age (*CMS*), and for the German collections (*AGDS*). Since 1970 this spate of publication of collections and series has continued apace, an absolute necessity for the advance of the subject, and several have been accompanied by study of special areas or subjects. The only new overall study has been by Peter Zazoff in his *Handbuch* (1983), which covered also the Roman period, down to Sasanian and Gnostic gems. It would perhaps be fair to say that the present volume profited from being compiled in a period (the 1960s) when the subject was still not too much regarded, and this considerably facilitated the collection of material for illustration. A measure of the raised scholarly consciousness of its potential is the fact that gems play a very full role in the documentation of the great iconographical lexicon of classical mythology (*LIMC*) whose eight double volumes and indexes have just been completed.

The occasion of this reprinting of the 1970 edition has given an opportunity to compile this brief Epilogue. It cannot be a full updating of each chapter, but I try to remark the more important developments in the study of each period and style, and to document them in the selective Bibliographical Notes appended. It has also allowed the illustration of a number of other gems, not all of them 'new', that is to say only discovered or published since 1970, but all of them useful addenda to the many which illustrate the main chapters. Some are 'old' gems, known from old publications, and one or two have even already figured in this book in drawings, but have re-emerged in 'new' collections or museums. Thus, our *Pl. 1016*, the first Bronze Age gold ring to have seen the light of day, in the early nineteenth century, was run to ground in a collection which had been given to the municipality of Péronne, where it had been cherished but not displayed. Other pieces already illustrated (*Figs. 212,241 = Pls. 1039,1054*) have come to my attention, sometimes quite dramatically, as when the late Professor R. M. Dawkins' brother visited me with one of his late brother's old socks full of Island Gems, or when Mr Harari's son came to tea with a box full of prime rings from old collections, many known but all lost to view for more than fifty years. Even excavation can rarely be more exciting.

For all their value and quality these are small objects, smaller than most coins (many are still kept in museum coin rooms), and can easily become overlooked. But coins are repetitive, like prints from a block or postage stamps; each gem is an original and appeals to a special type of connoisseur and collector. They ought also to appeal to any classical art historian as much as any other medium. In these large photographs they can make a wider appeal, but they can never quite convey the pleasure of holding one in the hand and scrutinizing it closely. It is not surprising that many of the 'new' gems I show are in private collections. Not all were acquired recently, however, and the common attitude to collectors today, that they simply encourage the looting of ancient sites, is not easily levelled against gem collectors, since no site can be targeted for

gems; they are the occasional by-product of excavation, or casual finds, and very often prove to be survivors from very old collections.

Study of the gems of the Minoans and Mycenaeans (Chapter II) has been advanced mainly by the continuing publication of the series *CMS* whch accords every piece full illustration, often also with drawing, and full description. This is a model publication which has embraced by now almost all the public and many private collections in the world, though it has still to include all the excavated sealings, which are properly given the same treatment as the gems, and which are often crucial to our understanding of sites and dates.

In other studies of Bronze Age seals there have been two main trends. One is towards a closer classification of the material in terms of workshop, groups and artists, using criteria used for other periods and media. Unanimity about results is not too easily achieved but this is the way to a better understanding of the history of style and regional influences. Criteria for attribution in this as in other periods are much the same as for other media—close attention to peculiarities of technique, proportions and composition, to determine combinations of rendering which may reveal a personality. Even at this scale individual profiles for men or animals may be distinguished—easiest where the material is plentiful, which is true of some periods in the Bronze Age, but later perhaps only in the Greek Archaic period.

The other trend involves a close study of the sealings in their contexts, and this has produced important observations about their use and the objects they sealed, as well as the organization of archives and storage of materials in Bronze Age sites where the sealings are plentiful.

New finds for the Geometric and Early Archaic period (Chapter III) have done little to disturb or advance our appreciation of it, other than by offering important new specimens (*Figs. 318, 319; Pl. 1017*). We still await publication of several major finds, as from Brauron. More relevant, perhaps, has been the study of the Syrian seals which were entering the Greek world in the eighth century (*Fig. 158*) and later and which may have had some effect—more on the production in the Geometric style, it seems, than in the orientalizing, where we look for the influence of the east mainly in other media (see the Syrian *Fig. 317*). This, perhaps, requires some explanation: it was possibly a matter of the technical difficulty of rendering fine intaglios in hard stone before use of the cutting wheel was re-learned. There was no problem with ivory, which Greek artists handled skillfully. There was no problem either with working the softer stones used for the remarkable series of Island Gems (*Figs. 175–177, 320; Pls. 219–273, 1018, 1019*), throw-backs in shape and sometimes decoration to Bronze Age models. The principal access of new material here has been from the excavations at the Greek colony of Cyrene in north Africa, which indicates close relations with island sources (probably fellow-Dorians), something indicated by other finds in Cyrenaica.

The full Archaic period (Chapter IV) of the sixth century and earliest fifth has also been illuminated more by studies peripheral to the main series, though this has been augmented by several finds and subjected to closer study in terms of source and artists, using criteria of connoisseurship already discussed (and see *Pl. 1025*). The main production seems still largely an East Greek and island phenomenon. More examples from Cyprus (*Figs. 187, 321; Pl. 329*) reinforce the notion that it was there that Greeks learned from Phoenicians the techniques required to master this, the last of the major orientalizing arts, and the shape on which to work—the scarab. It depended wholly on mastery of the drill and the cutting wheel, an instrument not used on hardstone gems in Greece since the Bronze Age. More trivial works in an egyptianizing style, like that of the Phoenicians, had been undertaken in glass and faience by Greek workshops much earlier, in Rhodes, and then in a factory in the Greek trading town of Naucratis in Egypt. These are better documented now.

The scarabs are among the finest of all the Archaic arts of Greece, and for quality can rival even the best gem engraving of later years. They were also influential outside Greece. They are clearly the source of the new series of carnelian scarabs which were long to be an important characteristic of Etruscan art. Closer

317

318 *319*

320 *321*

attention to the origins of the early Etruscan groups (*Pls. 408–410,1033*) shows that they may owe much to Greek work in Anatolia for the dominant Lydian power, since they are especially well represented in Lydian tombs inland from the Greek sites, and we can see in other arts a symbiosis of Greek and Anatolian styles. This is well in keeping with what we understand of the genesis of other Etruscan arts, since much can be attributed to inspiration from Greek artists, immigrant from the east, whence they were pressed first by the Lydians, then by the Persians. We shall return to Greeks and Persians, but it is in the Persian period that a major series of Phoenician scarabs was being produced, mainly in green jasper (*Pls. 414–420,1035–6*). These were affected to some degree by Greek styles and subjects, though for the most part the influences are Egyptian or Levantine. They have long been called 'Greco-Phoenician' but it is not necessary to think that any of the main series were cut by Greeks, and 'Classical Phoenician' is probably a better name for them.

They are most common on the western Phoenician sites at Carthage and in Sardinia and Spain, but this does not mean that all, or indeed any, were necessarily made there rather than in the east.

In the Classical period of the fifth and fourth centuries (Chapter V) the scarab was abandoned in favour of the rather larger scaraboid, a shape which had enjoyed a minor vogue in Syria beside the smaller, lumpy scaraboids which more truly match the scarabs for size and proportions (*p. 191*). The east was again becoming an increasingly important factor in Greek life, though it had little if any effect on Classical arts, quite unlike the Greek experience of two centuries before. The Persian empire was both threatening and welcoming, but well permeated by Greek artists and their work. This is most apparent in the works considered in Chapter VI, Greeks and Persians. Here too the story begins in the sixth century with seals made in Lydia, with eastern shapes and subjects, but also with Greek subjects and in styles related to the latest Greek Archaic, to serve officials in Persia's westernmost satrapies (*Pls. 823–4*). It is an extension of the Greco-Lydian styles already mentioned, but now decidedly for masters from a more remote location.

The Greco-Persian gems of the Classical period are the most expressive of the relationship with the new masters, mainly in Anatolia. The technique is distinctive, more eastern than Greek, but the shapes are as for the Greek Classical, there are many purely Greek subjects, and many of the Persian subjects are dealt with as only an artist trained in a Greek environment could have treated them. So we find rendering of dress and anatomy which reflects the new Greek interest in realism, and at the same time the unrealistic yet evocative use of the 'rocking horse' pose for racing animals, where the Greeks by then made them run or trot properly. Whether the artists were themselves Greeks we cannot know—the blend of Greek and eastern is so thorough—nor does it much matter in an environment where the pervasive Classical style was becoming increasingly adopted, or at least copied, by local artisans. What they achieved was to set the tone for eastern gem engraving for many years to come, in Persia and beyond. A renewed series of studies on the relationship of Persian arts with the west has focused attention on them, and their heritage.

Gems of the Hellenistic period were barely introduced in Chapter VII but have recently enjoyed a close and comprehensive study, which has also been devoted to the beginnings of cameo-cutting in the Greek world, a subject hardly mentioned in this book.

One area of study which is still dealt with only piecemeal is that of sealings, made by the types of stone and metal seals discussed in this volume. They appear on many different objects: real sealings for documents or property, on pottery, loomweights, tiles, various objects which the owner of a seal or gem thought to be improved by such decoration, or which he or she had good reason to wish to be labelled with such a personal mark. They have not been ignored in these chapters (*pp. 235–8, 424, 446–7, 457, 465*), but mainly as additional evidence for types to add to those attested by surviving seals and gems. In the Greek period there are probably at least as many devices known from sealings as there are from originals, though we are sometimes not given explicit clues to the shapes of the seals employed; even the difference between a seal-ring and a stone intaglio may be elusive. Apart from this value in increasing our corpus of types, it often happens that the sealings are more readily datable than originals. Moreover, the contexts in which they are used can say much about the purposes of the seals and about the society that used them. Some gems, of course, were made up as jewellery; otherwise, the sealings are our only physical evidence for the way they could be used and they deserve fuller attention and integration with other gem studies.

Scientific study of materials and techniques (Chapter VIII) depends very largely on engaging the interest of geologists and conservation laboratories. It is still possible to make serious mistakes over material. And it is slight comfort to reflect that we can now identify materials with greater accuracy than any artist of antiquity. What was important to him was colour, translucency and hardness, though recognizably strange materials from distant sources might be prized for their rarity. A detailed study by the scientists of the J. Paul Getty Museum in Malibu of gems in many collections has offered greater precision in defining varieties even

of the more familiar gems, which may help isolate groups and even dating. There is also better hope now of identifying sources, partly because world geology has been much enhanced through the demands of prospection for oil!

Modern publications of gems are more often of photographs of the original stone than of the impression (which is what the artist was working for). I reiterate my arguments (*pp. 10, 469*) in favour of impressions, which can indicate degrees of modelling, through shading, more effectively than photographs of originals, through reflection, however much more jewel-like the latter appear. But the art of making fine plaster impressions, which are the best for photography, seems to be passing, while many photographers have learned the special skills required for reproducing original gems. So there is a higher proportion of originals photographed in the new plates here. The drawings, as in the earlier chapters, reproduce subjects rather than nuances of style.

The study of ancient Greek gems and finger rings remains a very live and progressive subject. I hope that the reissue of this book will bring it to the attention of students and a public to whom the more conventional arts of ancient Greece may be more accessible and familiar.

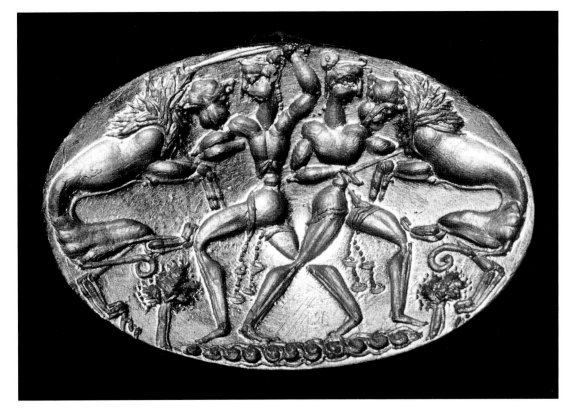

1016 4:1

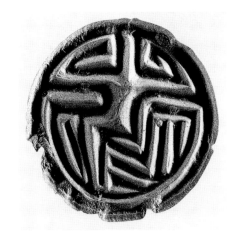

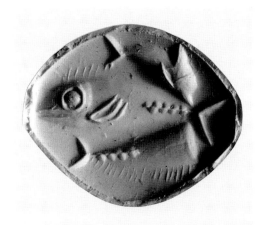

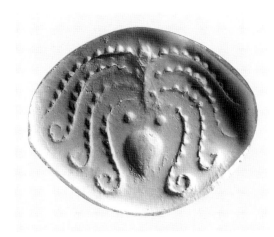

1017 2:1 1018 3:1 1019 3:1

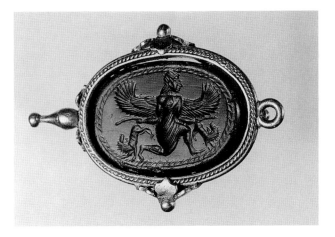

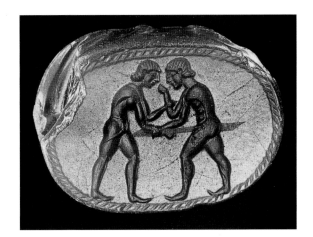

1020 2:1 1021 4:1

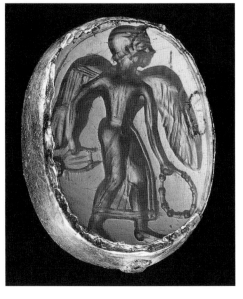

1022 4:1

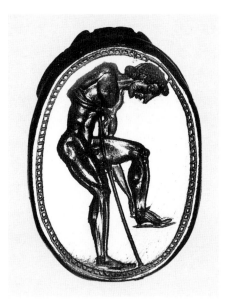

1023 4:1

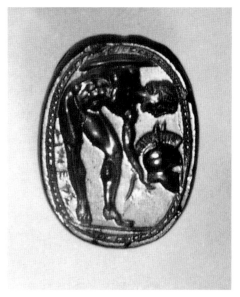

1024 4:1

1025

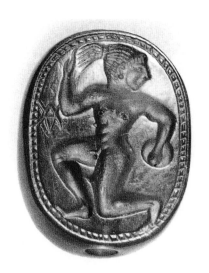

1026 4:1

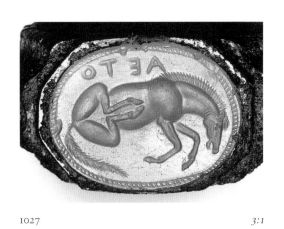

1027 3:1

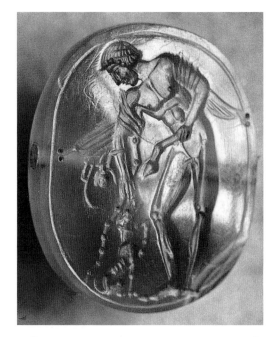

1028 6:1

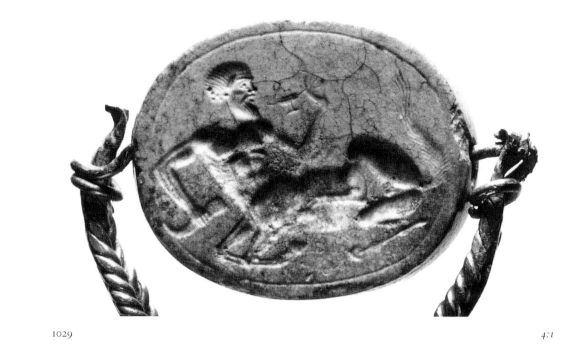

1029 *4:1*

1032 *2:1*

1030 *4:1*

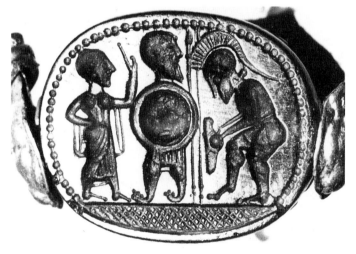

1031 *5:1* 1033 *6:1*

1034 *2:1* 1035 *4:1*

1036 *4:1*

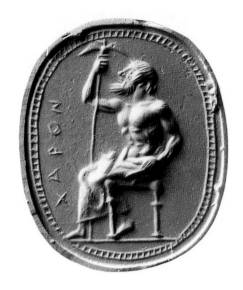

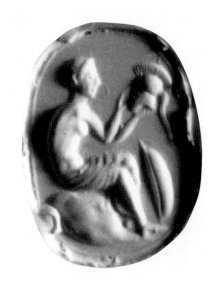

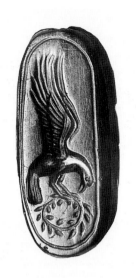

1039A

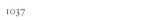

1037 *4:1* 1038 *4:1*

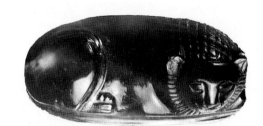

1039B *4:1*

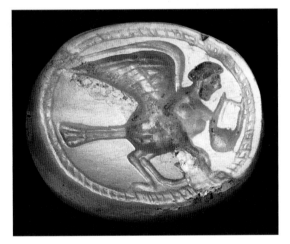

1040 *4:1*

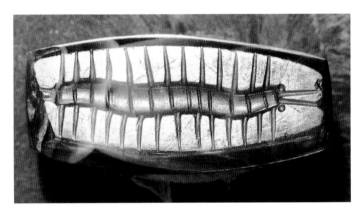

1041 *4:1*

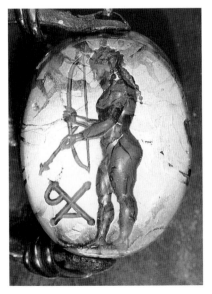

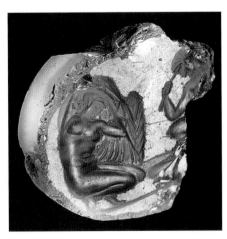

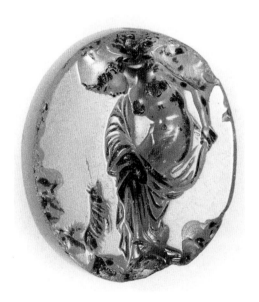

1042 *3:1* 1043 *2:1* 1044 *4:1*

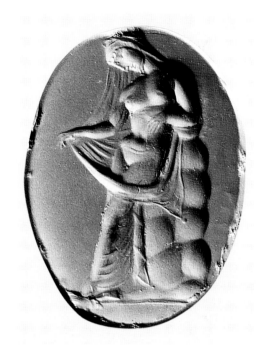

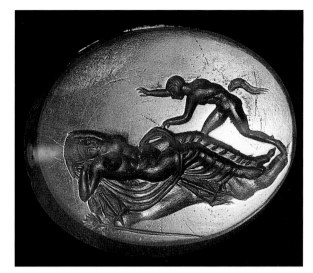

1046 *3:1* 1047 *2:1*

1045 *3:1*

1048 *3:1* 1049 *3:1*

1051 *2:1*

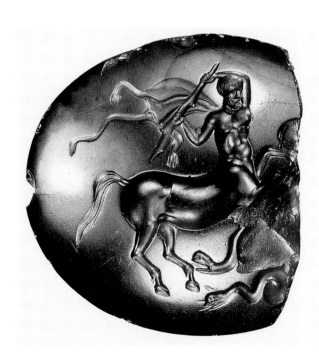

1050 *2:1* 1052 *2:1*

1053 3:1

1054 2:1 1055 2:1

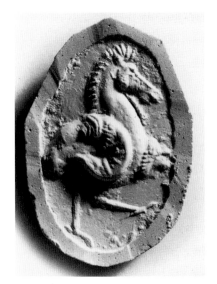

1057 3:1 1058 3:1 1059 3:1

1056 3:1

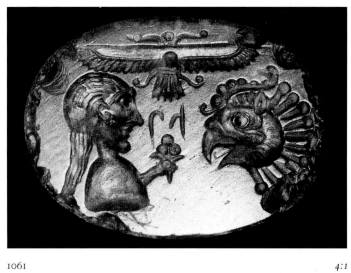

1061 4:1

1060 3:1

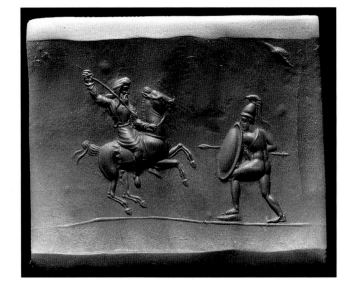

1062 2:1 1063 2:1

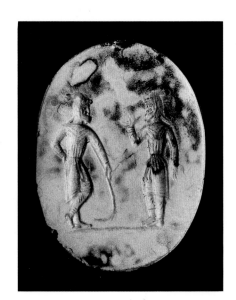

1064 3:1

1065 3:1

1066 3:1

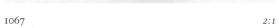

1067 2:1

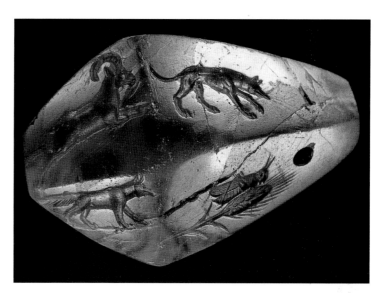

1068 3:1

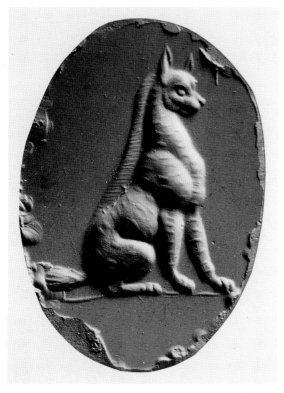

1069 4:1

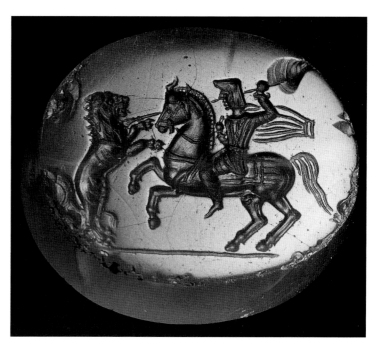

1070 3:1

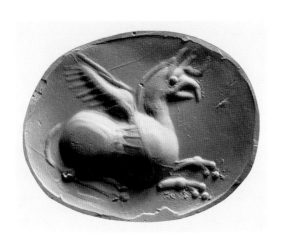

1071 3:1

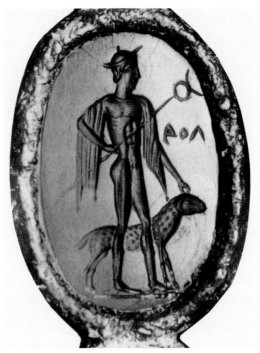

1072 4:1 1073 3:1

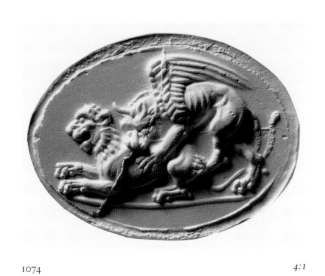

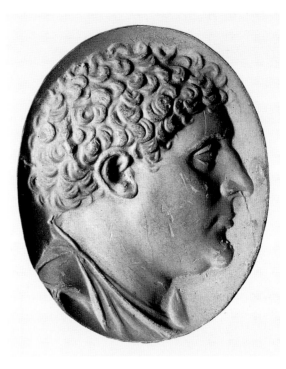

1074 4:1

1075 3:1

1076A 1076B 1076C 1076D 3:1

LIST OF ILLUSTRATIONS TO EPILOGUE
1970–2000

Measurements are given of the maximum dimension of the intaglio face, in millimetres

TEXT FIGURES

Fig. 317 Unknown; 18th-century English private collection. Haematite scarab. L. 23. A sphinx, griffin, locust, fish, eyes (?) and neo-Hittite hieroglyphs. The Syrian style that inspired orientalizing Greece. 8th cent. *OJA* 15 (1996) 331.

Fig. 318 Athens, Kerameikos, grave VDAk. 1. Ivory seal. 15 x 14. Two seated figures: a quadruped. 750–725 BC. *AM* 89 (1974) pl. 5. 1–5.

Fig. 319 Andros, from Zagora, temple. Bone seal. *Praktika* 1972, pl. 239. A recumbent lion on the back. Three geometric figures. For the type see *Fig. 173*. Late 8th cent. *Praktika Arch. Etaireias* 1972, pl. 239.

Fig. 320 Unknown. White lentoid. L. c. 16. A running winged man with winged heels holding a double axe. Possibly the carpenter hero Aristaios. A hardstone Island Gem. Early 6th cent. *JHS* 88 (1968) 4–5; *LIMC* Aristaios I, no. 16.

Fig. 321 Switzerland, private (M. P.). Agate scarab. L. 15. Herakles, with a club (?) fights the Hydra with the help of Iolaos, with a sickle (?). This looks more Cypriot (see *Pl. 329* for heavy exergue), than Greek, but its gold ring hoop may be Etruscan. Mid-6th cent. I. Jucker, *Italy of the Etruscans* (1991) no. 369.

BLACK AND WHITE PLATES

**Asterisked numbers indicate that the piece is illustrated in original. All other photographs show impressions*

GREEK BRONZE AGE

Pl. 1016* Péronne, Danicourt Collection, 'from Salonica'. L. 33. Two men wearing kilts and headdress fight lions with swords in a setting of rocks and trees. The style is that of rings found at Mycenae (*p. 56, Pls. 148–153*) and a similar device has been found on sealings from Pylos. This is the first Bronze Age gold ring to have been found in Greece. Early LHII. *Rev. Arch.* 1970, 3–8.

EARLY ARCHAIC

Pl. 1017 From Sparta. Red serpentine hemispherical seal. W. 26. A stylized seated figure? Early 7th cent. *IGems* 117, B17.

Pl. 1018 Bonn, Müller Collection. Green serpentine ('steatite') amygaloid, 'from Aegina'. L. 17. A dolphin, tunny and tunny tail. Island Gem. Late 7th cent.

Pl. 1019 Cyrene. Grey-green serpentine ('steatite') amygdaloid. L. 20. An octopus. Island Gem. Late 7th cent. *BSA* 63 (1968) 41–43.

ARCHAIC

Pl. 1020* Hanover 1970. 23. Cornelian scarab (modern setting). L. 20.5. A winged goddess running (Artemis?) holding two lions by their tails. The familiar *potnia theron*. Mid-6th cent. *AGDS* IV no. 20.

Pl. 1021* New York, Rosen Collection. Cornelian scarab. L. 17. Peleus wrestles with Atalanta, who wears a loincloth. About 500 BC. *LIMC* Atalante no. 76.

Pl. 1022* New York, Rosen Collection. Agate scaraboid, from Cyprus. L. 17. A winged figure, perhaps male, with lyre and wreath; possibly Apollo rather than Eros. Late 6th cent.

Pl. 1023* Malibu, J. Paul Getty Museum 81. AN. 76. 22. Cornelian scarab. L. 16. A youth stoops to fix his sandal. Attributed to Epimenes (*Pls. 355–357*). About 500 BC. *IR* no. 22.

Pl. 1024* New York 1987. 11. 7 (Helen H. Mertens, David L. Klein Jr. Memorial Foundation Inc., and Mrs Martin Fried Gifts, 1987). Cornelian scarab. L. 14. A youth with a shield,

held behind/above him, stoops to pick up a feathered helmet. Inscribed TIMEAS, probably the owner's name. Early 5th cent. J. Mertens, *Met. Mus. Journ.* 24 (1989) 53–56.

Pl. 1025 Heads enlarged from impressions of gems shown in *Pls. 355, 357, 356, 1023*. To demonstrate the criteria by which attribution to hands of engravers might be attempted. About 500 BC. *IR* 12–13.

Pl. 1026* Market, once Content Collection. Blue chalcedony scaraboid. L. 14. A youth, his hair caught back in a ponytail, runs holding a discus. A monogram (AV) before him. About 500 BC. *Nefer Gems* 1996, no. 7.

Pl. 1027* Switzerland, Private. Grey chalcedony cut scarab(?) set in Roman ring. L. 18. A rolling horse. Inscribed AETO, 'of Aetos', presumably the owner. About 500 BC.

Pl. 1028* Paris, Cab. Med. de Clercq 2815, from Cyprus. Onyx scaraboid, shallow, with a slightly convex engraved face and pierced across the narrow axis. L. 13. A youth wearing a chlamys, leaning on a gnarled stick and with oil bottle and strigil attached to his arm, offers an animal leg to a dog (see *AGGems* 100 for the subject on gems and elsewhere). Sketch marks around the head. The shape is unusual but the convex face is met at this period; probably meant for setting in jewellery. Early 5th cent. *de Clercq* pl. 19. 2815.

Pl. 1029* Bonn, Univ. Kunstmuseum B 305, bought in S. Russia. Pale blue chalcedony scaraboid (weathered or burnt) on a gold swivel. L. 20. A reclining centaur with drinking horn and a cup held as for the kottabos throw (cf. *Pl. 548*). Early 5th cent. E. Zwierlein-Diehl in *Periplous* (edd. G. Tsetskhladze et al., 2000) 397–402.

Pl. 1030* Paris, Cab. Med. Chandon de Briailles Coll. Grey chalcedony scaraboid. L. 14. A panther. Early 5th cent.

Pl. 1031 Malibu, J. Paul Getty Museum 81. AN. 76. 26. Cornelian scarab. L. 13. Lioness and cub. Early 5th cent. *IR* no. 26.

Pl. 1032 Syracuse 6675. Silver ring. L. 17. A warrior downs another by a waiting horse. A fish in the exergue. A gold stud by the horse. The hoop is broad and flat with a roll at the terminals. An unusually detailed narrative. About 500 BC.

ETRUSCAN

Pl. 1033* Malibu, J. Paul Getty Museum 81. AN. 76. 121. Cornelian scarab. L. 12. Achilles puts on a greave, watched by Hephaistos (notice his lameness) who has made his new armour and holds his shield and spears in readiness, and a woman, probably Thetis, Achilles' mother, who had negotiated the new armour after his old was lost with Patroklos. Late 6th cent. *IR* no. 121.

PHOENICIAN

Pl. 1034* Tunis, Bardo Museum, from Utica (near Carthage). Gold ring. L. 20. A crouching satyr, with the Phoenician disc and crescent above, lotus below. The Greek shape is used in the Punic world for both Greek and Phoenician devices. About 500 BC.

Pl. 1035* Malibu, J. Paul Getty Museum 81. AN. 76. 115. Green jasper scarab. L. 13. Herakles wrestles with the lion. Phoenician cross hatched ground, with a bud. The pose is a cramped version of the on-the-floor fight, as seen on Greek vases. 5th cent. *IR* no. 115.

Pl. 1036 Madrid 37017, from Ibiza. Green jasper scarab. L. 14. A woman holding a whip riding sidesaddle on a horse, seen from behind. Probably Selene, the moon goddess. 5th cent. *Praestant Interna* (Fest. U. Hausmann) pl. 66. 9; *Ibiza* no. 218.

CLASSICAL

Pl. 1037 Malibu, J. Paul Getty Museum 84. AN. 1. 12. Blue chalcedony scaraboid, type A. L. 17. Zeus seated on a stool, holding a sceptre topped by an eagle. Inscribed CHARON, probably the name of the owner. Early Classical, about 470 BC. J. Spier, *Ancient Gems . . . Getty Museum* (1992) no. 18.

Pl. 1038 Canada, Private Collection. Cornelian scarab. L. 17. A woman, her dress around her waist and legs, seated on rocks contemplating a helmet, a shield against her knee, probably Thetis preparing to re-arm Achilles. Mid-5th cent.

Pl. 1039* Once Harari Collection. Cornelian lion gem, from Corinth. L. 20. An eagle with a wreath. For the type see *pp. 205, 430*. This is our *Fig. 212*, rediscovered. Mid-5th cent. *Harari* no. 4.

Pl. 1040* Switzerland, Private. Blue chalcedony scaraboid, type A. L. 17. A siren holding a lyre. Mid-5th cent.

Pl. 1041* Paris, Cab. Med. Chandon de Briailles Collection. Agate sliced barrel. L. c. 20. A centipede.

Pl. 1042* Paris, Cab. Med. Chandon de Briailles Collection. Mottled jasper (reddish) scaraboid. L. 20. A naked youth standing, holding bow and arrow. The pose is statuesque, perhaps of an Apollo figure. The monogram may be a later addition. 5th cent.

Pl. 1043* New York, Rosen Collection. Rock crystal scaraboid, type A. L. 26. Two bathing women, one (un)dressing, the other fixing her hairband, a basin between them. Late 5th cent.

Pl. 1044* Switzerland, Private. Blue chalcedony scaraboid, type A. L. 18. A woman stooping towards a pet dog. Late 5th cent.

Pl. 1045 New York, Rosen Collection. Blue chalcedony scaraboid, type A. L. 26. A woman leaning on a rock, her himation pulled over her head but she holds it out to display her body. The display motif recalls Danae, though not in this pose. Late 5th cent.

Pl. 1046* Malibu, J. Paul Getty Museum 81. AN. 76. 31. Blue chalcedony scaraboid, type C. L. 26. A satyr uncovers a maenad sleeping on rocks, her thyrsos beside her. Late 5th cent. *IR* no. 31.

Pl. 1047 Canada, Private Collection. Mottled jasper scaraboid. L. 27. A piece of muzzle armour for a horse. 4th cent.

Pl. 1048* Bloomington 68. 133. Milky chalcedony scaraboid. L. 23. A dog seizing a heron. Late 5th cent. *Berry Gems* no. 23.

Pl. 1049* Malibu, J. Paul Getty Museum 81. AN. 76. 36. Blue chalcedony scaraboid, type A. L. 27. A woman rides a flying goose, her dress held out over her head. Aphrodite or Aura. Probably western Greek, late 5th cent. *IR* no. 36.

Pl. 1050* Malibu, J. Paul Getty Museum 85. AN. 370. 8, 'from Iran'. Brown chalcedony scaraboid engraved on the convex back. L. preserved 42. An unusually large stone. A centaur, with an animal skin flying from his shoulders, attacks a monster with a tree trunk. Of the victim we see only two snakes, which might be legs, as for a giant, but centaurs are not involved in gigantomachy. Early 4th cent. Spier, op. cit., no. 20.

Pl. 1051* Switzerland, Private. Clear glass scaraboid, type B. L. 30. A griffin attacking a goat. 4th cent.

Pl. 1052 From Vitsa Zagoriou. Clear glass scaraboid. One of two found at the shoulder of a 4th-cent. burial. Two lions sejant, regardant. As *AGDS* I, no. 287. *Archaeological Reports for 1973/4* 25, fig. 45.

CLASSICAL RINGS

Pl. 1053* Once Harari Collection. Gold ring. L. 22. Artemis holding a torch and riding a stag in a starry setting, recalling her role as moon goddess. Later 5th cent, perhaps western Greek. *Harari* no. 15; here *p. 440, no. 712*.

Pl. 1054* New York 1994. 230. 3, from Tarentum. L. 23. Hermes, wearing a chlamys, fastens wings to his raised foot. The pose appears also for Hermes, with boots not wings, on coins of Sybrita in Crete of about 330 BC. This is our *Fig. 241* rediscovered. 4th century, perhaps western Greek. *Met. Mus. Bull.* Fall 1995, 11; *Harari* no. 10.

Pl. 1055* Malibu, J. Paul Getty Museum 81. AN. 76. 75. Gold ring. L. 18. A winged woman seated on a stool being crowned by Eros. Late 5th cent. *IR* no. 75.

Pl. 1056* Malibu, J. Paul Getty Museum 81. AN. 76. 78. Gold ring. L. 21. Leda, half-naked, seated on rocks feeding the Zeus-swan from a phiale. Late 4th cent. *IR* no. 78.

Pl. 1057* Paris, Cab. Med., *de Clercq* no. 2798, pl. 19, from Cyprus. Gold ring. L. 16. Artemis riding a stag. De Clercq Group, *p. 437, no. 547*. 5th/4th cent.

Pl. 1058* Paris, Cab. Med., *de Clercq* no. 2827, pl. 19, from Tortosa. Gold ring. L. 14. 5. Herakles wrestling with the lion which is behind his body. The pose is Greek of the 4th century, but the hero should not be already wearing the lion-skin, as here. De Clercq Group, *p. 437, no. 562*.

Pl. 1059* Paris, Cab. Med., *de Clercq* no. 2830, pl. 20. Gold ring. L. 16. An ecstatic maenad holding a sword and a branch. De Clercq Group, *p. 437, no. 564*. 4th cent.

Pl. 1060 Switzerland, Private. Bronze ring. L. 20. A monster compounded of a bird, ram's head, horse's head and neck, and lion's head. 4th cent.

EASTERN AND GRECO-PERSIAN

Pl. 1061* Paris, Cab. Med. Chandon de Briailles Collection 54. Blue chalcedony scaraboid. L. 21. Under a Persian winged sun disc, the bust of a woman holding a flower, and the head of a horned griffin. The latter is also Persian, as used for column capitals at Persepolis. By comparison, the bust is ungainly. Inscribed in Aramaic *pata*, 'protége'. 5th cent. P. Bordreuil, *Cat. des sceaux ouest-sémitiques inscrits* (1986) no. 137.

Pl. 1062 New York, Rosen Collection. Blue chalcedony barrel. L. 29. A Persian horseman attacks a Greek hoplite. The style is almost purely Greek. Late 5th cent. *CAH* Plates to Vol. IV, no. 80b.

Pl. 1063* Paris, Cab. Med. Chandon de Briailles Collection. Pale blue chalcedony scaraboid, type C. L. 30. Two Persians in conversation, one leaning on a curved stick. Greco-Persian, Pendants Group, *p. 451, no. 127*.

Pl. 1064* Switzerland, Private. Blue chalcedony scaraboid, type A. L. 18. A Persian with bow, arrows and a bird. Late 5th cent.

Pl. 1065 Malibu, J. Paul Getty Museum 85. AN. 370. 26. White chalcedony scaraboid, type A. L. 22. A Persian couple make love, she holding a mirror, he unusually fully dressed; compare above, *p. 317, fig. 298*. Greco-Persian Phi Group. Late 5th cent. Spier, op. cit., no. 118.

Pl. 1066* Paris, Cab. Med. Chandon de Briailles Collection. Blue chalcedony scaraboid. L. 20. A rampant goat and a locust. Greco-Persian, late 5th cent.

Pl. 1067* Switzerland, Private. Grey chalcedony scaraboid, type A. L. 32. A winged bull. 5th/4th cent.

Pl. 1068* New York, Rosen Collection. Mottled jasper polyhedral pendant. L. 31. Eleven of the thirteen faces are engraved. Those illustrated show a goat, a dog, a fox and a locust on corn. Greco-Persian. 5th cent.

Pl. 1069 Malibu, J. Paul Getty Museum 81. AN. 76. 92. Blue chalcedony scaraboid, type C. L. 25. A hyena. Late 5th cent. *IR* no. 92.

Pl. 1070* New York, Rosen Collection. Grey/brown chalcedony scaraboid, type C. L. 28. A Persian horseman attacks a lion. Greco-Persian, approaching the Bern Group style. 4th cent.

Pl. 1071 Paris, Cab. Med. *de Clercq* II, no. 96. Greenstone scaraboid with grey streak, the back recut, tiny stringhole. L. 20. A recumbent horned griffin. Greco-Persian a globolo. 3rd cent.

Pl. 1072* Paris, Cab. Med., Seyrig 1973. 1. 489. Chalcedony scaraboid in silver mount. L. 21. Hermes, with petasos, caduceus and chlamys, with a ram, a common attribute for him. Inscribed in Phoenician (later) 'Baal'. The style is Greek sub-archaic (note the treatment of the torso), as on Classical Phoenician scarabs. This rather emaciated figure suggests Levantine origin, comparable with the later group of de Clercq rings (*p. 221*), with similar slim Greek figures and favouring Hermes. See also *Pl. 1073*. 5th cent. Bordreuil, op. cit., no. 37.

Pl. 1073* Jerusalem, Rockefeller Museum. Clay sealing from Samaria. L. 15. Hermes holding caduceus and *aphlaston* (from a ship; an unusual attribute for the god). A later example of the motif is associated with the battle of Actium (*LIMC* VI, Mercurius no. 124). See the last. M. J. W. Leith, *Wadi Daliyeh* I (1997), pl. 1. 2. Israel Antiquities Authority.

Pl. 1074 Paris, Cab. Med. *de Clercq* no. 2792, pl. 19, from Yakhmour. Black jasper (cut scarab?) set in a gold ring. L. 17. A lion attacked by a winged, horned lion. A very unusual fighting couple, probably only admissible in the eastern world. 4th cent.

HELLENISTIC

Pl. 1075 *London* 1184, pl. 17. Jasper ringstone. L. 28. Portrait head of King Philetairos of Pergamum (reigned 283–263 BC).

Pl. 1076* Woodstock, Boardman Collection. Blue chalcedony tabloid, L. 15. An unfinished gem with each side at a different stage of work, from a scratched sketch to fuller use of the cutting wheel for major areas and some finer detail being added. Ptolemaic, 3rd/2nd cent., with hellenized versions of Egyptian deities. The stone used to belong to the great Adolf Furtwängler, who published it in *AG* III, 400–1, figs. 207–210. *Harari* no. 44; A. Krug, *AA* 1997, 410–1, fig. 3.

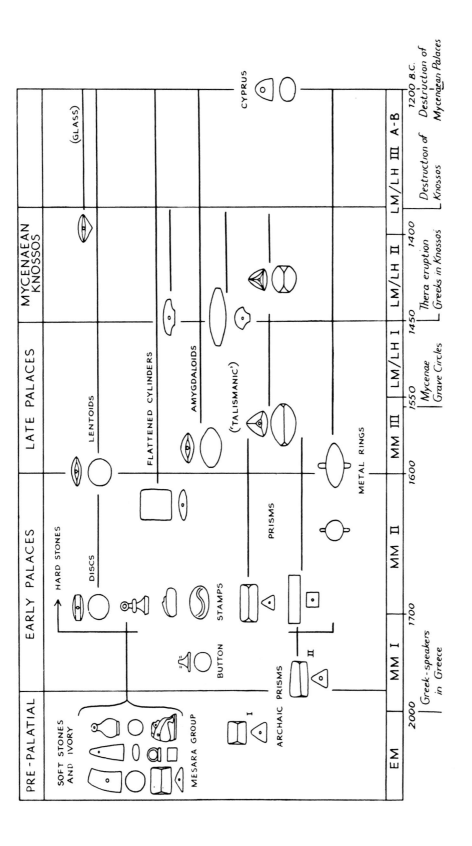

SUMMARY OF GEM AND RING SHAPES I

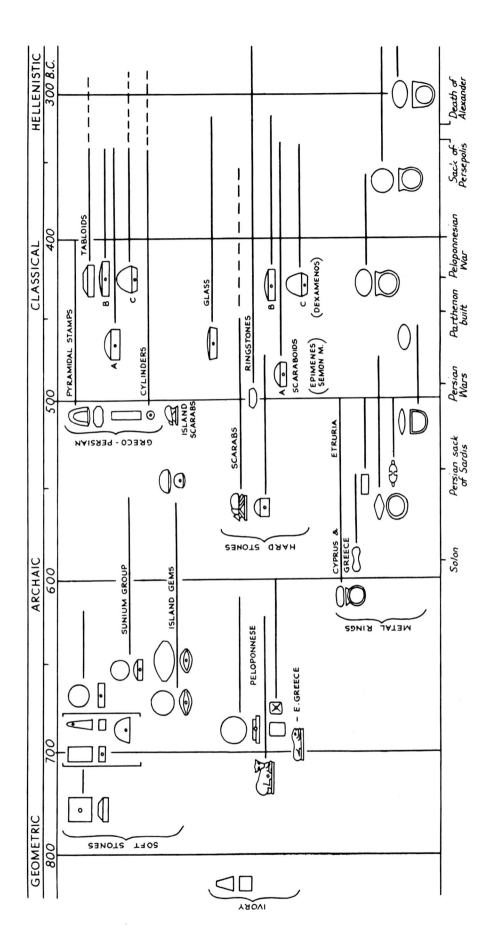

SUMMARY OF GEM AND RING SHAPES II

MINOANS AND MYCENAEANS

INTRODUCTION

GENERAL BIBLIOGRAPHY ON BRONZE AGE GREECE

General introductions to the archaeology and art of Bronze Age Greece may be found in:

Pendlebury, *The Archaeology of Crete* (London, 1939: a thorough but somewhat dated handbook).

Marinatos, *Crete and Mycenae* (London, 1960: excellent pictures, with commentary).

Hutchinson, *Prehistoric Crete* (Harmondsworth, 1962: a concise guide).

Matz, *Crete and Early Greece*; and *Minoan Civilisation; Maturity and Zenith* (Cambridge Ancient History, new edition, 1962).

Demargne, *Aegean Art* (London, 1964).

Higgins, *Minoan and Mycenaean Art* (London, 1967: good on 'minor' arts).

Schachermeyr, *Die minoische Kultur des alten Kreta* (Vienna, 1967: detailed discussion).

Vermeule, *Greece in the Bronze Age* (Chicago, 1964: detailed discussion).

Hood, *The Home of the Heroes* (London, 1967).

Taylour, *The Mycenaeans* (London, 1964).

Boardman, *Pre-Classical* (Harmondsworth, 1967) ch. i.

For chronology see especially Matz, Hutchinson, Hood; and Thomas, *Near Eastern, Mediterranean and European Chronologies* (Lund, 1967) 80ff.

GENERAL BIBLIOGRAPHY ON BRONZE AGE GEMS

The *Corpus minoischen und mykenischen Siegel* (*CMS*; Berlin, 1964–) under the supervision of Professor Matz proposes to publish all extant Bronze Age seals and sealings from Greece and Crete. Three volumes have appeared and, where possible, reference is here made to this publication only; we await still the important volumes on Heraklion Museum. The writer's review of *CMS* i appears in *Gnomon* 1966, 264–7, and, with Miss Gill, of *CMS* vii, viii in *Class. Rev.* xx, 225ff.

Apart from the publication of gems from excavations there is illustration of several of the Heraklion gems in *Arch. Eph.* 1907, pls. 6–8 (cf. 1913, 98ff.). Those in other major museums are usually included in their Classical gem catalogues but not, for instance, in New York (for which see *AJA* lxviii, 1ff., pls. 1–4).

Separate publications of important collections not yet in *CMS* are Mrs Sakellariou's *Les Cachets minoens de la Collection Giamalakis* (Paris, 1958: *Giam.*), now in Heraklion Museum, and Kenna's *Cretan Seals* (Oxford, 1960: *CS*) for Oxford. Evans' chapters on seals in *Palace of Minos* (*PM*) remain basic to any study of this subject, and especially his arrangement of the material in the Index volume (v)

164ff. Since he wrote the main new contributions have been by way of publication of new discoveries or collections, or some readjustment, usually slight, of his dating. Special studies of groups and periods will be noted below but there are important general studies by Biesantz in *Kretisch-mykenische Siegelbilder* (Marburg, 1954) and in the introductions to the books by Mrs Sakellariou (1958) and Kenna (1960), already cited. Levi's excellent publications of the A. Triada and Phaistos sealings should also be mentioned and an important contribution to study of the Knossos sealings is Miss Gill's concordance in *BSA* lx, 58ff., which draws on all available evidence, including the excavation notebooks.

NOTES ON SOME OTHER COLLECTIONS

AJA lxviii, pls. 1–4 illustrates a selection of the gems in New York, Pennsylvania, Harvard, Toronto and Boston. Other Seager gems in New York are here cited by their museum numbers, omitting the prefix 26.31—(thus, NY 103 = New York 26.31.103). For gems in Michigan see *Hesp.* xxiii, pl. 34; the Emmet Coll., *AJA* lxxii, 33ff. Zazoff republishes the Kassel gems in *AA* 1965, and the Jantzen collection (now in Hamburg) in *AA* 1963. Part of the Erlenmeyr collection in Basel is published in *Antike Kunst* iv and see the owners' article in *Orientalia* xxix, xxx, xxxiii. The Munich gems appear now in *Munich* i.

THE DISCOVERY OF BRONZE AGE GEMS

For the excavations see *CMS* i and other references below. Raspe, *Tassie's Gems* (London, 1791) pl. 11.665 = our *Pl. 113*.

'Inselsteine', see *IGems* 12–14.

Evans in Crete, see Joan Evans, *Time and Chance* (London, 1943) 308ff.

'Milk-stones', see Xanthoudides quoted in *BSA* xl, 44.

The lists and groups offered in the notes to this chapter do not attempt to place all extant gems and sealings in their right period and context, but they do attempt to present a good range of examples for each main period and style, so far as I can judge them from autopsy or publication. Where dates are given they refer to the context in which the gem was found. For some lists (the 'talismanic' and 'Mycenaean Knossos') I confine references to standard publications (*CS*, *CMS*, *Giam.*).

EARLY GREECE

Good general accounts of this period in Caskey, *Greece, Crete and the Aegean Islands in the Early Bronze Age* (Cambridge Ancient History, new edition, 1964) and his article

in *Hesp.* xxix, 285ff. On overseas connections, Schacher-meyr, *Ägais und Orient* 17.

CLAY STAMP SEALS AND RELATED IMPRESSIONS
In the east and Greece: Matz, *FKS* 235ff., 255ff. (Troy); *AJA* lxix, pls. 64–5, and lxxi, pl. 84 (Lycia); Schachermeyr, *Ägais und Orient* 17, figs. 36, 37 (Macedonia) and cf. Delvoye, *Mél. Picard* (Paris, 1949) i, 267ff.
EHII Corinth. *Hesp.* xxxvi, pl. 11d.
Thessaly. *BCH* lxxxix, 790, fig. 2.
Lesbos, Thermi. *Arch. Reports 1965–6* 44, no. 1.
Lemnos. Brea, *Poliochni* (Rome, 1964) i, 653–5 and pl. 129a (impression).
Blegen, *Zygouries* (Cambridge, 1928) pl. 21.4 (hemisphere).
Lerna. *Hesp.* xxvii, 82f.
A. Stephanos, Laconia.
Syros. Zervos, *L'Art des Cyclades* (Paris, 1957) fig. 101 (impression on vase).

LERNA SEALINGS (See *Figs. 1–11*)
Heath, *Hesp.* xxvii, 81ff.; ibid., 83, describes devices on a smaller group of sealings, rather earlier than the main find (and *Fasti Archeologici* xiv, 1056); Heath, 116–9, for a good survey of contemporary material in Greece.

Cf. Mycenae gold discs (LHI) as Marinatos, *Crete and Mycenae* pl. 202. Sakellariou compares Cretan motifs, *KChr.* 1961–2.i, 79–86. Hood, *JHS* lxxxiii, 196, recommends a date corresponding with MMI or even MMIIA, which seems very late.

STONE SEALS AND SEALINGS WITH PATTERNS RELATED TO LERNA OR CRETE
Mylonas, *A. Kosmas* (Princeton, 1959) fig. 116.13 (EHII); the shape is Anatolian, not Cretan.

Amorgos: Buchanan, *Cat. of Ancient Near Eastern Seals, Ashmolean Museum* (Oxford, 1966) i, pl. 48.741, a stamp cylinder; 'peripheral Jemdat Nasr' type.

Sealings: Blegen, *Troy* (Cambridge, 1961) i, 256, fig. 408 (Troy IIB). Persson, *Asine* (Stockholm, 1938) 235, fig. 172.6, 7; cf. 239 no. 7 and Blegen, *Zygouries* 106, fig. 9.1. *Asine* 235, fig. 172.5, spider in maeander device. Zervos, *L'Art des Cyclades* fig. 205, on a vase.

Other stone seals: *Asine* 235, fig. 172.3 (truncated cone); Raphina, *Praktika* 1953, 117, fig. 15 (cone).

Two hammer seals of Anatolian form and a ring seal, said to be from Laconia, are not closely datable: *FKS* 102, fig. 37; *BSA* lvi, 144, pl. 27c.

Stone amulets, tabloids with suspension loops and with relief patterns including spirals—*Asine* 241, fig. 173 (EHIII) = our *Fig. 12*, and fig. 174 (from Dendra); and for the shape at Lerna, *Hesp.* xxvii, 82. Cf. the rectangular stamp-like amulet in island stone with relief spirals from Kouphonisia, near Naxos, Berlin F 59, pl. 2, D 61, *IGems* 97.

For the cylinder patterns on vases from Lerna, Tiryns and Zygouries see Vermeule, *Greece in the Bronze Age* 39, pl. 4b; our *Fig. 13*. In the north clay cylinder seals are reported from Neolithic Photolivos, suggesting early knowledge of eastern practice.

PRE-PALATIAL CRETE

The early seals were usefully collected and thoroughly discussed by Matz in *Frühkretische Siegel* (Berlin, 1928: *FKS*) which repeats the illustrations to Xanthoudides, *The Vaulted Tombs of Mesara* (Liverpool, 1924) and adds many others. Plates 4, 13, 14, 15 in the latter are pls. 5, 7, 8, 9 in the former work.

THE MESARA GROUP (*Pls. 1–4*; *Figs. 14–27*).
Matz (*FKS*) illustrates all the early finds and lists them, adding pieces without context or provenience whose date may sometimes be questioned. He lists the finds from the A. Triada tholos later published by Banti in *Ann.* xiii–xiv. Other illustrations in Zervos, figs. 199, 205–6.

Other examples from excavations are: Krasi Pedeados, *ADelt* xii, 123; Vorou, *ADelt* xiii, 165f.; Trapeza Cave, *BSA* xxxvi, 95ff.; Lebena, *AA* 1962, 120f.; *KChr.* 1961–2.i, 90; *BCH* lxxxiii, 744, fig. 14; lxxxiv 845f., fig. 9; Ano Vianno, Mesara, A. Triada and Palaikastro, Platon in *Festschrift Matz* (Mainz, 1962) pls. 3–5; Archanes (Fourni), *Archaeology* xx, 276f., figs. 4–6; *BCH* xci, 786, figs. 6–8; *Ergon* 1967, 100f.; *ADelt* xxi, Chr., pls. 440–1. Myrtos, *Ill. London News* 17.ii.1968, 26, fig. 4; 8.ii.1969, 27, fig. 3 (EMII). See now *CMS* ii.1.

Other examples in collections are: *CS* 30, 31; *Giam.* 2–5, 7, 11–13, 16, 18, 23, 44, 45; Alexiou-Platon, *Ancient Crete* (London, 1968) 84 top and *ADelt* xxii Chr. pl. 356a (Metaxas Coll.); *Early Art in Greece* (Emmerich, 1965) 23f. (some).

Basic shapes (capital letters refer to Matz's classification):
(1) cylinders (B); also Vorou, Palaikastro, Archanes, and cf. *Festschrift Matz* pls. 3–5; NY 38, 39; Oxford 1968. 1836–7.
(2) geometric shapes: conoids (C); also Trapeza, Lebena, and cf. *Mallia Maisons* (Paris, 1959) ii, pl. 30.7; *BCH* lxx, 80, fig. 2a; *CMS* i, 422; Oxford 1968. 1841. Pyramids (D); also Archanes (stepped). Half-cylinders (G); and cf. *Kadmos* vi, 114ff. (a doubted example, engraved on the sides). Half-spheres (K); also Lebena. Tabloids (F). Cuboid with round faces (Q); also a triple cube from Archanes.
(3) bead shapes (E, H).
(4) stamp seals with handles (K, S); also Lebena, Phaistos (*Ann.* xxxv–xxxvi, 58, fig. 62.IV, stone); Oxford 1968. 1844.
(5) cylindrical or pear-shaped stamps (O, also Lebena, Myrtos; I, also Trapeza, Krasi).
(6) ring seals (N); also Lebena, Ano Vianno.

(7) figure seals (A); also Lebena (bull's leg, dog's heads, birds, woman); Krasi (foot); Trapeza (bird, monkey on knob); *Giam.* 2 (monkey), 3 (animal leg); *CMS* vii, 14 (a cup); *Munich* i, 1, pl. 1 (foot); *Antike Kunst* iv, pl. 3.35–6 (a foot); Archanes (dog?); Metaxas Coll. (lion, lion head, bird, two monkeys).

There is also a small number of Egyptian scarabs from the tombs and poor local imitations in soft stone and faience: Matz, T. and *Ann.* xiii–xiv, fig. 116, 258a, A. Triada.

On the seals with detachable parts see Platon in *Festschrift Matz* 14ff.

Contorted lions: on seals, *FKS* pls. 1.3, 2.2, 5, 7.4. Impressions, mainly from Mesara Group seals: Phaistos, *Ann.* xix–xx, types 170, 171(MMII): Knossos, Hood, *Home of the Heroes* 61 (EMIII); Palaikastro, *BSA* lx, 301, fig. 18.21, stamped on a jug handle (EMIII/MMI). The perforations of Mesara Group seals are often cut from more than two points on the ivory and meet each other at angles. These are for individual suspension rather than stringing on a necklace or wristlet. See *Giam.* p. 95.

A distinct group of 'depressed' prisms can be distinguished, in ivory and stone, some of which may be MMII: Palaikastro, *BSA* xl, 45, fig. 11; *Arch. Eph.* 1907 pl. 6.27; *FKS* pls. 8.5, 7; 9.8, 9. They are thought by Chapouthier to provide the link between the eastern gable seals and the commoner Cretan prisms (*BSA* xlvi, 42–4) but this seems very doubtful (see Sakellariou in *Minoica* 458f.).

Primitive clay seals in Crete: hemisphere—Myrtos; cylinders—*FKS* pl. 10.1 (A. Onouphrios), 11.18 (Gournia); cones—Hawes, *Gournia* 54, fig. 29; Hall, *Vrokastro* pl. 11.23, *FKS* pl. 11.19 (Gournia); Lebena, *KChr.* 1961–2.i, 90.

THE GROUP OF ARCHAIC PRISMS I (*Pls. 5–8*; *Figs. 28–30*) A good study of sources and dating by Sakellariou in *Minoica* (Berlin, 1958) 451ff. See *FKS* 24f. and pls. 17–21 for most illustrations. Also: Trapeza, *BSA* xxxvi, 96, fig. 21.15; Palaikastro, *BSA* xl, 45, fig. 8; Mallia, early MM, *BCH* lxxxix, 1001, fig. 3, lx 78ff., figs. 1, 3.6, 2b (wedge).

And in collections: *CS* 1–14, 18–24, 36–46 (16, 17, 25, ?29, 33—stamps of this class); *Giam.* 46, 47, 50–2, 55, 57–63, 65, 67, 68, 71, 79–89; *Arch. Eph.* 1907, pl. 6.9–11, 14, 19, 20, 23, 24, 35, 36, 39; *CMS* i, 414–9, 420 (cylinder), 424 (conoid); *CMS* vii, 2–12, (cf. 20, long reel), 206–9, 212, 253; *CMS* viii, 1–8, 9–12 and 14 (cones), 13, 15, 16, 17–8 (cones), 19, 100, 111, 112 (cone), 131 (conoid); *Berlin* F 62–3, pl. 2, D 1,2; *Newell Coll.* 545; Delaporte, *Louvre* i, pl. 59.Δ.25, 27, 32, 38; *Hesp.* xxiii, pl. 35.14, 15; *Antike Kunst* iv, pl. 3.32; Dresden, *AA* 1889, 173, fig. 65; *AJA* lxviii, pl. 3.1, 2, 6, 8; *Geneva Cat.* i, 187; NY 24–5, 71–5, 77, 81–2, 84–95, 101–3, 130, 154; *Munich* i, 15, pl. 3.

For the prisms from the Mesara area see especially *CS* pp. 26f.; *FKS* pls. 5.6 (Archaic Prisms II), 6.19, 8.7, 12, 9.6–9; *Ann.* xiii–xiv, figs. 112.253, 113.254, A. Triada.

Ivory prism and disc from Archanes (Fourni) with hieroglyphs, *Kadmos* v, 109ff. Cf. the stone disc with hieroglyphs from Knossos, *CS* 95; and the ivory half-cylinder, *CS* fig. 86. Other ivory seals from Archanes, see above.

From the text it will be seen that I broadly agree with Kenna's observation about the special character of these seals, whether or not 'amuletic' is the correct term; but I cannot follow his definition of the different treatment of one or two sides or the apparent suggestion that devices become more lifelike (*CS* pp. 21f.; *AA* 1964, 921f.). He also prefers a very early date for the start of the prism series.

CHRONOLOGY
On the chronology of seals in this period see *BSA* xxxvi, 95; *CS* pp. 13ff.; Sakellariou in *Giam.* pp. xi–xiii (useful collection of sources) and *Minoica* (Berlin, 1958) 451ff.; and on general problems Matz, *Minoan Civilisation* (1962, Cambridge Ancient History) 4f., *Crete and Early Greece* (London, 1962) 72–4; Hutchinson, *Antiquity* xxii, 61ff.; Schachermeyr, *Min. Kultur* (Stuttgart, 1964) 46; Zoes, *Arch. Eph.* 1965, 27ff.; Hood, *Bericht V. Int. Kongr. für Vor-u. Frühgeschichte* 398–403 and *Home of the Heroes* 32f., for high dates; Astrom, *KChr.* 1961–2.i, 137ff., and *Peprag. II Kret. Synedr.* i, 120ff., for low dates. In one of the Mesara tombs, Platanos B, which was still used in the Early Palace period, a Babylonian cylinder seal was found, generally dated to the time of Hammurabi. This would provide the possibility of absolute dating, within broad limits, for this phase, if the exact dates of the Babylonian worthy could be agreed. There are proposals for a higher absolute dating for this period, relying in part on what seems the rather unusual circumstance of pottery offerings in the tombs ceasing long before the offerings of seals (Hood, *JHS* lxxxiii, 196). And the suggestion has now been made that the cylinder could antedate Hammurabi by some 100 years, Buchanan, *Catalogue of Ancient Near Eastern Seals, Ashmolean Museum* i, 91; Kenna, *AJA* lxxii, 321ff. High dates for Platanos B are argued now by Branigan and Robinson, *Studi Micenei* v, 13ff. Other references for the cylinder by Buchholz in Bass, *Cape Gelidonya* (Philadelphia, 1967) 156. But absolute chronology is not our concern here.

CRETE: THE EARLY PALACES

On Cretan palaces and commerce see Schachermeyr, *Ägais und Orient* 65–8.

On the relations of seals and script see Kenna in *Kadmos* i, ii. Grumach in *Bull. John Rylands Lib.* 1964, 346ff. well explains the beginnings of the use of hieroglyphs. Evans called the more primitive hieroglyphs 'pictographs'. On the decorative use of hieroglyphs Kenna in *Fest. Grumach* (Berlin, 1967) 172ff.

MALLIA WORKSHOP. Dessenne, *BCH* lxxxi, 693–5 for a brief account and pictures; *Comptes Rendus* 1957, 123ff. for a fuller account and descriptions.

THE GROUP OF ARCHAIC PRISMS II (*Pls. 9–12; Fig. 31*)
Examples from excavations: Mallia workshop, and *BCH*
lxx, 78ff., fig. 3.1–5; Phaistos, Demargne, *Aegean Art*
fig. 142; Palaikastro, *BSA* xl, 45, figs. 1, 10, 12.

Examples in collections: *CS* 47–60, 64–73, 97–101, 103;
Giam. 78, 90–100, 104, 105, 114, 116; *Arch. Eph.* 1907, pl.
6.15, 22, 25, 26, 28, 29, 41; *CMS* i, 426 and cf. the tabloid
427; *CMS* vii, 13, 15–19, 28–30, 214–6, 254; *CMS* viii,
20–22 cf. 26, 27; *AJA* lxviii, pl. 3.5, 7; Delaporte, *Louvre* i,
pl. 59.Δ.24, 28; Vienna 1979, 1980; NY 76, 99–101, 113,
115, 120–1, 126, 129, 132, 134–44, cf. 125 (four-sided);
Mél. Dussaud (Paris, 1939) i, 122, fig. 1; *Munich* i, 16–18,
pl. 3; *ADelt* ix, par., 14, fig. 3.3.

On the reuse of older prisms, *CS* pp. 21, n. 8, 33. The
size of string-hole may be determined by the technique
of at least the older prisms in which the hole was sometimes
gouged, not drilled.

There are MMI sealings at Knossos with early hieroglyphs,
from the Monolith Pillar Basement, but it is not clear what
shape of seal is involved: *Scripta Minoa* i, P15, 16; Kenna,
CS p. 33, suggests a 'four-sided bead'. And from the Vat
Room Deposit, *PM* i, fig. 119d; Kenna in *Fest. Grumach*
172; doubts on the date, *BSA* lxii, 200, n. 35.

Button seals (soft stone). One from the Mallia workshop
(à prise pincée); Kamilari, *Ann.* xxxix–xl, no. 2; *CS* pp.
33f., 98, nos. 74–84; *Giam.* 17, 143, cf. 15; *FKS* pls. 7.10,
11.12; *CMS* vii, 21, 23, 24, 31; *CMS* viii, 23, 24, 113;
Antike Kunst iv, pl. 3.37; *ADelt* ix, par., 14, fig. 3.1.

Technique. See Kenna, *CS* pp. 36, 70ff., but I am not
sure that the drill was used at all freely on the early prisms
(ibid., p. 72 on no. 1).

PHAISTOS SEALINGS (*Figs. 33–50*)
Levi, *Ann.* xxxv–xxxvi, 7ff. Referred to by type numbers.
Fiandra, *Peprag. II Kret. Synedr.* i, 383ff., on their use.

Spiral patterns with floral additions, as nos. 150, 151, 155,
157–162, 164–5.

Hoop and Line style octopus on no. 206. This submission
of animal forms to the technique is seen on two discs,
CS figs. 48, 49 (Zervos, fig. 681), and compare *CMS* vii,
45. Kenna associates also the lentoid from a MMIII tomb
at Mochlos, ibid., fig. 50, our *Pl. 78*.

Crossed lions on no. 234, *Arch. Reports* 1962–3, 30, fig. 32.

'Architectural' patterns on nos. 44, 45, 51 and cf. nos.
35–53 *passim*. Other examples: Knossos sealings, *CS* figs.
65, 66 (Temple Repository and Magazine VI); Kamilari,
Ann. xxxix–xl, no. 12 (MMIII); impressed on a MMIII–LMI
'Medallion Pithos' at Knossos, *PM* i, fig. 410; Gournes
Pedeada, *ADelt* iv, pl. 5.3 (bronze disc); Knossos, Ailias
(stamp); *CS* 152–161 (discs, lentoids and an elliptical bead),
198 (flattened cylinder) and p. 110; *Giam.* 113 (four-sided
prism), 125–131 (discs and a flattened cylinder), 134
(cylinder); Avgo, *AJA* ix, 283, fig. 6; *CMS* i, 432; *CMS*
vii, 43, 220, 221; *CMS* viii, 41, 42, 105; *AJA* lxviii, pl.
3.14, 16, 17 (discs and a flattened cylinder); NY 199, 230,

231, 244, 324, 333, 356; *Antike Kunst* iv, pl. 5.56–60;
Delaporte, *Louvre* i, pl. 58.Δ.1–3; Brooklyn 35.749, 776;
Budapest 53.102; Mallia, *BCH* lxx, 83, fig. 4.

A number of these may be MMIII; certainly most of the
lentoids.

THE HIEROGLYPHIC DEPOSIT AT KNOSSOS (*Figs. 52–55*)
PM i, 271ff.; *Scripta Minoa* i, 144ff.; *CS* pp. 37–41; Gill,
BSA lx, 66ff. collects all references. Matz, *Min. Civ.* 19,
is quoted in the text.

'Portraits'. *Fig. 53; Pls. 14, 15. CS* p.40; Biesantz,
Marburger Winckelmannsprogr. 1958, 9ff.; Blegen *AJA*
lxvi, 245–7, believes in them as portraits; Marinatos, in
Festschrift Wegner (Münster, 1962) 9–12 with fig. 1, adds a
steatite lentoid from Anopolis with a 'portrait' in a later
(? much later) style.

SHAPES of seals in hard stone. Some examples listed may
be MMIII, but the style of the devices is represented in the
Hieroglyphic Deposit or earlier:

Discs: for examples with 'architectural' motifs and
Hoop and Line animals see above. The 'architectural'
theme may also be subordinated to an animal motif, as
our *Pl. 21*, or script (*Kadmos* ii, 1ff.) or it may serve as the
background to animal studies, our *Pl. 63*, perhaps MMIII.
Early examples in soft stone, as *CS* 89–93, cf. 94 and 95
(with hieroglyphs); *Giam.* 117, 118, 120 (possibly later).
Animal and other devices, *CS* 112–4, 191; *Giam.* 121
(A. architectural, B. animal); *Arch. Eph.* 1907, pl. 6.40;
CMS vii, 25–6, 42; *CMS* viii, 104; *Bull. Mus. Hongr.* xxix,
4, fig. 1; *Arch. Eph.* 1953–4.iii, 49, fig. 1.

Lentoids: at Mavrospelio, tomb XVII, in a pit with
debris from earlier burials (MMII), *BSA* xxviii, pl. 19.XVII.
P.11–3: P.11 is *CS* fig. 81 (cf. Zervos, fig. 438 r.; *Fest-
schrift Matz* 6 and pl. 1), by the same hand as *CS* fig. 80,
as Kenna observes, but not, I think, in any way to be
associated with the disc from beneath the Little Palace
staircase, our *Fig. 60*. I am not sure that the lentoids with
conoid backs, *CS* 104–7, can be so early.

Flattened cylinders: several with 'architectural' motifs,
see above. In the style of the Early Palace sealings, our
Fig. 56, with hieroglyphs on the reverse. With hieroglyphs
on both sides, *Giam.* 124. With an animal device, perhaps
MMII, Knossos, Ailias.
On the origin of the shape *PM* iv, 499. Cf. an early, tabloid
version, *Munich* i, 19, pl. 4.

Three-sided prisms: Hoop and Line, *CS* 109; NY 83.
Hieroglyphs (some with animals also), *CS* 146, 149, 166,
167, 172 (later?); *Giam.* 106, 107, 111; *Arch. Eph.* 1907,
pl. 6.21; *AJA* lxviii, pl. 2.8, cf. the rectangular bead, pl. 3.12;
Berlin F 59, pl. 2, D 61; *Kadmos* vi, pls. 2–4, 6; *CMS* vii, 36;
Antike Kunst, Solothurn (1967) pl. 49.396; NY 118, 124,
150, 153, 162. Cf. from Poros, Crete, *Ergon* 1967, 124,
fig. 125, set in gold. Animals only, probably MMIII, *CS* 168;
CMS vii, 45; *CMS* viii, 31.

Four-sided prisms: Hoop and Line, *CS* 147; *Giam.* 113 ('architectural'), 115; cf. NY 26, 45. Hieroglyphs, *CS* 148, 150, 151; *CMS* i, 425; *CMS* vii, 40; *AJA* lxviii, pls. 2.2, 4, 5, 3.18, 19; NY, 155–7, 161; *Berlin* F 56, pl. 2, D 7; *Kadmos* iv, 2, fig. 2; vi, pl. 7; Mallia (MMIII) *BCH* lxxxix, 1–9, figs. 1, 2; lxx, 81, fig. 3.7.

Eight-sided prism: our *Pl. 24*.

Hieroglyphic seals: see references in Grumach, *Bibliographie* and *Supplement* (Munich, 1967) i; *Fest. Grumach* 172ff.; *Kadmos* vii, 20ff., on their possibly cult texts.

Buttons: *CS* 110, 115; *CMS* viii, 37, 38; Hazzidakis, *Tylissos* (Paris, 1921) pl. 2a.

Pear-shaped: Kamilari, *Ann.* xxxix–xl, no. 6, apparently MMI–II and cf. no. 4 (our *Fig. 57*).

Loop-signets: (à tige, stalk-shaped, Petschaft mit Griffring). See *FKS* group M for earlier published specimens. Pendant type with hemispherical face: *Cretan Coll. in Oxford* (Oxford, 1961) no. 286; *JHS* lxxxvi, pl. 10.12 (cut down); *Giam.* 152; *CMS* i, 430; *Antike Kunst* iv, pl. 4.49, 50; Brock, *Fortetsa* (Cambridge, 1957) pl. 174.1171. With lengthened face, *CMS* i, 428, 429 and cf. the back of Delaporte, *Louvre* i, pl. 59.Δ.21 and sides of *CS* 122; and the gold signet from Mallia (below). Soft stone examples from Mesara, *FKS* pl. 9.10, 13; *Ann.* xiii–xiv, figs. 84.218, 99.235, A Triada. Metal, (*CS* 116 (bronze) is Near Eastern); cf. the gold weight *CS* 137; Seager, *Mochlos* (Boston, 1912) 66, fig. 35 (*FKS* pl. 13.10, silver); Mallia, our *Fig. 58*. Others: *CS* 117–122, 138, 139, 142; *Giam.* 148, 161, 163, 178, 183; *CMS* i, 423; *CMS* vii, 33, 34, 219, 255; *CMS* viii, 33, 34, 103; *Mochlos* fig. 27b (MMIII, *Marburger Winckelmannsprog.* 1958, pl. 14.27), fig. 14 (MMIII, *CS* fig. 55); Palaikastro, *BSA* xl, 45, fig. 13; *AJA* lxviii, pl. 1.9, 13, 20 (3.10, 2.7, 3.13); Bonn; *Berlin* F 88, pl. 3, D 10; *Arch. Eph.* 1907, pl. 7.43–5; *Newell Coll.* 531; *Hesp.* xxiii, pl. 34.13; *Kadmos* iv, 2, fig. 3; Phaistos, *Ann.* xix–xx, 58, fig. 62.II; Knossos, Ailias; Emmerich, 1965, no. 68; *AJA* lxxiii, pl. 12.10. The relationship of some of these loop-signets to Hittite stamp seals is worth notice. The shape of our *Pl. 23* and its material can be matched in Anatolia, where too we find the decorative border enclosing a formal pattern (as Delaporte, *Louvre* ii, pl. 98.13, 14) or hieroglyphs (as Delaporte, *Bibl. Nat.* pl. 38.649, comparing our *Fig. 52*).

S-pattern backs; *CS* 131 (*colour, p. 29.12*), 133, 135, 140, 141; *CMS* vii, 41; *CMS* viii, 102; *Antike Kunst* iv, pl. 4.51, 52.

Two animal foreparts: Mesara Group predecessors, Matz group A nos. 16–20. Early: *CS* 85 (our *Pl. 39*). In hard stone, *CS* 132 (our *colour, p. 39.1*); *Pauvert* pl. 6.72; *Berlin* F 55 pl. 2, D 9; *CMS* viii, 36. Cf. Mallia, *BCH* lxx, 80, fig. 2c.

Figure stamps (*CS* 85–88 may be earlier, in softer stone; see our *Pls. 39, 41*). Dog or lion, *CS* 130; *Giam.* 181; *CMS* vii, 39. Lion head, *Berlin* F 54, pl. 2, D 11. Cat, *CS* 129 (our *colour, p. 39.2*). Monkey, *CS* 86, 134 (our *Pl. 41, colour, p. 39.4*). Ducks, *CS* 87, 125, 128 (our *colour, p. 29.14*), 159.

Owl, *CS* 62, ivory, our *Pl. 38*. Human hand, our *colour, p. 29.13*; (*AJA* lxviii, pl. 1.10, 3.11, is Near Eastern). Animal paw, Kamilari, *Ann.* xxxix–xl, no. 13 (MMIII); our *Pl. 42*, and *Fig. 42*. Sea shell, *CS* 88, 136 (our *colour, p. 29.11*). Vase, *Giam.* 164.

Scarabs: a few copies of Egyptian scarabs have been noted in the Mesara tombs. There is an amethyst scarab from the Psychro Cave, *CS* 126, which seems to have been recut in the Cretan Hoop and Line style; and a 'Cretan' scarab of rock crystal from Knossos, Ailias, *CS* p. 37, perhaps in a MMIII context (*JHS* lxxiv, 166).

It might be argued that in view of the long use of the Mesara tombs, some of the Mesara Group seals should also be admitted as representative of the Early Palaces as late as MMII. I am encouraged to regard the Mesara Group as basically a MMI and earlier phenomenon because of the absence of hard stone seals (from tombs otherwise quite richly appointed) and the lack of many close parallels on the Phaistos sealings, which show continuity with the Mesara Group rather than any degree of contemporaneity. There are, however, some rock crystal pendants in seal forms, *VTM* 49, 69, 84, 124; Zervos, fig. 197.

Another important source for dating is the Ailias cemetery at Knossos, yet to be published. Kenna has described some of the finds, *CS* pp. 35, 37, 41, and see *JHS* lxxiv, 166 and *Arch. Reports* 1955, 33. Mr Hood has kindly shown me photographs.

CRETE: THE LATE PALACES

EXCAVATED SOURCES

Knossos, the Temple Repositories (MMIIIB). Full references given by Gill in *BSA* lx, 69ff. See especially *BSA* ix, 54ff.; *PM* i, figs. 363a, b, 411b, 514, 518, 519, 520, 522a. Discussed also in *CS* pp. 41–4 (correcting fig. 71, which is from a South Portico hoard, LMI, *PM* ii, fig. 517). Our *Figs. 62–66*; *Pl. 49*.

Knossos tombs: Upper Gypsades, MMIIIA, *BSA* liii–liv, pl. 62.XVIII.5; Mavrospelio, *BSA* xxviii, pl. 19.VI.1 (MMIIIA), IX.B.6, 7, D.3, 4, E.1 (LMIA); Ailias.

Knossos: N.W. Treasure House, LMIA, *PM* ii, fig. 388; Royal Road, LMIB, *Arch. Reports* 1959–60 23, fig. 27, 1961–62 29, figs. 38, 39; Hogarth's Houses, ibid., 1958 19, fig. 30.

Seager, *Mochlos* Tombs I (fig. 6; MMIII), III (fig. 14; MMIII), X (fig. 27; MMIII–LMI), XII (fig. 30; MMIII); and fig. 53, probably LMI, and the silver loop-signet, fig. 35.

Hall, *Sphoungaras* (Philadelphia, 1912), LMIA, 68–70, figs. 40, 43–5. Our *Figs. 83, 84*.

Hawes, *Gournia* (Philadelphia, 1908), LMIB, 54, fig. 30. Our *Fig. 82*.

Kamilari, *Ann.* xxxix–xl, nos. 5, 12–14, MMIII; others earlier or LMIA. Our *Fig. 85*.

A. Triada sealings, LMIB, Levi, *Ann.* viii–ix, 71ff. (Levi, *A. Tr.*). Our *Figs. 71–79*.

Zakro sealings, LMIB, Hogarth, *JHS* xxii, 76ff.; corrected and supplemented by Levi, op. cit., 157ff.; *CS* 12–39S. Our *Pls. 51–56*; *Fig. 68*. Miss Gill points out to me that *CS* 291 is in a related style, and see our *Fig. 80*; also *Munich* i, 51, pl. 7, *CS* 243 (the head).

Sklavokampo, LMIB, Marinatos, *Arch. Eph.* 1939–41, 87ff. Our *Figs. 67, 69*.

In *Kadmos* vi, 15ff., Betts studies the evidence for impressions found on different sites made from the same seal.

Examples from the main Knossos deposits are not stratigraphically separable from those baked in the LMIIIA destruction.

On sealings and Linear A accounting see Pope, *BSA* lv, 200f.

In Greece, Mycenae, Grave Circle B, early LHI, *CMS* i, 5–8.

Some Shapes

'Lentoid'. The use of the term derives from Pliny's (*Nat. Hist.* xxxvii, 196) description of Roman ringstones as 'lenticula': presumably like round lentil beans.

Four-sided prisms, with advanced or mixed hieroglyphs and other patterns: *CS* 169, 170 (*Pls. 45, 43*), cf. 171; *Giam.* 108–10, 112; *Arch. Eph.* 1907, pl. 6.32; *AJA* lxviii, pl. 2.1 (with acrobat), 3, 4 (our *Pl. 46*).

Three-sided prisms, flat faces, with advanced or mixed hieroglyphs and other patterns: *CS* 173, 174 (our *Pl. 48*); Mallia, *Peprag II Kret. Synedr.* i, pl. Ξ Θ .2; *Arch. Eph.* 1907, pl. 6.38; *AJA* lxviii, pl. 3.20; NY 175; *Berlin* F 58 (our *Pl. 47*; round faces); *Kadmos* ii, 79ff., pl. 1.I (our *Fig. 61*); vi, pl. 1. With animals: *CS* 168.

Impressions from hieroglyph seals: A Triada, Levi, fig. 29; Zakro, Levi, *A. Tr.* fig. 181, *JHS* xxii, pl. 10.136–7; Knossos, Oxford.

Flattened cylinder. A steatite example covered with gold sheet: our *Pl. 59*. One is double-pierced, like a spacer, *CS* 201.

Cross shaped beads: Oxford AE. 1233 (A. Pelagia, architectural pattern); NY 254.

Rings: a bronze example from Knossos with the ends of the hoop put through the bezel, *Arch. Reports 1958* 19, fig. 30. Mr Betts has remarked that this feature is betrayed also by some sealings. Other bronze rings, Hall, *Sphoungaras* (Philadelphia, 1912) fig. 43; *CS* 251. Religious scenes on the rings are best discussed in Nilsson, *Minoan-Mycenaean Religion* (Lund, 1950). The earlier rings have round bezels: the inscribed ring from Mavro Spelio, *PM* ii, 557, fig. 352 and *BSA* xxviii, 284, pl. 19; cf. *CSM* vii, 68; Knossos, Ailias; Poros, *Ergon* 1967, 124, fig. 125 (with cloisons).

The distinction between the best gems of MMIII–LMI and those of LMII–IIIA is a fine one and the study of them, based on dated sealings and other finds, must proceed by the identification of artists and workshops. This is not attempted here, but I list a selection of fine quality examples which seem to me most probably MMIII–LMI: *CS* 200–205 (our

Pls. 57–60; *colour, p. 39.11–13*), 206, 227 (our *Pl. 61*), 232–4 (our *Pl. 65*), 236–40 (our *Pls. 67, 68*), 242, 243, 250 (gold ring, our *Pl. 50*), 284 (our *Pl. 66*), 290; *Arch. Eph.* 1907, pls. 7.50, 99, 8.121, 130; *PM* ii, fig. 517; *CMS* vii, 44, 64, 65, 67, 68?, 71; *CMS* viii, 135; *AJA* lxviii, pls. 3.22, 4.11; *Munich* i, 73, pl. 8.

Materials. The same range of harder stones is employed, as well as, on occasion, the softer serpentine of which the black is now preferred to the green. Obsidian is attempted, see *KChr.* 1963, 352. In metal there is a lentoid of 'hammered silver or meteorite' from a MMIII tomb at Knossos, *BSA* liii–liv, pl. 62.XVIII.5; a silver loop-signet, *Mochlos* fig. 35, perhaps earlier; bronze flattened cylinder, *CS* 228; metal lentoid, *CS* 207, cf. p. 46, n. 2; gold plated steatite, *CS* 203; bronze lentoid, *Antike Kunst* iv, pl. 6.76, 77. For rings, see above.

'Talismanic' Gems

Discussed first by Evans, *PM* i, 672ff.; iv, 445ff. See also *CS* pp. 44f., 68f., 113–6. Some motifs are discussed in detail in *Giam.* pp. 73ff. Grumach, *Kadmos* vii, 20f.

Sealings from talismanic gems, Kenna, in *AA* 1964, 932, mentions two from Gournia, three from Zakro, six from A. Triada. Cf. Levi, *A. Tr.* figs. 30, 31, 32, 37, 57 and cf. 41–4; 172. And add Knossos: *BSA* lxii, 29ff., V, 1, 55.

Plump prisms: *CS* 164, 181, 188, 211, 270; *Mochlos* fig. 30 (MMIII); *Gournia* fig. 30.8 (LMIB; our *Fig. 82*); *Giam.* 188, 189; *AJA* lxviii, pl. 2.16, 4.4, 5, 6, 7, 8; NY 171, 178–84, 186; *CMS* i, 436, 437; *CMS* vii, 91; *CMS* viii, 70, cf. 110; *Arch. Eph.* 1907, pl. 7.46, 47; *Antike Kunst* iv, pl. 5.64; Delaporte, *Louvre* i pl. 58.Δ.12, 59.Δ.20; *Berlin* F 50, pl. 2, D 12. Some are carved on only two faces and a few on only one.

Less common shapes are cylinders, *CS* 355, 356; *AJA* lxviii, pl. 4.21; *Arch. Eph.* 1907, pl. 7.80; *Orientalia* xxx, pl. 66.85; pendant amulet, *CS* 187 (our *Pl. 74*).

For finds in Greece, see below, p. 413.

Architectural motifs in MMIII: Temple Repositories, *PM* i, fig. 411a, b; *BSA* lx, pl. 5.L8–12. The fine Kamilari armygdaloid, our *Fig. 85*, and an example from Episkopi. Brooklyn 35.779; *Geneva Cat.* i, 189 (amygdaloids). Several examples of the motif cited above, p. 407, are probably of this period. Also the bulla-shaped seal in New York which is inscribed, *Kadmos* ii, 1ff., fig. 2d; *AJA* lxviii, pl. 2.12, 3.30.

'Rustic shrines'. The translation shown in *PM* i, fig. 493; see also *Giam.* pp. 57f.

'Lion masks'. *BCH* lx, 86 and fig. 7. *Mochlos* fig. 53 (Zervos, fig. 633; probably LMI); *CS* 275, 276 (our *colour, p. 39.7*), cf. 353 (our *Pl. 202*) and *Giam.* 120; *Giam.* 396–8 and pp. 81f.; Zervos, fig. 671. The nose and forehead often are in the form of a papyrus, with side sprays for the cheeks, and the pattern derives from floral sprays with drill marks in the field, which become assimilated to a mask type, perhaps deliberately.

Well over 300 'talismanic' gems are known and full lists would be superfluous. I give here select references to examples of the principal motifs, and patterns:

Heart-shaped: *CS* 267; *Giam.* 199, 200; *CMS* vii, 225. Our *Pl. 70*.

Triangular: *CS* 259; *Giam.* 369, 370; *CMS* viii, 71 (our *Fig. 86*).

Kantharos (two-handled cup): *CS* 175, 176, 182, 183, 212; *Giam.* 381 (our *Fig. 87*), 382–7; *CMS* vii, 48, 49, 60, 246; *CMS* viii, 43.

Jug: *CS* 178, 179 (our *Pl. 72*), 180, 181, 210, 211, 217, 262 (our *Pl. 69*); *Giam.* 390–5; *CMS* i, 465, 466; *CMS* vii, 46, 47, 57; *CMS* viii, 118, 136, 153, (our *Fig. 89*), 154.

Cuttlefish: *CS* 184 (our *Pl. 71*), 185, 214–6, 218, 231; *Giam.* 406–17; *CMS* i, 450–5; *CMS* vii, 50, 51, 61; *CMS* viii, 43, 45, 46, 62 (our *Pl. 75*).

Octopus: *CS* 280, 281 (our *Pl. 79*); *Giam.* 215, 219–21 (see pp. 35f.); *CMS* vii, 80.

'Bundles'/fish, in pairs with a centre-piece, usually a star/sea-urchin, once a crab: *CS* 221, 222, 268; *Giam.* 405; *CMS* vii, 74, 222; viii, 61.

'Bundles'/fish, in singles, pairs or trios: *CS* 261, 266, 270; *Giam.* 399 (our *Fig. 90*), 400–3; *CMS* vii, 52, 81–4; viii, 58 (our *Fig. 91*), 120, cf. 153.

Vertical bundles, usually in pairs and with arcs (cf. scorpions as *CS* 230): *CS* 277–9; *Giam.* 216, 217; *CMS* i, 439.

Arc pattern resembling the last, and some octopuses or crabs: *CMS* i, 438, 440; vii, 62, 92; viii, 54, cf. 70. Cf. *Giam.* 204.

Fish: *CS* 189, 193, 355; *Giam.* 314–21, 324; *CMS* i, 456 (our *Fig. 93*), 457, 460 (our *Fig. 94*), 462; *CMS* vii, 73, 77, 229; *CMS* viii, 59, 60, 73, 123, 138.

Flying fish: *CS* 229 (our *Pl. 77*); *Giam.* 322–3, 325–7; *CMS* i, 409, 436, 461; *CMS* viii, 50.

Crab: *CMS* vii, 78 (our *Fig. 95*); *CMS* viii, 51.

'Rustic shrine' (see above): *CS* 254 (our *Pl. 76*), 255–8; *Giam.* 356; our *Figs. 84, 96*.

Birds: *CS* 186, 187 (our *Pl. 74*), 225; *Giam.* 418–21; *CMS* i, 469, 470; *CMS* vii, 53, 69, 259 (our *Fig. 97*); *CMS* viii, 57, 155, 158. A number of these might be classed with the later Cut Style.

Ships: *CS* 188, 288; *Giam.* 339–41; *CMS* i, 436; *CMS* vii, 72, 85, 101, 104 (our *Fig. 98*), 227; *CMS* viii, 49, 55, 74, 106 (our *Fig. 99*), 139. And see Betts, *AJA* lxxii, 149f.

Scorpions: *CS* 230; *CMS* vii, 75, 76 (our *Fig. 100*), 223.

Spiders and other insects: *CS* 265; *Giam.* 330–1, 332 (our *Fig. 101*), 333 (ibid., p. 50); *CMS* i, 464; *CMS* vii, 234. There is the possibility of confusion here with crabs.

Bucrania: *CS* 211, 264, 356; *Giam.* 354; *CMS* i, 437; *CMS* vii, 133; our *Fig. 82*.

Double axes: *CS* 272–4; *Giam.* 345, 346 (our *Fig. 102*), 347; *CMS* vii, 54; *CMS* viii, cf. 69.

Horns of consecration (alone; they commonly appear with kantharoi and jugs): *Giam.* 342 (our *Fig. 88*), 356

(with 'shrine'); *CMS* vii, 58, 226 (with floral). With jug, cf. *BCH* lx, 84.

Florals or trees: *Giam.* 202; *CMS* i, 437; *CMS* vii, 56, 59; *CMS* viii, 63 (our *Fig. 103*).

Mixed and indeterminate: *CS* 260; *Giam.* 189, 201, 203–5, 207, 214, 334; *CMS* i, 441, 446, 447; *CMS* vii, 55, 79, 230; *CMS* viii, 56, 67, 68, 70.

Star motifs, variously explained as sun discs or sea urchins, also appear, usually as subsidiary decoration, but cf. *Arch. Eph.* 1907, pl. 7.46.

Talismanic combined with other motifs on one stone: Delaporte, *Louvre* i, pl. 59.Δ.35 (with a bull in the Common Palatial Style).

A good group, coming close to the later Cut Style and favouring zigzag subsidiary patterns is formed by: *CS* 223 (our *Pl. 83*), 355; Oxford AE. 1231; *AJA* lxviii, pl. 3.27; NY 233 and another (our *Pl. 84*); *Arch. Eph.* 1907, pl. 7.73; *CMS* vii, 151, 164, cf. 93; *AA* 1963, 53, fig. 6; *Munich* i, 47, pl. 6; 63, pl. 7. The double zigzag appears on a number of Talismanic gems, as our *Pl. 69*; *Fig. 98*.

Naturalistic motifs in the talismanic technique, but still probably MMIII–LMI: *CS* 220, 221 (our *Pls. 81, 82*): perhaps by one artist. And cf. *CS* 262 and 147, a four-sided prism with abstract Hoop and Line motifs on three sides, a lion on the fourth; *Berlin* F 50, pl. 2, D 12; Delaporte *Louvre* ii, pl. 105.A.1163 (griffin on one side); *Munich* 1321; our *Pl. 78*.

'Talismanic' devices and vase painting. 'Bundles' and shells, *PM* iv, 316–8 and cf. the pattern on axes, ibid., fig. 315*bis*, a, b; hearts and ivy, ibid., 318–23; triangles and shells, ibid., 114; papyrus fresco and 'lion-mask', ibid., fig. 264c; arcs and rock pattern, ibid., 314f.; dolphins, ibid., fig. 239.

We may notice here also the famous Phaistos disc (MMIII; Marinatos, *Crete and Mycenae* pls. 72, 73, and Grumach, *Bibliographie* for other references; *Kadmos* vi, 101ff.; vii, 27ff.) whose stamped hieroglyphs recall seal usage. The outlines of the stamps used closely followed the shapes of the devices. Whatever may be thought of the origin of the script, the technique is Cretan, since it is employed also to decorate clay vessels from Phaistos, as *Festòs* (Rome, 1935) i, 229–31.

MYCENAEAN KNOSSOS

KNOSSOS SEALINGS

Miss Gill has recorded all available references to the sealings and their find places in *BSA* lx, adding to what has been published several important illustrations. See also Betts in *BSA* lxii for additions. Evans' main discussion of the finds was in *PM* iv, 591ff. and see the Index Vol. v. They have been often discussed since (as in *CS* pp. 56ff.) especially à propos of a recent abortive attempt to redate the Knossos destruction to about 1200 BC or later (cf. answers by Kenna, *Kadmos* iii, 39ff.; iv, 74–8 on the S.W. basement). Several

are countermarked in Linear B: Gill, *Kadmos* v, 1ff., our *Fig. 123*.

OTHER FINDS

Knossos, Isopata Royal Tomb (LMIIB). *Prehistoric Tombs at Knossos* (London, 1906, *PTK*) 154, fig. 138; *PM* iv, fig. 530, sealing, our *Pl. 98*.

Knossos, A. Ioannis warrior tombs (LMII). *BSA* xlvii, 275, fig. 16 (*CS* p. 63), our *Figs. 113, 114*; li, 94, fig. 5 (*CS* pp. 54f.).

Knossos, said to have been found with mature LMII pottery. *CS* 315, our *Pl. 114*.

Knossos, Mavrospelio (LMII). *BSA* xxviii, pl. 19.VIIA.14, 15, B.4–6; (LMIIIA.1) ibid., pl. 19.III.13, IV.6, 9, 11, 12, XVIIA.4, XVIIB.6–8.

Knossos, Isopata (LMII). *Tomb of the Double Axes* (London, 1914) fig. 14, our *Fig. 104*; fig. 16, our *colour, p. 49.1*; (LMIIIA.1) ibid., figs. 10, 20a, b, 55.

Knossos, Kephala tholos (LMII). *BSA* li, 80, fig. 2.18.

Knossos, Sellopoulo (LMIIIA.1/2). *Arch.Reports* 1957 24f., pl. 1h–j, our *Figs. 108–110*. Kenna in *Kadmos* iii, 37; *KChr.* 1963, 336. And a tomb dug in 1968 (LMIIIA.1), see *Arch. Reports 1968–69*, 33.

Archanes, Fourni (LMIIIA). *Archaeology* xx, 278, fig. 7, 280, fig. 13; *BCH* xci, 789ff., figs. 13, 16; *ADelt* xxi, Chr. pl. 444; *Praktika* 1966, pls. 148–9; our *Figs. 106–7, 125–6*.

Kamilari (? LMIIIA, last phase). *Ann.* xxxix–xl, nos. 16–19.

Kalyvia Mesara (LMIIIA). *Mon.Ant.* xiv, pl. 40; Kenna, *KChr.* 1963, 327ff., *AA* 1964, 945–7. Our *Figs. 105, 111–2, 124*.

Gournes Pedeada (LMIIIA–B). *ADelt* iv, pl. 5.1–6; *AA* 1964, 944–5.

Heraklion, Katsamba (LMIIIA). Alexiou, *Hysteromin. taphoi Katsambas* (Athens, 1967) pl. 14a.

SOME SHAPES

Three-sided prisms: Knossos, *BSA* xxviii, pl. 19.B4 (probably earlier); xlvii, 275, fig. 16.22; Kalyvia, *KChr.* 1963, pl. 13.12, 13; *PM* iv, fig. 495; *Giam.* 185, 186, 190, 226; Athens, Stathatou 280 (acrobat: animal heads: bird).

Cylinders: See *CS* p. 64. Knossos, *BSA* xlvii, 275, fig. 16.23 (our *Fig. 114*); Palaikastro, *BSA* xl, 45, no. 26; *PM* iv, figs. 351 (our *Fig. 127*), 437; *CS* figs. 138, 139?; no. 358 (our *Pl. 144*); *CMS* vii, 94. The authenticity of *CS* 357 has been questioned most recently by Gill in *BICS* viii, 7ff. Lists by Buchholz in Bass, *Cape Gelidonya* (Philadelphia, 1967) 152ff.

Lentoids; the low conoid backs may all be later than LM/LHII—there are none at Vaphio.

Gold rings: Knossos, Isopata, our *colour, p. 49.1*; Archanes, our *Figs. 125, 126; BCH* xc, 930; Kalyvia, *Mon.Ant.* xiv, figs. 11, 12, 50, 51, 53, 55 (*KChr.* 1963, pl. 12; and for the last see our *Fig. 124*); Avgo, *AJA* ix, 281, fig. 2; Knossos, Sellopoulo, 1968. Some Knossos sealings, *PM* iv, figs. 331

(591a), 596, 597Ae, k, Bf, m, 925; *BSA* lxii, 28ff., nos. 8, 12, 15, 16, 21, 31, 54, 60, 63. Cf. Bielefeld, *Schmuck* (Göttingen, 1968) 34–7. For cloisonnée bezels see below, p. 413.

Biesantz pointed out that the rings are to be seen in original, not impression, and discusses the implications of this. On most stone seals, many of which cannot be viewed in original because of the colouring of the stone, the problem of left or right does not arise because the subject is animal. Where it is human right-handedness in the impression seems general.

STYLES

A selection of references to examples of the main styles distinguished in the text is given here. This aspect of the study could be considerably advanced, Kenna has some remarks on artists in *Festschrift Matz* 8–13 and Miss Gill is preparing a fuller survey. Excavated specimens are cited first. Unusual shapes are indicated.

FINE STYLE

Knossos, Royal Tomb sealing, our *Pl. 98*.
Knossos sealings, *PM* iv, figs. 533, 542a, 597Aa, Be, n, 602, 604; *BSA* lx, pl. 9.660, 653; 17.R105; *CS* 40S, 51S (our *Pls. 100, 101*); *BSA* lxii, 30, no. 3. Our *Fig. 104*.

CS 285, 296–7, 301–2, 314, 343, 344 (all in *Pls. 85–99*): *Arch.Eph.* 1907, pl. 8.146 (*CS* fig. 135); *Pauvert* pl. 1.3, 6 (our *Pl. 87*); *AJA* lxviii, pl. 2.13; Richter, *Catalogue* (1920) pl. 2.

COMMON STYLE

Knossos tombs, *TDA* figs. 14, 20a, 55; *BSA* xxviii, pl. 19. III.13; xlvii, 275, fig. 16.22 (three-sided prism); li, 94, fig. 5.3, pl. 14c, d (cf. Cut Style).

Knossos, *CS* 315, our *Pl. 114*.

Knossos sealings, *PM* iv, figs. 343b, 487, 544c, 562 (*BSA* lx, pl. 6.R2), 597Ac, g, h, l, 597Ba, g, 614; *BSA* lx, pl. 7.R91; 8.U117; 19.U62,64; *BSA* lxii, 28ff. nos. 4, 6, 7, 9–11, 13, 17, 22, 25, 30, 32, 35–6, 57.

Heraklion, *Katsamba* pl. 14a.

Archanes, *BCH* xci, 791, fig. 16; our *Fig. 106*.

Kalyvia, *KChr.* 1963, pl. 14.15–9; 15.20–3. Our *Fig. 105*.

Gournes, *ADelt* iv, pl. 5.2, 4, 5, 6.

CS 244–7, 249 (our *Pl. 103*), 289, 292–3 (our *Pls. 112, 102*), 294, 300 (our *Pl. 108*), 303, 305–7 (our *Pls. 118, 119*), 308 (ring, our *Pl. 110*), 309, 311 (our *Pl. 105*), 315 (our *Pl. 114*), 316–7, 318 (our *Pl. 111*), 319, 325, 327, 329 (our *Pl. 121*), 330, 331, 333, 339, 352; *Giam.* 186 (prism), 224–5, 260, 312, 335; *CMS* i, 480, 488, 490–1, 506; *CMS* vii, 89, 95, 99–102, 105, 116 (our *Pl. 113*), 118 (our *Pl. 104*), 119, 124 (our *Pl. 109*), 126, 131 (our *Pl. 106*), 261; *CMS* viii, 66, 76, 77, 89, 126, 140, 141.

PLAIN STYLE

Knossos tombs, *TDA* fig. 20b; *BSA* xlvii, 275, fig. 16.20 (our *Fig. 113*), 21; li, 94, fig. 5.4, pl. 14a, b (a Fine Style

subject in Plain technique); Sellopoulo, our *Figs. 108–110*, and 1968.

Knossos sealings, *PM* iv, fig. 597Bc, d; *BSA* lx, pl. 8.U67, 115; 9.650; *BSA* lxii, 28ff., nos. 29, 43, 44, 62.

Archanes, *BCH* xci, 789, fig. 13; our *Fig. 107*.

Kamilari, *Ann.* xxxix–xl, no. 19.

Kalyvia, *KChr.* 1963, pl. 13.7–14 (12, 13, prisms); our *Figs. 111, 112*. Gournes, *ADelt* iv, pl. 5.1.

CS 248, 286 (our *Pl. 134*), 287, 298 (our *Pl. 138*), 305, 312 (our *Pl. 136*), 313, 320–3 (our *Pls. 122, 129, 132*; *colour p. 49.10, 11*), 328, 334, 336, 337, 341–2 (our *Pls. 123, 124*), 345 (our *Pl. 130*), 346, 349, 350–1 (our *Pl. 145*), 2P, 3P, 5–7P (our *Pl. 140*), 14P (*colour, p. 49.13*; cf. A. Ioannis); *Giam.* 190 (prism), 265, 301–2, 305–7, 328, 338, 357, 379–80, 392; *CMS* i, 484; *CMS* vii, 87–8, 96–8, 100, 103, 106, 108, 109, 110–2, 123, 127, 129, 130, 138, 233, 236, 248, 249 (our *Pl. 141*), 250–2, 257, 262; *CMS* viii, 90–1, 94, 107–8.

CUT STYLE

From Crete: Knossos, *BSA* xlvii, 275, fig. 16.23 (cylinder, our *Fig. 114*); *CS* cf. 10P, 11P, 13P, 15P (our *Pl. 143*); *Giam.* 185 (prism), 255, 257, 261; *PM* iv, fig. 495 (prism, our *Fig. 115*); *CMS* i, 481–2, 494; vii, 93, 139, 235; *Arch. Eph.* 1907, pl. 7.69; 8.148, 161; *Bull.Mus.Hongr.* xxix, 7, fig. 4; cf. *Pauvert* pl. 1.2.

From Greece: *CMS* i, Mycenae—56, 143, 146, 158 (LHIIIA late), Prosymna—206 (LHIIIA.1), 212 (LHIIIB), Perati —394 (LHIIIC), Menidi—387 (LHIIIB), Thebes—406 (LHI–II), Athens—404; Athens, Agora, *Hesp.* xxxv, 78, fig. 4, pl. 24f.; Thebes, *Arch. Eph.* 1910, 221, fig. 14; Naxos, *Praktika* 1965, pl. 216a; Ialysos, *CMS* vii, 151. Cf. *Hesp.* xxxi, pl. 101f, Kea; Melos, *AA* 1965, 14, fig. 2.7, 8; Dunbabin, *Perachora* (Oxford, 1962) ii, pl. 191.B2–5; *Berlin* F 43, pl. 1, D 36 (combined with Plain Style). Several are glass.

Others: *CMS* vii, cf. p. 187, no. 94 (cylinder), 120–2, 135, 152–3, 164, 165, 178, 258 (*Pl. 146*); *CMS* viii, 88, 101; *NY* 241, 271; *Bull.Mus.Hongr.* xxix, 7, fig. 4; *AG* fig. 19; *Geneva Cat.* i, 203; *Munich* i, 64, pl. 8; *Münzen und Medaillen* Sonderliste K, nos. 99, 100; cf. the cylinder, *Syria* xxxii, pl. 3.1, and *Geneva Cat.* i, 191.

Some examples with mainly drilled figures, also probably LMI: Kamilari, *Ann.* xxxix–xl, no. 18; *CS* 263; *Giam.* 226 (prism); *CMS* i, 478; *CMS* vii, 247; *Arch.Eph.* 1907, pl. 7.53, 8.151; Delaporte, *Louvre* i, pl. 59.Δ.30; Peabody 40/4673; Brooklyn 35.778; Palaikastro, *BSA* xl, 45, fig. 2; *AA* 1963, 44, fig. 4; *NY* 179, 238, 259; *Munich* i, 65, pl. 8.

SOME SUBJECTS

PM, through its Index volume, remains the most important single source and there are interesting accounts of particular motifs given by Mrs Sakellariou in *Giam.* both in the catalogue and appendixes. I give here some supplementary references, and others will be found in the List of Illustrations.

Linear devices in the field. Gill, *Kadmos* v, 11ff.

Griffins. Bisi, *Il Grifone* (Rome, 1965); Dessenne, *BCH* lxxxi, 203ff.; Delplace, *Ant.Class.* xxxvi, 49ff.

Minoan genius. Gill, *Ath.Mitt.* lxxix, 1ff.

Dragons. Gill, *BICS* x, 1ff.

Snake frames. Chapouthier, *REA* xlix, 22–4; cf. *BSA* xlvii, 272f.; *AA* 1965, 16f.; Gill, *Kadmos* viii, 85ff.

Sacral knots. Alexiou in *Europa* (Berlin, 1967; Festschrift Grumach) 1ff.

Priests with axes. Marinatos, *Kleidung* (Gottingen, 1967) 24. Perhaps as early as LMI, Mallia, *BCH* lxx, 148ff.

The goddess' robe. Demargne, *Mél.Picard* (Paris, 1948) i, 280ff.

Goddess with raised hands. Alexiou, *KChr.* 1958, 179ff.

Gestures. Brandt, *Gruss und Gebet* (Waldsassen, 1965).

Bulls on sacrificial tables. Sakellarakis in *Peprag.II Kret. Synedr.* i, 238ff.

Chariots. Alexiou, *AA* 1964, 785ff.; Wiesner, *Reiten und Fahren* (Göttingen, 1968).

Deity with animals. Spartz, *Das Wappenbild des Herrn und der Herrin der Tiere* (Munich, 1962).

Birds. Kenna, *Opusc. Ath.* viii, 23ff.

MYCENAEAN GREECE

Nearly all the rings, gems and sealings from excavations in mainland Greece are kept in Athens and have been published in *CMS* i, with indications of the dating of accompanying pottery, where available. Mrs Sakellariou's *Mykenaike Sphragidoglyphia* (Athens, 1966) is mainly valuable as a survey of the iconography of the gems. See also *CS* ch. vi.

SOURCES

CMS i lists sources, for which see also Biesantz, 145ff. Some supplementary references are given below.

Pylos, Gouvalari (LHII). *Praktika* 1963, pl. 89a, 92 –η.

Blegen, *Korakou* (LHII) 105, fig. 130.7.

Blegen, *Prosymna* (LHIIIA) figs. 586, 589.

A. Elias, Aetolia (LHIIIA). *BCH* lxxxviii, 762, figs. 1, 2 (*Praktika* 1963, pl. 167a, b), the gem with the spirals device.

Salamis (LHIIIA). *Arch.Reports 1966–67* 6, fig. 6; *ADelt* xx, Chr. pl. 103 ε, ζ; *BCH* xcii, 775, figs. 6, 7.

Athens (LHIIIA.1). *Hesp.* xxxv, 78, fig. 4, pl. 24f (probably Cretan).

Argos. Deshayes, *Deiras* pl. 69.4, 5 (LHIIIA.1), pl. 42.3, 4 (LHIIIA.2).

Argive Heraeum. *Hesp.* xxi, 183, no. 119, fig. 4, pl. 47.

Mycenae Grave Circle B: *CMS* i, 5–8. Sakellariou takes the two 'talismanic' gems and the disc with the man's head (nos. 5–7) as Helladic, and Kenna (*Charisterion . . . Orlandon* (Athens, 1966) ii, 322) takes no. 6 for a rare example of Helladic talismanic, but I can see no clear evidence for such a class of mainland seals.

Vaphio. A good description of the tomb in Vermeule, *Greece in the Bronze Age* (Chicago, 1964) 127ff. Problems of attribution and identity, *CS* pp. 80–2; Vermeule and Kenna, *Art Bulletin* 1961, 244; 1962, 168–70; Betts and Kenna, *AJA* lxx, 368ff.; lxxi, 409; *Nestor* 488f., 501f. (Sakellariou).

SOME SHAPES
Gold flattened cylinders (LHI–II). *CMS* i, 9–11, 293 (our *Pl. 152*).

Gold amygdaloids (LHII). *CMS* i, 274 (our *Pl. 151*), 283. For the cloisonnée, cf. the bezel of rings from Kalyvia, *Mon.Ant.* xiv, 592, fig. 53; Sellopoulo, 1968; Heraklion (Poros), *BCH* xcii, 1001, fig. 8; Vaphio, *Arch.Eph.* 1889, pl. 7.9; and Larisa, *ADelt* xix, Chr. 257: the technique was learned from Crete.

Gold mounting on lentoids, *CMS* i, 239, 255; long amygdaloids, 152, 205, 238; a flattened cylinder, 271.

All-stone rings. *CMS* i, 20 (chalcedony, our *Pl. 174*), 89 (jasper), 383 (agate, cf. the shape of the gold ring, 407); *LHG* pl. 1.4 (rock crystal, our *Pl. 181*).

Rings with a gold half bezel (perhaps all LHIIIA). *CMS* i, 91, 108, 200–1 and cf. the sealing, 313; Kalyvia, *Mon.Ant.* xiv, 593, fig. 55 (our *Fig. 124*), and ibid., 520, fig. 11, for a whole sheet bezel; 592, fig. 54, for a sheet ring, the bezel face missing, the core of 'paste' (cf. *PM* ii, fig. 34B). Rings of silver, lead, copper, iron, Persson, *Royal Tombs at Dendra* (Lund, 1931) 56f. Cf. the background of the Thebes fresco, Vermeule, pl. 27.

Cylinders. See Buchholz in Bass, *Cape Gelidonya* 152ff., and below, p. 416.

Barrels. *CMS* i, 107, 409.

Gold rings not in *CMS* i. Athens, *Hesp.* iv, 319f., figs. 7, 8 (Biesantz, pl. 7.46); Berlin F 1, pl. 1; Medeon, *ADelt* xix, Chr. pl. 263b right; Larisa, ibid., pl. 302a (early LHIIIB); Péronne, *AG* fig. 25; *PM* iv, fig. 574; *Festschrift Matz* (Mainz, 1962) pl. 6; Hamburg, *Archaeology* xv, 241 top and Hoffmann-von Claer, *Gold- und Silberschmuck* (Mainz, 1968) no. 107.

The gold rings are cast in three-piece moulds, see *BMC Jewellery* 40, fig. 7; and the intaglios for metal rings were sometimes cast on the bezel, as from the LHIIIB mould found at Eleusis, *Praktika* 1953, 80f., figs. 5–7, but intaglios in precious metal seem always to have been engraved.

Forgeries. Several gold rings, notably the famous Thisbe treasure, now in Oxford, were forged after the finds at Mycenae and Knossos became known. These were well discussed by Biesantz, but there are still some pieces, condemned by him, over which we may hesitate (as the Cretan ring, *CS* pl. 20, 1919.56; compare our *Fig. 125*).

SOME MATERIALS
Lapis lazuli. For the Thebes find see *ADelt* xix, Chr. 192ff., pl. 229; xx, Chr. pl. 276; *BCH* lxxxviii, 775ff.; *Kadmos* iii,

25ff.; Porada, *AJA* lxx, 194. Others, *CMS* i, 181, 255, 288–9; *CMS* vii, 168; cf. *CS* 235.

Lapis lacedaemonius. For its use for gems in *CMS* i, see Gill quoted in *Gnomon* xxxviii, 266. And below, p. 466.

Amber. *CMS* i, 154; cf. *Praktika* 1957, 120 (Rutsi).

Glass. Used occasionally from at least early LHII (as *CMS* i, 286).

CRETAN GEMS IN GREECE
'Talismanic'. *CMS* i, Mycenae—6, 7, 136; Prosymna—207–8, 213; Vaphio—261; Pylos—299 (recut ?).

Others (a *minimal* list). *CMS* i, Mycenae—5, 8, 151, 152; Vaphio—234, 236, 238, 242, 246, 259 (see references to Vaphio above); Perati—393; Pylos, Gouvalari, *Praktika* 1963, pl. 89a; *BCH* lxxxviii, 749, fig. 8.

Gold rings and seals. *CMS* i, Tiryns—180; Midea—191; Vaphio—219 (our *Pl. 154*).

Cut Style gems found in Greece—see Notes to the last section. The style, as defined above, and related to earlier 'talismanic' techniques in Crete, was possibly not foreign to mainland studios, but it comes close to a number of Plain Style gems in Crete and some groups listed below.

SELECTED GROUPS
The terminal dates for contexts are given. The earliest terminal date may give an idea of when the group was produced, and this is indicated.

Metal rings and seals:

A. LHI. A homogeneous, detailed style from Mycenae Grave Circle B and the Acropolis. *CMS* i, 9–11 (flattened cylinders), 15–18 (rings). And Péronne (*Rev. Arch.* 1970).

B. LHII. The motif and style of the fine Mycenae ring, *CMS* i, 58, are reflected in the ring in Hamburg, Hoffmann-von Claer, no. 107, and the all-stone ring of rock crystal in Boston, *LHG* pl. 1.4 (our *Pl. 181*). Another pair are the Pylos amygdaloids, *CMS* i, 274 (our *Pl. 151*), 283.

C. LHIIIA. The Tiryns ring, *CMS* i, 179, presents some problems (see now Gill, *Ath.Mitt.* lxxix, 12f.). In a comparable but poorer hieratic style are *CMS* i, 129 and 189 (LHIIIA.1); compare also 128 and the Pylos sealings, 304, 329, 370 (LHIIIB); also the Asine ring, 200 (LHIIIA.1) and Pylos sealing 307.

D. LHII–IIIA. A fine series of griffins, *CMS* i, 102, 293 (our *Pl. 152*; LHIIIA?), 304 (LHIIIB).

E. LHII–III. Some simpler and late animal studies, *CMS* i, 91, 125, 155 (LHIIIB), 253 (LHII); cf. 390 (LHIIIC) and *ADelt* xix, Chr. pl. 263b.

F. LHIIIA. Simple heraldic and religious, *CMS* i, 89, 108, 126; cf. 119 (our *Pl. 148*) and 127 (our *Pl. 150*); *ADelt* xix, Chr. pl. 302a (LHIIIB); ? *CS* 340 (our *Pl. 153*).

G. LHIII. Similar to, but poorer than the last, *CMS* i, 86–7, 218 (LHIIIB), 313 (LHIIIB).

Stone gems:

J. LHII. Fine lion studies deriving from gold rings of A,

the lions' heads resembling the Mycenae gold rhyton. *CMS* i, Vaphio (LHII)—243 (our *Pl. 155*), 247, 249, 250; Midea (LHIIIA.1)—185 (our *Fig. 129*); Pylos, Rutsi (LHII)—277; *Orientalia* xxxiii, pl. 5.21; and cf. *CMS* i, 62; *LHG* pl. 1.1 (Mycenae, our *Pl. 179*); *Munich* i, 46, pl. 6.

K. LHII. A different lion type with long angular muzzle is shown on *CMS* i, 112, 149 (Mycenae, LHIIIA.1), 290 (Pylos); and in a somewhat different style on 228 and 245 (Vaphio, LHII); cf. 294 (Pylos, LHIIIA) and *Munich* i, 64, pl. 8.

L. LHII–IIIA. Deriving from J, lions and animals in a detailed and fairly well modelled style. *CMS* i, Mycenae—103 (our *Pl. 172*), 123, 141 (LHIIIB); Midea—186, 193 (LHIIIA); Argos—204 (LHIIIA); Vaphio—248, 252 (LHII, our *Pl. 159*); Pylos, Gouvalari, *Praktika* 1963, pl. 92 γ, δ, η (LHII, possibly from Crete); *LHG* pl. 1.2 (our *Pl. 180*); cf. *Munich* i, 59, pl. 7.

M. LHII. A less fussy, simple but assured style with a preference for three-sided prisms. Perhaps Pylian. *CMS* i, Pylos (LHII) 271–3, 278, 280; *CMS* vii, 115 (our *Pl. 178*); Pylos, Gouvalari, *Praktika* 1963, pl. 92b (LHII); *Berlin* F 49, pl. 1, D 45 (Peloponnese). Cf. *CMS* i, 154 (Mycenae), 233 (Vaphio, LHII), 388 (Menidi, LHIIIB); *CMS* vii, 105 (Mycenae).

N. LHII. A rather mechanical style with double-linear detail. It resembles the rings of group D. *CMS* i, 167 (Mycenae), 223–4 (Vaphio, LHII, our *Pl. 160*).

O. LHII–IIIA. Much more emphasis on linear and drilled detail, notably for some fine, crossed animal compositions. Compare the animals of group Q. *CMS* i, Mycenae—36, 43, 78, 110 (our *Pl. 170*), 115, 116 (our *Pl. 169*), 133; Vaphio (LHII)—241, 251, 254, 256; cf. 248; Midea—194; *AJA* lxviii, pl. 2.26. Cf. *CMS* vii, 159; *Berlin* F 15, pl. 1, D 34; *Munich* i, 40–1, 43, pl. 6.

P. LHII–III. As O but freer use of drill detail and less attempt at realistic body contours. *CMS* i, Mycenae—45, 50, 72, 77, 106, 121, 122, 137, 190, cf. 84; Pylos—287 (LHII); Menidi—384 (LHIIIB); *AJA* lxviii, pl. 2.24; *Berlin* F 44, pl. 1, D 49, cf. F 16, Gythion; *Munich* i, 44, pl. 6; 57, pl. 7.

Q. LHII–III. Common Style animals with some use of outline and linear details and restrained use of drilled details. *CMS* i, Mycenae—20 (our *Pl. 174*); 63, 65–6 (LHIIIB); 75–6, 93–4, 95 (our *Pl. 173*), 111, 113, 124, 140 (LHIIIB), 142 (LHIIIB), 168; Midea—184, 187–8 (LHIIIA.1); Vaphio—235, 239, 240 (our *Pl. 158*); Pylos sealing—376 (LHIIIB); *CMS* vii, 127; *AJA* lxviii, pl. 2.23; Baltimore 42.402. Cf. *CMS* i, 99 (Mycenae), 266 (Pylos, Tragana, LHIIIA.1); *CMS* viii, 148; Thebes, *ADelt* xxii, Chr. pl. 160 γ.

R. LHIIIA. Closest to the Cretan Common Style with smoothly modelled animal bodies and ready use of the drill for details. *CMS* i, Mycenae—35, 41 (our *Pl. 168*), 48, 51, 64 (LHIIIB), 67, 69, 79, 83, 85, 104, cf. 172; Midea—181 (LHIIIA.1); Prosymna—216 (LHIIIB): Kampos—262;

Pylos, Tragana—267–8 (LHIIIA); Menidi–386 (LHIIIB); *CMS* vii, 175–6; *CMS* viii, 108, cf. 149; Thebes, *ADelt* xxii, Chr. pl. 160b, 162b.

S. LHII–IIIA. A rather flamboyant technique, of bristling manes and hatched detail, not very precise and given to heraldic and antithetic subjects. Compare rings of groups F and G. *CMS* i, Mycenae—46, 54, 71, 117, 144–5 (LHIIIB); Vaphio—232, cf. 220–1 (our *Pls. 161, 164*), 226–7, 229 (our *Pl. 163*), 231 (our *Pl. 166*), 244 (LHII).

T. LHIIIA. A drier version of the last, with more drill work and committed to heraldic and symmetrically posed subjects. *CMS* i, Mycenae—52 (our *Pl. 183*) 61, 73, 90, 92, 98 (our *Pl. 177*); cf. 53, 57 (LHIIIB), 105; Pylos, Rutsi—282 (LHIIIA); Menidi—389 (LHIIIB); *Munich* i, 56, 58, pl. 7; 66, pl. 5; *CMS* vii, 113 (Ialysos).

U. LHIIIA. Simple massive bodies with small heads. A distinctive variant on the Common Style animals of group Q. *CMS* i, Mycenae—55, 80 (our *Pl. 184*), 109; Midea—183 (LHIIIA.1); Athens—405; cf. Pylos sealings—318, 380; Pylos, Akona tomb II (LHIIIB), *Praktika* 1963, pl. 89b (*BCH* lxxxviii, 749, fig. 7); Perati (LHIIIC), *Praktika* 1961, pl. 7 right (*Charisterion . . . Orlandon* ii, pl. 65b).

V. LHIII. The plainest animal style, with elongated bodies, drill detail. *CMS* i, Mycenae—24, 26, 30, 82, 139 (LHIIIB), 171, 175; Asine—198–9 (LHIIIA); Nauplia—202; common on the Pylos sealings (LHIIIB)—315, 317, 323, 330, 334, 336–7, 355; Naxos, *Praktika* 1959, pl. 155b (LHIIIC); Thebes, *ADelt* xix, Chr. pl. 229b (cylinder); Perati (LHIIIC), *Praktika* 1961, pl. 7 left; 1962, pl. 10a (*Charisterion . . . Orlandon* (Athens, 1966) ii, pls. 65c, 66b): *CMS* vii, 160; *CMS* viii, 150; *Berlin* F6, 22 (our *Pl. 185*), 26, pl. 1, D 25, 44, 48; *Munich* i, 45, pl. 6.

SUBJECTS

Mrs Sakellariou gives a full survey in *Myk.Sphrag.* and see the Notes to the last section.

Lions in Greece. Brown, *The Etruscan Lion* (Oxford, 1960) 166f. The Knossos rhyton, Marinatos, *Crete and Mycenae* pl. 99. The Mycenae rhyton, ibid., pl. 176; cf. group J, above, for lions with this head type, and group K for examples with the elongated muzzle. On lion representations at Mycenae, Wace, *Studi Banti* (Rome, 1965) 337ff.

THE END OF THE BRONZE AGE

CRETE

For the contents of tombs at Sellopoulo, Kalyvia and Gournes, see Notes to the last section. LMIIIB contexts with gems are: Knossos, Upper Gypsades, *BSA* liii–liv, pl. 62.II.5 and III (sic; really II), 4 (LMIIIA.2–B); VII.20, 21. Knossos, Unexplored Mansion, 1968. Knossos, Zapher Papoura, Evans, *Prehistoric Tombs* (London, 1906) pl. 90.2, 3 (from a necklace). Maleme, west Crete, a tholos, our *Figs. 132, 133*. Tylissos reoccupation, Hazzidakis, *Villas*

minoens (Paris, 1934) 107, fig. 19 top. Olous, our *Fig. 130*. Episkopi Pedeada, *Praktika* 1952, 622, fig. 4; cf. *CS* p. 65, n. 11. Sphakia, *Praktika* 1955, pl. 110γ.

Lists of motifs need not be given. A good selection of late gems can be seen in *CS* 359ff. and most of the 'Peripheral'; and a majority of *Giam.* pls. 24, 25.

Select motifs:

Bird goddesses. See *Giam.* pp. 62f., nos. 373–8; *CS* 374, 376–8; *AJA* lxviii, pl. 2.27; NY 298–9, 309, 321; *CMS* i, 476; vii, 141–4; viii, 83; *Arch.Eph.* 1907, pl. 8.150; *Hesp.* xxiii, pl. 34.8, 9; *Munich* i, 94, pl. 10. Our *Pl. 200*.

Drill pattern. *CS* 392–3; *CMS* i, 431 (our *Fig. 131*), 442–3 (and in Greece, 401); *Arch.Eph.* 1907, pl. 8.131; Hazzidakis, *Tylissos* (Paris, 1921) pl. 2b.

Extreme disintegration of motifs. *CS* 394–5 (our *Pls. 195, 197*) perhaps with 105; *Munich* i, 24, pl. 4.

A clear and homogeneous group with lion studies, often with two set antithetically. *CS* 369–70, 373 (our *Pl. 193*), 36P; *Giam.* 265, 267, 270–7, 287–90, 297–9; *CMS* vii, 90, 197–8 (our *Pl. 191*), 238, 240; viii, 75, 79, 80, 125; *Berlin* F 30, pl. 1, D 42; Baltimore 42.403; Hazzidakis, *Villas minoens* 107, fig. 19 top; *AA* 1963, 53, fig. 8; NY 341, 352; *Munich* i, 54, pl. 7; *Praktika* 1950, 199, fig. 9 (from Epidaurus). Cf. with other motifs, *CS* 367–8, 374 (our *Pl. 200*), 25–6P, 30P, 35P; *Giam.* 291, 300, 375; *CMS* vii, 134–5; *Geneva Cat.* i, 200; NY 318, 320, 334, 336, 351, 353; *Munich* i, 55, pl. 7; 87, pl. 10.

Glass. *CS* 359–64. A possible mould for glass lentoids is shown ibid., fig. 170 (*PM* ii, fig. 134), showing that some at this date had their intaglios cast.

THE ISLANDS

Bronze Age gems found on Melos. *IGems* 97–9.

Ivory ring from Melos, our *Fig. 134*.

Naxos (LHIIIC). See *Fig. 135*.

Bronze Age gems in island stone. *IGems* 97 (for no. 4, *Berlin* F 59, see above, p. 405): *JHS* lxxxviii, 6.

Lentoid with two goats, *London* 193, pl. 4 (not in *CMS* vii); amygdaloid in the same style, our *Pl. 198*. Perhaps lentoids like *CS* 104 (from the islands) can be placed here.

On the islands at the end of the Bronze Age see Desborough, *The Last Mycenaeans* (Oxford, 1964) 227–33.

GREECE

For LHIIIB–C contexts see *CMS* i. Other sources are:

Pylos, Akona tomb 2 (LHIIIB). See *Fig. 136*.

Sparta, Menelaion. See *Fig. 137*.

Prosymna tomb 33 (LHIIIB) figs. 581 (cf. *CMS* viii, 147), 582.

Perati (LHIIIC). *CMS* i, 390–6 (see *Figs. 139, 140*); *Praktika* 1961, pls. 6, 7; 1962, pl. 10; *Charisterion . . . Orlandon* ii, 320ff., pls. 63–6 (but the previously cited photographs should be consulted: the differences in the drawings in *CMS* i, by the same artist, are informative).

Marmariani. *BSA* xxxi, 39, fig. 16.30.

Gritsa, Thessaly (LHIIIC). *Praktika* 1951, 147, fig. 17.

A. Theodoroi, Thessaly (LHIIIB). Ibid., 153, fig. 26, and 1952, 183, fig. 21H.

Kephallenia, Metaxata (LHIIIC). *Arch.Eph.* 1933, 90, fig. 39.

A. Elias, Aetolia, tholos (LHIIIB). *BCH* lxxxviii, 762, figs. 1, 2; *Praktika* 1963, pl. 167a, b, all but the seals with spirals and quadruped devices; Marathia, tomb 2 (LHIIIC), ibid., the quadruped device.

Epidaurus. *Praktika* 1950, 199, fig. 9.

Chalcis. *BSA* xlvii, 88, fig. 8.

Thebes. *Arch.Eph.* 1910, 221, fig. 14.

Rhodes, Ialysos (LHIIIC). *Ann.* vi–vii, 126, fig. 46; 139, fig. 62.

On the end of the Bronze Age in Greece see Desborough, *The Last Mycenaeans*.

Pylos sealings. See *Figs. 141–3*. Impressions from LHIIIA gems and rings seem to be *CMS* i, 302–9, 312–4, 318, 329, 361, 371–2, 374–5, 380; which are nearly one quarter of those listed in the volume.

The LHIIIC (?) style. Examples are: Gritsa and Marathia tomb 2, see above, and *Fig. 144*; *CMS* i, 21–2, 25, 27 (our *Fig. 145*), 29, 31–3, 38–9, 169, 174, 210, 295, 399, 400; *CMS* vii, 200, 203, 205 (our *Figs. 146–7*); *CMS* viii, 98 (our *Fig. 148*), 99; *Geneva Cat.* i, 202; *Orientalia* xxix, pl. 28.18; *Munich* i, 77, 78, pl. 9; 88, 89, pl. 10; Melos, *AG* pl. 61.5; Athens, Stathatos. *CMS* vii, 263–4, dated LHIIIC for 'style, provenience and stratigraphy' (ibid., ix) are in fact casual finds from Aegina and Mycenae. With arcs: *CMS* vii, 202; A. Elias, see above; cf. Hogarth, *Hittite Seals* 19, fig. 10 (Oxford 1892. 330). The animal forms and filling derive from a rather finer, earlier manner, as in LHIIIA examples, Blegen, *Prosymna* (Cambridge, 1937) fig. 586 (cf. *CMS* i, 204, Kalymnos) or 589 (that this shows goats and not centaurs was first noted publicly by Biesantz, 162 and Banti, *AJA* lviii, 310).

SEAL USE AND PRODUCTION

FORM AND USE OF SEALINGS

Lerna. *Hesp.* xxvii, 86ff., pl. 19.

Phaistos. *Ann.* xix–xx, 44ff.; Fiandra, *Peprag.II Kret. Synedr.* i, 383ff.

Knossos, Hieroglyphic Deposit. *Scripta Minoa* i, 145; Gill, *Kadmos* v, 1f.

Knossos, late palace sealings. Gill, *Kadmos* v, 2ff.

Mycenae. *CMS* i, 160–2, from stirrup vases, 163–6, 170; Bennett, *The Mycenae Tablets* 7, 103f.

Pylos. *CMS* i, 302–82; Blegen in Bennett, *The Pylos Tablets* (Princeton, 1955) ix.

Mycenaean filing system. Chadwick in *BICS* v, 1ff.

Bennett, *Mycenae Tablets* (Philadelphia, 1958) ii, 103, doubts the use to seal doors at Mycenae; cf. the sealings from the Royal Tomb, Knossos, *Prehistoric Tombs* 141, fig. 138 (our *Pl. 98*).

SEAL IMPRESSIONS ON POTTERY
For EH Greece, see above, p. 405.

Compare the decoration of the Phaistos disc, above, p. 410.

In Cyprus. Benson in *The Aegean and the Near East* (New York, 1956) 59ff.; Catling and Karageorghis, *BSA* lv, 123f.; idem, *Myc.Art from Cyprus* (Nicosia, 1968) pl. 38.

WEARING OF SEALS
Cup-bearer fresco. *PM* ii, figs. 441, 443: left wrist.

Knossos fresco. *Fest. Grumach* 66, fig. 7. Warriors.

Knossos, *BSA* li, 85: two at left wrist of warrior.

Knossos, *Prehistoric Tombs* 52: three at left wrist of warrior.

Vaphio, see above, p. 56 and *Arch.Eph.* 1889, 146f.; piles of gems at each wrist of warrior.

Prosymna 209, 267, 273: gold ring at forearm of 'priest'.

Pylos, Rutsi, *CMS* i, p. 304: a pile on the belly where the hands lay, with four in situ on the right wrist.

Persson, *Royal Tombs at Dendra* (Lund, 1931) 52: one at left wrist of 'queen'. The 'king's' rings and seals were placed in a gold cup on his chest.

Cf. Wace, *Chamber Tombs* (Oxford, 1932) 50, for two silver rings on the left hand, but these are plain rings, not signets.

Figurines. Knossos, Shrine of Double Axes, *PM* ii, fig. 192 (male votary; on wrists and forearm ?), fig. 192a ('Dove Goddess'; on each wrist); Spring Chamber goddess in shrine, ibid., fig. 63 (at each wrist ?); Mycenae, Mylonas, *Mycenae and the Myc.Age* (Princeton, 1966) 137 and fig. 128.

Mycenae fresco (1968): right wrist of goddess. *Antiquity* xliii, 95, fig. 2.

Pylos ii 13 Mnws, fresco: two on wrist.

Gems on necklaces. Mylonas, *Ancient Mycenae* (London, 1957) 155; Prosymna tomb 99.

WORKSHOPS
Mallia, see above, p. 406.

Knossos, Lapidary's workshop, *PM* iv, 594f.; Boardman, *Date of the Knossos Tablets* (Oxford, 1963) 12–14, fig. 3, 19f., pl. 7b. On identification of the clay nodules, Gill, *BSA* lx, 75.

Unfinished gems, see below, p. 466.

AEGEAN SEALS AND THE OUTSIDE WORLD

EGYPTIAN IN THE AEGEAN
Egyptian scarabs recut in Crete: *CS* 126; cf. *BSA* lxii, 39, no. 42. Possibly, Sackett-Popham, *Exc.Lefkandi Report* (London, 1968) fig. 80. Imitated, *Praktika* 1967, pl. 172.

The Spencer-Churchill scarab, *CMS* viii, 151 (*Kadmos* ii, 1ff., fig. 1), now in the British Museum, is wholly Egyptian in technique, shape and decoration. The inscription is in a garbled script, not demonstrably Cretan.

Pendlebury, in *Aegyptiaca* (Cambridge, 1930), listed many finds of Egyptian seals in Greece and Crete but his account can now be improved and his lists lengthened.

EASTERN IN THE AEGEAN
Impression of an Anatolian stamp at Phaistos, see above, p. 407. Impression of a Cypriot cylinder at Knossos, *PM* iv, fig. 593; Boardman, *Date of the Knossos Tablets* 72; Kenna, *AJA* lxxii, 333f.; Betts has doubts about the origins of this and the last, *BSA* lxii, 39, perhaps groundless.

Imported cylinders in Crete, Greece and the islands are listed usefully by Buchholz in Bass, *Cape Gelidonya* 152ff. See also Kenna, *AJA* lxxii, 321ff. and Buchanan, *BCH* xcii, 411f. Add:

Archanes. *Ergon* 1967, 102, fig. 110; *BCH* xcii, 990, fig. 12: lapis lazuli.

Crete ? Buchanan, *Catalogue, Oxford* i, pl. 59.959 and p. 188: Cypriot, haematite.

Mycenae, 1968. Silver, effaced.

On Neolithic Photolivos see above, p. 405.

On the Thebes find see above, p. 413.

Anatolian bullae in Greece. Boardman, *Kadmos* v, 47f.

AEGEAN INFLUENCE IN THE EAST
In general see Schachermeyr, *Ägais und Orient* (Vienna, 1967); *CS* p. 78.

Syrian cylinders. Seyrig publishes a number of relevant seals in *Syria* xxxii, 29ff., pls. 3.1, 4.2; xxxiii, 169ff.; xl, 253ff., pl. 21. Cf. Buchanan, op. cit., pp. 166, 176.

Cypriot cylinders. See notes on *Pl. 206*. Neatly classified by Porada, *AJA* lii, 178ff. (see especially her group III), and cf. Kantor, *Journal of Near Eastern Studies* xvi, 156ff.; Buchanan, op. cit. 186f., and *BCH* xcii, 410–5; Kenna, *BCH* xci, 552ff. (fig. 26 for an example in a version of the Plain Palace Style), *Syria* xliv, 111ff.; Karageorghis, *Myc. Art from Cyprus* (Nicosia, 1968) pl. 38.3, 4; *AJA* lxxii, pl. 123.11. For examples with Cypro-Minoan inscriptions see Masson, *BCH* lxxxi, 6ff. (and *Études Myc.* 1956, 199ff.); *BCH* xci, 251ff.; *BCH* xcii, 410–5; *Studi Micenei* iii, 95ff.; *Europa* (Fest. Grumach) pl. 14; *Kadmos* vii, 103, pl. 1, iii; our *Pl. 206*.

Cypriot cylinders with Aegean motifs. *BSA* lv, 122f.; *Syria* xxxvi, 111ff.; *Syria* xliv, 111ff.; Benson in *Aegean and the Near East*; Karageorghis, op. cit. pl. 38.

Cypriot conoid stamps. From Perati, *CMS* i, 396. General study by Schaeffer, *Enkomi-Alasia* (Paris, 1952) i, 69ff.; by Kenna, *BCH* xcii, 142ff. (for the head scarabs see below, p. 402). Good examples are our *Fig. 150*, from Enkomi with LHIIIB pottery; our *Pl. 203*; *BCH* lxxxix, 236, fig. 6; *SCE* ii, pl. 186. 643; *London* pl. 2.96–102; *Berlin* F 52–3, pl. 2, D 62–3. For a setting, *BMC Jewellery* pl. 8.814. A disc in an original style, *Rept.Dept.Ant.Cyprus* 1965, pl. 2.

Gold ring with engraved bezel: *Berlin* F 114, pl. 3 (from Idalion). Gold ring with stone bezel from Kouklia, our

Fig. 151 (compare rings from the same tomb with enamel inlays, *BCH* xcii, 167, fig. 2; Karageorghis, op. cit., pl. 32.1; Higgins, *Min.Myc.Art* (London, 1967) fig. 223). Ring stones, *London* 103, pl. 2; *Hesp.* Suppl. viii, pl. 41.15. Gold rings of eastern shape with stirrup shaped hoops,

see *AFRings* 28 with n. 88 (and Karageorghis, op. cit., pls. 32.2, 37.5, 6). See also the writer, in *BSA* lxv.

Finds in the Near East. Seals from 'near Gaza', *CS* 31–8P. Tell abu Hawam, *Quarterly Dept.Ant.Palestine* iv, 62, no. 399f.

NOTES TO CHAPTER III

THE GEOMETRIC AND EARLY ARCHAIC PERIODS

THE EARLY IRON AGE
For a sound discussion of Greece in these years see Desborough, *The End of Mycenaean Civilisation* (Cambridge Ancient History, revised edition, 1962), and at greater length in *The Last Mycenaeans* (Oxford, 1964).

For the migrations over the Aegean, Cook, *Greek Settlement in the East Aegean* (Cambridge Ancient History, revised edition, 1961).

BRONZE AGE SEALS IN LATER CONTEXTS
See *IGems* 100, 110, n. 1 for references.

In tombs at Vrokastro, Olous and Knossos in Crete; Lemnos, Melos, Siphnos (*BSA* xliv, pl. 29.6.14, in a Roman grave).

In votive deposits at Karphi (*BSA* xxxviii, 131f.), Perachora, Sparta, the Argive Heraeum, Sunium (Richter, *Engr.Gems* no. 67, as Archaic), Tocra (*Arch.Reports 1965–66* 25, fig. 3; *BSA* lxiii, 43, fig. 4a).

In a Classical setting, in Chania Museum.

Other objects in late contexts: *IGems* 110, n. 1. The Kea clay head, *Arch.Reports 1963–64* 21f.; the Knossos bowl in the basilica, *BSA* lvii, 195.

ORIENTALISING GREECE
In general on this period see Dunbabin, *The Greeks and their Eastern Neighbours* (London, 1957); and for the author's views, *Greeks Overseas* (Harmondsworth, 1964) ch. iii and *Pre-classical* (Harmondsworth, 1967) ch. iii.

On eastern artists in Crete and Greece see Dunbabin, chs. iii, iv; and the writer in *BSA* lxii, 57ff.

Eighth-century Egyptian or Egyptianising seals found in Greece, at Corinth, Eleusis and Athens, are discussed by Brann in *Hesp.* xxix, 406; they include the impression of one on a clay whorl.

EARLY IVORIES
See Barnett, *JHS* lxviii, 1ff.; Kunze, *Ath.Mitt.* lv, 147ff.; lx–lxi, 218ff.; Freyer-Schauenburg, *Elfenbeine . . . Samos* (Hamburg, 1966) i, especially 117ff.; *Greeks Overseas* 81–83.

Seals from Athens, Areopagus and Kavalotti Street; see our *Figs. 152, 153.*

GEOMETRIC STONE SEALS
Square Seals. *IGems* 112ff., Group A and *JHS* lxxxviii, 7, especially for eastern comparisons. The North Syrian square stamp, *Geneva Cat.* i, 114, pl. 47, had its string hole broken away and was pierced through to the face, like the Greek stamps, perhaps to admit a handle, since it could no longer be lifted from an impression by its string.

BRONZE FIGURE SEALS
See *IGems* 114, 155f., and *JHS* lxxxviii, 7.

The style of the bronze horses has been studied by Herrmann in *JdI* lxxix, 17ff.

IMPORTS FROM THE EAST
The Lyre-Player Group. See Buchner and Boardman in *JdI* lxxxi, 1ff. for lists, pictures and discussion of dates and origin. A gold pendant in the Victoria and Albert Museum (M134–1919), like those described ibid., 43, with suspension hoop and spirals, is set with a blue glass scaraboid. For another with an amber plaque see Strong, *BMCCarved Amber* (London, 1966) pl. 3.12. To the Lyre-Player Group add: new finds in Ischia; a scarab with a lion from Francavilla Marittima; Nicosia D.61, D.208, A. Irini 2216 and 2537; Basel, Erlenmeyr Coll. (two); Geneva, Dürr Coll.; Oxford, Griffith-Williams Coll.; Brauron.

Glass scaraboids. See *AGGems* 20–22; adding *Argive Heraeum* (Boston, 1905) ii, pl. 143.40 and p. 373, fig. 2 (Athens 10960, from Eleusis); Naples 1200 (sphinx, winged disc, beetle); *Geneva Cat.* i, pl. 59.143 (green, from Egypt). Faience seals. Most fully discussed in the publication of the finds at Perachora, by James in *Perachora* (Oxford, 1962) ii, 461ff. With these may be taken the recent find of a twin green jasper scarab set in gold from an eighth-century grave at Eretria, *Antike Kunst* ix, pl. 26.2, 3. This shows simple hieroglyphs and a flying bird as devices.

EARLY ARCHAIC STONE SEALS
Tabloids, hemispheres, pyramidal stamps, discs and animal seals: see *IGems* 116ff., Groups B1–24, C, D, E, G10–30; *JHS* lxxxviii, 8f.; adding our *Fig. 164*, as C21.

The major sources are the Argive Heraeum and Perachora

with examples also from Mycenae, Olympia, Sparta, Aegina, Asine, Argos, Megara—all sites in or near the Peloponnese; and from Crete, Brauron, Amorgos, Melos. On *IGems* C13, 14 see now Zazoff in *Opus Nobile* (Wiesbaden, 1969) 181ff. (see our *Pl. 208*).

SEAL USAGE
Early: Stamped whorl from Athenian Agora, *Hesp.* xxix, 406, fig. 2, pls. 89, 90. Stamped pithos from Knossos, *BSA* lvii, 31f., fig. 3, pl. 4a. Stamped plaque from Samos, and vase from Ischia. See *Fig. 166*.

Later use of stamps on pithoi and plaques. See *IGems* 161f., *Cretan Collection in Oxford* (Oxford, 1961) 113f. Sources are Corinth, Argos, Mycenae and Crete. Similar use in the east on a vase fragment from Nimrud, *JHS* lxviii, pl. 8g.

Later use of cylinders on pithoi and plaques, see Schäfer, *Studien zu den griechischen Reliefpithoi* (Kallmünz, 1957), especially 92f. Sources are mainly Crete and Rhodes. The early example from Miletus, *Istanbuler Mitt.* ix–x, pl. 56, seems to be from a cylinder but considerably retouched before firing. Greek stone cylinder in Frankfurt with running figures, *IGems* K3, pl. 17. Greek clay cylinder from Dodona, *Ergon* 1968, 44, figs. 48, 49.

Gold bands from matrices. Ohly, *Griechische Goldbleche* (Berlin, 1953) for Geometric from Athens; Reichel, *Griechische Goldreliefs* (Berlin, 1942) includes seventh-century reliefs. On the Cretan bands see now *BSA* lxii, 59ff., where the Teke example is dated to *c.* 800 BC or earlier. The Rhodian gold bands, Johansen, *Exochi* (Copenhagen, 1957) 78ff., 171ff., do not seem to have been impressed over matrices.

Bronze matrix from Corfu, Oxford G437: Payne, *Necrocorinthia* (Oxford, 1931) pl. 45.3; Higgins, *Greek and Roman Jewellery* (London, 1961) pl. 15.c–f; *IGems* 102. Casson studied the technique of the bar in *Trans.Int.Num. Congr. London* (1938) 40ff., and decided that a drill had been used on the intaglios. Payne's date for the bar is mid-seventh-century, nearly a century earlier than regular Greek use of a drill for intaglios in stone, but a case might be made for re-dating the bar, to the sixth century.

MYTHOLOGICAL AND RELATED SCENES on early seals other than the ivories; and including the Sunium Group (*IGems* 123ff.) discussed in the following section.

Ajax carries Achilles: seal impressions from Samos and Ischia (see above and *Fig. 166*).

Herakles (?) and Nessos: *IGems* C13, pl. 14 (our *Pl. 208*); C14 (with Deianira ?).

Centaurs: *IGems* F7, pl. 15; G24, 25, pl. 16; G33, pl. 16 (our *Pl. 211*); G40, L1, pl. 17 (our *Pl. 212*); and cf. p. 54, n. 1; C21 (our *Fig. 164*).

Herakles v. Apollo (?): *IGems* C15.

Typhon: *IGems* F9, fig. 12; G34, pl. 16.

Gorgons and the like: *IGems* G17.

Winged men: *IGems* F28, pl. 15 (our *Fig. 183*); G13, pl. 16; K3, pl. 17.

Winged horses: *IGems* F5, pl. 15 (our *Fig. 180*; foreparts); G33, pl. 16 (our *Pl. 211*); *JHS* lxxxviii, 8, F16bis, 20bis.

Sphinxes: *IGems* F22, 28, pl. 15 (our *Fig. 183*); H1; J1; L1, pl. 17 (our *Pl. 212*); and our *Pl. 278*.

Goddess and animal: *IGems* B24, pl. 14.

Duel: *IGems* B19, pl. 14; B21.

Man and woman: *IGems* C6, pl. 14; G14, pl. 16 (our *Pl. 210*); G15, pl. 16.

Love-making: *IGems* B23, pl. 14; F29, pl. 15 (our *Fig. 184*).

Twins (?): Bronze horse from Phigaleia, our *Fig. 157*.

Tripod: *IGems* F10, pl. 15 (our *Fig. 181*).

Man-monster: *IGems* F11, pl. 15 (our *Fig. 182*).

Other horses: four frontal, *IGems* F12, pl. 15; three foreparts, F13, fig. 12, F25bis; frontal chariot, F18.

Man fights lion: *IGems* F23.

Chimaera: *IGems* F24.

IVORIES

PELOPONNESIAN IVORIES
The main publications are Waldstein, *Argive Heraeum* (Boston, 1905) ii, 351ff.; Dawkins, *Artemis Orthis* (London, 1929) ch. viii; Dunbabin, *Perachora* (Oxford, 1962) ii, part ii; Marangou, *Lakonische Elfenbein- und Beinschnitzereien* (Tübingen, 1969). Other sources are, in the Peloponnese—Bassae, Olympia, Tegea, Mantinea (*ADelt* xviii, Chr. 89, pl. 103j), Mycenae; in Greece and the islands—Eleusis, Pherae, Mykonos, Siphnos, Crete; towards the west—Ithaca, Syracuse, Pontecagnano (*Mostra della Preist. e della Protost. nel Salernitano*, 1962, fig. 46; animal).

They are discussed briefly in *IGems* 145ff. and the dating of the Sparta ivories in *BSA* lviii, 1ff.

Clay disc from Dodona, inspired by the ivory discs, *Ergon* 1968, 45, fig. 50.

MYTHOLOGICAL SCENES OR FIGURES, other than winged feline monsters; on ivory discs unless otherwise stated:

Ajax carries Achilles: Perachora A23; *IGems* 147, fig. 16.

Herakles (?) fights a centaur: Perachora A29.

Duel: Perachora A35.

Centaurs: Perachora A65; *Artemis Orthia* pl. 156.7 (animal seal); Siphnos, *IGems* pl. 17b (our *Pl. 217*); possibly Ithaca, *BSA* xlviii, pls. 63,64.C63.

Chimaera: Perachora A30, 46 (with prey).

Gorgons and the like: *Artemis Orthia* pl. 141.2, 3 (head); 145.2; Argive Heraeum, *JHS* lxviii, pl. 7 (two figures).

Winged men: Perachora A32; *Olympia* iv, 188, no. 1194.

Man fights lion: Sparta, *IGems* pl. 20d (animal seal).

IVORIES AND THE BRONZE AGE
See *IGems* 153. The two discs with devices like Mycenaean are *Artemis Orthia* pl. 147 centre (cow and calf) and *IGems* pl. 17c, now re-published in *CMS* viii, 157.

EAST GREEK IVORY SEALS

See *IGems* 154f., *JHS* lxxxviii, 9ff. (p. 11f. on the ivory seal with two lions on the back from Samos, pl. 3, which may be Near Eastern).

Lion seals from Kameiros, Chios, Delos, Ithaca, Paros (?).

Oval seals from Kameiros, Chios, Ephesus, and similar from Ithaca, Delos, Sunium.

Hemicylinder from Samos.

The devices are sphinxes, horses, centaurs, men and one *potnia theron*.

ISLAND GEMS

See *IGems* and *JHS* lxxxviii, 1ff., for lists and discussion.

VARIOUS SHAPES

See *IGems* 73ff. for the varieties, from which we should single out: Prisms: *IGems* 315–318, of which 315 is illustrated here, *Pl. 222*; and 316, pl. 11, from Siphnos, is handled, *Pl. 221*. Finger ring: *IGems* 351, pl. 13, Siphnos, our *Pl. 220*. Animal seal: *IGems* 352, pl. 13, our *Pl. 219*. Oval seal: *IGems* 353, pl. 13 (*New York* 2, pl. 1), Delos. The device of a lion between two men, one inverted, and the rough filling ornament, is strongly reminiscent of the compositions on Syrian stamps. Stamp seal: *IGems* 359, fig. 6, pl. 13. The bell shape and spiral markings on Minoan seals, as *CS* pl. 6.120, 138, 139. The device is a ram, probably sixth-century. *JHS* lxxxviii, 6, 363 (*Munich* i, 3, pl. 1). Discs: *IGems* 321–331, to which add our *Pl. 223*; *JHS* lxxxviii, 5f., 321*bis*, 328*bis* (*Munich* i, 116, pl. 14; 139, pl. 16).

Of the earlier Archaic devices the following are notable: Centaurs: *IGems* 316, pl. 11; *JHS* lxxxviii, 4, 193*bis*. Winged horse: *IGems* 317, 328, pl. 11. Ship: *IGems* 316, pl. 11. Lion attacking man: *IGems* 354 (*New York* 6, pl. 1). Gorgoneion: *IGems* 357, pl. 13 (*London* 231, pl. 5).

LENTOIDS AND AMYGDALOIDS

These are listed in *IGems* and *JHS* lxxxviii, 3ff., adding: 22*bis*. Basel, Erlenmeyr. Green steatite lentoid. Goat and branch. 27*bis*. Basel, Erlenmeyr. Green steatite lentoid. Goat; pellets in the field. Cf. style of 27. Add to *IGems* 85f., group (d). 29*bis*. Zurich, Heller. Green steatite lentoid. Goat. Group (d). 40*bis*. Zurich, Heller. Green steatite lentoid. Goat. 187*bis*. Bonn, Müller. Green steatite lentoid. Satyr. See *Pl. 268*. 180A, 180B. Two stones. 214*bis*. BMWA. White stone lentoid. Griffin as *IGems* 214. 68 now in London, Bard, of dark green steatite. And see below.

The criteria of technique are discussed in *IGems* 18–20:

the main three phases are there labelled B, C, D. On p. 20 a small group is picked out which is distinguished by patterns of hoops, holes and straight incision which seems to derive from MM patterns. These are *IGems* 18, pl. 1; 112, pl. 5; 172, pl. 6; 300, pl. 10; 301; to which may be added Paris BN N4861. No close dating for them within the Island gem series is possible.

The only other seal shape from the studios of the major artists is the cylinder: *IGems* 332, pl. 11; 333. This is an unexpected direct copying of the eastern shape.

The Blind Dolphin Master. Works are listed in *IGems* 87, group (j), deleting 289 and adding 144 (now *CMS* vii, 183, as Bronze Age), and from *JHS* lxxxviii, 4f., 162*bis*, 246*bis*; and, as 265*bis*—Basel, Erlenmeyr. Green steatite lentoid. Winged horse. See also *BSA* lxiii, 41ff.

The Serpent Master. Works are listed in *IGems* 87f., group (k), adding 289, pl. 10, and from *JHS* lxxxviii, 3ff., 4*bis*, 65*bis*, 239*bis*, 242*bis*, 249*bis* (this is from Naxos), 249*ter*, 291*bis*, and, as 221*bis*, Neuchatel, Seyrig Coll., white steatite amygdaloid with griffin foreparts; as 232*bis*, Zurich, Heller, yellow steatite lentoid with winged goat. 4 is now in Bern (Merz).

Mythological scenes on Island gems: Suicide of Ajax: our *Pl. 264*. Prometheus: our *Pl. 267*. Herakles fights merman: our *Pl. 266*. Sacred marriage (?): our *Pl. 270*. Gorgons: *IGems* 179, 180, p. 7 (our *Pl. 265A*). Winged deity: *JHS* lxxxviii, 5, fig. 1, 188*ter*; 4, 188*bis* (this is inscribed *Borea*; if an Island gem it is the only one inscribed in Greek).

Island gems in harder materials are discussed and listed in *JHS* lxxxviii, 1–3, and cf. *AGGems* ch. xi.

THE SUNIUM GROUP AND CRETE

SUNIUM GROUP

IGems 123f., Group F, and *JHS* lxxxviii, 8; adding our *Pl. 278*. Brauron, *Praktika* 1949, 80, fig. 8.

Devices are listed above, p. 418, with other early stone seals.

Of other examples in this shape (*IGems* F16–27) proveniences are Corinth, Dystos (Euboea), Delos, Athens, Perachora, Dodona; and the inscription on F26, pl. 15 (*AGGems* 20, pl. 1) seems Euboean. An example with a high conical back was found in Tocra, *JHS* lxxxviii, 9, fig. 2, F17*ter*.

CRETAN AND OTHER DISCS

IGems 127ff., group G1–9, 31–40; *JHS* lxxxviii, 9.

ARCHAIC GEMS AND FINGER RINGS

For a full account and lists of the groups discussed in this chapter the reader is referred to the author's *Archaic Greek Gems* (London, 1968; here *AGGems*) and 'Archaic Finger Rings', in *Antike Kunst* x (1967) 3ff. (here *AFRings*). In the former the gems are discussed by groups and artists, but here they are re-grouped in broader series (cf. *AGGems* 172f.) and treated more in terms of their historical development. In the following notes the opportunity is taken to correct and supplement the lists in the above-mentioned publications, and to refer to matters more relevant to the nature of the present book. The illustrations to this chapter repeat many in *AGGems* but where possible I have included photographs of pieces not shown there, or views of the original stones instead of impressions.

Near Eastern Seals. On the groups imported to the Greek world see above, p. 417. The Syrian haematite group, *AGGems* 24, n. 5. Inscribed Phoenician seals, Galling, *Zeitschr. deutsch. Pal.-Vereins* lxiv, 121ff.

Scarab shapes. *AGGems* ch. II and 23ff. for Greeks in Cyprus.

Head scarabs. *AGGems* 161ff. Kenna (*BCH* xcii, 143, 155) seems to place all the Cypriot examples with negro heads in the Late Bronze Age, which is certainly not true of most. Enkomi 1004 (eleventh-century) is the earliest, and stylistically very different from the Archaic head scarabs. For the type in Iron Age Palestine see Giveon in *Studi sull'Oriente e la Bibbia* (Genoa, 1967: offerti . . . Rinaldi) 147ff. The Cypriot group: *AGGems* nos. 590–3.

Distribution and location of workshops. *AGGems* 171–6, 235f.

Inscriptions. *AGGems* 176f., 234, and for Thersis' scarab, no. 176, fig. 2. *Munich* i, 96, pl. 11 is not Cypro-Minoan of the tenth/eighth century but North Arabian.

Lions and lion fights. *AGGems* ch. XII. To the exceptional Greek rendering of two lions attacking a bull on no. 381, pl. 27, we may add our *Pl. 295* which follows more closely the Phoenician scheme (*AGGems* 123f., and n. 16).

ORIENTALISING
Gorgon-horse Group. *AGGems* 27ff., and, as 32*bis*, Solothurn, Schmidt Coll. Obsidian scarab. As our *Pl. 282*, with a Gorgon-horse, but without the lion or ground line and facing the other way. *Antike Kunst* (Solothurn, 1967) no. 399. As 47*bis*. Basel, Dreyfus. Gorgon-horse. Our *Pl. 290*. As 57*bis*. Once Heidelberg. Replica of no. 57. Creuzer, *Symbolik* i, 1, pl. 6.22.

Common Style animals. *AGGems* 143ff., and, as 474*bis*. Männedorf, Bollmann. Cornelian scarab. Bull. As 479*bis*. Leningrad 562. Cornelian scarab. Kneeling bull. As 484*bis*. Bowdoin 490. Bull. As 512*bis*. *Munich* i, 273,

pl. 32, from Corinth. Haematite scaraboid. Dog and fish.

Common Style lions. *AGGems* 125ff., and, as 377*bis*. Amsterdam 7895. Cornelian scarab. Walking lion. A black glass scaraboid version from Syria, Oxford 1889.983. As 377*ter*. London 753. Cornelian scarab. Summary crouching lion. As 379*bis*. London, Victoria and Albert 8856–1863. Burnt scarab. Lion. As 381*bis*. Bonn. Müller Coll. Two lions attack a bull. Our *Pl. 295*. As 381*ter*. Copenhagen 5394. Cornelian scarab. Lion attacks bull. Zazoff, *ES* no. 3. Same hand, *AGGems* no. 381, pl. 27. As 381*quater*. Rome, Villa Giulia. Cornelian scarab. Lion attacks bull. Zazoff, *ES* no. 4. As 391*bis*. *Munich* i, 196, pl. 22. Blue glass scaraboid. Lion attacks bull. Scheme A. As 399*bis*. London 944. Cornelian scarab. Lion attacks deer. Scheme E. As 402*bis*. Naples 1188. Lion. Our *Pl. 294*. As 405*bis*. Leningrad 572. Lion and cock joined. Our *Pl. 298*.

The Master of the London Satyr. See *Burlington Magazine* 1969, 587ff. To one hand may be ascribed *AGGems* nos. 90, 93 (our *Pl. 301*), 133 (our *Pl. 312*), our 133*bis* (*Pl. 311*), 406 (our *Pl. 323*), 407 (our *Pl. 324*), 410, 411, 412, and an agate scarab from Greece, in Zurich, Mildenberg, with a satyr with jug and amphora (as 93*bis*).

Satyr Group. *AGGems* 51ff., and 90–92: the pose for a satyr on a Greco-Punic ring, *Arch.Viva* i, 2, pl. xiv. 113: there is another summary version of this head on a scarab in Syracuse. Perhaps add 294 (see below).

Sphinx and Youth Group I, *AGGems* 65ff., and, as 127*bis*. Switzerland, Private, from Tarentum. Cornelian scaraboid. Eros flying. As 130*bis*. Rome, Villa Giulia. Forepart of a winged man-bull. Our *Pl. 314*. As 133*bis*. Leningrad 416. Winged horseman. Our *Pl. 311*. 138 is in Hanover.

Group of the Munich Protomes. *AGGems* 128ff. (no. 409 is from Cerveteri; Zazoff, *ES* no. 5).

THE DRY STYLE
Dry Style Groups. *AGGems* 77ff., and, as 189*bis*. Market. Cornelian scarab. Girl with mirror, as our *Pl. 360*. *Münzen und Medaillen*, Sonderliste L41. As 192*bis*. London 575. Cornelian scaraboid. Youth with strigil and aryballos. As 218*bis*. Basel, Erlenmeyr Coll. Cornelian scaraboid. Youth adjusts sandal. 226: see now Masson, *Syria* xliv, pl. 19.4, 5. As 228*bis*. Florence. Heads of a satyr and maenad joined.

Narrative. *AGGems* 45ff., nos. 72–75.

Sphinx and Youth Group II. *AGGems* 71ff.

Monsters. *AGGems* 153ff., nos. 575–89.

Group of the Tzivanopoulos Satyr. *AGGems* 103ff., and, as 293*bis*. Switzerland, Private, from Tarentum Rock crystal scaraboid. Warrior. 294: Leningrad 554. Omit here. The scarab is detailed in an Etruscan manner, but the style

is purely Greek. Perhaps add to the Satyr Groups. As 304*bis*. Oxford 1896–1908.0.14. Footprint. Our *Pl. 344*.

Group of the Beazley Europa. *AGGems* 106ff., and, 330: this is Péronne, Danicourt Coll. See *Pl. 349*.

Island Scarabs. *AGGems* 115ff.

LATE ARCHAIC GROUPS

Epimenes. *AGGems* 92ff. The attributions were made by Beazley.

Semon Master. *AGGems* 94ff., Miss Vollenweider had distinguished the nucleus of his work in our *Pls. 358, 359, 365, 366*.

Related works. *AGGems* 96ff., and, as 259*bis*. Switzerland, market, from Cyprus. Chalcedony scaraboid. A youth picks up a discus. Same hand as nos. 259–61: Master of the Oxford Athlete. *Basel, Münzen und Medaillen Sonderliste K*, no. 111. As 276*bis*. Bern, Merz Coll. Cornelian scarab with simple corner winglets. Eros flies with wreath and lyre. As 277*bis*. Nicosia, from Salamis, T73. Cornelian sliced barrel. As the last. *BCH* xcii, 318, fig. 106. 283: now Cologne, Band Coll. As 290*bis*. Leningrad 551. Herakles and snake. Our *Pl. 372*.

Anakles Group. *AGGems* 110f.

Group of the Leningrad Gorgon. *AGGems* 89ff., and, as 236*bis*. *Munich* i, 214, pl. 24, from Samos. Chalcedony scaraboid. Frontal winged Bes. Like the Leningrad Gorgon, this is related to Achaemenid work in borrowing the winged Bes motif. As 239*bis*. Leningrad 548. Helmeted head. Our *Pl. 382*. 243: in contrast with the last, the Athena head here, though detailed, is duller and more mechanical, and the piece is better treated as Greco-Phoenician. See *Pl. 418*.

Group of the Cyprus Lions. *AGGems* 130ff., and, as 418*bis*. Péronne, Danicourt Coll. Lion and goat. Our *Pl. 387*. 421: see now Masson, *Syria* xliv, pl. 19.2, 3. As 424*bis*. Once Cowper. Lion and limb. Our *Fig. 193*.

The Aristoteiches Group. *AGGems* 132ff., and, as 433*bis*. Bern, Merz Coll. Scaraboid. A lion, in style related to no. 433, pl. 31. As 440*bis*. Syracuse. A lion attacks a horse. Scheme D. As 440*ter*. *Munich* i, 197, pl. 22. Cornelian scarab. Lion attacks stag. Scheme A.

Of the other late lion types in *AGGems*, 452: Leningrad 676. Omit, as Etruscan. 456: Leningrad 582. This is a scaraboid.

Fine Style animals. *AGGems* 147ff., and, as 522*bis*. *Munich* i, 308, pls. 36, 68. Cornelian scarab. Bull and bird. As 524*bis*. Marzabotto. Bull and gadfly. Our *Fig. 194*. As 526*bis*. Leningrad 561. Bull. Our *Pl. 398*. As 533*bis*. Leningrad 568. Cornelian cut scarab. A boar. As 558*bis*. Basel, Dreyfus Coll. Winged boar forepart. Our *Pl. 399*. As 568*bis*. *Munich* i, 160, pl. 19. Cornelian scarab. Goat. As 572*bis*. Syracuse. Scarab. A flying bird.

GREEKS IN ETRURIA

For the author's views on the diaspora of East Greek artists see *Pre-classical* 148–51 and *AGGems* 137ff.

Relief gems. *AGGems* 164, nos. 596–600 and Zazoff, *ES* nos. 1316, 1317; and pseudo-scarabs in Etruria, *AGGems* 164f., adding an example with a siren back in Péronne, the device a warrior, inscribed *Achile*, and Zazoff, *ES* nos. 10, 1343.

Master of the Boston Dionysos. *AGGems* 48, 50, n. 13, no. 77. The group is well presented by Zazoff in *JdI* lxxxi, 63ff., and *ES* 17–21, with comparanda. Add our *Pl. 410*.

Late Archaic Greek work in Etruria. *AGGems* 111f., nos. 338–41.

GREEKS AND PHOENICIANS

On 'Greco-Phoenician' scarabs see *AGGems* 14–17, ch. III, 122 (the lion-fights). With the last goes *AGGems* no. 369, republished by Kenna, *BCH* xcii, 145, fig. 1.11, as Cypriot, Late Bronze Age; but the style and the beetle cannot be so early, and the two characters in the field are Iron Age Cypriot, not Bronze Age (if not Aramaic).

For finds in the west see especially Vercoutter, *Les objets égyptiens et égyptisants du mobilier carthaginois* (Paris, 1945); Vives y Escudero, *La Necropoli de Ibiza* (Madrid, 1917); Astruc, *Mem. de los mus. arcq.* xv, 110ff.

FINGER RINGS

This section is based on the article 'Archaic Finger Rings' in *Antike Kunst* x, 3–31, where the main types were distinguished and listed. Corrections and additions follow. There are a number of gold and silver rings, mainly of Types A and N, in Nicosia Museum, which will be published in *BSA* lxv. The Wyndham Cook ring (*AFRings* 5, n. 8) is now in the Moretti Coll.

Type A. As 16. Athens, from the Argive Heraeum. Silver. Lion and bull (?). Summary style. With mainly Late Geometric offerings placed in Mycenaean tombs, so this may be very early. *Arch.Eph.* 1937.i, 378, fig, 1.

Type B.I. As 1*bis*. *Southesk* i, pl. 11.L.16. Gold. Lion and sphinx, as B.I.1. As 21*bis*. Hamburg 1967.3, from Vulci. Gilt silver. Hippocamp: sphinx, winged beetle. Hoffmann and von Claer, *Gold- und Silber-schmuck* (Mainz, 1968) 15, no. 11. 30: now Bern, Merz Coll.

Type B.II. Professor Amandry tells me that he has seen on the market examples with a sphinx and griffin, and with a 'female chimaera'. As 2*bis*. Moretti Coll. Gold. Figures at a fountain. Replica of B.II.2. As 46*bis*. Luzern market. Gold. A lion and a seated man. *Ars Antiqua* June, 1966, pl. 17.100. 52: Richter, *Engr. Gems* no. 193. 55: Switzerland, Private. Gold. A sphinx before a tree. 56: Switzerland, Private. Gold. A standing dressed figure holding a fruit, with branches. 57: Basel, Dreyfus Coll. Gold. A man apparently killing a boar.

Type B.IV. The Forman Sale Catalogue (1899) no. 466 lists a gold example with a 'winged lion and harpy'. As 31*bis*. Riehen, Hoek Coll. Gold. Two sphinxes.

Type C. 8: Leningrad 547. Silver. A lion, as C.7.

Type D. 16: Vienna vii. 789. Gold. A chariot.

Type E. As *2bis*. Switzerland, Private. Gold. A bird. As *3bis*. From Locri (*c. 500*). Silver. Two birds. *Not. Scavi* 1911, suppl. 18, fig. 16. As *4bis*. Amsterdam 1616. Silver. Two insects. In a tomb group with the pins shown in Jacobsthal, *Greek Pins* (Oxford, 1956) fig. 122. 12: Syracuse 6675. Silver. This has a broad flat hoop and rolled mouldings at each side of the circular bezel. It shows three warriors fighting, one struck down, and a frontal horse, over an exergue with an inverted fish. The detail is fine and the piece seems ancient, despite its strange shape and device, which is clearly dependent on vase painting. See also Ponsich, *Nécr. Phén. de la région de Tanger* (Tangier, 1967) 175, 177.

Type F. Plain examples in gold and silver from Silaris, *Atti Soc. Magn. Graeca* vi–vii, pl. A top left and 47b; and silver from Trebenishte, *Öst. Jahreshefte* xxviii, 173, fig. 81. As *1bis*. Moretti Coll. Silver with two gold studs and a hole for a third. A crouching lion. As *1ter*. Zurich, Mildenberg Coll. Silver. A crouching lion with head turned back. 22, 23: See *Not. Scavi* 1952–3, 58, fig. 5. 37: Birmingham, from Cumae. Silver, collars on hoop. Running horse. *Apollo* 1968, 262, fig. 5. 38: Switzerland, Private. A seated man between two birds. Our *Pl. 430*.

Type G. 2: see Hoffmann and von Claer, 137f., no. 110. 3: Switzerland, Private. Gold. Standing draped figure. 4: Switzerland, Private. Gold. Hyakinthos. See *Pl. 432*. With the last two is another example, heavier, with the lions holding a cloison. And compare the four lions on a gold ring from Kerch, Reinach, *ABC* pl. 18.6; Artamonov, fig. 141.

Type J. 9: Switzerland, Private. Gold. Two birds. Lion head terminals to the hoop, as in Type K.

Type K. Also current in S. Italy. See *Not. Scavi* 1913, suppl. 138, fig. 182.

Type L. 7: Rome, Vatican. Bronze. Cock-horse. *Arch. Class.* xix, pl. 69.4. 8: Switzerland, Private. Silver. A cock? 9: *LondonR* 13, pl. 1, from Enkomi. Gold. A swan.

Type M. As *2bis*. Moretti Coll. Gold. Pointed oval. A siren with human arm. As *2ter*. Basel, Dreyfus Coll. Gold. Pointed oval. Flying Eros. See *Pl. 437*. 19: Moretti Coll. Gilt silver. Tiny oval. Man and woman.

Type N. Another example with animal device (cock and mouse) is Hamburg 1967.4, from Vulci, Hoffmann and von Claer, 172f., no. 109. For Punic and Greco-Punic see on

Pl. 660. 3: now Bern, Merz Coll. As *9bis*. Cambridge, from Marion. Silver. A lion. As *13bis*. Toronto 965.231.14, from Cyprus. Gold. A dog. *Lock Coll. of Cypriot Art* (Toronto, 1966) 54, no. 177. As *13ter*. *LondonR* 12, pl. 1, from Enkomi. Gold. A dog. As *19bis*. Aegina. Bronze. A hare? Furt-wängler, *Aegina* ii, pl. 116.44. As *35bis*. Once Guilhou. Gold. A hare. de Ricci, *Guilhou Coll.* pl. 8.491. 44: Marzabotto. Gold. A youth with one leg raised. Gozzadini, *Ulteriore scoperte di M.* (Bologna, 1870) pl. 17.22. 45: Casullis Coll., from Rhodes. Gold. A youth. Probably not ancient. Zervos, *Rhodes* (Paris, 1920) 190, fig. 385. 46: unknown. Herakles Soter. Our *Pl. 441*. 47: from Locri. Silver; spiral hoop. Eros flying. *Not. Scavi* 1917, 116, fig. 19. 48: from Locri. Bronze. Waterbird. Early fifth century tomb. Ibid., 127, fig. 33. 49: from Duvanlij. Gold. A cock. Filow, *Duvanlij* 45, fig. 53.

Type P. There is a group of oval bronze bezels and one bronze scaraboid in Vienna (VII.328). These have devices resembling the gold cartouche rings from Etruria (including a man riding a sphinx). Cf. also *Munich* i, 157, pl. 18; Oxford 1872. 1148.

CONCLUSION

Samian engravers. Mnesarchos, Diogenes Laertius viii, 1. Theodoros, Herodotus iii, 40, 41. In *Harvard Stud. Class. Phil.* lxxiii, 281ff., Holloway distinguishes an earlier Theodoros who was sculptor, engraver and collaborator of the architect Rhoikos on the earlier monumental Heraion on Samos, and a later Theodoros who was engineer at Ephesus. It is, however, difficult to believe that a Greek artist could win a reputation as a gem engraver before well after the mid-sixth century, and Polykrates' ring was probably the work of a contemporary Theodoros.

Solon and engravers. Diogenes Laertius i, 2, 9.

Coin die techniques. Casson's findings, published in *Trans. Int. Num. Congr. London* (1938) 40ff., may be questioned. On the use of hubs see now *Num. Chron.* 1966, 41ff.

Swivel hoops. See the Notes to ch. V, p. 447.

Lion rings (Type G) with stone scarabs. *AFRings* 20.

The rarer Archaic shapes for stone gems are: ringstones, *AGGems* nos. 41, 254, 263, 315, 321, 425, 426; sliced barrels, *AGGems* nos. 187, 326, and *277bis* (above).

CLASSICAL GEMS AND FINGER RINGS

In the notes to this chapter specimens of Classical gems and rings are listed serially, with summary references and descriptions, and referred to by their serial numbers. Fuller descriptions of illustrated pieces are to be found in the List of Illustrations. I have included in these lists all pieces of which I think I have adequate knowledge, but many I have not handled, nor can I give details of all shapes and materials. It has seemed better that some important pieces should be given a wrong place here than that they should have no place at all. Individual studies and better illustrations in Museum catalogues will enable them to be placed with greater accuracy.

SOURCES

SOUTH RUSSIA

The nineteenth-century finds were reported in *Compte-rendu de la Commission Impériale archéologique*, St. Petersburg (here *CR*) and the more important illustrated in the year after discovery. Reinach, *Antiquités du Bosphore cimmérien* (Paris, 1892: here *ABC*) gives an account, with commentary, of many of the Kerch groups. Minns, *Scythians and Greeks* (Cambridge, 1913) summarises the evidence with many, generally rather poor, pictures. Maximova, in articles and her catalogue of the Leningrad gems, has studied many of the finds and in Artamonov, *Treasures from Scythian Tombs* (London, 1969) there are a number of good pictures. On dating, see Schefold, *Untersuchungen* (Berlin, 1934), and *Handbuch* (Müller: Munich, 1954) vi.2, 452f. (the Scythian tombs). Generally on Greeks and Scythians see Minns; Rostovtseff, *Iranians and Greeks in South Russia* (Oxford, 1922); Boardman, *Greeks Overseas* (Harmondsworth, 1964) 245–279 and *Preclassical* (Harmondsworth, 1968) ch. vi.

The most important contexts with gems or rings are:

A. The Chertomlyk (Nikopol) tumulus, over 100 miles up the Dniepr. Minns, 155ff. Our nos. 551–2 in the debris of the 'king's' tomb. The 'queen' in the second chamber, which contained the famous silver vase, had a ring on each finger (see no. 550 and p. 220). The latest accompanying metal vases and jewellery are of the second half of the fourth century.

B. Iuz-Oba, cemetery ridge south of Kerch (Pantikapaion) in the east Crimea. Minns, 413. Our *Pl. 378* and nos. 59, 556 with jewellery and Athenian vases (*ARV* 1476, 2–3) of the first half of the fourth century.

C. Same location. *CR* 1860, v–vi. Our nos. 51, 134, 624, in a tomb, the debris of which contained an Athenian vase of the late fifth century (*ARV* 1185, 7).

D. Kerch. *ABC* 59. A tomb with red figure vases of the third quarter of the fourth century. Our nos. 151, 555, 1018 and Greco-Persian no. 321.

E. Kerch. *ABC* 56, found with gold coins of Lysimachos. Our nos. 148, 280.

F. Kerch, Temir-Gora. *CR* 1869, xiii. Our nos. 91, 281.

G. Kerch, Pavlovsky kurgan. Rostovtseff, 178f. Our nos. 71, 557, with jewellery (see *Pl. 822*) and Athenian vases. Schefold, *Untersuchungen* 67f., dates the burial to the beginning of the last quarter of the fourth century.

H. Nymphaeum, south of Kerch. Mixed finds from tumuli, now in Oxford. None of the jewellery or clay and silver vases need be later than the early fourth century (*JHS* v, 62ff., and on the confusion of the finds, Rostovtseff, *Skythien und der Bosphorus* (Berlin, 1931) 344). Our nos. 464, 490, 629, Greco-Persian no. 29.

J. Nymphaeum, tumulus 24. *Mat.Res.* lxix, 56ff., 104f. Includes red figure pottery of about 440 B C and our no. 35.

K. Nymphaeum, tumulus 17. Ibid., 71ff., 105ff. Our no. 467, with jewellery and black pottery of the later fifth century.

L. Taman, opposite Kerch. *CR* 1864, xi. Our nos. 52, 623, in a tomb.

M. The Great Bliznitza tomb, south of Phanagoria on the Taman peninsula. Minns, 423–9; Schefold, *Untersuchungen* 68–70. Several burials, apparently near contemporary, including much fourth-century jewellery (Higgins, *Greek and Roman Jewellery* (London, 1961) 212, and a coin of Alexander. All burials are probably somewhat earlier than the end of the fourth century. Segall, *Zur gr. Goldschmiedekunst* (Wiesbaden, 1966) 17ff. With main burial, of the 'priestess', our nos. 601, 614, and *Pl. 820*. With a second, cremation tomb of a lady, our nos. 329, 553, and the coin. A third burial contained an early Achaemenid stamp seal from Lydia, *CR* 1869, pl. 1.18.

N. Tomb north of Anapa (Gorgippia) on south shore of Taman peninsula. The Nereid Coffin (Minns, 324–8) containing a coin of Lysimachos, our Greco-Persian no. 67 and an Achaemenid cylinder, *CR* 1882/3, pl. 5.3.

O. The Seven Brothers Tumuli in the Kuban, east of the Taman peninsula. Minns, 210. Tomb VI, a warrior grave, with our no. 538 and *AGGems* no. 555.

THE EAST

Sardis. See *Sardis* xiii.1. The finds are in Istanbul.

Oxus. See Dalton, *The Oxus Treasure* (London, 1926). The finds are in London (*WA*).

Ur, Legrain *Ur* x. Porada discusses the coin casts and impressions in *Iraq* xxii, 228ff. These are from a Late Archaic coin of Aigai, an Attic tetradrachm of *c*. 450, and an early fourth-century coin of Dardanos. Porada, pl. 31.3 (Legrain, no. 717) and 31.7 (no. 748) are from finger rings owing something to Greek gem or coin devices; for the former (head of Zeus Ammon from a relief ring) Lycian

coins are compared; for the latter (Herakles and the lion) various sources are possible. The impressions from Greek gems are Legrain, nos. 734, 738, 746; from Greek finger rings are nos. 736, 737, 739, 740, 741, 742, 747, 750. All are late fifth-century and of high quality. See our *Figs. 276–9*. Other impressions are from Achaemenid finger rings, our *Figs. 313–15*.

Persepolis. Impressions from Greek gems and rings, Schmidt, *Persepolis* (Chicago, 1957) ii, seal nos. 44–55.

Samaria. Impressions from gems and rings, pre-332 B C. Freedman-Greenfield, *New Directions*, figs. 37–39.

IMPRESSIONS ON LOOM WEIGHTS
Olbia. *Mat.Res.* l, 191, figs. 1, 2. Barrel (?) of *c.* 400.
Kozani. *Praktika* 1965, pl. 39. Ringstones, fourth-third century.
Chalcidice. *ADelt* xix, pl. 58. Fourth century finger ring.
Delos. *EADélos* xviii, 161, fig. 17a, on a clay disc.
Olynthus. Robinson, *Olynthus* (Baltimore, 1930) ii, 118ff. Finger rings, pre-348 B C.
Delphi. *Fouilles de Delphes* (Paris, 1908) v, 198, on discs and pyramids, mainly from ringstones. Fourth-third century.
Corinth. *Corinth* xii (Princeton, 1952) 154, fig. 25 and pl. 75.1149; xv.2, 277, fig. 7. Fifth–fourth century finger rings.
Athens. *Hesperia* xvii, pl. 86.E25; Suppl. vii, 83, fig. 34 (Pnyx). Fifth–fourth century finger rings. Furtwängler, *Meisterwerke* (Leipzig, 1893) 257, fig. 33. *Ann.d'Ist.* 1872, pl. M.
Phaistos. *Annuario* xliii–xliv, 584–7, disc weights, from a scaraboid, rings and ringstone. Fourth century.
South Crete. *BSA* lxi, pl. 41i. Disc weight.
Himera. Marconi, *Himera* (Rome, 1931) 120, fig. 107. Fourth century rings.
Herakleia. Neutsch, *Herakleiastudien* (Heidelberg, 1967) 174f., pl. 40.1 and 4, apparently from rings, pl. 40.2 from a gem, on disc weights. Fourth century.
Ischia. Unpublished.
Ordona. Mertens, *Ordona* (Brussels, 1965) i, pl. 42; ii, pl. 22b.
Metapontum. *Not. degli Scavi* 1966, pls. 4.7–12; 5.6. Rings and a gem (4.12). Disc weights, fourth-third century.
Tarentum. *Rev.Arch.* 1932, i, 42f. lists types on disc weights (nos. 62–76) and pyramidal (no. 77), with pl. 4.2 (probably from a silver ring with gold stud). Fourth century.
Silaris Heraion. *Atti Soc. Magn. Gr.* vi–vii, pls. 16a, 17. Rings. Fourth century.
Gioia del Colle. *Not. degli Scavi* 1962, 161, fig. 153. Gems. Fourth-third century.
'Italy'. *Hesperia* Suppl. vii, 68, fig. 30. Finger ring. Fourth century.

OTHER IMPRESSIONS ON CLAY
Corinth. *Corinth* xv, 2, pl. 57.69, 70. Dumps impressed by finger rings.
Athens. Lang, *Agora* x (Princeton, 1964) 124ff. The follow-ing tokens seem impressed by finger rings: C5, 6, 7, 10, 11, 13, 14, 18, 20, 26. Late fifth–fourth century. Also *Journ.Int. Arch.Num.* viii, pl. 9.18, 24; 10.2.
Priene. Wiegand, *Priene* (Berlin, 1904) 465, fig. 572. Clay disc. Fourth century.
Leukas. *BMC Terracottas* (Walters: London, 1903) E112, fig. 87, a Larisa coin device copied for use on a sealing. Fifth century.
Paestum. *Röm.Mitt.* lxx, pl. 15.1, 2. Ring impression on clay bar. Fourth century.
Carthage. *Arch. Viva* i, 2, 141f.
S. Russia. Schefold, *Untersuchungen* 64, fig. 12, circular impression with a satyr head broadly resembling coins of Pantikapaion, on a clay jug.
Kerch. *Mat.Res.* ciii, 190ff., figs. 1, 3, 5. Vases. Fifth century?
Phanagoria etc. *Sov. Arch.* 1965.2, 186, fig. 1.1, 3, 7, 9. Fifth century rings and a tabloid.
Samos. Miss V. Grace has drawn my attention to some stamped amphora handles of the later fourth century which she will publish. They seem impressed by rings, and the devices include a bearded siren (as our *Fig. 259*), an archaising Athena (as our *Fig. 234*, and on a slim bezel), joined heads (as our *Fig. 257*) and some which one might otherwise have judged Hellenistic or early Roman—Eros with a wine amphora, Pan with a thyrsos. And on handles of unknown origin, pre-340 B C, *Hesp.* Suppl. x, pl. 77, 226–7.
Clay and lead tokens. Athens. *Agora* x, 76ff. (lead, late fourth century to Hellenistic), 124ff. (clay, mainly fourth-third century); for full references and discussion.

Official stamps. Athens. *Agora* x, 60f., pl. 18. Circular stamps, probably of metal, bearing versions of coin devices, used on official measures and amphora handles. Late fifth–fourth century. See also below, p. 448. Similar circular or square stamps with similar devices on dikasts' bronze pinakia, *BCH* lxxxvii, 653ff.; xci, 383; xciii, 571.

CLASSICAL GEMS
SHAPES
Furtwängler, *AG* iii, 126–36, gives a good account of the development of shapes, and of the origins of the ringstone, but while the scaraboids with engraved backs may have led directly to the larger Hellenistic ringstones, they could not alone have been responsible for the popularity of the rival form. They were probably themselves suggested by ring-stones and the fact that a convex surface gives a better impression.

The following shapes are represented in the list below, omitting the commonest—scaraboids with the flat face engraved:
Scaraboids cut on the back—nos. 20, 28, 34?, 35 (both), 37, 90, 160, 219, 231, 280, 292, 294–5, 353, 356, 358–60, 364, 378–81, 382 (both).
Scaraboids with a convex face—nos. 44, 170, 195, 207, 231, 241, 318, 323, 353, 357, 366, 377.

Scarabs—nos. 1–3, 5–7, 16, 21, 30, 41, 46–7, 72, 82, 87, 105, 147–9, 162–3, 169, 178–9, 191, 271, 325–31, 333–6.

Ringstones—nos. 111, 146, 164–6, 168, 232–4, 261 (flat), 265, 284, 286–7, 290–1, 337–43, 344–6 (flat), 347, 368.

Sliced cylinders and barrels—nos. 124–144.

Lions—nos. 243–55.

Tabloids—nos. 123, 238, 273, 425.

Cylinders—nos. 272, 383–5.

Rings—nos. 268, 460.

Pendants—nos. 309, 310.

Impressions—nos. 19, 23, 157, 181, 202–3.

'Cut' scarabs and scaraboids have had their backs cut away in recent times to serve as ringstones.

MATERIALS

The less common materials in the following list (omitting cornelian, chalcedony, agate, the pale jaspers, rock crystal) are:

Black jasper—nos. 28, 297–300, 302–3.

Green jasper—nos. 1, 111?, 301.

Red jasper—no. 201.

Mottled jasper—nos. 48–9, 52–3, 59, 80, 109, 119, 154, 172, 193, 278, cf. 283, 296, 305–8, 372, 382.

Onyx—nos. 82, 139?, 141, 143?, 195, 347.

Plasma—no. 4.

Amethyst—nos. 196, 233.

Lapis lazuli—nos. 45, 269.

Bronze—no. 242.

CATALOGUE

In the following lists minimal references are given—to basic publications, good illustrations and relevant discussions. It has not proved possible to insert references to all the illustrations in Miss Richter's new *Engraved Gems of the Greeks and Etruscans* (London, 1968) but some pieces and comments are noticed here and in other chapters. All pieces are scaraboids unless otherwise stated, and their shapes are indicated by (A), (B) or (C) given after the material, where known. The lists and summaries are defective because it has not always been possible to determine the exact shape of a scaraboid, or the colour of the stone, but the overall picture should not be misleading. If there is a hatched border to the device, (H) appears after the description. There are fuller descriptions and references in the List of Illustrations, and the stones and subjects listed here are indexed, together with the Greco-Persian, on pp. 458ff.

EARLY CLASSICAL

1　*London* 507, pl. 9. Green jasper scarab. Man's head (H). See *Pl. 444*.

2　*London* 508, pl. 9. Cornelian scarab. Youth's head (H). See *Pl. 445*.

3　Leningrad. Cornelian scarab. Three-quarter view of a man's head, wearing a pilos. *Mat.Res.* xcvi, 137, fig. 14.1.

4　*London* 504, pl. 9. Plasma. Joined heads of man and ram. See *Pl. 446*.

5　*Munich* i, 317, pl. 36, from Thebes. Cornelian scarab (simple). Youth's head.

6　*London* 510, pl. 9. Cornelian scarab. Woman's head and crescent (H). See *Pl. 447*.

7　*London* 509, pl. 9, from near Syracuse. Agate scarab. Woman's head (H). See *Pl. 448*.

8　Boston 98.716, from Greece. Jasper (A). Danae (H). See *Pl. 449*.

9　Unknown. Cornelian. Statue of a goddess on a base, wearing kalathos, holding fillet and bowl (H). *AG* pl. 13.16.

10　Paris, BN, de Luynes 254. Chalcedony (A). Demeter. See *Pl. 450*.

11　*New York* 68, pl. 11, from Cyprus. Chalcedony (A). Hades and Persephone. See *Pl. 451*.

12　Unknown. A satyr seizes a nymph (H). *AG* pl. 10.15.

13　*New York* 69, pl. 11, from Cyprus. Cornelian. Nike holding a wreath.

14　Paris, BN, de Luynes 264. Rock crystal (A). Skylla. See *Pl. 453*.

15　Paris, BN, de Luynes 289. Rock crystal (A). Sphinx. See *Pl. 454*.

16　*New York* 67, pl. 11. Agate cut scarab. Sagittarius (H). See *Fig. 201*.

17　Boston, *LHG* 49, pl. 3, from Delphi. Jasper (A). Apollo. See *Pl. 452*.

18　Once Sieveking. Chalcedony cut scaraboid. Apollo with bow and fawn (H). *Proc.Soc.Ant.* xi, 253, fig. 1, where it is compared with the earlier Apollo of Kanachos (Lippold, *Gr.Plastik* 87).

19　Paris, BN, de Luynes. Impression. Standing warrior, with helmet, spear and cloak (H). Aramaic inscription. de Vogüé, *Mél.* no. 22; Galling, *Zeitschr. deutsch. Päl. Vereins* lxiv, no. 108.

20　Boston, *LHG* 47, pl. 3. Cornelian, cut on the back. Apollo (H). See *Pl. 455*.

21　Bonn, Müller Coll. Cornelian scarab. Amazon. See *Pl. 456*.

22　Paris, BN, *Pauvert* 78, pl. 6, from Samos. Rock crystal (Archaic shape). A bowman with Scythian cap and bow-case, tests an arrow (H). *AG* pl. 9.20.

23　Teheran, from Persepolis. Clay impression. A youth leaning on a stick, his hand to his head. *Persepolis* ii, pl. 12.47.

24　*London* 449, pl. 8, from Amathus. Cornelian. Warship. See *Pl. 457*.

25　Bowdoin College 486. Chalcedony. Gorgoneion. See *Pl. 458*.

26　*London* 596, pl. 10, from Lesbos. Chalcedony (Archaic shape). Inscribed with the name *Isagor(as)*.

27　Péronne, Danicourt Coll., from Sparta. Chalcedony (A). Dog. Inscribed *Timodemo*. See *Pl. 459*.

28　*New York* 118, pl. 20, from Cyprus. Black jasper, engraved on the back. A dog curled up, tethered to a post (H).

29 Unknown. A Maltese dog (H). *AG* pl. 11.40; Lippold, pl. 87.7.

30 *Munich* i, 271, pl. 32, from Arcadia. Cornelian scarab. A Maltese dog. *MJBK* 1951, pl. 4.23.

31 *Munich* i, 260, pl. 31. Cornelian (A). A grazing horse (H).

32 *Berlin* D197, from Nymphaeum. White jasper (A). A leaping horse.

33 Boston 98.718, from Greece. Chalcedony (A). Cow and tree. See *Pl. 460*.

33*bis.* Market. Bull (H). *Münzen und Medaillen* Sonderliste L40.

34 Once Bulle. Cornelian (cut on the back?). A bull. Bulle, no. 13.

35 Leningrad, from Nymphaeum. Obsidian? (Archaic shape). A. Cow and calf. B. Winged disc. See *Pl. 461*.

36 Leningrad 564. Cornelian cut. Cow and calf (H).

37 Boston 27.664. Cornelian, cut on the back. Cow, calf and cock. See *Pl. 462*.

38 Boston, *LHG* 69, pl. 4. Cornelian. Mule. See *Pl. 463*.

39 Boston, *LHG* 72, pl. 5. Chalcedony cut. Goat.

40 *London* 590, pl. 10. Rock crystal (A). A goat (H). *LHG* pl. A.28.

41 *Munich* i, 267, pl. 31, from Olympia. Cornelian scarab. A sow. Others of this type, *AGGems* nos. 552–5.

42 Leningrad, from Kerch. Rock crystal (Archaic shape). Griffin. See *Pl. 464*

43 Boston 98.719. Chalcedony (A). A griffin, very like the last.

44 London 1925.10–17.2. Cornelian (A). Griffin. See *Pl. 465*.

45 Athens, NM, Stathatos 275. Lapis lazuli (A). A rearing goat.

46 Paris, BN, de Luynes 298. Cornelian scarab. Lion.

47 Paris, BN 1072. Cornelian scarab (carinated). A seated winged lion. Lippold, pl. 82.12.

48 Olympia 1193. Mottled jasper scaraboid (A). As the last (?) or a griffin. *Olympia* iv, 188.

DEXAMENOS AND HIS CONTEMPORARIES

Four gems are signed by Dexamenos, nos. 49–52. Beazley lists a selection of Furtwängler's attributions, which he accepts, in *LHG* p. 48f.—they are our nos. 55, 56, 59, 82, 83, 234, and he adds our no. 128. Furtwängler, in *AG* iii, 137–9, also compared our nos. 53, 91, 124, 125, 127, 174, 200. Miss Vollenweider, in *Connoisseur des Arts*, Feb., 1959, 54–9, discusses some of these and adds our no. 109. Miss Diehl lists attributions in *Berl.Mus.Ber.* xvii, 46f., publishing our no. 54; she attributes our nos. 67, 126, 127 to his workshop and dismisses nos. 53, 91, 200. On the dating and 'portraits' see the present writer in *Burlington Mag.* 1969, 591ff. On the possibility of early portraiture on gems and coins see Richter in *Rend.Pont.Acc.Rom.* xxiv, 52ff., where the Abdera coin here compared with no. 49 is fig. 18 (also

her *Portraits of the Greeks* (London, 1965) i, 79, fig. 305) and the satrap heads compared with the gold rings are figs. 19–22. For portraits on early fourth-century Lycian coins see Schwabacher in *Essays in Greek Coinage* (Studies, E.S.G. Robinson: Oxford, 1968) 111ff. And now Gauer, *JdI* lxxxiii, 161ff.

49 Boston, *LHG* 50, pl. 3, from Kara, Attica. Mottled jasper (A). Man's head. Signed *Dexamenos epoie* (H). See *Pl. 466*.

50 Cambridge, from Greece. Blue chalcedony (C). Woman and maid. Signed *Dexamenos*, and with the name *Mikes* (H). See *Pl. 467*.

51 Leningrad, from Kerch. Blue chalcedony (C). Flying heron. Signed *Dexamenos epoie Chios*. See *Pl. 468*.

52 Leningrad, from Taman. Mottled jasper (A). Heron and locust. Signed *Dexamenos* (H). See *Pl. 469*.

53 Leningrad, from Kerch. Mottled jasper (A). Amphora (H). See *Pl. 470*.

54 *Berlin* D158. Rock crystal (A). Youth's head. See *Pl. 471*.

55 *London* 529, pl. 9, from Greece. Rock crystal (A). Woman with harp. See *Pl. 472*

56 Boston, *LHG* 67, pls. 4, 10, from Messenia. Chalcedony. Horse. Inscribed *Potanea* (H). See *Pl. 473*.

57 Boston, *LHG* 49*bis*, pl. 3, from Melos. Rock crystal (A). Amazons and horse. See *Pl. 474*.

58 *Berlin* F348, pl. 7, D344. Cornelian. Horseman leaping over rocks (H). *AG* pl. 10.16.

59 Leningrad, from Kerch, Iuz-Oba. Mottled jasper. Horse (H). See *Pl. 475*.

60 Zürich, Remund Coll. (A). Horse. See *Pl. 476*.

61 *London* 550, pl. 10. Cornelian (A). A running horse. Olive twig above, and below there is a crab, half lost in a break (H).

62 *London* 588, pl. 10, from Lecce. Rock crystal (A). Horse. See *Pl. 477*.

63 *Berlin* F303, pl. 6, D196, from Crete. Cornelian (A/C). A loose horse. *AG* pl. 14.16; Lippold, pl. 89.14.

64 Paris, BN 1866. Blue chalcedony (A). Quadriga. See *Pl. 479*.

65 *London* 557, pl. 10. Chalcedony. Centaur (H). See *Pl. 478*.

66 Naples 1297. Agate (B). Woman's head. Signed *Sosias* (H). See *Pl. 480*.

67 *London* 518, pl. 9, from Ithome. Agate (A). Woman's head. Inscribed *Eos*. See *Pl. 481*.

68 Leningrad, from Kerch, Iuz-Oba. Chalcedony (B). Aphrodite, seated on a rock, suckles Eros, who stands at her knee. *AG* pl. 13.4; Lippold, pl. 24.1. On the subject see Shefton in Arias-Hirmer, *History of Greek Vase Painting* (London, 1962) 389f.

69 Once Arndt (A1483), from Olbia. Chalcedony. Woman seated playing with two balls (H). See *Fig. 202*.

70 *London* 531, pl. 9. Chalcedony (A/C). Woman with heron. See *Pl. 482*.

71 Leningrad, from Kerch, Pavlovsky kurgan. Cornelian scarab. Crouching naked woman (H). See *Pl. 483*.

72 *Berlin* F298, pl. 6, D165, from Athens. Cornelian scarab (elaborately frilled head to the beetle). As the last, but a slighter figure with smaller head, somewhat later (H). *AG* pl. 13.23.

73 Once Arndt. Cornelian. Herakles stands with lion skin, club and bow. Lippold, pl. 39.9.

74 Taranto, from Piazzale Sardegna, 1954. Cornelian. Lion-headed Herakles. See *Pl. 485*.

75 *Munich* i, 331, pl. 39. Cornelian (Archaic shape). Athlete (H). See *Pl. 484*.

76 *Berlin* (East) F318, pl. 6, from Tegea. Chalcedony (A/C). A youth seated on the ground. Inscribed . . .*siei*.

77 Paris, BN, *Pauvert* 83, pl. 6, from the south coast of the Black Sea. Agate (A). A youth binds a sandal (H). See *Fig. 203*.

78 *London* 515, pl. 9, from Kourion. Cornelian (A). Athena with snake and aphlaston. See *Pl. 486*.

79 *London* 520, pl. 9. Blue chalcedony (A). A sphinx. See *Pl. 487*.

80 *Munich* i, 297, pl. 34. Mottled jasper (A). Griffin. See *Pl. 491*.

81 *New York* 129, pl. 21. Chalcedony (B). Sea serpent. See *Pl. 488*.

82 *London* 511, pl. 9. Onyx scarab. Flying goose. See *Pl. 489*.

83 Boston, *LHG* 66, pls. 5, 10. Chalcedony (A). Heron. See *Pl. 490*.

84 Once Chandon de Briailles. Heron. See *Fig. 204*.

85 Leningrad. Chalcedony. As the last. *ABC* pl. 12a.8.

86 Boston 13.242, from Ithome. Chalcedony cut. Herons beside silphion. Inscribed *Polo* (H). See *Pl. 492*.

87 *New York* 125, pl. 21. Cornelian scarab. Quail (H).

88 Boston, *LHG* 81, pl. 5, from Egypt. Cornelian. A pigeon flying with a scroll. *AG* pl. 9.28; Lippold, pl. 94.10. For references to the use of carrier pigeons see d'Arcy Thompson, *Glossary of Greek Birds* (Oxford, 1895) 242. For the bird cf. coins of Sicyon of *c*. 400, Seltman, *Greek Coins* (London, 1933) pl. 34.20.

89 Boston 01.7562. Chalcedony (A). Eagle and snake. See *Pl. 493*.

90 *London* 552, pl. 10. Cornelian, cut on the back (A). Eagle and snake. See *Pl. 494*.

91 Leningrad, from Kerch, Temir-Gora. Chalcedony (A). An eagle carrying a dead fawn. *CR* 1870/1, pl. 6.16.

92 Heraklion, Metaxas Coll. 1249. As the last. *Pl. 495*.

93 Heraklion 725. Cornelian (A). Dog. See *Pl. 496*.

94 *London* 435, pl. 7, from Mesopotamia. Cornelian (A). A seated dog (H). For the scene on the convex back see *Pl. 864*.

95 Oxford 1892.1494, from Trikka. Blue chalcedony. Fox and grapes. See *Pl. 497*.

96 *London* 543, pl. 9. Rock crystal (A). A bull walking. *AG* pl. 11.32; Lippold, pl. 90.11.

97 Unknown. Bull. See *Pl. 499*.

98 Boston, *LHG* 79, pl. 4. Blue chalcedony (B). Bull. See *Pl. 498*.

99 Once *Cook* pl. 3.62. Chalcedony. As the last. *BFAC* pl. 110.M.122; *LHG* pl. A.26.

100 Paris, BN, *Pauvert* 63, pl. 5, from South Italy. Agate (A). Bull forepart. See *Pl. 500*.

101 *Munich* i, 310, pl. 36, from Caesarea. Blue chalcedony. As the last. See *Pl. 501*.

102 Boston, *LHG* 76, pl. 4. Agate (B). Bull calf. See *Pl. 504*.

103 *Munich* i, 306, pl. 35. Blue chalcedony (Archaic shape). A recumbent calf. *MJBK* 1951, pl. 3.13.

104 Boston, *LHG* 73, pl. 5, bought in Athens. Agate (A). A goat. In the field *pi*.

105 *London* 512. Cornelian scarab. Locust, corn and moth. See *Pl. 502*.

106 Leningrad, from Taman, Malaia Bliznitza. A locust. *CR* 1882/3, pl. 7.1.

107 Leningrad 583. Rock crystal (A). A wasp. See *Pl. 505*.

108 Boston, *LHG* 78, pl. 4. Cornelian (A). Snake (H). See *Pl. 503*.

109 Boston 27.690. Mottled jasper (A). Dolphin. See *Pl. 506*.

110 *London* 538, pl. 9. Rock crystal (A). Lion and stag (H). See *Pl. 507*.

111 Bowdoin College 488. Green ringstone. Lion and bull. See *Pl. 508*.

112 Unknown. Dogs and boar (H). See *Pl. 510*.

113 Paris, BN, *Pauvert* 49, pl. 5. Chalcedony (A). A griffin.

114 Bern, Merz Coll., from near Argos. A griffin.

115 *Geneva Cat.* i. 216, pl. 83. Rock crystal (A). Griffin. See *Pl. 512*.

116 Boston 95.81, from the Peloponnese. Chalcedony (C). Griffin and stag. See *Pl. 511*.

117 *London* 554, pl. 10. Mottled chalcedony (A). Peacock and snakes. See *Pl. 509*.

118 *New York* 130, pl. 21. Chalcedony (A). Kantharos and dolphins. See *Fig. 205*.

119 *Munich* i, 313, pl. 36, from Olbia. Mottled jasper (A). A kantharos.

120 Nicosia R.96, from Marion. Cornelian (A). Sandal (H). See *Pl. 513*.

121 Boston, *LHG* 68, p. 5. Chalcedony (Archaic shape). Hazel nut. See *Pl. 514*.

122 *Berlin* F305, pl. 6, D184, from Melos. Chalcedony (A). Pipe mouth-pieces. See *Fig. 206*.

123 Boston 95.85. Cornelian tabloid. Herm and caduceus. See *Pl. 515*.

CYLINDERS AND SLICED BARRELS

All are of agate except for three cornelian (nos. 125, 135, 137). All are sliced barrels of fairly standard proportions,

except nos. 127, 136, and 143 which are nearly cylindrical but sliced; nos. 128–131 are barrels, not sliced; no. 132 is an elongated sliced barrel; nos. 125 and 140 are very broad.

124 *London* 562, pl. 10, from Epirus. Boxer (H). See *Pl. 516.*

125 *London* 563, pl. 10, from Corfu. Youth with harp. See *Pl. 517.*

126 *Berlin* F332, pl. 7, D181, from Athens. Heron. *AG* pl. 14.11; Lippold, pl. 95.3.

127 Boston, from Greece. Heron. See *Pl. 518.*

128 Bowdoin College 491. Heron. *LHG* pl. B.4.

129 *New York* 122, pl. 21. A heron with a worm in its beak.

130 London, Mrs Russell Coll. Heron.

131 *Munich* i, 268, pl. 31. A heron. *MJBK* 1951, pl. 3.15 and 10, fig. 10.

132 Once Warren. Heron. See *Pl. 519.*

133 Boston, *LHG* 65, pl. 5, from Taranto. Lioness. See *Pl. 520.*

134 Leningrad, from Kerch. A griffin. *AG* pl. 11.41; Lippold, pl. 82.2.

135 Moscow 10561. Dog. See *Pl. 521.*

136 Oxford 1925.136. Dog with bone. See *Pl. 522.*

137 *New York* 117, pl. 20. A dog with a bone (H). *AG* pl. 9.55; Lippold pl. 87.14.

138 Boston 01.7550. Locust. See *Pl. 523.*

139 Boston, *LHG* 77, pl. 5. Sandal. See *Pl. 524.*

140 Oxford 1892.1537. Camel. See *Pl. 526.*

141 *New York* 132, pl. 22. Persian. See *Pl. 525.*

142 Once Cesnola. Two lions. Cesnola, *Cyprus* pl. 37.14; *Atlas* iii, pl. 25.15.

143 *New York* 124, pl. 21, from Cyprus. A heron, summarily cut.

144 Once Kestner. A lion. See *Pl. 527.*

AFTER DEXAMENOS

145 Once Blacas. Cornelian. Eros and shell. Signed *Phrygillos* (H). See *Pl. 529.*

146 *New York* 76, pl. 12, from near Catania. Cornelian ringstone. Herakles and the lion. See *Pl. 528.*

147 Boston, *LHG* 52, pl. 3. Cornelian scarab. Negress head. See *Pl. 530.*

148 Leningrad, from Kerch. Burnt scarab. Head of youth. Inscribed *Perga* (H). See *Pl. 531.*

149 Copenhagen. Cornelian scarab, Head of a girl. *AG* pl. 64.6; Lippold, pl. 64.10.

150 Boston, *LHG* 51, pl. 3. Blue chalcedony. Head of a woman.

151 Leningrad, from Kerch. Blue chalcedony (C). Persian. See *Pl. 532.*

152 Leningrad, from South Russia. Blue chalcedony (C). Artemis. See *Pl. 533.*

153 *Berlin* F316, pl. 6, D155, from Crete. Chalcedony (A). Odysseus (?). See *Pl. 535.*

154 Boston 01.7539. Mottled jasper (C). Odysseus (?). See *Pl. 537.*

155 Once Arndt, A1486, from Tripolis, North Africa. Mottled jasper. Warrior. See *Pl. 534.*

156 Private, from Smyrna. Chalcedony. A warrior adjusts a shield on his arm. *AG* pl. 63.10; Lippold, pl. 53.2.

157 Teheran, from Persepolis. Clay impression. A crouching warrior. *Persepolis* ii, pl. 12.46.

158 *London* 558, pl. 10. Chalcedony cut. Giant. See *Pl. 538.*

159 Paris, BN, ex Louvre. Chalcedony (A). Herakles and the lion. See *Pl. 536.*

160 Boston, *LHG* 61, pl. 4, from Greece, Cornelian, cut on the back. Theseus and the sow (H). See *Pl. 539.*

161 Athens, Num.Mus., *Karapanos* 330, pl. 5. Chalcedony (Archaic shape). Philoktetes. See *Pl. 540.*

162 Paris, BN, *Pauvert* 86, pl. 6. Cornelian scarab. Youth with a trident riding a sea horse. *AG* fig. 227; Lippold, pl. 5.4. More probably a marine hero than Poseidon. Cf. the Corinthian plaques, *Ant.Denkmäler* i, pl. 7.26; ii, pl. 39.16. Poseidon does not usually himself ride the monster (possible exceptions, Haspels, *Attic Black-figured lekythoi* (Paris, 1936) 250, 254–5; Beazley, *ABV* 181; Metzger, *Representations* (Paris, 1951) pl. 39.5) and he is normally bearded.

163 Paris, BN, de Luynes 263. Chalcedony scarab. Satyr and jar. See *Pl. 541.*

164 *New York* 97, pl. 17, from Sicily (?). Cornelian ringstone. Acheloos forepart. See *Pl. 542.*

165 *Berlin* F328, pl. 7, D153, from Asia Minor. Cornelian ringstone. Two youths with *astragaloi*. Inscribed *Dioskoroi*. See *Pl. 543.*

166 *Berlin* (East) F329, pl. 7. Cornelian ringstone. A crouching child watches a dog chase a stag. Below, a deer and a goose (?). *AG* pl. 10.21. The boy and bird seem interrupted by an eastern hunting scene.

167 New York, Velay Coll. Chalcedony. Woman. See *Pl. 544.*

168 *London* 599, pl. 10. Cornelian ringstone. Seated woman and child. See *Pl. 545.*

169 Leningrad, from Anapa. White scarab (well cut). A kneeling youth (H). *CR* 1882/3, pl. 2.8, 9. Cf. the ring, our *Pl. 682.*

170 Paris, BN, de Luynes 91. Cornelian, with a slightly convex face. A crouching Nike plays with *astragaloi*. *AG* pl. 14.27; Lippold, pl. 32.8.

171 *Berlin* F319, pl. 6, D150. Brown chalcedony (A). Woman crowned by Nike at a stele. See *Pl. 546.*

172 Syracuse. Mottled jasper. Naked woman and heron. See *Pl. 547.*

173 Péronne, Danicourt Coll. Blue chalcedony (A). Girl Pan. See *Pl. 548.*

174 Paris, BN 1689. Rock crystal (A). Girl centaur. See *Fig. 207.*

175 Paris, BN M 2847. Chalcedony. Siren with kithara. Lippold, pl. 79.3.

176 Oxford 1892.1486, from Spezia. Blue chalcedony (A). Naked girl dressing. See *Pl. 550*.

177 *Berlin* F315, pl. 6, D164, from Cyprus. Cornelian (A). As the last. *AG* pl. 13.24.

178 Once *Southesk* A38, pl. 2. Cornelian scarab. As the last (H). *AG* pl. 12.36.

179 *London* 566, pl. 10. Cornelian scarab. Seated woman and dog. *AG* pl. 14.39; Lippold, pl. 63.11.

180 *New York* 74, pl. 13, from Sparta. Chalcedony (C). Youth and girl. See *Pl. 551*.

181 Teheran, from Persepolis. Clay impression. As the last. See *Fig. 208*.

182 *New York* 73, pl. 12, from Kastoria. Cornelian (B). A. Heron (H). B. Woman and basin (H). See *Pl. 549*.

183 *Berlin* F312, pl. 6, D161. Chalcedony (A). A woman seated on a stool, with a lyre. Summary, stiff work. *AG* pl. 13.13; Greifenhagen, *Berl. Mus. Sonderheft* 1960, 13, fig. 7.

184 *Munich* i, 203, pl. 22. Rock crystal, broken (A). A woman's head, from a full figure (? a sphinx) (H).

185 Boston, *LHG* 60, bought at Damanhur. Blue chalcedony. Love-making. See *Pl. 552*.

186 *New York* 43, pl. 7, from Phaleron. Chalcedony. Warship. See *Pl. 553*.

187 Once Munich. Chalcedony (A). Heron draws bow. See *Pl. 554*.

188 *London* 553, pl. 10, from Kameiros. Chalcedony (A). Heron with antlers. See *Pl. 557*.

189 Private. Chalcedony, cut on the back. Heron with fly. *AJA* lxi, pl. 81.4.

190 Private. Chalcedony. A heron with a frog. See *Fig. 209*.

191 Paris, BN 1933*bis*. Cornelian scarab. Heron and reed. *AG* pl. 12.46.

192 *Berlin* F311, pl. 6, D180, from the Peloponnese. Blue chalcedony (A). A heron. *AG* pl. 14.17; Lippold, pl. 95.10.

193 Harvard, Fogg 60.636. Mottled jasper. Heron. See *Pl. 555*.

194 Oxford 1892.1476, from Smyrna. Rock crystal (A). A heron preening.

195 Athens, NM, Stathatos 271. Onyx, with lightly convex face. A flying heron. Amandry, *Coll. Stathatos* i, pl. 51.271.

196 Leningrad 585. Amethyst scarab. Heron. See *Pl. 556*.

197 Boston 01.7549. Chalcedony. Pegasos. See *Pl. 558*.

198 Hague. Chalcedony. Running horse. See *Pl. 559*.

199 Unknown. As the last. See *Pl. 560*.

200 Boston, *LHG* 55, pl. 4, bought in Athens. Chalcedony. Biga. See *Pl. 561*.

201 *New York* 79, pl. 13, from Trikkala. Red jasper (A). Biga. See *Pl. 563*.

202 Teheran, from Persepolis. Clay impression. A biga. The charioteer is probably a youth wearing a chlamys and not Herakles. *Persepolis* ii, pl. 12.44.

203 Teheran, from Persepolis. Clay impression. Frontal quadriga with a warrior (not 'Athena'). *Persepolis* ii, pl. 12.45.

204 Paris, BN. Chalcedony. A grazing quadruped with tusks (?). *Rev.Num.* ix, pl. 8.1 (as a bull with an elephant's head!).

205 Boston 27.687. Chalcedony. A standing stag. Richter, *Animals* fig. 145.

206 Unknown. Running stag. Inscribed *Panawidos*. See *Pl. 562*.

207 *New York* 107, pl. 19. Blue chalcedony, with a lightly convex face. A stag scratching its belly. A popular motif later; cf. *Ionides* no. 11 and p. 92.

208 *Berlin* F304, pl. 6, D172. Cornelian cut. A stag grazing. *AG* pl. 14.13; Lippold, pl. 92.8.

209 Boston, *LHG* 74, pls. 5, 10. Cornelian cut. Stag grazing. See *Pl. 566*.

210 Boston, *LHG* 75, pls. 5, 10. Rock crystal (A). Stag grazing. See *Pl. 564*.

211 Boston. Cornelian (A). Stag grazing. See *Pl. 565*.

212 Hamburg. Blue chalcedony. A stag grazing. *AA* 1963, 57, fig. 3.12; *LHG* pl. B.8.

213 Leningrad 590. Blue chalcedony cut. Stag grazing. See *Pl. 567*.

214 Munich. Chalcedony. A leaping stag and a dog. *MJBK* 1913, pl. 2.2.

215 *London* 549, pl. 10. Mottled cornelian (A). A deer leaping.

216 *London* 548, pl. 10. Agate (A). Stag. See *Pl. 568*.

217 Unknown. Stag and child. See *Pl. 569*.

218 Heraklion 161. White jasper (A). Stag grazing. See *Pl. 570*.

219 Leningrad 596. Cornelian, cut on the back. A running stag. Summary.

220 *Munich* i, 277, pl. 32, from Corinth. Mottled chalcedony (B). Goat. See *Pl. 571*.

221 Paris, de *Clercq* ii, pl. 5.101. Blue chalcedony (B). Goat. See *Fig. 210*.

222 Harvard, Fogg. Cornelian. A dog. *AJA* lvii, pl. 25.58.

223 Paris, BN M5749. Blue chalcedony (A). Dog. *Pl. 572*.

224 Unknown. Bull and locust. See *Pl. 573*.

225 Oxford 1922.15, from Cyprus. Blue chalcedony (A). Calf. See *Pl. 574*.

226 Oxford 1892.1542. Agate (A). Lion. See *Pl. 575*.

227 Oxford 1891.657, from Cyprus. Blue chalcedony (A). Lioness. See *Pl. 576*.

228 Leningrad 592. Chalcedony cut. A lion. *AG* pl. 11.34; Lippold, pl. 85.10.

229 *London* 598, pl. 10. Chalcedony cut. A chimaera.

230 Leningrad 581. Burnt (B). Chimaera. See *Pl. 577*.

231 London WA 119371. Cornelian with lightly convex face. A. Lion and stag. B. Goat. See *Pl. 578*.

232 *New York* 111, pl. 19. Cornelian ringstone. A lion attacks a stag.

233 *New York* 110, pl. 19. Amethyst ringstone. A griffin attacks a stag.

234 Paris, BN, de Luynes 200. Blue chalcedony (A). Griffin and horse. See *Pl. 579*.

235 Once Arndt, A1468, from Yosgat, near Ankara. A griffin.

236 Once *Evans*, pl. 2.26, from Rethymno. Rock crystal. Sphinx. See *Pl. 580*.

237 Once *Robinson* no. 16b., from Athens. Rock crystal. A sphinx (H). *BFAC* pl. 110, O.90.

238 *Berlin* F333, pl. 7, D183, from Greece. Chalcedony tabloid. A locust. *AG* pl. 11.42.

239 Salonika 5434, from near Pella. Rock crystal (A/B). Locust. See *Pl. 581*.

240 Once *Robinson* no. 16b, from Athens. Agate. A fly.

241 Leningrad 584. Cornelian, with lightly convex face. Fly. See *Pl. 582*.

242 Boston, *LHG* 85, pl. 5, from Athens. Bronze. Griffin and horse's head. See *Pl. 583*.

LION GEMS

These are discussed and listed in *AGGems* 165f., with references to plain specimens (also *Munich* i, 358, pl. 41). The list is repeated here but no. 622 (also in *PM* ii, fig. 559) is omitted, since I have not seen the stone and do not know how much, if any, of the back and intaglio is ancient. All are cornelian.

243 New York, Velay Coll. Naked woman (H). See *Pl. 585*.

244 *New York* 75, pl. 12. Eros flying.

245 Once *Southesk* B.4, pl. 2, from Corinth. Eagle and wreath. See *Fig. 211*.

246 *New York* 103, pl. 18. A bull (H).

247 Boston 01.7534. A plunging bull (H).

248 Leningrad, from Taman. A plunging bull by a tree. *CR* 1870/1, pl. 6.21a.

249 *New York* 55, pl. 9. On a rectangular plinth. Lion. See *Fig. 212*.

250 Leningrad, from Kerch. A racing lion. *CR* 1865, 77; *ABC* pl. 16.8; *IBK* pl. 14.15.

251 Paris, BN 1403. A lion, Babelon, *Camées* (Paris, 1897) pl. 19.192 (the back).

252 *Berlin* F330, pl. 7, D179, from Smyrna. A water bird attacking a dolphin.

253 Unknown. A dolphin man over waves. *Gaz.Arch.* 1875, 13. Perhaps a pirate being translated by Dionysos.

254 *Munich* i, 413, pl. 47. Woman and basin. See *Pl. 584*.

255 Leningrad. A trophy (H). *ABC* pl. 6.11, 12.

SOME PLAIN WESTERN GEMS

256 London, Sir John Soanes Museum, from Tarentum. Chalcedony cut. Warrior. See *Fig. 213*.

257 Boston, *LHG* 80, pl. 5, from Sicily. Chalcedony (A). Lioness. See *Pl. 586*.

258 *Berlin* F173, pl. 4, D166. Cornelian (A). On the face a lion, with an ear of corn (?) in the exergue (H). On the convex back a frontal quadriga over a hatched exergue (H).

On each side a lion and a griffin attack a stag. *AG* pl. 10.6; Lippold, pl. 85.1.

259 *London* 591, pl. 10, from Lecce. Rock crystal (A). Goat. See *Pl. 587*.

260 Lecce. Chalcedony. A boar. *LHG* pl. B.1.

261 *Berlin* F358, pl. 7, D230. Chalcedony ringstone (flat face). A bird. A later hand has lightly incised the feathers, too finely to show in impression. *AG* pl. 13.33; Lippold, pl. 94.1.

262 *Munich* i, 309, pl. 36, from Patras. Blue chalcedony (B). Bucranium. See *Pl. 588*.

263 Oxford 1892.1475, from Tarentum. Blue chalcedony (A). Fly. See *Pl. 589*.

THE FOURTH CENTURY: THE FINE STYLE

264 *London* 601, pl. 10. Blue chalcedony (C). Nike and trophy. See *Pl. 590*.

265 Boston, *LHG* 62, pls. 3, 10, from Granitsa. Cornelian ringstone. Kassandra. See *Pl. 591*.

266 Paris, BN 1549*bis*. Blue chalcedony (C). A crouching naked woman with a cloth. *AG* pl. 12.35; Lippold, pl. 63.10; Babelon, *Cat.* pl. 7; *Rev.Num.* ix, pl. 8.8.

267 Teheran, from Persepolis. Clay impression. As the last (not 'a man'). *Persepolis* ii, pl. 12.49.

268 Leningrad 575, from South Russia. Cornelian ring. Naked girl. See *Pl. 592*.

269 *London* 530, pl. 9, from Athens. Lapis lazuli (A). Woman dressing. See *Pl. 594*.

270 *Berlin* F313, pl. 6, D162, from Kyparissos. Chalcedony (C). Seated girl with stick. See *Pl. 593*.

271 *New York* 78, pl. 14. Cornelian scarab. A seated woman holding a bird.

272 London, Victoria and Albert 122–1864. Cornelian cylinder. Woman and heron. See *Pl. 595*.

273 *Berlin* F334, pl. 7, D152, from Athens, Theatre of Dionysos. Chalcedony tabloid. A dancing maenad with thyrsos and sword. *AG* pl. 13.11; Lippold, pl. 19.2. This is the Greco-Persian shape but the motif and style are purely Greek.

274 *Berlin* F314, pl. 6, D163, from Sparta. Rock crystal (A). A woman standing, holding a mirror. *AG* pl. 13.9.

274*bis* Florence. Cornelian. Hermaphrodite (?) anadoumene, by a basin. *AG* pl. 50.13 and ii, 314; Lippold, pl. 56.1.

275 Boston, *LHG* 58, pl. 4, from Kythera. Chalcedony (A). Diomedes. See *Pl. 596*.

276 Once *Evans*, pl. 2.27, from Chios. Chalcedony. Dionysos. See *Pl. 597*.

277 Paris, BN, ex Louvre 1630. Agate (A). Old man. See *Pl. 598*.

278 Leningrad. Mottled jasper. A youth crouches to feed a locust to a cock. Maximova, *Kat.* pl. 2.8.

279 Boston, *LHG* 57, pl. 3. Cornelian. Athena statue. See *Pl. 599*.

280 Leningrad, from Kerch. Chalcedony, cut on the

back. Man with kithara, seated on rocks. *AG* pl. 14.24.

281 Leningrad, from Kerch, Temir-Gora. Burnt (B). Youth with harp. See *Pl. 600*.

282 Leningrad. Burnt (A). Apollo and Marsyas. See *Pl. 601*.

283 *London* 570. Mottled red and clear chalcedony (B). Medusa head. See *Pl. 602*.

284 *London* 602, pl. 10. Cornelian ringstone. Sphinx. Inscribed *Thamypou*. See *Pl. 603*.

THE FOURTH CENTURY: THE COMMON STYLE

The gems listed here are roughly grouped: various gems with figure subjects (285–296); jasper scaraboids (297–303); still life (304–308); pendants (309–310); scaraboids with animal subjects (311–324); scarabs with animal subjects (325–336); ringstones with animal subjects (337–347).

285 Boston, *LHG* 56, pl. 4, from Asia Minor. Blue chalcedony (A). Eros. See *Pl. 604*.

286 Once Heyl. Cornelian ringstone. Eros holding a bird and a wreath. *AG* pl. 61.29.

287 *London* 1153, pl. 17. Cornelian ringstone. Woman with kithara. See *Pl. 605*.

288 Leningrad, from Kerch. Burnt (B). A seated woman, with Eros before her, jumping to kiss her. *AG* pl. 13.3; Lippold, pl. 25.3.

289 Nicosia 1949/II-2/1, from Palaekythra. Chalcedony (C). Seated woman. See *Pl. 606*.

290 Copenhagen. Cornelian ringstone. A woman seated holding a branch. *AG* pl. 64.12; Lippold, pl. 58.10.

291 Vienna. Cornelian ringstone. A seated woman pets a water bird. *AG* pl. 14.23.

292 *Berlin* F1010, pl. 12, from 'the Orient'. Cornelian, cut on the back. A figure seated on rocks. For this figure on finger rings see on *Pl. 804*. *AG* pl. 14.29.

293 Leningrad. Burnt. A naked woman stands by a wash basin petting a water bird which is standing on the rim (H). *CR* 1862, pl. 1.12.

294 Heraklion 162. Chalcedony, cut on the back (C). Centaur. See *Pl. 607*.

295 *Munich* i, 256, pl. 30. Cornelian, cut on the back. A centaur with a stick. Style as the last. *MJBK* 1951, pl. 4.24.

296 Athens, from Thebes. Mottled jasper. A horned winged Priapus. See *Fig. 214*.

297 *London* 517, from Greece. Black jasper (C). Woman with mask. See *Pl. 608*.

298 Copenhagen. Black jasper. A woman with a kithara seated on speckled rocks. *AG* pl. 64.13; Lippold, pl. 59.5.

299 *London* 532, from Greece. Black jasper (C). Naked woman. See *Pl. 609*.

300 *London* 2405, pl. 28. Black jasper. A grazing horse. See *Pl. 612*.

301 *London* 2104, pl. 26. Green jasper (C). Boy and horse. See *Pl. 611*.

302 *Berlin* (East) F306, pl. 6, from Tanagra. Black jasper

(A/C). A tripod. Inscribed *LU*, the *upsilon* with curved arms. The letters may have been added later.

303 *London* 526, pl. 9, from Greece. Black jasper (C). Herm. See *Pl. 610*.

304 Once *Evans*, pl. 3.31, from Athens. Rock crystal. Crater. See *Pl. 613*.

305 *Berlin* F320, pl. 6, D185. Mottled red jasper (A/C). A lidded amphora. *AG* pl. 13.41. This resembles the Panathenaic amphora.

306 Boston, *LHG* 84, pl. 5. Mottled jasper. A tripod. See *Fig. 215*.

307 Oxford 1921.1236. Mottled jasper (A). Kithara. See *Pl. 614*.

308 *New York* 99, pl. 17. Mottled jasper. A herm shown in three-quarter view. A branch leaning on its shoulder. Richter calls this Dionysiac, but the branch is not a thyrsos, and Dionysiac herms are not attested for the Classical period: see Lullies, *Die Typen der gr. Herme* (Königsberg, 1931) 51; Metzger, *Recherches* (Paris, 1965) 88f.

309 Cambridge CM 1552.1963. Cornelian pendant with an oval convex face and a pinched back. A lyre with a gorgoneion on the sound box and a bird perched on the bridge. *Southesk* i, pl. 9.I.10; Seltman, *Centenn. Publ. Amer. Num. Soc.* (1958) 600, fig. 3; *Arch. Reports* 1965/6 51.

310 *London* 564, pl. 10, from Athens. Cornelian pendant. A. Children. B. Sirens. See *Pl. 615*.

311 Istanbul, from Myrina. Cornelian. A griffin. Pottier-Reinach, *Myrina* (Paris, 1888) 200, fig. 19.

312 Boston. Chalcedony. A griffin.

313 Once *Southesk* B.12, pl. 3. Agate. A griffin.

314 Moscow. Chalcedony. A griffin (H). Zaharov, pl. 3.112.

315 Oxford 1921.1219. White jasper (A). Griffin. See *Pl. 616*.

316 Once *Evans*, pl. 2.25. Rock crystal. Griffin. See *Pl. 617*.

317 Kassell II.84. Agate (A). A griffin. *AA* 1965, 46, no. 23.

318 *Munich* i, 292, pl. 34, from the Greek islands. Cornelian, with a slightly convex face. A. A goat. B. A lion attacks a bull.

319 Oxford 1921.1229. Chalcedony (A/C). Griffin. See *Pl. 618*.

320 Péronne, Danicourt Coll. Agate (A). Lion. See *Pl. 619*.

321 Unknown. A lion with a spear in its mouth. *AG* pl. 13.44; Lippold, pl. 86.12. On the motif see Brown, *Etruscan Lion* (Oxford, 1960) 151. On a fourth-century coin of Kyzikos it is seen with a sword (or a limb?), *Nomisma* vii, pl. 5.17. An early example of the motif on the Solocha vase, Artamonov, pl. 155; Rostovtseff, *Iranians and Greeks* pl. 20.2.

322 Cambridge. Chalcedony (A). A lion attacks a bull. See *Pl. 620*.

323 *Berlin* F1008, pl. 12. Cornelian, with a lightly convex face. A horse with loose reins.

324 *Munich* i, 395, pl. 45. Agate (A). A fly in a wreath. *MJBK* 1951, pl. 3.18 and 10, fig. 9.

325 Baltimore 42.123. Blue chalcedony scarab. Lioness. See *Pl. 621.*

326 Paris, BN M5991. Cornelian scarab (simple, much worn, with gable carination). A lion with a spear in its mouth. *Rev.Num.* ix, pl. 8.15.

327 Oxford 1921.1228. Cornelian scarab. Griffin. See *Pl. 622.*

328 Leningrad. Burnt scarab. An eagle carries a hare. *CR* 1862, pl. 1.13.

329 Leningrad, from Bliznitza, second tomb. Burnt scarab. A stag. *CR* 1865, pl. 3.28.

330 Leningrad, from Kerch. Burnt scarab. A bull. *CR* 1860, pl. 4.9.

331 Leningrad, from Taman. Cornelian scarab. A lion. *CR* 1870/1, pl. 6.20.

332 Tarentum. Black. A stag. *Not. degli Scavi* 1936, 208.

333 Leningrad, from Kerch. Burnt scarab. A bull, *a globolo*. *ABC* pl. 16.15. Note that there is one Etruscan *a globolo* gem from South Russia, *CR* 1875, pl. 2.17 (Zazoff, *ES* no. 908, cf. no. 583).

334 Harvard, Fogg, from Patras (found in a grave with the next). Agate scarab. A stag. *Hesp.* Suppl. viii, pl. 41.13.

335 Harvard, Fogg (see the last). Cornelian scarab. A chimaera. Ibid., pl. 41.14.

336 Delphi, from a tomb. Cornelian scarab (simple). A duck. *ADelt* xix, Chr., pl. 258a, b.

337 *London* 560, pl. 10. Cornelian ringstone. Pigeon. See *Pl. 625.*

338 *Munich* i, 270, pl. 31. Chalcedony ringstone. Heron. See *Pl. 623.*

339 *Munich* i, 289, pl. 33. Cornelian ringstone. A lion with a spear between its forelegs. *MJBK* 1951, pl. 3.2.

340 Paris, BN. Cornelian ringstone. A lioness with a spear in her mouth. *Rev.Num.* ix, pl. 8.14.

341 *London* 606, from Amathus, tomb 79. Cornelian ringstone. A bull. *LondonR* 353, pl. 10.

342 Oxford 1941.308. Cornelian ringstone. Lion and stag. See *Pl. 624.*

343 Paris, *de Clercq* ii, pl. 7.99*bis*. Cornelian ringstone. A lion attacks a deer.

344 *Berlin* F353, pl. 7, D182. Cornelian ringstone (flat face). A heron and snake. *AG* pl. 14.35.

345 *Munich* i, 269, pl. 31. Cornelian ringstone (flat face). A heron. *MJBK* 1951, pl. 3.16.

346 *Berlin* F359, pl. 7, D177. Cornelian ringstone (flat face). A griffin attacks a stag. *AG* pl. 13.38. Unusual scheme, with the griffin obscuring the stag's body, and its head appearing frontal before the victim's neck.

347 *Berlin* F364, pl. 7, D176. Sardonyx ringstone. A griffin attacks a stag. *AG* pl. 13.39.

SOME PLAIN EASTERN GEMS

348 Oxford 1892.1489, from Larnaka. Blue chalcedony (C). Satyr. See *Pl. 626.*

349 Unknown. Satyr. See *Pl. 629.*

350 Paris, *de Clercq* vii.2, pl. 19.2809, from Tortosa. Chalcedony. Herakles with bow and club. On the back, a tortoise.

351 Oxford 1892.1478. Rock crystal (A). Pan. See *Pl. 627.*

352 Once Osborne, from Syria. Chalcedony. Pan. Osborne, *Engraved Gems* (New York, 1912) pl. 8.21.

353 Leningrad, Or. Dept. Cornelian. Lion and goat: boar. See *Pl. 628.*

354 *New York* 104, pl. 18. Cornelian. A zebu bull.

355 *New York* 96, pl. 17. Cornelian cut. A baby with a dog.

356 Baltimore 42.133. Cut on the back. Fawn. See *Pl. 630.*

357 Oxford 1896–1908.O.20. Chalcedony with a lightly convex face (A). A camel.

358 Cambridge. Chalcedony, cut on the back. A bull (?). Middleton, pl. 1.13.

359 Once *Robinson* no. 41, from near Babylon. Cornelian, cut on the back. A lion pursues a stag. The lion is of Greek type but the animals' gallop recalls Greco-Persian stones.

360 Athens, Num.Mus., *Karapanos* 489, pl. 7. Chalcedony, cut on the back, not pierced, but a cross cut at one end marking the place for the drill. A bull, unfinished.

361 Oxford 1921.1238. Agate (A). Two parrots. See *Pl. 631.*

362 Oxford 1891.332, from Syria. Blue chalcedony (A), with a lightly convex face. A bird displayed.

363 Leningrad 543. Chalcedony (A). Two birds on a bucranium.

364 Once Chevalier Petré. Chalcedony, cut on the back. A bird perched on a bucranium. Lajard, *Venus* pl. 3.3.

365 Oxford 1886.1106, from Jerusalem. Chalcedony (A). A bird, deer and star.

366 Oxford 1889.397, from Syria. Cornelian (A) with a lightly convex face. A camel and a tree.

THE LATEST CLASSICAL

A cornelian ringstone signed by Kallippos, in Boston, is assigned to this period by Miss Vollenweider (*Geneva* xii, 56f., with pl. 2.2, 4) and our no. 367, below, is attributed to his hand. The type of the signed gem is probably of this date but the form of its inscription suggests that it was executed in the early Roman period. The device is an Eros with spear and shield.

367 *London* 533, pl. 9, from Achaia. Chalcedony (C). Muse. See *Pl. 632.*

368 *Berlin* F351, pl. 7, D151. Cornelian ringstone. Eros. See *Pl. 633.*

369 Unknown. Winged girl and basin. See *Pl. 634.*

370 *London* 572, pl. 10. Mottled serpentine (B). Omphale. See *Pl. 635.*

371 *Berlin* F317, pl. 6, D156. Rock crystal (C). Herakles

with club and bow, leaning on a rock. A dull, repolished surface. *AG* pl. 10.41.

372 Oxford 1892.1485, from Sparta. Mottled jasper (C). Athlete. See *Pl. 636*.

373 Leningrad 599. Chalcedony cut. Danae. See *Pl. 637*.

374 Leningrad. Blue chalcedony (A). Naked woman dressing. See *Pl. 638*.

375 Once *Southesk* C.19, pl. 3. Cornelian ringstone. A naked woman crouches, pulling on her chiton. *AG* pl. 12.30.

376 Unknown. A nymph, her himation round her legs, stands by a pillar or *terma*, inscribing a prize amphora. *AG* pl. 14.34.

377 Paris, BN, de Luynes 89. Cornelian flat scaraboid with a convex face. Nike in a wheeling quadriga. *AG* pl. 9.53.

378 *London* 569, pl. 10, from Garma, North Persia. Chalcedony, cut on the back (B). Nike in biga. See *Pl. 639*.

379 Leningrad 604. Cornelian, cut on the back. Nike in a wheeling quadriga. *AG* pl. 14.38.

380 *New York* 98, pl. 17. Cornelian flat scaraboid, cut on the back. A leaping quadriga. *AG* pl. 9.52; Lippold, pl. 55.3.

381 *Munich* i, 316, pl. 36. Lapis lazuli flat scaraboid, cut on the back. As the last.

382 *Berlin* F1009, pl. 12, D224. Red and yellow jasper. On the face a profile man's head. On the convex back a shield with gorgoneion device.

383 Oxford 1892.1598, from Rhodes. Cornelian cylinder. Woman and heron. See *Pl. 640*.

384 Moscow. Cornelian cylinder. Woman and basin. See *Pl. 641*.

385 Paris, *de Clercq* i, pl. 36.410, from Syria. Cornelian cylinder. Nike with a thymiaterion. *AG* fig. 91.

On the late use of cylinders see *AG* iii, 133, where figures on an archaistic cylinder from South Russia are also illustrated (Dionysos and nymph with thyrsoi, fig. 92) and reference made to another archaistic cylinder (cornelian, from near Theodosia; *CR* 1868, pl. 1.4) showing Herakles fighting Apollo for the tripod. The latter is from a fourth-century grave. See also Buchanan, *Oxford Cat.* i, 208; and the writer in *Antike Kunst*, forthcoming.

GLASS SCARABOIDS

Some, probably sixth-century, of eastern manufacture, are: *Berlin* F191, pl. 4 (green; from Adalia; a lion); *London* 584, pl. 10 (green; from Olbia; goats at a tree); *Geneva Cat.* i, 210, pl. 80 and *Munich* i, 166, pl. 19 (clear; cow and calf); Basel, Erlenmeyr Coll. and London WA 130843 (blue; chariot); von der Osten, *von Aulock Coll.* no. 195 (blue; lion and bull); *Newell Coll.* pl. 31.465 (hero and lion); *Arethusa* v, pl. 8(7), 6 (blue; lion hunt). Examples of Achaemenid period glass conoids are *Berlin* F190, pl. 4; New York, Morgan Library (*CNES* i, pl. 126.843); *Iraq* xxix, pl. 10.4; *von Aulock Coll.* nos. 198, 200–2, 205–7 and p. 66; *Newell Coll.* pl. 31.464, 466; Delaporte, *Louvre* ii,

pl. 105.A1154–5; and cf. *AG* iii, 119. Glass tabloids with Achaemenid and Greco-Persian devices have recently been found near Tiflis.

Parthenon (and Delian) inventories mentioning σφραγῖδες ὑαλίναι are discussed in *AG* iii, 135; *New York* xxviii; *London* ix, xxxix. σφραγῖδες ὑαλίναι ποικίλαι are also mentioned. ποικίλαι should mean variegated, not simply coloured, and so could hardly be used of glass but would exactly suit, for instance, an agate. Herodotus uses the word for mottled red and grey granite (ii, 127; cf. Lucas-Harris, *Ancient Egyptian Materials* (London, 1962) 57f.). But it might mean simply 'decorated'.

In the following list all are scaraboids with flat backs except for the tabloid, no. 425, the ringstone no. 415, and the ring no. 460. Nos 386–7, 393, 395, 397–403, 405, 418–23 are in clear glass; no. 415 is brownish; nos. 389, 410, 443 are blue; the rest are green, sometimes yellowish.

386 Once Evans, from Spata, Attica. Man. Inscribed *Kastor* (H). See *Fig. 216*.

387 Copenhagen, from Corfu. A man with shield and torch. Inscribed *lampadias* (H). *AG* pl. 13.1; Kukahn, *Anthrop. Sarkophage* 56, fig. 44. Furtwängler thought this might be by the same hand as the last. Lampedodromoi (for which see now Greifenhagen, *Ein Satyrspiel des Aischylos?* 13ff.) do not usually carry arms.

388 *Berlin* F301, pl. 6, D154. Skylla (H). *AG* pl. 13.32; Lippold, pl. 6.2. Cf. Jacobsthal, *Die Mel. Rel.* 200, fig. 77; and in stone, as our *Pl. 453*.

389 *Munich* i, 255, pl. 30, from Athens. A centaur.

390 Copenhagen, *Thorwaldsen* 7, pl. 1. A seated sphinx. Cf. our Greco-Persian nos. 295–7.

391 *Berlin* F189, pl. 4, D206, from Athens. A bearded male sphinx.

392 *London* 567, pl. 10. Artemis (H). See *Pl. 642*.

393 *Munich* i, 315, pl. 36, from Laconia. Biga (H). See *Pl. 643*.

394 *Munich* i, 314, pl. 36. Quadriga (H). *AG* pl. 13.14.

395 Athens Market, from Greece. Danae seated on a stool. *AG* pl. 63.7.

396 *Munich* i, 286, pl. 33. A ram.

397 *New York* 108, pl. 19. Grazing stag. Apparently cast from the Berlin scaraboid, our no. 208, but possibly ancient.

398 *Munich* i, 257, pl. 30. A grazing horse (H). *MJBK* 1951, pl. 4.28.

399 *Munich* i, 258, pl. 30, from Athens. As the last.

400 Athens, Num. Mus., *Karapanos* 494, pl. 7. As the last. See *Pl. 644*.

401 *Munich* i, 259, pl. 30, from Kythera. Mare and colt.

402 *New York* 142, pl. 23. A griffin. Monumental ground line as on *Pl. 583*.

403 *London* 577. A seated woman, cross-legged, holding a flower (H). See *Pl. 645*.

404 Leningrad 606. Shaped back like a scaraboid. A seated woman (H).

405 *Munich* i, 334, pl. 39. A youth seated on an amphora;

a club beside him. *MJBK* 1951, pl. 4.27. Herakles is seen with a vase in western and Etruscan fountain scenes.

406 *Munich* i, 330, pl. 39. A seated man.

407 *Munich* i, 325, pl. 37. Diomedes kneels with sword and palladion. *AG* pl. 13.8.

408 *Munich* i, 328, pl. 38, from near Tarentum. Man with chlamys, helmet and shield.

409 *Berlin* (East) F322, pl. 6, from Arcadia. Dancer (H). See *Pl. 646*.

410 *Munich* i, 329, pl. 38. A maenad.

411 *Berlin* (East) F321, pl. 6. A facing head of Athena.

412 *Geneva Cat.* i, 217, pl. 83. Replica of the last.

413 Once Sambon. Head of Athena with a relief Skylla on the helmet. *Corolla Num.* pl. 14.15. Sambon argued that this was Western Greek because the device resembles coins of Thurium, but it was also known in Greece (Pharsalos, *BMC Thessaly* pl. 9.10) and the find places of other glass scaraboids seem to tell against a western origin for the majority.

414 *London* 592, from Greece. Eagles and a fawn. See *Pl. 647*.

415 *New York* 100, pl. 17. Cut as a ringstone. Winged centaur-lion holding a branch and a kantharos. *AG* pl. 10.52; Lippold, pl. 75.14. The date of this is not clear, but the device must go back at least to the fourth century since the wings are still sickles. For the earlier history of such a hybrid see *AGGems* 29 and our *Pl. 284*.

416 Salonika 5435. Woman's head (H). See *Pl. 651*.

417 Boston. Youth's head (H). See *Pl. 648*.

418 *Berlin* (East) F323, pl. 6, from Thurium, Acarnania. As the last.

418*bis* From Tanais. Youth's head. *AA* 1910, 207f., fig. 7.

419 Cambridge, from Greece. A man's head. *AG* pl. 10.44; Middleton, no. 9; *Rend.Pont.Acc.* xxxiv, 56, fig. 26; Richter, *Greek Portraits* iv, fig. 17. Cf. Zazoff, *ES* 103, n. 197 (Palermo).

420 *Munich* i, 323, pl. 37. Man's head. *MJBK* 1951, pl. 4.32.

421 *Munich* i, 324, pl. 37. Man's head.

422 Oxford, from Al Mina. Man's head (features broken away). Cf. the head on a glass conoid from the same site, *JHS* lviii, pl. 15.MNN.124.

423 *Munich* i, 318, pl. 37, from Athens. A facing woman's head. *MJBK* 1951, pl. 4.30.

424 *London* 578, from Odessa. A woman's head.

425 *Berlin* (East) F335, pl. 7, from Vulci, a 'fourth-century grave'. Tabloid. A woman's head, very like the last. See *Pl. 649*.

426 *Munich* i, 320, pl. 37. A woman's head, similar to the last.

427 *London* 579. A woman's head.

428 *Munich* i, 319, 321, 322, pl. 37. A woman's head.

429 Leningrad 607. A facing woman's head.

430 *London* 580. As the last.

431 Basel, Private. As the last.

432 *Berlin* (East) F327, pl. 6, from Kythera. Herakles by a tree.

433 London, Mrs Russell Coll. Half-naked woman. See *Pl. 650*.

434 *London* 571, pl. 10, from Olbia. A man leaning on a staff.

435 *Berlin* (East) F324, pl. 6, from Athens. Nike in a quadriga.

436 *London* 574, pl. 10, from Olbia. A Persian horseman. In front, perhaps, traces of a hunted animal in a position common in such scenes on Greco-Persian gems.

437 Leningrad 500. Hippocamp rider. See *Pl. 652*.

438 Salonika, from Olynthus. Herakles and the lion (?). *Olynthus* x, pl. 171.2649 and 528, fig. 33.

439 *Munich* i, 287, pl. 33. Two lions.

440 Salonika, from Olynthus. Goats and a kantharos. See *Pl. 653*.

441 Leningrad 559. A running man. Summary.

442 Leningrad K757, from Karagodeuasch, found with the next two in a late fourth-century tomb. A rearing, threatening lion in the eastern pose.

443 Leningrad K758 (see the last). A warrior.

444 Leningrad (see the last). Athena.

445 *Munich* i, 335, pl. 39. Pan?

446 *Berlin* (East) F325, pl. 6. A griffin.

447 Copenhagen, *Thorwaldsen* 8, pl. 1. A griffin.

448 *Munich* i, 298, pl. 34. Ringstone. Griffin and snake.

449 Oxford 1922.14. A hippocamp. See *Pl. 654*.

450 Basel, Private. A lion.

451 *Berlin* (East) F326, pl. 6, from Sparta. A lion.

452 *Munich* i, 272, pl. 32, from Megara. A lion (not 'a dog').

453 *London* 581, from Naukratis. A plunging bull, its head turned back (not 'a lion'). *Naukratis* i, pl. 20.13.

454 *London* 587, from Sardis. Cow and calf.

455 Cambridge. As the last.

456 *London* 589, from Olbia. Mare and colt.

457 *London* 582, from Beirut. A lion?

458 *London* 594, from Beirut. A crab. See *Pl. 655*.

459 Paris, BN M5449. A sphinx on a Doric capital (?) *Rev.Num.* ix, pl. 8.13. The style is different from the others listed here, but appears ancient.

460 Leningrad 608. Ring (Type VIII). Woman's head.

The impression on a clay weight from Tarentum in Oxford (1884.646) showing a horseman may be from a glass scaraboid.

CLASSICAL FINGER RINGS

Marshall's classification of shapes in *London R* xxxviiff. and the one given here compare as follows (Marshall's first): C.vii = II; C.x = I; C.xi = III; C.xii–xiv = VI–VIII; C.xv (cf. xxxiv) = VIII; C.xvi, xxviii, xxx = X; C.xvii = XI, XII; C.xxix = XV; C.xxxi = XIV; C.xxxiii = XVI; E.i = XIII; E.v = XVII.

There are gold studs in 25 silver rings; bronze studs (three) in silver ring no. 672; gold crescents in nos. 683, 736, 853, 920 (bronze); studs in bronze rings nos. 901, 940 (four), 942 (two), 944.

Technique. See above, p. 155 and *AFRings* 18. Hoop and bezel may be made separately and brazed together, especially for the earlier Classical rings. Three-piece moulds would normally be used for heavier rings. Some may have hammered bezels with the open ends of the hoop brazed together (as for the Archaic rings of Type F); or bezel and hoop might be cast flat and then bent and fastened in the same way; cf. the Egyptian mould for such a ring, Schäfer, *Goldschmiedearbeiten* (Berlin, 1910) 51, fig. 33, and fig. 31 for a three-piece mould. Hoffmann-Davidson, *Greek Gold* (Brooklyn, 1965) 251, suggest, à propos of our no. 515, that the main part of the intaglio was cast, which is surprising; nor do I think it very likely that the cire perdue method was used (ibid., 33). For Bronze Age moulds see p. 413.

Lead relief rings from South Italy. *BSR* xxxiv, 9f.

It has not been possible to define certainly the shapes of all the rings listed here, so the Type number is given in brackets if known; queried if guessed from an illustration; otherwise omitted. (H) indicates a hatched border to the device.

EARLY CLASSICAL: THE PENELOPE GROUP
With these may perhaps be taken *AFRings* N33 (closer to Type II), N40.

461 New York, Velay Coll. Gold (I). Penelope. Inscribed *Panelopa*. See *Pl. 656*.

462 *Geneva Cat.* i, 218, pl. 84. Gilt bronze (I). A seated woman holds a wreath (H).

463 Once Guilhou. Electrum (I?). Frontal Nike (H). Ricci, pl. 7.438. The Pan Painter attempts such figures, cf. *CVA* Oxford i, pl. 33.2.

464 Oxford 1885.492, from Nymphaeum, tumulus II. Gold (I). Sphinx (H). See *Pl. 657*.

465 Athens, from Eretria. Gold (I). Nike flying with a wreath. *Ath.Mitt.* xxxviii, pl. 16.5. For the motif on fifth-century rings see *BSR* xxxiv, 15.

466 Bern, Merz Coll. Gold (I). As the last (H). *Guilhou* pl. 4.81; Schefold, *Meisterwerke* no. 561.

467 Leningrad, from Nymphaeum, tomb 17. Gold (I). As the last. See *Pl. 658*.

468 Leningrad T.1885.1, from Phanagoria. Gold (I, the hoop not joined). Eros. See *Pl. 659*.

469 Leningrad T.1852.96, from Phanagoria. Gold (I/II). Summary version of the last.

470 Once Arndt, A2468, from Lesbos. Gold. Lion. See *Fig. 218*.

471 Harvard, Fogg, from Attica. Gold (I). Kybele in a lion chariot. *Hesp.* Suppl. viii, pl. 41.17.

472 *LondonR* 50, fig. 15, from Amathus, tomb 84 (early fifth century). Gold (I). Satyr with stick and wineskin (?).

473 Paris, *de Clercq* vii.2, 2798, pl. 19, from Marion. Gold. Artemis seated on a stag. Summary style. Richter, *Kypros* pl. 182.47. Cf. our no. 712.

474 Oxford F.94, bought in Athens. Silver (I, the ends of the hoop soldered). A palmette.

475 *LondonR* 44, pl. 2, from Tharros, tomb 12. Gold (IV). Boy, man and ewe. See *Pl. 660*.

476 Munich A2500, from Egypt. Silver. A man with a monkey which is fishing, squatting on a club or phallus (?).

THE WATERTON GROUP

477 London, Victoria and Albert 431-1871. Gold (I). Head. See *Pl. 661*.

478 London 1914.10-17.2. Gold (I). Artemis and altar. See *Pl. 662*.

479 Boston, *LHG* 48, pl. 3. Gold (I/III). Hermes. See *Pl. 663*.

480 *LondonR* 48, pl. 2. Gold (I). Penelope. Inscribed *philo kao*. See *Pl. 664*.

481 Leningrad П1877.1, from Kerch. Gold (I, with ovolo edge to bezel). Penelope. This and the next are rather more summary examples of the type, distinguished by the ovolo edge to the bezel.

482 Paris, Louvre Bj.1094. Gold (I, with ovolo edge to the bezel). A seated woman with a mirror.

483 *LondonR* 45, pl. 2, from Beirut. Gold (I). Girl and crescent. See *Pl. 665*.

484 Boston, *LHG* 53, pl. 3. Gold (I). Erotostasia. See *Pl. 666*.

485 Boston 99.437. Silver with gold stud (I). Danae. Inscribed *Dana*. See *Pl. 667*.

486 Leningrad 480. Gold (I). Man. See *Pl. 668*.

487 *New York* 89, pl. 16, from Macedonia. Gold (I). A seated woman with Eros and a bird.

488 Boston, *LHG* 83, pl. 4, bought in Sicily. Gold (I). Donkey. See *Pl. 669*.

CLASSICAL: LIGHT RINGS

489 *New York* 70, pl. 11. Gold (II, oval). Athena strikes down a giant. Cf. *AGGems* 101, n. 13.

490 Oxford 1885.484, from Nymphaeum, tumulus IV. Gold (II). Man's head. See *Pl. 670*.

491 *LondonR* 49, pl. 2, fig. 14. Gold (II). Horseman. See *Pl. 671*; colour, p. 217.2.

492 Plovdiv, from Golemata Mogila. Gold (II). Horseman. Inscribed *Skythodoko*. See *Pl. 672*.

493 Paris, BN, de Luynes 521, from Syria. Gold (II). Maenad with severed human head. See *Pl. 673*.

494 *New York* 83, pl. 15. Silver, with gold stud in the bezel and cavity for another (II). A maenad dancing holding a thyrsos and sword.

495 *LondonR* 66, pl. 3. Gold (II). Woman on a ship. See *Pl. 674*.

496 Boston 98.789. Silver (II). Thetis on hippocamp. See *Pl. 675*.

497 *New York* 84, p. 15. Gold (II). A seated woman holding a mirror and wreath. Richter, *Furniture* (London, 1966), fig. 186.

498 *LondonR* 77, pl. 3. Gold (II). A seated woman holds a bird.

499 *LondonR* 1036, pl. 27, from Asia Minor. Silver (I, but the hoop ends are set in from the bezel ends). Woman with distaff. Inscribed *A]polloṇi[d]ei*. See *Pl. 676*.

500 *LondonR* 39, fig. 10, from Selinus. Gold (II). Nike flying.

501 Leningrad. Gold (II). A heron flying. See *Pl. 677*.

502 Athens, Num.Mus., *Karapanos* 594, pl. 8. Silver. A rhyton with animal protome. Richter, *Engr. Gems* no. 175. On such vessels see Tuchelt, *Tiergefässe* (Berlin, 1962) 78ff., and our *Pl. 894*.

503 Bern, Merz Coll. Gold (II). A pelican. See *Fig. 219*.

504 *New York* 123, pl. 21. Silver with a gold stud (II). A heron.

505 Private. Gold (I). A griffin. Schefold, *Meisterwerke* (Basel, 1960) no. 564; once Guilhou, Ricci, pl. 4.190.

CLASSICAL: HEAVY RINGS

506 *Berlin* F287, pl. 6. Gold (III). Man's head. See *Fig. 220*.

507 Paris, BN, de Luynes. Gold, oval. A bearded negro head. Possibly later. *AG* pl. 10.43.

508 *Berlin* F286, pl. 6, from Sicily. Gold (III). Three-quarter facing head of a woman. *AG* pl. 10.37.

509 Leningrad 577. Gold (III). Woman's head. See *Pl. 678*.

510 Bern, Merz Coll. Gold (III, with twisted hoop). Three-quarter facing head of a woman. Schefold, *Meisterwerke* no. 584.

511 Leningrad II.1862.22, from Kerch. Gold (III). Woman's head.

512 Oxford F.115, from Constantinople. Gold (III). Woman's head. See *Pl. 679*.

513 *Berlin* F285, pl. 6. Gold (III, open, but not overlapping hoop). The facing head of a wreathed satyr. *AG* pl. 10.36; Lippold, pl. 14.5; Becatti, pl. 80.321.

514 Once Guilhou. Silver. Facing head of a satyr. Ricci, pl. 12.765.

515 Boston, *LHG* 54, pl. 4. Gold (III, oval, heavy). Amazon hunting deer. See *Pl. 680*.

516 Leningrad, from Kerch. Gold (III). Seated Persian tests arrow. Signed *Athenades*. See *Pl. 681*.

517 Leningrad, from Kerch. Gold massive hoop. Boy, tunny and prawn. See *Pl. 682*.

518 *LondonR* 61, pl. 2, from Kourion, tomb 73. Gold (III). Reclining woman. See *Pl. 683*.

519 *LondonR* 52, pl. 2, from Marion, tomb 66. Gold (III). Athena. Inscribed *Anaxiles*. See *Pl. 688*.

520 Once *Guilhou* 83, pl. 4. Gold (III). Athena. See *Fig. 221*.

521 *LondonR* 64, pl. 3. Gold (III). Maenad. See *Pl. 684*.

522 Paris, Louvre Bj.1051. Gold (III). As the last. See *Pl. 685*.

523 Boston 95.92. Gold (III). Thetis on hippocamp. See *Pl. 686*.

524 Paris, BN, de Luynes 515. Gold (III). Penelope. See *Pl. 687*.

525 Pforzheim 1954.18. Gold (III). Nike fastens her sandal. Schefold, *Meisterwerke* no. 562; Battke, *Geschichte* (Baden-Baden, 1953) pl. 4.18.

526 *Geneva Cat.* i, 219, pl. 84. Silver (III). A seated woman with a flower.

527 Once *Guilhou* 84, pl. 4. Gold (III?). A seated woman with Eros flying to her with a wreath.

528 Leningrad. Gold (III). A seated woman. See *Pl. 689*.

529 Berlin 31323, from Olbia. Gold (III?). A woman seated with a tympanon. Becatti, pl. 80.324.

530 Leningrad, from Kerch. Gold. Woman and dog. See *Pl. 690*.

531 *LondonR* 1039, pl. 27. Silver (III). A woman 'rides' Eros on her foot. Satyrs play this game with their young on fifth-century vases and later gems; references in *AA* 1965, 71; compare earlier tricks with wine jars (*BSA* xlvi, pl. 16b) and cups, and *Fig. 225*.

532 London 1907.12-.17.2, from Rhodes. Silver with a gold stud (III). Eros on dolphin. See *Pl. 691*.

533 London 1938.3-15.4. Silver with a gold stud and hole for another (III). Herakles and the lion. Once Guilhou, Ricci, pl. 9.550. Cf. for the pose the impressions, *Persepolis* ii, pl. 12.52; *Ur* x, nos. 748–9, and the gem, our *Pl. 536*.

533bis Nicosia J.775, from Marion. Silver (III). Seated youth with strigil. *BSA* lxv.

534 *New York* 93, pl. 16. Silver (III). Hermes leaning on a column. Cf. the rather earlier version, *Pl. 663*.

535 Once Guilhou. Gold. A frontal biga. Ricci, pl. 5.292.

536 Boston, *LHG* 82, pl. 5. Silver. Lion and club. See *Pl. 692*.

537 Boston 98.795. Gold (III). Lion attacking dolphin. See *Pl. 693*.

538 Leningrad, from the Seven Brothers' Tumulus. Gold (III). Lion and stag. See *Pl. 694*.

539 Leningrad, from Nymphaeum. Gold (I). Griffin and horse. See *Pl. 695*.

540 Paris, Louvre Bj.1085. Gold (III). A lion attacks a stag. Hoffmann-Davidson, *Greek Gold* 254f., no. 113. This is closely related in style to the following three.

541 Paris, BN, de Luynes 526. Gold (III). Lion and bull. See *Pl. 696*.

542 Paris, BN 495. Gold (III, tiny). Lion and stag. See *Pl. 697*.

543 Leningrad I.O.40, from Kerch, Iuz-Oba. Gold (III). A lion attacks a stag.

The following, in poorer style, may be added:

544 Paris, Louvre Bj.1350. Silver (III). A lion.

545 Once *Guilhou* 125, pl. 6. Gold (III?). A dog, branch and cross.

546 *LondonR* 1080, pl. 27. Silver with a gold stud (III). Dog in shell. See *Pl. 698*.

547 *New York* 131, fig., from Cyprus. Gold (III, very thin bezel). Summary opposed palmettes (H).

548 Paris, Louvre Bj.1348. Silver (III). Four palmettes, the larger with acanthus bases (H).

A PONTIC GROUP

549 Leningrad, from near Kerch. Gold (VII, with open overlapping hoop). A snake draws a bow. See *Pl. 699*.

550 Leningrad, from Chertomlyk. Gold (VII, with open overlapping hoop). A duck flying over bushes. See *Pl. 700*.

551 Leningrad, from Chertomlyk. Gold (VI, with open overlapping hoop). A bull and a tree. See *Pl. 701*.

552 Leningrad, from Chertomlyk. Gold (VI, with open overlapping hoop). A dog gnaws a bone. *CR* 1864, pl. 5.11; Lippold, pl. 88.6; Artamonov, fig. 111.

553 Leningrad, from Bliznitsa, tomb 2. Gold (VII?). Rhyton with winged lion forepart. A fly in the field. *CR* 1866, pl. 2.27.

554 Leningrad, from Taman. Gold (VI). Griffin-cock. See *Pl. 702*.

555 Leningrad, from Kerch. Gold (VII, flimsy). A duck flying and a fish. *ABC* pl. 18.1.

556 Leningrad, from Kerch, Iuz-Oba. Gold (VII). Locust on rose. See *Pl. 703*.

557 Leningrad, from Kerch, Pavlovsky kurgan. Gold (VII?). A flying bird seen from below. *CR* 1859, pl. 3.7.

558 Leningrad, from Kerch. Gold (VII?). A bird and a snake. *ABC* pl. 18.8.

THE DE CLERCQ GROUP

559 Paris, *de Clercq* vii.2, pl. 19.2810, from Amrit. Gold (II). Herakles. See *Fig. 222*.

560 Paris, ibid., pl. 19.2825, from Amrit. Gold (II). Warrior.

561 Paris, ibid., pl. 19.2826, from Amrit. Gold (II). Youth.

562 Paris, ibid., pl. 19.2827, from Tortosa. Gold (VI). Man with panther (?).

563 Paris, ibid., pl. 19.2824. Gold (VI). Woman and thymiaterion.

564 Paris, ibid., pl. 20.2830. Gold (II). Maenad with sword and branch.

565 Paris, ibid., pl. 20.2831. Gold (II). Maenad.

566 Paris, ibid., pl. 19.2829. Gold (II). Dancer.

567 Paris, ibid., pl. 19.2828, from Amrit. Gold (II?). Woman holding flowers, said to have been found with no. 571 and other gems, including a forgery, in an anthropoid sarcophagus.

568 Paris, ibid., pl. 20.2867, from Amrit. Gold (II). Lion and griffin. See *Fig. 223*.

569 Paris, ibid., pl. 20.2868, from Aradus. Gold (II). A lion attacks a griffin.

570 Paris, ibid., pl. 20.2869, from Amrit. Gold (II). A dog (?) attacks a lion. An odd group for Greek work but dogs appear in eastern lion hunts.

571 Paris, ibid., pl. 20.2870, from Amrit. Gold (II). Lion. See *Fig. 224*.

572 Paris, ibid., pl. 19.2800. Gold (II). A mare suckles a foal.

573 Paris, ibid., pl. 20.2866. Gold (VII?). A seated lion. The following perhaps go here:

574 *LondonR* 65. Gold (VI). A lion and crescent.

575 Schiller Coll. Gold (VII). Cow and calf. Zahn, *Schiller Coll.* pl. 51.1.

CLASSICAL: SUMMARY AND COMMON STYLES

576 Leningrad, from Olbia. Electrum (I?). Danae standing. Gaidukevich and Maximova, *Antichnie Gorod* (Moscow, 1955) i, 329, fig. 4.

577 London, Victoria and Albert 8767-1863. Gold (I). Woman. See *Pl. 704*.

578 Zurich, Mildenberg Coll. Gold (I). A standing woman.

579 Cambridge. Gold (I). Seated woman. See *Pl. 705*.

580 Istanbul, from Sardis, tomb 16. Gold (I). A seated woman with Eros (?). *Sardis* xiii.1, pls. 9, 11, no. 91.

581 *LondonR* 46, pl. 2. Gold (I). A dancing maenad with thyrsos and snake.

582 Basel, Private. Gold (I). A standing woman holding a wreath.

583 Once Warren, from Athens. Gold (I?). Nike with a wreath. *AG* pl. 9.37.

584 Moscow. Electrum. Naked girl at basin. See *Pl. 706*.

585 Moscow. Electrum. Eros. Zaharov, pl. 3.115.

586 *New York* 87, pl. 15. Gold (IV). A standing woman. Inscribed *Lysikr[ates*.

587 *New York* 86, pl. 15. Gold (IV). Girl with stick. See *Fig. 225*.

588 Paris, Louvre Bj.1084. Gold (IV?). Woman, sphinx and tripod. See *Pl. 707*.

589 *New York* 82, pl. 15, from Jannina. Silver. Maenad. See *Pl. 708*.

590 *Berlin* F288, pl. 6, from Kythnos. Gold (II). A dancing maenad with a branch and half a kid. *AG* pl. 10.33.

591 Once Arndt, A2568, from Lesbos. Gold. A dancing maenad with a sword and a kid. Awkward style.

592 *LondonR* 78, pl. 3, from Crete. Gold (IV, the bezel slightly raised). A woman's head, within a wreath.

593 Leningrad, from Kerch. Gold. A woman's head. *ABC* pl. 18.15.

594 Leningrad, from Kerch. Gold. A woman's head. *ABC* pl. 18.16. Summary.

595 Unknown. Metal prism. Eros: dog: woman: herm. See *Fig. 226*.

596 Munich A2498. Silver prism. A. Seated figure, as on *Pl. 804*. B. Seated dog. C. A fly. D. A heron.

THE KASSANDRA GROUP

597 *New York* 80, pl. 14. Gold (V). Kassandra. See *Pl. 709*.

598 *New York* 77, pl. 13, from Macedonia. Gold (V). Naked dancer. See *Pl. 710*.

599 Oxford F.119, from Macedonia. Silver (V). Naked dancer and satyr. See *Pl. 711*.

600 Tarentum. Gold. Kneeling girl. See *Pl. 712.*

THE IUNX GROUP

601 Leningrad, from Bliznitsa, main tomb. Gold (VI). Woman with iunx-wheel, and Eros. See *Pl. 713.*

602 *LondonR* 53, pl. 2. Gold (VI). Woman's head. See *Pl. 714.*

603 *LondonR* 67, pl. 3, from Cyprus. Gold (VI). Woman's head. See *Pl. 715.*

604 Bern, Merz Coll. Gold (VI). Woman's head with satyr cap. See *Fig. 227.*

605 *LondonR* 56, pl. 2, from Syracuse. Gold (VI). Eros fastens a woman's sandal. See *Pl. 716; colour, p. 217.1.*

606 *New York* 85, pl. 15. Gold (VI). A seated woman crowns what is apparently a female herm. For rare fourth-century representations of female herms see Lullies, *Typen* 55, and our no. 983. The boudoir setting on the ring suggests a domestic cult.

607 London, Victoria and Albert 430-1871. Gold (VI). Woman with Eros. See *Pl. 717.*

608 Munich A2486. Silver (VI). A woman seated on a rock. Bulle, no. 6.

609 *LondonR* 62, fig. 19. Gold (VI). Woman with Eros. See *Pl. 718.*

610 *LondonR* 55, fig. 17, from Ithaca. Gold (VI). Woman with Eros. See *Pl. 719.*

611 Once Hirsch. Gold (VI?). A youth leaning on a pillar, a dog beside him. An animal skin around his arm, so perhaps a young Dionysos. *Bedeutende Kunstwerke* (Luzern, 1957) pl. 46.88.

612 Bonn. Silver. Herakles with club and cup. *AG* pl. 61.31.

613 Kempe Coll. Gold (VI). A satyr with double pipes seated on an amphora. A *pedum* below. Hoffmann-Davidson, *Greek Gold* (Brooklyn, 1965) 253, no. 112. Apparently ancient; possibly western; cf. Trendall, op. cit. pl. 163.2; *Arch.Eph.* 1886, pl. 1.

614 Leningrad, from Bliznitsa. Gold (VI). Siren monster with kithara. See *Pl. 721.*

615 Leningrad, from Kerch. Gold. Eros (?) with a bow, crouching in a shell. *ABC* pl. 18.18.

616 *LondonR* 1046, from Cyrene. Silver (VI). Silphion. See *Pl. 720.*

THE NIKE GROUP

617 Leningrad, from Kerch. Gold (VII). Nike sacrifices a deer. See *Pl. 722.*

618 *LondonR* 51, pl. 2, from Kerch. Gold (VII). Nike with trophy. Inscribed *Parmenon basilei.* See *Pl. 724.*

619 *Berlin* F289, pl. 6, from Gythion. Gold (VII). Nike with branches. *AG* pl. 10.45.

620 *LondonR* 1258, pl. 30, from Naucratis. Gold plated bronze (VII). Eros with iunx wheel. See *Pl. 723.*

621 Leningrad II.1837.5, from Kerch. Gold (IX). Eros kneeling holds a bird. *ABC* pl. 18.3.

622 Paris, Louvre Bj.1050. Gold (VII). Crouching naked girl. See *Pl. 725.*

623 Leningrad, from Taman. Gold (VII). A woman, naked to the waist, standing by a basin. *CR* 1865, pl. 3.39.

624 Leningrad I.O.20, from Kerch, Iuz-Oba. Gold. (VI). A woman, naked to the waist, leans on a pillar while Eros fastens her sandal. *CR* 1861, pl. 6.6. Contrast the earlier treatment of the theme on *Pl. 716.*

625 Boston (now missing), from Kythnos. Gold (VII). Girl with knucklebones. See *Pl. 726.*

626 Leningrad I.O.30, from Kerch, Iuz-Oba. Gold (VI). Nike in biga. See *Pl. 727.*

627 Private. Gold (VII). Leda. See *Pl. 728.*

628 Nicosia J.627. Gold (VII). Woman's head. See *Pl. 729.*

629 Oxford 1885.490, from Nymphaeum, tumulus V. Gold (VII). Horned head. See *Pl. 730.*

630 *LondonR* 94, pl. 4, from Smyrna. Gold (VII). Gorgoneion. See *Pl. 731; colour, p. 217.6.*

631 Leningrad, from Chersonesos. Gold (VII). Bow and club. See *Pl. 732.*

THE SALTING GROUP

632 London, Victoria and Albert 552-1910. Gold (VIII). Goddess. See *Pl. 733; colour, p. 217.5.*

633 Cambridge, Lewis Coll. Gold. A standing woman. Middleton, J.1.

634 Vienna 217, from Campania. Gold. Aphrodite and Eros. See *Pl. 734.*

635 Oxford 1872.574, from Asia Minor. Silver (IX). A woman leaning on a column with sceptre and bird. Poorer style.

636 Munich A2528, from Melos. Silver with gilt bezel (VII). Woman's head.

637 London market, 1934. Gold. Kore with torches. See *Pl. 735.*

638 *LondonR* 58, pl. 2. Gold (VIII). Aphrodite with Eros. See *Pl. 736.*

639 London WA, obtained in Rawalpindi. Gold (IX). Omphale. See *Fig. 228.*

640 Paris, Louvre Bj. 1089, from Pyrgos. Gold. Woman with Eros. See *Pl. 737.*

641 *LondonR* 54, pl. 2, fig. 16. Gold (VIII). Eros on altar. See *Pl. 738.*

642 *LondonR* 59, pl. 2, from Phocaea. Gold (VIII). Woman and altar. See *Pl. 739.*

643 *Berlin* F291, pl. 6. Gold (VIII). Herakles with club and cup. *AG* pl. 10.42; Lippold, pl. 37.13. For the motif see also our no. 612. The type is mainly Hellenistic but he is seated with a cup on fourth-century coins of South Italy, Kraay-Hirmer, fig. 270, and is shown with a cup on earlier vases.

644 *LondonR* 1066, pl. 27. Silver (VIII). Man with torch. See *Pl. 740.*

645 Leningrad, from Karagodeuasch. Gold (VIII). A seated woman plays a lyre. Segall, *Zur gr. Goldschmiedekunst*

(Wiesbaden, 1966) pl. 46 below; Artamonov, pl. 316.

646 Boston. Gold (IX). Woman with Eros. See *Pl. 741.*

647 Once *Southesk* L.1, pl. 11. Gold. A seated woman balances a stick on her outstretched hand. An Eros before her, another behind flies to crown her. Compare our *Pl. 593.*

648 Once *Guilhou* pl. 6.124. Gold. Woman and loutrophoros. See *Fig. 229.*

649 *Olynthus* x, no. 473, fig. 15. Silver (VIII). A standing youth crowns another.

650 Jannina, from Kerasa. Silver. Orestes slays Klytaimnestra. See *Fig. 230.*

FOURTH CENTURY: ROUND BEZELS

651 *LondonR* 73, pl. 3, from Rhodes. Gold (IX). Woman's head.

652 Kempe Coll. Gold. Woman's head with 'melon' hair style. Hoffmann-Davidson, *Greek Gold* 256, no. 115. Cf. the head on coins of Pyrrhos, Kraay-Hirmer, fig. 476.

653 *LondonR* 1945. Silver (IX). As the last.

654 Istanbul, from Lampsakos. Gold, with decorated hoop. Woman plays *morra* with Eros. See *Fig. 231.*

655 Berlin 10823c, from Kalymnos. Gold (IX). Aphrodite teaches Eros to shoot. See *Pl. 742.*

656 Once *Evans*, pl. 4.57, from the Peloponnese. Eros at tomb. See *Pl. 743.*

657 Leningrad X.1899. Gold (IX). Athena. See *Pl. 744.*

658 Moretti Coll. Gold (IX). Woman with mask. See *Pl. 745.*

659 London WA, obtained in India. Gold (IX). Girl and boy play knucklebones. *Oxus Treasure* pl. 16.101. On the type, Dörig, *Mus. Helv.* xvi, 29ff.

660 Paris, *de Clercq* vii.2, pl. 20.2832, from Askalon. Gold. Nike carries a ship's *aphlaston* and *stylis*. For an earlier Nike carrying these emblems, shown on a Panathenaic vase, and for analogous scenes on coins see Johansen, *Eine Dithyrambosaufführung* (Copenhagen, 1959) 21ff. and fig. 8r. (*JdI* xlii, 182, fig. 15). Nike with *stylis* on gold coins of Alexander, and our *Fig. 245.* Our ring is third-century.

661 Once Arndt, A2470. Gold. Eros draws his bow.

662 Once Arndt, A2487/8. Silver with gold stud. Erotes with cocks. See *Pl. 746.*

663 Leningrad 578. Gold (IX). Kybele. See *Pl. 748.*

664 Riehen, Hoek Coll. Gold (XI). Nike and trophy. See *Pl. 747.*

665 London 1920.5-29.6, from Ithaca. Gold (XI). Woman with thymiaterion. See *Pl. 749.*

666 Once *Southesk* L.4, pl. 11. Gold. Thetis with a shield rides a hippocamp. Floral scroll border. Skimpy style.

667 Oppenländer Coll. Gold (XI). Elephant and driver. See *Pl. 750.*

668 *LondonR* 83, pl. 3, from Selino, Crete. Gold (IX). Arrowhead. See *Fig. 233.*

669 *LondonR* 90, from Crete. Gold (IX, but far flimsier than the last). The device is not deep cut but outlined in

dots—a spear head and the letters ΓΑ, as on the last.

670 Oppenländer Coll. Gold (XI?). Owl with armour. See *Fig. 232.*

671 *LondonR* 89, pl. 3, from Alexandria. Gold (XI). Bound rat. See *Pl. 751.*

672 *New York* 143, pl. 25. Silver with three bronze studs. Athena. See *Fig. 234.*

673 Gutman Coll. Gold; shape as the last (?). Archaising Athena, as the last, but with aegis instead of himation. Hoffmann-Davidson, *Greek Gold* 257, no. 117.

674 London 1926.5-10.1. Gold (XI). Facing head of a woman.

675 Rustington, Palmer Coll. Silver, convex face. As the last. Inscribed *doron.* See *Pl. 752.*

676 Bern, Merz Coll. Silver (XI). A seated woman with a dove. Schefold, *Meisterwerke* no. 582.

677 Oxford F.116, bought in Constantinople. Gold (IX). Woman with thymiaterion. See *Pl. 753.*

678 Salonika 5420, from Sedes, tomb Γ. Gold (IX). Woman suckles child. See *Fig. 235.*

679 Athens, Num.Mus., *Karapanos* 90, pl. 2. Silver. Seated woman.

680 Munich A2493, from Athens. Silver with a hole for a stud (X). A seated woman with a bowl (?).

681 *LondonR* 1055, from Greece. Silver (X). Seated woman with a bird.

682 *LondonR* 1110. Silver (X). A woman with a torch and wreath before a thymiaterion.

683 Oxford, Gordon Coll., from Piraeus. Silver with an inset gold crescent. Woman with torches. See *Fig. 236.*

684 Munich A2471. Silver (IX). Nike with wreath and branch.

685 *London R* 86, pl. 3, from Crete. Gold (XII). Nike and thymiaterion. See *Pl. 754.*

686 *New York* 90, pl. 16, from Macedonia. Gold (XII). A woman with thymiaterion.

687 London, U.C.L., from Kafr Ammar. Gold (IX). A woman with thymiaterion (?). Petrie, *Objects of Daily Use* pl. 8.114; *Heliopolis* xxxix, 18-24.

688 *LondonR* 88, from Crete. Gold (IX). A woman with thymiaterion. Inscribed *chaire.*

689 Once *Southesk* L.5, pl. 11. Gold. A woman with thymiaterion. Inscribed *chaire.*

690 Once *Guilhou* pl. 6.132. Gold. A woman, being crowned by Eros seated on her shoulder, at a thymiaterion.

691 Once *Cook* 3, pl. 1. Gold. A woman with a mirror, leaning on a column with a thymiaterion before her.

692 *LondonR* 1058, pl. 27, from Greece. Silver (XI). A woman carries a thymiaterion.

693 Munich. Silver. A goddess holding cornucopia and torch. *MJBK* 1909, pl. 2.12. A version of Tyche?

694 Basel, Dreyfus Coll. Gold (XI). Nike with a branch. Schefold, *Meisterwerke* no. 585.

695 *LondonR* 1048. Silver (X). A woman's head ('melon' hair).

696 *LondonR* 1090. Silver with a gold stud (X). As the last.

697 *LondonR* 1042. Gilt silver (X). A woman's head.

698 *LondonR* 1060. Silver (IX). A man's head.

699 Basel, Dreyfus Coll. Gold (IX). A bird standing with raised wing.

700 Pforzheim 1954. 21. Gold (IX). A recumbent stag. Schefold, *Meisterwerke* no. 568.

701 Basel, Dreyfus Coll. Gold (VIII). A recumbent stag. Resembling Greco-Persian. Schefold, *Meisterwerke* no. 569.

702 Munich A2483/4. Silver (XI). A leaping dog. Bulle, no. 3.

703 *LondonR* 1131. Silver (IX). Fox and vine. See *Fig. 237*.

704 *LondonR* 1047, from Greece. Silver (X). A bird tears a hare.

705 Luzern market, from Ephesus. Gold. A flying dove in a wreath. *Ars Antiqua* iv, pl. 54.167. Cf. coin devices of Sicyon, Kraay-Hirmer, fig. 510, from the later fifth century on; and Crete, *BMCCrete* pl. 14.1 (which looks more like a dove than an eagle).

706 *LondonR* 1043, from Greece. Silver (VIII). Knuckle-bone in wreath. See *Fig. 238*.

707 *LondonR* 113, from Crete. Gold (IX). A running hare.

708 Munich A2489. Silver (IX, with slightly convex bezel). Eagle and dolphin. See *Pl. 755*.

708*bis* From Derveni (c. 300). Gold (IX). Inscribed *Kleitai doron. Arch.Delt.* xviii, Chr., pl. 229.

WESTERN GREEK: FIFTH CENTURY

709 Munich A2481, from South Italy. Silver with gold stud (I). Woman. See *Pl. 756*.

710 Paris, Louvre Bj.1047. Gold (II). A woman with a bird, a crescent in the field.

711 *LondonR* 47, pl. 2, from Syracuse. Gold (IV). Head of a woman and a flower.

712 Once *Southesk* L.3, pl. 11. Gold. Artemis holding a torch rides a stag. A wreath and star patterns in the field. *AG* pl. 25.21 (as Italic); Lippold, pl. 22.2. For the motif cf. the Leningrad earring, Minns, 427, fig. 318 (*CR* 1868, pl. 1.3), a coin of Abydos, Babelon, pl. 168.2, and our no. 473.

713 *LondonR* 1035, from Capua. Silver (IV, with twisted hoop). Nike with a palm branch (?).

714 Tarentum. Gold. An old man and a dog. See *Pl. 757*.

715 Tarentum. Gold (III?). Winged nymph with caduceus and bird. See *Fig. 239*.

716 Tarentum. Gold (III?). Winged woman on capital. See *Pl. 758*.

717 Tarentum. Gold (III?). Woman with dove. See *Pl. 759*.

718 Tarentum. Gold. A woman dancing. Becatti, Pl. 80.327.

719 Munich A2467, from Sicily. Gold (III). A maenad with thyrsos and sword (?).

720 Once *Southesk* L.2, pl. 11. Gold. A seated woman with Eros and a bird. Sotheby, 6.vii.1964, lot 84 with fig.

721 London, Victoria and Albert 437-1871. Silver with gold stud (VI). Nike binds sandal. See *Pl. 760; colour, p.217.4*.

722 Würzburg 4810. Silver (III?). Thetis rides a hippocamp carrying a shield. *Ant.Kunstwerke aus dem Martin von Wagner Museum* (1945–61) pl. 47.68.

723 *New York* 88, pl. 16. Silver (III). A seated woman holds out a bird to Eros.

724 Unknown. Seated woman with bird. See *Fig. 240*.

725 Private, from Crispiano. Gold. A seated woman suckling a child. Becatti, pl. 80.326. Found with the jewellery, ibid., pls. 86, 102. 347, 388. Compare our *Fig. 235*.

WESTERN GREEK: FOURTH CENTURY

726 *New York* 81, pl. 14, from Sovana. Gold (V). Herakles' head. See *Pl. 761*.

727 *LondonR* 68, pl. 3, from Sicily. Gold (VIII). Athena's head. See *Pl. 762; colour, p. 217.3*

728 *Geneva Cat.* i, 220, pl. 84 (now missing). Gold (IX). Artemis. See *Pl. 763*.

729 *LondonR* 1079, pl. 27. Silver with gold stud in shoulder (VIII). Artemis. See *Pl. 764*.

730 *LondonR* 69, pl. 3. Gold (VIII). Athena. See *Pl. 765*.

731 Switzerland, Private, bought in Naples. Gold (IX?). Omphale. See *Pl. 766*.

732 *Berlin* F 290, pl. 6, bought in Italy. Gold (IX). A naked youth, with thyrsos and cup. *AG* pl. 10.50. The type resembles later figures of satyrs.

733 Once *Guilhou* 128, pl. 6, from Tarentum. Gold. Hermes. See *Fig. 241*.

734 Tarentum, from near Montemesola. Silver with gold stud. Perseus. See *Pl. 767*.

735 Tarentum 10006. Gold. Woman and pillar. See *Pl. 768*.

736 Munich A2501, from Preveza. Silver with gold stud and crescent inset (VII?). Seated woman, crowned by the Eros held on her outstretched hand. An earlier version on *Pl. 717*.

737 *LondonR* 72, fig. 30. Gold (IX). Dancing maenad with thyrsos and wreath.

738 *LondonR* 57, fig. 18. Gold (VIII). Nike crowns Herakles. See *Pl. 769*.

739 *LondonR* 71, pl. 3, from Ruvo. Gold (VIII). A biga.

740 *LondonR* 98, pl. 4. Gold (VIII). A lidded amphora. See *Pl. 770*.

WESTERN GREEK: FOURTH CENTURY: THE COMMON STYLE

741 Once *Guilhou* 122, pl. 6. Gold (VII?). Athena frontal (H).

742 Paris, Louvre Bj.1349. Silver (VII?). Woman and wreath (H). See *Fig. 242*.

743 Oxford F.124. Silver (VII). Thetis with a shield riding a hippocamp (H).

744 *LondonR* 1108. Silver (VII). A standing woman before an altar (?).

745 *LondonR* 1105, pl. 28. Silver (VII). A standing woman.

746 *LondonR* 1077, from Cumae. Silver with gold stud (VII). A seated woman with a wreath and a bird.

747 *LondonR* 1078. Silver with gold stud (VII). A seated woman with a bird.

748 *LondonR* 1067, from Naples. Silver (VII). A seated woman crowned by Eros, held on her hand.

749 *LondonR* 1088. Silver (VII). Nike. See *Pl. 771*.

750 *LondonR* 1076. Silver with gold stud (VII, slim bezel). Nike.

751 *LondonR* 1085. Silver with gold stud (VII). Maenad with a sword and thyrsos.

752 Paris, Louvre Bj.1055. Gold (VII). Eros by a thymiaterion. See *Pl. 772*.

753 Oxford F.153, from Vicarello. Silver (VII). Woman's head. See *Pl. 773*.

754 *Geneva Cat.* i, 215, pl. 82. Gilt bronze (VII). Facing head of a woman.

755 *Berlin* (East) F 294, pl. 6, from Potenza. Silver (VII). Facing head of a woman.

756 Once Guilhou. Silver. Facing head. Ricci, pl. 12.752.

757 *LondonR* 1069, pl. 27. Silver (VII). Facing head of a woman in a wreath. Very poor work.

758 *LondonR* 1049. Silver (VII). Gorgoneion (H).

759 *LondonR* 1054. Silver (VII). Head of a youth.

760 *LondonR* 1074, from Perugia. Silver (VII). A lion.

761 *LondonR* 1071. Silver (VII). A bird.

762 *LondonR* 1086. Silver (VI). A lion and a club (?). Cf. our *Pl. 692*.

763 *LondonR* 1102. Silver (VII). A bunch of grapes.

764 London market, 1965. Gold (VIII). Woman with torch and jug. See *Pl. 774*.

765 Munich A2485. Silver (VIII). A woman with a wreath, a branch behind her. Tremolo border.

766 *LondonR* 101. Gold (VIII). Nike with wreathes. See *Pl. 775*.

767 Munich A2496. Silver with gold stud (VIII?). Nike and trophy. See *Pl. 776*.

768 Paris, Louvre Bj.1042. Gold (X). Seated Nike. See *Pl. 777*.

769 Oxford F.120. Silver (VIII). A seated woman with Eros on her hand.

770 Private. Gold (VIII?). A seated woman with a bird and wreath. Schefold, *Meisterwerke* no. 581.

771 *LondonR* 70, pl. 3. Gold (VIII). A seated woman holds a bird out for Eros. *AG* pl. 9.43; Lippold, pl. 23.9.

772 Hamburg 1967. 147. Silver with gold stud (VIII). Seated woman with a bird. Hoffmann and von Claer, *Antiker Gold- und Silberschmuck* (Mainz, 1968) no. 111.

773 Hamburg 1967. 218. Silver with gold stud (VIII). Seated woman. Ibid., no. 112.

774 Hamburg 1925. 44. Silver (VIII). Seated woman with thymiaterion. Ibid., no. 113.

775 Hamburg 1967. 146. Silver with gold stud (VIII). Standing woman with thymiaterion. Ibid., no. 114.

776 Hamburg 1967. 217. Silver (VIII). Thetis rides a hippocamp, carrying a shield. Ibid., no. 115.

777 Oxford F.782. Silver with gold stud (IX). Seated woman. See *Pl. 778*.

778 *LondonR* 1050, pl. 27. Silver with gold stud (VIII). Seated woman. See *Pl. 779*.

779 *LondonR* 1062, pl. 27, fig. 132. Silver (VIII). A seated woman with a bird (H).

780 Oxford F.707. Silver (VIII). A seated woman holds a wreath over a thymiaterion (H).

781 *LondonR* 1070, pl. 27. Silver (X). Athena armed, with her owl.

782 *LondonR* 1087, pl. 27. Silver (X). Herakles at the tree of the Hesperides. See *Pl. 780*.

783 *LondonR* 74, pl. 3, fig. 21. Gold (X). Nike with a bird and wreath.

784 *LondonR* 105. Gold (X). Nike with a wreath.

785 *LondonR* 1072, pl. 27, from Naples. Silver (X). Nike holds a wreath over an altar.

786 *LondonR* 1106. Silver (X). Nike with a wreath. Double line border.

787 *LondonR* 1107. Silver (X). A seated youth tunes a lyre.

788 *LondonR* 1068, fig. 133, from Catania. Silver (X). A seated youth with a lyre. Chevron border. See *Pl. 781*.

789 Munich A2494. Silver (X). Eros with a thymiaterion. See *Pl. 782*.

790 *LondonR* 100, pl. 4, fig. 25. Gold (X). Eros flies.

791 *LondonR* 1073, pl. 27. Silver (X). A satyr.

792 Leningrad. Gold (X). Facing head of a woman. Pollak, *Nelidow Coll.* (Leipzig, 1903) pl. 18.415 and p. 142.

793 *LondonR* 1100. Silver (X). A quadruped suckles a child, before a tree. Possibly a wolf.

794 *LondonR* 1053. Silver (X). A rose in a wreath.

795 *LondonR* 1089. Silver (X). A rose. See *Pl. 783*.

796 *LondonR* 1456. Silver, gold plated (XI, a heavy ring). Head of a woman.

797 *LondonR* 1091. Silver with a beaten (crushed) gold plate as bezel (X). A mask (?).

798 Oxford F.154, from Vicarello. Silver (X). Facing head. See *Pl. 784*.

799 *LondonR* 92, pl. 4. Gold (X, but the bezel is a separate plate soldered to the open ends of the hoop). Eros flies with a wreath and fillet. Tremolo border.

800 Syracuse 42251, from Gela. Gold (II). Phrixos. See *Pl. 785*.

801 Basel, Dreyfus Coll. Gold (I). Eros. Broad bezel.

On the tremolo technique used on nos. 765, 798–800, see Jacobsthal, *Greek Pins* (Oxford, 1956) 209ff.; *JHS* lxxxviii, 12. It is also used on the gold scarab, *Pl. 821*, and the ring, *Pl. 441*.

WESTERN GREEK: FOURTH CENTURY: ROUND BEZELS

802 *LondonR* 42, pl. 2, from South Italy. Gold (XI). Nike in quadriga. See *Pl. 786.*

803 Oxford 1918. 62. Gold (XI). Nike and trophy. See *Pl. 787.*

804 *LondonR* 84, pl. 3, from Reggio. Gold (XII). Winged hippocamp. See *Pl. 788.*

805 Dresden Z.V.1461. Silver (VIII). As the last. See *Pl. 789.*

806 Vienna VII.949. Silver (XI). Biga. See *Pl. 790.*

807 Once *Guilhou* 86, pl. 4. Gold. Hippocamp. See *Fig. 243.*

808 Naples 126464. Gold, oval bezel. A griffin. Siviero, *Gli ori e le ambre* (Florence, 1954) no. 77 with fig.; Breglia, *Cat.* no. 95, pls. 17.5, 18.1.
The style resembles that of the last.

809 Paris, BN, de Luynes 517. Silver. Zeus seated crowned by Nike. Richter, *Engr.Gems* no. 270.

810 *LondonR* 1061. Silver (VIII). Athena seated, with helmet, shield and spear, filling the field.

811 Naples 25088, from Capua Vetere. Gold (XII). Athena. See *Fig. 244.*

812 Naples 25080, from Capua Vetere. Gold. A woman runs with two torches. Siviero, no. 94 with fig.; Breglia, no. 153, pl. 18.6.

813 Once *Ruesch* (Luzern, 1936) pl. 61.297. Gold (XII?). A woman stands with two torches.

814 Once *Ruesch* pl. 61.300. Gold. A woman leans on a column. Retouched?

815 *LondonR* 87, from Syracuse. Gold (XI). Nike with wreath and thymiaterion.

816 Once *Guilhou* 126, pl. 6. Gold. Nike with thymiaterion. See *Fig. 245.*

817 Bern, Merz Coll. Gold. Woman with thymiaterion. *Guilhou* 131, pl. 6; Schefold, *Meisterwerke* no. 583.

818 London, Victoria and Albert 429–1871. Silver (XI). Woman with thymiaterion. See *Pl. 791.*

819 *LondonR* 85, pl. 3, from Gela. Gold (XI). Woman by column. See *Pl. 792.*

820 Naples 25090, from Capua Vetere. Gold (XII). Eros on an altar. Siviero, no. 102, fig. and pls. 114a, b, 115; Breglia, no. 156, pl. 24.2.

821 *LondonR* 99, pl. 4. Gold (IX). Eros reads a scroll.

822 Oxford F.118. Gold (IX). Eros with a bow.

823 Once *Guilhou* 90, pl. 4. Gold. Eros shoulders a torch.

824 Once *Guilhou* 133, pl. 6. Gold. Eros with thyrsos and bowl.

825 Naples 25082, from Capua Vetere. Gold (XI). As the last. Siviero, no. 101, pl. 112c, d; Breglia, no. 157, pl. 24.5; Becatti, pl. 85.343.

826 Naples 126451. Gold (XI). Eros. See *Fig. 246.*

827 Oxford F.117, 'from Athens'. Gold. Eros and torch. See *Pl. 793.*
The following two rings go together for their shallow, sinuous figures and light, close set incision:

828 Munich A2465. Gold (IX). A maenad with thyrsos and animal (?). The inscription may be modern.

829 Paris, Louvre Bj.1052. Gold. A maenad with sword and thyrsos. Coche de la Ferté, *Les bijoux antiques* (Paris, 1956) pl. 22.2.

830 *LondonR* 91, pl. 4, from Pozzuoli. Gold (IX). The oval centre shows a seated figure with attendant. It is surrounded by a sinking, and this, with the flat border, is decorated with incised patterns and rouletting.

831 London, Victoria and Albert 458-1871. Silver (XII). A sea horse and two dolphins in a hatched border. A lumpy, provincial style; possibly Roman.

OTHER LATE TYPES

Type XIII:

832 Naples 24659, from Capua Vetere. Gold. A man's head. Siviero, no. 98, fig.; Breglia, no. 165.

833 *LondonR* 60. Gold. A woman's head.

834 *LondonR* 93, pl. 4. Gold. A woman's head. See *Pl. 795.*

835 *LondonR* 146. Gold. A naked woman wrings her hair. Beside her Eros and a basin with a dove on it.

836 London, Victoria and Albert 435-1871. Silver. Naked woman. See *Pl. 796.*

837 Leningrad 597. Gold. A naked woman, seen from behind, and a goose.

838 Munich A2502, from Preveza. Silver with gold stud. Eros with a iunx wheel (?).

839 Unknown. Gold. A man seated on an altar. *Auktion Basel* xviii, pl. 50.157.

840 *LondonR* 147. Gold. A Maltese dog.

841 *LondonR* 1260. Bronze. A fly.
With diamond shaped bezel and field:

842 *LondonR* 1081, pl. 27, from Naples. Silver. A woman with thymiaterion.

843 *LondonR* 115, pl. 4. Gold. A woman leans on a pillar.

844 *LondonR* 1082. Silver. A dolphin.

Type XIV:

845 *LondonR* 103. Gold. A woman's head.

846 *LondonR* 1095, pl. 27, from Greece. Silver. A man's head.

847 *LondonR* 1283. Bronze. Athena.

848 *LondonR* 1094, 1097, 1098. Silver. Nike with wreath.

849 *LondonR* 1093. Silver. Eros with bowl and thyrsos.

850 *LondonR* 102, from Kephallenia. Gold. Eros flying. Inscribed *chaire.*

851 *LondonR* 1096, from Thera. Silver. Herakles.

852 Munich A2503, from Teano. Silver. Nike crowns a seated man, a shield beside him. In a wreath.

853 *LondonR* 1092, pl. 27, fig. 132. Silver with inset gold crescent. Girl seated on lap of youth. See *Fig. 247.*

854 *LondonR* 104. Gold. Centaur and woman (?).

855 *LondonR* 76, from Sicily. Gold. A griffin.

856 *LondonR* 1101. Silver. A horse.

857 *LondonR* 75. Gold. A fly.

858 *LondonR* 1099. Silver. An eagle and a thunderbolt.

859 *LondonR* 1284. Bronze. A hand.

Type XV: with concave bezel:

860 *LondonR* 106, fig. 26. Gold. Goddess with torch.

861 *LondonR* 107, from Crete. Gold. A flying bird.

862 *LondonR* 108, from Crete. Gold. A flying bird.

863 *LondonR* 109, from Crete. Gold. A boar (?).

864 *LondonR* 1112, from Crete. Silver. A flying bird.

865 *LondonR* 1113, from Crete. A thunderbolt.

866 *LondonR* 122, fig. 29. Gold (with flat bezel). A mask. Cf. a gold ring, once Arndt A2472.

Type XVI:

867 *LondonR* 126, pl. 4. Gold. A woman's head.

868 *LondonR* 127. Gold. Dolphin and club.

869 *LondonR* 128, pl. 4. Gold. Hare and amphora.

870 *LondonR* 1104. Silver. Gorgoneion (?).

871 *LondonR* 1103, fig. 135. Silver. A bird on a rose. See *Fig. 248*.

872 *LondonR* 1281. Bronze. A water bird.

873 *LondonR* 1282. Bronze. Animal (?).

874 London, Bard Coll. Bronze. A figure seated on rocks. As no. 952.

Type X (flimsy, late):

875 *LondonR* 110, fig. 27, from Crete. Gold. A woman's head. Chevron border.

876 *LondonR* 111, from Crete. Gold. A flying bird in a wreath. See *Fig. 249*.

877 *LondonR* 112, from Crete. Gold. A star in a wreath.

878 *LondonR* 114, from Crete. Gold. A flying bird.

879 *LondonR* 79, from Crete. Gold. A bird with a wreath and a branch.

880 *LondonR* 1059, from Crete. Silver. Eros. See *Fig. 250*.

881 *LondonR* 1063, from Greece. Silver with gold stud. Footprint.

882 *LondonR* 1064, from Greece. Silver. Bull's head and star.

883 *LondonR* 1065, from Greece. Silver. Bull's head.

RINGS IN THRACE

884 Plovdiv, from Tzerovo. Gold scaraboid in gold swivel. Inscribed in Thracian. *AA* 1914, 420f., fig. 2a; Friedrich, *Kleinas.Sprachdenkmäler* (Berlin, 1932) 148; Dentschew, *Die Thrak.Sprachreste* 566ff.; *Glotta* xlv, 47ff.

885 Plovdiv, from Arabadžijskata Mogila. Gold (I). Horseman. Inscribed in Thracian. See *Pl. 794*.

886 Plovdiv, from Brezovo. Gold (IX). Woman and horseman. *Röm.Mitt.* xxxii, 24, fig. 1. Rostovtseff, *Iranians and Greeks* 231, says there is another like this, from Adrianople, in the Louvre.

887 Paris, BN, from Rachmanlij. Gold. Round bezel. Woman and horseman. Greco-Persian? Filow, *Duvanlij* (Berlin, 1930) pl. 8.10.

888 Plovdiv. Gold (XI?). Man with rhyton and horse. *Bull.Inst.Arch.Bulg.* xx, 589f.

889 Once Kibaltchitch 338, pls. 11, 13, from Novorossisk. Bronze (III?). A quadruped and branch. This seems in a style related to the last, and compare the following two:

890 Once *Guilhou* pl. 3.87. Gold (IX?). A horse and a tree.

891 Vienna VII.229. Gold. (VIII?). Quadruped.

BRONZE RINGS

A.

892 *LondonR* 1232, pl. 30, from Greece. (I). Athena.

893 From Dodona. (I). Woman and basket. *Praktika* 1952, 292, figs. 14.1, 15.

894 Munich A2565, from Athens. Penelope.

895 Athens, Num.Mus., *Karapanos* 258, pl. 4. Nike flying.

896 *LondonR* 1229, pl. 30. (I). Nike. See *Pl. 797*.

897 *LondonR* 1231. (I). Man with sword (?).

897*bis* From Kotilon. (I). Man with spear. *Arch.Eph.* 1903, pl. 12.

898 *LondonR* 1230, pl. 30, from Sidon. (I). Lobster. See *Fig. 251*.

899 From Dodona. Two horses (?). Karapanos, *Dodona* (Paris, 1877) pl. 50.6.

900 Athens, from Argive Heraeum. (II). A lion. *Argive Heraeum* ii, pl. 89.966.

B.

901 Munich A2537/8. (IV, with silver stud). Herakles. See *Pl. 798*.

902 *LondonR* 1261, pl. 31 (II). Thetis with a shield rides a hippocamp.

903 *LondonR* 1262. (II) A woman stooping to Eros (not 'reclining').

904 Munich A2569. (II). Maenad with sword and animal (?).

905 From Argos. (IV). Nike. *BCH* lxxxvi, 908, fig. 6 (not a 'personnage cuirassé (?) et ailé (?)').

906 Vienna VII.148. (IV). A draped figure.

907 *LondonR* 1241, pl. 30. (IV). Herakles. See *Pl. 799*.

908 *LondonR* 1237. (VI). A heron.

909 *New York* 121, pl. 20 (IV?). A goat.

910 *New York* 127, pl. 21 (IV?). An eagle and fawn. See *Fig. 252*.

911 Athens, Agora, Pnyx M7. (VI). A winged horse. *Hesp.* Suppl. vii, 103, fig. 46.3.

912 London 1935. 5–14.1. (VI). A winged horse (?).

913 Oxford 1914. 873. (IV). A sphinx (?). Style as the last.

914 Once Guilhou. Cock horse. Ricci, pl. 12.761.

915 Leningrad, from Kerch. Siren with pipes. *CR* 1875, pl. 2.21.

916 Leningrad, from Kerch. Two ducks. *CR* 1875, pl. 2.23.

C.

917 *LondonR* 1254. (VII). A woman's head.

918 From Stratos. A man's head. *ADelt* xvii, Chr. pl. 212b.

919 *LondonR* 1250, pl. 30. (VII). A man's head.

920 Munich A2531. (VII, with gold crescent inset). A man's head with mask. See *Pl. 800*.

921 *Olynthus* x, pl. 26.466. (VII). A man's head.

922 Leningrad, from Voronesh. (VII). A man's head.

923 Leningrad, from Voronesh, found with the last. (VII). Horseman.

924 Munich A2580. (VII). Woman on ship. See *Pl. 801*.

925 Munich A2547, from Lusoi. (VII). Thetis with shield on hippocamp.

926 London, Bard Coll. (VI). As the last.

927 *Berlin* F 295, pl. 6. (IX). A woman with two torches.

928 *Olynthus* x, pl. 26.453, 470. (VII). Draped figure.

929 *Olynthus* x, pl. 26.449. (VII). Woman with a flower and (?) (not Herakles with a club and animal!).

930 Munich A2564, from Athens. (VII). Kassandra kneels at the Palladion.

931 *LondonR* 1252, pl. 30, from Catania. (VII). Bust of a maenad. See *Pl. 802*.

932 Olympia 1185. (VII). A seated woman crowned by a flying Eros. *Olympia* iv, p. 186.

933 *Olynthus* x, pl. 27.472. (VII). A seated woman.

933*bis* Athens, from Parnes Cave. A seated woman. *Arch. Eph.* 1906, 97, fig. 3 right.

934 Oxford F.122. (VII). A woman with a basket.

935 *LondonR* 1251. (VII). A woman with thymiaterion.

936 Oxford 1941. 707, from Greece. Gilt (VII). As the last.

937 Munich A2545, from Tegea. (VII). A naked woman kneeling.

938 *LondonR* 1255. (VII). A naked woman standing.

939 *LondonR* 1335, from Smyrna. (VIII). Gold plated. Woman with thymiateria under an arch. See *Pl. 805*

940 Olympia 1187. (VII, with two gold studs). Athena (?). *Olympia* iv, p. 187.

941 *LondonR* 1233, pl. 30. (VII). Athena.

942 London 1908. 4–10.5. (VII, with gold and silver studs). Nike. See *Pl. 806*.

943 Oxford F.127 (VIII). Nike. See *Pl. 803*.

944 Munich A2563, from Athens (VII, with gold stud). A boy rides a dolphin.

945 From Dodona. (VII). Eros crouching (? not 'a sphinx'). Karapanos, *Dodona* pl. 50.7.

946 *Olynthus* x, pl. 26.450. (VII). Eros standing.

947 *Olynthus* x, pl. 26.451. (VII). Eros (?).

948 *Olynthus* x, pl. 26.459. (VII). Eros shoots. See *Fig. 254*.

949 *Olynthus* x, pl. 26.463. (VII). A baby Eros.

950 *New York* 95, pl. 16 (VII?). A crouching warrior.

951 Munich A2579. (VII). Dancing warriors (?).

952 London, Victoria and Albert 432-1871. (VII). Figure seated on a rock. See *Pl. 804*.

953 Munich A2546, from Arcadia. (VII). As the last, less detailed.

954 Munich A2561, from Piraeus. (VII). A man with a girl in his lap, her hand raised to her head. For the motif on vases see Schefold, *Untersuchungen* fig. 38 and pl. 22.1 (Dionysos and Ariadne), 28.3; on South Italian vases, as Trendall, op. cit., pl. 187.5 or an Attic terracotta, Peredolskaya, *Att. Tonfiguren* (Olten, 1964) pl. 9. It can be traced back to the Archaic period, as on the relief, *Ath.Mitt.* lxxvii,

pl. 35. The scheme is that used for groups of Aphrodite and Adonis.

955 Munich A2562, from Piraeus. (VII). As the last, a figure of Eros above.

956 London, U.C.L. 164, from Egypt. (VII). Frontal biga. Petrie, *Objects of Daily Use* pl. 13.164.

957 *New York* 72, pl. 12. (VIII). Herakles and the lion.

958 *Olynthus* x, pl. 26.447. (VII). Diomedes with the palladion.

959 *New York* 94, pl. 16. Herakles, with one foot raised.

960 Oxford 1885. 404, from Smyrna. (VII). Herakles standing, with club, bow and lion skin.

961 *LondonR* 1454, pl. 33. Iron (VII). A man with his foot raised on a rock.

962 *Olynthus* x, pl. 26.460. (VII). Hermes fastens a sandal, his caduceus before him.

963 Munich A2559. (VII). Hermes fastens a sandal.

964 *LondonR* 1239, pl. 30. (VII). As the last.

965 Olympia 1186. (VII). As the last. *Olympia* iv, p. 187.

965*bis* Athens, from Parnes Cave. As the last. *Arch.Eph.* 1906, 97, fig. 3 left.

966 Leningrad, from Kerch. (VII?). Hermes seated, caduceus before him. *CR* 1875, pl. 2.22.

967 *LondonR* 1234, pl. 30. (VII). Satyr and pipes.

968 *LondonR* 1238. (VII). Warrior.

969 From Stratos. Warrior kneeling behind his shield. *ADelt* xvii, Chr. pl. 212b.

970 *New York* 44, pl. 8. Gilt (VIII). Fat hunter. *Fig. 253*.

971 Munich A2574, from Athens. (VII). A fat man or satyr carrying a wine jar.

972 Munich A2573. (VIII). A satyr dancing.

973 Once Arndt, A2576. A young Pan plays the pipes, a thyrsos before him.

974 *Olynthus* x, pl. 27.476. (VII). A satyr carries a woman.

975 Munich A2577. (II). A young Pan lifts a woman.

976 Oxford 1885. 401, from Smyrna. (VIII). A dancing figure, with a satyr's mask behind.

977 Munich A2553/4, from Athens (VIII). A winged satyr with goat's legs holds a ribbon (?). See *Pl. 807*.

978 Munich A2570, from Athens. (VIII). Goats and a tree. See *Pl. 808*.

979 *Olynthus* x, pl. 26.448. (VII). A poppy. See *Fig. 255*.

980 Olympia 1188. (VII). Silphion plant, in a highly mannered form. *Olympia* iv, p. 187.

981 From Tarrha, Crete, a fourth-century grave. Silvered (VII). A rose. *Hesp.* xxix, pl. 30a, b.

982 *LondonR* 1455, pl. 33. Silvered iron, bronze bezel (VII). Panther on column. See *Fig. 256*.

983 Munich A2540/1. (VII). Herms and Bes. See *Pl. 809*.

984 Munich A 2542, from Athens. (VII). A goat leaping before a herm, a caduceus behind. See *Pl. 811*.

985 *Olynthus* x, pl. 26.452. (VII). As the last, with a tree (?); (not a thunderbolt, woman and griffin!).

986 Moscow. Caduceus, herm and altar with branches above. Zaharov, pl. 3.120.

444

987 Moscow. A dog and a pilos. Zaharov, pl. 3.119.

988 From Stratos. Frontal sphinx. *ADelt* xvii, Chr. pl. 212b.

989 *Olynthus* x, pl. 26.446. (VII). Joined heads. See *Fig. 257*.

990 Munich A2584, from Sicily. (VII). A grotesque of a boar's forepart, a mask and a human leg (?).

991 *LondonR* 1256, pl. 30 (X). Boy's head and shell. See *Fig. 258*.

992 *LondonR* 1253. (VII). Bearded siren. See *Fig. 259*.

993 *LondonR* 1263. (VII). A human head combined with a cicada (?). Cf. the Hellenistic gem, *AG* pl. 25.49.

994 *LondonR* 1240, pl. 30. (VII). Serpent sphinx. See *Pl. 810*.

995 Boston, *LHG* 59, pl. 3, bought in Sicily. Eros with a dog's body. See *Pl. 812*.

996 Sofia. A centaur with branches. *Archeologiya* 1960, 41, fig. 2.

997 Sofia. A horse. Ibid., 58, fig. 4.

998 *LondonR* 1235, pl. 30. (VII). A lion attacks a stag.

999 Paris, BN 608. (VII). A wingless griffin attacks a stag. See *Pl. 813*.

1000 Oxford F.123. (VII). Apparently as the last.

1001 *LondonR* 1236, pl. 30, from Selinus. (VII). A lion bites the edge of a shield.

1002 *Olynthus* x, pl. 26.465. (VII). A lion.

1003 *Olynthus* x, pl. 26.464. (VII). A Maltese dog.

1004 *Olynthus* x, pl. 27.482. (II). A dog.

1005 *Olynthus* x, pl. 26.467. (VII). A cock.

1006 *Olynthus* x, pl. 27.477. (VII). A cock.

1007 *Olynthus* x, pl. 27.484. (VII). A water bird (?).

1008 *Olynthus* x, pl. 26.462, fig. 14. (VII). A dove.

1009 *New York* 114, pl. 19. (VII). Cow and calf. An odd style, with no ground line.

1010 *Geneva Cat.* i, 146, pl. 60, from Apollonia, Cyprus. (VIII). A dog.

1011 Munich A2544, from South Russia. (VII). A sphinx, archaising.
D.

1012 Munich A2532, from Thebes. (X). Head of Zeus Ammon. See *Pl. 814*.

1013 Athens, Num.Mus., *Karapanos* 180, pl. 3. Wreathed head of a man. Cf. heads of Zeus on coins of Philip II, Kraay-Hirmer, figs. 562ff.

1014 Paris, *de Clercq* vii, 2, 2855, pl. 20. Man's head.

1015 Unknown, from Cappadocia. Head of a man with a cloth bound over his hair. *AG* pl. 61.48.

1016 *LondonR* 1273, from Sicily. (IX). Youth's head.

1017 *LondonR* 1279, pl. 31. (X). Youth's head. See *Pl. 816*.

1018 Leningrad, from Kerch. (XVII). Youth's head and shoulders. *ABC* pl. 18.12.

1019 Munich A2530. (X). Man's head.

1020 Leningrad, from Kerch. (IX?). Head of Athena. *Mat.Res.* lxix, 134, fig. 32.

1021 *Berlin* 30219,571. Woman's head.

1022 Harvard, Fogg, from Pagasai. 'Iron' (IX). Woman's head (melon hair). *Hesp.* Suppl. viii, pl. 43.26.

1023 Oxford 1941. 318. (IX). As the last. See *Pl. 815*.

1024 *LondonR* 1269. (X). As the last.

1025 *LondonR* 1278. (X). Woman's head with Egyptian ringlets.

1026 Munich A2560. (X). Hermes, seated on rocks.

1027 London, U.C.L. 162, from Egypt. (XI). Two women. See *Pl. 817*.

1028 Harvard, Fogg, from Pagasai. 'Iron' (X). Erotes wrestle. *Hesp.* Suppl. viii, pl. 44.29.

1029 Harvard, Fogg, from Pagasai. 'Iron' (X). A dancer (not 'Aphrodite undressing'). Ibid., pl. 44.30.

1030 Munich A2550, from Samos. (XI). Nike holds Eros. See *Pl. 818*.

1031 Munich A2551. Gilt (IX). Nike crowns trophy.

1032 *LondonR* 1315. (XVII). Nike with a branch.

1033 Munich A2548/9. (XVII). Nike with a wreath.

1034 Munich A2557/8. (IX). A herm wearing a cloak, with cornucopia. Herakles herms are sometimes shown with a cornucopia. 'Mantle-herms' appear first in the second half of the fourth century. On Herakles herms see now Hiesel, *Samische Steingeräte* (Hamburg, 1967) 50ff.

1035 Oxford F.125. Iron (IX). Standing figure.

1036 *LondonR* 1271. (XVII). A woman by a pillar.

1037 *LondonR* 1274. Gold plated (XI). A woman by a pillar.

1038 Oxford 1872. 259, from Smyrna. (IX). A woman by a pillar holding sceptre and bird.

1039 Munich A2555. Gilt (IX?). Eros draws a bow, kneeling.

1040 *LondonR* 1270. (X). Eros draws a bow standing.

1041 *LondonR* 1272. (X). Woman with two torches.

1042 Oxford F.126. Iron (X, separate plaque bezel). Seated man with a pillar behind.

1043 *LondonR* 1332. (XVII, very heavy). Janiform head. See *Fig. 260*.

DECORATIVE RINGS

For the Fortnum Group and the South Italian lead rings see the author's article in *BSR* xxxiv, especially pp. 9–17. To the Fortnum Group add—Bern, Merz Coll.; a lion.

Relief rings with pointed bezels: rosette or palmette patterns:

Gold: Leningrad, from Nymphaeum. *CR* 1877, pl. 5.13. Gutman Coll. Hoffmann-Davidson, *Greek Gold* 247, fig. 105. Pforzheim. Berlin 30219, from South Russia. Becatti, pl. 80.319. Athens, from Eretria. *Ath.Mitt.* xxxviii, pl. 16.9, 10. *LondonR* 905, pl. 23, from Eretria; 906, from Kourion; 907, pl. 23. From Ialysos, tomb 155. *Clara Rhodos* iii, 158, fig. 151.

Silver: Basel, Dreyfus Coll. Schefold, *Meisterwerke* no. 567. Once Guilhou. Ricci, pl. 9.543, 562, 569. *LondonR* 1026–30 (with gilding or gold relief, one from Naples), fig. 31.

Relief shield rings. References in *AFRings* 22, n. 68.

Relief rings, Type I, gold: Leningrad, from Kerch. Penelope. *AG* pl. 10.20. Leningrad, from Kerch. Penelope, the bow before her. *ABC* pl. 18.19. *Berlin* F 293. Penelope. Paris, *de Clercq* vii, 2446, pl. 16. Lion. Late Archaic, recalling the Group of the Cyprus Lions. From Paestum. *Atti Soc. Magn.Gr.* vi–vii, pl. 47b, c. Head of Athena. Fourth century. For a special class, with insects, from Marion in Cyprus, see *AFRings* 25, n. 82 and N 14, 15 (cicadas rather than bees).

Relief rings, Type III, gold: Naples 126430. Seated woman with branches. Becatti, pl. 80.323. Tarentum. Woman seated on altar with another. Becatti, pl. 81.331. Rome, Villa Giulia 2735, from Todi. Two naked women. Inscribed *Lasa fecuvia*. Becatti, pl. 85.341. Vienna VII.807. Frontal squatting youth. Cf. *Bull.Rhode Island* 1933, 23. Nike.

Relief rings, Type VII, gold: *Ars Antiqua* (Luzern) i, pl. 63.140b. Satyr, woman and Dionysos, in unusually high relief. The Naples ring inscribed *Pazalias* (Becatti, pl. 84.339) is modern: see *Enc.dell'arte antica* s.v. 'Pazalias'. Cf. a ring resembling Type XI, Louvre Bj.1107, with a gorgoneion, but this may be earlier.

Inlaid devices in metal: *LondonR* 1057. Silver (VIII). Inlaid gold crescent. *LondonR* 1316. Bronze (XVII). Inlaid gold crescent over a silver caduceus (?), over a silver altar. *Olynthus* x, pl. 27.474. Silver (VIII). Gilt relief inscription *doron*. Oxford 1921. 864. Silver (IX). Gilt relief inscription *Xenodokas* (Richter, *Engr. Gems* no. 487).

Gold lion seal. See *Pl. 819*.

Gold scarabs with intaglios: Leningrad, from Bliznitsa. Eros fastens Aphrodite's sandal. See *Pl. 820*. Pforzheim, from Sardis. Seated woman with bird. See *Pl. 821*. From the Kuban. Dancing woman. *Antichniya Istoriya* (Centen. Zhebelev) 186, fig. 7. *LondonR* 1634, pl. 35, from Tarentum. Seated woman. *New York* 91, pl. 16. Aphrodite holds a bird for Eros. *New York* 92, pl. 16. Eros holds grapes for a goose. Basel, Erlenmeyr Coll. Forepart of a winged boar. Late Archaic. Gilt silver. Basel, Dreyfus Coll., from Teano. Eros seated with a lyre.

Gold scarabs with reliefs: *LondonR* 1635, pl. 35. Woman dancing. Moretti Coll. Head of Hera. Hoffmann-Davidson, *Greek Gold* 245, no. 103. Gilt silver. Tarentum. Seated woman. Inscribed *Electra*. Becatti, pl. 81.332. Tarentum. Seated woman with mirror and wreath. Inscribed *doron*. *Ann.d'Ist.* 1874, 87. *Coll. Tyszk.* pl. 1.5. Seated woman with wreath. Once *Guilhou* pl. 3.67. Eros with pipes, in scrolls.

Gold box bezels; relief devices: *LondonR* 218, fig. 45, pl. 6, from Tarentum. Seated woman. Bachstitz Coll. Woman seated on altar. Becatti, pl. 81.330. Pforzheim. Eros with a wreath. Segall, *Zu gr. Goldschmiedekunst* pls. 31a, 33.

Gold box bezels; relief devices in scrolls: London 1923. 4–21.3, from Avola, Sicily. Man with sword (?). London 1934.11–15.1. Naked woman and pillar. See *colour, p. 217.7*. *LondonR* 908, pl. 23. The figure missing. *BMCJewellery*

2119, pl. 41, fig. 70, from Sicily, with coins of Agathokles. Eros. Private. Seated woman and bird. Schefold, *Meisterwerke* no. 586. Naples 126408, from Cumae. Elaborate. Gorgoneion. Siviero, pls. 84–7. *LondonR* 219, fig. 46, from Capua. Satyr's head. Like the last. Cf. Pforzheim, a flat scarab on one side, palmettes on the other (Segall, op. cit., pl. 31b); and Riehen, Hoek Coll., flat scarab on one side, intaglio Eros kneeling on the other. Silver ring of Type VI with gold relief device (goddess) in scrolls: *LondonR* 1056, pl. 27, from Nisyros.

Blue, gold and glass or crystal oval bezels: Leningrad, from Kerch, Pavlovsky kurgan. See *Pl. 822*. Volo, from Omolion, tomb B. A. Nereid on ketos. B. Eros on dolphin *ADelt* xvii, Chr. pl. 198γ and p. 177. Morley Coll. Ivory, with cut-out gold figures of Thetis and a hippocamp. Hoffmann-Davidson, *Greek Gold* (Brooklyn, 1965) 240f., no. 99. Cf. Paris, Louvre Bj.1088, an oval plaque of repoussée gold with a relief hunting scene. Coche de la Ferté, *Les bijoux antiques* pl. 42.2 (Pollak, *Nelidow Coll.* pl. 19.479 and p. 163 is the same or a replica). It is from the east and may be inspired by Persian hunting scenes. Cf. the shape of the onyx, *Munich* i, 303, pl. 35; and *ADelt* xxii, Chr. pl. 394.

Rings with glass-covered devices: Paris, Louvre Bj.1279. A dancer in cut out gold. Coche de la Ferté, op. cit., pl. 22.4; Hoffmann-Davidson, *Greek Gold* 248, no. 106. *LondonR* 1569, from Alexandria. A woman painted on the floor of the bezel of an all-glass Hellenistic ring, covered with a separate piece of glass. *LondonR* xxxvi mentions another with a hippocamp in gold. See Segall in *Fest. Mercklin* 167ff.

Discs from Pompeii. Naples 25222–3. See *Fig. 261*.

Bronze and iron relief rings: *LondonR* 1259, pl. 31 ('satyr walking'); 1266–8, pl. 31 (heads). From Pergamum. *Corolla Curtius* (Stuttgart, 1937) pl. 35.3–6. Philetairos. Iron, from Samothrace. *Essays Lehmann* (New York, 1964) 97ff., figs. 1–3. Head. London, Bard Coll. Two with heads of women. Eretria. *Antike Kunst* xi, 97f., pl. 26.2, 4. Herakliskos.

Gold relief ring: Munich 11083, *AA* 1957, 413, fig. 30, Alexander Balas.

SEAL AND GEM USAGE

ANCIENT AUTHORS AND INSCRIPTIONS

The testimony of authors and inscriptions is discussed most fully in *AG* iii, 133–5; *New York* xvi–xx, xxiv, xxix; Bonner, *Class.Phil.* iii, 399ff.; *BCH* vi, 121–3 (the Delos inscriptions, which are largely third-century or later). I give below references to the more useful passages, illustrating usage or words, mainly of the Classical period.

σφραγίς is the normal word for a seal, usually applied to a stone, whether or not it is set in a ring. δακτύλιος is a finger ring, with or without device, but plain rings without bezels are defined as ἀπείρων (Aristotle, *Phys.* 207a3) or

λεῖος. The device is a σῆμα, the word used for a device on a coin, or a blazon on a shield. Verbs from the roots σφραγ- or σημ - are used for the act of sealing. Clay is the usual recorded material (cf. Lykophron 1382; Athenaeus xiii, 585d; τοὺς ῥύπους, 'dirt' in Aristophanes, Lys. 1198; in Egypt γῆ σημαντρίς, Herodotus ii, 38). The sealing itself is a σημεῖον, σήμαντρον or σφράγισμα, which could apparently be protected by a shell-like cap, κόγχη (Aristophanes, Vesp. 585, 589) when attached to a document. On its own, as a token, the sealing may be called ἀποσφράγισμα (Athenaeus xiii, 585d). To carve an intaglio is γλύφειν (Herodotus vii, 69; Plato, Hipp.Minor 368b, c), whence δακτυλιογλύφος. Impressions or moulds (ἀπομάγματα) may be taken in plaster (Theophrastus, de Lap. 67; C.P. vi, 19.5). The bezel of a ring is called σφενδόνη, the part that Gyges turned to the inside of his finger to render himself invisible (Plato, Rep. 359e–360a; cf. Euripides, Hipp. 862; Aristotle, Phys. 207a3), and is also referred to as the 'bounding circle' of the seal containing the σῆμα σφραγῖδος ἕρκος, Sophocles, Trach. 614). One drachma is mentioned as the price of a ring (Aristophanes, Plut. 884; Athenaeus iii, 123) and three obols (half a drachma) for a forged substitute (Aristophanes, Thesm. 425f.). Some more detailed descriptions are given, especially in temple inventories. Polykrates' famous ring was a σφρηγὶς χρυσόδετος of emerald (sic): a 'seal bound in gold', so in a hoop and, if set on a ring, could at that date only have been set in a swivel ring. In the temple inventories the stone σφραγῖδες· are simply λίθιναι, and we have some grounds for suspecting that the ὑαλίναι might be rock crystal or chalcedony rather than glass (see p. 210). They are often described with χρυσ -adjectives (χρυσένδετος, περικεχρυσωμένη, περίχρυσος or simply δεδεμένη), set in gold, and when 'without rings' is specified we may be dealing with pendants rather than stones without their swivel hoops. Where the stone seals are called ψιλαί this might mean either 'bare', that is, without setting, or 'thin', that is, ringstones. Rings may be beaten in gold, χρυσήλατος (Euripides, Hipp. 862).

There follow some references in ancient authors to seal usage:

Domestic use, for sealing doors or property. Herodotus ii, 121a; Aristophanes, Lys. 1195, Thesm. 415 (on women's quarters), 425f., fr. 432, fr. 28 (snakes in box); Xenophon, Resp.Lac. vi, 4; Aeschylus, Agamemnon 609 (Klytaimnestra; some scholars have thought this refers to some form of sealed chastity belt. They are answered by Fraenkel in his edition of the play. But cf. the analogous use on a male, a form of sealed infibulation, threatened in Aristophanes, Aves 560).

Legal practice. Demosthenes xlii, 2 (on property); Plato, Leg. 856a (on evidence); Isocrates, Or. xvii, 33f. (voting urns); and often. See Class. Phil. iii, 406, on possible use of sub-seals on a document rather than simply outer seals to a closed scroll or tablet. On the Public Seal, see below.

On letters, usually a folded tablet, δέλτον. Euripides, I.A. 156, 325; Hipp. 862–5 (τύποι, impressions of gold bezel visible; the wrappings of the sealings to be uncovered to read the tablet); Lucian, Timon 22 (the σημεῖον removed, cord cut, tablet opened); Thucydides i, 132, 5 (re-sealing of improperly opened letter).

For identity. Aristophanes, Aves 1213 (a pass in wartime); Athenaeus xiii, 585d (a sealing used); Sophocles, Trach. 614, El. 1222f. (Orestes recognised by Electra; Kenna, JHS lxxxi, 103f., thinks this might have been a seal worn on the wrist and turned to show the device); Aristophanes, Eq. 951ff. (personal blazons); Menander, Epitr. 170ff. (recognition of baby by gold plated iron ring with bull or goat device, signed by Kleostratos); Plutarch, Timoleon 31 (personal rings used as lots, one with a trophy as device).

Symbol of office. Aristophanes, Eq. 947 (given to steward); Herodotus iii, 128, 2.

THE WEARING OF SEALS
A seal carried by every Babylonian (in the Persian period). Herodotus i, 195, 2.

Seals and rings are worn by fops (Aristophanes, Nub. 331f.) or the pompous (idem, Eccl. 632).

Position of bronze rings in Olynthus tombs, Olynthus x, 133. A finger ring is worn on the third finger of the right hand by women shown in the Etruscan Tomba degli Scudi, Pallottino, Etruscan Painting (Geneva, 1952), 105, 107.

Knots and amulets. Wolters, 'Faden und Knoten' in Archiv für Religionswiss. viii, Beiheft.

Rings as charms. Aristophanes, Plut. 884–5; Athenaeus iii, 96.

Stone seal and signet ring engraved by the same man. Plato, Hipp. Minor 368b, c, making a point of his versatility.

On inscriptions on bronze from Herakleia (IG xiv, 645; Uguzzoni-Ghinatti, Le tavole greche di Eraclea (Rome, 1968) 125ff.) names are qualified by two letters and what may be the description of their seal or blazon—tripod, caduceus, shield etc.

Sealing on a Chian amphora. Tanis ii, pl. 36.5; Boardman, Greeks Overseas 147, fig. 38.

Some examples of settings for Archaic and Classical gems:

Scarab or scaraboid in swivel hoop. Cypriot examples best shown in Cesnola Atlas iii, pl. 27 (heavy silver, cf. New York 58, 68, figs.), 29.13 (lighter gold; cf. New York 34, 41, figs. and 55 for a lion gem); London 606 (our no. 341; Murray, Exc.in Cyprus (London, 1900) pl. 14.26 for the hoop). Our colour, p. 149.5. Contrast the Etruscan, as London R 304–347, pls. 9, 10.

Gem suspended from a ring. New York 69, fig. (our no. 13; Atlas iii, pl. 29.11); Murray, pl. 13.13 (BMC Jewellery no. 2045).

Gems set on a chain. ABC pl. 17.10 (for our Pl. 638); our Pl. 378; ABC pl. 16.5 (Achaemenid cylinder, set by a

Greek); our *Pl. 933* (Greco-Persian cylinder); our *colour, p. 203.3* (Greek cylinder).

Gem on a gold bracelet. *Sardis* xiii. 1, pl. 9, no. 101 (our *Pl. 855*).

Ringstones in stirrup shaped hoops. For Archaic see *Pl. 386*; for Classical, our *Pl. 625*.

Barrels may be set in swivels (*Atlas* iii, pl. 27.7) or box bezels (*LondonR* 697, pl. 18, with a green glass sliced barrel from Egypt).

OFFICIAL SEALS

On the Athenian Public Seal see Wallace, *Phoenix* iii, 70ff., and Lewis and Wallace, *Phoenix* ix, 32ff.

From near Larisa Kremaste in Thessaly comes a unique two-sided bronze seal with fine intaglio devices of Skylla, and Thetis with armour on a hippocamp, and inscribed with the letters *LA*; *AJA* xxxviii, 219ff., figs. 1–4. The date is no later than the early fourth century and Robinson suggests that it might be the state seal of Larisa. This is not impossible but it is odd in being two-faced, the devices are not the obvious city blazons, and it is just possible that it

was used for impressing gold roundels. Robinson admits this possibility in *Studies Capps* (Princeton, 1936) 307, n. 8 (his parallels are the Archaic ivory discs !) where he publishes another bronze stamp (306ff., figs. 1–2), from Kerch, which he considered a 'state seal matrix', but which more probably was for making gold relief plaques. On the use of public seals see Dontas, *Arch.Eph.* 1955, 1ff. See also above, on *Pls. 528, 583*.

Compare the gold seal (our *Pl. 443*) inscribed *damo*, but it is too flimsy for regular seal use.

Lead and clay tokens. *Athenian Agora* x (see above, p. 424). Dikasts' bronze *pinakia*.

Clay amphora stamps. *BCH* lxxxvi, 510ff. On the choice of motifs, *Mél.Michalowski* (Warsaw, 1966) 669ff.

A rectangular bronze stamp with the name *Diphilos* in Pergamum Museum is associated with the first-century AD coroplast of that name by Mrs Thompson in *Studi Banti* (Rome, 1965) 319ff., pl. 70a–c, but the lettering is out of period, and Jeffery had already placed it in the fifth century BC in *Local Scripts* (Oxford, 1961) 360, 362, no. 14. Mrs Thompson mentions other late usage of stamps on tiles, lamps etc., loc. cit., 321f.

NOTES TO CHAPTER VI

GREEKS AND PERSIANS

The class of Greco-Persian gems was distinguished and discussed by Furtwängler in *AG* ch. V. Von Duhn, in *Symbolae Litt . . . J. de Petra* (Naples 1910) added several examples. The whole problem of the part played by Greek artists was treated by Moortgat in *Hellas und die Kunst der Achaemeniden* (Leipzig, 1926). In *AA* 1928, 648ff. Maximova listed and discussed gems with Persian subjects and declared for Persians imitating Greek work for the main class (her list, loc. cit., 650, n. 1). Seyrig, in *Archaeologica Orientalia* (New York, *in mem.* E. Herzfeld) 195ff. listed the tabloids and broadly agreed with Miss Maximova's conclusions. Richter, ibid., 189ff., in *Hesp.* Suppl. viii, 291ff. and *Engr. Gems* 125ff. saw Greek hands because details such as foreshortening are non-eastern and some gems bear purely Greek motifs. This possibly underestimates the competence of copyists and pupils, and at any rate all writers so far have dealt with only part of the material, and the proper relationship between the more Persian- and the more Greek-looking gems can only be understood from a more comprehensive viewpoint. I echo Amandry's words (writing à propos of jewellery, in *Mél. Michalowski* (Warsaw, 1966) 238) 'Comme dans le cas de gemmes, c' est assez vain de se demander si ces bijoux sont plus grecs que perses ou inversement, si les artistes étaient Grecs ou non.'

Achaemenid art and relations with Greece. Frankfort, *Art and Architecture of the Ancient Orient* (Harmondsworth, 1954) 213ff.; Ghirshman, *Ancient Iran* (Harmondsworth, 1954) 129ff.; Porada, *The Art of Ancient Iran* (London, 1965) ch. xii and bibliography on 265f.; Akurgal, *Die Kunst Anatoliens* (Berlin, 1961) 167ff. on Persians in Anatolia; on Greeks in Persia, Guépin in *Persica* i, 34ff., and *Persepolis* i, 88; Amandry in *Mél. Michalowski*.

History of Persia. Olmstead, *History of the Persian Empire* (Chicago, 1948); *Griechen und Perser*, Fischer Weltgeschichte 5; for the dual allegiance of Greek cities in Asia Minor, Cook in *Proc. Camb. Phil. Soc.* 1961, 9ff.

Coinage in the Persian Empire. Babelon, *Les Perses Achéménides* (Paris, 1893); Schlumberger, *L'argent grec dans l'empire achémenide* (Paris, 1953); Robinson, *NChr* 1958, 187ff.; Kraay-Hirmer, 358; Seyrig, in *Syria* xxxvi, 52 questions the identification of the King (but see Robinson, *NChr* 1961, 115f.).

Achaemenid glyptic. Useful accounts by Porada in *Corpus of Near Eastern Seals* (Washington, 1948) i, 101ff., and *JNES* xx, 66ff. (reviewing *Persepolis* ii); Buchanan, *Catalogue of Near Eastern Seals*, Ashmolean Museum (Oxford, 1966) i, 120. The present writer will publish an account of the pyramidal stamp seals in *Iran* 1970. For Achaemenid period glass conoids see above, p. 433.

Nagel lists dated seals and sealings in *Archiv für Orient-forschung* xx, 129ff. On the use of royal or official seals see *Persepolis* ii, 12ff.; Bivar, *NChr* 1961, 119ff.; Greenfield, *Journ. Amer. Or. Soc.* lxxxii, 297–9.

On the treatment of women in the east see now Pembroke in *Journal of the Warburg and Courtauld Inst.* 1967, 4ff.

On Greek representations of Persians, Gow, *JHS* xlviii, 133ff.; Schoppa, *Die Darstellung der Perser* (Coburg, 1933); Bovon, *BCH* lxxxvii, 579ff.; Thompson, *Iran* iii, 121ff. On pigtail jewellery, Korre, *Arch.Eph.* 1960, 119ff.

On Greeks fighting Persians, Gow, loc. cit.; Åkerström, *Arch. Terrak. Kleinasiens* (Lund, 1951) 183ff., identifying an encounter on Pazarli revetments (pls. 95–6) which he dates in the fifth century.

On the possible Greek origin of the rider motif on Greco-Persian gems, Farkas, *Persica* iv, 57ff.

In the following lists the material is always chalcedony and the shape a scaraboid unless otherwise stated. The colour is given, where known. Shapes of scaraboids are defined where known, according to the scheme for Greek stones.

COURT STYLE

Archaic Eastern

For some typical examples of cylinders in this style see the dated impressions, *Persepolis* ii, seals nos. 1–27.

The Darius cylinder: London WA 89132, Wiseman, 100; *AG* pl. 1.11; from Egypt (Yoyotte, *Rev. Ass.* 1952, 165–7).

The cylinder, heroes with lion and bull: London WA 893337, Wiseman, 105; *AG* pl. 1.14.

Archaic Western

The pyramidal stamps are discussed in *Iran* viii, 1970. Stamps of a similar shape but with rounded edges and an oval face are related to these and to be distinguished from the larger conoids with near-circular faces, but several of them are from Syria and Egypt, so this variant may have had a wider currency.

Scaraboids:

1 Once Arndt, A1419, from Tarentum. A Persian hero with two lion griffins. See *Fig. 280*.

2 Once Arndt, A1411. Royal sphinx and lion-griffin. See *Fig. 281*.

3 London WA120204. A royal (i.e. bearded head with tiara) siren with human arms.

4 Unknown. Winged bull. *AG* fig. 86.

5 *Berlin* F 187, pl. 4, D 202, from Sparta. Reddish. A royal sphinx. *AG* pl. 11.20.

6 Unknown. A winged bull; goat's head with human features. *AG* fig. 87.

7 Leningrad 594. Blue (A). Monster. See *Pl. 825*.

8 Leningrad. Blue (A). A Persian draws a bow, by a tree. See *Pl. 826*.

9 Oxford 1910. 613, from Sparta. Blue (A). A Persian with spear and bow. See *Pl. 827*.

10 Yale, *Newell Coll.* 461, pl. 31. A Persian draws a bow at a deer (for which compare Wyndham Cook Group, below). Late.

Classical Court Style

Western scaraboids and cylinders:

11 Paris, BN 1049 (E.1). Blue (A). Persian archer. See *Pl. 829*.

12 Once de Gobineau. Agate. Two Persians in a quadriga, one with bow. Rev. Arch. 1874.i, pl. 4.50.

13 *Berlin* F 180, pl. 4, D 195, from Attica. Cylinder. A horse. See *Pl. 831*.

14 Istanbul, from Sardis. Cornelian scarab. Bull. See *Pl. 828*.

15 *London* 585, pl. 10, from Syria. Blue (C). A butting bull.

16 *London* 544, pl. 9. Blue (A). Bull. See *Pl. 830*.

17 *Berlin* F 336, pl. 7, D 194. Cylinder. Brown. A bull, head frontal.

18 London WA 120224. (A). Two bulls, facing each other.

19 London WA 119873. (A). A bull.

20 Leningrad 566. (A). Deer and fawn. See *Pl. 832*.

21 *London* 534, pl. 9. Agate (C). A dog. See *Pl. 833*.

22 Paris, BN 1088. (C). A winged bull. See *Pl. 835*.

23 Leningrad. Cornelian scarab. Winged bull.

24 Leningrad. A royal sphinx. Reinach, *ABC* pl. 16.14.

25 Leningrad, from Kerch. Cornelian. Two royal sphinxes. Lydian inscription. See *Pl. 834*.

26 Once *Evans* pl. 2.21. A bicorporate sphinx. See *Pl. 836*.

27 Oxford 1965. 362. Red and yellow jasper (A). A royal winged bull. See *Pl. 837, colour, p. 307.5*.

28 Paris market, 1833. A royal sphinx. Lajard, *Mithra* pl. 46.13.

29 Oxford 1885. 491, from Nymphaeum. Blue (A). A lion-griffin. See *Pl. 838*.

30 Paris, BN D 1590. Cornelian cut. As the last. See *Pl. 839*.

31 Sangiorgi Coll. A lion-griffin. Pope, *Survey* 392, fig. 90b.

32 Paris, BN, *Pauvert* 37, pl. 4, from Hermione. Blue (A). As the last. Lippold, pl. 81.9.

33 Paris, Louvre A 777. Agate. As the last. See *Pl. 840*.

34 *Berlin* F 188, pl. 4, D 203, from Sparta. (A, shallow). As the last. *AG* pl. 11.19; Lippold, pl. 81.11.

35 Leningrad. As the last. Maximova, *Kat.* pl. 1.11.

36 Baltimore 42.839. As the last, but a lion's tail. See *Pl. 841*.

36*bis*. Once, Heidelberg. Cornelian scarab. As the last (?). Creuzer, *Symbolik* i.1, pl. 1.1.

37 Paris, BN 1090. Agate. A griffin. See *Pl. 842*.

38 Pforzheim. Blue. A leaping griffin, wingless. Only lightly cut Court Style markings. The griffin type is more Syrian than Greek or Persian; cf. no. 302. Battke, *Geschichte* (Baden-Baden, 1953) pls. 1.19, 28.19. This style with linear marking appears on some cylinders, as London WA 89696, 89574 (Wiseman, 110, 114).

39 London WA 132504 (electrotype). Cylinder. A Persian horseman spears a lion-griffin. See *Pl. 843*.

40 Leningrad ΓΛ 886, from Lydia. Cylinder fragment. Blue. A Persian spears a lion. See *Pl. 844*.

GREEK STYLE

Pyramidal stamps:

41 *New York* 33, pl. 6. Blue. Hermes. See *Pl. 845*.

42 Boston 95.80. Blue. Herakles with club and lion: Medusa with two lions. See *Pl. 846*.

43 Péronne, Danicourt Coll. Blue. A griffin attacks a stag. Cypriot inscription. See *Pl. 847*.

44 Unknown. A lion attacks a camel. Lajard, *Mithra* pl. 43.17.

45 Once de Bellesme. Haematite, oval face. Two birds tear the body of a calf. Inscription in the field. *Syria* iv, pl. 29.19.

46 *London* 609, pl. 10. Cornelian. A child with a vine. See *Pl. 848*.

Scaraboids, cylinders etc.:

47 Once Arndt, A1410. Onyx, said to be from Caria. A Persian spears a falling Greek. See *Pl. 849*.

48 *Moore Coll.* 102, pl. 11. Cylinder. A Persian wearing the tiara and holding a bow spears a falling Greek by a palm tree. Cf. the last. Pope, *Survey* pl. 124D.

49 Louvre. A mounted Persian attacks a Greek. *AG* pl. 12.18; Maximova, fig. 10.

50 *New York* 135, pl. 22. Plasma. A mounted Persian spears a fallen Greek. See *Fig. 282*.

51 Boston 03.1011. Cylinder. A Persian spears a boar. See *Pl. 850*.

52 *Munich* i, 327, pl. 38. White jasper (A). A Greek hoplite binds the straps of his boot (not greaves). See von Duhn, p. 13 and the next.

53 *Munich* i, 326, pl. 38. As the last, omitting the shield. On the back a Persian horseman chases a stag, see our no. 169. Text to Brunn-Bruckmann no. 553. For the action cf. the Parthenon frieze; Jacobsthal, *Die Mel. Rel.* 190 (dates to third quarter of the fifth century).

54 London WA, *Oxus* 113, fig. 62. A Greek spears a warrior. See *Pl. 851*.

55 Istanbul, from Daskylion. Clay impression. A Greek spears a fallen Greek. *Anatolia* i, pl. 12 top right.

56 Leningrad, from near Smela. Cylinder. Blue. A horse. Winged sun disc above. *Smela* i, 77; Minns, *Scythians and Greeks* fig. 85.

57 Taranto 12015. Cylinder. A bull. See *Pl. 852*.

58 Oxford 1892. 1482, from the Peloponnese. (A/C).

A Persian with a bow and a dead bird. See *Pl. 853*.

59 *New York* 133, pl. 22. Blue. A Persian woman with an ointment jar and bowl. See *Fig. 283*.

60 *Berlin* F 181, pl. 4, D 191, from Megalopolis. (A). As the last. See *Pl. 854*.

61 Istanbul, from Sardis. Blue (C). Athena and Hermes. See *Pl. 855*.

62 *London* 524, pl. 9, from the Punjab. Blue (C). Herakles, Nemea and the lion. See *Pl. 856*.

63 Oxford 1892. 1487, from Spezia. (C). A woman bather. See *Pl. 859*.

64 Paris, BN 1103. Blue (A). A woman bather. See *Pl. 858*.

65 Oxford 1892. 1488, from Syria. Blue (C). Aphrodite. See *Pl. 857*.

66 *London* 559, from Tarsus. Cornelian (B). A youth fastening a boot. See *Pl. 860*.

67 Leningrad, from north of Anapa. Cornelian prism. 1. A Persian. 2. A bearded Greek with a dog. 3. Cocks fight. 4. A naked woman. See *Pl. 861*.

68 Private, from Egypt (once Arndt). Tabloid. 1. Hermes. 2. A man's head. 3. A Maltese dog. 4. A running dog. 5. A calf. 6. A deer. *Arch. Or.* pl. 30.1, 2.

69 Boston, *LHG* 63, pl. 4 (back only) from Tripolitsa. (A). Love-making. See *Pl. 862*.

70 Cambridge. Onyx (broad C). A Persian horseman spears a stag. See *Pl. 863*.

71 Once *Cook* 174, pl. 7. Cornelian. A mounted Persian spears a fallen Greek.

72 *London* 435, pl. 7, from Mesopotamia. Cornelian (A). Persian horseman pursues two Persians in a biga. See *Pl. 864, colour, p. 307.3*.

73 *Munich* i, 291, pl. 34. (C). A lion. Lippold, pl. 84.10.

74 Baltimore 42.155. (C, cut). A lion and tree. See *Fig. 284*.

75 *London* 541, pl. 9, from Rhodes. Blue (A). A lion.

76 Boston. A lion. See *Pl. 866*.

77 *New York* 101, pl. 18. Blue. A lion. *Hesp.* Suppl. viii, pl. 35.5.

78 Dresden. A lion. See *Pl. 865*.

79 Leningrad, from Kerch. A lion. *AG* pl. 11.36; Lippold, pl. 84.8.

80 Paris, *de Clercq* ii, pl. 5.99. Blue (A). A lion tears a limb. See *Fig. 285*.

81 *Berlin* F 309, pl. 6, D 260, from Greece. Blue (C). A lion tears a limb (?), its head frontal.

82 *London* 536, pl. 9. (A). A lion attacks a horse. See *Pl. 867, colour, p. 307.1*.

83 'London'. A lion with shield and sword. See *Fig. 286*.

84 Boston 62.1153. Blue (A). A griffin. *MFA Bull.* lxi, 6, fig. 2.

85 Leningrad 593. Blue (A). A griffin attacks a stag. See *Pl. 868*.

86 *Munich* i, 299, pl. 35. Blue. (A). A griffin attacks a stag. *MJBK* 1951, pl. 4.21.

87 Once Naue, from Greece. A horned, lion-headed griffin. *AG* pl. 61.40; Lippold, pl. 81.5.

88 Oxford 1892. 1474. Cornelian (A). A dog. See *Pl. 869*.

89 Unknown, from India (?). A dog. *Journ. Num. Soc. India* xxiii, pl. 7.2.

90 *Berlin* F 174, pl. 4, D 193, from Greece. Cornelian (A). A bull. See *Pl. 870*.

91 Boston, *LHG* 64, pl. 4, from Greece. Agate. A zebu bull. See *Pl. 871*.

92 *New York* 102, pl. 18. Cut on the convex back. A plunging zebu bull. See *Fig. 287*.

93 *New York* 140, pl. 24. Blue. A charging boar. *Hesp.* Suppl. viii, pl. 35.1.

94 Oxford 1938. 961, from Crete. Cornelian cylinder. A boar. See *Pl. 872*.

95 Switzerland, market. Agate cylinder. Two stags. *Münzen und Medaillen* Sonderliste K, no. 84.

96 Paris, BN, *Pauvert* 57, pl. 5, from Sicily. Rock crystal (C). Two stags. See *Pl. 873*.

97 *London* 583. (C). A stag.

98 *Munich* i, 294, pl. 34. Chalcedony scarab. A running bear. See *Fig. 288*.

99 Paris, BN 1098.2. A goat. IBK, pl. 18.35.

100 Switzerland, market. Blue (C). A running goat. *Münzen und Medaillen* Sonderliste K, no. 107.

101 *London* 546, pl. 10. Agate, speckled and veined black. (A). A camel.

102 Paris, *de Clercq* ii, pl. 5.107. Agate (A). A Maltese dog.

103 Paris, BN M5448. (C). A Maltese dog. See *Pl. 874*.

104 Paris, Louvre AO 10.880. Biconvex. Blue. A cock. See *Pl. 875*.

105 Paris, *de Clercq* ii, pl. 5.104. Biconvex. Blue. Crouching lion with its forepaw on an animal head. Crescent and star.

THE MIXED STYLE

THE ARNDT GROUP

106 *Munich* i, 249, pls. 28, 29. Multifaced seal. See *Fig. 289*.

107 London WA 128847. Red jasper. Multifaced seal. See *Pl. 876*.

108 Paris, BN N3621. Blue (C). Three Persians with spears. See *Pl. 877*.

109 Leningrad, from north of Anapa. Cylinder. Blue. A Persian with tiara faces a radiate goddess standing on a lion's back. See *Pl. 878*.

110 Oxford 1921. 2. Blue (C). A Persian woman with a seated Persian. See *Pl. 880*

111 Istanbul, from Daskylion. Clay impression. A Persian holding a barsom bundle. Akurgal, *op. cit.*, fig. 123. Cf. the motif on the Kayseri altar, ibid., fig. 120, Daskylion relief (Nilsson, *Geschichte der gr. Religion* (Munich, 1961) ii, pl. 15.2) or the Oxus gold plaque, Porada, fig. 87.

112 *London* 434, pl. 7, from Etruria. Cornelian (B). A Persian woman. See *Pl. 879, colour, p. 307.2*.

113 *New York* 139, pl. 24, from near Bagdad. Agate tabloid. See *Fig. 290*.

114 *Munich* i, 250, pls. 28, 29, from near Antiochia. Cornelian, roughly pyramidal seal. 1. Two boars. 2. Running goat. 3. A dog scratching itself. 4. Fox. von Duhn, pl. 2.13–16.

115 Zurich, Remund Coll. Blue. A running lion.

116 Paris, BN, de Luynes 324. Blue hemispheroid. A running lion. Menant, *Glypt.or.* pl. 10.8; Perrot-Chipiez, iii, fig. 461; *Arethusa* v, pl. 8(7).15.

THE BOLSENA GROUP

117 Rome, from Bolsena. A Persian horseman attacks a Greek. See *Pl. 881*.

118 Bologna. A warrior on foot, similar to those on nos. 119, 120, 122, 123.

119 Private, from near Massyaf. Tabloid. Blue. *Fig. 291*.

120 Leipzig. Tabloid. 1. Persian horseman and Greek. 2. Bear. 3. Cocks fight. 4. A fox seizes a stork. 5. Dog. 6. Wounded hyena. IBK pls. 15.17, 21, 33, 34, 16.1; *AG* pl. 11.7, 9; Maximova, fig. 15; Richter, *Animals* (Oxford, 1930) figs. 41, 47, 48, 166, 216.

121 Leningrad 375, from Asia Minor. Blue (A/C). A Persian horseman pursues two riders. See *Pl. 882*.

122 Leningrad 4297. A Persian horseman spears a Greek. Maximova, fig. 2.

123 Basel, private. White veined marble conoid. A Persian horseman spears a Greek over the fallen body of another Greek. See *Pl. 883*.

124 Paris, BN. Tabloid. 1. A man with trident spear. 2. Quadruped. 3. Hyena. 4. Dog. 5. Fox. 6. Foxes couple. *Rev. Num.* ix, pl. 8.7.

THE PENDANTS GROUP

125 Cambridge. (C). A Persian with spear. See *Pl. 884*.

126 Leningrad ΓΛ 895. (A/C). A Persian draws a bow. See *Pl. 887*.

127 Unknown. Two Persians in conversation. Maximova, fig. 14.

128 Paris, BN 1095. Blue (C). A Persian spears a boar, with a dog. See *Pl. 885*.

129 *New York* 137, pl. 22. (C). A Persian horseman shoots at a lion with a bow. *Hesp.* Suppl. viii, pl. 34.1.

130 London WA 119919. (C). A Persian horseman spears a charging bear. See *Pl. 886*.

131 *New York* 134, pl. 22. Black jasper. A Persian horseman spears an animal. *Hesp.* Suppl. viii, pl. 34.4.

132 *Berlin* F 182, pl. 4, D 187. (C). A Persian horseman spears a boar, a dog below. *AG* pl. 11.3.

133 London WA 120332. Banded pink chalcedony (A). A Persian horseman chases a stag, a fox below. See *Pl. 888*.

134 Boston 98.708. Cylinder. A Persian horseman attacks a charging lion. See *Pl. 889*.

135 Paris, BN, *Pauvert* 17, pl. 3. Cornelian cylinder. A Persian horseman spears a bear.

136 Paris, *de Clercq* i, pl. 33.362. Cylinder. A Persian horseman chases a stag.

137 *New York* 136, pl. 22. Blue. A Persian horseman chases a fox. Two foxes transfixed by a spear lie below.

138 Sangiorgi Coll. A Persian horseman chases a fox. See *Fig. 292*.

139 Yale, *Newell Coll.* pl. 31.459. A Persian horseman faces a charging lion. See *Fig. 293*.

140 Paris, BN. Cornelian cylinder. A Persian on foot faces a bear. Delaporte, *Bibl.Nat.* 405, pl. 38.

141 Cooke Coll. Cylinder. A Persian spearman faces a boar charging from a thicket. Pope, *Survey* pl. 123S.

142 *Munich* i, 234, pl. 26. A Persian hero fights a goat.

143 *Berlin* F 183, pl. 4, D 186, from Ithome ('Mykonos', on an impression in Oxford). (A). A Persian with a dead fox. Before him a horseman. See *Pl. 890*.

144 *London* 436, pl. 7, from Cyprus. Pink pear-shaped pendant. 1. Persian man and woman. 2. A seated Persian woman and child. See *Pl. 891, colour, p. 307.4*.

145 Once Arndt. Cornelian pear-shaped pendant. *Fig. 294*.

146 *New York* 119, pl. 20. Pear-shaped pendant. On one side near the base a Maltese dog carrying an aryballos (?).

147 Munich. Agate pear-shaped pendant. 1. Persian with spear. 2. A Persian horseman pursues a stag. Maximova, fig. 13; *MJBK* 1909, pl. 2.6.

148 London WA 119942. A bottle-shaped stamp with figure-eight face. A boar.

149 Baltimore 42.517. (C). A Persian with a bird and a woman. See *Pl. 892*.

150 Paris, Louvre A1228. Tabloid. Blue. See *Pl. 893*.

151 *New York* 138, pl. 23. Agate tabloid. See *Fig. 295*.

152 Private, bought in Aleppo. Tabloid. Blue. 1. A Persian horseman hunts a stag. 2. Antelope. 3. Bear. 4. Running goat. 5. Running lion. 6. Running hyena. *Arch. Or.* pl. 31.2.

153 London WA 128850, from Babylonia. (A). A running stag.

154 *New York* 115, pl. 20. A dog tears a stag. See *Fig. 296*.

155 *Berlin* F 307, pl. 6, D 198, from Athens. Blue (A). A dog attacks a deer. See *Pl. 895*.

156 Boston 01.7560. (A). A running deer. See *Pl. 896*.

157 Cambridge. (C). A running boar.

158 London WA 120346. (A). A boar attacked by two dogs. See *Pl. 897*.

159 Paris, Louvre AO 6916. Blue. (C). A rhyton. See *Pl. 894*.

160 Cambridge. (A). A plunging bull. See *Pl. 898*.

161 *Berlin* F 310, pl. 6, D 171, bought in Athens. (A). A plunging bull. See *Pl. 899*.

162 *New York* 116, pl. 20. Cornelian. Dog. See *Pl. 900*.

163 *London* 547, pl. 10. (A). A camel. See *Pl. 901*.

164 Hamburg. A running bear. *AA* 1963, 57f., fig. 3.11.

165 *Munich* i, 290, pl. 33. A lion. *MJBK* 1951, pl. 3.4.

166 *Munich* i, 300, pl. 35. (A). A quail. *MJBK* 1951, pl. 3.17.

167 *Munich* i, 301, pl. 35, from the south coast of the Black Sea. Cornelian scarab. A quail.

168 Leningrad 586. Scarab, as the last. Blue. A quail. See *Pl. 902*.

169 *Munich* i, 327, pl. 38. (A). A Persian horseman chases a stag. Reverse of no. 53.

THE PHI GROUP

170 Yale, *Newell Coll.* 460, pl. 31. Cornelian. On the convex back a Persian woman with cup and wreath. *Hesp.* Suppl. viii, pl. 34.3.

171 *London* 433, pl. 7. A Persian woman. See *Pl. 903*.

172 Würzburg. A Persian woman with a cup. von Duhn, fig. 2.

173 Leningrad, from Phanagoria, 1954. As the last (?). *Sov.Arch.* 1965.2, 186, fig. 1.11.

174 Once *Southesk* i, pl. 16.10, from Spezia. A Persian man and woman. See *Fig. 297*.

175 Bologna. A Persian.

176 *Berlin* F 186, pl. 4, D 190, from Athens. (A). A Persian. For his stick cf. our no. 127. The pose is Greek. *AG* pl. 11.14; Maximova, fig. 8.

177 Munich A1432. Love-making. See *Fig. 298*.

178 Paris, BN 1104. Tabloid. Blue. See *Pl. 906*.

179 London WA 89816. Cylinder, half missing. Blue. A Persian horseman shoots at a lion. See *Pl. 904*.

180 London WA 120325. (C). A Persian horseman spears a boar. See *Pl. 905*.

181 Private. A Persian horseman shoots at a stag. *Arch. Or.* pl. 30.3.

182 Paris, *de Clercq* ii, pl. 5.102. Blue (A). A running fox and a fly.

183 *New York* 141, pl. 23. Blue. A running goat. *Hesp.* Suppl. viii, pl. 35.2.

183 *bis*. Männedorf, Bollmann. Persian horseman spears a boar. Summary.

THE GROUP OF THE LEAPING LIONS

184 Paris, BN M6000. Blue (C). A leaping lion. See *Pl. 907*.

185 Paris, Louvre A1229. Blue (A). A leaping lion and running fox. See *Pl. 908*.

186 Paris, BN, *Pauvert* 59, pl. 5. (A). A lion attacks a stag. See *Pl. 909*.

187 Paris, BN, de Luynes 205. Blue (C). A lion attacks a bull. *Arethusa* v, pl. 8(7).1.

188 Leningrad, from the Kuban, Seven Brothers tumulus. (A). A bear. See *Pl. 910*.

189 Unknown. A horse. See *Fig. 299*.

190 *Geneva Cat.* i, 209, pl. 80. A bull runs.

191 Oxford 1892. 1544. Blue (A). A bull, head frontal. See *Pl. 911*.

192 Oxford 1889. 398, bought in Beirut. (A). A bull.

193 Unknown. Two bulls rampant, heads turned back.

194 *Berlin* F 193, pl. 4, D 201. (A, cut). Two bulls play. See *Pl. 913*.

195 *Munich* i, 304, pl. 35. A bull. *MJBK* 1951, pl. 3.12.

196 Oxford 1892. 1477. (C). A running bull. See *Pl. 912*.

197 Boston, *LHG* 71, pl. 5. Cylinder. A boar. See *Pl. 914*.

198 Paris, BN 1198*ter*. A boar. Richter, *Engr.Gems* no. 514.

199 *Geneva Cat.* i, 211, pl. 81. (A). A running goat.

200 Oxford 1892. 1470. Blue (C). A running goat. See *Pl. 915*.

201 Unknown. A running goat. See *Pl. 916*.

202 *Geneva Cat.* i, 212, pl. 81. A running goat (human features?).

203 *Berlin* F 192, pl. 4, D 192, from Megara. Blue (A) A goat. *AG* pl. 11.17.

204 Dresden. A goat with human features. *AG* pl. 12.5; Lippold, pl. 92.6.

205 *Munich* i, 295, pl. 34, from Adana. Blue. A running camel. *MJBK* 1951, pl. 4.19; *BonnerJb.* clv–clvi, pl. 6.2.

206 Liverpool M10542. Rock crystal. (C). A kneeling camel. See *Pl. 917*

207 London WA 119878. (C). A winged bull. See *Pl. 918*.

208 London WA 119884. (C). A winged bull.

209 Cambridge. (B). A winged bull. See *Pl. 919*.

210 Paris, BN 1089. Blue (C). An upright winged bull. See *Pl. 920*.

211 Once Morrison (32) and Warren. Blue. A flying bull. See *Pl. 921*.

212 Bern, Merz Coll. A flying bull.

212*bis.* Market. (C). A flying bull. *Auktion Basel* xxii, pl. 67.200.

213 Paris, BN 1089.2. Blue (A). A winged bull. See *Pl. 922*.

214 Once Munich. Blue. A winged bull with a goat's head, upright. *MJBK* 1911, pl. B2.

215 Paris, BN, *Pauvert* 38, pl. 4, from Rome. (C). A winged bull with a goat's head. See *Pl. 923*.

216 *Munich* i, 253, pl. 30. (A). A seated griffin. *MJBK* 1910, pl. B8.

217 Teheran, from Persepolis. Clay impression. A bull with head turned frontal (?). *Persepolis* ii, seal no. 70.

218 Teheran, from Persepolis. Clay impression. A rearing bull. Ibid., no. 71.

219 Teheran, from Persepolis. Clay impression. A running dog. Ibid., no. 75.

THE CAMBRIDGE GROUP

220 Cambridge. Persian horsemen hunt a lion and a boar. See *Pl. 924*.

221 Athens, Num. Mus., *Karapanos* 626, pl. 8. (C). A Persian spears a boar. See *Pl. 925*.

222 London WA 120326. Blue (C). A Persian horseman shoots at a goat. See *Pl. 927*.

223 Paris, BN M4903, 1097*bis*. Blue (C). A replica of the last. *Rev. Num.* ix, pl. 8.6.

224 Paris, Louvre A1241. Blue. A Persian horseman spears a boar. See *Pl. 926*.

225 Jerusalem, German Inst., from Jaffa. Yellow. A Persian horseman spears a lion. Inscribed in Aramaic. Galling, pl. 12.145.

226 Paris, Louvre A1242. Tabloid. Blue. See *Pl. 929*.

227 Leningrad 428, from Kerch. A Persian shoots from a quadriga. See *Pl. 928*.

228 Paris, BN 1093. Blue (C). Two bears and a snake. See *Fig. 300*.

229 London, Erskine Coll. (C). A dog faces a boar.

230 *Munich* i, 231, pl. 25. Blue. A Persian hero fights a goat. von Duhn, fig. 4.

231 Paris, Louvre A1243. Blue (C). A Persian hero fights a winged goat. See *Pl. 930*.

THE WYNDHAM COOK GROUP

232 Paris, *de Clercq* ii, pl. 5.103, from Cyprus. Blue (B). A seated lion.

233 Leningrad 587. (A). A seated dog. See *Pl. 931*.

234 Paris, BN M5908. (A). A lion walking. See *Pl. 932*.

235 *London* 535, pl. 9. Cornelian (A). A lion with head turned back. *AG* pl. 64.16; Lippold, pl. 86.5.

236 *London* 537, pl. 9. A lion attacks a bull. See *Pl. 935*.

237 *London* 540, pl. 9, from Greece. Cornelian (A). A lion attacks a stag.

238 *Berlin* (East) F 308, pl. 6, from Athens. (A). A lion attacks a stag. *AG* pl. 11.22; Lippold, pl. 85.7.

239 New York L 45.55.16. Blue. A griffin tears the hind legs of a deer. See *Fig. 301*.

240 Taranto 5370, from Monteiasi. Cylinder on a gold chain. A lion attacks a stag. See *Pl. 933*.

241 Oxford 1925.134 (formerly Wyndham Cook Coll.). Prism. Blue. See *Pl. 934*.

242 Once von Aulock. Prism. 1. Heron scratching its head. 2. Running stag. 3. Foxes couple. 4. Cock treads hen. *Arch. Or.* pl. 30.4–8.

243 Oxford 1925. 135. Rock crystal. (A). A dog attacks a stag. See *Pl. 936*.

244 *Munich* i, 36, pl. 5 (as prehistoric). Cornelian, cut on the back. A replica of the last; perhaps not ancient.

245 Rome, Mus. Naz. 50588. A dog attacks a boar. *Rend. Pont. Acc.* xxx–xxxi, 226, fig. 18.

246 Oxford 1892. 1538. (A). A fallen deer. See *Pl. 937*.

247 Oxford 1892. 1543, from Piraeus. Blue (A). A bitch seizes a hare. See *Pl. 938*.

248 Syracuse. A deer standing.

249 *New York* 113, pl. 19. A kneeling antelope. *Hesp.* Suppl. viii, pl. 36.4.

250 Paris, BN 1047. As the last. Richter, *Engr. Gems* no. 431.

251 Oxford 1892. 1471. Blue (A). A running antelope.

252 Oxford 1921. 1242, from Persia. Blue (C). A running antelope. See *Pl. 939*.

253 Oxford 1921. 1240. Blue (A). A running stag.

254 *New York* 109, pl. 19. A stag.

255 *Berlin* F 296, pl. 6, D 199. Scarab. A stag.

256 Oxford 1892. 1469, bought in Smyrna. Blue (A). A stag. See *Pl. 940*.

257 Leningrad 589. Blue (A). A reclining stag. See *Pl. 941*.

258 Leningrad, from Kerch. A stag. *AG* pl. 11.25; Maximova, *Kat.* pl. 1.13.

259 *Berlin* F 297, pl. 6, D 173, bought in Smyrna. Cornelian scarab. A stag.

260 *Munich* i, 282, pl. 33. Blue. A grazing stag. *MJBK* 1951, pl. 3.7.

260bis. Bonn, Müller Coll. A stag scratching its muzzle.

261 Oxford 1892. 1472. (A/C). A horned deer suckles a fawn. See *Pl. 942*.

262 Cambridge. Cornelian, high sides, flat back. A running goat.

263 *Munich* i, 279, pl. 32. (A). A running goat. *MJBK* 1951, pl. 3.9.

264 *Munich* i, 281, pl. 33. A running goat. See *Pl. 943*.

265 *Baldwin Brett Coll.* 134, pl. 12. A running goat.

266 *New York* 120, pl. 20. Blue. A ram. *Hesp.* Suppl. viii, pl. 36.2.

267 Ackermann Coll. A goat. Pope, *Survey* pl. 124T.

268 Moscow. Two goats' foreparts joined. Zaharov 110, pl. 3.

269 Oxford 1921. 1224. (A). A boar's head. See *Pl. 944*.

270 Paris, Louvre A1234. Blue (C). A running boar. See *Pl. 945*.

271 *London* 551, pl. 10. Cornelian, cut on the back. A running boar.

272 Boston 27.695. A heron.

273 Indiana 14, bought in Istanbul. A heron. See *Fig. 302*.

274 Ankara, from Alishar. Blue. As the last. *Alishar Hüyük* iii, 92, fig. 90.979a.

275 Boston 01.7564. Two quail. See *Pl. 946*.

276 Teheran, from Persepolis. Clay impression. A heron balancing a jug on its head. *Persepolis* ii, seal no. 67.

THE TAXILA GROUP

On the site see Olmstead, 381f.; Marshall, *Taxila* i (Cambridge, 1951), and for the gems listed here, Young in *Ancient India* i. They are from the Bhir mound.

277 From Taxila. Agate pear-shaped pendant. A lion attacks a stag. See *Fig. 303*.

278 From Taxila. Agate tabloid. As the last, same hand. See *Fig. 304*.

279 From Taxila. Green jasper scaraboid. A running stag. See *Fig. 305*.

280 Bonn, Müller Coll. Chalcedony scaraboid. A lion attacks a stag. See *Pl. 947*.

281 London, Bivar Coll. Obsidian (?). Tabloid. A stag. See *Pl. 948*.

282 Cambridge. From N.W. India. (A). Standing lion. See *Pl. 949*.

283 Cambridge. Mottled brown chalcedony round scaraboid. Man (Greek?) and Persian woman. See *Pl. 950*.

OTHER HELLENISING GEMS

284 London, Bard Coll. (C). Erotes seated on rocks. See *Pl. 951*.

285 *Munich* i, 284, pl. 33, from Caesarea. A horned deer suckles a child. *MJBK* 1951, pl. 3.6.

286 Athens, Num. Mus., *Karapanos* 233, pl. 4. Blue (C). A bitch suckles a child. See *Pl. 952*.

287 *London* 491, pl. 8, from Asia Minor. (A/C) A warship. See *Pl. 953*.

288 *London* 593, pl. 10. (C). Two dolphins, with sketches round one head.

289 *London* 568. (C). Cut on the convex back. Nike slays a zebu. Richter, *Engr. Gems* no. 349. Perhaps not ancient: the choice of a zebu is odd, its tail is a lion's, Nike holds what seems to be a spear, and the large stone (apparently ancient) is not pierced.

290 Oxford 1892. 1480. (A). A warrior. *AG* pl. 12.27.

291 Leningrad 574. Blue (C). Kneeling warrior. See *Pl. 954*.

292 *London* 528, pl. 9, from Sparta. Agate (C). Kneeling warrior with pilos helmet. Left-handed (anathema for a hoplite!) and with oval shield. Lumpy treatment of body but apparently ancient.

293 *Munich* i, 342, pl. 40. Onyx, incomplete. A standing warrior with pilos helmet.

294 Kassel. Blue (A/C). A warrrior in pilos helmet, but in Persian dress. *AA* 1965, 45f., fig. 7.22.

295 *Geneva Cat.* i, 208, pl. 80. (A). A sphinx. See *Pl. 956*.

296 Unknown, from Laconia. Cornelian scarab. A slight version of the last. *AG* pl. 6.69.

297 Athens, Num. Mus., *Karapanos* 464, pl. 6. (A). A sphinx. See *Pl. 955*.

298 Boston 01.7547, from Mycenae. Rock crystal. A griffin. See *Pl. 957*.

299 Dresden. A griffin. *AG* pl. 12.51.

300 Paris, BN, de Luynes 210. Cornelian. (A). A griffin. See *Pl. 958*.

301 Baltimore 42.124. Cornelian scarab, elongated. A griffin. *BFAC* pl. 110. M130.

302 Once Dressel. A wingless griffin with horse's mane. Letters in the field, probably later. *AG* pl. 12.45.

303 Geneva 20497. (A). A griffin attacks a horse. *Southesk* i, pl. 2.B3.

304 Leningrad 591. Blue (C). Lioness and cub. See *Pl. 959*.

305 Munich i, 293, pl. 34. Agate. A lion.

306 Once *Evans* pl. 2.29, from Athens. A deer with heron's head antler. See *Fig. 306*.

307 *London* 545, from Athens. Agate. (A/C). A bull.

308 *Munich* i, 302, pl. 35, from Attalia. Cornelian. A bull.

309 Bowdoin College. A calf. *LHG* pl. B.5.

310 Leningrad 588. (B). A walking goat.

311 Indiana 13, from Ikaria. Blue. A running boar (Greek type).

312 Paris, Louvre AO.1178. (A/C). A grazing antelope. See *Pl. 960*.

313 Paris, BN. Cut on the convex back. Multicorporate deer. See *Pl. 962*.

314 Unknown, from Greece. A goat (ridden by an Eros, added later). *AG* pl. 63.9; Lippold, pl. 29.2.

315 *Munich* i, 274, pl. 32. Blue (B). A goat and a tree. See *Pl. 961*.

316 Bern, Merz Coll. A goat, similar to the last.

317 *Munich* i, 275, pl. 32. As the last.

318 Oxford 1921. 1231. Cornelian with lightly convex face (A). An ibis (?). *AG* pl. 31.8.

319 Unknown. Limestone disc. A bird similar to the last. Sotheby, 23.i.1967, lot 181.

320 *New York* 126, pl. 21. Rock crystal. A quail. See *Fig. 307*.

321 Leningrad, from Kerch. Cornelian scarab. A stag. *ABC* pl. 16.9.

322 *Munich* i, 283, pl. 33. Cornelian ringstone. A stag scratching itself. *MJBK* 1923, pl. B3.

323 *Munich* i, 305, pl. 35. Onyx ringstone. A goat.

324 Oxford 1892. 1473. Pale green-blue stone (A). A stag.

325 Once *Guilhou* 63, pl. 3. Prism (?). A stag and a flower.

326 Boston 03.1013. A seated Persian woman with a harp, and a Maltese dog. On the back, a Persian woman with a bird, and a child. See *Pl. 964*.

327 Paris, BN M6790. Blue (A) cut on the back, not pierced. A racing griffin.

328 Once Arndt. Disc. 1. Heron holding a stone. 2. An ant attacks a locust. See *Fig. 308*.

329 *Munich* i, 394, pl. 45. Cornelian. Disc, as the last. 1. A stag and a tree. 2. A bee. There may be a reference in the devices to Ephesian Artemis.

330 Bonn, Müller Coll., from Greece. Agate round ringstone with convex face. A heron. See *Pl. 963*.

331 *Berlin* F 1012, pl. 12, from Laconia. Cornelian, shape as last but pierced. Summary lion attacking stag.

OTHER STYLES

LINEAR STYLE

332 Paris, BN 1098. Black steatite with a lightly convex face, engraved on both sides. 1. A Persian horseman. 2. A boar. *AG* pl. 12.8, 9.

333 *New York* 128, pl. 21. Black steatite. A hawk.

THE BERN GROUP

These are stones of the group which Maximova describes as Persian work in the west (*AA* 1928, 675, n. 3).

On the horned horses see Bivar, *Journ. Num. Soc. India* xxiii, 314–6; and in general, Babelon, *Les rois de Syrie* (Paris, 1890) xx, xxiii–xxv. They occur on Seleucid and Bactrian coins, and have been associated with stories and descriptions of Alexander's horse Bucephalus.

334 Bern, Merz Coll. Two horsemen hunt a stag and an antelope. See *Pl. 965*.

335 Once Draper. Cylinder. Foot soldiers and cavalry. See *Fig. 309*.

336 Leningrad. Pale orange stone (A). A man with chlamys, shield and spear fights a rearing lion.

337 Cambridge. Pale red all-stone ring. A seated woman with flower. See *Pl. 966*.

337*bis*. Market. A woman dancing.

338 Leningrad. Hemi-spheroid. A woman standing.

338*bis*. Leningrad ΓΛ.93. Spearman with shield.

339 *Munich* i, 278, pl. 32 (as 276), from Athens. Cornelian (A). A running goat. *MKBK* 1951, pl. 3.10.

340 Leningrad. Two stags. See *Pl. 967*.

341 *Munich* i, 276, pl. 32 (as 278). Cornelian ringstone. A grazing goat.

342 Once Maskelyne. Cornelian ringstone. A stag. See *Pl. 968*.

343 Dresden. Cornelian. A lion tears a limb. See *Pl. 970*.

344 Oxford, Eastern Art 1958. 39. A zebu and a seated woman. See *Pl. 969*.

345 Oxford, Eastern Art 1958. 39.VIII, from N.W. India. Dark green jasper (A, shallow walls). A seated woman. Summary.

346 Cambridge, from N.W. India. (A). Standing lion.

347 Unknown, from India. A horseman with spear. *Journ. Num. Soc. India* xxiii, 314–6, pl. 7.3.

348 London WA 120333. High-walled scaraboid. Horseman with cloak and spear. See *Pl. 971*.

349 Oxford 1891. 325, from Egypt. (A/C). Horseman.

350 Paris, BN 1096. Blue (A). A Persian spears a boar. See *Pl. 972*.

351 *Berlin* F 184, pl. 4, D 188, bought in Istanbul. Rock crystal (B). A horseman, with a dog, chases a goat. *AG* pl. 11.5.

352 Paris, Louvre A1240. (A). A horseman spears a stag. See *Pl. 973*.

353 Oxford 1892. 1596, from Ephesus. Jasper. (A). A horseman fights a warrior over the body of another. See *Pl. 974*.

354 London, Bivar Coll. Mottled jasper (A). A horseman chases a lion. See *Pl. 975*.

354*bis* Unknown. Duel. *Liv. Annals* xxiii, pl. 27.5.

355 Paris, BN 1099. Tabloid. A man before a winged centaur. See *Pl. 976*.

356 Neuchatel, Seyrig Coll., bought in Aleppo. Tabloid. Blue. Two animals fight. *Arch. Or.* pl. 31.4.

357 Baltimore 42.460. Tabloid. A lion attacks a goat. See *Pl. 977*.

358 Oxford 1889. 400, from Beirut. Blue (A). A dog(?) attacks a deer.

359 Leningrad 390. Blue (A). A horse and bird.

360 Paris, BN, de Luynes 206. Blue (A). With slightly convex face. A leaping griffin. See *Pl. 978*.

361 Oxford, Eastern Art 1958.39.V, from N.W. India. Dark grey jasper (A). Lion and bucranium(?).

362 Leningrad 393. Blue (A). A winged horse-fish.

363 Leningrad 570. Cornelian. (A, with a convex face). As the last, wing lowered, a fish beside.

364 Leningrad 571. (B). A winged horse-fish and a fish. See *Pl. 979*.

Related to the Bern Group are:

365 Brussels. Jasper cylinder. A horseman pursues two on a camel. Speleers, *Cat. des Intailles* ii, 1458.

366 Neuchatel, Seyrig Coll., bought in Aleppo. Tabloid. Blue. 1. Siren with scorpion tail (compare our *Pl. 721*). 2. Boar. 3. Dog. 4. Fox. 5. Deer. *Arch. Or.* pl. 31.3.

367 Geneva P.846. Cornelian tabloid without bevelled back. 1. Lion with limb. 2. Griffin.

368 Rome, Terme 80647. Chalcedony tabloid. Boar. Richter, *Engr. Gems* no. 516.

369 *Berlin* F 185, pl. 4, D 189. Tabloid. Blue. A horseman fights a warrior. *AG* pl. 11.15.

370 Baltimore 130. Tabloid. Blue. As the last. See *Fig. 310*.

371 New York, Morgan Library. Cornelian cylinder. A horseman fights a warrior. Ward 1055; Porada, *CNES* i, 834, pl. 125.

372 Leningrad 542. Blue (A). A man spears a boar (or bear?).

373 *London* 573. Blue (A). A man spears a boar.

374 Leningrad 413. Blue (A). As the last. See *Pl. 980*.

375 Basel, Dreyfus Coll. Agate (A). A man spears a boar. See *Fig. 311*.

376 Leningrad 595. Cornelian ringstone. A Persian horseman shoots at a stag. Maximova, fig. 16.

377 *Geneva Cat.* i, 147, pl. 60. Blue glass tabloid. Two quadrupeds.

377*bis*. Manchester. Rock crystal scarab. Two quadrupeds.

A GLOBOLO

On 'Indo-Ionian' see Bivar in *Journ. Num. Soc. India* xxiii, 313–6. Several of these stones have unusually small perforations.

378 *New York* 112, pl. 19. Cone. A deer and a snake. *Hesp.* Suppl. viii, pl. 36.3

379 Once *Evans*, 40, pl. 3, from Naxos. A goat. See *Pl. 981*.

380 Bonn, Müller Coll. A goat. See *Pl. 982*.

381 Unknown, from India (?). A deer (?). Bivar, pl. 7.4.

381*bis*. Bonn, Müller Coll. Agate. A running goat.

382 Oxford, Eastern Art 1958.39.III, from N.W. India. Lapis lazuli ringstone (?). A crouching lion.

383 Leningrad 6441. (A). A winged lion. See *Pl. 983*.

384 Oxford 1895. 97. (A). A lion tears a limb. See *Pl. 984*.

385 Unknown, from India (?). As the last. Bivar, pl. 7.5.

386 Cambridge, from N.W. India. Pale greenish chalcedony (C). As the last. See *Fig. 312*.

386*bis*. Unknown. Cornelian. As the last. *Cambridge History of India* i, pl. 33h.

387 Athens, Num. Mus., *Karapanos* 486, pl. 7. Blue (C). A bull.

388 Bonn, Müller Coll. A reclining zebu. See *Pl. 985*.

389 Ankara, from Alishar. As the last. *Alishar Hüyük* iii, 92, fig. 90.979 (as a winged unicorn, Greek).

390 Once *Southesk* ii, pl. 1.P10. Hemispheroid. As the last.

391 Leningrad. Hemi-spheroid. As the last. See *Pl. 986*.

392 Unknown, from India (?). A zebu with human features (?). Bivar, pl. 7.6.

393 *London* 309, pl. 6, from Egypt. (B). A cow suckles a calf. Star above.

394 Oxford 1895. 95, from Sidon. (C). A cow suckles a calf. See *Pl. 987*.

395 *Geneva Cat.* i, 78, pl. 36, from Egypt. (A). A goat.

396 Oxford 1891. 330, from Egypt. Cornelian (C). A running winged quadruped. See *Pl. 988*.

397 Delhi, from Taxila. A zebu and sphinx. *Taxila* pl. 207.3.

398 Delhi, from Taxila. Black agate. A lion; a device above. *Taxila* pl. 207.2 (the device taken for the *nandipada* symbol).

399 Delhi, from Taxila. Clay. A winged bull (?). *Taxila* pl. 207.5.

Compare, perhaps, the square black stamp with columnar handle showing a sea-elephant, with a device as on no. 384; *Proc. Soc. Antiq.* viii, 375, fig. 3.

FINGER RINGS

400 Berlin F 179, pl. 4, from Cyprus. Silver (III). A Persian woman with a cup.

401 London WA, *Oxus* 106, pl. 16. Gold (III). Two bull foreparts as a capital. See *Pl. 989*.

402 London WA, *Oxus* 107, pl. 16. Gold (III). A stag.

403 London WA, *Oxus* 108, pl. 16. Gold (III). A running wingless griffin.

404 London WA, *Oxus* 110, pl. 16. Gold (III). A lion.

405 London WA, *Oxus* 109, pl. 16. Gold (III) circular bezel. A griffin.

406 Teheran, from Persepolis. Gold (III). A stag. *Persepolis* ii, pl. 18, PT 3 60.

407 Oxford 1909. 1091, from Memphis. Silver (III). A winged bull. Petrie, *Palace of Apries* pl. 26g and p. 16.

408 Paris, BN, de Luynes 122. Silver. A Persian woman with a bowl.

409 Munich A1421, from Mersin. Silver (VII). A Persian woman seated. See *Pl. 990*.

410 London WA, *Oxus* 103, pl. 16. Gold (VI). A Persian woman seated. See *Pl. 991*.

411 London WA, *Oxus* 104, pl. 16. Gold (VI). A Persian woman seated with a flower.

412 London WA 119984. Bronze. A Persian with a spear.

413 Baltimore 57.1007. Bronze (VI). A Persian horseman chases a stag. See *Pl. 992*.

414 Once Guilhou, de Ricci, pl. 9.535. Silver. A horseman and a woman.

415 Paris, BN, from Rachmanlij. Gold, circular bezel. A horseman and a woman. Filow, *Duvanlij* (Berlin, 1930) pl. 8.10.

416 London WA, *Oxus* 105, pl. 16. Gold (VI). A royal sphinx, with Aramaic inscription.

417 Moscow. Bronze. A Persian hero fights a lion. Zaharov, 116, pl. 3.

418 *LondonR* 1244, pl. 30. Bronze (VI). A winged horned lion. See *Pl. 993*.

419 *LondonR* 1247, pl. 30. Bronze (VII). A running winged bull.

420.*LondonR* 1245, pl. 30. Bronze (VI). A winged bull. See *Pl. 994*.

421 Istanbul, from Sardis, tomb 381. Gold (VII). A lion. See *Pl. 995*.

422 *LondonR* 1246, pl. 30. Bronze (VI). A lion and a crescent.

423 *LondonR* 1243, pl. 30. Bronze (IX). A dog and an antelope (?).

424 Teheran, from Persepolis. Bronze (IV). A dog and quarry. Very like the last. *Persepolis* ii, pl. 18. PT 5 734.

425 Teheran, from Persepolis. Bronze (IV). A cow and calf (?). *Persepolis* ii, pl. 18. PT 5 808.

426 Munich A2572, from S. Russia. Bronze (VII). A goat and a flower.

427 *LondonR* 1248. Bronze (VII). Joined foreparts of a winged goat and an antelope (?).

428 Impression from Samaria (mid fourth century). Two royal scorpion sirens. Freedman-Greenfield, *New Directions* fig. 39.

There are other, minor Achaemenid rings from a village at Susa, *Mem. Miss. Arch. Iran* xxxvi, pl. 47, bronze and iron, some with relief scenes, and the impression, pl. 50.G.S.960; and from Taxila, *Taxila* ii, 638.

Achaemenid finger ring impressions:

Ur x, pls. 39–42 passim (see above, p. 423); all from pointed bezels except nos. 722, 782, 791, from round bezels, and 783, oval. Nippur. Legrain, *Culture of the Babylonians* (Philadelphia, 1925) nos. 808–44, 970–6, 988, 991, 996–7; mainly pointed bezels, some oval. *Persepolis* ii, pl. 12.50, 51 (Aktaion ?), 52 (Herakles and the lion, not 'wrestlers'), 53; pl. 13.54, 55 (Hermes fastens a sandal, caduceus before him; not 'seated'), 64; pl. 14.66, 68, 69, 72, 76, 77. Susa. *Mem. Miss. Arch. Iran* xxxvi, pl. 50 G.S. 960 (pl. 17.13), G.S. 2249 (hexagonal; from rock crystal prisms ?). The rings with a narrow bezel (III) continue in use in the Seleucid period. Cf. the sealings, *Yale Class.Stud.* iii, pls. 2.4 (with inset crescent ?), 3.

SUMMARY

Comparable Greco-Persian arts:

Metalwork. See especially Amandry in *Antike Kunst* i,

9ff.; ii, 38ff.; *VIII Congr. Arch. Class.* 581ff.; *Arch. Eph.* 1953/4.ii, 11ff.

Reliefs. Akurgal, *Die Kunst Anatoliens* (Berlin, 1961) 167ff., especially fig. 119. The Daskylion reliefs, *Ann. Arch. Mus. Istanbul* xiii–xiv, pls. 1–7; Hanfmann, *BASOR* 1966, 10–13; Akurgal, *Iranica Antiqua* vi, 147ff. In Egypt, showing Greek influence: *Führer durch das Berliner äg. Museum* (1961) pl. 56. The boar hunt on foot on a Xanthos sarcophagus, *Mél. Michalowski* 359, 363, fig. 6.

Coins. I give selected references to Babelon (and others) for motifs mentioned: Hero fighting lion: pl. 116.3 (Syria); 106.8, 9 (Tarsus); 118 (Sidon). Lion-monster: pl. 93.24, 25; 96.28; 100.1 (Lycia). Chariot: pls. 118–121 (Sidon); see Seyrig, *Syria* xxxvi, 52–6. Royal guards: pl. 106.6, 7 (Cilicia). Persian horsemen: pl. 91.9–17 (Cyprus); a good Carian example, *Boston Museum Year* 1966, 35 below. Plunging bulls, including zebu: pl. 112.12–22 (Phoenicia; attacked by lion); 97.12–14 (Lycia); also on East Greek coins, Lesbos, Parion. Bull's capital: pl. 97.4, 5 (Lycia). Combined heads: pl. 124.7, 10, 11 (Phoenicia).

There are many representations of Persians ranging from Greek to Greco-Persian in style. Most Greek are the satrap 'portraits' (pl. 88), the archer on a Carian coin (pl. 91.6), the horsemen on Cilician coins (pl. 106.1, 3, 6, 10). For the crouching warrior, as on our no. 291, see the coin of the satrap Orontas, *BMCIonia* pl. 31.10.

SHAPES AND MATERIALS

Shapes other than scaraboids cut on the flat face are represented in the list above as follows:

Scaraboids cut on the back—nos. 72, 92, 170, 244, 271, 289, 326 (both), 332 (both).

Scaraboids with a lightly convex face—nos. 88, 318, 327, 332, 354, 360, 363.

Cylinders—nos. 13, 17, 39, 40, 48, 51, 56–7, 94–5, 109, 134–6, 140–1, 179, 197, 240, 335, 365, 371.

Tabloids—nos. 68, 113, 119, 120, 124, 150–2, 178, 226, 278, 281, 355–8, 366–70, 377. Cf. the impressions, *Sov. Arch.* 1965.2, 186, fig. 1.7 (deer); *Meidum and Memphis* iii, pls. 35, 36, no. 38 (horseman).

Prisms—nos. 67, 241, 242, 325. Cf. the impression, *Mat. Res.* l, 191, figs. 1, 2 (Persian tests arrow).

Multi-faced—nos. 106, 107.

Scarabs—nos. 14, 23, 98, 167, 255, 259, 296, 301, 321.

Pyramidal stamps—nos. 41–46.

Conoids—nos. 123, 378.

Hemi-spheroids—nos. 116, 338, 390–1.

Ringstones—nos. 322–3, 330–1, 341–2, 376, 382.

Discs—nos. 319, 328–9.

Pear-shaped—nos. 114, 144–7, 277.

Stone ring—no. 337.

Others—nos. 104–5 (biconvex), 148 (bottle-shaped) 262 (weight stamp).

Clay impressions—nos. 55, 111, 217–9, 276.

MATERIALS (other than plain chalcedony, agate, cornelian)
Jaspers—black—nos. 131, 361; green—nos. 279, 345; red—
no. 107; other—nos. 27, 353-4, 365?
Rock crystal—nos. 206, 320, 351.
Onyx—nos. 47, 70.
Others—nos. 45 (haematite), 50 (plasma), 123 (marble),
281 (obsidian ?), 324 (green-blue), 332-3 (black serpen-
tine).
The pear-shaped pendants may be Babylonian in origin.
See Lajard, *Mithra* pl. 16.7.

The history of the scaraboid in Assyrian and Babylonian
glyptic requires more attention. The type with a low
conoid back and sometimes a shallow convex face seems
attested for neo-Babylonian at least. A surprising example
of a domed (C) scaraboid decorated with a Babylonian
'astral' pattern was found at Susa (*Mem. Miss. Arch. Iran*
xxxvi, pl. 50.G.S.2370). Either these simple Babylonian
patterns were still being cut in the fifth century, or the
domed scaraboid, not otherwise demonstrably earlier
than the second half of the fifth century, must also be
derived from a rare Babylonian form. There are other
finds of Babylonian seals in late contexts; e.g., Delaporte,
Louvre, ii, pl. 121.A794, impression on a tablet of Kambyses
period.

Some Achaemenid cylinders and a few stamps (specified)
with subjects related to those of the Greco-Persian gems
and possibly deriving something from them in detail or
composition may be mentioned here:

Boar-hunt on foot, sometimes the hunter has his left
arm wrapped in a cloak, and the boar is in a thicket (as
our no. 141): *Moore Coll.* 105, pl. 11; Berlin, Moortgat,
772, 773, pl. 90; Legrain, *Culture* 987, pl. 60; *Berytus* viii,
pl. 11b; London WA 103005, 89144 (Wiseman, 111) and
cf. 102557, 129570; Oxford, Buchanan, *Cat.* i, pl. 45.691;
Boston 36.207 (Frankfort, *Cylinder Seals* (London, 1939)
pl. 37f); *de Clercq* ii, pl. 3.76 (pyramidal stamp).

Boar-hunt on horseback: *Moore Coll.* 104, pl. 11 (Pope,
Survey pl. 123.0); Berlin, Moortgat, 769, pl. 90; Legrain,
Culture 990, pl. 60; *Munich* i, 251, pl. 30.

Bear-hunt on horseback: cf. *Persepolis* ii, seal no. 34.

Goat or antelope-hunt on horseback: Berlin, Moortgat,
770, pl. 90; Legrain, *Culture* 991, pl. 60 (stamp); London
WA 89507, 89694 (Cullimore, 162).

Lion-hunt on horseback: Oxford, Buchanan, i, pl.
45.688; Drouot, 25.iv.1966, no. 115; London WA 89583
(Wiseman, 108), 130808.

Lion-hunt from chariot: the Darius cylinder; Legrain,
Culture 987, pl. 60 (stamp).

Lion-fights close to Archaic Greek Common Style (see
p. 143): London WA 129596 (*Southesk* ii, pl. 9.Qd.21).

Horseman: Legrain, *Culture* 985, 992, pl. 60.

Persian fights Greek: *AG* figs. 83, 84; *Persepolis* ii, seal
no. 28; *CNES* i, pl. 125.833; London WA 89333 (Wise-
man, 117); Legrain, *Culture* 995, pl. 60 (stamp).

Persian fights other foreigners: Driver, *Aram. Doc.* pl.
23; *Persepolis* ii (see p. 10f.), seal nos. 29, 30; Delaporte,
Bibl.Nat. pl. 28.403; Ward 1048; *Newell Coll.* 453, pl. 31;
London WA 132505 (Ward 1052); Seyrig 163; cf. Legrain,
Culture 986, pl. 60. For these see also Junge, *Klio* Beiheft
xli; Strelkov, *Bull. Iranian Inst.* v, 17ff.; Nagel, *Archiv. für
Orientforschung* xx, 133ff.

Seated women: *Karapanos* 625, pl. 8 (conoid); *de
Clercq* i, pl. 34.385 (*AG* fig. 80); ii, pl. 3.64 (stamp); Lajard,
Venus pl. 1.17; cf. *Oxus* no. 115, 32, fig. 63.

INDEX TO GEMS LISTED IN NOTES TO CHAPTERS V AND VI

Italicised numbers refer to the Greco-Persian stones (Chapter VI)

COLLECTIONS

1003; 465-1002; 466-921; 467-1005; 470-928*bis*; 472-933; 473-649; 476-974; 477-1006; 482-1004; 484-1007; 2648-440; 2649-438.
SOFIA 996–7.
(STRATOS) 918, 969, 988.
SYRACUSE 172, 800, *248*.
TARENTUM 74, 332, 600, 714-8, 734-5, *57, 240*.
(TAXILA) *277-9*.
TEHERAN 23, 157, 181, 202, 203, 267, *217-9*, *276*, *406*, *424-5*.
VIENNA 291, 634, 806, 891, 906.
WURZBURG 722, *172*.

PRIVATE COLLECTIONS (including pieces in old collections, not already listed):
Ackermann 267; Arndt A1410-47; A1411-2; A1419-1; A1468-235; A1483-69; A1486-155; A2468-470; A2470-661; A2487/8-662; A2568-591; A2576-973; 73, 187, *145, 328*; Bard 874, 926, *284*; Bivar *281, 354*; Blacas 145; Brett 265; Bulle 34; Cesnola 142; Chandon de Briailles 84; Cook 99, 691, *71*; Cooke *141*; de Bellesme *45*; de Gobi-neau *12*; Draper *335*; Dressel *302*; Dreyfus 694, 699, 701, 801, *375*; Erskine *229*; Evans 386; *Evaṇs 21-26*; *25-316*; *26-236*; *27-276*; *29-306*; *31-304*; *40-379*; *57-656*; Gordon 683; Guilhou 463, 514, 520, 527, 535, 545, 648, 690, 733, 741, 756, 807, 816, 823, 824, 890, 914, *325, 414*; Gutman 673; Heyl 286; Hirsch 611; Hoek 664; Kempe 613, 652; Kestner 144; Kibaltchitch 889; Maskelyne *342*; Merz 114, 466, 503, 510, 604, 676, 817, *212, 316, 334*; Metaxas 92; Mildenberg 578; Moore *48*; Moretti 658; Morrison *211*; Müller 21, 260*bis*, *280, 330, 380, 381bis, 388*; Naue *87*; Oppenländer 667; Osborne 352; Palmer 675; Petré *364*; Remund 60, *115*; Robinson 237, 240, 359; Ruesch 813, 814; Russell 130, 433; Sambon 413; Sangiorgi *31, 138*; Schiller 575; Seyrig 356, 366; Sieveking 18; Southesk 236, 276, 304, 316, 656, *26, 306, 379*; Velay 167, 243, 461; von Aulock *242*; Warren 132, 583, *211*.

MARKETS:
Athens 395; London 637, 764; Paris *28*; Switzerland 705, *95, 100*.

SUBJECTS

The numbers of the Greco-Persian stones (Notes to Chapter VI) are italicised. Select references are added to the more important subjects on ancient impressions (see pp. 423–24)

Acheloos forepart: no. 164.
Aktaion: *Persepolis* ii, no. 51.
Amazons: nos. 21, 57, 515.
Anahita: no. *109*.
Antelopes: nos *151-2, 226, 249-52, 312, 423, 427* (with goat forepart).
Apollo: nos. 17-8, 20, 477 (head), 282 (with Marsyas).
Arrowhead: no. 668.
Artemis: nos. 152, 392, 473 (on stag), 478, 712 (on stag), 728-9.
Astragal: no. *706*.
Athena: nos. 78, 279, 444, 519-20, 657, 672-3, 730, 741, 781, 810-1, 847, 892, 940, 941; Legrain, no. 1020; *Corinth* xii, no. 1138; head—nos. 411-3, 727, 1020; with giant—no. 489; with Hermes—no. *61*.
Bear: nos. *98, 107, 113, 120, 152, 164, 188, 226-7* (two). See Persians hunting.
Bes: no. 983.
Birds: cocks—nos. 37, 278, 1005-6, *67* (fight), *104, 106, 119* (fight), *120* (fight), *242* (coupling); parrots—no. 361; pelican—no. 503; pigeons—nos. 88, 337; peacock—no. 117; quail—nos. 87, *150, 166, 167-8, 275, 320*; owls—no. 670 (armed), *Rev.Arch.* 1932.i, 42, 71; others—nos. 261, 309, 336, 362-5, 550, 555, 557-8, 699, 705, 761, 861-2, 864, 871, 876, 878-9, 916, 1008, *40-1, 45* (two attack calf), *113, 145, 150, 318-9, 333, 359*; *Agora* x, C20; *Corinth* xii, no. 1114, xv.2, 277, 43; *Fig. 268* (armed). See Eagles, Herons, Women.
Boars and sows: nos. 41, 260, 353, 863, *93-4, 114, 148, 157-8, 197-8, 229, 245, 269* (head), *270-1, 311, 331, 366, 368*. See Persians hunting, Dogs.
Bow: no. 631.
Bucranium: nos. 262, 363-4, 882-3; *Agora* x, C18; Ischia.
Bulls and cows: forepart—nos. 100-1; cow and calf—nos. 35-7, 454-5, 575, 1009, *393-4, 425*; zebu—nos. 354, *91-2, 289, 344, 388-92, 397*; capital—no. *401*; others—nos. 33-4, 96-9, 102-3, 224-5, 246-8, 330, 333, 341, 358, 360, 453, 551, *14-9, 45, 57, 68, 90, 106, 151, 160-1, 178, 190-6, 217-8, 307-9, 387*; *Mat.Res.* ciii, 193. See Lions. winged—nos. *4, 6, 22-3, 207-15, 399, 407, 419, 420*.
Camels: nos. 140, 357, 366, *44* (lion v.), *101, 163, 205-6, 365* (ridden).
Celts: no. *335*.
Centaurs: nos. 65, 294-5, 389, 854 (with woman), 996, *335* (winged, v. man); centauress—no. 174.
Chariots: quadriga—nos. 64, 203, 258, 380-1, *394*; *Persepolis* ii, no. *45*; biga—nos. 200-2, 393, 535, 739, 806, 956; *Persepolis* ii, no. *44*; *Hesp.* Suppl. vii, 83, 56. See Persians, Nike.
Chimaera: nos. 229-30, *335*.
Children: nos. 166, 217 (suckled by deer), 310, 355 (with dog), 793 (suckled by wolf), *46, 144, 326*. See Women.

Club: nos. 536, 631, 762, 868; *Herakleiastudien* pl. 40.3, 4.

Columns: no. 982 (with lion); *Himera* fig. 107 (with bird); *Corinth* xii, no. 1170 (with feline); *Fig. 275* (with dog).

Crab: no. 458.

Danae: nos. 8, 373, 395, 485, 576; *Ur* x, no. 742.

Deer: nos. 356, 365, 515, 617, *20* (with fawn), *68*, *106*, *155–6*, *178*, *241*, *246* (fallen), *248*, *261* (with fawn), *285* (suckles child), *306* (heron head antler), *313* (multicorparate), *358*, *366*, *378*, *381*. See Dogs, Griffins, Lions.

Demeter: no. 10.

Diomedes: nos. 275, 407, 958.

Dionysos: nos. 276, 611?; *Rev.Arch.* 1932.i, 42, 65.

Dogs and bitches: Maltese—nos. 29, 30, 840, 1003, *68*, *102–3*, *107*, *146*, *178*, *326*; *Hesp.* Suppl. vii, 83, *65*; with bone—nos. 136–7, 552; scratching—nos. *106*, *114*; suckles child—no. *286*; v. boar—nos. 112, *158*, *229*, *245*; v. stag—nos. 166, 214, *154–5*, *243–4*, *358*; v. lion—no. 570; v. hare—no. *247*; others—nos. 27–8, 93–4, 135, 222–3, 355, 545, 546, 595–6, 702, 987, 1004, 1010, *21*, *40*, *68*, *88–9*, *106–7*, *119–20*, *123*, *128*, *132*, *162*, *178*, *219*, *233*, *351*, *366*, *423*, *424*; *Himera* fig. 107; *Figs. 266, 275*.

Dolphins: nos. 109, 118, 252 (bird v.), 537 (lion v.), 708, 831, 844, 868, 944 (ridden), *288*; *Rev.Arch.* 1932.i, 42, 72.

Eagles: with snake—nos. 89–90; with hare—nos. 328, 704; with fawn—nos. 91–2, 414, 910; with wreath—no. 245; with dolphin—no. 708; with thunderbolt—no. 858.

Elephant: no. 667.

Eros, erotes: flying—nos. 244, 468–9, 790, 799, 801, 838, 850; Legrain, no. 1015; on dolphin—no. 532; reads—no. 821; with bow—nos. 368, 615 (in shell), 655 (lesson), 661, 822, 948, 1039–40; on altar—nos. 641, 820; at tomb—no. 656; with thymiaterion—nos. 752, 789; with torch—nos. 656, 823, 827; with thyrsos—nos. 824–5, 849; with dog's body—no. 995; wrestling—no. 1028, Ischia; with Nike—no. 1030; others—nos. 145 (with shell), 285 (with goose), 286 (with bird), 585, 595, 620–1, 662, 826, 880, 945–7, 949, 955, *62*, *284*, *314*; *Corinth* xii, nos. 1196, 1139; *Fig. 267* (bound to trophy); *Hesp.* Suppl. vii, fig. 48.18; *Fig. 272*. See Women.

Erotostasia: no. 484.

Fish: nos. 517, *363–4*.

Flowers: nos. 794–5, 871, 979, 981.

Footprint: no. 881.

Foxes: with grapes—nos. 95, 703; with bird—nos. *106*, *120*; with locust—no. *113*; coupling—nos. *123*, *242*; others—nos. *107*, *114*, *119*, *123*, *133*, *182*, *185*, *226*, *241*, *366*. See Persians hunting.

Frog: no. 190.

Giant: no. 158. See Athena.

Goats: nos. 39–40, 45, 104, 220–1, 231, 259, 318, 440 (two with kantharos), 909, 978, 984–5 (with herm), *99*, *100*, *106–7*, *114*, *152*, *178*, *183*, *199–203*, *204* (human face), *226*, *262–5*, *267*, *268* (two foreparts), *310*, *314–7*, *323*, *339*, *341*, *379–80*, *381bis*, *395*, *426–7*. See Lions, Persian hero and Persians hunting.

Goat-sphinx: no. 7.

Gorgoneion: nos. 25, 283, 309, 382, 630, 758, 870.

Grapes: no. 763.

Greeks (on Greco-Persian stones): v. Greek—nos. *54–5*; others—nos. *52*, *53*, *66–7*, *107*, *118*, *290–4*, *335–6*. See Persians.

Griffins: v. stag—nos. 116, 233, 258, 346, 347, 999, 1000, *43*, *85–6*, *303*; v. horse—nos. 234, 242 (horse head), 539; v. lion—nos. 568–9; with limb—no. *239*; others—nos. 42–4, 48?, 80, 113–5, 134, 235, 311–7, 319, 327, 402, 446–8, 505, 808, 855, *37–8*, *84*, *215*, *298–302*, *327*, *360*, *367*, *403*, *405*; *Ordona* i, pl. 42.2, 6.

Hades and Persephone: no. 11.

Hand: no. 859.

Hares: nos. 707, 869, *247*.

Heads: men—nos. 1–3, 5, 49, 54, 148, 382, 417–22, 477, 490, 506, 698, 759, 832, 846, 918–22, 991 (in shell), 1013–9, *68*; women—nos. 6–7, 66–7, 149–50, 416, 423–31, 460, 508–12, 592–4, 602–3, 628, 636, 651–3, 674–5, 695–7, 711, 753–7, 792, 796, 798, 833–4, 845, 867, 875, 917, 1021–5; negro—no. 507; negress—no. 147; horned—no. 629; joined with animal—nos. 4, 990, 993; joined human—nos. 604, 989, 1043; Ur and Nippur impressions; *Figs. 271, 313*.

Herakles: v. lion—nos. 146, 159, 438, 957, *42*, *62*, *Figs. 278*, *314*; *Persepolis* ii, no. 52; *Ur* x, nos. 747–8; head—no. 726; by tree—nos. 432, 782; crowned by Nike—no. 738; v. hydra—*Rev.Arch.* 1932.i, 42, 63; with tripod—*Agora* x, C6A; with Typhon—*Mat.Res.* ciii, 192; with snakes—ibid.; others—nos. 73–4 (lion head), 350, 371, 559, 612, 643, 851, 901, 907, 959–60; *Rev.Arch.* 1932.i, 42, 62; *Himera* fig. 107.

Hermaphrodite (?): no. 274*bis*.

Hermes: nos. 479, 534, 733, 962–6, 1026, *41*, *61* (with Athena), *68*; *Persepolis* ii, no. 55; *Hesp.* Suppl. vii, fig. 48.1 (carries Dionysos); *Fig. 277* (crowned by woman).

Herms: nos. 123, 303, 308, 595, 606, 983–6, 1034; *Rev. Arch.* 1932.i, pl. 4.2; *ADelt* xiii, par. 32, fig. 3.

Herons (any water birds): nos. 51–2, 70, 82–6, 126–32, 143, 166, 172, 182, 187 (with bow), 188 (with antlers), 189–96, 252 (v. dolphin), 338, 344–5, 501, 504, 596, 872, 908, 1007, *120*, *150*, *241–2*, *272–4*, *276* (with jug), *328*, *330*. *Arch.Viva* i, 2, 141f. See Women.

Hippocamps: ridden—nos. 162, 437; winged—nos. 804, 805, *362–4*; others—nos. 162, 437, 449, 807, 831; *Ordona* i, pl. 42.1. See Thetis.

Horses, mares, mules: head—no. 242; winged—nos. 197, 911, 913; *Corinth* xii, no. 1195; *Hesp.* Suppl. vii, fig. 48.15; mare and colt—nos. 401, 456, 572; others—nos. 31–2, 38, 56–7, 59–63, 198–9, 300–1, 323, 398–400, 488, 856, 890, 899, 997, *13*, *51*, *56*, *189*, *359*; *Ur* x, no. 767 (multicorporate ?); *Himera* fig. 107; *Fig. 279*. See Griffins, Horsemen, Lions, Persians.

Horsemen: nos. 57–8, 436 (Persian), 491–2, 515, 885, 888, 923, *335*, *347–9*; *Rev.Arch.* 1932.i, 42, 69; with woman—nos. 886–7, *414–5*; v. stag—nos. *334*, *352*; v. antelope—

no. *334*; v. goat—no. *351*; v. man—nos. *353, 369–71*; v. lion—no. *354*; v. camel-riders—no. *365*. See Persian horsemen.

Hunters: nos. 970, *372–5* (v. boar); *Ur* x, no. 750. See Persians hunting.

Hyenas: nos. *106, 113, 120* (wounded), *123, 151, 152, 226*.

Insects: nos. 105, 107, 189, 240, 263, 324, 596, 841, 857, *182, 328–9*. See Locusts.

Iunx-wheel: nos. 600, 620, 838.

Kassandra: nos. 265, 597, 930.

Kastor: no. 386.

Kore: nos. 637, 683, 812–3, 860, 927, 1041.

Kybele: nos. 471, 663; *Samaria* iii, pl. 15.43.

Leda: no. 627.

Lions, lionesses: chariot—no. 471; winged—nos. 47–8, *383*; on column—no. 982; two on altar—*Fig. 264*; with spear—nos. 321, 326, 339, 340; with club—nos. 536, 762; with shield—no. 1001; with animal head—nos. *105, 361*; with cub—no. *304*; v. stag—nos. 110, 231–2, 258, 342–3, 359, 538, 540, 542–3, 998, *186, 237–8, 240, 277–8, 280*; v. dolphin—no. 537; v. bull—nos. 111, 318, 322, 541, *187, 236*; v. goat—nos. 353, *357*; v. griffin—nos. 568–9; v. camel—no. *44*; v. horse—no. *82*; v. man—nos. *336, 417*; with limb—nos. 249, 320, 571, *80–1, 343, 367, 384–6*; as hoplite—no. *83*; others—46, 133, 142, 144, 226–8, 250–51, 257–8, 325, 331, 439, 442, 450–2, 457, 470, 554, 570, 573–4, 760, 900, 1002, *42, 73–9, 107, 109, 115–6, 119, 150–2, 165, 184–5, 232, 234–5, 282, 305, 346, 382, 398, 404, 421–2*; *Ordona* i, pl. 42.3; *Corinth* xv. 2, 277.15. See Herakles, Persians hunting, Persian hero.

Lion-griffins: nos. *2, 29–36, 87, 418*. See Persian hero.

Lizards: nos. *113, 241*.

Lobster: no. 898.

Locusts: nos. 52, 105, 106, 138, 224, 238–9, 278, 556, *113, 150, 328* (v. ant).

Loomweights: *Corinth* xii, nos. 1129, 1145; *Fig. 265*; *Ann.d'I.* 1872, pl. M.f.

Love-making: nos. 185, *69, 177–8*.

Lyre or kithara: nos. 307, 309; *Hesp.* Suppl. vii, 83, 66.

Maenads: nos. 273, 410, 493–4, 521–2, 564–5, 581, 589–91, 719, 737, 751, 828–9, 904, 931; Legrain, no. 1004.

Masks: nos. 797, 866.

Medusa: no. *42*. See Gorgoneion.

Men (on Greek gems and rings): standing—nos. 23, 75 (athlete), 124 (boxer), 180–1 (with girl), 434, 486 (athlete), 561–2, 611, 961, *Rev.Arch.* 1932.i, 42, 68 (boxer); seated—nos. 76–7, 125 (with harp), 280 (with kithara), 281 (with harp), 372 (athlete), 405 (on amphora), 406, 533*bis* (with strigil), 787–8 (with lyre), 839 (on altar), 853 (girl on lap), 954–5 (girl on lap), 1042, *Ur* x, nos. 739–41 (with lyre), *Agora* x, C6B (girl on lap), *JIAN* viii, pl. 9.18 (girl on lap); *Fig. 276* (girl on lap); seated on rocks—nos. 292, 596, 874, 952–3; kneels—nos. 169, 278, 517; runs—no. 441; with astragaloi—nos. 165 (two), 659 (with woman); with horse—no. 301; Persian—nos. 142, 151, 516 (tests arrow); milking ewe—no. 475; fishing—no. 476; old man—nos.

277, 714 (with dog); with torch—nos. 387, 644; crowns youth—no. 649; rides dolphin—no. 944.

Monkey: no. 476.

Monsters: nos. 415 (centaur-lion), 914 (cock-horse), 253 (dolphin-man), 554 (griffin-cock), 74 (lion-headed man), 81 (sea serpent), 994 (serpent sphinx), 204 (tusked animal).

Muse: no. 367.

Nike (and unidentified winged women): flies—nos. 465–7, 500, 595, *Corinth* xii, no. 1104; with astragaloi—no. 170; crowns man—no. 852; crowns woman—no. 171; crowns Herakles—no. 738, *Rev.Arch.* 1932.i, 42, 64; crowns Zeus—no. 809; with trophy—nos. 264, 618, 664, 767, 803, 1031, *Ur* x, no. 738, *JIAN* viii, pl. 10.2 (carries trophy; and Oxford); *Fig. 263*; in quadriga—nos. 377, 379, 435, 802; in biga—nos. 378, 626; holds Eros—no. 1030; with thymiaterion—nos. 385, 685, 815–6, *Herakleiastudien* pl. 40.2, *Corinth* xii, no. 1141, xv, 2, 277, 42; with altar—no. 785; binds sandal—nos. 525, 721; kills deer—no. 617; with aphlaston—no. 660; with caduceus and bird—no. 715; naked, on basin—no. 369; on capital—no. 716; others—13, 463, 583, 619, 684, 694, 713, 749, 750, 766, 768, 783–4, 786, 848, 896, 905, 942–3, 1032–3, *289*.

Nut: no. 121.

Odysseus: nos. 153–5.

Omphale: nos. 370, 639, 731.

Orestes slays Klytaimnestra: no. 650.

Palmette: nos. 474, 547–8.

Pan: nos. 351–2, 445, 973, 975, *Corinth* xii, no. 1112; female Pan—no. 173.

Penelope: nos. 461, 480–1, 524, 894.

Perseus: no. 734.

Persians: nos. 141, 151, *106–7, 108* (three), *111, 123, 125, 127, 147, 175–6, 294, 338bis, 412*; bowmen—nos. 8, 9, 11, 58, 67, *106–7, 126, 145*; tests arrow—nos. 516, 145, *Mat.Res.* l, *191*; faces goddess—no. 109; with woman—nos. 110, 144, 149, 174, *283*; in chariot—nos. 12, 72, 227.

Persian hero; v. lion-griffin—nos. *1, 39*; v. goat—nos. *142, 230*; v. winged goat—no. *231*; v. lion—no. *417*.

Persian hunter on foot: v. deer—no. *10*; v. lion—no. *40*; v. Greek—nos. *47–8*; v. boar—nos. *51, 128, 141, 221*; v. bear—no. *140*.

Persian hunter or warrior on horse: no. *331*; v. Greek—nos. *49, 50, 71, 117, 119, 120, 122–3*; v. stag—nos. *70, 133, 136, 147, 151, 152, 169, 181, 376, 413*; v. boar—nos. *113, 132, 180, 220, 224, 350*; v. lion—nos. *129, 134, 139, 179, 220, 225–6*; v. bear—nos. *130, 135*; v. fox—nos. *137–8, 143*; v. goat—nos. *222–3*; v. ?—no *131*; chases biga—no. *72*; chases riders—no. *121*.

Persian women: nos. *59–60, 106–7, 110, 112, 144* (with child), *145, 149, 170–4, 283, 326* (with harp), *326* (with child), *337–8, 344, 345, 400, 408–11*.

Philoktetes: no. 161.

Phrixos: no. 800.

Pipes: no. 122.

Priapos: no. 296.

Rams: nos. 396, 475, *266*, *Hesp.* Suppl. vii, fig. 48.16 (head).

Rats (mice): nos. 671 (bound), *150*.

Rhyta: nos. 502, 553, *159*, *Fig. 315*.

Royal siren: no. *3*.

Royal sphinx: nos. *2, 5, 24–5, 28, 416*.

Royal winged bull: no. *27*.

Sagittarius: no. 16.

Sandals: nos. 120, 139.

Satyrs: with woman—nos. 12, 599, 974; with jar—nos. 163, 971, *Corinth* xii, nos. 1109–10; *Fig. 262*; head—nos. 513–4, *Priene* 465, Schefold, *UKV* fig. 12; others—nos. 348–9, 472, 613, 732?, 791, 967, 972, 976, 977 (winged); *Fig. 268*.

Shells: nos. 145, 546, 615, 991.

Shield: no. 382.

Ships: nos. 24, 186, 495, 924, *287*.

Silphion: nos. 86, 616, 980.

Sirens: nos. 175, 310, 614 (monster), 915, 992, *366*.

Skylla: nos. 14, 388, *Herakleiastudien* pl. 40.1.

Snakes: nos. 108, 117, 448, 549 (with bow), 558, *227*, *378*.

Spearhead: no. 669.

Sphinx: nos. 15, 79, 184, 236–7, 284, 390–1 (male), 459 (on capital), 464, 588 (on tripod), 912, 988, 1011, *26* (bicorporate), *295–7, 397*; *Hesp.* Suppl. x, pl. 77.226; *ADelt* xiii, par. 32, fig. 3; *Corinth* xii, no. 1144 (two on altar).

Stags: nos.' 205–16, 217 (with child), 218–9, 329, 332, 334, 397, 473, 700–1, 712, *95–7, 107, 119, 151, 153, 242–4, 253–6obis, 279, 281, 321* (scratching), *324–5, 329, 340, 342, 402, 406*. See Dogs, Griffins, Lions, Persians hunting.

Star: no. 877.

Theseus: and sow—no. 160.

Thetis: nos. 496, 523, 666, 722, 743, 776, 902, 925–6.

Thunderbolt: no. 865.

Tortoise: no. 350.

Tripods: nos. 302, 306.

Triptolemos: *Agora* x, L94.

Trophy: nos. 255, 664.

Vases: nos. 53, 118, 304, 305, 648, 740, 869, *Hesp.* Suppl. vii, figs. 48, 7, 8; *Ann.d'I* 1872, pl. M.f; *Figs. 269, 271, 315*.

Warriors (on Greek gems and rings): nos. 19, 22, 155–7,

256, 387, 408, 443, 560, 897, 897*bis*, 950–1, 968–9; *Persepolis* ii, no. 46; *Corinth* xii, no. 1082; *Ann.d'I* 1872, pl. M.a; *Fig. 273* (with lion).

Winged disc: nos. 35, *13, 21, 26, 40, 56, 185, 227*.

Women, seated: with lyre or harp—nos. 55, 183, 298, 645; with Eros—nos. 288, 487, 527, 580, 600, 607, 609, 640, 646, 654 (*morra*), 720, 723, 736, 748, 769, 771, 773, 932, 933*bis*, Legrain, no. 1005, *Sov.Arch.* 1965.2, 186; suckles—nos. 68 (Eros), 678, 725; balances stick—nos. 270, 647, *Hesp.* Suppl. vii, 83, 59; with balls—no. 69; with tympanon—no. 529; with child—no. 168; with dog—nos. 179, 530; with bird—nos. 271, 291, 498, 676, 681, 720, 723–4, 746–7, 770–2, 779; on ship—nos. 495, 924; with distaff—no. 499; crowns herm—no. 606; with loutrophoros—no. 648; with thymiaterion—nos. 774, 780; on crescent/swing—no. 483; with astragaloi—nos. 625, 659; others—nos. 50, 289–90, 403–4, 462, 482, 497, 526, 528, 579, 582, 588, 595, 608, 679–80, 777–8, 830, 933–4. See Penelope.

Women, standing: dancing—nos. 167, 409, 566, 718, 1029; with Eros—nos. 531, 605, 610, 690, 903; with mask—nos. 297, 658; with heron—no. 383; with basin—no. 384; balances stick—no. 587; with altar—nos. 642, 744; with torch—no. 764 (See Kore); with lyre—no. 287; with thymiaterion—nos. 563, 665, 677, 682, 686–92, 775, 817–8, 842, 935–6, 939, *Ann.d'I* 1872, pl. M.c; goddess on base—no. 9; goddess with cornucopia and torch—no. 693; others—nos. 567, 578, 586, 632–3, 709–10, 717, 735, 742, 745, 765, 814, 819, 843, 893, 906, 928, 928*bis*, 929, 1027, 1036–8.

Women, naked or half-naked, not seated: crouching—nos. 71–2, 176–8, 180–1, 243, 266–9, 374–5, 600, 622, *64*; reclining—no. 518; with bird—nos. 70, 172, 272, 293, 837; crowned by Nike—no. 171; with Eros—nos. 624, 634, 638, 655, 835; stands by basin—nos. 182, 254, 293, 369 (winged), 584, 623, 835; stands with mirror—no. 274; inscribes amphora—no. 376; others—nos. 299, 433, 598–9, 635, 836, 938, *65, 67*; *Fig. 274*.

Zeus: nos. 809, 1012 (Ammon head).

NOTES TO CHAPTER VII

HELLENISTIC GREECE AND ROME

The best study of Hellenistic gems and rings is still Furtwängler's ch. vi, in *AG*. The Hellenistic artists who introduced the style to Rome are well studied and illustrated by Vollenweider in *Die Steinschneidekunst und ihre Künstler im spätrepublikanischer und augusteischer Zeit* (Baden-Baden, 1966), and a study of Italian portrait gems by the same writer is imminent. Signatures of Hellenistic artists are listed in Richter, *Engr. Gems* 18f. (omitting Pazalias, see

ibid., 19; *Enc. dell'Arte antica* s.v.); and for engravers of the period of Alexander see Kaiser in *JdI* lxxvii, 227ff.

AG iii, 148, 161, draws attention to a number of very late scaraboids with early Hellenistic subjects stylistically later than the latest classical scaraboids in our chapter V. Cf. *Munich* i, 353, pl. 41; 360, pl. 42.

Selinus hoard of sealings: *Not.degli Scavi* 1883, 473ff., pls. 4–12.

Cyrene hoard of sealings: *Annuario* xli–xlii, 39ff.; the latest are second century AD.

Seleucid sealings: McDowell, *Stamped and Inscribed objects from Seleucia on the Tigris* (Ann Arbor, 1935); Rostovtseff, *Yale Class.Stud.* iii, 1ff.; Johansen, *Acta Arch.* i, 41ff.

Impressions on lamps: Curtius, *Röm.Mitt.* xlv, 33ff.

Samos amphora handles: see above, p. 424.

Cylinders fall from favour, but there are some four-sided prisms: *London* 608, pl. 10. Amethyst (or blue glass ?). Dancers. *AG* pl. 10.49. *Berlin* F 337, pl. 7, D 116, from Aphrodisias. Cornelian. Two youths; two tripods. *AG* pl. 10.51. *London* 605, pl. 10, from Sicily. Chalcedony. Lion: bull: horse: panther with thyros. And compare examples with Egyptian motifs: Once Robinson. Chalcedony. *AG* iii, 400ff., figs. 207–210, unfinished. Oxford 1892.1409. Eight-sided. Buchanan, *Cat.* i, pl. 63.1047. Perhaps also *Munich* i, 359, pl. 42.

Ring mounts for Hellenistic gem stones: for some typical examples see *LondonR* xlii and pls. 11, 12.

The earlier type of stirrup shaped hoop is used for an 'Indian emerald' without intaglio, from a fourth-century grave near Salonika: *Met.Mus.Bull.* 1937, 290ff.; Segall, *Zur gr.Goldschmiedekunst* (Wiesbaden, 1966) pl. 45 below. Compare too *CR* 1870/1, pl. 6.20; 1880, pl. 3.6.

On Hellenistic portrait rings in general see *AG* iii, 150, 165.

On the Herakleidas ring and Ptolemaic portrait rings see especially Vollenweider in *Mus.Helv.* xv, 27ff.; also Charbonneaux in *Mon. Piot* l, 95ff.; Richter, *Portraits of the Greeks* (London, 1965) 266; and cf. the ring from Egypt with the bust of Berenike II (?) as Artemis, once Hirsch, *Bedeutende Kunstwerke* (Luzern, 1957) pl. 46.89 (Schefold, *Meisterwerke* no. 605); Richter, *Engr. Gems* no. 641 (Arsinoe III ?); *Rev.Arch.* 1968, 245f., fig. 10 (Cleopatra I).

Rings with Isis busts: our *Pl. 1012*; *LondonR* 96, 97, pl. 4.

Some Egyptian rings of Hellenistic type with circular bezels and summary representations of deities are: in gold—Oxford, from Faras, tomb 2782, *Liverpool Annals* xi, pl. 58.5; Segall, *Benaki* (Athens, 1938) pl. 39.149; *LondonR* 117–121, pl. 4; Vernier, *Cat.Cairo* pl. 26.52.295; in bronze—*LondonR* 1308, 1309, 1318. For late Egyptian rings see Schäfer, *Ägyptische Goldschmiedearbeiten* 125ff.

Some special types are gold rings with inset stone intaglios cut to the shape of a head, and gold rings with relief busts. For these see Amandry, *Coll.Stathatos* (Strasbourg, 1953) i, 105f. Compare too the relief portrait rings, noted above, p. 446.

Hellenistic cameos. The best account remains *AG* iii, 151ff., and see the works by Miss Vollenweider, cited above.

NOTES TO CHAPTER VIII

MATERIALS AND TECHNIQUES

MATERIALS

For Pliny there is a translation and good commentary by S. H. Ball, in *A Roman Book on Precious Stones* (Los Angeles, 1950). And for Theophrastus' *On Stones* editions with translations by Caley and Richards (Columbus, 1956) and Eichholz (Oxford, 1965).

A thorough account of materials by G. F. Herbert Smith, *Gemstones* (London, 1950). *Encyclopaedia Britannica* articles are useful. There are several handbooks for the amateur gemmologist, the most practical being C. Ellis, *The Pebbles on the Beach* (London, 1954).

For a detailed account of materials available in Egypt see Lucas-Harris, *Ancient Egyptian Materials* (London, 1962) ch. xvi.

For the Greek Bronze Age see Bielefeld, *Schmuck* (Göttingen, 1968) 24ff.; for stone vases, Warren, *Proc. Preh.Soc.* xxxiii, 37ff., *Minoan Stone Vases* (1970).

AG iii, 383ff. remains the best account of the ancient use of different materials.

For the changing of colours by heat or boiling there is a detailed account in Billing, *The Science of Gems, Jewels, Coins and Medals* (London, 1875) 56ff., 110f.

Additional Notes on Materials

The Greek names given are generally those used by Theophrastus.

STEATITE. See *IGems* 16; Pliny, *Nat.Hist.* xxxvii, 186.

SERPENTINE. On the material of Minoan stone vases see Warren, *KChr.* 1965, 8; *BSA* lx, 155.

ROCK CRYSTAL (κρύσταλλος, ὕαλος, see above, p. 415). For Cretan deposits see Marinatos, *Arch.Eph.* 1931, 158–60. For the use of the natural crystal see our *Pl. 276* and *JHS* lxxxviii, 2.

AMETHYST (ἀμέθυσον, ἀμέθυστος).

CHALCEDONY (ἴασπις). See also Bühler, *Antike Gefässe aus Chalcedon* (Würzburg, 1966).

CORNELIAN or SARD (σάρδιον). On the India trade in cornelian and agate see Arkell, *Antiquity* x, 292–305.

AGATE (ἀχάτης).

ONYX (ὀνύχιον). For examples of Etruscan exploitation of the banding in cutting scaraboids see Zazoff, *ES* nos. 29, 39, 121, 124, 260, 261. A central broad white band across the stone is often preferred and this is the scheme later copied in glass.

JASPER (green— σμάραγδος or πρασῖτις ?; red— οἱματῖτις ?;

yellow— ξανθή (?)

CHRYSOPRASE (ὄμφαξ ?).

PLASMA (πρασῖτις ?).

LAPIS LACEDAEMONIUS (σμάραγδος ?; see *Class.Review* viii, 221f.). For the sources and use see Waterhouse and Hope Simpson, *BSA* lv, 105–7 and above, p. 413. Its use for vases, Warren, *BSA* lxii, 199.

LAPIS LAZULI (σάπφειρος). There is a forthcoming survey of ancient use of the material by G. Hermann (see *Iraq* xxx, 21ff.). Bronze Age use, see p. 413.

HAEMATITE (αἱματῖτις ?).

OBSIDIAN. Renfrew et al., *BSA* lx, 225ff. (240 for Bronze Age seals); *KChr.* 1963, 352.

AMBER (ἤλεκτρος or ἤλεκτρον, *sucinum*). See Strong, *BMCCarved Amber*; Boardman, *Greek Emporio* (London, 1967) 238; Beck, *Gr.Rom. and Byz.Stud.* vii, 191ff.; ix, 5ff.; *IGems* 128, 152 (in Etruria also *Not.Scav.* 1963, 221, fig. 94k). Amber scarabs mentioned, *ABC* 59. Caley and Richards, in their edition of Theophrastus, hold that Greek λυγγούριον (taken to be the petrified urine of lynxes) was amber; see Strong, op. cit., 5. Magnetic properties, Plato, *Timaeus* 80c.

SHELL. *CMS* viii, 143. See *IGems* 136, also for references to use of tridacna shell (adding *AA* 1965, 827ff. (Samos); *Iraq* xxvi, 97 (Kish); Akurgal, *Birth of Greek Art* fig. 105a (Smyrna); *Antiquity* xli, 197ff.); Mallowan, *Nimrud* i, 295, fig. 271.

CORAL (κοράλλιον). See *IGems* 126; *Perachora* ii, 525f.; Boardman-Hayes, *Tocra* (London, 1966) i, 167.

IVORY. For the ancient sources see Barnett, *JHS* lxviii, 1 and *Nimrud Ivories* (London, 1957) 165, n. 1. It was being shipped, perhaps for Greece, at Al Mina (*JHS* lxxxv, 13) and in 677 BC the King of Sidon had a stock of elephant tusks and hides to be seized by the Assyrians (cf. Moscati, *World of the Phoenicians* (London, 1968) 20f.).

GLASS. See Forbes, *Studies in Ancient Technology* (Leiden) v.

FAIENCE. For the Naukratis seals see *AGGems* 161.

PRECIOUS METALS. See Forbes, viii and *Berghau, Steinbruchtätigkeit und Hüttenwesen* (Göttingen, 1967). For tremolo decoration see above, p. 441.

LEAD. Archaic rings, *IGems* 157; West Greek rings, *BSR* xxxiv, 9f.

WOOD. Wormeaten wooden seals: Aristophanes, *Thesm.* 427 (θριπήδεστα σφραγίδια). Eustathius on *Odyssey* i, 150 (used for economy). Schol. Lykophron, *Alex.* 508 (before discovery of κρυφίας σφραγῖδας). Hesychius, s.v. θριπόβρωτος (used by Laconians; first by Herakles, according to Philostephanos).

On Plato's theory of colour and other Greek views see Gaiser in *Synusia* (Fest. Schadewaldt) 173ff.

TECHNIQUES

Emery. On its use for Archaic and Classical sculpture see Adam, *Technique of Greek Sculpture* (London, 1966) 78f.

Modern techniques. Natter, *Traitise de la méthode antique de graver en pierres fines comparée avec la méthode moderne* (London, 1754), is the source of most recent accounts.

Bow drills in antiquity. Vernier, *La bijouterie et la joaillerie égyptiennes* (Cairo, 1907) 62–66, and for cutting wheels, 139f. For three operated by a single bow see Davies, *Rekhmire* (New York, 1935) 49 and pl. 54. In use on an Etruscan scarab, London 645, pl. 11 (Zazoff, *ES* no. 152); and another, a globolo. On perforating beads, Lucas-Harris, op. cit., 42–44; and for the Indian workshop, Mackay, *Journ.Amer.Or.Soc.* lvii, 1–15. For wheel engraving and cutting on glass and stone Charleston's article in *Journal of Glass Studies* vi, 83ff., is most informative.

Grooved pebbles used with a drill (?): Vernier, op. cit., 140, figs. 197–200. There are examples in Oxford from Sidon. It is not clear whether these are trial pieces or guides (used in pairs) for a drill. The grooves are often irregular, occasionally arranged in a star pattern. Even if they have anything to do with drilling it is not certain that they were used by gemsmiths rather than carpenters.

Tubular drill. In Egypt, Lucas-Harris, op. cit., 66f., 423–6. In Bronze Age Greece, Casson, *Technique of early Greek sculpture* (Oxford, 1933) 209ff.; Warren, op. cit.

Running drill. Adam, op. cit., 61ff. on its use and effect.

Unfinished gems: Bronze Age—*CS* figs. 166, 167; *CMS* vii, 156; *CMS* i, 192; *BMQ* xxiii, 109, fig. 3. Archaic and Classical—*AGGems* no. 62, pl. 4; no. 282, pl. 19; our *Pl. 446*. Hellenistic—*AG* iii, 400f. Roman—Rodziewicz in *Mél.Michalowski* 629ff.

Forgeries and late copies. See *Ionides* ch. v for discussion; *AG* iii, 373ff. and Dalton, *BMCEngraved Gems of the post-classical periods* (London, 1915). Two forgeries in rock crystal can be attributed to one hand: Boston 01.7558 (*AGGems* 40, n. 1) and London 542, pl. 9 (these are Richter, *Engr.Gems* nos. 145 and 377).

Lenses. Bronze Age crystal inlays suspected as lenses: *BSA* xxviii, 288; *Ant.Journ.* viii, 329; *PM* iii, 111; iv, 928.

Burning glass. Aristophanes, *Nub.* 766–772. The evidence for the use of lenses is discussed in Blümner, *Technologie* (Leipzig, 1875–87) iii, 297ff. and ibid., 313ff. on Nero's emerald; and by Forbes, *Studies* v, 186f.

GENERAL

P. Zazoff, *Die antiken Gemmen* (1983)—also on Roman and later.

Surveys of literature: M. Maaskant-Kleibrink, *BABesch* 44 (1969) 166–180 (for 1960–1968), 58 (1983) 132–177 (for 1970–1980).

Collections of essays: *Ancient Art in Seals* (ed. E. Porada, 1980); *7000 Years of Seals* (ed. D. Collon, 1997); *Engraved Gems: Survivals and Revivals* (ed. C. M. Brown, 1997); *La glyptique des mondes classiques* (ed. M. A. Broustet, 1997); *Classicism to Neoclassicism* (edd. M. Henig, D. Plantzos, 1999, Fest. G. Seidmann).

MINOANS AND MYCENAEANS

CMS I (1965), Suppl. (1982)—Athens; II. 1–7 (1969–1999) —Heraklion; IV (1969)—Metaxas Coll.; V (1992–3), Suppl. 2 (1996)—smaller Greek colls.; VII (1967)—English colls. (not Oxford); VIII (1966)—English private; IX (1972)—Paris, Cab. Med. ; X (1980)—Switzerland; XI (1988)—smaller European colls.; XII (1972)—New York; XIII (1974)—other American colls. Several *Beihefte* with collections of relevant essays.

General: J. G. Younger, *CMS* Beih. 4 (1991: bibliography to 1990); 5 (1995), relation to other arts. Forthcoming general book by O. Krzyszkowska, *Aegean Seals: An Introduction.*
Early: P. Yule, *Early Cretan Seals* (1980) and *BSA* 78 (1983)— chronology and scarabs; K. Sbonias, *Frühkretische Siegel* (1995); bone and ivory, I. Pini, *CMS* V, Suppl. 1A xvii–xxv; most ivory now identified as hippopotamus; role of Egypt, scarabs, I. Pini, *PACT* 23 (1989) 99–109.
Early Palaces: transition—J. G. Younger, *B.A. Aegean Seals in their Middle Phase* (1993) and in *Aegaeum* 3 (1989) 53–64.
Late Palaces: Talismanic—A. Onassoglou, *Die talismanischen Siegel* (1985).
Ringstones: Y. Sakellarakis in *Greek Offerings* (ed. O. Palagia, 1997) 23–29.
Stylistic groups: J. G. Younger, series of articles in *Kadmos* 21–26, 28 (1982–89) and *CMS* Beih. 3.
Rings: A. Xenaki-Sakellariou, *PACT* 23 (1989) 147–154 and in *CMS* Beih. 3 (1989) and 5 (1995).
Glass: I, Pini, *Jb. Röm.-Germ. Zentralmus. Mainz* 28 (1981) 48–81.
New finds: *CMS* Beih. 1, 3 and 5. Y. & E. Sakellarakis, *Archanes* II (1997) 648–701.
Sealings: Chania—I. A. Papapastolou, *Ta sphragismata ton Chanion* (1977) and E. Hallager, *The Master Impression* (1985). A. Triada—*CMS* II. 6; Zakro—*CMS* II. 7 and J. Weingarten, *The Zakro Master* (1983). *Eadem,* articles in

Kadmos 25–27 (1986–88) and *OJA* 7 (1988), 11 (1992) and 16 (1997, Lerna). M. R. Popham and M. A. V. Gill, *The Latest Sealings from the Palace and Houses at Knossos* (1995). I. Pini, *Die Tonplomben . . . Pylos* (1997).
Manufacture: L. Gorelick, A. J. Gwinett, *Iraq* 54 (1992) 57–64.
Iconography: J. G. Younger, *The Iconography of Late Minoan and Late Mycenaean Seals* (1988), *Bronze Age Aegean Seals* (1993).

GEOMETRIC AND EARLY ARCHAIC

Syria: J. Boardman, in *Insight through images* (Fest. E. Porada, 1986, with P. R. S. Moorey) and *OJA* 15 (1996) 327–340; *AA* 1990, 1–17 (Lyre Players).
Crete: J. Boardman in *Eilapine* (Fest. N. Platon, 1987) 293–297; *Archaiologia* May 1985, 19 (Idaean Cave, ivory).
In Italy: K. M. Phillips, *Parola del Passato* 182 (1978) 355–369 (Murlo); *Atti Colloq. preist./protoist. della Daunia* (1973) 388, pl. 87 (ivory, two lions)
Aegina: I. Pini, *AA* 1987, 424–433. Epidauros: *Ergon* 1976, 116. Dodona: *Ergon* 1968, 44–45. *Paros* (1998) 60, fig. 62 (bone). *Archaiognosia* 6 (1989/90) pls. 6–7 (clay). J. Dörig, *Art Antique . . . Suisse Romande* (1973) nos. 102, 104 (bronze).
Island Gems: S. Lowenstam in *The Extramural Sanctuary of Demeter and Persephone at Cyrene* III (1987, ed. D. White) part I.
Phoenician: A. F. Gorton, *Egyptian and egyptianizing scarabs* (1966)—from Punic and other sites.

ARCHAIC

Cyprus: J. Boardman in *Cyprus and the East Mediterranean* (ed. V. Tatton-Brown, 1990) 44–49; *BSA* 65 (1970) 5–15—rings; *Études chypriotes* XIII (1991) 159–171—Amathus; O Masson, *Centre d'études chypr.* 24 (1995) 7–33; A. Reyes, forthcoming.
Etruscan: and Lydian, J. Spier in *Periplous* (edd. G. Tsetskhladze et al., 2000) 330–335; E. Zwierlein-Diehl, ibid., 397–402. General: (Zazoff, *ES*); W. Martini, *Die etr. Ringsteinglyptik* (1971); I. Krauskopf, *Heroen, Götter und Dämonen auf etr. Skarabäen* (1995).
Phoenician: J. Boardman, *Escarabeos de piedra procedentes de Ibiza* (1984); in *Praestant Interna* (Fest. U. Hausmann, 1982) 295–297—Greek myths; in *Tharros* (ed. R. D. Barnett, 1987) 98–105; in *Eirene* 31 (1995) 62–68—negroes; forthcoming.
Stamps on Boeotian tiles: C. S. Felsch, *AM* 94 (1979) pls. 1–6.
General: E. Walter-Karydi, *Jb. Berliner Museen* 17 (1975) 5–44; J. Boardman in *Greek Art: Archaic into Classical* (ed. C. G. Boulter, 1985) 83–95; J. Spier, *BICS* 37 (1990) 107–120— emblems.
Rings: H. Luschey in *Praestant Interna* (*supra*) 298–305.

NOTES TO EPILOGUE

CLASSICAL

Dexamenos: M. L. Vollenweider, *Rev. numismatique* 16 (1974) 143–148 (gem with cricket).

Phrygillos: E. Zwierlein-Diehl, *Antike Kunst* 35 (1992) 106–117.

Rings: M.-A. Zagdoun in *L'Antre Corycien* II (*BCH* Suppl. 9, 1984) 183–260—bronze, from a cave near Delphi.

GREEKS AND PERSIANS

General: N. M. Nikulina, *Iskysstvo Ionii i Achemenidskogo Irana* (1994)—fully illustrated account, and *Antike Kunst* 14 (1971) 90–106. Discussion in J. Boardman, *Persia and the West* (2000) ch. 5, with references to work from the Persian side by M. C. Root and M. Garrison.

Lydian pyramidal: J. Boardman, *Iran* 36 (1998) 1–13.

Greco-Persian: J. Boardman in *Rev. Arch.* 1976, 45–54.

HELLENISTIC

Archives et Sceaux du monde hellénistique (ed. M.-F. Boussac; *BCH* Suppl. 29, 1996). D. Plantzos, *Hellenistic Engraved Gems* (1999)—comprehensive; and in *BICS* 41 (1996) 115–131, *OJA* 15 (1995) 39–61 (cameos); for cameos also M. Henig, *The Content Cameos* (1990); J. Spier, *J. Walters Art Gallery* 47 (1989) 21–38 (Ptolemaic garnets); H. Platz-Horster, *Niederdeutsch. Beiträge zur Kunstgesch.* 34 (1995) 9–25.

Sealings, classical and later (a selection): from Doliche (Syria) —M. Maaskant, *BABesch* 46 (1971) 23–63; *Studies . . . P. von Blanckenhagen* (1979) pls. 35–6 (amphorae); on loomweights from Nekyomanteion, Acheron—C. Tsouvara-Souli, *Dodone* 12 (1983) 9–43; from Kallipolis (Aetolia)—P. A. Pantou, *Ta sphragismata* (1985); *Röm. Mitt.* 98 (1991) pls. 24–7 (Carthage); *Les Sceaux de Délos* I (M.-F. Boussac), IIA (N. Stampolidis, 1992); M. J. W. Leith, *Wadi Daliyeh* I (1997)— Samaria (12–17, general on sealing).

MATERIALS AND TECHNIQUES

Technologie et analyse des gemmes antiques (ed. T. Hackens, *PACT* 23, 1993); *Gemology and Ancient Gemstones* (edd. M. Greenberg, L. Thoresen, Malibu, 2000)—identity and sources.

Colour in glyptic—J. Boardman, *Jewellery Studies* 5 (1991) 29–31.

Unfinished—A. Krug, *AA* 1997, 407–414.

Good *plaster* impressions are not easily made and only the finest quality dental plaster should be used, very lightly tinted with powder colour to give a hard opaque surface. The natural white is more difficult to view and photograph. The impression can be taken directly from the stone if it is first cleaned thoroughly with dilute soft soap which is allowed to dry on. Otherwise impressions and casts in other materials must be taken, from which plaster impressions may be made. This is necessary when facilities for using plaster on the stone are not available. *Plasticene* (Harbutt's) makes a good impression. The surface has to be smooth (pressed on a polished surface) and is best dusted with talcum to stop the stone sticking. It is usually necessary to help the material into the recesses of deep intaglios by finger pressure, and not rely on a simple downward stamp. Care must be taken that there is no movement of the stone in the plasticene in this process. It can be transported without difficulty and kept for years, although it becomes brittle and is easily distorted in early days. *Guttapercha* takes a good impression but requires more preparation. *Vinogyl* acts like plasticene but has to be set by heating in an oven and sometimes loses definition in the process. *Silicon rubber* makes a quite perfect impression but requires the careful measuring of two liquids and preparation of the stone. And there is *sealing wax*. All these materials yield viewable records of the stone. *Latex rubber*, in various forms, is easy to carry and use, although liquid, and makes a perfect impression but it is transparent and not easily viewable. It shrinks slightly (as does plaster) but this can be corrected in subsequent photography and enlargement. It also tends to pick up pieces of talcum from plasticene if used to make a cast from a plasticene impression (silicon does not). There are other methods. The most complicated and one of the least satisfactory is described in *Museum News* 1966, 49ff. and involves use of molten paraffin, black silicon and a vacuum chamber. The method described in *Peprag. II Kret.Synedr.* i, 278, gives a transparent impression which gives a view never intended for any Greek stone in antiquity. The author has found that the best impressions are made from silicon rubber casts, taken from latex rubber impressions. The casts, which are perfect, indestructible, and reproduce all surface detail including all undercutting on convex stones, can then be used many times to prepare plaster impressions, or can be viewed on their own. Of all these materials, however, only the plaster lacks the surface sheen which is disturbing to the camera.

The same standards should be applied to the photography of impressions as to the photography of relief sculpture. Heavy black shadows may be dramatic, but they obscure outlines and are intolerable, although still commonplace in picture books on gems. Impressions need to be trimmed close to the background level of the impression to avoid shadows cast from the 'walls', but not so close as to misrepresent the shape of the face of the stone. Diffused light together with one major light source give the best conditions. Daylight and a pocket mirror may prove enough. Two major sources of light may catch all outlines but they can produce grotesque double shadows and tend to flatten relief. Obviously, group photography of impressions or stones is not likely to prove very successful.

Photographing the stone intaglios themselves presents different problems. If they are opaque or only little transparent a reflected light off the stone is required from a source as close to the lens as possible so that the stone is only a little tilted and distorted. In practice this distortion could be corrected in printing, with odd effects on other parts of the stone visible, and on any broad areas of deep relief in the intaglio. So it is best avoided: the eye makes the necessary correction and an impression should always be illustrated as well. Direct reflection from the polished background into the lens is not always satisfactory and a twilight effect on the background is best. The same applies to the photography of metal ring bezels. If the surface is dull or mottled a raking light throwing shadows in the intaglio may be used, but the results are imperfect. Light can be reflected vertically on to the stone or ring from a sheet of clear glass held at 45° between camera and object.

If the stone is transparent it can be lit from behind by a source carefully adjusted and directed by a mirror. This requires experience derived from practice and is sometimes impossible if the stone is too convex or mottled in texture. It can properly be used only on ringstones which have no perforations and which in antiquity were mounted with metal foil backing so that they could be viewed by reflected light. Some good photographs of this type can be seen in Miss Vollenweider's *Steinschneidekunst* and Wilkins' photographs in *Ionides*. Transparent stones of the Classical period are generally best not photographed with a back light, which gives undue prominence to the perforation. They may be photographed set on an opaque dark background with reflected light, or perhaps better not at all. The impression is the thing.

ABBREVIATIONS

other than the self-explanatory

AA	*Archäologischer Anzeiger*, in *JdI*.	*CNES*	*Corpus of Near Eastern Seals* (i, the Morgan Library, New York, by E. Porada, 1948).
ABC	S. Reinach, *Antiquités du Bosphore cimmérien* (Paris, 1892).	*Cook*	C. H. Smith and C. A. Hutton, *Wyndham F. Cook Collection* ii (London, 1908).
ABV	J. D. Beazley, *Attic Black-Figure Vase-Painters* (Oxford, 1956).		
ADelt	*Archaiologikon Deltion*.	*CR*	*Compte-Rendu de la Commission Impériale archéologique*, St. Petersburg.
AFRings	J. Boardman, 'Archaic Finger Rings' in *Antike Kunst* x (1967), 3–31.	*CS*	V. E. G. Kenna, *Cretan Seals* (Oxford, 1960).
AG	A. Furtwängler, *Die antiken Gemmen* (Leipzig-Berlin, 1900).	*CVA*	*Corpus Vasorum Antiquorum*.
AGDS	*Antike Gemmen in deutschen Sammlungen*.	de Clercq	*Collection de Clercq*, i, Cylinder Seals, by M. de Clercq and M. J. Ménant (Paris, 1888); ii, Stamp Seals, by L. de Clercq (Paris, 1903); vii.2, Greek and Roman gems, by A. de Ridder (Paris, 1911).
AGGems	J. Boardman, *Archaic Greek Gems* (London, 1968).		
AJA	*American Journal of Archaeology*.		
Ann.	*Annuario della regia Scuola archeologica di Atene*.		
Arch.Eph.	*Archaiologike Ephemeris*.	Delaporte, *Bibl.Nat.*	L. Delaporte, *Catalogue des cylindres orientaux et des cachets assyro-babyloniens, perses et syrocappadociens de la Bibliothèque Nationale* (Paris, 1910).
Arch.Or.	*Archaeologia Orientalia*, in memoriam E. Herzfeld (New York, 1952).		
Arias-Hirmer	P. Arias, M. Hirmer, B. Shefton, *History of Greek Vase Painting* (London, 1962).	Delaporte, *Louvre*	L. Delaporte, *Catalogue des cylindres, cachets et pierres gravées de style orientale, Musée de Louvre* (Paris, 1920–23).
Artamonov	M. I. Artamonov, *Treasures from the Scythian Tombs* (London, 1969).	*Ergon*	*To ergon tes en Athenais archaiologikes Etaireias*.
ARV	J. D. Beazley, *Attic Red-Figure Vase-Painters* (Oxford, 1963).	*Evans*	*Pierres gravées: collection d'un archéologue-explorateur*, Drouot, 8.v.1905.
Ath.Mitt.	*Athenische Mitteilungen*.	*FKS*	F. Matz, *Frühkretische Siegel* (Berlin-Leipzig, 1928).
Babelon	E. Babelon, *Traité des monnaies grecques et romaines* (Paris, 1901–32).	Geneva Cat.	M. L. Vollenweider, *Catalogue raisonnée des sceaux, cylindres et intailles*, i, 1967.
BABesch	*Bulletin van de Vereeniging . . . Antieke Beschaving*.		
BCH	*Bulletin de Correspondance Hellénique*.	*Giam.*	A. Sakellariou, *Les Cachets minoens de la Collection Giamalakis* (Paris, 1958).
Becatti	G. Becatti, *Oreficerie antiche delle minoiche alle barbariche* (Rome, 1955).	*Guilhou*	Catalogue, Sotheby, 12.xi.1937.
Berlin D	E. Diehl, forthcoming catalogue of gems in W. Berlin (1970).	Guilhou, Ricci	S. de Ricci, *Catalogue of a Collection of Ancient Rings formed by the late E. Guilhou*, 1912.
Berlin F	A. Furtwängler, *Beschreibung der geschnittenen Steine in Antiquarium* (Berlin, 1896).	*Harari*	J. Boardman and D. Scarisbrick, *The Ralph Harari Collection of Rings* (1977).
BFAC	*Burlington Fine Arts Club: Exhibition of Greek Art* (London, 1904).	*Hesp.*	*Hesperia*.
BICS	*Bulletin of the Institute of Classical Studies*, London.	IBK	Imhoof-Blumer and O. Keller, *Tier- und Pflanzenbilder auf Münzen und Gemmen* (Leipzig, 1889).
BMC	British Museum Cat. followed by subject, or, for coins, the area.	*IGems*	J. Boardman, *Island Gems* (London, 1963).
BMQ	*British Museum Quarterly*.		
BSA	*Annual of the British School at Athens*.	*Ionides*	J. Boardman, *Engraved Gems: the Ionides Collection* (London, 1968).
BSR	*Papers of the British School at Rome*.		
Bulle	E. Bulle, 'Antike geschnittene Steine' in *Zeitschrift der Münchener Altertums vereins* 1903/4, 1ff.	*IR*	J. Boardman, *Intaglios and Rings* (1975) [now in Malibu].
CMS	*Corpus minoischen und mykenischen Siegel*, ed. F. Matz.	*JdI*	*Jahrbuch des deutschen archäologischen Instituts*.

JHS	*Journal of Hellenic Studies.*
Karapanos	I. N. Svoronos, in *Journal internationale d'archéologie numismatique* xv (1913), 147–84.
KChr	*Kretika Chronika.*
Kraay-Hirmer	C. M. Kraay and M. Hirmer, *Greek Coins* (London, 1966).
Legrain	L. Legrain, *The Culture of the Babylonians* (Philadelphia, 1925).
LHG	J. D. Beazley, *The Lewes House Gems* (Oxford, 1920).
Lippold	G. Lippold, *Gemmen und Kameen* Stuttgart, 1922).
London	H. B. Walters, *Catalogue of the Engraved Gems in the British Museum* (London, 1926).
LondonR	F. H. Marshall, *Catalogue of the Finger Rings, Greek, Etruscan and Roman, in the British Museum* (London, 1907).
London WA	British Museum, Department of Western Asiatic Antiquities.
Louvre, Bj.	A. de Ridder, *Cat. sommaire des bijoux antiques, Louvre* (Paris, 1924).
Mat.Res.	*Materiali i issledovaniya po arkheologii SSSR.*
Maximova	A. Maximova, 'Griechische-persische Kleinkunst in Kleinasien nach den Perserkriegen', in *AA* 1928, 648ff.
Maximova, *Kat.*	A. Maximova, *Antichnie resnie kamni Eremitazha* (Leningrad, 1926).
Middleton	J. H. Middleton, *The Engraved Gems of Classical Times with a catalogue of the gems in the Fitzwilliam Museum* (Cambridge, 1891).
MJBK	*Münchener Jahrbuch der bildenden Kunst.*
Mon.Ant.	*Monumenti antichi.*
Munich i	E. Brandt, *Antike Gemmen in deutschen Sammlungen,* i, Staatliche Münzsammlung, München, i, 1968.
New York	G. M. A. Richter, *Catalogue of Engraved Gems, Metropolitan Museum of Art, New York* (Rome, 1956).
New York, ANS	New York, American Numismatic Society.
Newell Coll.	H. H. von der Osten, *Ancient Oriental Seals in the collection of Mr Edward T. Newell* (Chicago, 1934).
NSc	*Notizie degli Scavi.*
Num.Chron.	*Numismatic Chronicle.*
OJA	*Oxford Journal of Archaeology.*
ÖJh	*Jahreshefte des österreichischen archäologischen Institutes, Wien.*
Oman	C. C. Oman, *Cat. of Rings, Victoria and Albert Museum* (London, 1930).
Oxus	O. M. Dalton, *The Treasure of the Oxus* (London, 1965).
PACT	*Journal of the European Network of the Scientific and Technical Group for Cultural Heritage.*
Pauvert	E. Babelon, *Collection Pauvert de la Chapelle, Intailles et Camées* (Paris, 1899).
PM	A. J. Evans, *Palace of Minos,* i–iv (London, 1921–35), and Index volume, v (1936).
REA	*Revue des Études Anciennes.*
Rev.Arch.	*Revue Archéologique.*
Robinson	Christies, 22.vi.1909; collection of Charles Newton-Robinson.
Röm.Mitt.	*Römische Mitteilungen.*
Ruesch	*Sammlung A. Ruesch, Zurich;* Auktion, Luzern, Galerie Fischer, Aug. 1936.
SCE	*The Swedish Cyprus Expedition* (Stockholm, 1934–).
Selection	A. J. Evans, *Selection of Greek and Roman Gems* (Oxford, 1938).
Southesk	*Catalogue of the Collection of Antiquities formed by James, Ninth Earl of Southesk,* ed. Lady Helena Carnegie (London, 1908).
Thorwaldsen	P. Fossing, *Catalogue of the antique engraved gems and cameos, Thorwaldsen Museum, Copenhagen* (Copenhagen, 1929).
Tzivanopoulos	I. N. Svoronos in *Journal internationale d'archéologie numismatique* xvii (1915) 71.
Vollenweider	M. L. Vollenweider, *Die Steinschneidekunst und ihre Künstler in spätrepublikanischer und augusteischer Zeit* (Baden-Baden, 1966).
von Duhn	F. von Duhn, 'Alcune nuove gemme Greco-persiane' in *Symbolae Litt. . . . J. de Petra* (Naples, 1911).
VTM	S. Xanthoudides, *The Vaulted Tombs of Mesara* (Liverpool, 1924).
Wiseman	D. J. Wiseman, *Cylinder Seals of Western Asia* (London, 1959).
Zaharov	A. A. Zaharov, *Gemmi gosudartstvennogo Istoricheskogo Muzeya* (Moscow, 1928).
Zazoff, *ES*	P. Zazoff, *Etruskische Skarabäen* (Mainz, 1968).
Zervos	C. Zervos, *L'Art de la Crète* (Paris, 1956).

SUMMARY GAZETTEER OF COLLECTIONS

This omits unpublished private collections and collections with only Roman gems. There are very few publications resembling corpora, listing examples from all collections. *CMS* should do this for Bronze Age gems, and see *IGems*, *AGGems* and Zazoff, *ES* for fairly comprehensive Archaic Greek and Etruscan lists. The Notes to our chapters V and VI attempt this for Classical and Greco-Persian gems.

AMSTERDAM. Some Greek, Etruscan and Greco-Phoenician.

ATHENS, British School. Bronze Age and Island gems.

ATHENS, National Museum. Bronze Age gems in *CMS* i. Material from excavations, mainly Archaic from Perachora, Argive Heraeum, Sparta, Dodona, Sunium, and a few other gems, including some from the Stathatos Collection (Amandry, *Coll.Stathatou* i).

ATHENS, Numismatic Museum. Greek and Roman from two private collections, published by Svoronos in *Tzivanopoulos* and *Karapanos*.

BALTIMORE, Walters Art Gallery. See *Archaeology* xv, 121ff.; *W.A.G. Bulletin* xiii, 44, and *W.A.G.Journal* vi, 60ff. Near Eastern in *Iraq* vi, 3ff.

BERLIN. The main collection published by Furtwängler in *Berlin F* is now split, with most of the Greek in the west, being republished by Dr Diehl in *Berlin D*, most of the Roman in the east (Pergamon Museum), where also are the eastern gems published by Moortgat.

BIRMINGHAM, City Museum. *CMS* i, 263–4.

BOSTON, Museum of Fine Arts. Includes the Warren collection published by Beazley in *LHG*, and many other stones. For Bronze Age gems see *AJA* lxviii, 1ff. Uzman Collection, *Bull.Mus.Fine Arts* lxi, 4ff.

BRAURON. Rich find of Archaic gems; see *AGGems* 11f., above, p. 419.

BRESLAU. Bronze Age and Island gems. See *Arch.Zeitung* 1883, pl. 16.

BRUNSWICK, Bowdoin College. See Herbert, *Ancient Art in Bowdoin College* (Cambridge, 1964).

BUDAPEST, National Museum. Few Etruscan, Phoenician and Island gems, to be published in the Museum *Bulletin* (xxix, 3ff., for the Bronze Age gems).

CAGLIARI. Greco-Phoenician from Tharros. Many illustrated in *AG* pl. 15.

CAMBRIDGE, Corpus Christi College. Lewis Collection published by Middleton.

CAMBRIDGE, Fitzwilliam Museum. Bronze Age gems in *CMS* vii. Greek, Etruscan, Phoenician and other Near Eastern, including the Leake Collection, published by Middleton. Near Eastern in *Iraq* xxi.

CHIOS. Finds from Phanai (*BSA* xxxv, pls. 32–3) and Emporio (*Greek Emporio* 237, pl. 95).

COPENHAGEN, National Museum, Greek, Etruscan and Greco-Phoenician.

COPENHAGEN, Thorwaldsen Museum. Published by Fossing in *Thorwaldsen*.

CORINTH. *Corinth* xii, and other finds from excavations reported in *Corinth* and *Hesp.*

CORNETO. Some Greek, many Etruscan.

DELOS. Archaic and later. Few in *EADélos* xviii.

DRESDEN. See *AA* 1898, 64f. and for Bronze Age and Island gems, *Ath.Mitt.* xxi, 217ff., pl. 5.

FLORENCE. Some Greek, many Etruscan.

GENEVA, Musée d'Art et d'Histoire. Includes the Fol Collection (Fol, *Cat.du Musée Fol* ii), Duval Collection (Deonna in *Arethusa* ii, pls. 3–5, 18–19) and Kenna Collection (Bronze Age gems in *CMS* viii). A new publication by Vollenweider is appearing (*Geneva Cat.*).

GÖTTINGEN. Crome in *Nachrichten von der Gesellschaft d.Wiss. zu G.* 1931, 1. A new publication is in hand.

HAGUE, Royal Cabinet of Coins and Medals. See Guépin in *Bull.Vereen.* xli, 50ff.

HAMBURG. Includes the Jantzen Collection, published by Zazoff in *AA* 1963. For the finger rings see Hoffmann-von Claer, *Antiker Gold- und Silber-schmuck* (Mainz, 1968). A new publication is in hand.

HANOVER, Kestner Museum. The Kestner Collection, *AA* 1928, 693ff. A new publication is in hand.

HARVARD, Fogg Museum. Includes much of the D. M. Robinson Collection (*AJA* lvii, 5ff.; *Hesp.* Suppl. viii, 305ff.). Bronze Age gems, see *AJA* lxviii, 1ff.

HARVARD, Peabody Museum. Some Bronze Age gems.

HERAKLION. Finds from excavations in Crete. See excavation reports and *Arch.Eph.* 1907, pls. 6–8. Bronze Age gems and sealings will appear in *CMS*. There are also a few Greek, Etruscan and Roman gems.

INDIANA. *Selection of Ancient Gems from the Coll. of Burton Y. Berry* Indiana Univ.Art Mus.Publ. v (Bloomington, 1965). Some Bronze Age and Greek gems.

ISTANBUL. The old collection is mainly Roman with few Greek. Also the finds from Sardis (*Sardis* xiii.1) and some Archaic from Ephesus.

KARLSRUHE. Diehl and others in *Ruperto-Carola* xx, 3ff.

KASSEL. Bronze Age and Island gems in *Ath.Mitt.* xi, 170ff., pl. 6. Select republication by Zazoff, with later stones, in *AA* 1965, 1ff. A new publication is being prepared.

LENINGRAD. Maximova, *Kat.* (in Russian, with few pictures). Includes the Imperial collection, the Ross collection, the Orléans collection (in Reinach, *Pierres gravées*). The finds from South Russia were published in numbers of *CR*; for those from Kerch see *ABC* and for general references, Minns, *Scythians and Greeks* (Cambridge, 1913). Newer pictures in Artamonov.

LIVERPOOL, City Museum. Bronze Age gems (once Bosanquet) in *CMS* vii and *JHS* lxxxvi, pl. 10. Otherwise mainly Roman stones.

LONDON, British Museum. Greek and Roman Dept.: Greek and Roman gems published by Walters in *London*, the rings by Marshall in *LondonR*. The Bronze

472

Age Greek gems are in *CMS* vii and a new catalogue of the collection, or parts of it, is planned. The Tharros scarabs have been transferred to the Western Asiatic Dept. and will be republished shortly. Western Asiatic Dept.: gems and rings published in Dalton, *The Oxus Treasure*, and by Wiseman. A rich collection of Greco-Persian and Achaemenid gems, and the Tharros material.

LONDON, Sir John Soanes Museum. Mainly Roman, but some Greek and Etruscan. Unpublished catalogue by Vermeule.

LONDON, University College. Some Greek and Roman gems and rings from Egypt. See Petrie, *Objects of Daily Use*.

LONDON, Victoria and Albert Museum. The rings are published by Oman. There are also one or two Bronze Age, Greek and Etruscan gems.

MANCHESTER, University Museum. Finlay collection of Bronze Age (in *CMS* vii) and Island gems.

MICHIGAN. Some Bronze Age gems in *Hesp.* xxiii, pl. 34 passim.

MONTREAL, McGill University. Unpublished catalogue by E. M. Cox.

MOSCOW, Historical Museum. Published by Zaharov.

MUNICH, Staatliche Münzsammlung. Mainly the Arndt collection, but not all the Arndt collection (including pieces published by Bulle and von Duhn) entered the collection, and other gems (reported in *MJBK*) are now missing. A new publication (*Munich*) is in hand. Many pieces were illustrated in Lippold, and the Arndt collection is described in *MJBK* 1951. The collection has record of the Arndt gems whose whereabouts are not now known.

MYKONOS. Some Archaic stones from Rheneia.

NAPLES. Greek and Roman gems. Finger rings in Siviero, *Gli ori e le ambre* (Rome, 1954), and Becatti, *Catalogo* (Rome, 1941).

NEW HAVEN, Yale. A rich Near Eastern collection including now the Newell collection (*Newell*).

NEW YORK, American Numismatic Society. Mainly Etruscan and Roman gems.

NEW YORK, Metropolitan Museum. The Bronze Age gems (Seager collection) will appear in *CMS*; see provisionally Richter, *Catalogue* (1920) and *AJA* lxviii, 1ff. The Greek and Roman gems are published by Richter in *New York*.

NEW YORK, Morgan Library. Cylinder seals in *CNES* i.

NICOSIA. The Bronze Age gems are to be published in *CMS* and elsewhere, and a new publication of the Iron Age gems is planned. For the finds from Swedish excavations see *SCE*. For local styles see Notes, above, p. 420. Rings, *BSA* lxv.

OXFORD, Ashmolean Museum. Bronze Age gems published by Kenna in *CS*. A new publication of the Greek, Etruscan and Roman gems is in hand. For Etruscan and

South Italian finger rings see *BSR* xxxiv, 1ff. Gems from the collections of Spencer-Churchill (*Exhibition of Antiquities*, 1965) and Beazley (*Beazley Gifts 1912–1966*, 1967).

PARIS, Bibliothèque Nationale, Cabinet des Médailles. Some published in *Rev.Num.* ix, pl. 8. The eastern stones are published in Delaporte, *Bibl.Nat.* Other collections, kept separately, are those of Pauvert de la Chapelle (published in *Pauvert*), de Clercq (only the Greek and Roman stones published in *de Clercq*; see *Rev.Num.* 1968, 31ff.) and de Luynes (not published as a collection, but for some Greek and eastern stones see *Arethusa* v, pls. 6–10). There are also stone gems transferred from the Louvre, published by de Ridder (Louvre, Bj.).

PARIS, Louvre. In the Greek and Roman Dept. there are finger rings listed in de Ridder, Louvre, Bj., and the finger rings from *de Clercq*. In the Oriental Dept. the main collection, including some Greek is published in Delaporte, *Louvre*. There are also the eastern stones from *de Clercq* (see *Revue du Louvre* 1968).

PÉRONNE, Hôtel de Ville. The Danicourt collection. Some Greek and Etruscan, but mainly Roman.

PFORZHEIM, Schmuckmuseum. Mainly jewellery and rings. Battke, *Geschichte des Ringes* (Baden-Baden, 1963) and *Ringe aus vier Jahrtausenden* (Frankfurt, 1963).

PHILADELPHIA. In the Classical Dept. the Somerville Collection, published by the collector in *Engraved Gems* (Philadelphia, 1889) and summarised by Vermeule in *Cameos and Intaglios, University Museum* (Philadelphia, 1956). In the Near Eastern Dept. some scarabs, seals and sealings published by Legrain in *Culture of the Babylonians*. Some foreign gems in the Egyptian Dept. Bronze Age gems, see *AJA* lxviii, 1ff.

RHODES. From excavations in the island, published in *Clara Rhodos*.

ROME, Terme Museum. Mainly Roman. Righetti in *Rend.Pont.Acc.* xxx–xxxi, 213ff.

ROME, Villa Giulia. Some Greek, many Etruscan.

SALONIKA. Finds from North Greece, Greek and Roman, and notably from Olynthus (*Olynthus* x).

SAMOS, Vathy Museum. Finds from the Heraion; cf. *JHS* lxxxviii, 9f.

SPARTA. A number of the Artemis Orthia finds; the rest are in Athens or dispersed (mainly London, Oxford, Cambridge).

TARANTO. Some Greek and Etruscan rings, published in *Iapygia* x, 5ff. Also Greek and Etruscan stones.

TORONTO. Some Greek and Roman, including some from the Cook collection. For Bronze Age gems see *AJA* lxviii, 1ff.

VIENNA. Later gems in Eichler and Kris, *Die Kameen* (Vienna, 1927). Some Greek and Etruscan also.

SOME PRIVATE COLLECTIONS (published, intact, or dispersed):

ARNDT. See Munich.

DAWKINS. The Bronze Age gems in *CMS* viii, of which several now in Oxford after sales, Sotheby 11.vii.1967, 29.i.1968 (see *Class.Rev.* 1969, 226). Earlier sales of Island gems were Sotheby i.vii.1957, 19.vi.1961; some in Basel, *Münzen und Medaillen* Sonderliste K.

DE CLERCQ. Published in *de Clercq*, now in Paris, Bibliothèque Nationale and Louvre.

EMMET, Wilton. Bronze Age. *AJA* lxxiii, 33ff.

ERLENMEYR, Basel. Several of the Bronze Age gems published by the collectors in *Antike Kunst* iv and *Orientalia* xxix, xxx, xxxiii.

EVANS. The major part is in Oxford. The gems in *Evans*, sold in 1905, are dispersed. The Greek gems in *Selection* are mainly in New York, Metropolitan Museum and Velay Coll.; others in Baltimore and St. Louis, private.

IONIDES, London. See *Ionides*.

METAXAS, Heraklion. *CMS* iv.

ROBINSON, D. M. See Harvard.

SOUTHESK. Published in *Southesk*. Sold in 1952. Many pieces now in London, WA and Bard Coll., and Geneva (once Kenna Coll.).

SPENCER-CHURCHILL. The Bronze Age gems in *CMS* viii are now in London; the Greek and Etruscan in Oxford (q.v.).

ADDENDA 1970–2000

BERLIN. E. Zwierlein-Diehl, *AGDS* II (1969). (= 'Berlin D' in earlier chapters and lists here)

BLOOMINGTON. *Ancient Gems from the Collection of Burton Y. Berry* (1969).

BOLOGNA. A. R. M. Bizzarri, *La Coll. di Gemme del Mus. Civico Arch.* (1987).

BONN. H. Platz-Horster, *Die ant. Gemmen im Rheinischen Landesmuseum* (1984).

BRUNSWICK. V. Scherf, *AGDS* III (1970).

BUDAPEST. J. Boardman, *Bull. Mus. Hongrois* 32/33 (1969) 7–17.

CAMBRIDGE. Fitzwilliam Museum—M. Henig, *Classical Gems* (1994). Corpus Christi College—M. Henig, *The Lewis Coll. of Gemstones* (1975).

EXETER, Royal Albert Memorial Museum. S. H. Middleton, *Seals, Finger Rings, Engraved Gems and Amulets* (1998)

GENEVA. *Geneva Cat.* II (1976)—portraits, masks, symbols; III (1983)—Kenna coll. etc.

GÖTTINGEN. P. Gercke, *AGDS* III (1970).

THE HAGUE. M. Maaskant-Kleibrink, *Cat. of the Engraved Gems in the Royal Coin Cabinet* (1978).

HANOVER. M. Schlüter, G. Platz-Horster, *AGDS* IV (1975).

KASSEL. P. Zazoff, *AGDS* III (1970).

MALIBU. J. Spier, *Ancient Gems and Finger Rings: J. Paul Getty Museum* (1992). The collection published by J. Boardman, *Intaglios and Rings* (1975) is now in Malibu (numbers prefixed 81. AN. 76.).

MUNICH. E. Brandt et al., *AGDS* I. 1 (1968), I. 2 (1970), I. 3 (1972).

NAPLES. Scarabs—P. G. Guzzo, *Mélanges école française de Rome* 83 (1971) 325–366. U. Pannuti, *Cat. della Collezione Gliittica* I (1983)

OXFORD. J. Boardman, M. L. Vollenweider, *Cat. of the Engraved Gems and Finger Rings* I (1978). B. Buchanan, P. R. S. Moorey, *Ancient Near Eastern Seals* III (1988).

PARIS. Bibl. Nat.—M. L. Vollenweider, *Camées et intailles* I. *Les portraits grecs* (1995).

PÉRONNE. Danicourt Coll.—J. Boardman, *Rev. Arch.* 1970, 3–8; 1971, 195–214.

SOFIA. A. Dimitrova-Milceva, *Ant. Gemmen und Kameen aus dem arch. Nationalmuseum* (1980).

ST. PETERSBURG. O. Neverov, *Antique Intaglios in the Hermitage Collection* (1976); *Antique Cameos . . .* (1971). A new catalogue forthcoming.

TBILISI. M. Lordkipanidze, *Kolchidskie Perstin-pechati* (1975); *Drevneishie Perstin-pechati, Iberii i Kolchidi* (1981)—rings from Georgia.

VIENNA. E. Zwierlein-Diehl, *Die antiken Gemmen des Kunsthistorischen Museums* I (1973), II (1979)—format as *AGDS*.

SOME PRIVATE COLLECTIONS

HARARI. J. Boardman and D. Scarisbrick, *The Ralph Harari Coll. of Finger Rings* (1977)—dispersed.

MERZ. M. L. Vollenweider, *Deliciae Leonis* (1984).

SWITZERLAND. Forthcoming, C. Wagner and J. Boardman.

WIEGANDT. H. Wiegandt, *Charms of the Past* (1998).

Engraved gems frequently appear in auction and sale catalogues, e.g., Christie's and Sotheby's (London and New York), Bonhams (London), Münzen und Medaillen—now J.-D. Cahn AG (Basel), F. Sternberg (Zurich), Numismatic Art and Ancient Coins (Zurich), Nefer (Zurich), Antiqua (Woodlands, California), and others.

INDEX TO GEMS ILLUSTRATED

The references are to plate numbers. References to text figures are italicised. Some sites are listed if the whereabouts of the stones is not known

References are to page numbers. Fuller subject indexes are referred to or given in the Notes. The selective references here are to discussions of the more important motifs, subjects, names and materials not readily traced from the Table of Contents